Guide to Information Resources in Ethnic Museum, Library, and Archival Collections in the United States

Recent Titles in
Bibliographies and Indexes in Ethnic Studies

Annotated Bibliography of Puerto Rican Bibliographies
Fay Fowlie-Flores, compiler

Racism in the United States: A Comprehensive Classified Bibliography
Meyer Weinberg, compiler

Ethnic Periodicals in Contemporary America: An Annotated Guide
Sandra L. Jones Ireland, compiler

Latin American Jewish Studies: An Annotated Guide to the Literature
Judith Laikin Elkin and Ana Lya Sater, compilers

Jewish Alcoholism and Drug Addiction: An Annotated Bibliography
Steven L. Berg, compiler

Guide to Information Resources in Ethnic Museum, Library, and Archival Collections in the United States

Compiled by

Lois J. Buttlar
and Lubomyr R. Wynar

Bibliographies and Indexes in Ethnic Studies, Number 7

Greenwood Press
Westport, Connecticut • London

Library of Congress Cataloging-in-Publication Data

Buttlar, Lois.
 Guide to information resources in ethnic museum, library, and
archival collections in the United States / compiled by Lois J.
Buttlar and Lubomyr R. Wynar.
 p. cm.—(Bibliographies and indexes in ethnic studies, ISSN
1046–7882 ; no. 7)
 Includes bibliographical references and index.
 ISBN 0–313–29846–7 (alk. paper)
 1. Ethnology—United States—Library resources—Directories.
 2. Ethnology—United States—Archival resources—Directories.
 3. Ethnological museums and collections—United States—Directories.
 I. Wynar, Lubomyr Roman, 1932– . II. Title. III. Series.
 Z1361.E4.B89 1996
 [E154.A1]
 305.8′0025′73—dc20 95–39038

British Library Cataloguing in Publication Data is available.

Library of Congress Catalog Card Number: 95–39038
ISBN: 0–313–29846–7
ISSN: 1046–7882

First published in 1996

Greenwood Press, 88 Post Road West, Westport, CT 06881
An imprint of Greenwood Publishing Group, Inc.

Printed in the United States of America

The paper used in this book complies with the
Permanent Paper Standard issued by the National
Information Standards Organization (Z39.48–1984).

10 9 8 7 6 5 4 3 2

Contents

Preface ...ix

Alphabetical Guide to Ethnic Resources

Afghanistan American Resources (*See also* Asian American Resources)1
African American Resources ...1
Albanian American Resources ..33
American Indian Resources (*See* Native American Resources)
Arab American Resources (*See also* Egyptian American Resources)34
Armenian American Resources ...36
Asian American Resources (*See also* Afghanistan American, Cambodian American,
Chinese American, Filipino American, Indian American, Japanese American, Korean
American, Laotian American, Sri Lankan American, Thai American, Tibetan
American, and Vietnamese American Resources) ...45
Austrian American Resources (*See also* German American Resources)53
Basque American Resources ..54
Belarusian American Resources ..55
Belgian American Resources ...56
Black American Resources (*See* African American Resources)
British American Resources ...58
Cambodian American Resources (*See also* Asian American Resources)60
Carpatho-Ruthenian American Resources (*See also* Ukrainian American
 Resources) ..60
Chinese American Resources (*See also* Asian American Resources)62
Croatian American Resources ...68
Cuban American Resources (*See also* Hispanic American and Latin American
 Resources) ..70
Czech American Resources (*See also* Czechoslovak American Resources)71
Czechoslovak American Resources (*See also* Czech American and Slovak
 American Resources) ..76
Danish American Resources (*See also* Scandinavian American Resources)79
Dutch American Resources ...80
Egyptian American Resources (*See also* Arab American Resources)87

Estonian American Resources ...88
Filipino American Resources (*See also* Asian American Resources)89
Finnish American Resources (*See also* Scandinavian American Resources)89
French American Resources ..91
German American Resources (*See also* Austrian American and Swiss American
 Resources) ...99
Greek American Resources ..127
Hispanic American Resources (*See also* Cuban American, Latin American,
 Mexican American, Puerto Rican American, and Spanish American
 Resources) ..130
Hungarian American Resources ...136
Icelandic American Resources (*See also* Scandinavian American Resources)142
Indian American Resources (*See also* Asian American Resources)142
Irish American Resources (*See also* Scotch-Irish American Resources)144
Italian American Resources ..149
Japanese American Resources (*See also* Asian American Resources)154
Jewish American Resources ..157
Korean American Resources (*See also* Asian American Resources)182
Kurdish American Resources ...182
Laotian American Resources (*See also* Asian American Resources)184
Latin American Resources (*See also* Cuban American, Hispanic American,
 Mexican American, Portuguese American, Puerto Rican American, and
 Spanish American Resources) ...184
Latvian American Resources ...186
Lithuanian American Resources ...189
Macedonian American Resources ...198
Maltese American Resources ..198
Mexican American Resources (*See also* Hispanic American and Latin American
 Resources) ..199
Multi-ethnic Resources ...203
Native American Resources ...237
Norwegian American Resources (*See also* Scandinavian American Resources).........265
Polish American Resources ..269
Portuguese American Resources (*See also* Latin American Resources)..................283
Puerto Rican American Resources (*See also* Hispanic American and Latin
 American Resources) ..284
Romanian American Resources ...286
Russian American Resources ..289
Scandinavian American Resources (*See also* Danish American, Finnish American,
 Icelandic American, Norwegian American, and Swedish American Resources)..292
Scotch-Irish American Resources (*See also* Irish American and Scottish
 American Resources)..294
Scottish American Resources (*See also* Scotch-Irish American Resources)294
Serbian American Resources ..296
Slovak American Resources (*See also* Czechoslovak American Resources)297
Slovenian American Resources ..301
Spanish American Resources (*See also* Hispanic American and Latin American
 Resources ...302
Sri Lankan American Resources (*See also* Asian American Resources)309
Swedish American Resources (*See also* Scandinavian American Resources)310

Swiss American Resources (*See also* German American Resources)319
Thai American Resources (*See also* Asian American Resources)........................323
Tibetan American Resources (*See also* Asian American Resources)323
Turkish American Resources ..324
Ukrainian American Resources (*See also* Carpatho-Ruthenian American
 Resources) ..327
Vietnamese American Resources (*See also* Asian American Resources)341
Welsh American Resources ..342

Institution Index ..345

Geographic Index ..355

Preface

Changing population demographics in the United States have led to a recognition and appreciation of the nation's rich variety of ethnic customs, traditions, arts, languages, and literature. Preservation and understanding of each group's cultural heritage and history are directly related to the resources, programs, and services offered at ethnic museums, libraries, archives, and special ethnic collections found in other general cultural and educational institutions. In most cases, resource centers are maintained directly by ethnic communities themselves through historical, recreational, social, fraternal, business, literary, educational, and cultural organizations, including the ethnic press. Some groups have attempted to pass on to their descendants a sense of their ethnic roots and origins through the assembling of cultural artifacts, clothing and costumes, objects of art, and examples of craftsmanship in museums and/or art galleries. Many organizations collect and/or publish books and periodicals related to the ethnic group. Still others maintain archival records that document through personal correspondence, newspaper accounts, census and church records, and other primary sources the group's experience in the United States from first generation pioneers and immigrants who settled the country and developed its industries, to the contributions of their descendants in all walks of life. Also documented is the situation of more recent refugees who have sought asylum from political and economic oppression. Some organizations maintain all of these types of collections, while others maintain only one or two.

These cultural institutions are rich in materials that allow educators, scholars, researchers, interested citizens, genealogists, and information specialists to discover and document information related to each group. Unfortunately, many of the materials housed in these ethnic and other organizations are not indexed by major standard indexing and abstracting services. Researchers are not aware of many of these unique and very valuable resources and, therefore, cannot access or utilize them.

It is important that access be provided to all available information about the groups that comprise American society--especially those fugitive and unknown resources and primary sources held in museum, library, and archival collections sponsored by ethnic organizations or that are contained in major educational institutions or research centers that maintain repositories of an ethnic group's records.

Purpose

Members of ethnic groups gain a sense of identity as they develop a link with their past history and pride in their cultural heritage as they understand how it has contributed to the multicultural mosaic that represents the United States. The purpose of *Guide to Information Resources in Ethnic Museum, Library, and Archival Collections in the United States* is to provide comprehensive and current coverage of the descriptions of these ethnic resources that are authentic sources of information about America's diverse cultural groups. The *Guide* also provides important details about these collections (e.g., their size; type; availability to the public; special features such as guides, reading rooms, and copying facilities; publications issued; and programs and services provided (guided tours, lectures, presentations to schools, loans, exhibits, audiovisual productions, performing arts presentations, in-service programs for teachers, cooperative activities with institutions of higher education, etc.). It is hoped that ongoing requests for additional information can now be more adequately met.

Scope

The *Guide* includes resources representing over 70 ethnic groups arranged in 68 categories, including a multi-ethnic section. The latter category was utilized not only for institutions and organizations which cover several ethnic groups, but also for some selected major research-oriented centers which are not sponsored by ethnic groups or organizations. The latter may also be concerned with various aspects of ethnicity (immigration, urban and social problems, etc.) and ethnic studies programs.

Methodology

Information provided is based on a comprehensive national survey of ethnic and other institutions conducted from 1993-1995. Names and addresses of these organizations and other institutions were identified from the records and previous surveys and publications of the Center for the Study of Ethnic Publications and Cultural Institutions, School of Library and Information Science, Kent State University, as well as from the latest editions of the *Official Museum Directory*, the *Encyclopedia of Associations, Subject Collections: A Guide to Special Book Collections and Subject Emphases as Reported by University, College, Public, and Special Libraries, and Museums in the United States and Canada* (by Lee Ash), *Directory of Special Libraries and Information Centers*, and *Directory of Archives and Manuscript Repositories in the United States*.

Questionnaires were mailed to 2,340 ethnic organizations to determine whether they had ethnic museum, library, or archival collections and to institutions of a non-ethnic nature known to have extensive holdings related to a particular ethic group or groups. Institutions with modest, but important, collections related to some of the smaller or newer ethnic groups were also included in the survey. With respect to very large groups, such as African Americans and Native Americans, however, inclusion was more selective. Final content coverage of the *Guide* was also dependent on the return

of the questionnaire by the ethnic group or organizational members. Respondents provided information on approximately 676 of the 786 entries; approximately 14% of the entries were constructed from records of the center and other secondary sources.

Arrangement

Institutions are arranged in alphabetical order under 68 categories. These include 62 individual ethnic group categories as well as the multi-ethnic category and other categories which represent clusters of ethnic groups, i.e., Asian American Resources, Czechoslovak American Resources, Hispanic American Resources, Latin American Resources, and Scandinavian American Resources. Complete entries provide information in the following sequence:

1. Name of cultural institution
2. Type of institution (museum, library, archives, art gallery)
3. Address
4. Telephone number
5. Fax number
6. Sponsoring organization
7. Personnel
8. Contact person
9. Date founded
10. Scope
11. Availability (Open to public, hours, Not open to public, Open by appt. etc.)
12. Admission (Free, fee, donation)
13. Visitors (General public, School groups, Ethnic community)
14. Staff (full-time, designated ft; part-time, designated pt; volunteers)
15. Operating budget
16. Publications
17. Collection
18. Comments (brief annotations based on the official statement given in the questionnaire, or, in some cases, published in the institution's official publication or descriptive brochure).

Indexes

An institutional index lists all of the institutions alphabetically by name. It is followed by a geographic index which lists institutions alphabetically first by state and then by city. The Contents serves as a subject index.

Alphabetical Guide to
Ethnic Resources

A

AFGHANISTAN AMERICAN RESOURCES

(*See also* Asian American Resources)

AFGHANISTAN STUDIES ASSOCIATION Library
 c/o Center for Afghanistan Studies
 University of Nebraska at Omaha
 ASH 238
 Omaha, NE 68182-0006 402-554-2901; Fax 402-554-3242

Contact: Thomas E. Gouttierre, Secy. of Exec. Comm.
Founded: 1971; Scope: National
Availability: Open to the public; Admission: Free
Visitors: General public, Ethnic community

Collection: 10,000 books and periodicals

Comments: The association promotes research and study of Afghanistan and also helps
Afghanistan American scholars. Services include a speakers' bureau.

AFRICAN AMERICAN RESOURCES

AFRICAN AMERICAN COLLECTION Library
 Hillman Library
 University of Pittsburgh
 Pittsburgh, PA 15260 412-648-7714

Sponsoring organization: University of Pittsburgh
Contact: Pearl Woolridge
Scope: National
Availability: Open to the public; Admission: Free
Visitors: General public
Staff: 2 ft, 1 pt; Operating budget: $25,000

Collection: 17,000 books and periodicals. The collection is cataloged; copying
facilities are available.

Comments: The purpose is to serve undergraduates, as well as to provide materials that
support the academic curriculum and document the African American experience.

AFRICAN AMERICAN MUSEUM <u>Museum</u>
(Formerly Afro-American Cultural and Historical Society Museum)
 1765 Crawford Rd.
 Cleveland, OH 44106 216-791-1700

Contact: Joyce Morrow Jones, Exec. Dir.
Founded: 1953; Incorporated: 1960; Scope: Local
Availability: Open to the public; Admission: Fee
Visitors: General public, School groups
Staff: 3 (2 ft, 1 pt); Operating budget: $100,000
Publications: *African American Museum Newsletter*, quarterly

Collection: Books, periodicals, audiovisual materials, artifacts and realia, paintings and
other works of art, and archives (printed materials).

Comments: The purpose is to collect, preserve, and share information and artifacts that
represent the contributions of Africans and African descendants. Museum services
include guided tours and educational lectures; the museum participates in ethnic
festivals.

AFRICAN AMERICAN MUSEUM <u>Museum</u>
(Formerly Museum of African American Life & Culture) <u>Library</u>
 3536 Grand Ave. <u>Archives</u>
 Dallas, TX 75210 214-565-9026; Fax 214-421-8204

Sponsoring organization: Foundation for African American Art
Personnel: Dr. Harry Robinson, Jr., Dir.; Edleeca Thompson, Art Curator
Contact: Daphne Stephenson, Archivist, P.O. Box 150153, Dallas, TX 75315-0153
Founded: 1974; Scope: Local, State
Availability: Open T-F 12-4; Admission: Free/Donation
Visitors: General public, School groups, Ethnic community
Staff: 14 ft, 3 pt, 125 volunteers
Publications: Membership newsletters and flyers

Collection: Ca. 375 books, periodicals, audiovisual materials, ca. 200 artifacts, ca.
350 works of art, and 3,500 cubic feet of archival materials (unpublished records,
printed and pictorial materials, theses and dissertations, manuscripts, and oral
histories). A reading room is available for researchers.

Comments: The purpose is to collect, preserve, and exhibit historical materials and
works of art that document the African American experience. Programs and services
include guided tours, educational lectures, speakers, crafts classes, conferences,
workshops and seminars, and an arts and crafts souvenir shop.

AFRICAN AMERICAN RESOURCE CENTER, <u>Library</u>
HOWARD UNIVERSITY
(Formerly Afro-American Reading Room)
 500 Howard Place, NW
 Washington, DC 20059 202-806-7242

Sponsoring organization: Howard University
Contact: E. Ethelbert Miller, Dir., P.O. Box 746, Howard University
Washington, DC 20059
Founded: 1969; Scope: International
Availability: Open to the public; Admission: Free
Visitors: General public, Students and faculty
Staff: 5 (1 ft (salaried), 4 pt)

Collection: Ca. 1,500 books, ca. 1,500 periodicals, audiovisual materials, and archival records (personal papers and correspondence). The collection is cataloged; a reading room and copying facilities are available.

Comments: The collection supports the curriculum and research on the African American experience at this traditionally black university. Programs include educational lectures and performing arts presentations.

AFRICAN CULTURAL CENTER <u>Museum</u>
 731 Rock Creek Church Road, NW <u>Library</u>
 Washington, DC 20010 202-882-7465 <u>Archives</u>
 <u>Art Gallery</u>

Sponsoring organization: The African Cultural Foundation, Inc.
Personnel: Dr. William Hawkins, Vice Pres.; Ilara Thomas, Treas.
Contact: Dr. Mohamed Sesay, Pres.
Founded: 1982; Scope: Local, State, Regional, National, International
Availability: Open by special appt.; Admission: Free
Visitors: General public, School groups, Ethnic communities
Staff: 104 (4 ft, 100 pt volunteers); Operating budget: $38,000
Publications: *African Cultural Center Almanac for 1993*; also publishes membership newsletters and flyers.

Collection: Books, periodicals, audiovisual materials, artifacts, works of art, 10 cartons of archival materials (unpublished records, manuscripts, and oral histories). The collection is not cataloged; a reading room is available.

Comments: The purpose is to promote information and cultural exchange among peoples of African descent, to promote African history and culture, and to provide a forum for discussions. Different rooms include: The Martin Luther King, Jr. Room, the Kwame Nkruma Room, the Wole-Soyinka Room, the Marcus Garvey Room, the International Room, the Marian Makeba-Bob Marley-Stevie Wonder Room. Services include guided tours, educational lectures, radio and TV programs, speakers, performing arts presentations, crafts classes, and an arts and crafts souvenir shop. The center supports research, has workshops, in-service programs, and courses for teachers, and offers work experience for college credit.

AFRO-AMERICAN CULTURAL FOUNDATION <u>Museum</u>
 10 Fiske Place, Suite 204-206 <u>Library</u>
 Mt. Vernon, NY 10550 914-665-0784 <u>Archives</u>

Contact: Charles Smith, Exec. Dir.
Founded: 1969

Availability: Open to the public; Admission: Donation
Visitors: General public, Ethnic community
Publications: *Black Survival Seminar*, irreg.; *Guide to Black Westchester*, biennial;
Guide Book to Black Organizations in Westchester County, irreg.; *New Black Image*,
quarterly; also publishes bibliographies of African American books.

Collection: 500 books, audiovisual materials, artifacts (emphasis is on African
American history in Westchester County, New York), and archives (personal papers
and correspondence, unpublished materials, etc.)

Comments: The purpose is to recognize the contributions of African Americans, to
study the problems of racism, and to preserve African American history and culture.
The museum was established in honor of businesswoman Madam C. J. Walker (1867-
1919), and it sponsors a traveling exhibit; other services include educational lectures
and seminars, a speaker's bureau, and research programs.

AFRO-AMERICAN HISTORICAL AND CULTURAL MUSEUM Museum
 701 Arch St. Library
 Philadelphia, PA 19106 215-574-0381; Fax 215-574-3110

Personnel: Nanette Acker Clark, Exec. Dir.; Richard Watson, Dir. of Exhibits; Pearl
Robinson, Dir. of Education
Contact: Karen Buchholz, Dir. of Collections
Founded: 1976; Scope: Regional
Availability: Open T-Sat., 10-5, Sun., 12-6
Admission: $4 adults, $2 students, children, senior citizens and handicapped
(museum); other collections are free
Visitors: General public, School groups, Ethnic community
Staff: 125 (23 ft, 2 pt, salaried; 100 volunteers); Operating budget: $1,700,000
Publications: Promotional brochures; calendar of events.

Collection: Over 1,500 books, over 1,000 periodicals, over 1,000 audiovisual
materials plus 500,000 photographs, over 500 artifacts, over 250 works of art, and
1,131 linear ft. of archival materials (personal papers and correspondence, unpublished
records, printed and pictorial materials, theses and dissertations, manuscripts, and oral
histories). The collection is not cataloged, but there are indexes available for many
collections; an unpublished guide and copying facilities are available.

Comments: The purpose is to collect, preserve, and present the contributions of
African Americans in Philadelphia and the Delaware Valley region. Services include
exhibits, arts programs, tours, educational lectures, loans to educational institutions,
school presentations, radio programs, speakers, and an arts and crafts souvenir shop.

AFRO-AMERICAN HISTORICAL AND GENEALOGICAL SOCIETY Library
 P. O. Box 73086
 Washington, DC 20056 202-234-5350

Contact: Sylvia Cooke Martin, Pres.
Founded: 1977; Scope: National
Availability: Open to the public; Admission: Free

Visitors: General public
Operating budget: Less than $25,000
Publications: Newsletters; a quarterly journal.

Collection: Historical and genealogical records on Afro-American family and church history.

Comments: The society collects, maintains, and preserves materials that document Afro-American history and culture for research and publication. It also conducts seminars, workshops, and school education projects; sponsors conferences and exhibits, and awards internships for archivists and librarians.

AFRO-AMERICAN HISTORICAL SOCIETY MUSEUM Museum
 1841 Kennedy Blvd. Library
 Jersey City, NJ 07305 201-547-5262; Fax 201-547-5392

Contact: Neale E. Brunson, Dir.
Founded: 1977; Scope: State
Availability: M-F 12-5 (July-Aug.), M-Sat. 12-5 (Sept.-June); Admission: Free
Visitors: General public, Ethnic community
Publications: Newsletter

Collection: 3,500 books, audiovisual materials (civil rights posters, films), artifacts and realia (black dolls, Pullman porters).

Comments: This museum preserves African American history, especially in Jersey City. It offers tours, educational lectures, audiovisual presentations, and exhibits.

ALEXANDRIA LIBRARY, LLOYD HOUSE ARCHIVES Library
 220 N. Washington St. Archives
 Alexandria, VA 22314 703-838-4577

Personnel: Sande O'Keefe, Photograph Libn.
Contact: Yvonne Carignan, Branch Libn.
Founded: 1938; Scope: Regional
Availability: Open to the public T-Sat. 10-4; Admission: Free
Visitors: General public, School groups, Ethnic community
Staff: 11 (2 ft, 5 pt, salaried; 4 volunteers); Operating budget: $186,500
Publications: *Fireside Sentinel*, 1987- , bimonthly; books and reference materials (e.g., *African American History Sources: A Bibliography* and *African American History & Genealogy: A Resource Guide*).

Collection: 16,000 books, 50 periodicals, 25 works of art, and 495 linear ft. of archival materials (personal papers and correspondence, unpublished records, printed materials, theses and dissertations). Newspapers (*Alexandria Gazette*) and Virginia census records are on microfilm. The collection is cataloged; a published guide, reading room, microform reader and printer, and copying facilities are available.

Comments: The mission of the library is to collect, preserve, and make accessible to the public historical research materials on state, local, and regional history. Lloyd

House is a branch of the library which emphasizes books, photos, maps, microforms, and manuscripts pertaining to Alexandria and Virginia history and genealogy. Sources cover slavery, the colonial period, the Revolutionary War, the Civil War and Reconstruction, among other topics. The collections support graduate and undergraduate level research programs in conjunction with institutions of higher education.

THE ANACOSTIA MUSEUM Museum
(Formerly The Anacostia Neighborhood Museum)
 1901 Fort Place, SE
 Washington, DC 20020 202-287-3380

Sponsoring organization: Smithsonian Institution
Personnel: Steven C. Newsome, Dir.; Sharon A. Reinckens, Deputy Dir.;
Zora M. Felton, Dir. of Education Dept.; Portia James, Historian;
Laurie Hinksman, Registrar
Contact: Louis C. Hicks, Public Program Officer
Founded: 1967; Scope: Regional
Availability: Open to the public; Admission: Free
Visitors: General public
Staff: 2 ft, salaried; 10 volunteers; Operating budget: $158,000
Publications: *Newsletter of the Anacostia Museum*, 1990- ; exhibition catalogs.

Collection: Books, 2,000 periodicals, 3,000 artifacts, audiovisual materials, works of art, and archives (personal papers and correspondence, printed and pictorial materials, manuscripts). The collection is partially cataloged; some periodicals are in microform. Copying facilities are available.

Comments: The purpose is to preserve and interpret the historical experience of African Americans in the Washington, DC area and that of the "upper south," (Virginia, Maryland, North Carolina, and Georgia). Coverage also is given to contemporary social issues (housing, transportation, health care) and their impact on African American communities. Programs include guided tours, educational lectures, loans and presentations to schools, performing arts presentations, crafts classes, and a souvenir shop. An internship program through the Smithsonian Institution provides work experience for college credit.

ASSOCIATION FOR THE STUDY OF Museum
AFRO-AMERICAN LIFE AND HISTORY Archives
(Formerly Association for the Study of Negro Life and History)
 1407 14th St. NW
 Washington, DC 20005 202-667-2822

Contact: Karen A. McRae, Exec. Dir.
Founded: 1915; Scope: National
Availability: Open to the public; Admission: Free
Visitors: General public, Ethnic community
Operating budget: $200,000
Publications: *Journal of Negro History*, quarterly; *Negro History Bulletin*, quarterly.
Collection: Artifacts, realia (furnishings), archival materials (unpublished papers,

manuscripts and other materials related to Africans and African Americans).

Comments: The association consists of scholars, students, and other researchers interested in the history of African American life and experience. Services include educational programs, an essay contest for college students related to Black History Month. The association operates the Carter G. Woodson home in Washington, DC.

AVERY RESEARCH CENTER FOR Museum
AFRICAN AMERICAN HISTORY AND CULTURE Library
 125 Bull St. Archives
 College of Charleston
 Charleston, SC 29424 803-727-2009

Sponsoring organization: College of Charleston
Contact: Dr. W. Marvin Dulaney, Dir.
Founded: 1985; Scope: State
Availability: Open to the public M-F 2-4, Archives M-F, Sun. 1-4:30
Admission: Free/Donation
Visitors: General public, School groups, Ethnic community
Staff: 9 (5 ft, 4 pt); Operating budget: $300,000
Publications: Promotional materials; newsletters and flyers.

Collection: Books, periodicals, video and audio tapes, artifacts, works of art, and archival materials (personal papers and correspondence, organizational records and photographs, theses and dissertations, manuscripts, and oral histories). The collection is cataloged; an unpublished guide, reading room, and copying facilities are available for researchers.

Comments: The center is a collaborative effort of the College of Charleston and the Avery Institute of Afro-American History and Culture, a Charleston community-based historical society. Archival collections are used to present exhibits and educational programs for the public in conjunction with local and national African American celebrations and holidays. (Organizations are invited to deposit their inactive records.) Services include group tours (by appointment), lectures, loans and presentations to schools, speakers, films, and participation in ethnic festivals. Provides opportunities for graduate and undergraduate research and in-service training for teachers.

BECK CULTURAL EXCHANGE CENTER Museum
 1927 Dandridge Ave. Library
 Knoxville, TN 37915 615-524-8461 Archives

Personnel: Margaret S. Carson, Archivist
Contact: Robert J. Booker, Exec. Dir.
Founded: 1975; Scope: Local
Availability: Open to the public; Admission: Free
Visitors: General public, School groups, Ethnic community
Staff: 30 (2 ft, 1 pt, salaried; 27 volunteers); Operating budget: $60,000

Collection: Books, artifacts, works of art, 30 boxes of photographs and archival records. (personal papers and correspondence, unpublished records, printed and

pictorial materials, theses and dissertations, oral histories). The collection is cataloged; a reading room and copying facilities are available.

Publications: Local histories; promotional brochures.

Comments: The center researches, collects, and preserves materials that describe the achievement of African Americans in the Knoxville area. It features the William H. Hastie Room, commemorating the first Black federal judge in the United States. Programs include guided tours, educational lectures, loans and presentations to schools, speakers, films, crafts classes, and in-service courses or workshops for teachers. The center supports undergraduate and graduate level research.

BLACK AMERICAN CINEMA SOCIETY Library
 3617 Monclair St.
 Los Angeles, CA 90018 213-737-3292

Contact: Mayme Agnew Clayton, Founder and Dir.
Founded: 1975; Scope: National
Availability: Open by special appt. only; Admission: Free
Visitors: General public, Ethnic community
Operating budget: $32,000
Publications: *Black Talkies Souvenir Book*, annual.

Collection: 30,000 books on African American history, films (including early Black film productions), sound recordings, objects of art, artifacts, and documents.

Comments: The purpose is to emphasize African American contributions to the film media, and also the treatment of African Americans throughout the history of motion pictures. The society provides financial assistance to black film producers. Services include film presentations, and educational seminars during Black History Month.

BLACK ARCHIVES, HISTORY AND RESEARCH FOUNDATION Archives
OF SOUTH FLORIDA, INC.
 5400 NW 22nd Ave., Bldg. B, Suite 101
 Miami, FL 33142 305-636-2390

Personnel: Dorothy Fields, Archivist; Carmetta Russell, Chair, Bd. of Dirs.
Contact: Valerie D. Riles, Interim Exec. Dir.
Founded: 1977; Scope: Local, State, Regional, National
Availability: Open to the public; Admission: Free
Visitors: General public, School groups
Staff: 8 (1 ft, 2 pt, 5 volunteers); Operating budget: $50,000
Publications: *Heritage Education Teacher's Guide*.

Collection: Books, periodicals, audiovisual materials, artifacts, works of art, and archives (personal papers and correspondence, unpublished records, printed and pictorial materials, manuscripts, and oral histories). A reading room and copying facilities are available for researchers.

Comments: Preserves and interprets materials that document the heritage of the African

American in South Florida. Programs provided include guided tours, loans and presentations to school, speakers or resource people; the foundation works with the Chapman House Project, Dade County's Ethnic Heritage Children's Folklife Museum.

BLACK ARCHIVES OF MID-AMERICA, INC. Museum
 2033 Vine St. Archives
 Kansas City, MO 64108 816-483-1300

Contact: Ruby M. Jackson, Exec. Dir.
Founded: 1974; Scope: Local, State, Regional, National, International
Availability: Open to the public; Admission: Fee
Visitors: General public; School groups; Foreign visitors and scholars
Staff: 7 (3 ft, 2 pt, 2 volunteers); Operating budget: $242,000
Publications: *Archival Griot*, 1984- annual; souvenir journal.

Collection: Books, periodicals, audiovisual materials, artifacts, works of art, and 1,800 cubic ft. of archives (personal papers and correspondence, unpublished records, printed and pictorial materials, theses and dissertations, manuscripts, and oral histories). Copying facilities are available.

Comments: The purpose is to preserve the history and experience of African Americans in the Midwestern states of Missouri, Kansas, Iowa, and Oklahoma through guided tours, educational lectures, loans and presentations to schools, TV programs, speakers, traveling exhibits, and a special exhibit during Black History Month.

BLACK FILMMAKERS HALL OF FAME, INC. Archives
 405 14th St., Suite 515
 Oakland, CA 94612 510-465-0804; Fax 510-839-9858

Contact: Mary Perry Smith, Pres.
Founded: 1973; Scope: National
Availability: Open by special appt.; Admission: Free
Visitors: General public, Ethnic community
Staff: 1; Operating budget: $200,000
Publications: *Black Filmworks*, annual; also publishes a film catalog.

Collection: Archives (biographical materials).

Comments: Collects and preserves information about black filmmakers and their achievements in the American film industry. The organization sponsors a Black Filmworks Festival and a speakers' bureau, supports research, and offers rewards.

BLACK HERITAGE MUSEUM Museum
 Miracle Center Mall (Upper level)
 3301 Coral Way
 Coral Gables, FL 33145 305-252-3535

Personnel: Mrs. L. S. Houston, Curator
Contact: Mrs. P. G. Stephens Kruize, Pres. and Founder; P.O. Box 570327, Miami, FL 33257-0327

Founded: 1987; Scope: Local, State, Regional, National, International
Availability: Open to the public; Admission: Donation
Visitors: General public, School groups, Ethnic community
Staff: 3 (1 ft, 1 pt, 1 volunteer); Operating budget: $32,000
Publications: Membership newsletters and flyers
Collection: 3,000 books, periodicals, audiovisual materials, artifacts, and works of art.

Comments: Promotes racial harmony by increasing awareness and understanding of black culture and heritage. Features collections related to Dr. Martin Luther King, Jr., Afro-Cuban art, black heritage dolls, black heritage music, and the black church. The program includes guided tours, educational lectures, loans and presentations to schools, radio programs, TV programs, speakers, resource people, and participation in ethnic festivals.

BLACK RESOURCES INFORMATION COORDINATING SERVICES Library
 614 Howard Ave.
 Tallahassee, FL 32304 904-576-7522

Contact: Emily A. Copeland, Pres.
Founded: 1972; Scope: National
Availability: Open by appt.; Admission: Free
Visitors: General public, Ethnic community
Staff: 5
Publications: *Brics Bracs*, quarterly; *Media Showcase*, annual; *Minority Information Trade Annual*; also publishes bimonthly newsletter and *Guide to Afro-American Resources*.

Collection: 8,000 titles (books, periodicals, cassettes, slides, microfiche, microfilms).

Comments: The purpose is to coordinate and disseminate information on the African-American community. It provides bibliographic, genealogical, and other research services, educational lectures, and a national exhibit program.

BOOKER T. WASHINGTON NATIONAL MONUMENT Museum
 Rt. 3, Box 310
 Hardy, VA 24101 703-721-2094

Sponsoring organization: U.S. Dept. of Interior/National Park Service
Contact: Mary Green-Victory, Supt.
Founded: 1956; Scope: National
Availability: Open to the public; Admission: Fee
Visitors: General public, School groups
Staff: 17 (10 ft, 2 pt, 5 volunteers); Operating budget: $400,000

Collection: Ca. 800 books, artifacts and realia.

Comments: The museum provides information on Booker T. Washington's early environment and its impact on him as well as his achievements as an adult. Services include guided tours, educational lectures, school presentations, and a costumed demonstration program. The museum participates in ethnic festivals.

BUFFALO AND ERIE COUNTY PUBLIC LIBRARY Library
NORTH JEFFERSON BRANCH
 332 East Utica St.
 Buffalo, NY 14208 716-883-4418

Personnel: Mary Whetzle, Branch Mgr.; Kathryn Galvin, Asst. Branch Mgr.;
Scope: Regional
Availability: Open M,Th 12-8; T,F 9:30-5:30; W 1-5:30; Admission: Free
Visitors: General public
Staff: 4 (2 ft, 2 pt, salaried)
Publications: Annual in-house bibliographic compilations
Collection: 9,000 books, 350 periodicals, audiovisual materials (150 videos, 4 locally
produced murals, and photographs of Harriet Tubman's home, etc.), archives (personal
papers and correspondence and unpublished records). The collection is cataloged; a
reading room and copying facilities are available. Local newspapers, church histories,
individual and organizational papers are in microform.

Comments: The library has the largest collection of African American history materials
in western New York. Services and programs include school presentations and exhibits
of fiction works by African Americans.

BURLINGTON COUNTY HISTORICAL SOCIETY Museum
 457 High St. Library
 Burlington, NJ 08016 609-386-4773; Fax 609-386-4828 Archives

Contact: Ms. Rhett Pernot, Dir.
Founded: 1915; Scope: Local, State, Regional
Availability: Open M-Th, 1-4; W, 10-12, Sun. 2-4; Admission: Free
Visitors: General public
Staff: 1 ft, 5 pt
Publications: *Burlington County Historical Society Newsletter*, quarterly.

Collection: Ca. 3,500 books, ca. 50 periodicals, 50 audiovisual materials, ca. 3,500
artifacts, 2 boxes of archival records (personal papers and correspondence, unpublished
records, printed and pictorial materials, manuscripts); includes the Manumission papers
and records of the Abolition Society. The collection is cataloged; a reading room and
copying facilities are available.

Comments: The goal is to preserve the history of Burlington County, including its
African American community. Programs include guided tours and lectures.

CALIFORNIA AFRO-AMERICAN MUSEUM Museum
(Formerly California Museum of Afro-American History & Culture) Library
 600 State Drive
 Los Angeles, CA 90037 213-744-7432

Sponsoring organization: State of California
Personnel: Terrie Rouse, Exec. Dir.; Rick Moss, Curator; Nancy McKinney, Editor;
Faye Jonason, Registrar
Contact: Angela Bonner, Deputy Dir.

Founded: 1981; Scope: Local, State, Regional, National, International
Availability: Open to the public; Admission: Free
Visitors: General public, School groups, Ethnic community
Staff: 38 (10 ft, 3 pt, 25 volunteers); Operating budget: $1,125,000
Publications: *Museum Notes*, 1992- , quarterly; exhibition catalogs.

Collection: Over 6,000 books, 2,000 periodicals, 250 audiovisual materials, ca. 700
works of art, over 2,000 artifacts, and over 700 boxes of archives (personal papers and
correspondence, manuscripts, and oral histories). Some materials are in microform.
The collection is cataloged, and a reading room is available.

Comments: Collections of African art and examples of historical material culture
reflect African American life. Programs include guided tours, educational lectures,
loans to schools, speakers, performing arts presentations (dance, drama, choir), films
and AV productions, crafts classes, and an arts and crafts/souvenir shop. Traveling
exhibitions, teacher in-service programs, summer session classes, and internships for
college credit are also provided. The museum participates in ethnic festivals.

CENTER FOR AFRO-AMERICAN STUDIES LIBRARY Library
University of California at Los Angeles
 44 Haines Hall
 405 Hilgard Ave.
 Los Angeles, CA 90024-1545 310-825-6060/206-8800

Sponsoring organization: University of California at Los Angeles
Contact: Gladys Poteat Lindsay, Libn.
Founded: 1969; Scope: State, Regional
Availability: Open to the public; Admission: Free
Visitors: General public, School groups, Ethnic community
Staff: 4 (1 ft, 3 pt); Operating budget: $42,000

Collection: 5,600 books, 44 periodicals, 1,012 audiovisual materials, archives
(pictorial materials and journals). The collection is cataloged; a published guide and
copying facilities are available.

Comments: The collection serves as an important source of information on issues
relevant to African Americans in the state. Guided tours, loans and presentations to
schools, speakers, and a book talk during African American history month are
provided.

CHARLES L. BLOCKSON AFRO-AMERICAN COLLECTION Library
 Temple University Libraries
 Sullivan Hall
 Temple University
 Philadelphia, PA 19122 215-787-6632

Sponsoring organization: Temple University
Contact: Charles L. Blockson, Curator
Founded: 1983; Scope: State, National, International
Availability: Open to the public; Admission: Free

Visitors: General public; national and international scholars
Staff: 3 ft; 1 pt Publications: *Museum Notes*, 1992- , quarterly; exhibition catalogs.

Publications: Promotional brochures.

Collection: 40,000 volumes, periodicals, and archives (personal papers and correspondence, unpublished records, pictorial materials, theses and dissertations, manuscripts, oral histories). Includes slave narratives, anti-slavery broadsides, signed letters, posters, sheet music. Some records are in microform. The collection is cataloged; a published guide is available.

Comments: The focus is on historical materials related to the African Diasporic experience. The slave narratives and materials on the underground railroad are two of the special collections. The library provides educational lectures, radio programs, speakers or resource people, and special exhibitions.

CHATTANOOGA AFRICAN-AMERICAN MUSEUM Museum
 730 E. Martin Luther King Blvd. Library
 Chattanooga, TN 37403 615-267-1076

Sponsoring organization: Chattanooga African-American Heritage Council
Personnel: Wallace Powers, Pres. of the Bd.
Contact: Vilma S. Fields, Dir.
Founded: 1977; Scope: Local, State, National, International
Availability: Open to the public M-F 9:30-4:30; Admission: Fee
Visitors: General public, School groups, Ethnic community
Staff: 15 (3 ft, 2 pt, salaried; 10 volunteers); Operating budget: $135,000
Publications: *The Heritage*, 1991- quarterly; *African American Presence in Chattanooga 1900-1940*; also publishes newsletters, flyers, and books.

Collection: 20,000 books, audiovisual materials, ca. 1,500 artifacts, works of art, and archival materials (printed materials, oral history videotapes). The collection is cataloged; copying facilities are available.

Comments: The museum is dedicated to the preservation and dissemination of the history and culture of Africans and Americans of African descent, housing research materials and artifacts that document the contributions of African-Americans to the development of the United States and Chattanooga, in particular. Services include lectures, educational seminars, a speakers' bureau, an African Ball, exhibitions featuring local and regional African American artists, an African cultural festival, guided tours, school presentations, radio and TV programs, performing arts presentations, films and AV productions, and a souvenir shop. The museum collection supports research at the graduate and undergraduate levels.

CONNECTICUT AFRO-AMERICAN HISTORICAL SOCIETY Museum
(Formerly New Haven Afro-American Historical Society) Library
 444 Orchard St. Archives
 New Haven, CT 06511 203-776-4907

Personnel: Clinton Robinson, Pres. of the Bd.; Eva Spence Johnson, V. Pres.

Contact: Edna Carnegie, 9 University Place, New Haven, CT 06511-3224
Founded: 1970; Scope: Local, state
Availability: Open by special appt. only; Admission: Donation
Visitors: General public
Staff: 2 volunteers; Operating budget: $5,000
Publications: Books; promotional brochures; and membership newsletters.

Collection: Ca. 1,500 books, 1,500 periodicals, audiovisual materials, artifacts, 15 file drawers and 55 boxes of archives (personal papers and correspondence, unpublished records, printed and pictorial materials, theses and dissertations, and oral histories). The collection is partially cataloged; a published guide to a part of the collection, a reading room, and copying facilities are available.

Comments: The society sponsors exhibits and programs that describe the African American experience. It provides guided tours, loans and presentations to schools, radio and TV programs, and speakers. It also presents free materials on Black history to teachers, sponsors Black History Month each year, provides guided tours, loans and presentations to schools, and participates in ethnic festivals.

COUNTY OF LOS ANGELES PUBLIC LIBRARY Library
BLACK RESOURCE CENTER
 150 E. El Segundo Blvd.
 Los Angeles, CA 90061 310-538-3350

Sponsoring organization: County of Los Angeles Public Library
Personnel: Marq Hawkins, Library Asst.
Contact: Louise Parsons, Libn.
Founded: 1978; Scope: Local, state, regional, national
Availability: Open to the public, restricted access; Admission: Free
Visitors: General public, School groups, Ethnic community
Staff: 2 ft, 2 pt

Collection: Ca. 1,500 books, ca. 200 periodicals, 200 audiovisual materials, pamphlets, posters, theses, videos, and calendars. Some monographs and periodicals are in microform. The collection is cataloged; an unpublished guide, reading room, and copying facilities are available.

Comments: The Black Resource Center provides reference and referral services for libraries and the general public. Emphasis is on social, historical, and cultural information by and about Black Americans. Materials document the contributions of Blacks in American history. Provides guided tours, loans and presentations to schools, and participates in ethnic festivals.

DELTA BLUES MUSEUM Museum
DIVISION OF THE CARNEGIE PUBLIC LIBRARY Library
OF CLARKSDALE MS
 114 Delta Ave.
 Clarksdale, MS 38614 601-624-4461

Contact: Sid F. Graves, Jr., Exec. Dir.

Founded: 1979; Scope: National
Availability: Open to the public; Admission: Free
Visitors: General public
Staff: 10 ft, 2 pt
Publications: *Feelin' the Blues Calendar*, annual; promotional brochures.

Collection: Ca. 1,500 books, periodicals, ca. 1,500 audiovisual materials, artifacts, works of art, and archival materials. Some periodicals are in microform. The collection is partially cataloged; a reading room and copying facilities are available.

Comments: The purpose is to collect and preserve information about the history and significance of the blues, a unique form of African American music and part of the African American cultural heritage. Provides guided tours, educational lectures, school presentations, speakers, performing arts presentations, an arts and crafts souvenir shop, and participates in ethnic festivals.

DETROIT PUBLIC LIBRARY Library
E. AZALIA HACKLEY MEMORIAL COLLECTION
 5201 Woodward
 Detroit, MI 48202 313-833-1488 or 313-833-1460

Sponsoring organization: Detroit Public Library
Contact: Agatha Pfeiffer Kalkanis
Founded: 1943; Scope: Local, State, Regional, National, International
Availability: Open to the public; Admission: Free
Visitors: General public, School groups
Staff: 1 ft

Collection: 2,150 books, periodicals, 1,475 musical scores, 2,125 long-playing recordings, 2,200 photographs, and archives (personal papers and correspondence, unpublished records, printed and pictorial materials, theses and dissertations, and manuscripts). Over 250,000 items are contained in the vertical file (newspaper and magazine articles, programs, playbills, etc.). The collection is cataloged; a published guide, reading room, and copying facilities are available.

Comments: The purpose is to collect materials concerning African Americans in the performing arts and to promote research in the history of African American performers. The collection emphasizes African Americans, but it attempts to have international coverage as well. The Annual E. Azalia Hackley Memorial Concert is presented each February as part of the Black History Month celebration. Guided tours are available.

DUSABLE MUSEUM OF AFRICAN AMERICAN HISTORY, INC. Museum
 740 E. 56th Place Library
 Chicago, IL 60637 312-947-0600

Contact: Ramon Price, Curator
Founded: 1961; Scope: National
Availability: Open daily 10-5; Admission: $3 adults, $2 seniors/students, $1 children
Visitors: General public, Ethnic community
Publications: Calendar; promotional brochures; books.

Collection: 6,000 books on Africa and the African American experience, sound recordings, pictures, photographs, slides, sculpture, prints, and artifacts.

Comments: This historical museum preserves the African American culture and experience in the United States. Programs include guided tours, lectures, exhibits, classes, and a souvenir/gift shop.

FOUNDATION FOR RESEARCH IN THE Library
AFRO-AMERICAN CREATIVE ARTS
 P.O. Drawer I
 Cambria Heights, NY 11411

Contact: Joseph Southern, Pres.
Founded: 1971; Scope: National
Availability: Open by appt.; Admission: Free
Visitors: General public, Ethnic community
Operating budget: $45,000
Publications: *Black Perspective in Music*, annual (back copies available 1973-1990).

Collection: Audio tapes containing oral histories of Black musicians.

Comments: The purpose is to conduct research on African American contributions to the creative arts (music, theater, and dance).

FREDERICK DOUGLASS NATIONAL HISTORIC SITE Museum
 1411 W Street SE Library
 Washington, DC 20020 202-426-5961; Fax 202-426-0880 Archives

Sponsoring organization: National Park Services, U.S. Dept. of the Interior
Personnel: Bill Clark, Site Mgr.
Contact: Cathy Ingram, Curator
Founded: 1962; Scope: National
Availability: Open daily 9-5 (Apr.-Oct.); 9-4 (Nov.-Mar.)
Admission: Free/Donation
Visitors: General public, School groups, Ethnic community
Staff: 13 (9 ft, salaried; 4 volunteers)
Publications: Brochures and pamphlets

Collection: Ca. 3,000 books, over 1,000 periodicals, over 3,000 artifacts and realia, works of art, and archival materials (personal papers and correspondence, unpublished records, printed materials, pictorial materials, and manuscripts). The collection is cataloged; a published guide and copying facilities are available for researchers.

Comments: The purpose is to preserve the record of the contributions of Frederick Douglass through guided tours, presentations to schools, and exhibits of cultural artifacts.

GEORGE WASHINGTON CARVER NATIONAL MONUMENT Museum
 P.O. Box 38 Library
 Diamond, MO 64840 417-325-4151; Fax 417-325-4231 Archives

Sponsoring organization: Natl. Park Service, U.S. Dept. of the Interior
Personnel: Tammy Benson, Chief, Visitor Services & Resource Mgt.
Contact: John Neal, Supt.
Founded: 1943; Scope: National, International
Availability: Open to the public; restricted access; Admission: Fee
Visitors: General public, School groups, Ethnic community
Staff: 175 (11 ft, 4 pt, 160 volunteers); Operating budget: $450,000

Collection: Books (biographies of Carver and local histories), over 1,500 artifacts, 110 linear ft. of archival records (personal papers and correspondence, unpublished records, pictorial materials, theses and dissertations, manuscripts). Census records and letters are in microform. The collection is cataloged; a reading room and copying facilities are available.

Comments: The monument preserves the site where George Washington Carver was born and lived until he was between 10 and 12 years old; it also collects artifacts and archival materials related to Dr. Carver's life and work. Programs include guided tours, educational lectures, loans and presentations to schools, speakers, performing arts (dance, drama, choir, instrumental) presentations, films, and an arts and crafts souvenir shop. Research at the graduate and undergraduate levels is supported; work experience and courses for college credit and in-service programs are also available.

THE GREAT BLACKS IN WAX MUSEUM, INC. Museum
 1601 East North Ave.
 Baltimore, MD 21213 301-563-3404

Personnel: Dr. Elmer P. Martin, Vice Pres.
Contact: Dr. Joanne M. Martin, Exec. Dir.
Founded: 1983; Scope: National
Availability: Open T-Sat. 9-6, Sun. 12-6; Admission: Fee
Visitors: General public
Staff: 4 ft, 3 pt, salaried; 30 volunteers; Operating budget: $220,000
Publications: *GBIW Newsletter*, quarterly.

Collection: Artifacts, over 100 wax figures of historical personalities from African American history, pamphlets, articles, and archival materials. The collection is cataloged, a published guide is available.

Comments: The exhibits dramatize great African men and women and highlight their achievements and contributions to American and world history. Services include tours and a souvenir/gift shop.

GREAT PLAINS BLACK MUSEUM Museum
 2213 Lake St. Library
 Omaha, NE 68110 402-345-2212

Contact: Bertha W. Calloway, Director and Curator
Founded: 1975; Scope: Local, State, Regional
Availability: Open M-F 8:30-5; Admission: $2 adults, $.50 children
Visitors: General public, Ethnic community

Publications: *The Black Cowboy*

Collection: 1,000 books including rare and out-of-print books about African Americans, periodicals (newspapers), audiovisual materials (photographs, slides, jazz sound recordings, and archival materials (oral histories, unpublished documents). The collection contains materials on African Americans of the Great Plains, with particular attention to African American women.

Comments: This history museum preserves African American history through guided tours, lectures, audiovisual and performing arts presentations, festivals, and exhibits.

HARRIET BEECHER STOWE CENTER Museum
(Formerly Stowe Day Foundation) Library
 77 Forest St. Archives
 Hartford, CT 06105 203-522-9258; Fax 203-522-9259

Personnel: Jo Blatti, Exec. Dir.; Suzanne Zack, Asst. Libn.; Kristen Froehlich, Curator, Elizabeth Newell, Education Dir.
Contact: Diana Royce, Libn.
Founded: 1941; Scope: National, International
Availability: Open M-F 9-4:30 (Library); M-Sat. 9:30-4, Sun. 12-4, June-Oct. and Dec. (Museum); Admission: Free for library; Fee for Museum
Visitors: General public
Staff: 9 ft, salaried, 12 pt; Operating budget: $700,000
Publications: *The Chronicle*, 1994- , quarterly.

Collection: Ca. 750 books, 1,500 periodicals, 50 audiovisual materials, artifacts, works of art, and archives (personal papers and correspondence, printed and pictorial materials, theses and dissertations, and manuscripts) related to African American history and culture. The Stowe manuscripts include 11 extant manuscript pages of *Uncle Tom's Cabin* plus many foreign editions and translations of the work. The collection is cataloged; a reading room and copying facilities are available.

Comments: The museum is located in the last residence of author Harriet Beecher Stowe. Activities and programs include guided tours, educational lectures, loans and presentations to schools, speakers or resource people, and a souvenir shop.

HATCH-BILLOPS COLLECTION, INC. Archives
 491 Broadway, #7
 New York, NY 10012-4412 212-966-3231

Personnel: Camille Billops, Pres.
Contact: James V. Hatch, Secy.
Founded: 1970; Incorporated: 1976; Scope: International
Availability: Open by special appt. only; Admission: Free
Visitors: Scholars
Staff: 2
Publications: *Artist and Influence*, 1982- , annual.

Collection: Ca. 4,500 books on the cultural arts with comprehensive African American

and foreign publications; ca. 1,400 periodical titles dating from the 1890s onward; ca. 10,000 35mm color slides of artists, their work and exhibitions, 1973- ; 1,400 taped interviews with artists of all disciplines, 1970- ; 1,600 exhibition catalogs (shows of individuals and groups from 1930- ; 500 theater programs, 1890- ; 500 plays by African American writers from 1858- ; 800 posters, including theater, dance, poetry, exhibitions, etc. from 1920- ; 6,000 vertical file folders of clippings, letters, announcements, brochures, etc.; 2,000 photographs, 1890- ; archival records (personal papers and correspondence, unpublished materials, printed and pictorial materials, theses and dissertations, manuscripts, and oral histories). The collection is partially cataloged; an unpublished guide and reading room are available.

Comments: This nonprofit research library was founded to: 1) collect and preserve primary and secondary resource materials in the Black cultural arts; 2) provide tools and access to these materials for artists, scholars and the general public, and 3) develop programs in the arts which use the resources of the collection. Services include speakers or resource people and salon interviews with artists. Graduate level research in conjunction with colleges and universities is possible.

HEARTMAN COLLECTION Library
(Formerly Heartman Negro Collection on Negro Life and Culture)
 3100 Cleburne St.
 Houston, TX 77004 713-527-7149

Sponsoring organization: Texas Southern University
Contact: Dorothy H. Chapman, Libn.
Founded: 1948; Scope: International
Availability: Open to the public; Admission: Free
Visitors: General public, School groups, Ethnic community
Staff: 3 ft, salaried; Operating budget: $4,000

Collection: 35,000 books, periodicals, audiovisual materials, works of art, maps, broadsides, documents, lithographs, cartoons, diaries, scrapbooks, and archives (66 file drawers of clippings, personal papers and correspondence, printed and pictorial materials, theses and dissertations, sheet music). The collection dates from 1600 to 1969. It is cataloged; a reading room and copying facilities are available.

Comments: The collection is by and about African Americans; it is a non-circulating special collection and supports graduate and undergraduate research. Services include guided tours, educational lectures, and loans to other educational institutions.

INTERNATIONAL BLACK WRITERS Library
 P. O. Box 1030
 Chicago, IL 60690 312-924-3818

Contact: Mable L. Terrell, Exec. Dir. and Pres.
Availability: Open by special appt.; Admission: Free
Visitors: Ethnic community
Operating budget: $40,000
Publications: *The Black Writer*, quarterly; *In Touch*, monthly; a periodical directory of African American writers and publications devoted to an annual poetry contest.

Collection: 500 books

Comments: The purpose is to conduct research on black writing and history; to support new black writers through awards and recognition; and to conduct educational seminars in writing and music, including special programs for children.

LANGSTON HUGHES COMMUNITY LIBRARY Library
& CULTURAL CENTER
 102-09 Northern Blvd.
 Corona, NY 11368 718-651-1100

Sponsoring organization: Queens Borough Public Library
Personnel: Joan Whittaker, Curator; Charlyne Gadsden, Asst. Branch Mgr.
Contact: Andrew P. Jackson, Exec. Dir.
Founded: 1969; Incorporated: 1980
Availability: Open to the public; Admission: Free
Visitors: General public, School groups, Ethnic community
Staff: 35 (9 ft, 11 pt, salaried; 15 volunteers); Operating budget: $85,000
Publications: Newsletters and flyers

Collection: 45,000 books, audiovisual materials, artifacts, works of art, and theses and dissertations. The Schomberg clipping is in microform. The collection is cataloged; a reading room and copying facilities are available.

Comments: It is the home of the Black Heritage Center of Queens County and features over 20,000 volumes of materials written by, about, or related to African Americans. Services include guided tours, educational lectures, school presentations, speakers or resource people, instrumental presentations, films and AV productions, art exhibitions, annual festivals, and a homework assistance program.

LANGSTON HUGHES MEMORIAL LIBRARY Library
SPECIAL COLLECTIONS AND ARCHIVES Archives
 Lincoln University
 Lincoln University, PA 19352 215-932-8300

Sponsoring organization: Lincoln University
Personnel: Emery Wimbish, Jr., Libn.; Khalil Mahmud, Archivist
Contact: Ruth Hunter, Acting Spec. Coll. Libn.
Founded: 1854; Scope: State, Regional, International
Availability: Open to the public, Restricted access; Admission: Free
Visitors: General public, Students and faculty
Staff: 3 (2 ft, 1 pt); Operating budget: $10,000 book budget
Publications: Accession lists

Collection: 27,735 books, periodicals, audiovisual materials, paintings and other works of art, and 380 linear ft. of archives (personal papers and correspondence, unpublished records, pictorial materials, theses and dissertations, and manuscripts). Some periodicals, rare books, and indexes are in microform. The collection is cataloged; published and unpublished guides, a reading room, and copying facilities are available for researchers.

Comments: The university serves African American and other minorities. It has sponsored a conference entitled Langston Hughes: The Man and the Writer. It provides educational lectures, loans to educational institutions, exhibits, and supports research at the graduate and undergraduate levels. Materials represent all aspects of the African American experience.

MARTIN LUTHER KING, JR., Museum
CENTER FOR NONVIOLENT SOCIAL CHANGE, INC. Library
 449 Auburn Ave., NE Archives
 Atlanta, GA 30312 404-524-1956; Fax 404-522-6932

Personnel: Jesse Hill, Chm. Bd. Dirs.; Coretta Scott King, Pres.
Contact: Denise McFall, Public Information Officer
Founded: 1968; Scope: International
Availability: M-Sat. 8:30-5:30, Sun. 9-8; Admission: Free
Visitors: General public
Publications: Promotional brochures; quarterly newsletter.

Collection: 5,000 books, periodicals, audiovisual materials, 2,000 ft. of archival materials pertaining to the history of African Americans and the civil rights movement, with particular emphasis on the life of Martin Luther King, Jr. Furnishings and other personal effects from the King family home are preserved and on display. A reading room is available for researchers.

Comments: The history museum and archives are part of an educational center located at the Martin Luther King, Jr. National Historic Site. Services include guided tours, lectures, and an audiovisual and performing arts presentations.

MARTIN LUTHER KING, JR. NATIONAL HISTORIC SITE Museum
AND PRESERVATION DISTRICT Library
 526 Auburn Ave., NE
 Atlanta, GA 30312 404-331-3920; Fax 404-331-1064

Sponsoring organization: National Park Service
Contact: Gayle Hazelwood
Founded: 1980; Scope: National
Availability: Open daily 9-9 (Summer), 9-5:30 (Winter); Admission: Free
Visitors: General public, School groups, Ethnic community
Publications: Catalog; promotional brochures; quarterly newsletter.

Collection: Ca. 750 books, ca. 200 periodical titles, audiovisual materials, historic site and buildings, furnishings, and oral histories. Also on the site is the Martin Luther King, Jr. Center for Nonviolent Social Change, Inc. which has 5,000 books and 2,000 ft. of archival materials related to Dr. King personally and the civil rights movement in general. The collection is cataloged.

Comments: This site is the neighborhood where Dr. Martin Luther King spent his boyhood and includes his birthplace and his boyhood home, church, and grave. The purpose is to preserve his contributions to African Americans and to document that experience as part of the history of the civil rights movement. Activities and services

include guided tours (including a walking tour), lectures, audiovisual and performing arts presentations, experiences for college credit, and a souvenir gift shop.

THE MATTYE REED AFRICAN HERITAGE CENTER Museum
 North Carolina A & T State University
 200 Nocho St.
 Greensboro, NC 27107 919-334-7874

Sponsoring organization: North Carolina A & T State University
Contact: Conchita Ndege
Founded: 1968; Scope: Local, State
Availability: Open to the public; Admission: Free
Visitors: School groups, Ethnic community
Staff: 2 ft
Publications: Catalog of collections

Collection: 1,200 books, 6,000 works of art. The collection is cataloged; a published guide is available.

Comments: The museum offers guided tours, school presentations, speakers or resource people, performing arts presentations, films and AV productions, and an arts and crafts souvenir shop. It supports graduate and undergraduate research.

THE MELVIN B. TOLSON BLACK HERITAGE CENTER Library
 Langston University Archives
 Langston, OK 73050 405-466-3346 Art Gallery

Sponsoring organization: Langston University
Personnel: Ronald Keys, Curator, Obidike Kamau, Information Specialist
Contact: Edward Grady, Asst. Curator
Founded: 1970; Scope: Local, State, Regional
Availability: Open to the public 65 hrs/wk; restricted access; Admission: Free
Visitors: General public, School groups, Ethnic community
Staff: 10 (3 ft, 5 pt, salaried; 2 volunteers)
Publications: Annual report

Collection: Less than 5,000 books, ca. 1,000 periodicals, audiovisual materials, artifacts, works of art, and 20 boxes of archival materials (personal papers and correspondence, printed and pictorial materials). The collection is partially cataloged; a reading room and copying facilities are available.

Comments: The purpose is to provide information about Africans and African-Americans. Services include guided tours, educational lectures, loans and presentations to schools, radio programs, and speakers or resource people. Undergraduate and graduate level research is supported in conjunction with colleges and universities.

MOORLAND-SPINGARN RESEARCH CENTER Museum
 Howard University Library
 500 Howard Place, NW Archives
 Washington, DC 20059 202-806-7239

Sponsoring organization: Howard University
Founded: 1973; Scope: International
Availability: Open to the public, 9:00 am-8:00 pm (M-H); 9:00-4:30 p.m. (F-S)
Admission: Free
Visitors: General public, School groups, Ethnic community

Collection: Over 150,000 books, pamphlets, periodicals and microforms in numerous languages, including rare works from the 16th century on. Collection strength is in the first editions and works of early 20th century writers (e.g., W.E.B. Du Bois, Richard Wright, James Baldwin). Archival materials include theses and dissertations on topics related to Africans and African Americans, biographical materials, manuscripts, oral histories, African American music, prints and photographs and other graphic images, as well as records that document the history of Howard University. The collection is cataloged; a reading room and copying facilities are available.

Comments: The center is a comprehensive repository of materials that document the African and African American experience. It began from the donated collections of its benefactors--black theologian Dr. Jesse E. Moorland and Arthur B. Spingarn, a prominent attorney and social activist who collected materials produced by African Americans. The museum exhibits visual documentation of African American history and culture. Microform, photographic, and reproduction services are available.

MUSEUM FOR AFRICAN ART Museum
 593 Broadway
 New York, NY 10012 212-966-1313; Fax 212-966-1432

Contact: Elizabeth Bigham
Founded: 1984; Scope: International
Availability: Open to the public; Admission: Fee
Visitors: General public, School groups, Ethnic community
Staff: 37 (18 ft, 4 pt, salaried; 15 volunteers)
Publications: *Tattler*, 1993- quarterly; also publishes books and collection catalogs.

Collection: The museum presents four major exhibitions of African art, both traditional and contemporary, each year. Each exhibition is accompanied by a substantial, full-color catalog. Archival records include personal papers and correspondence, unpublished records, printed and pictorial materials, theses and dissertations, and manuscripts. Copying facilities are available.

Comments: The museum sponsors scholarly symposia, a film series, lectures, story-telling workshops, dance and music performances, guided tours, school presentations, and speakers.

MUSEUM OF AFRICAN AMERICAN ART Museum
 4005 Crenshaw Blvd., 3rd Flr. Library
 Los Angeles, CA 90008 213-294-7071

Contact: Belinda Fontenote-Jamerson, Pres.
Founded: 1976; Scope: National, International
Availability: Open W-Sat. 11-6, Sun. 12-5; Admission: Free

Visitors: General public
Publications: *International Review of African American Art*; also publishes books.

Collection: 300 books on African and African American art, history, literature, and culture; artifacts, works of art (paintings, prints, ceramics, sculptures). A reading room is available.

Comments: The purpose is to promote and preserve African American art and culture; emphasis is given to leading contemporary artists and Harlem Renaissance Art. Activities include lectures, films, gallery talks, exhibits, and a souvenir gift shop.

MUSEUM OF AFRICAN-AMERICAN CULTURE Museum
 1403 Richland St. Library
 Columbia, SC 29201 803-252-1770/1450

Sponsoring organization: Richland County Historic Preservation Commission
Contact: Charles L. McCallum, Chairman
Founded: 1978; Scope: Local, State, Regional
Availability: T-F 10:15-3:15, Sat. 10:15-1:15
Admission: $3 adults, $1 seniors and students
Visitors: General public, Ethnic community

Collection: Books, furnishings, artifacts, works of art.

Comments: This restored historic house, the Mann-Simons Cottage, preserves antebellum life in Columbia, South Carolina and the role and culture of African Americans. Services and programs include guided tours, exhibits, performing arts presentations, and a souvenir gift shop.

MUSEUM OF AFRICAN AMERICAN HISTORY Museum
 301 Frederick Douglass Library
 Detroit, MI 48227 313-273-4508 Archives

Personnel: James Wyatt, Deputy Dir.; Margaret Ward, Libn./Archivist
Founded: 1965; Scope: Local, State, Regional, National, International
Availability: Open to the public; Admission: Free (Donation)
Visitors: General public
Staff: 35 (10 salaried, 20 volunteers)
Publications: *African American News Quarterly*, quarterly

Collection: 4,000 books, 30 periodicals, 100 audiovisual materials, 2,000 artifacts, 20 works of art, and archival materials (personal papers and correspondence, printed and pictorial materials, theses and dissertations, manuscripts, and oral histories). The collection is not cataloged; a reading room and copying facilities are available for researchers.

Comments: The mission is to educate people about African American life and culture. The museum celebrates Black History Month, Martin Luther King Day, Black Music Month and Kwanzaa; presents the African World Festival; and cosponsors Paul Robeson Scholarship Awards, Children's Day, Noel Night, and Festival of the Arts. It

provides guided tours, educational lectures, loans and presentations to schools, speakers, dance, drama, choir, instrumental performances, films and AV productions, crafts classes, and a souvenir shop.

MUSEUM OF AFRICAN AMERICAN LIFE & CULTURE Museum
 1111 First Ave., P.O. Box 150153 Library
 Dallas, TX 75215 214-565-9026; Fax 214-421-8204 Archives

Sponsoring organization: Foundation for African-American Art
Personnel: Hugh G. Robinson, CEO; Billy R. Allen, Pres.; Harry Robinson, Jr., Dir.;
W. Marvin Dulaney, Curator; Edleeca Thompson, Curator
Founded: 1972; Scope: Local, state, regional, national
Availability: Open to the public M-F 9-5; Admission: Free
Visitors: General public, Ethnic community
Publications: Newsletter, quarterly.

Collection: 1,500 books, works of art and folk art, artifacts, archives (Texas Black Women's Archives).

Comments: The museum preserves African American culture and history in Texas. Activities provided include educational lectures for children and adults, loans of materials, a history conference and fair, and a literary conference.

MUSEUM OF AFRO-AMERICAN HISTORY Museum
(Formerly American Museum of Negro History) Library
 Abiel Smith School
 46 Joy St.
 Boston, MA 02114 617-742-1854; Fax 617-742-3589

Contact: Monica Fairbairn, Pres.
Founded: 1965; Scope: National
Availability: Open to the public
Visitors: General public, School groups, Ethnic community
Staff: 7
Publications: *Collection of Afro-American History*, annual; *Black Heritage Trail*, irreg.; *Museum-Smith Copurt News*, quarterly; also publishes newsletters and audiovisual programs (slide-tape). The emphasis of the collection is on 19th and 20th century history.

Collection: Artifacts, audiovisual materials, 4,000 books (jointly maintained with Suffolk University in the area of African American literature); audiovisual materials (slide-tape, filmstrips, films). The collection is cataloged; a guide to the collections is available.

Comments: Collects, preserves, and exhibits materials and information about the history and cultural heritage of African Americans. The organization conducts research. Services include guided tours of a 19th century black neighborhood which is called the Black Heritage Trail and a 20th century community called Roxbury Heritage Trail. The museum also owns and operates the oldest black church existing in North America.

MUSEUM OF THE NATIONAL CENTER <u>Museum</u>
OF AFRO-AMERICAN ARTISTS
 300 Walnut Ave.
 Boston, MA 02119 617-442-8614

Personnel: Harriet Kennedy, Asst. Dir./Registrar
Contact: Edmund Barry Gaither, Dir.
Founded: 1969; Scope: International
Availability: Open daily 1-6 (July-Aug.), T-Sun. 1-5 (Sept.-June); Admission: Fee
Visitors: General public, School groups, Ethnic community
Staff: 22 (4 ft, 8 pt, salaried; 10 volunteers); Operating budget: $225,000

Collection: 3,000 works of art, ca. 1,000 artifacts, slides. The collection is cataloged; an unpublished guide is available.

Comments: The purpose is to collect and preserve works of African American artists and information about their contributions to America's cultural heritage.

NATIONAL AFRO AMERICAN MUSEUM <u>Museum</u>
AND CULTURAL CENTER <u>Library</u>
(Formerly National Afro American Museum Project) <u>Archives</u>
 1350 Brush Row Road (Box 578)
 Wilberforce, OH 45384 513-376-4944

Sponsoring organization: Ohio Historical Society
Personnel: Dr. John E. Fleming, Dir.; June Powell, Chief of Education; Dr. Floyd Thomas, Curator; Isabel Jasper, Curator
Contact: Debbie Clements, Dir. of Publicity
Scope: National
Availability: Open by special appt. T-Sat. 9-5, Sun. 1-5; Admission: Fee
Visitors: General public, Ethnic community
Staff: 50 (10 ft, 15 pt, 25 volunteers) Operating budget: $1,000,000
Publications: Publishes a museum newsletter and promotional brochures.

Collection: 3,000 books on the African American experience, 1,000 periodicals, audiovisual materials, ca. 750 artifacts, works of art, and archival materials (unpublished records, pictorial materials, theses and dissertations, manuscripts). The collection is cataloged. Copies are made by reference staff.

Comments: Preserves and interprets the lives of African Americans throughout their history in Africa, North America, and other countries. Materials reflect their diverse traditions, values, social customs, and experiences. Services include guided tours, lectures, school presentations, radio and TV programs, speakers, performing arts presentations, and a book/gift shop. The center participates in ethnic festivals.

NATIONAL BLACK PROGRAMMING CONSORTIUM <u>Archives</u>
 929 Harrison Ave., Suite 101
 Columbus, OH 43215 614-299-5355; Fax 614-299-4761

Sponsoring organization: Corporation for Public Broadcasting

Personnel: Jackie Tshaka, Festival Coord.; John Patterson, Jr., Dir. of Membership &
Sales
Contact: Mable J. Haddock, Exec. Dir.
Founded: 1979; Scope: National, International
Availability: Open M-F, 9-6; Admission: Free
Visitors: General public, Ethnic community
Staff: 10 (6 ft, 2 pt, 2 volunteers)
Publications: *Take One*, 1980- quarterly; *Take Two*, 1994- , semi-annual; also
publishes catalogs.

Collection: Ca. 1,500 films and videos; the collection is partially cataloged.

Comments: Provides the Public Broadcasting Service with positive images of African
Americans and a link between the viewing public, independent filmmakers, and PBS
affiliates. Programs include school presentations, TV programs, speakers, film and
audiovisual productions. The organization participates in ethnic festivals.

NORTHERN CALIFORNIA CENTER FOR AFRO-AMERICAN Museum
HISTORY AND LIFE Archives
(Formerly East Bay Negro Historical Society)
 5606 San Pablo Ave.
 Oakland, CA 94608 510-658-3158

Contact: Dr. Lawrence P. Crouchett, Dir.
Founded: 1965; Scope: Local, state
Availability: Open to the public; restricted access; Admission: Free
Visitors: General public, School groups, Ethnic community
Staff: 5 (2 ft, 1 pt, 2 interns); Operating budget: $72,000
Publications: *From the Archives*, 1990- , quarterly; catalog of collections; membership
newsletters and flyers.

Collection: Ca. 1,500 books, audiovisual materials, artifacts and realia, archives
(personal papers and correspondence, unpublished records, printed and pictorial
materials, theses and dissertations, manuscripts, oral histories). The collection is
cataloged; an unpublished guide, reading room, and copying facilities are available for
researchers.

Comments: The purpose is to collect, preserve, and disseminate information related to
the history and experiences of African Americans in California and the East Bay area in
particular. Programs include guided tours, educational lectures, loans and presentations
to schools, and TV programs. The collection supports research at the undergraduate
and graduate levels; in-service programs for teachers are also available.

OBERLIN COLLEGE ARCHIVES Archives
 420 Mudd Center
 148 West College St.
 Oberlin, OH 44074 216-775-8739

Sponsoring organization: Oberlin College
Contact: Roland M. Baumann, Archivist and Dept. Head

Founded: 1966; Scope: National
Availability: M-F, 1-5; Admission: Free
Visitors: General public
Staff: 2 ft, 1 pt, salaried; 3 volunteers; Operating budget: $140,000
Publications: Formal annual report; catalog of collections.

Collection: Audiovisual materials, artifacts and realia, works of art and archives
(personal papers and correspondence, unpublished records, pictorial materials,
manuscripts, and oral histories). The collection is cataloged; finding aids, calendars,
published subject guides, a reading room, and copying facilities are available.

Comments: Records of the college and the Oberlin community include documentation
of the African American experience through antislavery, black education (including a
history of scholarships for blacks), and other movements with which Oberlin has been
associated. Special programs include educational lectures, support of research at
graduate and undergraduate levels, and work experience for college credit.

OHIO STATE UNIVERSITY BLACK STUDIES LIBRARY Library
 1858 Neil Avenue Mall
 Columbus, OH 43210 614-292-2393

Sponsoring organization: Ohio State University
Personnel: William Studer, Dir., Ohio State University Libraries
Contact: Eleanor M. Daniel, Head, Black Studies Library
Founded: 1971; Scope: State, Regional, National, International
Availability: Open to the public; Admission: Free
Visitors: General public
Staff: 5 (2 ft, 3 pt)
Publications: *Selected List of Titles Received*, 1973- , monthly.

Collection: 30,000 books, 200 periodicals, 5,000 audiovisual materials, and archives
(printed materials, theses and dissertations). Some records are in microform. The
collection is cataloged; an unpublished guide, reading room and copying facilities are
available.

Comments: The Black Studies Library provides guided tours, educational lectures,
loans to schools and other institutions, radio programs, and speakers or resource
people. The collection supports undergraduate and graduate level research.

PAUL ROBESON LIBRARY Library
 100 New St.
 Syracuse, NY 13202 315-472-0130

Sponsoring organization: State University of New York
Personnel: Florence Beer, Dir.; Grace Lai, Libn.
Founded: 1969; Scope: State
Availability: Open to the public; Admission: Free
Visitors: General public; Staff: 2 ft

Collection: Over 1,500 books, periodicals, and audiovisual materials. The collection

is cataloged; a reading room and copying facilities are available.

Comments: Paul Robeson Library is part of Syracuse Educational Opportunity; about one-third of the collection consists of minority materials.

RHODE ISLAND BLACK HERITAGE SOCIETY Library
 46 Aborn St. Museum
 Providence, RI 02903 401-751-3490

Contact: Linda A'vant-Deishinni, Dir.
Founded: 1975; Scope: State
Availability: Open M-F 9-4:30; Admission: Free
Visitors: General public, Ethnic community
Publications: *Rhode Island Black Heritage Society Bulletin*, quarterly.

Collection: 2,500 books on African American history, artifacts. A reading room is available.

Comments: The purpose is to preserve African American culture and history through research facilities, guided tours, lectures, audiovisual and performing arts presentations, TV programs, exhibits, and loans or traveling exhibits.

SAN FRANCISCO AFRICAN AMERICAN HISTORICAL Museum
AND CULTURAL SOCIETY, INC. Library
 Fort Mason Center Bldg. C Rm. 165
 San Francisco, CA 94123 415-441-0640; Fax 415-441-7683

Contact: Juliana Haile, CEO
Founded: 1955; Scope: Local, State
Availability: T-Sun. 12-5; Admission: $1 adults, $.50 children
Visitors: General public, Ethnic community
Publications: Quarterly newsletter.

Collection: 3,000 books, encyclopedias, periodicals, pamphlets, audiovisual materials (photographs), works of art (African American art, Haitian art).

Comments: The center preserves African American culture and history through guided tours, lectures, audiovisual and performing arts presentations, festivals, African American history classes, crafts classes for seniors, and a museum gift shop.

SCHOMBURG CENTER FOR RESEARCH IN BLACK CULTURE Museum
 The New York Public Library Library
 515 Malcolm X Blvd.
 New York, NY 10037-1801 212-491-2200; Fax 212-491-6760

Personnel: Howard Dodson, Chief; Elsie Gibbs, Pres.; Laurel Dupiessis, Head, Art & Artifacts
Contact: Alice Adamczyck, Head Reference
Founded: 1925; Scope: International
Availability: Open to the public; Admission: Free

Visitors: General public, School groups, Ethnic community
Publications: *The Schomburg Center*, irreg.; also publishes exhibition catalogs.

Collection: 100,000 volumes on African American history and culture, periodicals, audiovisual materials (audio and video recordings), works of art (paintings, photographs, drawings, paintings, sculpture), artifacts, and archives (personal papers and correspondence, unpublished materials, clippings, programs, broadsides, sheet music, etc.). Part of the collection is in microform. The collection is cataloged; a reading room and copying facilities are available.

Comments: The center is a major source of materials on African American history and life. Its goals are to preserve African American culture, conduct research, and promote African American contributions. Services include educational lectures, exhibitions, receptions for authors, and symposia. The center participates in ethnic festivals.

SUFFOLK UNIVERSITY COLLECTION Library
OF AFRO-AMERICAN LITERATURE
 Sawyer Library
 Suffolk University
 8 Ashburton Place, Beacon Hill
 Boston, MA 02108 617-573-8532

Sponsoring organization: Suffolk University and Museum of African-American History
Personnel: Robert Bellinger, Curator, History Instructor
Contact: Edmund G. Hamann, Library Dir.
Founded: 1971; Scope: Local, National
Availability: Open to the public; Admission: Free
Visitors: General public, Students and faculty
Staff: 11 ft
Publications: Catalog of collections; annual list of new acquisitions.

Collection: 4,000 books (fiction, non-fiction prose, drama, and poetry) and periodicals. Various collected works of individuals are in microform. The collection is cataloged; published and unpublished guides and copying facilities are available for researchers.

Comments: The collection is the joint project of Suffolk University and the Museum of Afro-American History, a United States national historic site. It includes works by all important black American writers from the eighteenth century to the present as well as numerous related historical, literary-historical, critical, biographical, and bibliographical works. Services include educational lectures, speakers or resource people, and research at the graduate and undergraduate level. Courses for college credit in Afro-American literature are available.

TUSKEGEE INSTITUTE NATIONAL HISTORIC SITE Museum
 1212 Old Montgomery Rd. Library
 Tuskegee Institute, AL 36088 205-727-6390; Fax 205-727-4597
 Mailing address: P.O. Drawer 10, Tuskegee Institute, AL 36087

Sponsoring organization: National Park Service, Dept. of the Interior, Southeast Region

Contact: Mr. K. G. Jones, Chief of Interpretation and Visitor Services
Founded: 1941; Scope: National
Availability: Open daily 9-5; Admission: Free

Collection: 200 books plus the collection of the George Washington Carver Museum
(artifacts, furnishings of The Oaks, the home of the Booker T. Washington family,
works of art, and archival materials related to the history of Tuskegee Institute).

Comments: The purpose of this historic black institute is to preserve African American
history and culture and, particularly, the contributions and life stories of George
Washington Carver and Booker T. Washington. Programs include guided tours,
exhibits, lectures, arts and crafts demonstrations, audiovisual and performing arts
presentations, and a gift shop.

VIRGINIA UNION UNIVERSITY Library
 1500 N. Lombardy St.
 Richmond, VA 23220 804-257-5820/5822; Fax 804-257-5818

Personnel: Vonita W. Foster, Library Dir.
Contact: Lenora A. Myers
Founded: 1865; Scope: National
Availability: Restricted access; Admission: Free
Visitors: General public, School groups
Staff: 12 (10 ft, 2 pt, salaried)
Publications: *The Tower*, 1990- , biannual

Collection: Over 500 books, 15 periodicals, 1,000 artifacts, 25 works of art, and
archives (personal papers and correspondence, unpublished records, pictorial materials,
theses and dissertations, manuscripts, and oral histories). The collection is cataloged;
an unpublished guide, reading room, and copying facilities are available.

Comments: The goal is to preserve, maintain, and strengthen the African American
collection. A unique feature is the extensive collection of the Honorable L. Douglas
Wilder, the first African American governor of Virginia. Services include guided
tours, educational lectures, speakers, and films and audiovisual productions.

VIVIAN G. HARSH RESEARCH COLLECTION Archives
OF AFRO-AMERICAN HISTORY AND LITERATURE
 9525 S. Halsted St.,
 Chicago, IL 60628 312-747-3396

Personnel: Mary A. William, Asst. Curator; Michael Flug, Sr. Archivist; Dorothy
Lyles, Tech. Services, Denise English, Preservationist
Contact: Robert Miller, Curator
Founded: 1932 Scope: Local, State, Regional, National, International
Availability: M-Th 9-9; F, S, 9-5, Sun. 1-5 Admission: Free
Visitors: General public
Staff: 5 ft, 4 pt
Publications: Annual report; bibliographical updates every five years on African
Americans, e.g., Carter Godwin Woodson, 1990- ; Gwendolyn Brooks, 1989- ;

Mary Jane McLeod Bethune, 1990-; Dr. Martin Luther King, Jr., 1990- ; Richard Wright, 1991- ; James Baldwin, 1994- ; Malcolm X, 1994- ; Harold Washington, 1987- . The organization publishes a serials holding list and a guide to microform holdings at the Vivian G. Harsh Research Collection of Afro-American History and Literature.

Collection: 70,000 books, 250 periodicals, 500 audiovisual materials, 30 artifacts, and 1,200 linear ft. of archival materials (personal papers and correspondence, unpublished records, pictorial materials, theses and dissertations, manuscripts, and oral histories). The WPA Illinois Writer's Project, "The Negro in Illinois" is in microform. A published guide to the collection, a reading room, and copying facilities are available.

Comments: The Chicago Public Library renamed its special collection of African American materials the Vivian G. Harsh Collection of Afro-American History and Literature in 1970; in 1975 it was moved to the new Carter G. Woodson Regional Library. Its objectives are to collect materials about the African American experience, particularly in Chicago. Programs and services include guided tours, loans to schools and other educational institutions, school presentations, and speakers or resource people. It supports undergraduate and graduate level research, provides work experience for college credit, and in-service programs for teachers.

WELLESLEY COLLEGE, CLAPP LIBRARY, Library
SPECIAL COLLECTIONS
 Wellesley, MA 02181 617-283-2129; Fax 617-283-3640

Personnel: Micheline Jedrey, Libn.
Contact: Ruth R. Rogers, Spec. Coll. Libn.
Scope: Regional
Availability: Open M-F, 9-5; Admission: Free
Visitors: General public
Staff: 2 ft, 1 pt, salaried; Operating budget: $35,000 for materials
Publications: *Friends of the Wellesley College Library* newsletter, 2/yr.; also publishes catalog of collections; membership newsletters and flyers.

Collection: Ca. 800 books; the collection is cataloged. A published guide, reading room, and copying facilities are available.

Comments: This collection on slavery, emancipation, and Reconstruction is the Elbert Collections, assembled by Ella Smith, the second black graduate of Wellesley College, and her husband, Dr. Samuel G. Elbert. The collection includes personal narratives, tracts and pamphlets, autobiographies, volumes of poetry, novels, and folklore, as well as items related to Charles Chestnutt, Paul Laurence Dunbar and James Weldon Johnson.

WESTERN STATES BLACK RESEARCH Archives
EDUCATIONAL CENTER Art Gallery
 3617 Montclair St.
 Los Angeles, CA 90018 213-737-3292; Fax 213-737-2842

Personnel: Betty Spruill, Administrative Dir.

Contact: Dr. Mayme A. Clayton, Exec. Dir.
Founded: 1976; Scope: Regional, National, International
Availability: Open by special appt.; Admission: Fee
Visitors: General public, School groups, Ethnic community
Staff: 2 ft, volunteers; Operating budget: $90,000
Publications: Membership newsletters and flyers; also publishes *BACS* (Black American Cinema Society Awards Souvenir Book), 1976- , annual.

Collection: 20,000 books, 3,000 periodicals, 300 films, 4,000 recordings, 250 artifacts, 200 paintings and works of art, and archival records (personal papers and correspondence, unpublished records, printed materials, pictorial materials, theses and dissertations, manuscripts, and oral histories). The organization's collection is not cataloged; some records are maintained in microform. A reading room is available for visitors.

Comments: The goal is to promote intercultural understanding and to establish an African American Cultural Center which would emphasize the contributions of African Americans. Programs include guided tours, educational lectures, speakers bureau, workshops and seminars, films and film festivals, awards ceremony, and specialized research services.

WILBERFORCE UNIVERSITY REMBERT E. STOKES Archives
LRC LIBRARY
 North Bickett Road
 Wilberforce, OH 45384-1003 513-376-2911, x628

Sponsoring organization: Wilberforce University
Contact: Jacqueline Brown, Archives Dir.
Founded: 1856; Scope: Local
Availability: Open by special appt. only; Admission: Free
Visitors: General public, Students and faculty
Staff: 1 pt

Collection: Books, periodicals, audiovisual materials, artifacts, works of art, and archives (personal papers and correspondence, unpublished records, theses and dissertations, pictorial materials, manuscripts, oral histories). Some records are maintained in microform; a reading room and copying facilities are available for researchers.

Comments: The archives of this traditionally black university documents its history and supports research related to various aspects of the African American experience in the United States.

ALBANIAN AMERICAN RESOURCES

ARCHBISHOP FAN NOLI LIBRARY (Biblioteka Noliane) Museum
 523 East Broadway Library
 South Boston, MA 02127 617-268-3184 Archives

Sponsoring organization: Albanian Orthodox Archdiocese in America, Inc.
Personnel: Very Rev. Arthur Liolin, Dir.
Contact: Dorothy Adams, Secy.
Founded: 1970; Scope: National
Availability: Restricted access; Admission: Donation
Visitors: General public, School groups, Ethnic community
Staff: pt; Operating budget: $25,000

Collection: 5,000 books, 120 periodicals, works of art, artifacts, and 80 file drawers
of archival materials (personal papers and correspondence, unpublished records,
pictorial materials, theses and dissertations, manuscripts, and oral histories).
Newspapers in Albanian are in microform. The collection includes rare books
unavailable elsewhere in the United States and is cataloged; a reading room and copying
facilities are available.

Comments: The library serves as a resource for studies in Albanian language, culture,
history, and sociology, as well as immigration studies. Programs include guided tours,
educational lectures, school presentations, speakers, drama presentations, and
participation in ethnic festivals. The library supports research at the graduate and
undergraduate level and offers work experience for college credit.

AMERICAN INDIAN RESOURCES

(*See* Native American Resources)

ARAB AMERICAN RESOURCES

(*See also* Egyptian American Resources)

ANTIOCHIAN VILLAGE HERITAGE AND LEARNING CENTER Museum
 722 North, P. O. Box 638 Library
 Ligonier, PA 15658-0638 412-238-3677

Sponsoring organization: Antiochian Orthodox Christian Archdiocese of North
America
Personnel: Rt. Rev. George Geha, Exec. Dir.
Contact: Paul D. Garrett, Dir. of Info. Services, 10 W. Madison St., Latrobe, PA
15650
Founded: 1987; Scope: International
Availability: Open, with restricted access; Admission: Free
Visitors: General public, School groups, Ethnic community
Staff: 1 ft, salaried; Operating budget: $50,000

Collection: Ca. 17,962 books, 7,942 periodicals, 536 audiovisual materials, 1,511
artifacts, 493 works of art, 12 file drawers of archives (personal papers and
correspondence, unpublished records, pictorial materials, manuscripts and oral
histories). Many journal runs, manuscripts, and monographs are in microform. The
collection is cataloged; a reading room and copying facilities are available for
researchers.

Comments: Preserves Middle Eastern cultural and spiritual values including those of the Orthodox Christian faith and promotes knowledge and appreciation of Christian Arab history. The center is affiliated with the St. John of Damascus Association which publishes *Sacred Art Journal*, a quarterly published since 1979. Services include guided tours, educational lectures, loans to educational institutions, speakers, formal classes in Byzantine iconography, children's summer camp, and a souvenir gift shop.

ARAB AMERICAN INSTITUTE
Library

918 Sixteenth St. NW, Suite 601
Washington, DC 20006 202-429-9210

Personnel: Dr. James Zogby, Exec. Dir.
Contact: J. Peter Timko, Exec. Asst.
Founded: 1985; Scope: National
Staff: 14
Publications: *Issues*, bimonthly; also publishes articles.

Collection: Books, periodicals, and archival materials on the history of the Middle East and on the Arab experience in America.

Comments: The institute provides information on Arab-Americans elected to office and encourages their political activity. It sponsors educational seminars and lectures.

AWAIR: ARAB WORLD AND ISLAMIC RESOURCES
Library
AND SCHOOL SERVICES
Archives

2095 Rose St., Suite 4
Berkeley, CA 94709 510-704-0517

Personnel: Joseph Schechla, Exec. Officer; James Zogby, Exec. Officer
Contact: Audrey Shabbas, Exec. Dir.
Founded: 1991; Scope: National
Availability: Open to the public (answers E-mail requests: AWAIR @ igc-apc.org)
Admission: Free
Visitors: Ethnic community, Teachers
Staff: 10 (3 ft, 3 pt, 4 volunteers); Operating budget: $100,000
Publications: *Middle East Resources*, quarterly; *AWAIR Catalogue*, annual; curriculum guides, membership newsletters and flyers, and a formal annual report.

Collection: Ca. 100 books, 100 periodicals, 100 audiovisual materials, and archival materials (unpublished records, printed materials, theses and dissertations). The collection is not cataloged; a reading room is available.

Comments: The purpose is to increase understanding of the Arab region, Arab Americans, and America Muslims as contributors and citizens. The organization provides teacher-training workshops, educational lectures, school presentations, radio programs, and speakers.

CENTER FOR ARAB-ISLAMIC STUDIES
Library

P. O. Box 678
Brattleboro, VT 05301 802-257-0872

Contact: Samir Abed-Rabbo
Founded: 1980; Scope: National
Availability: Open by appt.; Admission: Free
Visitors: General public, Ethnic community
Operating budget: $25,000
Publications: *The Search: Journal for Arab and Islamic Studies*, annual

Collection: 1,500 books on Arab/Islamic affairs

Comments: Arab American and other educators who wish to further studies of Arab history and culture and the relationship between Americans and Arabs.

NATIONAL MUSEUM OF AMERICAN HISTORY	<u>Library</u>
SMITHSONIAN INSTITUTION ARAB AMERICAN COLLECTION	<u>Archives</u>
Archives Center, Rm. C340	<u>Art Gallery</u>
Washington, DC 20560 202-357-3270	

Personnel: John Fleckner, Chief Archivist, Archives Center; Richard Ahlborn, Curator, Community Life Division
Contact: Alixa Naff, Research Assoc., Archives Center
Founded: 1984; Scope: Local, State, Regional, National, International
Availability: Open to the public; Admission: Free
Visitors: General public
Staff: 4 (2 ft, 1 pt, salaried; 1 volunteer)

Collection: Books, artifacts, 70 cubic ft. (170 containers) of archival materials (unpublished records, printed materials, pictorial materials, theses and dissertations, and oral histories). A significant portion of the records are maintained in microform, e.g., unpublished church board and youth club minutes. The collection is cataloged; an unpublished guide, reading room, and copying facilities are available for visitors and researchers.

Comments: The purpose of the organization is to preserve and make available for research, publication, and education, the immigration and assimilation experience of Arab-speaking people in the United States, with primary focus on the years between 1880 and 1940. The museum provides educational lectures, speakers or resource people, and participates in ethnic festivals.

ARMENIAN AMERICAN RESOURCES

THE ARARAT FOUNDATION <u>Library</u>
 8909 Captains Row
 Alexandria, VA 22308 703-780-2853

Contact: Dean V. Shahinian, Exec. Dir.
Founded: 1985; Scope: Regional
Availability: Not open to the public
Staff: Volunteers

Collection: 200 books, 8 periodical titles; the collection is not cataloged.

Comments: The objective is to promote the Christian faith and Armenian culture. The foundation provides illustrated cultural seminars, distribution of literature, and conducts various activities in parishes and at colleges and universities. It also provides educational lectures, speakers, or resource people; the foundation participates in ethnic festivals.

ARMENIAN ARTISTS ASSOCIATION OF AMERICA Library
 32 Commonwealth Rd., P.O. Box 140
 Watertown, MA 02172 617-923-9174

Personnel: Robert Mardirosian, Chairman; John Dasho, Treas.
Contact: Richard H. Tashjian, Vice Chairman
Founded: 1973; Scope: National
Availability: Not open to the public; Admission: Donation
Staff: 3 volunteers

Collection: Videos, slides, contemporary art of Armenia, paintings and graphics. The collection is not cataloged.

Comments: The association fosters the promotion of artists of Armenian descent through exhibits and lecture series. Activities include TV programs, films, and participation in ethnic festivals.

ARMENIAN ASSEMBLY RESOURCE LIBRARY Library
 122 C Street, NW, Ste. 350
 Washington, DC 20001 202-393-3434; Fax 202-638-4904

Sponsoring organization: Armenian Assembly of America
Contact: Rouben Adalian, Dir. of Office of Research and Analysis
Availability: Open by appt. M-F 9:30-5:30; Admission: Free
Publications: *The Armenian Genocide in the U.S. Archives 1915-1918.*

Collection: 400 books, 60 periodicals, 800 audio tapes, 200 video tapes, 25 films. The collection is cataloged.

Comments: The library documents media coverage of Armenians and Armenian issues, including comprehensive coverage of the Armenian genocide and holocaust.

ARMENIAN BEHAVIORAL SCIENCE ASSOCIATION Archives
 314 Dartmouth Court
 Paramus, NJ 07652 212-636-6393

Contact: Harold Takooshian, Exec. Officer
Founded: 1987; Scope: International
Availability: Open by special appt.; Admission: Free
Visitors: Ethnic community
Staff: Volunteers
Publications: *Bulletin of Armenian Behavioral Science Association*, 1988- ,

semiannual; *Directory of Armenian Behavioral Scientists* (biennial); publishes newsletters and flyers.

Collection: 5 cartons of unpublished archival records; the collection is cataloged.

Comments: The purpose is to collect, organize, and disseminate information about behavioral scientists of Armenian ancestry in North America and around the world.

ARMENIAN CULTURAL FOUNDATION Museum
 441 Mystic St. Library
 Arlington, MA 02174 617-646-3090

Contact: Hagop Atamian, Curator
Founded: 1945; Scope: National
Availability: Open by appt. only M-Th 9-12
Staff: 1 pt

Collection: Over 5,000 books, periodicals, 19th and 20th century newspapers. The collection is partially cataloged; a published guide, reading room, and copying facilities are available.

Comments: The purpose is to promote and preserve Armenian history, culture and literature, and especially to preserve the memory of Yeghia Demirjibashian, Armenian poet and philosopher.

ARMENIAN FILM FOUNDATION Library
 2219 E. Thousand Oaks Blvd., Ste. 292 Archives
 Thousand Oaks, CA 91362 805-495-0717; Fax 805-379-0667

Contact: Dr. J. Michael Hagopian, Chairman
Founded: 1979; Scope: International
Availability: Not open to the public
Operating budget: Varies from $25,000 to $100,000

Collection: Films, videos, and archives of historical film footage; a published guide is available.

Comments: The foundation documents on film and video all aspects of Armenian heritage and life and purposes to create worldwide recognition of the Armenian people and their contributions. It disseminates films to libraries and offers an internship program.

ARMENIAN GENERAL BENEVOLENT UNION Library
 585 Saddle River Rd.
 Saddle Brook, NJ 07662 201-797-7600

Contact: Rima Keushgerian
Availability: Open to the public

Collection: 4,000 books, 25 periodicals on Armenian history, literature and culture.

ARMENIAN LIBRARY & MUSEUM OF AMERICA Museum
 65 Main St. Library
 Watertown, MA 02171 02172

Personnel: Lucine Barsamian, Admin. Asst.; Susan Lind-Sinanian, Conservator
Contact: Gary Lind-Sinanian, Acting Dir.
Founded: 1971; Scope: National
Availability: Open Sun.-T, 1-5
Visitors: General public, School groups, Ethnic community
Staff: 2 ft, 1 pt, salaried; 60 volunteers; Operating budget: $160,000
Publications: *Alma Newsletter*, 1973- , 3/yr.; *Alma Matters*, 1991- , semiannual.

Collection: 14,000 books, 125 periodical titles, 40 audiovisual materials, 7,000
artifacts (textiles, rugs, ceramics, religious art, coins, metalware, stamps, Urartian
architectural models, costumes, geological and botanical specimens, utensils),
incunabula, maps, calendars, posters, sheet music, pamphlets, photographs, early sound
recordings, documents, and manuscripts.

Comments: Objectives are to preserve the Armenian heritage, both past and present,
and to promote an awareness and appreciation of the culture and contributions of the
Armenian people through exhibits and diverse educational programs. The museum and
library also serve as a national repository of information on Armenian history and
culture. Provides guided tours, lectures, school presentations, speakers, crafts classes,
souvenir shop, and participates in ethnic festivals.

ARMENIAN LITERARY SOCIETY-NEW YORK Library
 Armenian Hai Keragenoutian Paregamner
 77 Everett Rd.
 Demarest, NJ 07627 201-767-1494

Personnel: Charles Kasbarian, Associate
Contact: Arthur Hamparian, Acting Director
Founded: 1956; Scope: National
Availability: Open by special appt. only; Admission: Free
Visitors: General public, School groups, Ethnic community
Staff: 1 volunteer
Publications: *Kir ou Kirk*, 1956- ; temporarily discontinued.

Collection: Books and periodicals. The collection is not cataloged; a reading room and
copying facilities are available.

Comments: Encourages the Armenian written word and the distribution and
dissemination of books of Armenian interest in both Armenian and English.

ARMENIAN MISSIONARY ASSOCIATION OF AMERICA Library
A. A. BEDIKIAN LIBRARY
 140 Forest Ave.
 Paramus, NJ 07652 201-265-2607

Contact: Dikran Youmshakian, Library Mgr.

Availability: Open to the public; Admission: Free
Publications: Produces pamphlets in Armenian, English and Turkish.

Collection: 10,000 books related to Armenia and Armenian issues worldwide, various
reference tools; a reading room and copying facilities are available.

Comments: The association helps Armenians with immigration, naturalization,
education, and other social problems. Activities include educational lectures, loans to
schools, presentations of choral music, film productions, seminars, and conferences.

ARMENIAN NUMISMATIC SOCIETY Library
 8511 Beverly Park Place
 Pico Rivera, CA 90660-1920 310-695-0380

Contact: Y. T. Nercessian, Secy.
Founded: 1971; Scope: International
Availability: Open by special appt.; Admission: Free
Staff: pt; Operating budget: $2,000
Publications: *Armenian Numismatic Journal (Hay Drambitakan Handes)*, 1975- ,
quarterly; also publishes books.

Collection: Books, periodicals, and archival materials (personal papers and
correspondence, unpublished records, printed materials). The collection is cataloged;
an unpublished guide and reading room are available.

Comments: The purpose is to collect and publish information on Armenian coins,
medals, bank notes, etc. Services include educational lectures and school presentations.

ARMENIAN REFERENCE AND RESEARCH LIBRARY Library
 395 Concord Ave. Archives
 Belmont, MA 02178 617-489-1610

Sponsoring organization: National Association for Armenian Studies and Research
Personnel: Manoog S. Young, Chairman, Bd. of Dirs., NAASR, Inc.; Sandra L.
Jurigian, Admin. Dir.
Contact: Hagop Hachikian, Asst. Libn. & Research Asst.
Founded: 1955; Scope: National
Availability: Open, restricted access to some materials; Admission: Free/Donation
Visitors: General public, School groups, Ethnic community, Researchers and students
Staff: 10 (2 ft, 3 pt, salaried; 5 volunteers); Operating budget: $125,000
Publications: *NAASR Newsletter*, 1984- , quarterly; *Journal of Armenian Studies*,
1975- , semi-annual; also publishes books (chronicles, conference proceedings,
memoirs, etc.).

Collection: Over 15,000 books, periodicals, audiovisual materials and 75 boxes and/or
file drawers of archival materials (personal papers and correspondence, unpublished
records, printer materials, pictorial materials, theses and dissertations, manuscripts, oral
histories and clippings file). The collection is partially cataloged; a limited number of
items are in microform. A reading room and copying facilities are available for
researchers.

Comments: The purpose is to foster Armenian studies, research, and publication of scholarship related to Armenia and Armenian Americans. Services provided include guided tours, educational lectures, and speakers or resource people.

ARMENIAN SOCIETY OF LOS ANGELES Library
ARMENAK AND NUNIA HAROUTUNIAN LIBRARY
 221 South Brand Blvd.
 Glendale, CA 91206 818-240-0619; Fax 818-241-1073

Personnel: Cathy Mackertichian, Pres.
Contact: T. Der Sarkissian
Founded: 1980; Scope: Local
Availability: Open 9-1; Admission: Fee (Donation)
Visitors: Ethnic community
Staff: 1 volunteer; Operating budget: $5,000
Publications: *Newsletter of Armenian Society of L.A.*, 1994- , monthly

Collection: Over 5,000 Armenian-language books on Armenian history, literature and culture; 12 periodicals.

Comments: The purpose of the organization is to provide cultural activities for members. These include performing arts presentations (dance, drama, and choir), and participation in ethnic festivals.

CALIFORNIA STATE UNIVERSITY, FRESNO Library
KALFAYAN CENTER FOR ARMENIAN STUDIES PROGRAM Archives
 Sahatdjian Library and Avedian Archives
 5245 N. Backer Ave.
 Fresno, CA 93740-0004 209-278-2669; Fax 209-278-2129

Personnel: Barlow Der Mugredechian
Contact: Dr. Dickran Kouymjian
Founded: 1977; Scope: Local, State, Regional, National, International
Availability: Restricted access; Admission: Free
Visitors: General public
Staff: 2 ft
Publications: *Armenian Studies News Service*, 1985- , monthly; *Hye Shjarzhoom*, 1979- , quarterly.

Collection: 3,000 books, 50 periodicals, 50 audiovisual materials and archival materials (personal papers and correspondence, unpublished records, theses and dissertations, manuscripts, and oral histories). The collection is not cataloged; a reading room and copying facilities are available for undergraduate and graduate level researchers.

Comments: Provides a repository of research materials on areas of Armenian studies including history, art, language, and Armenian cultural heritage. Programs include lectures, radio and TV programs, speakers, and films. The organizations's collections support research. It also offers in-service programs, and courses or workshops for teachers.

KRIKOR AND CLARA ZOHRAB INFORMATION Library
CENTER OF THE ARMENIAN DIOCESE Archives
 630 Second Ave.
 New York, NY 10016-4885 212-686-0710; Fax 212-779-3558

Sponsoring organization: Armenian Church of America
Personnel: Very Rev. Fr. Krikor Maksoudian, Dir.
Contact: Aram Arkun, Asst. Dir.
Founded: 1987; Scope: National, International
Availability: Open 9-5; Admission: Free
Visitors: General public, School groups, Ethnic community
Staff: 5 (4 ft, 1 pt, salaried); Operating budget: $361,000
Publications: *Krikor and Clara Zohrab Information Center News Digest*, 1991- ,
weekly; also publishes books.

Collection: 15,000 books, ca. 350 periodicals, ca. 350 audiovisual materials, and
archival materials (personal papers and correspondence, unpublished records, pictorial
materials, theses and dissertations, and manuscripts). Materials from the ABC FM
archives, American Patriarchate, are in microform. The collection is cataloged; a
reading room and copying facilities are available.

Comments: The purpose is to promote the understanding of Armenian history and
culture by providing a reference library for scholars and the general public. Services
include guided tours, educational lectures, loans and presentations to schools, speakers,
and films and AV productions.

MAMIGONIAN FOUNDATION Library
 14513 Woodcrest Dr.
 Rockville, MD 20853 301-460-0353

Contact: John L. Gueriguian, M.D., Exec. Dir.

Collection: 1,500 books in Armenian and other languages covering Armenian topics,
artifacts (rugs, coins), works of art (paintings), and archival records.

Comments: The purpose is to provide materials and information that document
Armenian history, geography, art, literature, and culture.

NATIONAL ASSOCIATION FOR ARMENIAN STUDIES Library
AND RESEARCH
 395 Concord Ave.
 Belmont, MA 02178-3049 617-489-1610

Contact: Manoog S. Young, Board Chairman
Founded: 1955; Scope: National
Availability: Open by appt.; Admission: Free
Visitors: General public, Ethnic community
Staff: 5; Operating budget: $125,000
Publications: *Journal of Armenian Studies*, semiannual; also publishes books on
Armenia and the Armenians.

Collection: 1,000 books, primarily in English.

Comments: The association promotes the study of Armenian history and culture through research and publications. It operates an Armenian Book Clearing House and Distribution Center and the Armenian Heritage Press for publication of popular and scholarly titles. It cooperates with major universities (Harvard University, University of Chicago, Columbia University, the University of Massachusetts, among others) to sponsor research and offer Armenian studies for course credit. Services include grants and scholarships, educational seminars and lectures, exhibits, and guided tours.

PROJECT SAVE, INC. <u>Archives</u>
 46 Elton Ave.
 Watertown, MA 02172-4116 617-923-4563

Contact: Ruth Thomasian, Exec. Dir.
Founded: 1975; Scope: National
Availability: Open by appt.; Admission: Free/Donation
Visitors: General public, Ethnic community
Staff: 1 ft, 1 pt; Operating budget: $100,000
Publications: Photograph calendar, 1985- , annual; *Treasured Images* (exhibit catalog).

Collection: Ca. 1,500 books, audio tapes, archives (personal papers and correspondence, 15,000 photographs, oral histories). The collection is not cataloged; a reading room and copying facilities are available.

Comments: Project SAVE is a photograph archives of Armenian people and places. The purpose is to visit people in their homes in order to preserve the Armenian culture which was nearly destroyed by the 1915 genocide. Activities include guided tours, educational lectures, school presentations, and sale or use of photographs. The archives supports graduate level research, provides work experience for college credit, and provides in-service programs, courses or workshops for teachers.

RENSSELAER POLYTECHNIC INSTITUTE <u>Library</u>
ARMENIAN ARCHITECTURAL ARCHIVES PROJECT <u>Archives</u>
 Brunswick Hills, East Road
 Troy, NY 12180 518-274-4526

Personnel: John F. Dojka, Archivist and Architecture Libn.
Contact: Dr. V. Lawrence Parsegian, Project Dir., Pres., Armenian Education Council
Founded: 1966; Scope: National, International
Availability: Open, restricted access; Admission: Free
Visitors: Architecture students and scholars of Armenian architecture
Staff: 1 volunteer

Collection: Books and 42,000 photographs of 940 Armenian historic monuments, in seven volumes, plus microfiche documentation from many libraries in Europe and the U.S. Includes photographs of monasteries, fortresses, bridges, and sites.

Comments: The collection was assembled through the cooperative efforts of Research on Armenian Architecture, the Armenian Educational Council Inc. of the United States,

a $75,000 grant from the Samuel H. Kress Foundation, and contributions from private donors. The volumes are now found in over 110 research libraries of the U. S. and Europe. The collections support graduate level research.

ST. MARY'S ARMENIAN APOSTOLIC CHURCH, Library
BALIAN LIBRARY
 4125 Fessenden St. NW
 Washington, DC 20016 202-363-1923; Fax 202-537-0229

Contact: Elizabeth Kayaian Garabedian, Director
Founded: 1988; Scope: National, International
Availability: Not open to the public; Admission: Free
Staff: 1 ft volunteer; Operating budget: $500
Publications: Formal annual report.

Collection: 1,200 books, 3 periodical titles, audiovisual materials, artifacts (coins), and archives (theses and dissertations, printed materials). A published guide to the collection and copying facilities are available.

Comments: The library preserves Armenian history and culture, with emphasis on the history of St. Mary's Armenian Apostolic Church. Guided tours are available.

ST. NERSES SHNORHALI LIBRARY Library
 138 East 39th St.
 New York, NY 10016 212-689-7810

Sponsoring organization: Armenian Apostolic Church of America
Contact: Houri Ghougassian, Libn.
Founded: 1975; Scope: National
Availability: Restricted access; Admission: Free
Visitors: Scholars and students of Armenian studies
Staff: 1 pt volunteer; Operating budget: $10,000
Publications: *Outreach* (official publication of the church).

Collection: Over 5,000 books, periodicals. The collection is partially cataloged; a reading room and copying facilities are available.

Comments: The library serves as an information center for promoting education regarding the religious and cultural history of the Armenian people. Lectures are provided.

UNIVERSITY OF MICHIGAN, DEARBORN Archive
CENTER FOR ARMENIAN RESEARCH, PUBLICATION
& ECONOMIC DEVELOPMENT
 4901 Evergreen Rd.
 Dearborn, MI 48128-1491 313-593-5181; Fax 313-593-5452

Sponsoring organization: Knights of Vartan/University of Michigan, Dearborn
Personnel: Dr. Elise K. Parsigian, Assoc. Dir.
Contact: Dr. Dennis R. Papazian, Dir.

Founded: 1985; Scope: Local, State, National, International
Availability: Open to the public; Admission: Free
Visitors: General public, Ethnic community
Staff: 2 ft, 2 pt (1 salaried), 2 volunteers; Operating budget: $50,000

Collection: 2,400 books, 8,000 periodicals, 98 audiovisual items, 16 file drawers of archival materials (personal papers and correspondence, unpublished records, theses and dissertations, manuscripts, and oral histories). U.S. State Dept. Archives on the Armenian Genocide; Consuls' Reports from Tiflis (Russia), Tabkiz (Persia), and other cities in the Ottoman Empire, 1890-1920; the collection of Dr. Parsegian on Armenian architecture; and several newspapers and journals (e.g., *The Armenian Review* and *The Armenian Weekly)* are all maintained in microform. The collection is fully cataloged; an unpublished guide, reading room, and copying facilities are available for researchers.

Comments: The Center is affiliated with the University of Michigan-Dearborn and its purpose is to provide resources and accurate information on Armenian history and the Armenian genocide for students, scholars, the media, and public officials and to foster scholarship in Armenian studies. It sponsors guided tours, educational lectures, radio and TV programs, speakers or resource people, and provides work experience and courses for college credit.

ZORYAN INSTITUTE LIBRARY Library
 19 Day St.
 Cambridge, MA 02140 617-497-6713

Availability: Open by appt. only; Admission: Free

Collection: 8,019 books, 68 periodical titles, 2,359 videotapes, sound tapes, photographs, maps. The collection emphasizes Armenian genocide and diaspora, Armenian studies, and contemporary life.

ASIAN AMERICAN RESOURCES
(*See also* Afghanistan American, Cambodian American, Chinese American, Filipino American, Indian American, Japanese American, Korean American, Laotian American, Sri Lankan, Thai American, Tibetan American, and Vietnamese American Resources)

ASIA RESOURCE CENTER Library
(Formerly Southeast Asia Resource Center)
 P. O. Box 15275
 Washington, DC 20003 202-547-1114

Contact: Roger Rumpf, Dir.
Founded: 1971; Scope: National
Availability: Open to the public; Admission: Free
Visitors: General public, Ethnic community
Staff: 4; Operating budget: $100,000
Publications: *Indochina Newsletter*, bimonthly; also publishes books.

Collection: Books, periodicals, audiovisual materials (films, slide-tape programs)

Comments: The objective of the center is to collect and disseminate materials and information on the people, culture, and political situation in Asia. It sponsors a traveling exhibit on Vietnamese folk art and maintains a speakers' bureau.

THE ASIA SOCIETY Museum
 725 Park Ave. Library
 New York, NY 10021 212-288-6400; Fax 212-517-8315 Archives
 Art Gallery

Personnel: Marshall M. Bouton, Exec. Vice Pres.
Contact: Ambassador Nicholas Platt, Pres.
Founded: 1956; Scope: International
Availability: Open to the public; Admission: Donation
Visitors: General public, School groups, Ethnic community
Staff: 119 (79 ft, 20 pt, salaried; 20 volunteers); Operating budget: $9,908,000
Publications: Publishes formal annual report; *Asia*, 1984- , quarterly newsletter; also publishes exhibition catalogs (exhibitions change two-three times/year).

Collection: Books, periodicals, audiovisual materials, and archival records (personal papers and correspondence, printed materials). The collection is not cataloged.

Comments: This educational, non-political organization is dedicated to building bridges of understanding between Asians and Americans. The programs of the organization include guided tours, lectures, school presentations, radio and TV programs, guest speakers, dance presentations, choral presentations, films productions, AV productions, and participation in ethnic festivals. The organization also operates an arts and crafts souvenir shop.

ASIAN AMERICAN ARTS ALLIANCE Library
 339 Lafayette St., 3rd Flr. Archives
 New York, NY 10012 212-979-6734; Fax 212-979-8472

Personnel: June Choi, Exec. Dir.; Christine Lipat, Programs Mgr.
Contact: Janice Pono, Resource Library Coordinator
Founded: 1983; Scope: National
Availability: Restricted access
Admission: Free
Visitors: General public, Ethnic community
Publications: *Dialogue*, quarterly newsletter.

Collection: 125 books, 300 periodicals, 30 audiovisual materials, and 3 boxes and 8 file drawers of archives (personal papers and correspondence, unpublished records, printed materials, pictorial materials, theses and dissertations, and oral histories). Circulation of materials is limited to contributing members. A reading room is available for researchers.

Comments: The focus is on providing information, networking and advocacy services and on increasing the support, recognition, and appreciation of Asian American arts. Educational seminars and workshops are offered.

ASIAN AMERICAN ARTS CENTRE Archives
26 Bowery
New York, NY 10013 212-233-2154; Fax 212-766-1287

Contact: Robert Lee, Dir.
Founded: 1974; Scope: National
Availability: Open by appt.
Visitors: General public
Publications: *Artspiral*, newsletter; brochures; collection catalogs and books.

Collection: The Artist Slide Archive is a registry of over 500 Asian American artists and provides a permanent historical records of their works.

Comments: The centre has ongoing exhibits of the works of contemporary Asian American artists; it conducts research, holds educational presentations in the New York City public schools, and sponsors an Artists-In-Residence program for emerging Asian American artists. Activities include audiovisual presentations.

ASIAN ART MUSEUM OF SAN FRANCISCO Museum
Golden Gate Park
San Francisco, CA 94118 415-668-8921; Fax 415-668-8928

Personnel: Rand Castile, Dir.; Emily Sano, Chief Curator, Deputy Dir.
Contact: Libby Ingalls
Founded: 19
66; Scope: International
Availability: Open to the public; Admission: Fee (Free to members and school groups)
Visitors: General public, School groups, Ethnic community
Staff: 55 (41 ft, 11 pt, 3 volunteers)
Publications: *Treasures*, 1992- , quarterly newsletter; *Triptych*, 1981- , 5/yr; also publishes exhibition catalogs, gallery guides, and books.

Collection: 20,000 books, periodicals, 40 videos, 300 audio tapes, 12,000 works of art, and archives (personal papers and correspondence, unpublished records, pictorial materials, theses and dissertations, manuscripts). Early accession records and object cards are on microfiche. The collection, known as the Avery Brundage Collection, is cataloged; an unpublished guide, reading room, and copying facilities are available.

Comments: The purpose is to increase understanding and appreciation of Asian fine arts and culture. Special programs include guided tours, exhibits, educational lectures, loans to schools and other educational institutions, school presentations, speakers, dance/drama/instrumental presentations, films and AV productions, and an arts and crafts souvenir shop. The museum provides support for research.

ASIAN CINEVISION Archives
32 E. Broadway
New York, NY 10002

Contact: Peter Chow, Exec. Dir.

Founded: 1976; Scope: National
Availability: Open by special appt. only; Admission: Free
Visitors: General public, Ethnic community
Staff: 8; Operating budget: $600,000
Publications: *CineVue*, 5/yr.; also publishes annual supplement to *Asian American Media Reference Guide*.

Collection: Print and video archives

Comments: The organization encourages the production of Asian-American video arts in order to promote and explain Asian American culture and heritage.

ASIAN STUDIES NEWSLETTER ARCHIVES Archive
 9225 Limestone Place
 College Park, MD 20740-3943 301-935-5614

Contact: Frank Joseph Shulman, Curator and Bibliographer
Founded: 1970; Scope: International
Availability: Open by appt. only; Admission: Free
Visitors: General public
Staff: 1 pt; Operating budget: $1,000

Collection: 1,500 titles of academic and cultural newsletters and association bulletins dealing with Asian studies and Asian affairs, 350 linear shelf ft. of archives. The collection focuses on the countries and cultures of East Asia, Southeast Asia, South Asia, and the Middle East. The collection is partially cataloged.

Comments: The purpose is to preserve a centralized collection of newsletter-type materials containing information about the state of Asian studies, Asia-related organizations, and the activities of various institutions and individuals, and to create a database as the basis for preparation of bibliographies and reference tools.

DONN V. HART SOUTHEAST ASIA COLLECTION, NIU LIBRARIES Library
 Founders Memorial Library
 Northern Illinois University
 DeKalb, IL 60115 815-753-1808/9; Fax 815-753-2003

Contact: May Kyi Win, Curator
Founded: 1964; Scope: Local, State, Regional, National, International
Availability: Open to the public M-F, 8:00-4:30; Admission: Free
Visitors: General public
Staff: 7 (3 ft, 4 pt); Operating budget: $50,000
Publications: Catalog of collections

Collection: 58,512 books, 680 periodicals, 10,724 pamphlets, and archives (personal papers and correspondence, unpublished records, theses and dissertations, and manuscripts). The collection is cataloged; a published guide, reading room, and copying facilities are available.

Comments: The purpose is to meet the research and instructional needs of students and

faculty, particularly in the Southeast Asia Program. Guided tours, speakers or resource people, and graduate and undergraduate level research programs are offered.

EAST-WEST CULTURAL CENTER Library
 Sri Aurobindo Center
 12329 Marshall St.
 Culver City, CA 90230 310-390-9083

Contact: Mr. Debashish Banerji, Secy.-Treas.
Founded: 1953; Scope: National
Availability: Open to the public; Admission: Free
Visitors: General public, Ethnic community
Staff: 4; Operating budget: Less than $25,000
Publications: Books

Collection: 2,000 books

Comments: Emphasis is on the contributions made by those interested in promoting eastern religions and arts, particularly in Eastern Indian philosophy, history, literature, and culture, with the goal to integrate Eastern and Western culture and values. Services include classes in Hindi, Punjabi, Sanskrit, and Yoga.

HONOLULU ACADEMY OF ARTS Museum
 900 S. Beretania St. Library
 Honolulu, HI 98614 808-532-8700; Fax 808-532-8787

Personnel: George R. Ellis, Dir., CEO & Pres. Bd.; Henry B. Clark, Vice Chm.; David J. de la Torre, Assoc. Dir.; Stephen Little, Curator, Asian Art.
Founded: 1922; Scope: State
Availability: Open to the public, daily; 10-4:30 T-Sat, 1-5 Sun.
Admission: Suggested donation $4; seniors, military, students $2; under 12 free
Visitors: General public
Staff: 80 ft, 55 pt, salaried, 400 volunteers
Publications: Catalog of collections

Collection: 40,000 books on Asian gardens, art, folk arts and crafts; works of art (paintings, sculpture, decorative arts, Japanese prints and arts of Oceania).

Publications: *Honolulu Academy of Arts Journal*; also publishes exhibition catalogs, promotional brochures and a news calendar.

Comments: Preserves oriental art and culture via exhibits (e.g., Depictions of Hawaii and its People; The View from Within: Japanese-American Art from the Internment Camps; Artists of Hawaii, etc.). Provides tours, lectures, audiovisual and dance presentations, loans to schools, children's programs, and participates in ethnic festivals.

NATIVE HAWAIIAN CULTURE AND ARTS PROGRAM Museum
 Bishop Museum Library
 680 Twilei Rd., Suite 560
 Honolulu, HI 96817 808-532-5630

Contact: Lynette Paglinawan, Exec. Dir.
Founded: 1986; Scope: National
Availability: Open to the public
Visitors: General public, Ethnic community
Staff: 9; Operating budget: $1,000,000
Publications: Annual report; promotional materials.

Collection: Books, periodicals, audiovisual materials, artifacts.

Comments: Preserves Native Hawaiian arts, culture, history, and traditions. It
sponsors research related to Native Hawaiian language, folklore, and ceremonies, and
disseminates findings and information. It maintains a speakers' bureau.

OAKLAND PUBLIC LIBRARY-ASIAN BRANCH Library
 449 9th St.
 Oakland, CA 94607 510-238-3400

Contact: Suzanne Lo, Branch Head Libn.
Founded: 1975; Scope: Local
Availability: Open to the public; Admission: Free
Visitors: General public
Staff: 12 (2 ft, 10 pt)
Publications: Newsletters and flyers

Collection: 42,000 books, 200 periodical titles, over 1,000 audiovisual materials. The
collection is cataloged; a published guide, reading room, and copying facilities are
available.

Comments: The objective is to provide a bilingual collection and print and nonprint
materials in Chinese, Japanese, Korean, Filipino, Vietnamese, Thai and Cambodian, as
well as English. Bilingual staff members give library tours, assist research inquiries on
Asian subjects, and provide information and referral services. Additional features of
the library are the filmstrip collection, clippings, picture, and poster files, curriculum
materials and materials for English-language instruction. The Asian Branch sponsors
cultural programs, receptions, and book signings for authors.

PACIFIC ASIAN MUSEUM Museum
(Formerly Pacifuculture Foundation)
 46 N. Los Robles
 Pasadena, CA 91101 818-449-2742; Fax 818-449-2754

Personnel: David Kamansky, Dir. and Curator; Sherrill Livingston, Dir. of Admin.;
Elaine Wintman, Dir. of Development
Contact: Dorothy A. Roraback, Asst. to Dir.
Founded: 1961; Scope: Local, International
Availability: Open to the public; Admission: Fee
Visitors: General public, School groups
Staff: 12 ft, 7 pt, 396 volunteers; Operating budget: $860,000
Publications: *Pacific Asia Museum Newsletter*, bimonthly; annual report; catalogs of
exhibitions.

Collection: 3,500 books on Oriental arts, 17,641 works of art, plus archival records consisting of printed and pictorial manuscripts. The collection is not cataloged; a reading room and copying facilities are available.

Comments: The museum promotes understanding of the arts and cultures of Asian and Pacific Island peoples through exhibitions and educational programs that depict their history and heritage.

SAN FRANCISCO PUBLIC LIBRARY-CHINATOWN BRANCH Library
 1135 Powell St.
 San Francisco, CA 94108 415-274-0275

Contact: Elsie Wong, Branch Libn.
Scope: Local
Availability: Open to the public; Admission: Free
Visitors: General public
Staff: 19 (9 ft, 10 pt); Operating budget: $592,000

Collection: 90,000 books, 75 periodical titles, and 1,250 audiovisual materials. Materials are available in English, Chinese, and Vietnamese; the Chinese language collection is the largest in the area. Some records are in microform. The collection is cataloged; a published guide, reading room, and copying facilities are available.

Comments: The library serves the Asian community with books and audiovisual materials about both Asians and Asian Americans and by presentations to educational institutions.

SOUTHEAST ASIA RESOURCE ACTION CENTER-SEARAC Library
(Formerly Indochina Resource Action Center-IRAC)
 1628 Sixteenth St., NW, 3rd Flr.
 Washington, DC 20009 202-667-4690; Fax 202-667-6449

Contact: Cuong H. Nguyen, Chief Libn.; 7907 Towerbell Ct., Annandale, VA 22003
Founded: 1983; Scope: National
Availability: Open M 10-3 and by special appt.; Admission: Free
Visitors: General public
Staff: 1 pt, salaried; Operating budget: $2,400
Publications: Reference tools related to the Asian community.

Collection: 500 books, 1,000 periodicals, 100 audiovisual materials. The collection is cataloged.

Comments: The center provides a collection of books and periodicals for researchers on Southeast Asian refugee resettlement in the United States.

UNIVERSITY OF IDAHO Museum
ASIAN AMERICAN COMPARATIVE COLLECTION Library
(Formerly Chinese Comparative Collection; Asian Comparative Collection)
 Laboratory of Anthropology
 Moscow, ID 83844-1111 208-885-7905; Fax 208-885-5878

Contact: Priscilla Wegars, Curator
Founded: 1982; Scope: State, National, International
Availability: Open by special appt.; Admission: Free
Publications: *Asian American Comparative Collection Newsletter*, 1984- , quarterly;
also publishes books, flyers, and reprints of theses and dissertations.

Collection: 1,000 books, periodicals, 1,500 AV materials, 1,500 artifacts, and archives
(personal papers and correspondence, unpublished records, pictures, theses, oral
histories, manuscripts). The collection is cataloged; copying facilities are available.

Comments: The objective is to obtain artifacts and bibliographical materials related to
Asians, primarily Chinese and Japanese, and Filipinos and Koreans to a lesser extent.
Activities include guided tours, loans to other institutions, and school presentations.

UNIVERSITY OF MICHIGAN Library
AMERICAN ORIENTAL SOCIETY
 Harlan Hatcher Library, Rm. 111E
 Ann Arbor, MI 48109-1205 313-747-4760

Sponsoring organization: University of Michigan
Contact: Jonathan Rodgers, Secy.-Treas.
Founded: 1842; Scope: National
Availability: Open to the public; Admission: Free
Visitors: General public, Ethnic community
Staff: 4; Operating budget: $150,000
Publications: *Journal of the American Oriental Society*, quarterly; *American Oriental
Series*, irregular monograph series; *American Oriental Series Essays*; periodic series.

Collection: 22,413 books and periodicals dealing with oriental culture.

Comments: The society promotes research in oriental languages, history, and culture.
It grants scholarships for the study of Chinese art.

WING LUKE ASIAN MUSEUM Museum
(Formerly Wing Luke Memorial Museum)
 407 Seventh Ave. S.
 Seattle, WA 98104 206-623-5124

Personnel: Ron Chew, Dir.; Charlene Mano, Education Coordinator; Diane Narasaki,
Dev. Dir.; Ruth Vincent, Regional Coll. Mgr.
Contact: Olivia Tagvinod
Founded: 1967; Scope: Local, National, International
Availability: Open by special appt. only; Admission: Fee
Visitors: General public, School groups, Ethnic community
Staff: 3 ft, 13 pt, 35 volunteer; Operating budget: $340,000
Publications: *The Wing Luke Asian Museum Membership Newsletter*, quarterly; also
publishes exhibit catalogs.

Collection: 500 books, 8,000 artifacts, paintings, photographs, 2 drawers of archives
(personal papers and correspondence, unpublished records, pictures, oral histories).

The collection is cataloged; a reading room and copying facilities are available.

Comments: The museum seeks to promote understanding between Asian and non-Asian communities by collecting, organizing, and displaying objects and photographs from the Seattle international district related to Asian heritage and culture. Programs and services include guided tours, and loans and/or presentations to schools.

AUSTRIAN AMERICAN RESOURCES
(*See also* German American Resources)

AUSTRIAN CULTURAL INSTITUTE <u>Library</u>
(Formerly Austrian Institute) <u>Art Gallery</u>
 11 East 52nd St.
 New York, NY 10022 212-759-5165

Contact: Dr. Wolfgang Waldner, Dir.
Founded: 1962; Scope: International
Availability: Open to the public; Admission: Free
Visitors: General public
Staff: 8 ft
Publications: *Austria Kultur*, bimonthly.

Collection: Over 1,500 books, periodicals, and audiovisual materials. The collection is cataloged; a reading room and copying facilities are available for researchers.

Comments: The institute offers Austrian cultural and scientific events and acts as a cultural exchange clearinghouse between Austria and the U.S. The library focuses on history, music, literature, fine arts, dramatic art, folklore, etc. It provides lectures, loans to schools, performing arts presentations, films, and traveling exhibitions on art, literature, and culture. It organizes panel discussions, symposia, music events, and ethnic festivals in cooperation with American or Austrian partner organizations.

FEDERATION OF ALPINE AND SCHUHPLATTLER CLUBS <u>Library</u>
IN NORTH AMERICA
 54 Cathedral Lane
 Cheektowaga, NY 14225 716-892-4119

Contact: Walter R. Wieand, Pres.
Founded: 1966; Scope: National
Availability: Open by appt.; Admission: Free
Visitors: General public, Ethnic community
Operating budget: Less than $25,000
Publications: *Gauzeitung*, monthly (10/yr).

Collection: Books

Comments: The objective is to promote Austrian and Bavarian culture and dance. Services include educational and children's programs, dancing contests, etc.

B

BASQUE AMERICAN RESOURCES

BASQUE EDUCATIONAL ORGANIZATION Library
 P. O. Box 640037 Archives
 San Francisco, CA 94164-0037 415-583-4035; Fax 415-753-0298

Contact: Martin Minaberry, Coordinator
Founded: 1983; Scope: National
Availability: Open by appt.; Admission: Free
Visitors: General public, Ethnic community
Operating budget: Less than $25,000

Collection: Books, audiovisual materials (videos), archives (biographical materials, unpublished papers, etc.) maintained in the Basque Cultural Center in San Francisco.

Comments: The objective is to collect and share information about Basque culture, history, and heritage. Educational programs, folk dance and music presentations, sports training, and a book series are offered.

SOCIETY OF BASQUE STUDIES IN AMERICA Museum
 19 Colonial Gardens
 Brooklyn, NY 11209 718-745-1141

Contact: Ignacio R. M. Galbis, V. Pres.
Founded: 1978; Scope: National
Availability: Open by appt.; Admission: Free
Visitors: General public, Ethnic community
Publications: *Journal of Basque Studies in America*, annual.

Collection: Artifacts related to Basque culture; Basque Hall of Fame

Comments: Promotes information about the Basque community in America through research, speakers, and exhibits on Basque culture and contributions (Hall of Fame).

UNIVERSITY OF NEVADA, RENO Library
BASQUE STUDIES PROGRAM (Euskal Mintegia) Archives
 University of Nevada Library
 Reno, NV 89557-0012 702-784-4854; Fax 702-784-6010

Personnel: William A. Douglass, Coordinator; Linda White, Asst. Coordinator
Contact: Jill Berner, Office Mgr.
Founded: 1967; Scope: State
Availability: Open to the public; Admission: Free
Visitors: General public, School groups, Visiting scholars
Staff: 11 ft; Operating budget: $274,000
Publications: Newsletter, 1968- , semiannual; Occasional papers series.

Collection: 30,000 books, 2,500 periodicals, films, videos, recordings, and archives (personal papers and correspondence, unpublished records, pictorial materials, theses and dissertations). About 1,500 titles are added annually. The collection is partially cataloged; a reading room and copying facilities are available.

Comments: The collection supports the Basque Studies Program which focuses on the history, heritage, and culture of Basque Americans and promotes research on special topics related to Basque studies. Guided tours and AV productions are available.

BELARUSIAN AMERICAN RESOURCES

BELARUSAN-AMERICAN COMMUNITY CENTER POLACAK Library
 11022 Webster Rd. Archives
 Strongsville, OH 44136 216-238-3842

Sponsoring organization: Mother of God Zyrovicy Cathedral
Contact: Paul Wasilewski, Cultural Dir., 6734 Baxter Ave., Cleveland, OH 44105
Founded: 1990; Scope: Local, State, National, International
Availability: Open by special appt.; Admission: Free
Visitors: Ethnic community
Staff: 3 volunteers; Operating budget: $10,000 plus donations
Publications: Membership newsletters and flyers; also publishes periodicals.

Collection: Ca. 750 books, 350 periodicals, artifacts, works of art, and archives (personal papers and correspondence, pictorial materials, and manuscripts). The collection is not cataloged; a reading room and copying facilities are available.

Comments: The purpose is to preserve Byelorussian American culture, history and heritage.

BYELORUSSIAN INSTITUTE OF ARTS AND SCIENCES, INC. Library
 230 Springfield Ave. Archives
 Rutherford, NJ 07070 201-933-6807; Fax 201-438-4565

Contact: Vatted Chapel, Pres.
Founded: 1951; Scope: International
Availability: Open by special appt. only; Admission: Free
Visitors: General public, Ethnic community
Staff: 4 (1 pt, 3 volunteers); Operating budget: $10,000
Publications: *Zapisy/Annals*, 1952- , annual; also publishes monographs.

Collection: 5,000 books, 65 periodical titles, 100 ft. of archival records (personal papers and correspondence), some in microform. The collection is not cataloged; a reading room and copying facilities are available.

Comments: The Institute cooperates with scholarly institutions to facilitate research on Belarusan topics. It provides school presentations and participates in ethnic festivals.

CHRIST THE REDEEMER PARISH LIBRARY Library
 3107 W. Fullerton
 Chicago, IL 60647 312-342-7373

Sponsoring organization: Christ the Redeemer Byzantine Bielorusian Catholic Church
Contact: Rev. Joseph Ciroc, Admin. of Parish
Founded: 1960; Scope: National, International
Availability: Restricted access; Admission: Free
Visitors: General public, Ethnic community
Staff: 1 ft, salaried

Collection: Ca. 1,250 books, over 500 periodicals, 3 file cabinets of archival records (personal papers and correspondence, unpublished records, theses and dissertations, pictorial materials, manuscript). A reading room and copying facilities are available.

Comments: Preserves the history of the church and parish, provides materials that support research and work for college credit, makes presentations to schools, provides radio and TV programs, speakers, a gift shop, and participation in ethnic festivals.

BELGIAN AMERICAN RESOURCES

CENTER FOR BELGIAN CULTURE OF WESTERN ILLINOIS, INC. Library
 712 18th Ave.
 Moline, IL 61265 309-762-0167

Personnel: Hubert Vande Voorde, Pres.; Celie Donohue, Archivist
Contact: Joan Loete, Libn. and Newsletter Editor, 3605 34th Ave., Moline, IL 61265
Founded: 1963; Incorporated: 1971; Scope: Regional
Availability: Restricted access; Admission: Free
Staff: 20 volunteers
Publications: Newsletter, 1969- monthly

Collection: Books, periodicals, audiovisual materials, artifacts, works of art and 12 cartons of archival records (personal papers and correspondence, unpublished records, pictorial materials, manuscripts, oral histories and genealogical materials). The collection is partially cataloged; a reading room and copying facilities are available for researchers.

Comments: The purpose is to preserve the Belgian culture and heritage and to provide social interaction for members of the center. The center also maintains archival records for historical and genealogical research.

GENEALOGICAL SOCIETY OF FLEMISH AMERICANS <u>Library</u>
18740 13 Mile Rd. <u>Archives</u>
Roseville, MI 48066 810-776-9579

Personnel: Marc Van Guseghem, Pres.; Dorothy Campau, V. Pres.; Madeline
Tanghe, Rec. Secy.; Marge Brooks, Treas.
Contact: Margaret Roets, Corr. Secy.
Founded: 1976; Scope: International
Availability: Open by special appt., restricted access; Admission: Free to members
Staff: 6 volunteers; Operating budget: Ca. $2,000
Publications: *Flemish American Heritage*, 1983- , semiannual; *GSFA Newsletter*,
1983- , semiannual.

Collection: 200 books, 35 periodicals, 25 artifacts, and archival materials (printed
materials, pictorial materials, and oral histories). Ethnic newspapers dating back to
1907 are in microform. The collection is partially cataloged; a reading room is
available.

Comments: The society attempts to preserve the Flemish customs and heritage through
books and artifacts; it conducts genealogical research and provides research assistance
for members. Additional services include educational lectures and presentations to
schools.

UNIVERSITY OF WISCONSIN-GREEN BAY <u>Library</u>
COFRIN LIBRARY SPECIAL COLLECTIONS DEPT. <u>Archives</u>
2420 Nicolet Dr.
Green Bay, WI 54302 414-465-2539

Contact: Debra L. Anderson, Archivist
Founded: 1972; Scope: Regional
Availability: Open to the public; Admission: Free
Visitors: General public
Staff: 1 ft, 1 pt, volunteer)
Publications: *Belgian American Research Materials*

Collection: Books, periodicals, archival materials (personal papers and
correspondence, unpublished records, print and pictorial materials, manuscripts, oral
history tapes, and architectural survey maps), audio-visual materials regarding Belgian
Americans are also integrated into the depository's holdings. The collection is
cataloged; a published guide, reading room, and copying facilities are provided for
researchers.

Comments: The Special Collections Department of Cofrin Library publishes a special
bibliographic guide which focuses on the local rural Walloon settlement in northeastern
Wisconsin and includes Flemish materials.

BLACK AMERICAN RESOURCES
(*See* African American Resources)

BRITISH AMERICAN RESOURCES

ST. JOHN'S CHURCH AND PARISH MUSEUM Museum
 100 W. Queensway, P.O. Box 313
 Hampton, VA 23669 804-722-2567

Sponsoring organization: Diocese of Southern Virginia
Personnel: Rev. Rodney Caulkins, Dir.; Beverly Gundry, Parish Historian and
Curator
Founded: 1976; Scope: Local, Regional
Availability: Open daily except Sunday; Admission: Free
Visitors: General public

Collection: Early Bibles and prayer books, audiovisual materials (photographs and
illustrations), artifacts from the original seventeenth century church building and site
(including gravestones of early English settlers).

Comments: The purpose is to preserve this early parish established by English settlers
in 1610. Services include guided tours and exhibits.

WILLIAM HUNTER SOCIETY Library
 24 Kay St. Archives
 Newport, RI 02840 401-846-7711

Contact: Capt. Howard Browne
Founded: 1974; Scope: National
Availability: Open by appt.; Admission: Free
Visitors: General public, Ethnic community
Operating budget: Less than $25,000
Publications: Directory of members

Collection: 1,000 books and archival records (primarily biographical information)

Comments: The purpose is to study Loyalists during the American Revolution and to
identify individuals who contributed to the preservation of the Anglo-American culture
and heritage. The organization, named after a Tory physician, sponsors visiting
professorships and fellowships in his name and maintains a hall of fame.

YALE CENTER FOR BRITISH ART Museum
 1080 Chapel St.
 New Haven, CT 06520 203-432-2800; Fax 203-432-0965

Sponsoring organization: Yale University
Personnel: Duncan Robinson, Dir.; Constance Clement, Asst. Dir. for Education and
Information; Beth Miller, Asst. Dir. for Dev.; Patrick Noon, Curator of Prints,
Drawings, and Rare Books; Susan Casteras, Curator of Paintings
Contact: Martin Pigott, Coord. of Info., Box 2120 Yale Station, New Haven, CT
06520
Founded: 1977; Scope: International

Availability: Open to the public; Admission: Free
Visitors: General public, School groups, Visiting scholars
Staff: 95 (50 ft, 15 pt, 30 volunteer), 65 salaried; Operating budget: 1,000,000
Publications: Membership newsletters; periodicals; annual report; catalog of
collections; and a biannual calendar of events.

Collection: 22,000 books, 1,200 paintings, 18,000 drawings, 30,000 prints, reference
library and photo archive of 110,000 books and photographs. The collection is
cataloged; a reading room and copying facilities are available.

Comments: The Center preserves British art and culture and mounts six to eight special
exhibitions per year, provides concerts, gallery talks, films, and children's programs.
It also provides guided tours, educational lectures, loans and presentations to schools,
instrumental concerts, and senior citizens' seminars.

C

CAMBODIAN AMERICAN RESOURCES
(*See also* Asian American Resources)

CAMBODIAN BUDDHIST SOCIETY, INC. Museum
 13800 New Hampshire Ave.
 Silver Spring, MD 20904 301-622-6544

Contact: Dr. M. Tarun Khemradhipati, Treas.
Founded: 1978; Scope: National
Availability: Open by special appt. only; Admission: Free
Visitors: General public, Ethnic community
Staff: 12 volunteers
Publications: *Vatt Khmer*, quarterly.

Collection: 110 vols. of Buddhist Bible (*Tripitaka*) and other books on Cambodian culture and religion.

Comments: The purpose of the organization is to preserve Cambodian life, culture, and religion and to provide assistance to Cambodian American refugees. It provides Cambodian language classes for children (Khmer language).

CARPATHO-RUTHENIAN AMERICAN RESOURCES
(*See also* Ukrainian American Resources)

BYZANTINE CATHOLIC SEMINARY LIBRARY Library
 3605 Perrysville Ave. Archives
 Pittsburgh, PA 15214-2297 412-321-8383; Fax 412-321-9936

Personnel: Monsignor Russell A. Duker, Rector of Seminary
Contact: Daniel K. Karlson, Interim Dir.
Founded: 1951; Scope: Local, State, Regional, National, International
Availability: Open by special appt., restricted access; Admission: Free/Donation
Visitors: General public, School groups, Ethnic community
Staff: 6 (1 ft, 1 pt, 4 volunteers)

Collection: 5,000 books, periodicals, audiovisual materials, artifacts, works of art, and archives (personal papers and correspondence, theses and dissertations, manuscripts). The collection is cataloged; a reading room and copying facilities are available.

Comments: The library houses one of the country's largest and rarest collections of Ruthenian/Carpatho-Rusyn and Byzantine Catholic literature. It provides a quality research facility for the seminarians of the Byzantine Catholic Rite and for all interested in Ruthenian/Carpatho-Rusyn literature and heritage. Guided tours are available.

DIOCESAN CULTURAL MUSEUM Museum
 1900 Carlton Rd. Library
 Parma, OH 44134-3129 216-741-8773; Fax 216-741-9356 Archives

Personnel: Bishop Andrew Pataki, Dir.; Msgr. Robert Yarnovitz, Supervisor
Contact: Susan Mandzak, Curator, 4681 Summer Lane, Brooklyn, OH 44144
Founded: 1982; Scope: Local, Regional
Availability: Open by special appt.; Admission: Free
Staff: 1 pt volunteer; Operating budget: $3,000

Collection: Ca. 3,500 books, periodicals, audiovisual materials, artifacts, works of art, and archives (personal papers and correspondence, pictorial materials, theses and dissertations). The collection is cataloged; a reading room is available.

Comments: The objectives are to collect and preserve materials relating to Eastern European Byzantine Catholic people and the growth and development of the Byzantine Catholic Church in the United States, and to foster appreciation of related folk arts and crafts, customs, and traditions. Guided tours are available. The museum sponsors the Annual Byzantine Heritage Day.

HERITAGE INSTITUTE Library
OF THE BYZANTINE CATHOLIC DIOCESE OF PASSAIC
 445 Lackawanna Ave.
 West Paterson, NJ 07424 201-890-7777; Fax 201-890-7175

Sponsoring organization: Byzantine Catholic Diocese of Passaic, NJ
Personnel: Rev. Robert Hospodar, Archivist
Contact: Rev. Michael J. Dudick, Pres.
Founded: 1973; Scope: Regional
Availability: By special appt. only, restricted access; Admission: Free
Visitors: General public, School groups, Ethnic community
Staff: 3 pt, 2 volunteers; Operating budget: $25,000
Publications: Various books and articles

Collection: Over 10,000 books (including rare books), periodicals, plus artifacts, works of art, and 15 files of archival material (personal papers and correspondence, unpublished records, pictorial materials, theses and dissertations, manuscripts, and oral histories). Some records are in microform. The collection is partially cataloged; a reading program and copying facilities are available.

Comments: The institute is dedicated to the memory of pioneer clergy and laity who emigrated to the U.S. from Eastern Europe and to preserving their faith and culture. The religious section features antique icons, rare chalices, vestments, and cultural items which include folk art, carvings, embroidery, folk costumes, paintings and other works of art.

LEMKO ASSOCIATION <u>Museum</u>
 556 Yonkers Ave.
 Yonkers, NY 10704 609-758-1115; Fax 609-758-7301

Personnel: Mary Barker, V. Pres.; Tod Rudowsky, Secy.
Contact: Alan Horonchak, Pres., P. O. Box 156, Provinceline Road, Allentown, NJ
08501-0156
Founded: 1929; Scope: National
Availability: Not open to the public; Admission: Free
Staff: 4 volunteers
Publications: *Karpatska Rus*, 1929- , biweekly

Collection: Ca. 500 books, 250 periodicals, 100 artifacts, and archival records
(personal papers and correspondence, printed and pictorial materials).

Comments: The purpose is to maintain the culture and traditions of the Lemko
immigrants and to benefit subsequent generations of Carpatho-Ruthenian Americans.

ST. VLADIMIR'S ORTHODOX THEOLOGICAL SEMINARY <u>Library</u>
LIBRARY
 575 Scarsdale Rd.
 Crestwood, NY 10707 914-961-8313

Sponsoring organization: St. Vladimir's Orthodox Theological Seminary
Contact: Eleana Silk, Libn.
Founded: 1983; Scope: International
Availability: Open to the public; Admission: Free
Visitors: General public, Ethnic community
Staff: 1 ft, 1 pt, 4 students; Operating budget: $120,000

Collection: 81,000 books, 350 periodical titles, 2,500 audiovisual materials, archival
records (personal papers and correspondence, unpublished records, printed materials,
theses and dissertations, manuscripts, and oral histories) on Carpatho Ruthenians. The
collection is cataloged, except for the archival records. Theses are in microform; a
reading room and copying facilities are available.

Comments: The seminary is affiliated with the Orthodox Church in America and it
trains clergy and lay leaders for the Eastern Orthodox Church. The collection supports
the curriculum. Guided tours, loans of materials to educational institutions,
computerized indexing of religious materials, and research at the graduate level are
provided.

CHINESE AMERICAN RESOURCES
(*See also* Asian American Resources)

CHEW KEE <u>Museum</u>
 Main St.
 Fiddletown, CA 95629 209-267-1310

Sponsoring organization: Fiddletown Preservation Society
Contact: Jane Russell, Pres., Fiddletown Pres. Soc., P.O. Box 484, Sutter Creek, CA
95685
Founded: 1968; Scope: Local
Availability: Sat., 12-4 (Apr. through Oct.); Admission: Donation
Visitors: General public, School groups, Ethnic community
Staff: Volunteers

Collection: Artifacts and archival records (personal papers and correspondence,
unpublished records, and oral histories). The collection is cataloged.

Comments: The purpose is to preserve Chinese history and culture through guided
tours, educational lectures, and school presentations.

CHINA INSTITUTE IN AMERICA Museum
 125 East 65th St.
 New York, NY 10021 212-744-8181

Personnel: John Bryan Starr, Pres.; Nancy Jervis, V. Pres.; Candace Lewis, Gallery
Dir.
Contact: Simon C. Lee, Asst. to Pres.
Founded: 1926
Availability: Open daily 9-5; some restricted access; Admission: Fee, Donation
Visitors: General public, School groups, Ethnic community
Staff: 20 ft, 3 pt; Operating budget: $1,700,000
Publications: Monthly newsletter; annual report; catalog of exhibitions.

Collection: Books, artifacts, photographs, paintings, engravings, other works of art.

Comments: Objectives are to present scholarly exhibitions of traditional Chinese art.
The institute also conducts educational lectures, sponsors international symposia,
provides presentations to schools, speakers or resource people, and participates in
ethnic festivals on occasion.

CHINATOWN BRANCH LIBRARY Library
LOS ANGELES PUBLIC LIBRARY
 536 W. College St.
 Los Angeles, CA 90012 213-620-0401

Contact: Carol Duan, Sr. Libn.
Founded: 1977; Scope: Local, Regional, State, National, International
Availability: Open to the public daily; Admission: Free
Staff: 19 plus volunteers; Operating budget: $56,000 (materials)

Collection: Books, periodicals, audiovisual materials, and artifacts for children and
adults. Periodicals in English are in microform. The collection is cataloged; a reading
room and copying facilities are available.

Comments: The library serves English and Chinese speaking communities in southern
California and beyond; a significant Chinese Heritage collection in English is featured.

CHINATOWN HISTORY MUSEUM Museum
(Formerly New York Chinatown History Project) Library
 70 Mulberry St., 2/Fl. Archives
 New York, NY 10013 212-619-4785

Personnel: Fay Chew, Exec. Dir.; Sue Lee, Asst. to the Exec. Dir.;
Mei-Lin Liu, Archivist; Adrienne Cooper, Program Dir.
Contact: Lamgen Leon, Office Mgr.
Founded: 1980; Incorporated: 1992; Scope: Local, State, Regional, National
Availability: Open to the public and by special appt., restricted access;
Admission: Fee
Staff: 29 (5 ft, 4 pt, 20 volunteers); Operating budget: $300,000
Publications: Newsletters; annual report; post cards; catalogs; and Cantonese opera
programs.

Collection: Ca. 1,500 books, 750 periodicals, 1,250 audiovisual materials, 1,250
artifacts, 200 linear ft. of archival materials, (personal papers and correspondence,
unpublished records, pictorial materials, theses and dissertations, oral histories),
Cantonese opera costumes and musical instruments (1,000 objects). The collection is
cataloged; a reading room and copying facilities are available for researchers.

Comments: The museum preserves Chinese American history and culture. It provides
materials for graduate and undergraduate research, work experience for college credit,
guided tours, educational lectures, school presentations, speakers or resource people,
drama presentations, and films and AV productions.

CHINESE CONSOLIDATED BENEVOLENT ASSOCIATION Museum
 62 Mott St. Library
 New York, NY 10013 212-226-6280

Contact: Victor Lui, Secy.
Incorporation date: 1890; Scope: Local
Availability: Open by special appt. only; Admission: Free
Visitors: General public, School groups, Ethnic community
Staff: 4 (ft and pt, salaried); Operating budget: $70,000

Collection: Photographs and archival materials (pictorial materials).

Comments: The organization provides a Chinese school for students (K-12) and
tutoring in English for new Chinese immigrants. It also provides translation services,
school presentations, speakers, drama, choral, and instrumental presentations. It
supports research and participates in ethnic festivals.

CHINESE CULTURE CENTER OF SAN FRANCISCO Library
 750 Kearny St. Art Gallery
 San Francisco, CA 94108 415-986-1822; Fax 415-986-2825

Sponsoring organization: Chinese Culture Foundation of San Francisco
Personnel: Kathleen Guan, Exec. Dir.
Contact: Manni Liu, Curator

Founded: 1965; Scope: Local
Availability: Open T-Sat., 10-4; Admission: Free, Donation
Visitors: General public, School groups, Ethnic community
Staff: 25 (3 ft, 7 pt, salaried); 15 volunteers; Operating budget: $300,000
Publications: *Chinese Culture Center Newsletter*, bi-annual; books, brochures, and catalogs.

Collection: Permanent and temporary exhibitions of historical significance (e.g., Chinese Of America: 1876-1980; Chinese Women of America--A Pictorial History; Stories from China's Past; Contemporary Chinese Paintings). The collection includes printed materials, audiovisual materials (historical photographs of Chinese Americans), artifacts, and works of art.

Comments: The center fosters appreciation of Chinese and Chinese American art, history, and culture. It sponsors Chinese festival celebrations and walks to historic Chinatown in San Francisco. Services include guided tours, lectures, speakers, dance and choir presentations, genealogy research, internships for youth, and a souvenir shop.

CHINESE CULTURE INSTITUTE Museum
 276 Tremont St. Archives
 Boston, MA 02116 (617) 542-4599; Fax 617-338-4274 Art Gallery

Personnel: Liu Tian Wei, Curator; Yen Hing, Education Dir.; Tang Peijun, Gallery Mgr.
Contact: Dr. Doris C. J. Chu, Pres.
Founded: 1980; Scope: Regional
Availability: Open to the public; (except archives); Admission: Free
Visitors: General public, School groups
Staff: 11 salaried, 21 volunteers; Operating budget: $250,000
Publications: Exhibition catalogs; books about Chinese painting and Chinese Americans.

Collection: 3,000 books, 270 works of art, and 15 boxes of old photos and archival materials (unpublished records, pictorial materials, theses and dissertations). The collection is not cataloged; copying facilities are available.

Comments: The mission is to promote cultural understanding through education, outreach activities in the schools, art education programs, and a monthly concert series. Services include lectures, loans and presentations to schools, speakers, drama and instrumental presentations, and an arts and crafts souvenir shop. Work experience for college credit is also available.

CHINESE HISTORICAL SOCIETY OF AMERICA Museum
 650 Commercial St.
 San Francisco, CA 94111 415-391-1188

Personnel: Bruce Chin, 1st V. Pres.; Lorraine Dong, 2nd V. Pres. and Bulletin Editor; Annie Soo, Secy; Jean Jew, Treas.
Contact: Enid Ng Lim, Pres.
Founded: 1963; Scope: National

Availability: Open Tues.-Sat. 12-4:00; Open Sun. and M by special appt.
Admission: Free (or donation)
Visitors: General public, School groups, Ethnic community
Publications: *Chinese American History & Perspective*, 1987- , annual; *The Bulletin*, 1967- , monthly (except July & August); also publishes books.

Collection: Books, periodicals, photos and archival records (personal papers and correspondence, unpublished records, pictorial materials, theses and dissertations, and oral histories). The collection is accessioned, but not cataloged.

Comments: The purpose is to acquire and preserve all artifacts, manuscripts, books and works of art on the history of the Chinese living in the United States. The organization issues papers and publicity pertaining to the findings of the Society and promotes contributions of Chinese Americans. Services include guided tours, lectures, and an art gift shop; the Society has a booth at local ethnic festivals.

CHINESE INFORMATION AND CULTURE CENTER Library
 2F, 1230 Avenue of the Americas Art Gallery
 New York, NY 10020 212-373-1800; Fax 212-373-1866

Sponsoring organization: Coordination Council of North American Affairs
Personnel: Pai Yun-feng, Dir.
Contact: Vicky Tseng, Library Coordinator
Founded: 1991; Scope: National
Availability: Open to the public; Admission: Donation
Visitors: General public, School groups, Ethnic community
Staff: 6 (5 ft, 1 pt)
Publications: *CICC Currents*, bimonthly

Collection: 30,000 books, 250 periodicals. The collection is cataloged; a reading room and copying facilities are available.

Comments: The Center provides resources that promote cultural and educational exchange between Americans and Chinese. Activities include guided tours and participation in ethnic festivals.

CHINESE MUSIC SOCIETY OF NORTH AMERICA Archives
 7501 Lemont Rd.
 Woodridge, IL 60517 708-910-1551; Fax 708-910-1561

Personnel: Billie Jefferson, Admin.; Yuan-Yuan Lee, Dir., Music Research Institute
Contact: Sinyan Shen
Founded: 1976; Scope: International
Availability: Open by special appt. only
Staff: 4 ft, 20 pt; Operating budget: $300,000
Publications: *Chinese Music*, 1978- , quarterly; *Chinese Music Monograph Series*, 1991- , annual; also produces a masterpiece recording series.

Collection: Books, periodicals, audiovisual materials, works of art, and archival materials (personal papers and correspondence, unpublished records, and manuscripts).

Chinese music journals are in microform. The collection is cataloged; an unpublished guide, a reading room and copying facilities are available.

Comments: The purpose is to increase understanding of Chinese music; the society produces 65 concerts and productions a year in North America and Europe and also sponsors the Chinese Music International Conference.

KAM WAH CHUNG & CO. MUSEUM Museum
 City Park Canton St. JD
 450 E. Main
 John Day, OR 97845 503-575-0028

Sponsoring organization: City of John Day
Contact: Carolyn Minnhimer, Curator
Founded: 1977; Scope: Local, State, International
Availability: Open May 1-Oct. 31; Admission: Fee
Visitors: General public
Staff: 1 ft, salaried; Operating budget: $14,000
Publications: *Kam Wah Chung & Co. Museum*, 1977- , annual; also publishes books.

Collection: Over 5,000 books, audiovisual materials, artifacts, and archives (personal papers and correspondence, unpublished records, pictorial materials, theses and dissertations, manuscripts, and oral histories). Some materials are in microform at the Oregon Historical Society in Portland. The collection is cataloged.

Comments: The purpose is to honor the history of the Chinese in the area. Activities include talk tours, educational lectures, and speakers. Annual festivals include traditional Chinese dancers and music, crafts, and exhibits.

ORGANIZATION OF CHINESE AMERICANS Archives
 10001 Connecticut Ave. NW, Suite 707
 Washington, DC 20036 202-223-5500

Contact: Daphne Kwok, Exec. Dir.
Founded: 1973; Scope: National
Availability: Open by appt.; Admission: Free
Visitors: General public, Ethnic community
Staff: 2; Operating budget: $90,000
Publications: *Image*, quarterly; also publishes biennial convention proceedings; a semiannual membership directory; chapter newsletters; and a textbook on the Chinese in America.

Collection: Textbooks on the Chinese in America, biographical archives and records and statistics related to the organization.

Comments: The goals are to promote cultural awareness, eradicate negative stereotypes about Chinese Americans, sponsor cultural exhibits, and conduct educational seminars. The organization provides aid to Indochinese refugees, and conducts research on cultural, political, and educational topics. It maintains a speakers' bureau and participates in ethnic festivals.

OROVILLE CHINESE TEMPLE Museum
 Library
 1500 Broderick St.
 Oroville, CA 95965 916-538-2415; Fax 916-538-2426

Sponsoring organization: City of Oroville
Contact: Jim P. Carpenter, Dir. Parks, 1735 Montgomery St., Oroville, CA 95965
Founded: 1863; Scope: Local, Regional
Availability: Open M, Th-Sun., 11-4:30, W, 1-4; Admission: $2, under 12 free
Visitors: General public, Ethnic community

Collection: Library and restored temple building (1863) complete with religious statues
and other artifacts.

Comments: Preserves Chinese American religious history and promotes it through
exhibits and guided tours.

UNIVERSITY OF CALIFORNIA Library
CENTER FOR CHINESE STUDIES LIBRARY
 2223 Fulton St., Basement
 Berkeley, CA 94720 510-642-6510; Fax 510-643-7062

Sponsoring organization: University of California
Personnel: C. P. Chen, Head Libn. (Emeritus); Annie Chang, Acting Head Libn.;
John Sweeney, Library Asst.; Jeff Kapellas, Library Asst.; Kaidi Zhan, Specialist
Founded: 1959; Scope: International
Availability: Restricted access; Admission: Free
Visitors: General public, School groups, Ethnic community
Staff: 4 (2 ft, 2 pt)

Collection: 55,000 books, ca. 250-499 periodicals, over 500 audiovisual materials,
Chinese newspapers (1949-) in microform. The collection is cataloged; a reading room
and copying facilities are available.
Publications: Bibliography of Chinese legal materials.

Comments: The library primarily collects historical and social science materials on the
People's Republic of China and subscribes to Chinese newspapers. It is affiliated with
the Institute of East Asian Studies, University of California, Berkeley, and the
Association for Asian Studies, Ann Arbor, MI.

CROATIAN AMERICAN RESOURCES

CROATIAN ETHNIC INSTITUTE Museum
 Library
 Archives
 4851 S. Drexel Blvd.
 Chicago, IL 60615

Contact: Ljubo Krasic, Dir.
Founded: 1975; Scope: National, International
Availability: Open to the public; Admission: Free

Visitors: General public, School groups, Graduate Students
Publications: Manuals for teaching Croatian language; also publishes promotional brochures.

Collection: Over 5,000 monographs dealing with Croatian and South Slavic cultures, history, and literature (over 1,000 volumes written or published by Croatian immigrants), magazines, over 150 serial titles, 80 newspaper and periodical titles, manuscripts, artifacts, items related to Croatian folklore, musical instruments, numismatics, and philately. The archives hold personal papers and correspondence; manuscripts; parish records; census and annual reports; documents and records of many cultural, fraternal, benevolent and political organizations; sport clubs, musical societies, travel agencies and businesses; and over 5,000 documents related to Croatians in refugee camps, including photographs, oral histories, memoranda, by-laws, etc.

Comments: The objectives are to maintain and preserve a collection of materials on Croatians and their descendants, to encourage the production of curricular materials for ethnic heritage studies, and to conduct research on the sociological, demographic, and historical aspects of Croatian immigration and life in the new country. Services include exhibits, educational lectures, speakers and/or resource people, and assistance to college students, curriculum specialists, and other scholars.

JUGOSLAVIA STUDY GROUP Archives
 1514 N. 3rd Ave.
 Wausau, WI 54401-1903 715-675-2833

Sponsoring organization: Croatian Philatelic Society
Contact: Michael J. Lenard, Chairman
Founded: 1974; Scope: International
Availability: Open to the public; Admission: Donation
Staff: 1 volunteer
Publications: Membership newsletters and flyers; various research articles on Yugoslavian philately.

Collection: Books, periodicals, audiovisual materials, artifacts and archival materials (unpublished records and pictorial materials). The collection is not cataloged.

Comments: The purpose is to share knowledge about stamp collecting in Croatia and the area that was formerly Yugoslavia. Services include school presentations, speakers, slide presentations, and answers to questions about Yugoslavian philately.

OUR CROATIA INC./CROATIAN HERITAGE MUSEUM Museum
AND LIBRARY Library
 Route 91 & Lakeshore Blvd.
 Eastlake, OH 44095 216-442-0231 or 216-327-9498

Personnel: Branka Malinar, Pres.; Nick Babic, Treas.; Judi Krizmanich, Secy.
Contact: Fran Babic, Curator, 6974 Gates Rd., Gates Mills, OH 44040
Founded: 1983; Scope: Regional, National, International
Availability: Open to the public; Admission: Free
Visitors: General public, School groups, Ethnic community

Staff: 12 volunteers; Operating budget: $10,000
Publications: Informational brochures

Collection: 2,500 books, 5,000 periodicals, ca. 50 audiovisual materials, ca. 250-499
artifacts, ca. 50 works of art, 1 box of archival records (pictures, oral histories, and
minutes of lodge meetings).

Comments: Dedicated to the collection and preservation of Croatian and Croatian
American history and culture through education and research. The museum and library
provide guided tours, adult education lectures, school presentations, speakers or
resource people, and changing exhibits.

CUBAN AMERICAN RESOURCES
(*See also* Hispanic American and Latin American Resources)

CENTER FOR CUBAN STUDIES/CUBAN ART PROJECT Library
 124 West 23 St., 2d Flr. Archives
 New York, NY 10011 212-242-0559; Fax 212-242-1937 Art Gallery

Contact: Sandra Levinson, Dir.
Founded: 1972; Scope: National
Availability: Open by special appt.; Admission: Free
Visitors: General public
Staff: 5 (1 ft, 4 pt, salaried); Operating budget: $200,000
Publications: *Cuba Update*, bimonthly; also publishes books and collection catalogs.

Collection: Books, periodicals, audiovisual materials, works of art, and 2,000 square
ft. of archives (personal papers and correspondence, unpublished records, pictures,
theses and dissertations, manuscripts, and oral histories). The collection is cataloged;
published and unpublished guides, a reading room, and copying facilities are available.

Comments: The center fosters information exchanges between Cubans and Americans
via educational and cultural programs. Services include guided tours, exhibits,
educational lectures, radio programs, speakers, films, and an arts and crafts souvenir
shop. Research at the graduate and undergraduate levels is supported in conjunction
with colleges and universities.

CUBAN MUSEUM OF ARTS AND CULTURE Museum
 1300 S. W. 12th Ave.
 Miami, FL 33129 305-858-8006; Fax 305-858-9639

Personnel: Jose Jimenez, Pres.; Cristina Nosti, Dir.
Founded: 1985; Scope: Local, State, Regional, National
Availability: W-Sun. 1-5; Admission: Free
Visitors: General public, Ethnic community
Publications: Catalogs of the collection

Collection: Artifacts, works of art.

Comments: This ethnic art museum depicts Cuban and Cuban American history and culture and preserves and displays the work of Cuban and Cuban American artists.

UNIVERSITY OF MIAMI OTTO G. RICHTER LIBRARY <u>Library</u>
ARCHIVES AND SPECIAL COLLECTIONS <u>Archives</u>
 P. O. Box 248214
 Coral Gables, FL 33124 305-284-3247; Fax 305-665-7352

Personnel: William E. Brown, Jr., Head Archives and Spec. Coll.; Esperanza de Verona, Asst. Head
Founded: 1978; Scope: Local, state, regional, national, international
Availability: Open M-F, 9-4; Restricted access; Admission: Free
Visitors: General public
Staff: 6 ft, 1 pt

Collection: 1,500 books, 5,000 periodicals, 1,500 audiovisual materials, and archives (personal papers and correspondence, unpublished records, 40 cubic ft. of The Truth about Cuba Committee Papers, pictures, manuscripts, information about prominent leaders in the Cuban American community, and oral histories). Some materials are in microform. A reading room and copying facilities are available.

Comments: The purpose is to preserve the history and culture of Cubans and Cuban Americans. Programs and activities include educational lectures and speakers.

CZECH AMERICAN RESOURCES
(*See also* Czechoslovak American Resources)

AMERICAN SOKOL EDUCATIONAL & <u>Library</u>
PHYSICAL CULTURE ORGANIZATION <u>Archives</u>
 6424 W. Cermak Rd.
 Berwyn, IL 60402 708-795-6671; Fax 708-795-0539

Personnel: Annette B. Schabowski, Archivist; Jane Sterba, Librarian
Contact: Nancy Pajeau, Secy.
Founded: 1865; Scope: Local, State, Regional, National, International
Availability: Open by special appt. only; Admission: Free
Publications: *American Sokol*, 1865- , monthly

Collection: Over 1,500 books, periodicals, artifacts, and works of art. Archival records include printed and pictorial materials, theses and dissertations. The collection is cataloged; an unpublished guide and copying facilities are available.

Comments: The purpose is to educate Czech-American youth about their heritage. The organization supports physical fitness, gymnastic classes, and folk dancing.

BILY CLOCK EXHIBIT <u>Museum</u>
 323 South Main St.
 Spillville, IA 52168 319-562-3569

Contact: Joyce Fuchs, Mgr., P. O. Box 61, Spillville, IA 52168
Founded: 1947; Scope: International
Availability: Open to the public; Admission: Fee
Visitors: General public
Staff: 8 (2 ft, 6 pt)
Publications: Brochures; a book about the exhibit.

Collection: 40 carved clocks, 2 carved models, artifacts and realia, paintings and other works of art, and archives. The collection is cataloged.

Comments: Spillville, a Czech village, features the Bily clock display, St. Wenceslaus Church, and the house of Czech composer Antonin Dvorak. The Bily Clock Exhibit features tours where guides play the music boxes, demonstrate moving parts, and talk about them and their Czechoslovak carvers; it also participates in ethnic festivals.

CLARKSON HISTORICAL SOCIETY Museum
 221 Pine St.
 Clarkson, NE 68629

Personnel: Jon Smith, V. Pres.; Dee Pering, Treas., Salvamir Vodehnal, Secy.
Contact: Evelyn D. Podany, Pres., R.R. 1, Box 10, Clarkson, NE 68629
Founded: 1967; Scope: Local, State
Availability: Open by special appt.; Admission: Donation
Visitors: General public, School groups, Ethnic community
Staff: 6 volunteers; Operating budget: $10,000

Collection: Books, farm machinery, art objects, 1,500 artifacts. The collection is cataloged.

Comments: Preserves the culture and heritage of Clarkson, settled primarily by Czechs. The museum is open to the public for Czech Days, the last weekend in June, with attendants to answer questions. Activities include guided tours and ethnic festivals.

CZECH CATHOLIC UNION Archives
 4239 Dolloff Rd.
 Cleveland, OH 44127 216-341-0444

Personnel: Joseph A. Kocab, Pres.
Contact: Mary Ann Mahoney, Secy.-Treas.
Founded: 1879; Scope: National
Publications: Publishes annual report.

Collection: Archival records

Comments: This fraternal organization provides life insurance benefits to members with particular attention to those of the Czech American community.

CZECHOSLOVAK DAILY HERALD Archives
 6426 West Cermak Rd.
 Berwyn, IL 60402 708-749-1891; 708-749-1935

Sponsoring organization: Denni Hlastec Printing and Publishing Co.
Contact: Josef Kucera, Pres.
Founded: 1891; Scope: International
Availability: Open by special appt.
Staff: 13 (3 ft, 5 pt, 5 volunteers); Operating budget: $150,000 (for newspaper)
Publications: Publishes Czechoslovak *Daily Herald*, 1891- , daily; and *Sunday Herald*, 1891- ,weekly.

Collection: The collection consists of past issues of the newspaper and archival materials which are available in microform at several libraries.

Comments: The newspaper provides politically unbiased news on Czechoslovakia, and on historical, political, ethnic, and other events in the United States and Canada.

SLAVONIC BENEVOLENT ORDER OF THE STATE OF TEXAS Museum
(SPJST) MUSEUM Library
 520 N. Main ST. Archives
 Temple, TX 76501

Personnel: Howard B. Leshikar, Pres.
Founded: 1897, Library, 1963; Scope: State
Availability: Open to the public; Admission: Free
Visitors: General public, Ethnic community

Collection: 23,000 books (18,000 in Czech language), periodicals, almanacs dating from 1879, newspapers, prayer books, Bibles, over 2,000 artifacts, and genealogy materials.

Comments: The purpose is to collect and preserve artifacts and books that provide a record of Czech history and heritage.

SOKOL DETROIT Library
 23600 West Warren Ave.
 Dearborn Heights, MI 48127 313-278-2558; Fax 313-278-9493

Contact: Lillian K. Teichman, Libn., 8977 Manor, Allen Park, MI 48101-1421
Availability: Open to members
Visitors: Membership
Staff: 2 ft

Collection: 2,000-3,000 books, over 50 periodicals. Archival records consist of unpublished records, pictorial materials, personal papers and correspondence, and materials relating to Czechoslovak history, biographies, organizations, migration, culture, etc. from 1870 on. The collection is cataloged; an unpublished guide and reading room are available.

Comments: The collection preserves the Czech ethnic identity, provides a social and recreational center for Czech-Americans, and supports research on Czech immigration to Michigan. Services include lectures, school presentations, radio programs, speakers, performing arts presentations, films, crafts classes, and Czech language instruction.

SOKOL GREATER CLEVELAND Museum
4939 Broadway Ave. Library
Cleveland, OH 44127 Archives

Contact: Mary J. Kotlan, Libn., 4397 W. 10th St., Cleveland, OH 44109
Founded: 1976; Scope: Local
Availability: Not open to the public
Staff: 1 volunteer
Publications: *Sokol Greater Cleveland Newsletter*

Collection: Books, periodicals, artifacts and realia, and archives (journals, letters,
diaries, etc.). The collection is cataloged.

Comments: The purpose is to preserve Czech American heritage and culture, provide
fitness and gymnastic training, and maintain contact with Czech sister organizations.

SOKOL GYMNASTIC ASSOCIATION ST. LOUIS Library
4690 Lansdowne Ave. Archives
St. Louis, MO 63116 314-752-8168

Personnel: C. D. Jerabek, Pres.; S. Jerabek, V. Pres.
Founded: 1865; Scope: International
Availability: Not open to the public
Staff: Volunteers
Publications: *Sokol News*, monthly

Collection: Books, periodicals, artifacts and realia, photographs, and archives
(unpublished records and pictorial materials).

Comments: The collection supports and documents the objectives and activities of the
Sokol which emphasizes gymnastics and Czech history, culture and traditions.

SOKOL SOUTH OMAHA Museum
2021 U St. Library
Omaha, NE 68107-3766 402-731-1065

Contact: E. J. Pavoucek, Curator or Doris Novotny Ettlin, Libn.
Founded: 1986 (museum), 1978 (library); Scope: Local, Regional, National
Availability: Open to the public (museum); by special appt. (library); Admission:
Free
Visitors: General public, School groups, Ethnic community
Staff: Volunteers
Publications: *Sokol South Omaha Newsletter*, 1965- , monthly; annual report.

Collection: Ca. 1,500 books, 1,500 periodicals (includes *Vlasta*, *Kvety*, *Our Gardens*,
Czechoslovak Life, *Hlas Jednoty*, *Svobodna Skola*, *Svodobne Ceskoslovensko*); art
books, artifacts, and archives (many Czech language newspapers, pictorial materials,
oral histories); the collection is partially cataloged; a reading room is available.

Comments: The purpose is to promote and preserve Czech culture and heritage; the

library answers reference questions about Czech history and culture and Czech language classes are taught from October. Services include guided tours, educational lectures, loans and presentations to educational institutions, radio and TV programs, dance presentations, crafts classes, and a souvenir shop.

UNIVERSITY OF NEBRASKA, LINCOLN Library
CZECH HERITAGE COLLECTION Archives
 Don L. Love Library
 Lincoln, NE 68588 402-472-2526

Scope: National
Availability: Open to the public; Admission: Free
Visitors: General public

Collection: 3,000 books; audiovisual materials (pictures, audiotapes), and archival materials (personal papers, manuscripts, photographs). Some of the collection is in microform. The collection is cataloged; copying facilities are available for researchers.

Comments: The purpose is to preserve the history and cultural heritage of Czechs who settled in the United States, particularly on the plains of Nebraska.

WESTERN FRATERNAL LIFE ASSOCIATION Archives
(Formerly ZCBJ-Western Bohemian Life Association)
 1900 First Ave. NE
 Cedar Rapids, IA 52402

Personnel: Raymond L. Miller, Pres.; Robert Hoida, Chairman of the Bd.
Contact: Cathy Langer, Publication Coordinator
Founded: 1897; Scope: National
Availability: Restricted access; Admission: Free
Visitors: General public
Staff: ft
Publications: *Fraternal Herald* (*Bratrsky Vestnik*), 1898- , monthly.

Collection: Archives contain bound copies of *Fraternal Herald* magazine

Comments: The organization provides fraternal life insurance benefits to members of the Czech American community and sponsors other social, recreational, and cultural activities.

WILBER CZECH MUSEUM Museum
 102 W. Third St., Box 652
 Wilber, NE 68465 402-821-2183

Personnel: Lillian Wanek, Curator
Contact: Irma Ourecky, 321 S. Harris, Box 632, Wilbur, NE 68465
Founded: 1962; Scope: Local
Availability: Open to the public, daily 1-4; Admission: Free, donations accepted
Visitors: General public, Ethnic community
Publications: Promotional brochures; also publishes books.

Collection: Artifacts and realia (Czech dolls, dishes, quilts, costumes, decorative arts, and replicas of homes of Czech immigrants).

Comments: The objective is to collect materials that document Czech American history and traditions. Services include guided tours, crafts (quilting, rug making, wheat weaving), and participation in ethnic festivals.

CZECHOSLOVAK AMERICAN RESOURCES
(*See also* Czech American and Slovak American Resources)

CZECH AND SLOVAK MUSEUM AND LIBRARY Museum
 10 - 16th Ave., SW Library
 Cedar Rapids, IA 52404 319-362-8500 Archives

Sponsoring organization: Czech Fine Arts Foundation, Inc.
Personnel: Nan Wolverton Franklin, Curator; John Rocarek, Library Dir.
Contact: Patricia A. Hikiji, Exec. Dir., P. O. Box 5398, Cedar Rapids, IA 52406-5398
Founded: 1974; Scope: Local, State, Regional, National, International
Availability: Open to the public; Admission: Fee
Visitors: General public, School groups, Ethnic community
Staff: 23 (1 ft, 7 pt, 15 volunteers); Operating Budget: $95,000
Publications: *The Bridge*, 1991- , quarterly

Collection: Over 1,500 books, periodicals, and artifacts. Archival records include personal papers and correspondence, printed materials, pictorial materials, and oral histories. The collection is partially cataloged.

Comments: The museum and library collect, preserve, and share Czech, Moravian, and Slovak culture. Guided tours, loans to educational institutions, school presentations, speakers or resource people, drama and choral presentations, a crafts/souvenir shop, and arts and crafts demonstrations promote understanding of the heritage and contributions of Czechs and Slovaks.

CZECHOSLOVAK GENEALOGICAL SOCIETY INTERNATIONAL Library
(Formerly Czechoslovak Genealogical Society) Archives
 P. O. Box 16225
 St. Paul, MN 612-426-1226 or 612-739-7543

Personnel: Paul Makousky, Treas.; Lucille Micka, Library Chair
Contact: Mark Bigaouette, Pres., 4219 Thornhill Lane, Vadnais Heights, MN 55127
Founded: 1988; Scope: International
Availability: Open to the public; Admission: Free
Visitors: General public
Staff: Volunteers; Operating budget: $40,000
Publications: *Our Family*, 1987- , quarterly; *Czechoslovak Surname Index, Vols. 1-3.*

Collection: Books, periodicals, maps, audiovisual materials, and records of Czech

settlements; old Bohemia land records and fraternal periodicals in microform are included. The collection is cataloged; an unpublished guide, a reading room, and copying facilities are available.

Comments: The purpose is to facilitate the genealogical research interests of Czechoslovak Americans by providing a networking system through quarterly meetings, workshops, and a major conference held every two-three years. Special library instruction classes are held on how to use the genealogical collection. The Society also participates in ethnic festivals.

CZECHOSLOVAK HERITAGE MUSEUM, LIBRARY, Museum
AND ARCHIVE Library
 2701 S. Harlem Ave. Archives
 Berwyn, IL 60402 708-795-5800

Sponsoring organization: CSA Fraternal Life
Personnel: Deborah Zeman, Dir. and V. Pres. of CSA Fraternal Life
Contact: Dagmar Bradac, Reference Libn., Curator
Founded: 1974; Scope: National
Availability: Open M-F, 10-4; Admission: Donation
Visitors: General public, School groups, Ethnic community
Staff: 4 (1 pt salaried, 3 volunteers)

Collection: 1,500 books, ca. 100 periodicals, ca. 750 artifacts, ca. 750 works of art, and 3,000 linear ft. of archival records (personal papers and correspondence, unpublished records, theses and dissertations, manuscripts, oral histories and genealogical materials). The collection is cataloged; an unpublished guide, reading room, copying facilities, and interlibrary loan services are available.

Comments: The purpose is to preserve Czech, Slovak, and Moravian history, culture, and heritage. The organization supports formal research and prepares a monthly column, "Museum Musings," which appears in the *CSA Journal* (1891- , monthly).

NATIONAL CZECH AND SLOVAK MUSEUM AND LIBRARY Museum
 10 16th Ave. SW Library
 Cedar Rapids, IA 52406 319-362-8500; Fax 319-363-2209

Sponsoring organization: Czech Fine Arts Foundation
Contact: Pat Hikiji
Founded: 1978; Scope: National, International
Availability: Open T-Sat., 9:30-4:00; Admission: Fee
Visitors: General public, School groups, Ethnic community
Staff: pt
Publications: *MOST*, 1989- , quarterly

Collection: 10,000 books, 2,000 periodicals, 300 paintings and other works of art, prints, graphic materials, maps, 2,000 artifacts (including ethnic dolls), 200 works of art, and archival materials (printed materials and pictorial materials, and oral histories). The collection is partially cataloged; copying facilities are available for researchers.

Comments: The purpose is to collect, preserve, and display Czech and Slovak culture and history. Programs include guided tours, lectures, loans and presentations to schools, speakers, dance presentations, crafts classes, and a crafts souvenir shop.

SOKOL MINNESOTA Museum
(Formerly Sokol St. Paul) Library
 383 Michigan St. Archives
 St. Paul, MN 55102 612-290-0542

Personnel: Don Pafko, Pres.
Contact: Ken Wyberg, 5604 Morgan Ave. S., Minneapolis, MN 55419
Founded: 1892; Scope: State
Availability: Open by special appt. only; Admission: Free
Visitors: General public, Ethnic community
Staff: 3 pt, 20 volunteers); Operating budget: $35,000
Publications: *Sokol Minnesota Slovo*, 1977- , monthly; membership newsletters

Collection: Books, periodicals, archival records (unpublished materials, printed materials), artifacts and realia, paintings and other works or art.

Comments: The objectives are to maintain an interest in the Czechoslovakian American heritage, promote the learning of Czech and Slovak languages and culture, unite Minnesota's Czechoslovak American community, and participate in ethnic festivals.

UNIVERSITY OF CHICAGO LIBRARY Library
ARCHIVES OF CZECHS AND SLOVAKS ABROAD Archives
 1100 East 57th St.
 Chicago, IL 60637 312-702-8456; Fax 312-702-0853

Contact: June Pachuta Farris, Slavic and East European Studies Bibliographer
Founded: 1972; Scope: International
Availability: Open M-F, 8:30-4:45, Sat., 9-12:45; Admission: Free
Staff: 1 pt volunteer

Collection: Over 5,000 books, over 1,200 periodical titles, 574 linear ft. of archival materials (unpublished records, manuscripts), audiovisual materials, theses, and dissertations. Some newspaper runs are in microform. An unpublished guide to the archives and copying facilities are available. Acquisitions are dependent on donations.

Comments: The Archives was founded as a repository for published and unpublished materials by and about the various waves of Czech and Slovak immigration throughout the world. Guided tours, specialized reference assistance, speakers or resource people are furnished. The collection supports research at both the graduate and undergraduate levels. The bibliographer participates in ethnic exhibits.

D

DANISH AMERICAN RESOURCES
(*See also* Scandinavian American Resources)

DANA COLLEGE, C. A. DANA-LIFE LIBRARY
 Blair, NE 68008 402-426-7300; Fax 402-426-7332

<div align="right">Library
Archives</div>

Scope: Regional
Availability: Open to the public; Admission: Free
Visitors: General public

Collection: 10,000 books on Danish history and literature, oral history tapes of Danish immigration and settlement in Nebraska and the Midwest.

Comments: Preserves the ethnic history and culture of the Danish and other Scandinavians in Nebraska and provides materials for ethnic scholars and researchers.

DANISH BROTHERHOOD IN AMERICA
 3717 Harney St.
 Omaha, NE 68131-3844 402-341-5049; Fax 402-341-5049

<div align="right">Library
Archives</div>

Personnel: Jerome Christensen, Secy.-Treas./CEO
Contact: Jennifer Denning-Kock, Fraternal Dir.
Founded: 1882; Scope: Local, State, Regional, National
Availability: Restricted access; Admission: Free
Visitors: General public
Staff: 9 ft
Publications: *American Dane*, 1916- , monthly

Collection: Books, periodicals, artifacts and realia, and archives (unpublished records, printed materials, oral histories), artifacts and realia); membership lists are in microform. A reading room and copying facilities are available.

Comments: Promotes and perpetuates Danish culture and traditions, provides fraternal insurance benefits, sponsors scholarships for students, and participates in festivals.

DANISH IMMIGRANT ARCHIVES
 Grand View College
 1351 Grandview Ave.
 Des Moines, IA 50316 515-263-2951; Fax 515-263 2998

<div align="right">Archives</div>

Sponsoring organization: Grand View College
Contact: Dr. Rudolf Jensen, Dir. and Archivist
Founded: 1975; Scope: International
Availability: Open by special appointment only; Admission: Free
Visitors: General public, Ethnic community
Staff: 1 pt, salaried; Operating budget: $3,000

Collection: 4,500 books, 500 periodicals, audiovisual materials, 50 paintings and other works of art, 55 linear ft. of archives (personal papers and correspondence, unpublished records, theses and dissertations, manuscripts, oral histories). Most primary material is in the Danish language. The collection is cataloged; an unpublished guide to serials, a reading room and copying facilities are available.

Comments: The Archives preserves information by and about Danish American immigrants and research publications on Scandinavian immigration and culture in general. Classics of Scandinavian literature, Lutheran Church publications, and Danish and Danish-American newspapers and periodicals present Danish history, culture, and geography, and information about individual families, Danish music, and other topics.

THE DANISH IMMIGRANT MUSEUM Museum
AND BEDSTEMOR'S (GRANDMOTHER'S) HOUSE
 Box 178, 4228 Main St.
 Elk Horn, IA 51531

Personnel: Dennis Nissen, Dir. of Dev.
Contact: June Sampson, Exec. Dir.
Founded: 1983; Scope: National, International
Availability: Open to the public; Admission: Fee (for Bedstemor's House)
Visitors: General public, School groups
Staff: 38 (4 ft, 4 pt, 30 volunteer); 8 salaried; Operating budget: $230,000
Publications: *America Letter*, 1986- , quarterly; membership newsletters.

Collection: Over 1,000 books, over 250 periodicals, audiovisual materials, artifacts, paintings and other works of art, and archival records (personal papers and correspondence, unpublished records, pictorial materials, and oral histories). The collection is not cataloged, but is accessioned; copying facilities are available.

Comments: The purpose of the museum is to collect, preserve, study, and interpret the artifacts and traditions of the Danes in North America. It operates a 1908 historic home, Bedstemor's House. provides guided tours, educational lectures, loans and presentations to schools, speakers or resource people, and sponsors a folk festival.

DUTCH AMERICAN RESOURCES

CALVIN COLLEGE/ Archives
CALVIN THEOLOGICAL SEMINARY ARCHIVES
 3207 Burton St., SE
 Grand Rapids, MI 49546 616-957-6313; Fax 616-957-6470

Personnel: Zwanet C. Janssens, Archivist
Contact: Dr. H. J. Brinks, Curator
Founded: 1962; Scope: International
Availability: Open M-F, 9-5; Admission: Free
Visitors: General public, Students, Faculty, Researchers
Staff: 12 (3 ft, 6 pt, 3 volunteers); Operating budget: $110,000
Publications: *Origins*, 1982- , semiannual; *Newsletter for the Friends of the Archives*,
1986- , annual; also publishes reports and books.

Collection: 2,300 books, ca. 100 periodicals, over 500 audiovisual materials, archives
(personal papers and correspondence, unpublished records, pictorial materials, theses
and dissertations, 2,680 linear ft. of manuscripts, oral histories, photographs, 3,237
reels of microfilmed minutes of church, school, and other meetings). The collection is
cataloged; an unpublished guide, reading room and copying facilities are available.

Comments: The archives reflect the historical experience of Dutch immigration and
settlement, the establishment of Dutch institutions from 1846 to the present, and the
mission of Calvin College and the Christian Reformed Church. They support graduate
and undergraduate research. Activities include guided tours, lectures, and speakers.

CAPPON HOUSE MUSEUM Museum
 228 E. 9th St.
 Holland, MI 49423 616-392-6740

Sponsoring organization: Holland Historical Trust
Contact: Anne Kiewel
Scope: Regional
Availability: Open M-S 1-4 (May-Sept.); Admission: Fee
Visitors: General public, School groups, Ethnic community

Collection: 500 books and manuscripts on the family of Isaac Cappon, Holland's first
mayor; seven restored rooms with original furnishings.

Comments: This Victorian home was built in 1874 and remained in the Cappon family
until 1978. The museum offers guided tours, educational programs, and celebration of
special events such as Victorian Day and Tulip Time.

DORDT COLLEGE LIBRARY/DUTCH MEMORIAL COLLECTION Library
 498 4th Ave. N.E.
 Sioux Center, IA 51250 712-722-6042; Fax 712-722-4498

Contact: Sheryl Sheeres Taylor, College Libn.
Founded: 1955; Scope: Local, Regional
Availability: Open by special appt.; Admission: Free
Visitors: General public, School groups
Staff: 1 pt

Collection: Ca. 3,500 books, 350 periodicals, and archival records (personal papers
and correspondence, unpublished records, printed materials). Local newspapers are in
microform. The collection is not cataloged; copying facilities are available.

Comments: The purpose is to preserve Dutch history and culture; guided tours are provided.

DUTCH FAMILY HERITAGE SOCIETY Library
 2463 Ledgewood Dr. Archives
 West Jordan, UT 84084 801-967-8400

Contact: Mary Lynn Spijkerman, Editor/Pres.
Availability: Not open to the public
Staff: 1 ft
Publications: *Dutch Family Heritage Society Quarterly*, 1987- , quarterly

Collection: Books, periodicals, and genealogical materials (some in microform) are collected. The society developed databases for Dutch immigrant genealogies, especially the Colonial Dutch.

Comments: The society promotes pride in the Dutch heritage and the study and gathering of Dutch histories and traditions in America. It provides educational lectures, supplies speakers, and makes available reprints of out-of-print books.

HERRICK PUBLIC LIBRARY Library
 300 S. River
 Holland, MI 49423 616-394-1400

Personnel: Robert Sherwood, Dir.; Diane Corradini, Head, Adult Services
Contact: Kelli Perkins, Reference Libn.
Availability: Open to the public; Admission: Free
Visitors: General public

Collection: Books and periodicals pertaining to the Dutch in America and genealogies of many Dutch names associated with the founding of Holland, Michigan. Also included are some Dutch cookbooks, costumes, and customs. The collection is cataloged; a reading room and copying facilities are available.

Comments: The purpose is to document the Dutch immigration to America and the settlement of a Dutch community in Holland, Michigan.

THE HOLLAND MUSEUM Museum
(Formerly Netherlands Museum) Library
 31 W. 10th St. Archives
 Holland, MI 49423 616-394-1362

Sponsoring organization: Holland Historical Trust
Contact: Ann Kiewel, Dir.
Founded: 1937; Scope: Regional
Availability: Open M,W,F, Sat., 10-5; Th, 10-8, Sun., 2-5
Visitors: General public, Ethnic community
Staff: 16 (4 ft, 12 pt); Operating budget: $275,000
Publications: Newsletter, quarterly; also publishes books, e.g., *Guide to the Archives of the Netherlands Museum*.

Collection: Books, audiovisual materials, artifacts, realia, and archival materials (personal papers and correspondence, documents, unpublished genealogical records).

Comments: The museum collects, preserves, and interprets materials related to the Dutch heritage and traditions of the early settlers from the Netherlands in Holland and western Michigan. It offers guided tours, educational lectures, loans to schools, radio and TV programs, speakers, and an arts and crafts souvenir shop.

HOLLAND SOCIETY OF NEW YORK Library
 122 E. 58th ST. Archives
 New York, NY 10022 212-758-1675

Founded: 1885; Scope: Regional
Availability: Open Sat., 11-4; Admission: Donation ($3)
Visitors: General public
Staff: 1 ft, 3 pt
Publications: *De Halve Maen: Magazine of the Dutch Colonial Period in America*, quarterly; *The Holland Society of New York Newsletter.*

Collection: 7,000 books (3,000 on local history, 3,000 family histories and genealogies, 1,000 reference works), periodicals, archives (personal papers and correspondence, unpublished records, pictorial materials).

Comments: Members are descendants of the original settlers of New Netherland in the United States. The collection focuses on New Amsterdam and Hudson River settlements and follows early Dutch migration in America. Programs include lectures on the early history of New Netherland.

THE JOINT ARCHIVES OF HOLLAND Archives
(Formerly Union of Archives of Holland Museum.,
Hope College & Western Theological Seminary)
 Hope College Van Whalen Library
 Holland, MI 49423 616-394-7798; Fax 616-394-7965

Personnel: Jenifer A. Smith, Coll. Mgr.
Contact: Larry J. Wagenaar, Dir.
Founded: 1988; Scope: Regional
Availability: Open to the public; Admission: Free
Visitors: General public, School groups, Ethnic community
Staff: 2 ft, 4 pt, 8 volunteers
Publications: *Joint Archives Quarterly*, 1988- , quarterly; *Guide to the Collections* and supplement

Collection: 10,000 linear ft. of archival records (personal papers and correspondence, unpublished records, theses and dissertations, pictorial materials, manuscripts, and oral histories). Ethnic newspapers and church records are in microform. The collection is cataloged; a published guide, reading room, and copying facilities are available.

Comments: The purpose is to preserve all materials and records that document Dutch American history, culture, achievements, and experience in America. Activities

include guided tours, educational lectures, and school presentations.

NEW CASTLE HISTORICAL SOCIETY Museum
 4th & Delaware St.
 New Castle, DE 19720

Personnel: Richard R. Cooch, Pres.
Contact: Kathleen Bratton, Dir.
Founded: 1934; Scope: State, Regional
Availability: T-Sat. 11-4, Sun. 1-4 (Mar.-Dec.)
Admission: Fee for Amstel House & Dutch House, Library museum free of charge
Visitors: General public
Staff: 1 ft, 8 pt, salaried; 20 part-time volunteers, 3 interns
Publications: Books

Collection: Artifacts, realia and 18th century Dutch furnishings, historic buildings

Comments: The society collects and preserves materials related to the early Dutch
settlement of the city. It sponsors a program called "A Day in Old New Castle."
Activities include tours.

OLD DUTCH PARSONAGE Museum
 38 Washington Place
 Somerville, NJ 08876 908-725-1015

Contact: Jim Kurzenberger, Curator
Founded: 1947
Availability: Open by appt.; Admission: Free
Visitors: General public

Collection: Artifacts, furnishings, and historic Old Dutch parsonage which was the
home of Jacob Hardenbergh, first president and founder of Rutgers University.

Comments: The museum preserves Dutch culture through preservation of a Dutch
parsonage home which has been furnished with typical Dutch style furniture and
decorations. Guided tours, and an arts and crafts workshop are available.

PETER ALRICHE FOUNDATION Archives
 248 Upper Gulph Rd.
 Radnor, PA 19087 215-688-7532

Personnel: Richard Blair Marshall, M.D., Pres.
Contact: William Morris Alrich, Exec. Secy.
Founded: 1981; Scope: National
Admission: Free
Staff: 1 volunteer; Operating budget: $350
Publications: *Peter Alriche Newsletter*, 1988- , 2-3/yr.; also publishes booklets and
brochures (e.g., *The Alriches of Spotsylvania*, *17th and 18th Century Dutch in the Port
Penn Area*, and *Peter Alriche--New Castle Merchant, Indian Trader, Plantation Owner
and Politician*).

Collection: 20 books and archival materials (personal papers and correspondence). The collection is not cataloged; a reading room is available for researchers.

Comments: The purpose is to maintain Alriche family genealogical records and to publish research on this Dutch family.

TRINITY CHRISTIAN COLLEGE DUTCH HERITAGE CENTER Library
 6601 W. College Dr. Archives
 Palos Heights, IL 60463 708-597-3000

Contact: Hendrik Sliekers, Curator
Founded: 1981; Scope: Local, Regional
Availability: Open by special appt. only; Admission: Free
Visitors: General public, Ethnic community
Staff: 1 ft

Collection: Ca. 200 books, 20 file drawers of archives (personal papers and correspondence, printed materials, manuscripts, family histories, oral histories, church and school records, photographs, anniversary booklets, journals, immigrant newspapers, society minutes and records, business records, and other records related to the college). The Dutch newspaper *Onze Toekomst* is in microform. The collection is cataloged; copying facilities are available.

Comments: The center collects material on the history, culture, customs, and institutions of Dutch Americans in the greater Chicago area. Objectives include creating exhibits and promoting a better understanding of Chicago Dutch relationships--past, present, and future. Activities include an annual bus tour to former Dutch churches in Chicago and an annual Dutch dinner.

VAN WYCK HOMESTEAD MUSEUM Museum
 P. O. Box 133, Routes 9 and I84 Library
 Fishkill, NY 12524 914-896-9560

Sponsoring organization: Fishkill Historical Society
Personnel: William Wolfson, Dir.; Barbara Wilman, Libn.
Contact: Roy Jorgensen, Pres.
Founded: 1966; Scope: Local, Regional
Availability: Open Sun. 1-5 and by appt.; Admission: Fee
Visitors: General public, School groups
Staff: 10 volunteers; Operating budget: $14,000
Publications: Annual report; catalog of collections; membership newsletters and flyers.

Collection: Ca. 350 books, periodicals, over 5,000 artifacts, works of art and archival materials (personal papers and correspondence, unpublished records, pictorial materials and oral histories). Journals and account books are in microform. A reading room is available for researchers.

Comments: The museum preserves the history of the area settled by early Dutch colonists. Activities include guided tours, educational lectures, school presentations, speakers, and an arts and crafts souvenir shop.

ZEELAND HISTORICAL SOCIETY
37 E. Main Ave.
Zeeland, MI 49464 616-772-4079

Museum
Library
Archives

Personnel: Wilma Veldheer, Curator
Contact: Mary Jane Van Der Weide, Dir., 57 E. McKinney St., Zeeland, MI 49464
Founded: 1974 Incorporated: 1975; Scope: Local, Regional
Availability: Open 9-1 Th and Sat.; Admission: Donation
Visitors: General public, School groups
Staff: 59 pt; Operating budget: $10,000
Publications: *Timeline*, 1976- , quarterly; annual yearbook, 1976- ; Visitor flyers;
historical data about the Zeeland community.

Collection: 200 books, 10 periodical titles, 3,500 artifacts, and 16 linear ft. of archives
(personal papers and correspondence, unpublished records, pictorial materials, oral
histories, and manuscripts). The collection is cataloged; a reading room is available.

Comments: The purpose is to preserve Dutch culture and heritage and to educate the
general public by maintaining a museum, library, and archives documenting through
artifacts and other records the Dutch history and experience. Services include guided
tours, educational lectures, loans to educational institutions, and a literary club.

E

EGYPTIAN AMERICAN RESOURCES
(*See also* Arab American Resources)

AMERICAN COPTIC ASSOCIATION Library
 P.O. Box 9119 G.L.S.
 Jersey City, NJ 07304 201-451-0972

Contact: Dr. Shawky F. Karas, Pres.
Founded: 1974; Scope: National
Availability: Open by appt.; Admission: Free
Visitors: General public
Collection: 1,000 books on Coptic psychology, sociology, and history.

Publications: *The Copts*, quarterly; also publishes books, census and other reports.

Comments: The purpose is to preserve the history and experience of Coptic
(Christian) Egyptians who have immigrated to the United States. The association
sponsors lectures and conducts research on Egyptian culture.

ROSICRUCIAN EGYPTIAN MUSEUM AND ART GALLERY Museum
 1342 Naglee Ave.
 San Jose, CA 95191 408-947-3631; Fax 408-947-3677

Sponsoring organization: The Rosicrucian Order, AMORC
Personnel: Grant Schar, Dir.; Cynthia Stretch, Registrar
Contact: Susan Wageman, Exhibitions Curator
Founded: 1932; Scope: International
Availability: Open T-Sun. 9-5 (except holidays); Admission: Fee
Visitors: General public, School groups
Staff: 16 salaried (10 ft, 6 pt) plus volunteers
Publications: *Making Mummies* (Grant Schar, 1991); also publishes brochures and
instructional materials.

Collection: Ca. 6,000 artifacts; the collection is cataloged

Comments: The museum preserves the Egyptian ancient culture, art, and heritage. It
is part of the Rosicrucian Park complex which also includes a contemporary art gallery,
planetarium, and science center. The museum conducts formal research programs; a
library is also maintained on site at the Rosicrucian Order, AMORC.

ESTONIAN AMERICAN RESOURCES

ESTONIAN ARCHIVES IN THE U.S., INC. Library
 607 East 7 St. Archives
 Lakewood, NJ 08701 908-363-6523

Sponsoring organization: Estonian National Council, Inc.
Personnel: Georg Viiroja, Dir. of the Archives, Archivist; Reinhold Nomman, Treas.
Contact: Dr. Olga Berendsen, Pres. Bd. of Dirs., Archivist, 4b Cannas Dr.,
Lakewood, NJ 08701
Founded: 1965; Scope: National
Availability: Open by special appt. only; Admission: Free
Visitors: General public, Ethnic community
Staff: 1, plus volunteers; Operating budget: $17,500

Collection: Ca. 12,000 books, 87 periodicals, ca. 20,000 photos, 37 audiovisual
materials, 1,275 artifacts, 333 works of art, and 343 ft. of archival records (personal
papers and correspondence, unpublished records, pictorial materials, theses and
dissertations, manuscripts). Items on displaced persons are microfilmed. Cataloging of
the collection is in progress; a reading room and copying facilities are available.

Comments: The purpose is to collect historical material pertaining to Estonian
Americans. Some materials are related to refugees (displaced persons), most of whom
emigrated to the U.S. Guided tours and lectures to Estonian groups are provided.

ESTONIAN HOUSE (Eesti Maja) Library
 243 E. 34th St.
 New York, NY 10016 212-685-7467

Contact: Priit Parming; Virve Vaher
Scope: Local
Availability: Open by special appt.; Admission: Donation
Visitors: Ethnic community
Staff: Volunteers

Collection: Books and three bookcases of archival materials; the collection is
cataloged.

Comments: The Estonian House houses a memorial collection of materials in the
Estonian language.

F

FILIPINO AMERICAN RESOURCES

(See also Asian American Resources)

FILIPINAS AMERICAS SCIENCE AND ART FOUNDATION Library
 1209 Park Ave.
 New York, NY 10128-1717 212-427-6930

Contact: J.C. R. L. Villamaria, III, Chairman
Founded: 1976; Scope: National
Availability: Open by appt.; Admission: Free
Visitors: General public, Ethnic community; Operating budget: $750,000
Publications: *Town House International School Newsletter*, monthly; also publishes
brochures.

Collection: 1,300 books, archival materials (biographical records of those included in
hall of fame).

Comments: The purpose is to increase awareness and understanding of Filipino and
other Asian cultures by conducting cultural events and maintaining a hall of fame of
outstanding Filipino Americans. Sponsors programs for children and charities.

FILIPINO AMERICAN WOMEN'S NETWORK Library
 2525 Columbus Ave. S.
 Minneapolis, MN 55404-4433

Contact: Elsa J. Batica
Availability: Open by special appt. only); Admission: Free
Collection: Ca. 200 items

Comments: The association supports the needs of Filipino American women
and participates in ethnic festivals that promote Filipino heritage and culture.

FINNISH AMERICAN RESOURCES

(See also Scandinavian American Resources)

ASTORIA PUBLIC LIBRARY Library
 450 Tenth St.
 Astoria, OR 97103 503-325-7323

Sponsoring organization: Young Women's Christian Temperance Union
Contact: Bruce Berney
Founded: 1892; Scope: Local
Availability: Open M-Sat.; Admission: Free
Visitors: General public
Staff: 3 ft, salaried

Collection: Ca. 200 books and periodicals. The collection is cataloged; a guide to the collection, reading room, and copying facilities are available.

Comments: The ethnic collection emphasizes the history, culture, and contributions of Finnish Americans who settled in the area.

FINNISH-AMERICAN HISTORICAL SOCIETY OF THE WEST Museum
 P. O. Box 5522 Library
 Portland, OR 97208 503-654-0448 Archives

Personnel: Herb Matta, Pres.
Contact: Gene A. Knapp, Editor-Controller, 12602 S.E. 24th Ave., Portland, OR 97208
Founded: 1962; Scope: Regional
Availability: Open summer weekends and holidays; Admission: Donation
Visitors: General public, School groups
Staff: 10 volunteers
Publications: *Finnam Newsletter*, 1962- , quarterly; also publishes monographs (e.g., *The Finns of ...* series); and a catalog of collections.

Collection: Ca. 500 books, 50 periodicals, 500 artifacts, 3,200 cubic ft. of archival records (printed materials, manuscripts, oral histories). The collection is cataloged; a published guide and reading room are available.

Comments: The purpose of this historical society is to preserve the cultural heritage of America's Finnish settlers in the West. The society maintains The Erik Lindgren Home as a monument to these early Finnish settlers. It maintains a reference library and also has an active research and publishing committee. The society participates in ethnic festivals.

SUOMI COLLEGE FINNISH-AMERICAN HERITAGE CENTER Museum
 601 Quincy St. Archives
 Hancock, MI 49930 906-487-7367; Fax 906-487-7366

Sponsoring organization: Suomi College
Personnel: E. Olaf Rankinen, Archivist; Lorraine Richards, Asst. Archivist
Contact: Susan J. King, Dir.
Founded: 1896; Archives est. 1932; Scope: Local, State, Regional, National, International
Availability: Open daily 9-4; Admission: Free
Visitors: General public, School groups, Ethnic community
Staff: 1 ft, 1 pt, volunteers; Operating budget: $109,000
Publications: *Finnish-American Heritage Centerline*, 1991- , quarterly

Collection: Over 5,000 books, 5,000 periodicals, ca. 1,250 audiovisual materials, ca. 1,250 artifacts, ca. 300 paintings and other works of art, and 15,000 linear ft. of archival records (personal papers and correspondence, unpublished records, pictorial materials, theses and dissertations, manuscripts, and oral histories). Newspapers and church registries are in microform. The collection is cataloged; a reading room and copying facilities are available.

Comments: Goals are to collect and preserve materials which document the Finnish immigrant movement in North America, to establish a genealogical research center, and to provide educational programming and exhibitions that showcase diverse talents. Activities include guided tours, educational lectures, school presentations, speakers, dance, drama, choral and instrumental presentations, films and audiovisual productions, and crafts classes.

FRENCH AMERICAN RESOURCES

AMERICAN-CANADIAN GENEALOGICAL SOCIETY Library
 4 Elm St., P.O. Box 6478 Archives
 Manchester, NH 03108-6478 603-622-1554

Personnel: Roger Lawrence, Pres.; Robert Maurier, Archivist; Brenda Costello, Treas.; Constance Hamel, Library Dir.
Contact: Judith Arseneault, Membership
Founded: 1973; Scope: International
Availability: Open W, F, Sat.; Admission: $2
Visitors: General public
Staff: 50 volunteers; Operating budget: $36,000
Publications: *American-Canadian Genealogist*, 1973- , quarterly; also publishes books.

Collection: Over 5,000 books, 1,250 periodicals, 2,500 audiovisual materials, and archives (unpublished records, marriage repertoires primarily of the Province of Quebec). Genealogical records are also in microform. The collection is cataloged; a reading room and copying facilities are available.

Comments: Teaches to trace French roots. Provides lectures, school and TV programs, speakers, films, International French Festival, and Bastille Day Celebration.

AMERICAN-FRENCH GENEALOGICAL SOCIETY Library
 P. O. Box 2113
 Pawtucket, RI 02861

Contact: Janice M. Burkhart, Pres. and Libn.
Founded: 1978 Scope: Local, State, Regional, National, International
Availability: Restricted access; Admission: Free
Visitors: General public
Staff: 15 volunteers; Operating budget: $15,000
Publications: *Je Me Souviens*, 1978- , semiannual; *AFG News*, 1989- , bimonthly; vital statistics, marriage and baptismal record books.

Collection: 5,000 books, 1,500 periodicals, ca. 50 audiovisual materials and ca. 50 artifacts, archival records (unpublished records, printed materials, theses and dissertations). Vital statistics from Massachusetts, Vermont, and Quebec are in microform. The collection is cataloged; an unpublished guide, reading room, and copying facilities are available.

Comments: The purpose is to facilitate genealogical research related to French Americans.

ASSOCIATION CANADO AMERICAN Library
 53 Concord St. Archives
 Manchester, NH 603-625-8577

Personnel: Dr. Robert Beaudoin
Contact: Paul Pare
Founded: 1896; Scope: International
Availability: Open by special appt.; Admission: Free
Visitors: General public
Staff: pt, salaried
Publications: Catalog of collections

Collection: 3,000 books, 300 periodicals, 150 audiovisual materials, 70 works of art, and archival materials (printed and pictorial materials, theses and dissertations, newspapers in microform). The collection is cataloged; copying facilities are available.

Comments: The purpose is to present art exhibits of various French artists. Services include guided tours, educational lectures, and participation in ethnic festivals.

BAYOU FOLK MUSEUM Museum
 Maine St. Library
 Cloutierville, LA 71416 318-379-2233
 Mailing address: P. O. Box 2248, Natchitoches, LA 71457

Contact: Maxine Southerland, Pres.
Founded: 1965; Scope: Regional
Availability: M-Sat. 10-5, Sun. 1-5; Admission: $3.50 adults, $1 children
Visitors: General public

Collection: Books, audiovisual materials, artifacts and furnishings, and the historic home of Kate Chopin, nineteenth century Creole writer.

Comments: The collections emphasize the lifestyle, culture, and contributions of Creoles in Louisiana. Activities include guided tours, lectures, and exhibits.

FRENCH ART COLONY Museum
 530 First Ave., P.O. Box 472 Library
 Gallipolis, OH 45631 614-379-2887

Personnel: Lee Miller, Dir.; Janice Thaler, Pres. and Curator; Saundra Koby, Secy.; Peggy Evans, Treas.; Mary Bea Sheets, Program Dir.

Founded: 1971; Scope: Local, State, Regional
Availability: Open T-F, 10-3, Weekends, 1-5; Admission: Free
Visitors: General public
Publications: *Currents*, monthly newsletter

Collection: Artifacts, realia, antiques, objects of art.

Comments: French culture is preserved through the fine arts. Activities include guided tours, lectures and discussions, music and dance presentations, educational programs for children and adults, a yearly photography contest, and arts and crafts.

FRENCH AZILUM, INC. Museum
 R.R. 2, Box 266 Library
 Towanda, PA 18848 717-265-3905 Archives

Sponsoring organization: Pa. Historic & Museum Commission
Contact: Pat Zalinski, Site Mgr.
Founded: 1954; Scope: State
Availability: Open to the public; Admission: Fee
Visitors: General public, School groups
Staff: 9 (1 ft, 4 pt, 4 volunteers); Operating budget: $30,000
Publications: *French Azilum Newsletter*; publishes promotional brochures and flyers.

Collection: Ca. 200 books, ca. 750 artifacts, and archival records (personal papers and correspondence). The collection is cataloged; a reading room and copying facilities are available.

Comments: French Azilum is the site of a colony for refugees from the French Revolution who settled on the Susquehanna River. The LaPorte house, built in 1836 by a descendant of the colony, reflects French influence, art, and culture. Services include guided tours, educational lectures, school presentations, speakers, and a souvenir shop.

FRENCH INSTITUTE/ALLIANCE FRANCAIS Library
 22 East 60th St.
 New York, NY 10022-1077 212-355-6100; Fax 212-935-4119

Personnel: Jean Vallier, Dir.
Contact: Fred J. Gitmer, Library Dir.
Availability: Open M & Th, 12-8, T & W, 10-8, F, 11-3 (reference use only for non-members); Admission: Initial visit free; then daily pass or membership
Visitors: General public, School groups, Ethnic community
Staff: 3 ft, 4 pt, salaried; 30 volunteers
Publications: Quarterly library newsletter and acquisitions list.

Collection: 45,000 books (bibliographical, biographical, and lexicographical works), 110 periodical titles (Paris dailies *Le Monde* and *Le Figaro*), and 2,250 audiovisual recordings of plays, poetry, short stories, interviews with prominent French people, language instruction for children and adults, and vocal music on French literature, art, history, and every aspect of French civilization, life, and thought The collection is cataloged; a reading room, listening booths, and copying facilities are available.

Comments: The institute was formed by the merger of the Alliance Francaise de New York (founded in 1898) and the French Institute in the United States (founded in 1911). Services include speakers, dance, drama, and instrumental presentations, films and AV productions. The institute supports undergraduate and graduate level research in cooperation with colleges and universities.

THE FRENCH LEGATION Museum
 802 San Marcos St.
 Austin, TX 78702 512-472-8180

Sponsoring organization: Daughters of the Republic of Texas, Inc.
Personnel: Louise Polley, Chairwoman
Contact: Lisa L. Jones
Founded: 1840; Scope: State
Availability: Open T-Sun., 1-5; Admission: $2.50 adults, $1 children 10-18, $.50 Children under 10
Visitors: General public, School groups, Ethnic community
Staff: 1 ft, 3 pt, 9 volunteers; Operating budget: $25,000
Publications: Collection catalogs; publishes books about the French Legation in Texas.

Collection: Books, periodicals, audiovisual materials, period furnishings, and archival records (printed and pictorial materials). Copying facilities are available.

Comments: The purpose is to preserve the French influence in Texas, particularly of the early French Legation in the early and middle nineteenth century. Activities include guided tours and an annual Christmas open house.

THE FRENCH LIBRARY IN BOSTON Library
 53 Marlborough St.
 Boston, MA 02116 617-266-4351; Fax 617-266-1780

Personnel: Phyllis Dohanian, Dir.
Contact: Jane Stahl, Libn.
Founded: 1945; Scope: National
Availability: Open to the public; Admission: Free
Visitors: General public, School groups, Ethnic community
Staff: 16 salaried (11 ft, 5 pt) plus volunteers
Publications: *Bibliophile*, 1950- , bimonthly; *Bastille Day Program Book*, 1985- , annual; annual report; membership newsletters.

Collection: Over 25,000 books, 45 periodical titles, films, videos, ca. 1,500 audio cassettes, and archival records of French filmmaker M. Carne. The collection is cataloged; a published user's guide, reading room, and copying facilities are provided for researchers.

Comments: The library is a nonprofit cultural organization devoted to promoting the language and culture of France and the Francophone world. It offers language classes, film presentations, book discussions, educational lectures, art and photography exhibitions, concerts, translation and interpretation services, wine-tastings, cooking demonstrations, and children's events.

HUGUENOT HISTORICAL SOCIETY Museum
 P. O. Box 339, 18 Brodhead Ave. Library
 New Paltz, NY 12561 914-255-1660 Archives
 Art Gallery

Personnel: Leslie Lefevre-Stratton, Curator
Contact: Timothy F. Harley, Acting Dir.
Founded: 1894; Scope: Local, State, Regional, National, International
Availability: Open 9-4 (summer); also by special appt.; Admission: $6 adults, $5
seniors, $3 children 7-12, Free children under 7
Visitors: General public, School groups
Staff: 10 ft, 4 pt, salaried
Publications: Formal annual report; membership newsletters and flyers

Collection: Over 5,000 books, periodicals, artifacts and realia, works of art, and
archival materials (personal papers and correspondence, unpublished records, pictorial
materials, and oral histories). The collection is cataloged; a reading room and copying
facilities are available.

Comments: The purpose is to preserve and protect the homes and artifacts of the
Huguenot refugees who settled in the community in 1658. The society also sponsors
Huguenot Street with original French Huguenot homes (e.g., Jean Hasbrouch Memorial
House, 1692-1712, Abraham Hasbrouch House, 1698, LeFevre House, 1705, DuBois
Fort and a French church). Activities include guided tours, educational lectures,
speakers, and an arts and crafts souvenir shop.

HUGUENOT SOCIETY OF SOUTH CAROLINA Library
 138 Logan St. Archives
 Charleston, SC 29401 803-723-3235; Fax 803-853-8476

Personnel: Barbara P. Claypoole, Dir.
Contact: Melissa W. Ballentine, Archivist
Founded: 1885; Scope: International
Availability: Open to the public; Admission: Fee
Visitors: General public, Ethnic community
Staff: 7 (3 ft, 4 volunteers); Operating budget: $100,000
Publications: *Transactions of the Huguenot Society of SC*, 1885- , annual

Collection: 2,000 books, 2,000 periodicals, 200 artifacts, 100 works of art, and 24 file
drawers of archival records (personal papers and correspondence, unpublished records,
pictorial materials, theses and dissertations, manuscripts, oral histories, and
genealogical records in microform). The collection is cataloged; a reading room and
copying facilities are available.

Comments: The organization preserves French Huguenot history and culture and
provides genealogical records to assist researchers. It provides educational lectures and
presentations to schools.

MADAWASKA HISTORICAL SOCIETY Museum
 P. O. Box 258
 Madawska, ME 04756 207-728-4518

Personnel: Claude L. Cyr, Pres.
Contact: Bernette Albert, Dir., Museum Project
Founded: 1968; Scope: Local; Admission: Free
Availability: Open to the public (summer only)
Visitors: General public, School groups, Ethnic community
Staff: 11 (1 pt, salaried; 10 volunteers); Operating budget: $2,000
Publications: *Madawaska Historical Society Newsletter*, 1968- , annual; also publishes
books and promotional brochures.

Collection: 500 books, 500 periodicals, 1,500 artifacts, 1,000 photos, and archival
materials (personal papers and correspondence, unpublished records, pictorial materials,
theses and dissertations, manuscripts, oral histories). Genealogical records are in
microform. The collection is accessioned, but not cataloged; a reading room and
copying facilities are available.

Comments: The purpose is to preserve the history of an early French and Acadian
settlement in Maine via some restored buildings (Albert Homestead and a one-room
schoolhouse). Services include guided tours, educational lectures, loans to schools, and
school presentations. The society participates in ethnic festivals.

MICHEL BROUILLET HOUSE & MUSEUM Museum
 509 N. 1st St.
 Vincennes, IN 47591 812-885-4173

Personnel: Jimmy Morrison, Chairman of Bd.; Richard Day, Pres. and Curator
Contact: Richard Day, Pres. and Curator, P. O. Box 1979, Vincennes, IN 47591
Founded: 1949; Scope: National
Availability: Open daily 1-4 (May-Oct.); Admission: $1 adults; $.50 children
Visitors: General public, School groups
Publications: *Old Northwest Corporation Newsletter*, monthly

Collection: Artifacts, realia, and furnishings

Comments: The purpose is to preserve the way of life of the early French settlers of
Vincennes, Indiana through exhibits, dioramas, guided tours, lectures, and special
presentations.

NATIONAL HUGUENOT SOCIETY Library
 9033 Lyndale Ave. S. #108 Archives
 Bloomington, MN 55420-3535

Contact: Arthur Louis Finnell
Scope: National
Availability: Open to the public; Admission: Donation
Visitors: General public
Staff: 1 pt
Publications: *The Cross of Languedoc*, 1960- , semi-annual; *Register of Ancestors*

Collection: 1,000 books, 500 periodicals, works of art, and archival records (personal
papers and correspondence, unpublished materials, pictorial materials, theses and

dissertations, pictorial materials, and manuscripts). Application papers for state societies are in microform. The collection is cataloged; a reading room is available.

Comments: Membership consists of descendants of the 18th century French Huguenots. Services include educational lectures and speakers or resource people.

THE ROQUE HOUSE Museum
 No. 1 Rue Beauport
 Natchitoches, LA 71457 318-352-1714
Mailing address: 424 Jefferson St., Natchitoches, LA 71457

Personnel: Robert B. DeBlieux, Chairman; Lori Tate, Museum Shop Mgr.
Founded: 1968; Scope: Local, State, Regional
Availability: Open to the public daily, 9-6; Admission: Free
Visitors: General public

Collection: Artifacts, furnishings, historic building

Comments: The object is to preserve French culture in the United States by restoration of this 1803 French colonial building. Services include a visitor center, guided tours, lectures, exhibits, and participation in ethnic festivals.

SAINTE MARIE AMONG THE IROQUOIS Museum
 One Onondaga Lake Parkway Library
 Liverpool, NY 13088 315-453-6767; Fax 315-457-3681 Archives

Sponsoring organization: Onondaga County Parks
Personnel: Robert Geraci, Acting Dir.; Adria Tarbell, Native Interpretation Coordinator
Contact: Valerie Jackson Bell, Curator of Historic Interpretation
Founded: 1933; Scope: Local, Regional, International
Availability: Open by special appt. only; Admission: Fee
Visitors: General public, School groups, Ethnic community
Staff: 16 ft, salaried

Collection: Ca. 500 books, 50 periodicals, audiovisual materials, ca. 500 artifacts, 50 works of art, archival records (printed materials, pictorial materials). The collection is cataloged; an unpublished guide, reading room, and copying facilities are available.

Comments: The purpose is to present a balanced history of French Americans with emphasis on their interaction with the Iroquois. Guided tours, educational lectures, school presentations, speakers, crafts classes, and a souvenir shop are provided.

TANTE BLANCHE MUSEUM Museum
 U.S. #1 Library
 Madawaska, ME 04756 207-728-4272

Sponsoring organization: Madawaska Historical Society
Personnel: Claude L. Cyr, Pres.
Contact: Roger Thibadeau, Museum Mgr., P.O. Box 99, Madawaska, ME 04756

Founded: 1968; Scope: Regional
Availability: M-F, 10:30-3:30 (June-Aug.); Admission: Free or donation
Visitors: General public

Collection: Books, artifacts, furnishings, historic building and shrine (Acadian Cross), and archival records.

Comments: The purpose of this history museum is to preserve and display materials that portray Acadian and French Canadian culture. Programs include guided tours, educational lectures, exhibits, genealogical research, and an annual Acadian festival.

UNION SAINT JEAN BAPTISTE MALLET LIBRARY Library
 One Social St. Archives
 Woonsocket, RI 02895 401-766-3014

Contact: Sr. Charles Emice, P.M., Libn.
Founded: 1902; Scope: International
Availability: Open to the public; Admission: Free
Visitors: General public, School groups, Ethnic community
Staff: pt

Collection: Books, periodicals, audiovisual materials, artifacts, works of art, and 3,000 square ft. of archival materials (personal papers and correspondence, unpublished records, pictorial materials, theses and dissertations, manuscripts, and oral histories). Some records are in microform. The collection is cataloged; a reading room and copying facilities are available.

Comments: Promotes understanding of the French heritage in North America.

G

GERMAN AMERICAN RESOURCES

(See also Austrian American and Swiss American Resources. It should be noted that the German-speaking Amish and Mennonite groups are included altogether here, although some may be of Swiss or other descent as well.)

ADAMS COUNTY HISTORICAL SOCIETY <u>Archives</u>
 P. O. Box 102
 Hastings, NE 68902 402-463-5838

Contact: Catherine Renschler, Exec. Dir.
Founded: 1968; Scope: Local, State
Availability: Open M-F, 9-4; Admission: Free, Donation
Visitors: General public, School groups
Staff: 1 ft, 1 pt, 20 volunteers; Operating budget: $50,000
Publications: *Historical News*, 1968- , bimonthly; also publishes brochures.

Collection: Ca. 200 books, 200 periodicals, archival records (personal papers and correspondence, unpublished records, pictorial materials, manuscripts, and oral histories). The collection is cataloged; a published guide, reading room, and copying facilities are available.

Comments: Collects and preserves materials related to the culture and history of German Americans and Germans from Russia as the major ethnic groups that settled in Adams County. Activities include guided tours, school presentations, speakers, work experience for college credit, and research programs in conjunction with several universities.

ALPINE HILLS HISTORICAL MUSEUM <u>Museum</u>
 106 West Main St., P.O. Box 1776
 Sugarcreek, OH 44681 216-852-4113

Sponsoring organization: Alpine Hills Historical Society
Contact: Les Kaser, Curator, P.O. Box 293, Sugarcreek, OH 44681
Founded: 1972; Scope: Local, International
Availability: Open to the public; Admission: Donation
Visitors: General public, School groups
Staff: 1 ft
Publications: *Alpine Hills Newsletter*, annual.

Collection: Audiovisual materials, artifacts and realia, works of art, and archival

materials (journals, letters, diaries, records, etc.). The collection is cataloged.

Comments: The displays depict the early days of the community and its Swiss and Amish heritage; the museum also includes a large collection of horse-drawn farm machinery and tools used by the pioneers of the area, an exact replica of an Amish kitchen, a complete replica of an 1890 Cheese House, and a printing shop where the Amish newspaper The Budget was printed, among other items.

AMANA HERITAGE SOCIETY Museum
 P. O. Box 81 Library
 Amana, IA 52203 319-622-3567 Archives

Personnel: Catherine Oehl, Curator; Barbara Hoehnle, Libn;
Contact: Lanny Haldy, Exec. Dir.
Founded: 1968; Scope: Local
Availability: Open by special appt.; Admission: Fee
Visitors: General public, School groups, Ethnic community
Staff: 30 (3 ft, 25 pt, 2 volunteers); Operating budget: $150,000
Publications: Memberships newsletters and brochures describing collections.

Collection: Books, periodicals, audiovisual materials, 7,000 artifacts, ca. 100 works of art, and 180 linear ft. of archives (personal papers and correspondence, unpublished records, pictorial materials, theses and dissertations, manuscripts, oral histories). Some records are in microform. The collection is cataloged; a reading room is provided.

Comments: The society is a nonprofit organization that preserves Amana's cultural heritage and that of its German descendants. It operates the Museum of Amana History, the Communal Kitchen and Coopershop Museum, the Communal Agriculture Exhibit, and the Village of Amana. It provides guided tours, educational lectures, loans to schools, school presentations, speakers, films and AV productions, and an arts and crafts/souvenir shop. The society participates in ethnic festivals, provides work experience for college credit, and supports research.

AMERICAN HISTORICAL SOCIETY OF GERMANS FROM RUSSIA Museum
 631 D St. Library
 Lincoln, NE 68502-1199 402-476-2023; Fax 402-476-7229 Archives

Contact: Kathy Schultz, Dir.
Founded: 1968; Scope: International
Availability: Open 9-12, 1-3:30; restricted access; Admission: Free
Visitors: General public, School groups
Staff: 8 ft, 1 pt, plus volunteers); Operating budget: $400,000
Publications: *Journal of the AHGSR*, 1969- , quarterly; *Clues*, 1968- , annual; membership newsletters.

Collection: Ca. 3,000 books, periodicals, audiovisual materials, artifacts, works of art, and archives (personal papers and correspondence, theses and dissertations, pictorial materials, and oral histories). Church records and obituaries are in microform. The collection is cataloged; a reading room and copying facilities are available for researchers.

Comments: The purpose is to promote understanding of the history of Germans from Russia and a better appreciation of their culture. The society provides guided tours, school presentations, speakers or resource people, and participates in ethnic festivals.

AMERICAN HISTORICAL SOCIETY OF GERMANS FROM RUSSIA Museum
CENTRAL CALIFORNIA CHAPTER Library
 3233 N. West Archives
 Fresno, CA 93705-3402

Contact: Gilbert Axt, Chapter Pres.
Founded: 1971; Scope: Local
Availability: Open to the public; also by appt.; Admission: Donation/Free
Visitors: General public, School groups, Ethnic community
Staff: 25 pt, volunteers; Operating budget: $40,000
Publications: *Central California - Newsletter*, 1971- , monthly

Collection: 1,000 books, 10 periodicals, 100 artifacts, and archival materials (census records); a reading room and copying facilities are available.

Comments: The purpose is to compile and preserve historical facts about German forefathers who migrated from Germany to Russia during the years 1763-1861 and then later to the United States, South America, and Canada. The collection consists of art, literature, folklore, and other items for exhibit and educational use. Services include guided tours, educational lectures, school presentations, speakers, workshops, and discussions to increase the general public's knowledge of Germans from Russia. The organization sponsors a scholarship for German Russian studies.

AMERICAN INSTITUTE FOR CONTEMPORARY Library
GERMAN STUDIES-AICGS
 Suite 350, 11 Dupont Circle NW
 Washington, DC 20036 202-332-9312; Fax 202-265-9531

Sponsoring organization: The Johns Hopkins University
Personnel: Robert Gerald Livingston, Dir.
Contact: Cornelia Danier, Libn.
Founded: 1986; Scope: International
Availability: Open to the public; Admission: Free
Visitors: General public
Staff: 1 ft, 1 volunteer; Operating budget: $50,000
Publications: Research reports

Collection: Over 4,000 books, ca. 100 periodical titles; newspaper records are in microform. Approximately 80% of titles are in German. The collection is cataloged; a reading room and copying facilities are available. Newspapers are in microform. Reference service available by telephone, fax or Bitnet (AICGSDOC@JHUVM.H CF.JHU.EDU).

Comments: The Institute is affiliated with The Johns Hopkins University and was established to promote research related to Germany and German affairs. It conducts a seminar series and an annual conference and maintains a library.

ARCHIVES OF THE MENNONITE CHURCH
1700 South Main
Goshen, IN 46526 219-535-7477; Fax 219-535-7660

Sponsoring organization: Historical Committee of the Mennonite Church
Personnel: Dennis Stoesz, Archivist
Contact: Levi Miller, Dir.
Founded: 1937
Availability: Open to the public; Admission: Free
Visitors: General public
Staff: 10 (2 ft, 4 pt, salaried; 6 volunteers); Operating budget: $75,000
Publications: *Mennonite Historical Bulletin*

Collection: 4,000 linear ft. of archives (personal papers and correspondence and
unpublished records). The collection is cataloged; an unpublished guide is available.
Some records are in microform. A reading room and copying facilities are available.

Comments: The purpose is to interpret and communicate Anabaptist and Mennonite
life and thought to the church and world.

BETHEL COLLEGE
MENNONITE LIBRARY AND ARCHIVES
300 East 27th St.
North Newton, KS 67117 316-283-2500; Fax 316-284-5286

Sponsoring organization: Bethel College and the General Conference Mennonite
Church
Personnel: John D. Thiesen, Archivist; Barbara A. Thiesen, Libn.
Founded: 1936; Scope: Local, State, Regional, National, International
Availability: Open M-F 10-12, 1-5; Admission: Free
Visitors: General public
Staff: 5 (1 ft, 4 pt; 3 volunteers); Operating budget: $70,000
Publications: *Mennonite Life*, 1946- , quarterly; also publishes *Gleanings from the
Threshing Floor*.

Collection: 35,000 books (including some rare books 450 years old), 3,500
periodicals, 10,000 color slides and other audiovisual materials, artifacts (including
communion ware from West Prussia in the 1700s), 500 works of art (prints, paintings,
etchings), and ca. 5,000 cubic ft. of archives (personal papers and correspondence,
unpublished records, pictorial materials, theses and dissertations, over 2,000
manuscripts, oral histories --including the Schowalter Oral History Collection of 1,500
tapes). Some materials are in microform. The collection is cataloged; an unpublished
guide, reading room, and copying facilities are available.

Comments: The Mennonite Library and Archives collect, preserve, and make available
for research materials related to Anabaptist/Mennonite studies.

BUKOVINA SOCIETY OF THE AMERICAS
722 Washington, P.O. Box 81
Ellis, KS 67637 913-726-4568

Personnel: Raymond Haneke, Pres.; Joseph Erbert, Secy.; Bernie Zerfas, Treas.; Raymond Schoenthaler, Curator
Contact: Oren Windholz, V. Pres. & Exec. Dir., P.O. Box 1083, Hays, Kansas 67601
Founded: 1988; Scope: Local, National, International
Availability: Open, restricted access; Visitors: General public, Ethnic community
Staff: 11 volunteers; Operating budget: $5,000
Publications: *Bulletin*, 1991- , quarterly

Collection: Books, periodicals, audiovisual materials, artifacts and realia, works of art, and archival materials (personal papers and correspondence, unpublished records, pictorial materials, oral histories).

Comments: The purpose is to preserve the German Bukovinan heritage. Each July a convention and festival are held with people attending from the U.S., Canada, and Germany. Services include guided tours, lectures, speakers, and films. The society works in conjunction with Fort Hays University and Kansas University.

DEUTSCHHEIM STATE HISTORIC SITE Museum
 109 W. 2nd St. Library
 Hermann, MO 65041 314-486-2200 Archives

Sponsoring organization: Missouri Dept. of Natural Resources, Div. of State Parks
Contact: Dr. E. M. Renn, Dir.
Founded: 1979; Scope: State, Regional
Availability: Open to the public; Admission: Fee
Visitors: General public, School groups, Ethnic community
Staff: 7 (3 ft, 4 pt)
Publications: *Der Maibaum* (Journal of the Deutschheim Association), 1993- , quarterly; also publishes informational handouts, guides to specific exhibits, books and cookbooks (e.g., *Missouri Germans and the Question of Slavery, A Missouri German Christmas*).

Collection: Books, periodicals, audiovisual materials, artifacts, works of art, and archival records (personal papers and correspondence, unpublished records, pictorial materials, manuscripts, oral histories). The census records from 1840s, 1850s, and 1860s, as well as two newspapers and town records from 1840-1870 are in microform. The collection is cataloged; a reading area and copying facilities are available.

Comments: The purpose is to preserve and conduct research related to the history and cultural heritage of the early German immigrants who settled in Missouri. Services include guided tours, educational lectures, school presentations, radio programs, speakers, and an arts and crafts souvenir shop.

EDEN THEOLOGICAL SEMINARY, EDEN ARCHIVES Library
 Luhr Library, 475 E. Lockwood Ave. Archives
 St. Louis, MO 63119-3192 314-961-3627; Fax 314-961-5738

Contact: Dr. Lowell H. Zuck, Dir.
Founded: 1925; Scope: Regional, National, International

Availability: 8:30 -12, T and Th; Admission: Free
Visitors: General public
Staff: 2 pt; Operating budget: $8,700
Publications: Biennial newsletter

Collection: 4,400 books, 200 vertical file drawers of reports, manuscripts, archival materials, 35 vols. of photocopied German-American clergy and immigration-mission documents; 150 microfilm reels of church records. The Harbaugh manuscripts, consisting of 200 letters and documents relating to the German Reformed Church in Pennsylvania, are housed in the Luhr Library. The collections are cataloged; a reading room and copying facilities are available.

Comments: The purpose is to catalog and make available records of the United Church of Christ congregations and agencies belonging to the former Evangelical Synod of North America. Services include guided tours and educational lectures.

FRANKENMUTH HISTORICAL ASSOCIATION Museum
 613 S. Main St. Archives
 Frankenmuth, MI 48734 517-652-9701

Personnel: Stewart E. Lauterbach, Exec. Dir.
Contact: Mary Neuchterlein, Coll. Mgmt. Libn.
Founded: 1963; Scope: Local
Availability: Open, restricted access; Admission: Fee
Visitors: General public, School groups, Ethnic community
Staff: 205 (2 ft, salaried, 3 pt, 200 volunteers)
Publications: Annual booklet of local businesses and places of historical interest; histories; cookbooks; anniversary publications.

Collection: Ca. 1,500 books, over 500 periodicals, audiovisual materials, over 3,000 artifacts, 100 works of art, 12 file drawers and over 40 linear ft. of archives (personal papers and correspondence, unpublished records, pictorial materials, theses and dissertations, 19th-century manuscripts, oral histories and emigration papers, and microfilms of church records and English-language newspapers). The collection is cataloged; a reading room and copying facilities are available.

Comments: Holdings and exhibits cover the German-Lutheran mission to the Chippewa Indians, four "Franken" communities, and the German American influence on the Frankenmuth community. Education programs for students include a lecture on local dialect, "hands-on" programs for children, Pioneer Living program at Wolkensdoerfer Log House, theater workshop at Fischer Hall. Local genealogical information is also available. Speakers, crafts classes, and an arts and crafts/souvenir shop are provided.

FRANKLIN AND MARSHALL COLLEGE Library
SHADEK-FOCKENTHAL LIBRARY Archives
 Lancaster, PA 17604 717-291-4225; Fax 717-291-4160

Contact: Ann Kenne, College Archivist and Spec. Coll. Libn.
Scope: Regional
Availability: Open M-F, 9-5; Admission: Free

Visitors: General public
Staff: 1 ft, 1 pt

Collection: Ca. 3,500 books, 100 periodicals, and fraktur materials. The collection is cataloged; a reading room and copying facilities are available for researchers.

Comments: The purpose is to collect, preserve, and make available materials that document the German American cultural heritage. Programs also support undergraduate and graduate level research.

THE FREE LIBRARY OF PHILADELPHIA Library
RARE BOOK DEPARTMENT
 1901 Vine St.
 Philadelphia, PA 19103 215-686-5416; Fax 215-563-3628

Personnel: Elliot Shelkrot, Pres. and Dir.
Contact: Martha Repman, Head, Rare Book Dept.
Founded: 1891; Scope: State, National, International
Availability: Open M-F 9-5; Admission: Free
Visitors: General public, School groups, Ethnic community
Staff: 5 ft
Publications: *The Pennsylvania German Fraktur of the Free Library of Philadelphia* (1976)

Collection: Books, periodicals, archives, 2,400 Pennsylvania German imprints and broadsides, 1,000 Pennsylvania German fraktur and manuscript music and record books. The collection is partially cataloged; a published guide and reading room are available.

Comments: This major rare book collection documents the history and culture of the Pennsylvania German community. Guided tours are available.

FREEMAN ACADEMY HERITAGE ARCHIVES AND MUSEUM Museum
 748 South Main St. Library
 Freeman, SD 57029 605-925-4237 Archives
 Art Gallery
Sponsoring organization: Coalition of Mennonite Churches
Personnel: Cleon Graber, Chairman of the Bd.; Ralph Kauffman, Curator
Contact: Rachel Senner, Archivist, 220 E. 7th St., Box 697, Freeman, SD 57029
Founded: 1955; Scope: Local, State, Regional
Availability: Open W 2-4; Admission: Fee (Museum); Free (Library and Archives)
Visitors: General public, School groups, Ethnic community
Staff: 16 (2 pt, 14 volunteers); Operating budget: $5,000
Publications: Promotional brochures

Collection: 1,300 books, periodicals, audiovisual materials, 5,000 artifacts, works of art, and 158 boxes of archives (unpublished records, pictorial materials, theses and dissertations, manuscripts, and oral histories). The collection is cataloged; the 1880 census records and the Freeman Courier are in microform. A reading room and copying facilities are available.

Comments: The objectives are to collect and preserve the history and culture of this German Mennonite community from Russia as well as to complete a collection of Hutterian Brethren Colony writings. The archives contain the only Mennonite archival materials in the state, telling the story of the people that came to South Dakota from Russia. Services include guided tours, school presentations, and speakers.

FREISTADT HISTORICAL SOCIETY Library
 10729 W. Freistadt Road
 McQuon, WI 53029 414-242-2045

Sponsoring organization: Trinity Lutheran Church
Contact: LeRoy Boehlke, Archivist
Founded: 1964; Scope: Local
Availability: Information supplied upon request; Admission: Donation
Staff: 1 volunteer
Publications: Various monographs

Collection: Books and archives (unpublished records, printed materials, church record books). The collection is not cataloged.

Comments: The purpose is to preserve the records of German immigrants, immigration, and the Lutheran Church. The society participates in ethnic festivals.

GEORGIA SALZBURGER SOCIETY MUSEUM Museum
 Rte 1, Box 478B
 Rincon, GA 31326 912-754-6333

Personnel: John W. Gnann, Pres.
Founded: 1925; Scope: State
Availability: Open to the public W, Sat.-Sun., 3-5; Admission: Free
Visitors: General public
Publications: Newsletters; also publishes books (*Salzburger Genealogy*; *Salzburger Cook Book*, etc.).

Collection: Books, Bibles, artifacts, historic buildings (the Jerusalem Lutheran church of 1769, residential dwelling), archival materials (genealogical records of the Salsburger family), maps, deeds, and documents related to early community settlers.

Comments: The purpose is to preserve the records of the Salzburger German American family. Services include regular meetings and tours for visitors.

GERMAN-AMERICAN INFORMATION Library
AND EDUCATION ASSOCIATION
 P.O. Box 10888
 Burke, VA 22015 703-425-0707

Contact: Stanley Rittenhouse, Pres.
Founded: 1986; Scope: National
Availability: Open by appt.; Admission: Free
Visitors: General public, Ethnic community

Publications: *GIEA Newsletter*, irreg.

Collection: Books, periodicals, and other materials related to German Americans.

Comments: The purpose of the organization is to preserve the German cultural heritage, history, and culture, and to promote the image of Germans and German Americans.

GERMAN AMERICAN WORLD SOCIETY Library
(Formerly German Education Society)
 529 A Central Ave.
 Jersey City, NJ 07307 201-420-0159

Contact: John R. Lawrora, Exec. Secy.
Founded: 1980; Scope: National
Availability: Open by appt.; Admission: Free
Visitors: General public
Operating budget: Less than $25,000
Publications: *German-American World*, bimonthly

Collection: The collection is a small library to support placement services and research, including statistical compilations.

Comments: The objective of the society is to provide information about German American history and culture. It provides educational offerings in German language and culture, conducts research, and participates in ethnic festivals.

GERMAN HISTORICAL INSTITUTE Library
 1607 New Hampshire Ave. NW
 Washington, DC 20009 202-387-3355; Fax 202-483-3430

Sponsoring organization: VW Foundation
Personnel: Dr. Detlef Junker, Dir.
Contact: Luzie Nahr, Asst. Libn.
Founded: 1987; Scope: International
Availability: Open M-F, 10-6; Admission: Free
Visitors: General public
Staff: 20 ft, 1 pt
Publications: *Bulletin*, 1987- , semi-annual; also publishes reference guides, monographs, an *Annual Lecture Series*, as well as occasional lectures.

Collection: 16,000 books, 200 periodicals, and archival materials (theses and dissertations); national inventory of documentary sources are in microform. The collection is cataloged; a reading room and copying facilities are available for researchers.

Comments: This research center for German and German American history emphasizes research on German and American relations and German immigration, and provides information on various archival sources. Services include educational seminars and lectures, and speakers or resource people.

GERMAN SOCIETY OF PENNSYLVANIA Library
JOSEPH HORNER MEMORIAL LIBRARY Archives
 611 Spring Garden St.
 Philadelphia, PA 19123 215-627-2332; Fax 215-627-5297

Personnel: Bernard Freightage, Pres.; Margaret Castrogionanni, Libn.
Contact: Dr. Karl Otto, Library Committee Chairman
Founded: 1764; Scope: National
Availability: Open to the public for reference use only; Admission: Free
Visitors: General public, School groups, Ethnic community
Staff: 4 ft and pt, salaried; Operating budget: $200,000
Publications: *The New Pennsylvania State Messenger*, 1989- , monthly

Collection: 90,000 books, 10,000 periodicals, 70 audio tapes, and archives (personal
papers and correspondence, unpublished records, pictorial materials, theses and
dissertations, 19th century newspapers in microform). The collection is partially
cataloged; a reading room and copying facilities are available.

Comments: Propagates the German cultural heritage and maintains a major German
American library. The society conducts German language classes, provides awards and
scholarships to students of German, and sponsors German festivals (Oktoberfests).
Programs include guided tours, lectures, loans to schools, speakers, choir and
instrumental performances, films and AV productions.

GERMANS FROM RUSSIA HERITAGE SOCIETY Museum
(Formerly North Dakota Historical Society of Germans from Russia) Library
 1008 East Central Ave. Archives
 Bismarck, ND 58501 701-223-6167

Personnel: Al Feist, Pres.; George Bowman, V. Pres.
Contact: Rachel Schmidt, Office Mgr.
Founded: 1971; Scope: International
Availability: Open to the public; Admission: Free
Visitors: General public
Staff: 2 pt; Operating budget: $75,000
Publications: *Heritage Review*, 1971- , quarterly; *GRHS Newsletter*, 1971- , biannual

Collection: 4,000 books, 2,000 periodicals, 50 audiovisual materials, artifacts, 10
drawers of archives (personal papers and correspondence, pictures, theses, manuscripts,
oral histories, 102,000 obituaries, pedigree charts). The collection is partially
cataloged; a reading room and copying facilities are available.

Comments: Preserves the common history and cultural heritage and provides social
activities for the immigrants who left Germany in the 17th and 18th centuries and settled
in the Volga area of Russia before emigrating to America.

GERMANTOWN HISTORICAL SOCIETY Museum
(Formerly Germantown Site and Relic Society) Library
 5501 Germantown Ave. Archives
 Philadelphia, PA 19144 215-844-0514; Fax 215-844-2831

Personnel: Elizabeth Soloman, Curator
Contact: Barbara Warnick Silberman, Mng. Dir.
Founded: 1900; Scope: Local, State, Regional, National
Availability: Open to the public; Admission: Fee (Free to members)
Visitors: General public, School groups, Ethnic community
Staff: ft, pt, and volunteers; Operating budget: $150,000
Publications: *The Germantown Crier*, 1949- , semiannual; also publishes books.

Collection: 3,000 books, 4 periodical titles, videos, 20,000 artifacts, glass plate
negatives, cassette interviews, and 50 cartons and 150 linear ft. of archival records
(personal papers and correspondence, unpublished records, pictorial materials,
manuscripts, and oral histories). The collection is cataloged; a reading room and
copying facilities are available.

Comments: The purpose is to provide information and educational resources about
Germantown and its founding by German settlers. Services include guided tours,
educational lectures, loans and presentations to schools, speakers, and a souvenir shop.

GLUCKSTAL COLONIES RESEARCH ASSOCIATION
611 Esplanade
Redondo Beach, CA 90277 310-540-1872; Fax 310-792-8058

Library
Archives

Personnel: Carolyn Wheeler, Research Dir.
Contact: Margaret Freeman, Chairman
Founded: 1986; Scope: International
Availability: Open by special appt. only; Admission: Donation
Visitors: General public
Staff: Volunteers; Operating budget: $2,000-$3,000
Publications: *Gluckstal Colonies Research Association Newsletter*, 1986- ; publication
on immigration and ship passenger lists, etc. in progress.

Collection: 50 books, over 100 periodicals, audiovisual materials (audio-tapes), 12 file
drawers and 10 yards of archival materials (personal papers and correspondence,
unpublished records, pictorial materials, manuscripts, oral histories). Some records are
in microform. The collection is not cataloged; copying facilities are available.

Comments: The purpose is to coordinate the efforts of research on German descendants
of the Gluckstal colonies in South Russia and to locate, gather, organize, and access all
sources pertaining to the colonies of Bergdorf, Kassel, Gluckstal, Neudorf, and their
daughter colonies. Services include educational lectures.

GOETHE HOUSE NEW YORK GERMAN CULTURAL CENTER
1014 Fifth Avenue
New York, NY 10028 212-439-8700

Library

Personnel: Dr. Heinz-Hugo Becker
Founded: 1957 Scope: State, National
Availability: Open to the public; Admission: Free
Visitors: General public
Staff: 22 (19 ft, 3 pt, salaried)

Publications: Newsletter for members

Collection: 10,600 books, 130 periodical titles, 2,500 audiovisual materials, and archival records. The collection is cataloged; a published guide, reading room, and copying facilities are available.

Comments: Promotes an awareness and appreciation of German culture; provides in-service training for German language teaching, supplying textbooks and teaching materials; and awards scholarships for German studies. The center provides loans to schools and school presentations, film screenings, exhibitions, workshops, seminars, lectures, panel discussions, and press conferences. It has programs for graduate credit in conjunction with colleges and universities and supports research at the graduate level.

GOSCHENHOPPEN HISTORIANS, INC. Museum
 120 Perkiomen Ave. Library
 Green Lane, PA 18054 215-234-8953

Personnel: Alan Keyser, Curator; John Schilling, Chairman of Bd.; Ethel Simmons, Secy.
Contact: Norman C. Hoffman, Pres., 172 Stone Rd., Barto, PA 19504-9329
Founded: 1964; Scope: Local
Availability: Open to the public; Admission: Free
Visitors: General public, School groups, Ethnic community
Staff: 35 (1 salaried, 34 volunteers); Operating budget: $10,000
Publications: *Goschenhoppen Newsletter*, 1964- , monthly; *Intelligencer*, annual; also publishes books (e.g., cookbooks, quilt books).

Collection: Books, artifacts, and archival materials (pictorial materials and oral histories). The collection is not cataloged; a reading room and copying facilities are available.

Comments: The organization has preserved the historic Henry Antes House, a prosperous mid-18th century Pennsylvania German farmstead. It conducts seminars; has antique shows, a youth organization, a general store, a folklife museum, and a folk festival. It sponsors guided tours, an organ concert series, educational lectures, school presentations, speakers, and Pennsylvania German language classes (12-week course). The organization also participates in ethnic festivals. Some 250 volunteers demonstrate various arts, crafts, and cooking related to the Pennsylvania German culture each year in August.

GOSHEN COLLEGE MENNONITE HISTORICAL LIBRARY Library
 1700 South Main St.
 Goshen, IN 46527 219-535-9418

Personnel: Joe Springer, Curator
Contact: Dr. John D. Roth, Dir., Goshen College, Goshen, IN 45626
Founded: 1906; Scope: Local, State, Regional, National, International
Availability: Open to the public; Admission: Free
Visitors: General public, School groups
Staff: 6 (2 ft, 4 pt, and volunteers)

Collection: Over 34,000 books, 10,953 periodicals, 46 audiovisual materials, 890 artifacts and works of art, and archival materials (unpublished records, pictorial materials, theses and dissertations). Some records are in microform. The collection is cataloged; a reading room and copying facilities are available.

Comments: The library maintains a comprehensive collection of materials by and about Mennonites, Amish, and Hutterites including a rare book collection focused on the Radical Reformation, particularly the Anabaptists of the 16th century and their Dutch, German, and Russian Mennonite descendants. A genealogical collection of 4,000 volumes is devoted to Mennonite family names. Patrons include scholars, graduate and seminary students, pastors, college faculty and genealogists. Services include guided tours, educational lectures, loans and presentations to schools, and speakers.

HANS HERR HOUSE Museum
 1849 Hans Herr Dr.
 Willow Street, PA 17584 717-464-4438

Sponsoring organization: Lancaster Mennonite Historical Society
Personnel: Henry G. Benner, Chairman of Bd.
Contact: Martin A. Franke, Dir.
Founded: 1974; Scope: International
Availability: Open to the public; Admission: Fee
Visitors: General public, School groups
Staff: 2 pt, 90 volunteers; Operating budget: $54,000
Publications: *Herr House Foundation Newsletter*, 1979- , quarterly; also publishes monographs.

Collection: Books, 3,000 artifacts, home furnishings of the 17th and 18th centuries, 15 works of art, ca. 12 boxes and 1 file cabinet of archival materials (personal papers and correspondence, unpublished records, printed and pictorial materials, and oral histories). The collection is partially cataloged; copying facilities are available.

Comments: The Hans Herr House collects, exhibits, and interprets artifacts about the life, history, and faith of Swiss-German Mennonites in Lancaster County, PA. It maintains the 1719 Herr House, the oldest building in Lancaster County, and the oldest Mennonite meetinghouse in North America. Services include guided tours, lectures, loans to schools, school presentations, speakers, and an arts and crafts souvenir shop. Work experience for college credit is available through a summer intern program for majors in museum related studies. The organization participates in ethnic festivals.

HISTORIC HERMANN MUSEUM Museum
 4th & Schiller Sts.
 Hermann, MO 65041 314-486-2017/2781

Sponsoring organization: Historic Hermann, Inc.
Contact: Gennie Tesson, 120 4th St., Hermann, MO 65041
Founded: 1956; Scope: Local
Availability: Open to the public; Admission: $1.00 adults, $.50 children
Visitors: General public, School groups
Staff: Volunteers

Publications: Publishes a formal annual report; membership newsletters and flyers; also publishes books.

Collection: Books and artifacts; German school records in microform. The collection is cataloged.

Comments: The village of Hermann was settled by German immigrants, and the museum contains furnishings handmade in Germany around the turn of the century. It features guided tours, crafts classes, an arts and crafts souvenir shop, and various ethnic festivals (Wurstfest, Maifest, Volksmarch, Oktoberfest, and Christmas).

HOLMES COUNTY PUBLIC LIBRARY <u>Library</u>
 28 West Jackson St.
 Millersburg, OH 44654 216-674-5972; Fax 216-674-1938

Personnel: Rennee Croft, Dir.
Contact: Matt Nojonen, Adult Services
Founded: 1905; Scope: Local
Availability: Open to the public; Admission: Free
Visitors: General public
Staff: 1 ft

Collection: Books, genealogical materials, and archives (printed materials); some records are in microform. The collection is cataloged; copying facilities are available.

Comments: The purpose is to obtain books published concerning the Amish and to maintain an up-to-date collection on the subject.

INDIANA UNIVERSITY-PURDUE UNIVERSITY AT INDIANAPOLIS <u>Library</u>
SPECIAL COLLECTIONS AND ARCHIVES <u>Archives</u>
 University Library
 755 W. Michigan St.
 Indianapolis, IN 46202 317-274-0464; Fax 317-274-0492

Contact: Eric Pumroy, Head, Spec. Coll. and Archives
Founded: 1976; Scope: State, National, International
Availability: Open M-F, 8-5; Admission: Free
Visitors: General public, Ethnic community
Staff: 7 (2 ft, 5 pt); Operating budget: $100,000

Collection: Books, periodicals, audiovisual materials, and archives (personal papers and correspondence, unpublished records, theses and dissertations, pictorial materials, manuscripts, and oral histories). The collection is cataloged.

Comments: Published and unpublished records of German American organizations and individuals are found in this national repository for records of the American Turners.

IOWA WESLEYAN COLLEGE CHADWICK LIBRARY <u>Archives</u>
 601 N. Main St.
 Mt. Pleasant, IA 52641 319-385-6320

Personnel: Dr. Louis Haselmayer, Dir.
Contact: Lynn Ellsworth, Asst. Archivist
Founded: 1992; Scope: State, Regional
Availability: M-Th, 1-5 (Sept.-June)
Visitors: General public, Ethnic community; Admission: Free
Staff: 2 (1 pt, salaried, 1 volunteer); Operating budget: $10,000

Collection: Over 500 books, periodicals, audiovisual materials, artifacts, 4 file drawers and ca. 96 linear ft. of archival materials on German American Methodism, 1800s through 1900s. A card index, reading room, and copying facilities are available.

Comments: The purpose of the archival ethnic materials is to preserve the history of German American Methodism in this Methodist college.

JUNIATA COLLEGE BEEGHLY LIBRARY Library
 18th and Moore Sts. Archives
 Huntingdon, PA 16652 814-643-4310; Fax 814-643-3620

Contact: Donald F. Durnbaugh, Archivist
Founded: 1876; Scope: State
Availability: Open by special appt.; Admission: Free
Visitors: General public
Staff: 1 volunteer

Collection: 1,000 books, 10 linear ft. of archival materials (personal papers and correspondence and manuscripts). Includes Pennsylvania-German imprints and manuscripts from the 18th and 19th centuries. The collection is cataloged; a reading room and copying facilities are available.

Comments: The purpose is to preserve materials that document Pennsylvania German history and culture and make it available to scholars and other researchers.

JUNIATA DISTRICT MENNONITE HISTORICAL SOCIETY Library
 HCR 63 Archives
 Richfield, PA 17086 717-694-3211

Sponsoring organization: Juniata District of Lancaster Mennonite Conference
Personnel: Lloyd S. Graybill, Chairman; J. Lloyd Gingrich, Secy.
Contact: Noah Zimmerman, Dir. 717-694-3543
Founded: 1951; Scope: Local, Regional, National, International
Availability: Open to the public; Admission: Free
Visitors: General public
Staff: 1 pt; Operating budget: $10,000
Publications: *Historical Center ECHOES*, 1978- , quarterly

Collection: Books, periodicals, artifacts and realia, paintings and other works of art, and 40 drawers of archives (personal papers and correspondence, unpublished records, genealogical materials). The archives contain about 50 Bibles, many in German. The collection is cataloged; a reading room and copying facilities are available for researchers.

Comments: The purpose is to preserve the denominational and local history of central Pennsylvania and Mennonite culture. Services include guided tours, lectures, and speakers; an annual meeting with a genealogical or historical theme is held.

LANCASTER MENNONITE HISTORICAL SOCIETY <u>Museum</u>
 2215 Millstream Rd. <u>Library</u>
 Lancaster, PA 17602-1499 717-393-9745 <u>Archives</u>

Personnel: Lloyd Zeager, Libn.
Contact: Carolyn C. Wenger, Dir.
Founded: 1958; Scope: International
Availability: Open to the public; Admission: Fee
Visitors: General public, School groups, Ethnic community
Staff: 20 (6 ft, 3 pt, salaried; 11 volunteers); Operating budget: $280,000
Publications: *Pennsylvania Mennonite Meetings*, 1978- , quarterly; *Mirror*, 1969- , quarterly; *Mennonite Sources and Documents* series; also publishes occasional non-series books and promotional brochures.

Collection: Over 1,500 books, periodicals, audiovisual materials, ca. 750 artifacts, works of art, and 1,000 cubic ft. of archival materials (personal papers and correspondence, unpublished records, pictorial materials, theses and dissertations, manuscripts, oral histories). The collection is partially cataloged; a shelf list is available. Some manuscript collections, census records, tax lists, and Bible records are in microform. A reading room and copying facilities are available.

Comments: Focuses on the historical, religious, and cultural background and genealogy of Mennonite and Amish groups in southeastern and south central Pennsylvania.

LUTHERAN THEOLOGICAL SEMINARY AT PHILADELPHIA <u>Library</u>
KRAUTH MEMORIAL LIBRARY
 7301 Germantown Ave.
 Philadelphia, PA 19119-1794 215-248-4616; Fax 215-248-4577

Personnel: John E. Peterson, Curator of Archives
Contact: The Rev. David J. Wartluft, Dir. of Library
Founded: 1864; Scope: Regional, National
Availability: Open; restricted access; Admission: Free
Visitors: General public, School groups, Ethnic community
Publications: *The Reporter*, 1981- , irreg. Staff: 6 ft, 2 pt, salaried; Operating budget: $280,000 (Lib.); $20,000 (Arch.)

Collection: Books, artifacts, and ca. 2,500 linear ft. of archives (unpublished records, pictorial materials, manuscripts, and oral histories). Journals of Henry Melchior Muhlenberg and some periodical titles are in microform. The collection is partially cataloged; a finding aid, reading room, and copying facilities are available.

Comments: The purpose is to document, preserve, and make available for research the legacy of the Halle tradition of German Lutheranism. The correspondence of H.M. Muhlenberg is being translated into English. Speakers or resource people, workshops on archives and writing congregational history are offered.

MENNO-HOF MENNONITE AMISH VISITORS CENTER Museum
 S. R. 5
 Shipshewana, IN 46565 219-768-4117

Sponsoring organization: Mennonite Anabaptist Information Center
Contact: Tim Lichti, P.O. Box 701, Shipshewana, IN 46565
Founded: 1984; Scope: Local, State, Regional, National, International
Availability: Open to the public; Admission: Donation
Visitors: General public, School groups
Staff: 88 (2 ft, 3 pt, 83 volunteers); Operating budget: $155,000
Publications: *Reunion*, 1990- , quarterly; also publishes formal annual report.

Collection: Audiovisual materials; a reading room is available.

Comments: Features Mennonite history and culture through storytelling, utilizing
slides, light shows, and a video depicting a Swiss courtyard, dungeons, a harbor in
Amsterdam, a meeting place, and a tornado theater. Covers Mennonite, Amish,
Anabaptist, and Hutterites. Services include guided tours, loans and presentations to
schools, speakers, films and AV productions, and an arts and crafts souvenir shop.

MENNONITE HERITAGE MUSEUM Museum
 200 North Poplar St.
 Goessel, KS 67053 316-367-8200

Sponsoring organization: Mennonite Immigrant Historical Foundation
Personnel: Lloyd Schroeder, Bd. Pres.; Marlene Schroeder
Contact: Kristine Schmucker, Curator
Founded: 1974; Scope: Local
Availability: Open T-F 10-5, Sat.,Sun 1-5 (Mar.-Nov.); Admission: $2.50 adults, $1
children
Visitors: General public, School groups, Senior citizens groups
Staff: 18 (1 ft, 2 pt, 15 volunteers)
Publications: *Mennonite Heritage Museum Newsletter*, semi-annual

Collection: Ca. 250 books, 100 periodicals, 500 photographs, over 1,000 artifacts, and
archives (unpublished records, manuscripts). The collection is partially cataloged; a
reading room is available.

Comments: The museum commemorates the centennial of the German Russian
Mennonite settlement in central Kansas with eight buildings depicting aspects of
Mennonite and local history, including farming implements and machinery. Services
include guided tours, lectures, school presentations, work experience for college credit,
and internships for graduate students. The museum participates in ethnic festivals.

MENNONITE HISTORIANS OF EASTERN PENNSYLVANIA Museum
 565 Yoder Rd., Box 82 Library
 Harleysville, PA 19438 215-256-3020 Archives

Personnel: Carolyn S. Nolan, Dir.; Arlin D. Lapp, Pres.
Contact: Joel D. Alderfer, Curator and Libn.

Founded: 1974; Scope: Regional
Availability: Open T-Sat., 10-5, Sun. 2-5; Admission: Free, donations accepted
Visitors: General public, Ethnic community
Publications: Promotional brochures; monthly newsletter.

Collection: Books on Mennonite-Anabaptist history, Pennsylvania Dutch culture, genealogy, cookbooks, a collection of Bibles and century books, photographs, slides, artifacts (costumes, farm implements, quilts, needlework, glassware, pottery, etc.). Includes the Pennsylvania German Fraktur (illuminated writing) collection.

Comments: Preserves Pennsylvania German history and culture; offers guided tours, slide lectures, and sponsors an annual Apple Butter Frolic and folk art sales.

MENNONITE HISTORICAL SOCIETY OF IOWA Museum
 411 9th St., P.O. Box 576 Library
 Kalona, IA 52247 319-656-2519 Archives

Personnel: Lester J. Miller, Pres.
Contact: Lois Gugel, Archivist
Founded: 1969; Scope: Local, State
Availability: Open to the public; Admission: Fee
Visitors: General public, School groups, Ethnic community
Staff: 5 pt, salaried plus volunteers; Operating budget: $20,000
Publications: *Reflections*, 1987- , quarterly

Collection: Ca. 1,500 books, 200 periodicals, audiovisual materials, ca. 500 artifacts and archives (personal papers and correspondence, unpublished records, pictorial materials, theses and dissertations, manuscripts, and oral histories). The collection is cataloged; an unpublished guide, reading room, and copying facilities are available.

Comments: The village includes the Kalona Depot, the Iowa Mennonite Museum of Archives, the Wahl Museum and the Wahl House, the Line Shaft Building, and Buggy Shop. The purpose is to preserve all aspects of Mennonite and Amish life. The society is in the process of updating "Cemetery Directory of Amish and Mennonites in Wiowa, Washington and Johnson Counties." It provides guided tours, speakers or resource people, and participates in ethnic festivals.

MENNONITE INFORMATION CENTER Museum
 5798 C.R. 77
 Berlin, OH 44610 216-893-3192

Personnel: Wayne R. Miller, Trustee, Pres.; Paul A. Miller, Trustee, Treas.
Contact: Verna Schlabach, Dir., P.O. Box 324, Berlin, OH 44610
Founded: June 4, 1979; Scope: Local, National, International
Availability: Open to the public; Admission: Fee
Visitors: General public, School groups
Staff: 2 ft, 2 pt, 20 volunteers; Operating budget: $160,000
Publications: *Flame* 1990- , quarterly

Collection: Audiovisual materials and works of art. The collection includes the

"Behalt" mural, a cyclorama by German artist Heinz Gaugel, which depicts the history of the Amish, Mennonite, and Hutterite people.

Comments: Provides information to the public on Amish Mennonite and Hutterite history and the background and culture of the Anabaptists. Services included guided tours, educational lectures, and films and audiovisual productions.

MORAVIAN HISTORICAL SOCIETY Museum
 214 E. Center St. Library
 Nazareth, PA 18064 215-759-5070 Archives

Contact: Susan M. Dreydoppel, Exec. Dir.
Founded: 1857; Scope: Local, State, Regional, National, International
Availability: Open to the public 1-4 daily; Admission: Donation
Visitors: General public, School groups
Staff: 1 ft, 1 pt, 25 volunteers; Operating budget: $80,000
Publications: Membership newsletters and flyers; periodicals.

Collection: 5,000 books, ca. 50 periodical titles, audiovisual materials, 3,000 artifacts, over 500 works of art, 100 linear ft. of archives (personal papers and correspondence, unpublished records, pictorial materials, theses and dissertations, manuscripts). The collection is partially cataloged; a reading room and copying facilities are available.

Comments: The purpose is to collect, interpret, preserve, and publish the history of Moravian church members, as a German-speaking denomination especially in the 18th century. A variety of artifacts and records document early German settlers and customs. Guided tours, lectures, loans and presentations to schools, and speakers are provided. The museum supports research and provides work experience for college credit.

MORAVIAN MUSEUMS OF BETHLEHEM, INC. Museum
 66 W. Church St. Library
 Bethlehem, PA 18018 215-867-0173

Sponsoring organization: Moravian Congregation of Bethlehem
Personnel: Judy C. Strock, Dir.; Paul Larson, Chair and Curator; Kay Black, Co-chair
Founded: 1938; Scope: State, Regional
Availability: Open T-Sat., 1-4 (Feb.-Dec.)
Admission: $5 adults; $3 students; offers community walking tours by appt., $10 adults, $5 college students, $3 high schools students and under.
Visitors: General public, School groups
Staff: 62 (2 ft, salaried; 60 volunteers)

Collection: 500 books, periodicals, artifacts (furniture, musical instruments, dolls and toys, clothing, utensils), and archival materials (diaries, genealogical records, music, etc.).

Comments: The object is to preserve the culture and religious traditions of the German Moravian immigrants who settled in Bethlehem. Services include guided tours, lectures, a walking tour (including a special Christmas candlelight tour), performing arts presentations, and special exhibits.

MORAVIAN MUSIC FOUNDATION Library
 20 Cascade Ave.
 Winston-Salem, NC 27127 919-725-0651

Contact: E. Allen Schultz, Exec. Dir.
Founded: 1956; Scope: National
Availability: Open by appt.; Admission: Free
Visitors: General public, Ethnic community
Staff: 3
Publications: *Moravian Music Journal*, semiannual; also publishes early Moravian music, manuscript catalogs, and a semiannual newsletter.

Collection: 6,000 books on hymnology, Moraviana, Americana, and church music.

Comments: The purpose of the foundation is to preserve early Moravian music and culture in the U.S. It is supported primarily by contributions from Moravian churches.

MUSEUM OF AMANA HISTORY Museum
 P. O. Box 81 Library
 Amana, IA 52203 319-622-3567

Sponsoring organization: Amana Heritage Society
Personnel: Barbara S. Hoehnie, Program Dir.; Catherine Oehl Guerra, Curator
Contact: Lanny Haldy, Exec. Dir.
Founded: 1968; Scope: Local
Availability: Open to the public; Admission: Fee
Visitors: General public, School groups, Ethnic community
Staff: 2 ft, 18 pt, 2 volunteers; Operating budget: $160,000
Publications: *Altes und Neues,* 1968- , quarterly; List of publications available by mail.

Collection: Ca. 1,500 books, periodicals, audiovisual materials, 10,000 artifacts, works of art, and 250 linear ft. of archives (personal papers and correspondence, unpublished records, pictorial materials, theses and dissertations, manuscripts, oral histories and photographs). Rare books, manuscripts, local newspapers, and genealogical records are in microform. The collection is cataloged; an unpublished guide is available.

Comments: The museum contains exhibits in three 19th century buildings: The Noe House built in 1864 and originally a communal kitchen, The School House (1870), and the original washhouse/woodshed. The purpose is to preserve Amana's cultural heritage for the community. Activities include guided tours, educational lectures, loans and presentations to schools, speakers, films and AV productions, a museum bookstore, and participation in local ethnic festivals.

NORTH DAKOTA STATE UNIVERSITY LIBRARIES Library
GERMANS FROM RUSSIA HERITAGE COLLECTION Archives
 P. O. Box 5599
 Fargo, ND 58105-5599 701-237-8416; Fax 701-237-7138

Sponsoring organization: North Dakota Institute for Regional Studies
Personnel: John E. Bye, Archivist
Contact: Michael M. Miller, German Russian Bibliographer
Founded: 1978; Scope: Regional
Availability: Open to the public; Admission: Free
Visitors: General public, Ethnic community
Staff: 17 (2 ft, 5 pt, 10 volunteers)
Publications: *Researching the Germans from Russia (1987)*, an annotated bibliography.

Collection: 1,000 books, 600 periodicals, 400 audiovisual materials, artifacts, and ca. 10 linear ft. of archives (personal papers and correspondence, unpublished records, pictorial materials, theses and dissertations, manuscripts, oral histories, and family histories). German-Russian newspapers are in microform. The collection, the most comprehensive one in North America of materials on Black Sea Germans and Bessarabial Germans of South Russia, is cataloged; a published guide, reading room, and copying facilities are available.

Comments: The collection supports research about Germans from Russia in the United States and is the official repository of the Germans from Russia Heritage Society. Activities include guided tours, educational lectures, and radio programs.

OHIO AMISH LIBRARY, INC. Library
 4292 SR 39 Archives
 Millersburg, OH 44654

Personnel: Atlee D. Miller, Chairman; Edward Kline, Secy.-Treas.
Contact: Paul Kline, Libn.
Founded: 1986; Scope: Local, Regional, National
Availability: Open to the public; Admission: Free
Visitors: General public, Ethnic community
Staff: 2 volunteers; Operating budget: $1,500
Publications: *Ohio Amish Library Newsletter*, 1990- , biannual; *Heritage Review*, 1990- , annual.

Collection: Ca. 750 books, periodicals, audiovisual materials, artifacts, works of art, 20 boxes and 70 ft. of archival materials (personal papers and correspondence, unpublished records, theses and dissertations, and oral histories). The collection is not cataloged; a reading room and copying facilities are available.

Comments: The library was founded to collect and preserve books and other printed matter unique to Amish society. It also collects family histories and genealogies which are available to genealogy researchers and translates the German *Ausbund* into English.

ORANGEBURGH GERMAN-SWISS GENEALOGICAL SOCIETY Archives
 P. O. Box 974
 Orangeburgh, SC 29116

Personnel: Frederick A. Smith, Pres.
Contact: James Gressette
Founded: 1981; Scope: Local

Availability: Open by appt. only
Publications: *Orangeburgh German-Swiss Newsletter*, quarterly; *First Families* (a history of first German-Swiss to settle in Orangeburgh, 1735-1737).

Collection: Books

Comments: The purpose is to identify and publish resources on the German Swiss and also provide opportunities for fellowship among members.

OREGON MENNONITE ARCHIVES AND LIBRARY (OMAL) Library
 9045 Wallace Rd. Archives
 Salem, OR 97304 503-371-3612, ext. 248

Sponsoring organization: Oregon Mennonite Historical and Genealogical Society
Personnel: Charity Krofp, Libn.; Hope Lind, Archivist; Margaret Shetler, Archivist
Founded: 1992; Scope: Local, State, Regional
Availability: Open to the public; Admission: Donation
Visitors: General public, School groups
Staff: 10-15 pt volunteers; Operating budget: $1,000
Publications: *OMHGS Newsletter*, 1988- , semiannual

Collection: Books, periodicals, and 25 linear ft. of archival materials (personal papers and correspondence, unpublished records, and manuscripts). The collection is cataloged; a reading room and copying facilities are available.

Comments: The purpose is to collect, organize, and make accessible for research printed materials and records relating to Oregon Mennonites, their history and thought, including both churches and families. Services include speakers or resource people; the organization supports graduate and undergraduate level research.

PA. DUTCH FOLK CULTURE SOCIETY, INC. Museum
 Lenhartsville, PA 19534 Library

Contact: Florence Baver, Pres.-Treas., 33 Price Dr., Topton, PA 19562
Founded: 1965; Scope: Local, State, Regional
Availability: Open to the public
Admission: Fee (Free to members); $3.00 adults, $1.50 children
Visitors: General public, School groups (by appt.)
Operating budget: $30,000
Publications: *PA. Dutch News and Views*, 1969- , semi-annual; promotional brochures.

Collection: 5,000 books, 500 periodicals, 10,000 artifacts, archives (genealogical records and local histories). The collection is cataloged; a published guide, reading room, and copying facilities are available.

Comments: The objectives are to preserve the Pennsylvania Dutch heritage, homelife and dialect. The society sponsors the Folklife Museum, Log House, Farm Equipment Building, House of Fashions, Genealogy and Folklore Library, a restaurant, and gift shop. Guided tours, workshops, lectures, speakers, and demonstrations are provided.

The society provides work experience for college credit and supports research.

PALATINES TO AMERICA Library
 P. O. Box 101
 Capital University
 Columbus, OH 43209-2394

Personnel: Marjorie Kroehler, Pres.
Contact: S. Jean Hall, National Libn.
Founded: 1975; Scope: State, International
Availability: Open to the public; Admission: Free
Visitors: General public
Staff: 1 pt, salaried, plus volunteers
Publications: *Palatine Immigrant*, quarterly; *The Palatine Patter* (newsletter); also publishes *Ancestor Chart Index*.

Collection: Ca. 500 books, ca. 250 periodicals. Maintains immigrant ancestor register and ancestor charts. The collection is cataloged; an unpublished guide, reading room, and copying facilities are available.

Comments: Provides service to researchers interested in the migration of German-speaking people from Europe to America, promotes interest in and study of German immigration, facilitates information exchange on German-speaking immigrants, and bestows annual Harvey Harsh and Citation awards.

THE PENNSYLVANIA GERMAN SOCIETY Library
(Formerly Pennsylvania German Folklore Society)
 P.O. Box 397
 Birdsboro, PA 19508 215-582-1441

Personnel: Richard Druckenbrod, Pres.; John P. Diefenderfer, V. Pres.
Contact: Lucille S. Smith, 502 Reeder St., Easton, PA 18042
Founded: 1891; Scope: International
Availability: Open when staff member present; Admission: Free
Visitors: General public, Ethnic community
Staff: 1 ft; Operating budget: $115,000
Publications: *Der Reggeboge* (The Rainbow), 1891-1960, semiannual

Collection: Books, periodicals, primary source archival materials. A catalog of publications and a reading room are available.

Comments: Promotes Pennsylvania Germans through publications, workshops, lectures, loans and presentations to schools, speakers, and ethnic festivals.

PEQUA BRUDERSCHAFT (BROTHERHOOD) LIBRARY Library
 275 Old Leacock Rd., P.O. Box 25 Archives
 Gordonville, PA 17529

Personnel: Stephen Stoltzfus, Chairman; Melvin Petersheim, Treas.; Samuel Stoltsfus, Secy.

Contact: Abner Beiler, 176 N. Hollander Rd., Gordonville, PA 17529
Founded: 1979; Scope: Local, Regional
Availability: Open, restricted access; Admission: Free, Donation
Visitors: General public, School groups
Staff: Volunteers

Collection: Books, periodicals, artifacts, works of arts, fractures of book plates, and
25 boxes of archival records (personal papers and correspondence, unpublished records,
pictorial materials, and manuscripts). Some records are in microform. The collection
is partially cataloged; a reading room and copying facilities are available.

Comments: Preserves Old Order Amish church related history through diaries, letters,
ledgers, Bibles, etc. of the early immigrants who were members.

PIONEER MUSEUM COMPLEX AND VEREIN KIRCHE ARCHIVES Museum
 309 N. Main St. Archives
 Fredericksburg, TX 78624 512-997-2835

Sponsoring organization: Gillespie County Historical Society
Personnel: Elmer Luckenbach, Pres.; Evelyn Stork, Head Docent of Pioneer Museum;
Hans Bergner, Head Docent of Verein Kirche Archives
Contact: Linda Crow, 312 W. San Antonio, Fredericksburg, TX 78624
Founded: 1935; Scope: Local, State, Regional
Availability: Open to the public; Admission: Fee
Visitors: General public
Staff: 3 ft, 7 pt, 10 salaried; 5 volunteers
Publications: Newsletter; monographs

Collection: Books, periodicals, audiovisual materials, artifacts, works of art, and
archives (personal papers and correspondence, unpublished records, pictorial materials,
theses and dissertations, manuscripts, and oral histories). The collection is partially
cataloged; a reading room and copying facilities are available. Historical buildings in
the museum complex contain artifacts and realia (Kammlah House, general store,
smoke house, barn and other farm buildings, blacksmith shop, wagon shed with horse-
drawn vehicles, log cabin, fire department, and the Weber Sunday House).

Comments: The Gillespie County Historical Society is dedicated to conservation and
preservation of historical buildings, including the Pioneer Museum Complex, in order
to preserve the cultural heritage of this German community. Guided tours, educational
lectures, school presentations, and an arts and crafts/souvenir shop are available.

PUBLIC LIBRARIES OF SAGINAW Library
 Hoyt Public Library Branch
 505 Janes Ave.
 Saginaw, MI 48607 517-755-9827

Personnel: Marcia Warner, Head Hoyt Branch
Contact: Anna Mae Maday, Mgr., Eddy Historical Collection
Founded: 1890; Scope: Local
Availability: Open T & Th 9-9, W, F, Sat. 9-5; Admission: Free

Visitors: General public, School groups
Staff: 8 (1 ft, 2 pt, salaried; 5 volunteers)
Publications: Catalogs of the collections

Collection: Books, periodicals, and archival materials (newspapers, genealogies); city directories are in microform. The collection is cataloged; a published guide, reading room, and copying facilities are available.

Comments: The Eddy Historical and Genealogical Collection has extensive materials related to ethnic groups, particularly German Americans, German Lutherans, and Germans and East Prussians from Russia. Programs include guided tours, educational lectures, and participation in ethnic festivals.

SCHOENBRUNN VILLAGE STATE MEMORIAL Museum
 U.S. Rt. 250 & State Rt. 259, P.O. Box 129
 New Philadelphia, OH 44663 216-339-3636

Sponsoring organization: Ohio Historical Society
Personnel: Linda Beal, Volunteer Coord.
Contact: Susan Goehring, Site Mgr.
Founded: 1923; Scope: State, Regional
Availability: Open M-Sat. 9:30-5, Sun. 12-5 (Apr.-Oct.); Admission: $4 adults; $1 children
Visitors: General public, School groups
Staff: 48 (2 ft, 6 pt, paid; 40 volunteers); Operating budget: $120,000

Collection: Books, artifacts, and 17 reconstructed log dwellings of the Moravian Indian Mission

Comments: The Moravians were German settlers who organized a Christian mission to evangelize Native Americans in Ohio. Services include tours, lectures, and a souvenir/gift shop. A cemetery from the 1770s is on the site. Moravian records are available through Moravian Archives (Bethlehem, PA).

SCHWENKFELDER LIBRARY Museum
 105 Seminary St. Library
 Pennsburg, PA 18073 215-679-3103

Contact: Dennis K. Moyer, Dir.
Founded: 1946; Scope: Local, International
Availability: Open M-F, 9-4; Admission: Donation/Free
Visitors: General public, School groups, Ethnic community
Staff: 4 (1 ft, 2 pt, 1 volunteer); Operating budget: $90,000
Publications: Books

Collection: 30,000 books, 200 periodical titles, 5,000 artifacts related to Pennsylvania Dutch household life, 100 works of art, and 100 linear ft. of archives (personal papers and correspondence, unpublished records, pictorial materials, theses and dissertations, manuscripts, and oral histories). Newspapers and books on Silesia are in microform. The collection is cataloged; a reading room and copying facilities are available.

Comments: The purpose is to preserve the writings of Schwenkfeld, a German theologian, and the history and culture of his followers in the U.S. The collection contains materials on the Radical Reformation, Pennsylvania German culture, and genealogy.

THE SOCIETY FOR THE HISTORY Archives
OF THE GERMANS IN MARYLAND
 P.O. Box 22585
 Baltimore, MD 21203 301-321-8608; Fax 301-685-0450

Founded: 1886; Scope: Regional
Availability: Not open to the public
Publications: *The Report: Journal of German-American History*, 1887- , irreg.; also publishes books and essays.

Collection: Records and archival materials relating to the activities of German Americans in Baltimore and the state of Maryland.

Comments: The society supports research and publication related to preservation of the German American heritage and culture in Maryland as well as the history of German immigration and settlement in the new world.

SOPHIENBURG MUSEUM AND ARCHIVES Museum
 401 W. Coll St. Archives
 New Braunfels, TX 78130 512-629-1900 (Museum)
 200 N. Seguin St.
 New Braunfels, TX 78130 512-625-1572 (Archives)

Sponsoring organization: Sophienburg Memorial Association
Personnel: Clyde Blackman, Museum Dir.
Contact: Iris T. Schumann, Archivist
Founded: 1926; Scope: Local
Availability: Open to the public; Admission: Fee
Visitors: General public
Staff: 2 ft, 135 pt (3 salaried, 134 volunteers); Operating budget: $87,000
Publications: *Sophienburg Association News* (Verein's Nachrichten), 1981- , quarterly; *Archives Activities*, 1990- , monthly; also publishes cookbooks and other titles. A forthcoming publication lists the first wave of immigrants who founded New Braunfels as well as the three succeeding generations.

Collection: Ca. 1,500 books, 750 periodicals, 1,500 audiovisual materials, over 1,500 artifacts, works of art, and 1,180 linear ft. of archival materials (personal papers and correspondence, unpublished records, theses and dissertations, pictorial materials, manuscripts, oral histories). Newspapers, government records, and photograph negatives are in microform. The collection is partially cataloged; a reading room and copying facilities are available.

Comments: The purpose is to promote the preservation of the German cultural history of the community, the largest settlement of Germans in the state. Services include guided tours, lectures, loans and presentations to schools, radio programs, speakers,

films and AV productions, and community educational classes in genealogy and local history. The association gives invited programs at local colleges and universities.

TABOR COLLEGE Archives
CENTER FOR MENNONITE BRETHREN STUDIES
 Tabor College
 Hillsboro, KS 67063 316-947-3121; ext. 318/342

Personnel: Lois Hiebert, Research Asst.
Contact: Peggy Goertzen, Interim Dir.
Founded: 1974; Scope: Local, State, Regional, National
Availability: Open to the public; Admission: Free
Visitors: General public
Staff: 3 pt, salaried
Publications: *CMBS Newsletter*, semi-annual; also published *Conference in Pilgrimage* (1992).

Collection: Books, periodicals, and 1,000 linear ft. of archival materials (personal papers and correspondence, unpublished records, pictorial materials, manuscripts, oral histories). Church and census records, bulletins, and newspapers are in microform. The collection is partially cataloged; a reading room and copying facilities are available.

Comments: The objective is to collect, preserve, research, and publish materials relating to the Mennonite Brethren as well as local history. Activities include educational lectures, speakers or resource people, and participation in the Hillsboro Folk Festival, an annual celebration of Mennonite culture.

UNIVERSITY OF CINCINNATI Library
GERMAN-AMERICANA COLLECTION Archives
 Blegen Library M.L. 113, Archives and Rare Books Dept.
 P.O. Box 210113
 Cincinnati, OH 45221 513-556-1958; Fax 513-556-2113

Contact: Dr. Don Heinrich Tolzmann, Curator
Founded: 1974; Scope: National
Availability: Open to the public (M,W,F 8-12 and by appt.); Admission: Free
Visitors: General public, students, faculty, visiting researchers
Staff: 1 ft
Publications: Exhibit catalogs

Collection: 5,000 books, over 150 periodical titles, audiovisual materials, and 125 boxes of archival records (personal papers and correspondence, unpublished records, theses and dissertations, manuscripts). Newspapers and church records are in microform. The collection is cataloged; a published guide, reading room, and copying facilities are available.

Comments: This is one of the nation's largest collections of German Americana emphasizing history, literature, and culture. The library participates in ethnic festivals and in German American community events.

THE UNIVERSITY OF TEXAS AT AUSTIN Archives
WINEDALE HISTORICAL CENTER
 P.O. Box 11
 Round Top, TX 78954 409-278-3530; Fax 409-278-3531

Personnel: Dr. Don Carleton, Dir.
Contact: Gloria Jaster, Mgr.
Founded: 1967; Scope: Local, State
Availability: Open by special appt. only; Admission: Fee
Visitors: General public
Staff: 18 (8 ft, 10 pt; salaried); Operating budget: $250,000
Publications: *The Quid Nunc*, 1970- , quarterly

Collection: 1,500 books, over 5,000 artifacts, works of art, and 5 file drawers of archives (unpublished records and oral histories). The collection is cataloged; a reading room and copying facilities are available.

Comments: The Center preserves German history and culture of the area. It provides work experience for college credit, in-service programs, courses or workshops for teachers, courses for college credit, and it supports research at the graduate and undergraduate levels. Programs include guided tours, performing arts presentations, crafts classes, and an arts and crafts/souvenir shop.

WELD LIBRARY DISTRICT, LINCOLN PARK BRANCH Library
(Formerly Greeley Public Library)
 919 7th St.
 Greeley, CO 80631 303-350-9210; Fax 303-350-9215

Sponsoring organization: American Historical Society of Germans from Russia
Personnel: Luella Kinnison, Dir. of the District; Charlene Parker, Branch Mgr.
Contact: Margaret Langley, Reference Libn.
Scope: Regional
Availability: Open to the public; Admission: Free

Collection: 1,266 books related to Germans from Russia and their descendants. The collection is cataloged; a published guide, reading room, and copying facilities are available.

Comments: This collection is housed in a public library; its purpose is to preserve the written history of German Americans whose families immigrated from Russia.

WILLARD LIBRARY OF EVANSVILLE Library
REGIONAL AND FAMILY HISTORY CENTER
 21 First Ave.
 Evansville, IN 47710 812-425-4309; Fax 812-425-4303

Personnel: Greg Hager, Dir.
Contact: Lyn Martin, Spec. Coll. Libn.
Founded: 1976; Scope: Regional
Availability: Open to the public; Admission: Free

Visitors: General public
Staff: 6 pt, 14 volunteers; Operating budget: $515,606

Collection: Over 5,000 books, ca. 50 periodicals, and archival materials (government records, church records, court records, Evansville newspapers, manuscripts, photographs, and other unpublished materials). Some records are microfilmed. The collection is cataloged; a published guide and copying facilities are available.

Comments: The library documents the experience of the early German immigrants who settled in Indiana and surrounding areas. Services include guided tours.

ZOAR VILLAGE STATE MEMORIAL Museum
 Main St. (State Rt. 212), P.O. Box 404 Archive
 Zoar, OH 44697 (216) 874-3011

Sponsoring organization: The Ohio Historical Society
Contact: Kathleen M. Fernandez, Site Mgr.
Founded: 1930; Scope: Local, State
Availability: Open to the public; Admission: Fee
Visitors: General public, School groups
Staff: 50 (4 ft, 11 pt, 35 volunteers); Operating budget: $243,000
Publications: *Zoar: An Ohio Experiment in Communalism*; also publishes promotional brochures.

Collection: 500 books, 1,000 audiovisual materials, 5,000 artifacts, 50 works of art and German-American folk arts. Archives are housed at the Ohio Historical Society Library and consist of two collections (88 boxes in the Zoar Collection 110 and 3 boxes of the Nixon Papers Collection 680) and include personal papers and correspondence, unpublished records, pictorial materials, theses and dissertations, and manuscripts. The collection is cataloged; a reading room and copying facilities are available.

Comments: German Separatists settled the community of Zoar, "a sanctuary from evil," in their escape from religious persecution. Services include guided tours, speakers, and an arts and crafts souvenir shop. The organization sponsors work experience for academic credit in conjunction with colleges and universities.

GREEK AMERICAN RESOURCES

AMERICAN HELLENIC EDUCATIONAL Library
PROGRESSIVE ASSOCIATION (AHEPA) Archives
(Formerly Order of AHEPA)
 1909 Q St., NW, Suite 500
 Washington, DC 20009 202-232-6300; Fax 202-232-2140

Contact: George Savidis, Dir. of Public Affairs
Founded: 1923; Scope: National, International
Availability: Open by special appt.; Admission: Free
Visitors: General public

Staff: 12 ft; Operating budget: $1,000,000
Publications: *The AHEPAN*, 1923- , quarterly; also publishes formal annual report, membership newsletters and flyers, periodicals.

Collection: Books, periodicals, audiovisual materials, and archives (some materials in microform) covering Greek history and Americans of Greek descent. Library materials are primarily historical and biographical in nature.

Comments: This major fraternal organization promotes Greek-American relations through financial aid, educational projects, and exhibitions. Library materials are primarily historical and biographical in nature.

CENTER FOR NEO-HELLENIC STUDIES Archives
 1010 West 22nd St.
 Austin, TX 78705 512-477-5526

Personnel: C. A. Robinson, Secy.
Contact: E. G. Arnakis, Acting Dir.
Founded: 1965; Scope: International
Availability: Not open to the public
Publications: *Bulletin* (newsletter); various monographs.

Collection: Archives (personal papers and correspondence, unpublished records, and manuscripts). The collection is not cataloged.

Comments: The center is an educational, nonprofit organization founded for the advancement of knowledge concerning the history and culture of modern Greece. It publishes works related to American interest in Greek history and culture.

ST. PHOTIOS NATIONAL GREEK ORTHODOX SHRINE Museum
 41 St. George St., P.O. Box 1960 Library
 St. Augustine, FL 32084 904-829-8205 Archives

Sponsoring organization: Greek Orthodox Archdiocese of North and South America
Personnel: Bishop John Kallos, Pres.; Fr. Dimitrios Couchell, Exec. Dir.;
Contact: Andrew S. Thomakos, Assoc. Dir.
Founded: 1965; Scope: National
Availability: Open to the public; Admission: Free
Visitors: General public
Staff: 8 (4 ft, salaried; 4 volunteers); Operating budget: $374,000
Publications: *Friends*, 1985- , annual; newsletters; brochures; other historical publications.

Collection: Ca. 750 books, ca. 200 periodicals, audiovisual materials, artifacts, works of art, and archives (personal papers and correspondence, unpublished records, pictorial materials, and oral histories). The collection is not cataloged.

Comments: The mission is to preserve the historic Avero House and the story of the 500 Greek colonists brought to Florida by Dr. Andrew Turnbull in 1768. Fleeing to St. Augustine in 1771, the remnant of that colony was given the Avero House, which

was purchased by the Greek Orthodox Archdiocese in 1965. A video, exhibits, memorial chapel, and bookstore provide information about the New Smyrna Colony and Greeks in America. Guided tours, speakers, and films are provided.

TARPON SPRINGS CULTURAL CENTER Museum
 101 S. Pinellas Ave. Library
 Tarpon Springs, FL 34689 813-942-5605; Fax 813-937-8199

Sponsoring organization: Municipal government
Contact: Dr. Kathleen Monahan, Dir. & Public Relations
Founded: 1987; Scope: Local, State, Regional
Availability: T-Sat. 10-4; Admission: Free, donations accepted
Visitors: General public, Ethnic community
Staff: 25 (3 ft, 2 pt, paid; 20 volunteers)

Collection: Books, audiovisual materials, artifacts, and archival materials (photographs, newspaper clippings, etc.) on Greek American culture in Tarpon Springs.

Comments: The goal is to preserve the culture and heritage of the Greek American settlers in the Tarpon Springs area. Services include guided tours, lectures, loans to schools, exhibits, performing arts presentations (dance), audiovisual film presentations, and workshops. A souvenir/craft shop is maintained.

THE THEODORE J. GEORGE LIBRARY (AND BOOKSTORE) Library
 Annunciation Cathedral Archives
 24 W. Preston St.
 Baltimore, MD 21201 410-528-0155 (W Th, 10-3); 410-825-2420 (Other times)

Sponsoring organization: Annunciation (Greek Orthodox) Cathedral
Personnel: Alexandria C. Maistros, Asst. Libn.; Betty Jean Alevizatos, Archivist
Contact: Theodore J. George, Libn., 15 Cedar Ave., Towson, MD 21204
Founded: 1954; Scope: Local
Availability: Open W, Th, 10-3; Sun., 10-1); Admission: Refundable deposit
Visitors: General public
Staff: 10 volunteers; Operating budget: $10,000-$15,000
Publications: *The Herald*, 1937- ; *Greek Orthodox Cathedral of the Annunciation*, monthly; annual report; newsletters; catalog of collections.

Collection: 11,000 books, over 1,000 periodicals, videos, and archives (personal papers and correspondence, unpublished records, pictorial materials, and oral histories). The collection is bilingual. A reading room and copying facilities are available.

Comments: The library was established to enrich the Greek School program for children and adults, but the scope was later broadened to house 26 categories of materials. Guided tours, educational lectures, loans to schools, school presentations, TV programs, speakers, dance, choir, films and AV productions, crafts classes, and an arts and crafts/souvenir shop are provided. The library participates in ethnic festivals.

H

HISPANIC AMERICAN RESOURCES
(*See also* Cuban American, Latin American, Mexican American, Puerto Rican American, and Spanish American Resources)

BACA HOUSE AND PIONEER MUSEUM IN TRINIDAD, CO Museum
 300 East Main St., P.O. Box 472
 Trinidad, CO 81082 719-846-7217

Sponsoring organization: Colorado Historical Society
Contact: Paula Manini, Site Admin.
Scope: Local, State, Regional
Availability: Open M-S 10-4, Sun. 1-4, Memorial Day-Labor Day (museum); restricted access to archives;
Admission: $2.50 adults; seniors and children 6-16 $1.25
Visitors: General public, School groups, Ethnic community
Staff: 24 (2 ft, 7 pt, salaried; 15 volunteers); Operating budget: $10,000
Publications: *Colorado History News,* monthly; annual reports.

Collection: Books, periodicals, audiovisual materials, works of art, artifacts (which comprise 85% of the collection), 3 book cases and 2 file cabinets of archival materials (personal papers and correspondence, unpublished records, pictorial materials, theses and dissertations, manuscripts, oral histories, and photos). The collection is cataloged; inventory lists, an unpublished guide, and copying facilities are available for researchers.

Comments: The purpose is to preserve Colorado history. Guided tours are available May to September and year-round by appointment. Sponsors Santa Fe Trail Festival in June and has seasonal and Christmas events. Services include educational lectures, loans and presentations to schools, TV programs, speakers, performing arts presentations, crafts classes, and a souvenir shop.

CASA DE UNIDAD CULTURAL ARTS AND MEDIA CENTER Archives
 1920 Scotten Art Gallery
 Detroit, MI 48209 313-843-7307

Personnel: David W. Conklin, Co-Dir.
Contact: Marta E. Lagos, Co-Dir.
Founded: 1981; Scope: Local, State, Regional, National, International
Availability: Open 9-5; Admission: Fee
Visitors: General public, School groups, Ethnic community

Staff: 4 ft, 4 pt, 2 volunteers; Operating budget: $100,000+
Publications: *El Barrio*, 1981- , quarterly; also publishes books and other bilingual publications.

Collection: Ca. 1,250 books, periodicals, audiovisual materials, 47 works of art. The collection is not cataloged; an unpublished guide is available.

Comments: The purpose is to preserve and create an awareness of the Hispanic cultural heritage of Southwest Detroit. Services include guided tours, educational lectures, school presentations, radio and TV programs, speakers, performing arts presentations, and workshops in art/graphics, writing and photography.

EL PUEBLO MUSEUM Museum
324 W. 1st St.
Pueblo, CO 81003 719-583-0453

Sponsoring organization: Colorado Historical Society
Personnel: Deborah Espinosa, Curator; Margie Montez, Asst. Curator
Founded: 1959; Scope: Regional
Availability: Open T-Sat. 10-3; Admission: $2 adults, $1 seniors and children 6-12
Visitors: General public
Staff: 1 pt, salaried; 4 pt volunteers, 3 interns
Publications: *Colorado Heritage*, quarterly; *Colorado History News*, monthly.

Collection: Artifacts related to the Spanish and Spanish/Mexican periods and furnishings related to the historic El Pueblo Trading Post.

Comments: Preserves the history and culture of the Spanish, Mexican, and other settlers in southern Colorado; provides educational programs for children and exhibits.

THE HISPANIC SOCIETY OF AMERICA Museum
Audubon Terrace, 613 West 155th St. Library
New York, NY 10032 212-926-2234

Personnel: Theodore S. Beardsley, Jr., Dir.; Priscilla E. Muller, Museum Curator;
Gerald J. MacDonald, Curator of Modern Books
Contact: Mitchell A. Codding, Asst. Dir.
Founded: 1904; Scope: National
Availability: Open T-Sat. 10-4:30, Sun. 1-4; Admission: Free, donations accepted
Visitors: General public, School groups
Publications: Monographs and catalogs of the collections

Collection: The museum contains 11,776 artifacts and works of art; the library contains over 200,000 manuscripts and more than 200,000 early and modern books on Spanish and Portuguese art, history, and literature. The iconography collection holds prints, maps and globes, as well as an extensive photographic image reference archival collection.

Comments: The objective is to offer a free public museum and research library representing the culture of Hispanic peoples.

LA CASA DE LA RAZA, INC. Art Gallery
 601 East Montecito St.
 Santa Barbara, CA 93103 805-965-8581; Fax 805-965-6451

Contact: Armando Vallejo, Exec. Dir.
Founded: 1971; Scope: Regional, International
Availability: Open 9-5; Admission: Free
Visitors: General public
Staff: 3 ft, 4 pt, salaried; 150 volunteers; Operating budget: $225,000
Publications: *Xalman Literary Magazine*, 1972- , annual

Collection: Works of art (paintings and murals)

Comments: This cultural arts and social services agency preserves the cultural heritage
of Hispanics through art exhibits, poetry readings, folklore, dance, and theater.
Activities include school presentations and participation in ethnic festivals.

LA RAZA/GALLERIA POSADA Museum
 704 O St.
 Sacramento, CA 95814 916-446-5133

Personnel: Tere Romo, Exec. Dir.; Lupe Gonzalez-Martin, Pres. of the Bd.
Founded: 1972; Scope: National
Availability: Open T-Sat. 10-6; Admission: Free, donations accepted
Visitors: General public, School groups, Ethnic community
Publications: *La Raza Galeria Posada*, quarterly; *Pincel y Pluma*, quarterly newsletter;
also publishes annual book catalog.

Collection: Poster art of national Chicano and other Latin artists.

Comments: The Hispanic cultural heritage is preserved through folk art and a variety
of traditional and contemporary works of art. The museum also sponsors an annual art
sale, workshops, storytelling sessions for children, guided tours, and exhibits on a
rotating basis.

LOS COLORES Museum
 P. O. Box 2820, 4499 Corrales Rd.
 Corrales, NM 87048 505-898-5077; Fax 505-898-5118

Personnel: Andrew Nagen, Founder; Nancy Hollander, Bd. Pres.; Gay Betzer, Asst.
Contact: Dee Turner, Admin.
Founded: 1990; Scope: Regional
Availability: Open daily 1-4 pm; Admission: Free
Visitors: General public, School groups, Ethnic community
Staff: 2 pt, salaried; plus volunteers
Publications: *El Zarape*, 1990- , quarterly; also publishes promotional brochures and
exhibit catalogs.

Collection: Woven Mexican serapes representing 200 years of Mexican weaving and
folk art.

Comments: Weaving traditions and folk art of Mexico and New Mexico preserve the Hispanic heritage and history. Services include guided tours, educational lectures, programs for students in grades K-12, and research opportunities for graduate students.

MISSION SAN JUAN BAUTISTA MUSEUM Museum
 2nd & Mariposa Sts.
 San Juan Bautista, CA 95045

Contact: Rev. Max Santamaria, Pastor
Founded: 1797; Scope: Local, State
Availability: Open daily 9:30-5, Mar.-Oct.; daily 9:30-4:30, Nov.-Feb.
Admission: $.50 adults, $.25 students and seniors; groups $15
Visitors: General public, School groups, Ethnic community
Publications: Books and pamphlets about the restoration of the mission.

Collection: Mexican and Spanish colonial artifacts, furnishings, and other religious relics that are in one of the original Franciscan missions in California.

Comments: The purpose is to preserve Hispanic religious culture through educational children's programs and tours. The mission is adjacent to the historic San Juan Bautista State Historical Park with traditional Hispanic buildings.

MISSION SAN JUAN CAPISTRANO MUSEUM Museum
 Ortega Hwy. & Camino Capistrano, P.O. Box 697
 San Juan Capistrano, CA 92693 714-248-2043; Fax 714-240-8091

Sponsoring organization: Diocese of Orange County California
Contact: Nicholas M. Magalousis, Dir.
Founded: 1980; Scope: Local, State, National
Availability: Open daily 8:30-5; Admission: $3 adults, $.50 ages 3-12
Visitors: General public, School groups, Ethnic community
Publications: Museum newsletter

Collection: Artifacts of the Spanish rancho era (ca. 1800), works of art (historic murals)

Comments: This mission for the local Hispanic and American Indian populations is maintained to preserve the Spanish culture and heritage. It offers guided tours, lectures, audiovisual presentations, and formal programs for children and adults.

PINAL COUNTY HISTORICAL SOCIETY AND MUSEUM Museum
 715 S. Main St., P.O. Box 851 Library
 Florence, AZ 85232 602-868-4382

Personnel: Boyd Johnson, Pres.; Bonnie Bean, V. Pres.; Alma Yost, Conservator and Recording Secy.; Isabelle Ellis, Treas.
Founded: 1959; Scope: Local, Regional
Availability: W-Sun. 12-4; Admission: Free
Visitors: General public, School groups
Publications: Tour guides

Collection: 150 books, artifacts, realia, archival materials (clippings)

Comments: The purpose is to preserve local history emphasizing the contributions of Hispanic (Spanish and Mexican) settlers. Activities include guided tours and lectures.

THE SANTA BARBARA HISTORICAL SOCIETY Museum
 136 E. De la Guerra St., P.O. Box 578 Library
 Santa Barbara, CA 93101 805-966-1601

Personnel: William F. Luton, Jr., CEO; Charles L. Turner, Exec. Dir.; David Gladhill, Pres.
Contact: Michael Redmon, Libn.
Founded: 1932; Scope: Regional
Availability: T-F 10-5, Sat.-Sun. 12-5; Admission: Free
Visitors: General public
Staff: 8 ft, 1 intern
Publications: *Noticias*, quarterly

Collection: 6,000 books of California history, periodicals (local newspapers), AV materials, buildings and furnishings, Spanish and Mexican artifacts, archives (manuscripts, photographs, genealogical records). A reading room is available.

Comments: Preserves California history, culture, and genealogy including that of the Hispanic settlers. Provides guided tours, lectures, educational programs, and exhibits.

SANTA BARBARA MISSION ARCHIVE-LIBRARY Library
 Old Mission, 2201 Laguna St. Archives
 Santa Barbara, CA 93105-3697 805-682-4713

Contact: Fr. Virgilio Biasiol, O.F.M., Dir.
Founded: 1786; Scope: Regional
Availability: Open T-Sat. 9-12, 1-4, by appt. only; Admission: Free
Visitors: Access limited to scholastic, historical, and research studies.
Publications: Promotional brochures

Collection: Ca. 4,000 original books of the California missionaries (encyclopedias, dictionaries, histories, biographies, literature, agriculture, music, mathematics, Scriptures, ethics, civil and canon law, hagiography and religion), and ca. 5,000 books on Spain and Hispanic America; periodicals, liturgical calendars, newspapers (books and bound periodicals total 14,000). Also includes 12,000 photographs of the late mission period in California, Spain, and Mexico; 1,000 brochures and pamphlets; 75 historical paintings and sketches; 13 Borein mission etchings. The archives contain the De la Guerra collection, second largest after the Vallejo Collection, of materials related to California's Hispanic past and covering the period from 1798-1885. Also houses copies from the Archdiocesan Archives in San Francisco (over 2,300 documents), many genealogical documents, California mission music fragments (choir books, etc.), manuscript holdings, personal papers and correspondence, and geologic maps.

Comments: The archive is a repository for research materials in the field of Hispanic California mission studies.

SANTUARIO DE NUESTRA SENORA DE GUADALUPE Museum
 100 Guadalupe St.
 Santa Fe, NM 505-988-2027

Personnel: Emilio I. Ortiz, Dir., Raymond Herrera, CEO
Founded: 1975; Scope: Local, State, Regional
Availability: Open M-Sat. 9-4 (May-Oct.), M-F 9-4 (Nov.-Apr.);
Admission: Free/donations Visitors: General public, Ethnic community
Staff: 1 ft, paid; 9 volunteers
Publications: *Noticias*, quarterly (newsletter)

Collection: Spanish and Hispanic art (Spanish colonial mural, New Mexican Santero art) housed in historic church built by the Franciscans ca. 1780.

Comments: Preserves Hispanic life and culture, particularly through the work of Hispanic artists. Provides guided tours, lectures, music, and dramatic performances.

TUBAC PRESIDIO STATE HISTORIC PARK Museum
 One Presidio Drive, P.O. Box 1296
 Tubac, AZ 85646 602-398-2252; Fax 602-398-2252

Sponsoring organization: Arizona State Parks Board
Contact: Robert Barnacastle, Park Mgr.
Founded: 1959; Scope: Local, State
Availability: Open daily 8-5; Admission: $2 adults, $1 children 11-19
Visitors: General public, School groups
Staff: 4 ft, salaried; 20 part-time volunteers

Collection: Artifacts, realia, costumes, furnishings

Comments: The park museum and visitor center are to preserve Spanish and Mexican history, art, and culture of the area through exhibits and demonstrations, guided tours, lectures, and audiovisual presentations.

YOLO COUNTY HISTORICAL MUSEUM Museum
 512 Gibson Rd. Library
 Woodland, CA 95695 916-666-1045

Contact: Monika Stengert, Dir. and Curator
Founded: 1979; Scope: Local
Visitors: General public
Admission: $2 adults, Free to members and children
Staff: 1 pt, salaried; 45 pt volunteers
Publications: Catalogs of exhibits

Collection: Artifacts, furnishings, and buildings

Comments: This local history museum has major exhibits on the history, culture, and contributions of the residents of Yolo County with emphasis on the Spanish and Mexican settlers and residents. Activities include guided tours, lectures, and exhibits.

HUNGARIAN AMERICAN RESOURCES

AMERICAN HUNGARIAN EDUCATORS' ASSOCIATION Library
 P.O. Box 4103
 Silver Spring, MD 20914 301-236-4044

Contact: E. M. Basa, 707 Snider La, Silver Spring, MD 20905
Founded: 1974; Scope: International
Availability: Open by special appt.; Admission: Free
Visitors: General public

Collection: Books and audiovisual materials

Comments: The purpose is to collect material on Hungary and Hungarian studies
programs, including Hungarians in the U.S. and to provide information upon request.

AMERICAN HUNGARIAN FOUNDATION Museum
(Formerly American Hungarian Studies Foundation) Library
 300 Somerset St., P. O. Box 1084 Archives
 New Brunswick, NJ 08903

Contact: August J. Molnar, Pres.
Founded: 1954; Scope: National
Availability: Open T-Sun. 11-4; Admission: Free, donations accepted
Visitors: General public, Ethnic community
Publications: *Hungarian Heritage*, 3/yr; *Hungarian Studies Newsletter*, 3/yr; also
publishes *Hungarian Reference Shelf Series* (v. 1-5).

Collection: 37,000 books, 500 paintings, audiovisual materials, artifacts, and archival
records (manuscripts, personal papers, pictorial materials).

Comments: The purpose is to further knowledge and appreciation of Hungarian
culture, history, and experience in the U.S. The foundation sponsors research projects
on Hungarian immigration and provides educational programs for college credit.
Services include several exhibits per year and other educational programs.

AMERICAN HUNGARIAN LIBRARY AND HISTORICAL SOCIETY Library
 213 E. 82nd St.
 New York, NY 10021 212-744-5298

Contact: Otto Hamos, Pres.
Founded: 1955; Scope: National
Availability: Open by appt.; Admission: Free
Visitors: General public

Collection: 6,000 books of Hungariana (lending library); the collection is cataloged.

Comments: The society promotes research and preserves the records of Hungarians in
America, with special focus on the contributions of Hungarian Americans.

AMERICAN HUNGARIAN MUSEUM, PASSAIC Museum
(Formerly American Hungarian Folk Museum) Library
 P. O. Box 262 Archives
 Bogota, NJ 07603 201-273-0013; Fax 201-836-1590

Sponsoring organization: American Hungarian Educators' Association
Personnel: Kalman Magyar, Dir.
Contact: Emese Kerkay, Curator
Founded: 1981; Scope: Regional, International
Availability: Open to the public; Admission: Donation
Visitors: General public, School groups, Ethnic community
Staff: 5 pt, 10 volunteers; Operating budget: $50,000
Publications: Membership newsletters and flyers

Collection: Books, periodicals, artifacts and realia, paintings and works of art, and 20
ft. of archives (personal papers and correspondence, unpublished records, printed and
pictorial materials, theses and dissertations, manuscripts, and oral histories). The
collection is cataloged; a reading room and copying facilities are available.

Comments: The purpose is to collect and preserve information about Hungarian culture
in America. The museum conducts guided tours and provides educational lectures,
speakers, dance and instrumental performances, exhibits, crafts classes, and a souvenir
shop. It also supports research and participates in ethnic festivals.

AMERICAN HUNGARIAN REVIEW Library
 5410 Kerth Rd.
 St. Louis, MO 63128 314-487-7566

Contact: Elizabeth Konnyu
Founded: 1967; Scope: National, International
Availability: Not open to the public; Admission: Free
Visitors: Ethnic community
Staff: 1 pt
Publications: *American Hungarian Review*, 1960- , annual; also publishes books.

Collection: 5,000 books, 200 periodicals, 50 artifacts, 50 works of art, furnishings,
and archives (personal papers and correspondence, theses and dissertations,
manuscripts, and oral histories). The collection is cataloged; copying facilities are
available.

Comments: The purpose is to present information about Hungarian history and culture
and to conduct research. Programs include educational lectures, loans to schools,
school presentations, radio and TV programs, speakers, exhibits, performing arts
presentations (dance, drama, choir, instrumental), and films.

CLEVELAND HUNGARIAN HERITAGE SOCIETY MUSEUM Museum
 5686 Ridgebury Blvd., P.O. Box 24134 Library
 Cleveland, OH 44124 216-442-3466 Archives
 Art Gallery

Personnel: Dr. Magdalene Meszaros, Secy.

Contact: Otto Friedrich, Exec. Dir.
Founded: 1985 Scope: Local
Availability: Open to the public; Admission: Free
Visitors: General public
Staff: 5 volunteers; Operating budget: $10,000
Publications: *Review: The Second One Hundred Years*, 1986- , quarterly

Collection: Books, periodicals, audiovisual materials, artifacts, works of art, and
archival materials (personal papers and correspondence, unpublished records,
manuscripts, and oral histories). The collection is cataloged.

Comments: The museum sponsors one or two exhibitions each year to interpret the
Hungarian heritage to Hungarian Americans and others in the local community.

HUNGARIAN/AMERICAN FRIENDSHIP SOCIETY Library
 2811 Elvyra Way, #236
 Sacramento, CA 95821 916-489-9599; Fax: 916-489-9599

Contact: Douglas P. Holmes, Dir.
Founded: 1982; Scope: International
Availability: Open by special appt.; Admission: Free
Visitors: Scholars and researchers
Publications: *Old Hungary*, 1993- , quarterly; also produces travel videos showing
ancestral villages in Hungary and Slovakia.

Collection: Books, periodicals, audiovisual materials, and 50 linear ft. of archives.
The collection is not cataloged; church records of Hungary and Slovakia, books, maps,
census records, and ship passenger lists are on microfilm.

Comments: This is primarily a genealogy group with interests in all areas within the
old Hungarian empire; it has large collections of Hungarian references. Services also
include speakers or resource people.

HUNGARIAN COMMUNION OF FRIENDS Library
 P. O. Box 112, 423 N. Johnson St. Archives
 Ada, OH 45810 419-634-2056

Personnel: Dr. Balazs Somogyi, Pres.; Dr. Louis Elteto, Exec. Secy.
Contact: Andrew Ludanyi
Founded: 1967; Scope: International
Availability: Open by special appt. only; Admission: Free
Visitors: Ethnic community
Staff: 7 pt, 1 salaried, 3 volunteers; Operating budget: $40,000
Publications: *Here-There* (Itt-Ott), 1967- , quarterly

Collection: Ca. 4,000 books, 110 periodical titles, audiovisual materials, artifacts,
works of art, 20 boxes and two file drawers of archival materials (personal papers and
correspondence, unpublished records, printed materials, pictorial materials, oral
histories). The collection is partially cataloged; a reading room is available for
researchers.

Comments: The organization attempts to promote the history and culture of Hungarians and Hungarian Americans through annual and special conferences, workshops, lecture tours, instructional programs, and assistance to students in Hungarian studies programs. It provides educational lectures, school presentations, radio and TV programs, speakers or resource people, and films and AV productions.

HUNGARIAN CULTURAL AND EDUCATIONAL HOUSE, INC. <u>Library</u>
 561 W. Diversey Pkwy., Ste. 219
 Chicago, IL 60614 312-477-1485; Fax 312-477-2698

Sponsoring organization: Hungarian House
Contact: Ferenc J. Mozsi, Vice Pres. and Dir.
Founded: 1979; Scope: Local
Availability: Open M-F 9-5; Admission: Free
Visitors: General public, Ethnic community
Staff: 3 pt volunteers; Operating budget: $15,000
Publications: *Szivarvany* (Rainbow), 1980- , 3/yr.

Collection: 1,000 books, 15 periodical titles, 200 audiovisual materials

Comments: Preserves Hungarian history and culture; provides educational lectures.

HUNGARIAN CULTURAL FOUNDATION <u>Library</u>
 820 Church St. <u>Archives</u>
 Decatur, GA 30030 404-377-2099

Contact: Joseph M. Ertavy, Pres., P.O. Box 364 Stone Mountain, GA 30086
Founded: 1966; Scope: Local, National, International
Availability: Open by special appt. only; Admission: Free
Visitors: General public
Staff: 5 (1 pt, 4 volunteers); Operating budget: $5,000
Publications: Books

Collection: 6,000 books, ca. 75 periodicals, audiovisual materials, artifacts, works of art, and 24 file drawers of archives (personal papers and correspondence, unpublished records, theses and dissertations, manuscripts, and other printed materials). The collection is not cataloged; copying facilities are available.

Comments: Publishes materials about Hungarian culture and the achievements of Hungarians. Services include educational lectures, concerts, exhibits, TV programs, speakers, school presentations, and support of research.

HUNGARIAN FOLK-ART MUSEUM <u>Museum</u>
 546 Ruth St.
 Port Orange, FL 32127 904-767-4292

Contact: Dr. Michael J. Horvath
Founded: 1979; Scope: National
Availability: Open M-F 9-9, Sat. 9-12; Admission: Free, donations
Visitors: General public, School groups, Ethnic community

Publications: Monthly newsletter

Collection: 50 books on folk art, audiovisual materials (photographs, video recordings), art objects, artifacts (clothing, ceramics).

Comments: The museum attempts to preserve Hungarian culture through exhibits of traditional Hungarian folk art. Services include guided tours.

HUNGARIAN SCOUT ASSOCIATION ABROAD Museum
 P. O. Box 68 Library
 Garfield, NJ 07026 Archives

Contact: Gabor Bodnar, Secy. Genl.
Founded: 1947; Scope: International
Availability: Available, restricted access; Admission: Free
Visitors: Ethnic community
Publications: *Hungarian Scout Magazine*, semiannual; *Scout Leaders' Magazine*, semiannual; also publishes scouting handbooks and textbooks.

Collection: 5,000 books, periodicals, audiovisual materials, artifacts, and archives (personal papers and correspondence, unpublished records, theses and dissertations, pictorial materials, and manuscripts). The collection is not cataloged; copying facilities are available.

Comments: The purpose is to promote the Hungarian heritage and culture through scouting activities. The association sponsors competitions, bestows awards, and participates in ethnic festivals.

KOSSUTH FOUNDATION Library
 c/o Butler University
 Indianapolis, IN 46208 317-283-9532

Sponsoring organization: Butler University
Contact: Dr. Janos Horvath, Pres.
Founded: 1957; Scope: National
Availability: Open by appt.; Admission: Free
Visitors: General public, Ethnic community
Staff: 3

Collection: 3,000 vol. research library

Comments: Promotes U.S.-Hungarian relations, assists Hungarian students in the U.S., and supports research about Hungary, Hungarians, and Hungarian Americans.

MINNESOTA HUNGARIANS Library
 476 Summit Ave.
 St. Paul, MN 55102 612-293-0152

Personnel: Dr. Tibor Zoltai, Pres.; Martha Nemesi, Secy.
Contact: Steve Szabados, 11720 Thornhill Rd., Eden Prairie, MN 55344

Incorporated: 1978; Scope: State
Availability: Open by special appt.; Admission: Fee
Staff: 2 volunteers; Operating budget: $500
Publications: *Minnesota Hungarians Newsletter* , 1987- , annual.

Collection: Books, periodicals, audiovisual materials, and 30 linear ft. of archives
(printed and pictorial materials). The collection is cataloged; an unpublished guide is
available.

Comments: The objectives are to help preserve the Hungarian heritage and to facilitate
further cultural exchanges and programs with Hungary. The organization participates
in ethnic festivals.

THE VARDY COLLECTION HUNGARIAN CULTURAL SOCIETY Library
OF WESTERN PENNSYLVANIA Archives
 5740 Aylesboro Ave.
 Pittsburgh, PA 15217 412-422-7176; Fax 412-434-5197

Sponsoring organization: Hungarian Cultural Society of Western Pennsylvania
Personnel: Dr. Steven Bela Vardy; Dr. Agnes Huszar Vardy
Founded: 1964; Scope: National, International
Availability: Open by special appt. only; Admission: Free
Visitors: Ethnic community, Visiting scholars
Staff: 2 ft; Operating budget: $6,000
Publications: Books; articles; brochures.

Collection: 12,000 books, 3,000 periodicals, emigre newspapers, 40 cubit ft. of
archives (unpublished records, manuscripts). A partial list of emigre newspapers is
available.

Comments: The library contains one of the most extensive collections that documents
Hungarian history and the Hungarian experience and culture in America. The society is
involved in various TV programs pertaining to Hungarian American history and has
organized monthly scholarly lectures by visiting scholars, writers, and/or artists.

I

ICELANDIC AMERICAN RESOURCES
(See also Scandinavian American Resources)

PIONEER HERITAGE CENTER AT ICELANDIC STATE PARK <u>Museum</u>
 HCR3, Box 64 A
 Cavalier, ND 58220 701-265-4561; Fax 701-265-4443

Sponsoring organization: Northeastern North Dakota Heritage Association
Personnel: Rosemarie Myrdal, Pres.; Lorraine Schroeder, V. Pres.
Contact: Dennis Clark, Interpretive Coordinator
Founded: 1986; Scope: Local, State, Regional
Availability: Open to the public; Admission: Fee
Visitors: General public, School groups
Staff: 15 (2 ft, 5 pt, 8 volunteers)
Publications: *Home Quarter,* 1988- , quarterly; also publishes booklets and
monographs (e.g., *The Children's Memoirs* (1990); *100 Years of State Government in
North Dakota* (1992); *Just a Few Facts N Things about Neche* (1992) which have
appeared in the *Cavalier Chronicle.*

Collection: Books, audiovisual materials, artifacts and realia, and archives (personal
papers and correspondence, pictorial materials, manuscripts, and oral histories). The
collection is cataloged; a reading room and copying facilities are available for
researchers.

Comments: One of North Dakota's key centennial projects, the center is a living
tribute to the people who settled North Dakota from 1870 to 1920. Icelandic culture
and the values and beliefs brought to this country are emphasized in the story of the life
and achievements of the first settlers. Included are historic buildings, living history
demonstrations, ethnic celebrations, traveling exhibits, speakers, and film presentations.
Guided tours, educational lectures, school presentations, speakers, and an arts and
crafts souvenir shop are available.

INDIAN AMERICAN RESOURCES
(See also Asian American Resources)

THE ASSOCIATION OF INDIAN MUSLIMS OF AMERICA <u>Library</u>
 P.O. Box 10654
 Silver Spring, MD 20904 410-730-5456

Contact: Kaleem Kawaja, Dir.
Founded: 1985; Scope: International
Availability: Open by special appt.; Admission: Free
Visitors: General public, Ethnic community
Staff: 9 volunteers; Operating budget: $3,000
Publications: *The ATM*, 1987- , quarterly

Collection: Books, periodicals, and archives (unpublished records and printed materials). The collection is cataloged; an unpublished guide is available.

Comments: The purpose is to provide a forum for bringing together expatriate Muslims from India who live in the U.S. The association provides information about Indian Muslims to the media, government, educational institutions, and the general public; it also helps to preserve the Indian Muslim culture.

CULTURAL ASSOCIATION OF BENGAL Library
 101 Iden Ave.
 Pelham Manor, NY 10803 914-738-5727

Personnel: Mihir Sen, Pres.; Pranab Das, Exec. Secy.
Contact: R. K. Daltz
Founded: 1971; Scope: International
Availability: Not open to the public; Admission: By membership
Visitors: Ethnic community
Staff: 10 volunteers; Operating budget: $30,000
Publications: *Sangbad Bichitra*, semi-monthly

Collection: 5,000 books (fiction, history, biography)

Comments: The objective is to promote Bengali language, history, and cultural heritage. Special programs for children, dance, and drama presentations are provided.

INDIA STUDY CIRCLE FOR PHILATELY Library
 P.O. Box 70775
 Washington, DC 20024 202-260-4346

Contact: John Warren, Regional Secy.
Founded: 1950; Scope: International
Publications: *India Post: North American Newsletter*, 1950 - , quarterly; also publishes books and manuals on philately, membership directories, and library acquisition lists.

Collection: Ca. 200 books and periodicals on Indian philately and archival materials (printed materials). The collection is cataloged; an unpublished guide is available.

Comments: The purpose is to preserve Indian history and culture through study of India's stamps and postal history.

VIVEKANANDA VEDANTA SOCIETY Museum
 5423 S. Hyde Park Blvd. Library
 Chicago, IL 60615 312-363-0027

Sponsoring organization: Ramakrishna Math and Mission
Personnel: Raj Thakral, Treas.; S. L. Bhatia, Vice Pres.; Octavia Harrison, Secy.
Contact: Swami Varadananda, Pres.
Founded: 1930; Scope: Local, International
Availability: Open to the public; Admission: Free
Visitors: General public
Staff: 15 (10 ft, 5 volunteers); Operating budget: $2,000
Publications: Newsletters

Collection: 7,500 books, 20 periodical titles. The collection is cataloged; an
unpublished guide and a reading room are available.

Comments: The society was founded to teach Indian religious doctrines and languages
through classes, lectures, and library materials. The museum preserves examples of
Indian culture; services include tours and speakers.

IRISH AMERICAN RESOURCES
(*See also* Scotch-Irish American Resources)

AMERICAN AID TO ULSTER Library
 P. O. Box 42
 Philadelphia, PA 19105 215-467-5142

Contact: Annette L. Ravinsky, Exec. Dir.
Founded: 1981; Scope: National
Publications: *AATU Newsletter*, quarterly; also publishes brochures and flyers.

Collection: 200 books

Comments: Promotes Irish history and culture and the establishment of religious
separation of Ulster from the Reublic of Ireland; raises money to help victims of
religious persecution in Ireland; and conducts seminars and educational lectures.

AMERICAN CONFERENCE FOR IRISH STUDIES (ACIS) Archives
(Formerly American Committee for Irish Studies)
 English Dept.
 Indiana University-Purdue University
 Fort Wayne, IN 46805 219-481-6765

Contact: James Donnelly, Exec. Dir.
Founded: 1959; Scope: National
Availability: Open to the public; Admission: Free
Visitors: General public
Publications: *ACIS Newsletter*, 3/yr.; also published books including *A Guide to Irish
Studies in the United States*.

Collection: Books, periodicals, and archival materials related to Irish studies
curriculum and research. Some materials are on microfilm.

Comments: Scholars interested in Irish history and culture (art, folk art, language, literature, sociology, politics and economics) are served by this collection. Exhibits are on display at the annual conference.

AMERICAN IRELAND EDUCATION FOUNDATION, INC. Library
 54 S. Liberty Dr.
 Stony Point, NY 10980 914-947-2726; Fax 914-947-2599

Personnel: Albert Doyle, Vice Pres.
Contact: John Finucane, Pres.
Founded: 1975; Scope: National
Availability: Open M-F 9-5, S 10-5
Visitors: General public
Staff: 6 pt
Publications: *American Irish Newsletter*, 1975- , monthly

Collection: 1,200 books, 100 periodicals, and 2 file cabinets of archival materials. The collection is cataloged; a reading room and copying facilities are available.

Comments: Promotes awareness of Irish culture and history, educates the public about conflict in Northern Ireland, and preserves the history of the Irish in America. The foundation participates in ethnic festivals and sponsors an arts and crafts souvenir shop.

AMERICAN IRISH BICENTENNIAL COMMITTEE Archives
 3917 Moss Dr.
 Annandale, VA 22003-1921 703-354-4721

Contact: Col. Joseph F. O'Connor
Founded: 1971; Scope: National
Availability: Open by special appt. only
Staff: 4; Operating budget: $200
Publications: *Stars and Harp*, semiannual

Collection: 4 boxes of archival records

Comments: The purpose is to promote contributions of Irish Americans to the formation of the United States through recreation of historic and other events, folk festivals, and academic exchange programs. Services include performing arts presentations and participation in ethnic festivals.

AMERICAN IRISH HISTORICAL SOCIETY Library
 991 Fifth Ave.
 New York, NY 10028 212-288-2263; Fax 212-628-7927

Personnel: Keven M. Cahill, Pres.-Genl.
Contact: Alec Ormsby, Dir.
Founded: 1897; Scope: National
Availability: Open M-F 10:30-5, restricted access; Admission: Free
Visitors: General public
Staff: 5 (1 ft, 4 pt; 2 salaried, 3 volunteer)

Publications: *The Recorder*, 1940- , semi-annual; newsletters

Collection: 30,000 books, 5,000 periodicals, ca. 100 artifacts, ca. 200 works of art, 127 linear ft. and 27 boxes of archives (personal papers and correspondence, unpublished records, theses and dissertations, manuscripts). A reading room and copying facilities are available.

Comments: The purpose is to make known the contributions of the Irish in America. The society sponsors weekly lectures, readings, recitals, plays, etc.

AN CLAIDHEAMH SOLUIS - THE IRISH ARTS CENTER Library
 553 W. 51st St.
 New York, NY 10019 212-757-3318

Contact: Nye Heron, Exec. Dir.
Founded: 1972; Scope: National
Availability: Open to the public
Visitors: General public
Publications: *An Gael: The Magazine of Irish America*, quarterly

Collection: Books and works of art

Comments: The purpose is to promote Irish culture through music, dance and dramatic performances, workshops in the performing arts, speakers, and off-Broadway theater.

CONNOLLY BOOKS Archives
 P.O. Box 24744
 Detroit, MI 48224 313-885-5618

Contact: Dan O'Rourke
Founded: 1992; Scope: Regional
Availability: Open by special appt. only; Admission: Free
Visitors: Ethnic community
Staff: 2 volunteers
Publications: Irish newspapers and magazines

Collection: Books, periodicals, and archives (personal papers and correspondence). The collection is not cataloged; a reading room is available.

Comments: The organization is a bookstore that focuses on Irish political history and resources for political action related to Ireland. It carries the *American Irish Newsletter* and other periodicals on the Irish and Irish Americans. It provides speakers and a referral service for information about the Irish and Ireland.

IRISH AMERICAN CULTURAL ASSOCIATION (IACA) Library
 10415 S. Western
 Chicago, IL 60643 312-233-9799

Contact: Thomas R. McCarthy, Pres.
Founded: 1974; Scope: National

Collection: Books and other materials on Irish-American topics

Comments: The purpose is to study Irish and Irish American culture and to promote understanding and appreciation of it through educational lectures, and financial assistance to Irish performers, artists, and writers.

IRISH AMERICAN CULTURAL INSTITUTE Library
 3 Elm St. Archives
 Morristown, New Jersey 07960 201-605-1991

Personnel: Edward Ginty, New Jersey State Dir.
Contact: John P. Walsh, Natl. Dir.
Founded: 1993 (library and archives); Scope: National, International
Availability: Open M-F, 10-4; Admission: Free
Visitors: General public, Ethnic community
Staff: 5 (2 ft, 3 volunteers); Operating budget: $10,000
Publications: *Eire*Ireland*, quarterly

Collection: Ca. 3,000 books, periodicals, audiovisual materials, and archives (pictorial materials, theses and dissertations, and manuscripts). The collection is cataloged; a reading room and copying facilities are available.

Comments: The purpose is to promote Irish literature and arts. Programs include educational lectures, speakers, drama presentations, films, and participation in the annual Irish Festival at Garden State Arts Center.

IRISH AMERICAN HERITAGE MUSEUM Museum
 19 Clinton Ave. Library
 Albany, NY 12207 518-432-6598; Fax 518-432-6794
 Rte. 145, East Durham, NY 12423 518-634-7497 (Summer exhibit museum)

Contact: Monique Desormeau, Dir.
Founded: 1986; Scope: National
Availability: Open to the public; Admission: Fee
Visitors: General public
Staff: 2 ft, volunteers; Operating budget: $150,000
Publications: *IAHM Newsletter*, 1990- , quarterly; also publishes an annual report.

Collection: 600 books, 87 artifacts, and archives (personal papers and correspondence and other printed materials). The collection is cataloged; a published guide, reading room, and copying facilities are available for researchers.

Comments: The museum is dedicated to collecting, preserving, interpreting, and disseminating information to enhance and extend Irish American history and culture through its collections, exhibitions, and programs. It provides educational lectures, performing arts presentations, and sponsors occasional internships for college students.

THE IRISH FAMILY NAMES SOCIETY Archives
 P. O. Box 2095
 La Mesa, CA 91943-2095 619-466-8739

Contact: W. P. Durning, Dir.
Founded: 1978; Scope: National
Availability: Not open to the public
Staff: 3 ft volunteers; Operating budget: $10,000
Publications: The Celtic Knot, 1978- , quarterly (newsletter); various books (e.g., *A Guide to Irish Roots* (1986).

Collection: Ca. 500 books; ca. 50 periodicals; archives contain records related to genealogical histories.

Comments: Traces from documents and oral traditions genealogies of Irish families. The society researches Gaelic-Irish prior to 1600, provides lectures and speakers.

IRISH GENEALOGICAL FOUNDATION Library
 Box 7575 Archives
 Kansas City, MO 64116 816-454-2410; Fax 816-454-2410

Sponsoring organization: Irish Family Journal
Personnel: Michael O'Laughlin, Dir.
Founded: 1978; Scope: International
Availability: Open to members by appt.; Admission: Free
Staff: 1 ft, 1 pt
Publications: *Olochlainns Journal of Irish Families*, 1978- , bimonthly; newsletters; also publishes books.

Collection: Over 1,000 books and periodicals and archival records (unpublished records, pictorial materials, manuscripts, and family histories). The collection is cataloged; an unpublished guide is available.

Comments: The purpose is to promote Irish American history and culture through preservation of genealogical resources. The organization provides lectures and radio programs. It participates in research on Irish family histories and in ethnic festivals.

IRISH GENEALOGICAL SOCIETY Library
(Formerly Irish Family History Society; Irish Ancestral Research Assn.) Archives
 21 Hanson Ave.
 Somerville, MA 02143 617-666-0877

Personnel: Joseph M. Glynn, Jr., Dir.
Founded: 1976; Scope: National
Publications: *Irish Genealogy*; also publishes books and manuals.

Collection: Books and archival materials (biographies of Irish family members).

Comments: The purpose is to encourage research on Irish genealogy and to preserve the Irish heritage in America. Services include educational lectures and seminars.

IRISH HERITAGE FOUNDATION (IHF) Library
 2123 Market St.
 San Francisco, CA 94114 415-621-2200

Contact: John Whooley, Pres.
Founded: 1965; Scope: National
Publications: *Irish Herald Newspaper*, monthly

Collection: 1,000 books

Comments: The objective is to preserve Irish history and to promote Irish heritage and
culture. Services and programs include instructional classes in the Irish language.

UNITED IRISH CULTURAL CENTER Library
2700 45th Ave. Archives
San Francisco, CA 94116 415-661-2700

Contact: Thomas J. Carey, Libn.
Founded: 1975; Scope: National
Availability: Open, restricted access; Admission: Free
Visitors: General public, School groups, Ethnic community
Staff: 8 (1 pt, 7 volunteers)
Publications: *Foras Cultuir Gaeil Aontuighthe/United Irish Cultural Center, Inc. of
San Francisco*, 1972- , monthly

Collection: Ca. 3,500 books, periodicals, audiovisual materials, artifacts, works of art,
pamphlets, and 6 boxes of archives (personal papers and correspondence, unpublished
records, photographs). The collection is cataloged; copying facilities are available.

Comments: The library collects textual and visual materials which document the
culture and history of Ireland and the Irish people. It promotes and preserves the
traditions of Ireland in literature, art, music, dance, drama, and athletics, and
participates in ethnic festivals.

ITALIAN AMERICAN RESOURCES

AMERICAN COMMITTEE ON ITALIAN MIGRATION Archives
(Comitato Americano per Lemigrazione Italiana)
 352 W. 44th St.
New York, NY 10036 212-247-7373

Sponsoring organization: National Catholic Resettlement Council
Contact: Rev. Walter Tomelotto
Founded: 1952; Scope: National
Availability: Open to the public; Admission: Free
Visitors: General public
Staff: 7 (3 ft, 2 pt, 2 volunteers)

Collection: Archival records of the organization

Comments: The purpose of the organization is to assist Italian American immigrants to
the United States in the resettlement process.

AMERICAN ITALIAN CONGRESS Library
 111 Columbia Heights
 Brooklyn, NY 11201 718-852-2929

Contact: Dr. John N. La Corte, Genl. Dir.
Founded: 1949; Scope: National
Availability: Open by special appt.
Visitors: General public, Ethnic community
Publications: *Brooklyn Review Magazine*, irreg.; *Italian-American Review*, annual.

Comments: The congress is a federation of Italian American organizations that coordinates the activities of affiliated organizations.

AMERICAN ITALIAN HISTORICAL ASSOCIATION Archives
 209 Flagg Place
 Staten Island, NY 10304 718-667-6628

Contact: Rudolph Juliani, Pres.
Founded: 1966; Scope: National
Availability: Open by appt.; Admission: Free
Visitors: General public, Ethnic community
Publications: Annual proceedings and a quarterly newsletter for the membership which contains notes about conferences, research in progress, and book reviews.

Collection: Archival materials (published and unpublished materials, papers and correspondence, organizational records, and manuscripts) related to Italian American history and culture.

Comments: Preserves the Italian American culture and experience in the new world. Services include seminars, conferences, and awards for scholarly papers by and about Italian Americans.

THE GARIBALDI-MEUCCI MUSEUM Museum
OF THE ORDER OF THE SONS OF ITALY IN AMERICA Library
 420 Tompkins Ave. Archives
 Staten Island, NY 10305-1704 718-442-1608

Sponsoring organization: Sons of Italy Foundation
Contact: Carol Quinby, Curator/Dir.
Founded: 1956; Scope: International
Availability: Open T-Sun., 1-5
Staff: 12 (1 ft, 7 pt, salaried; 4 volunteers; Operating budget: $125,000
Publications: Annual report; membership newsletters; and promotional brochures.

Collection: Over 1,200 books, audiovisual materials, 100 artifacts, 30 works of art, and 68 linear ft. of archives (personal papers and correspondence, unpublished records, pictorial materials). The collection is not cataloged; copying facilities are available.

Comments: This historic house is preserved as a memorial to the lives of Antonio Meucci and Giuseppe Garibaldi, Italian immigrants who lived in it. The house was

turned over to the members of the first Italian American community on Staten Island in honor of Garibaldi and his contributions as an inventor and to preserve and exhibit historical materials relating to the role of Italian-Americans in the United States. Services include guided tours, educational lectures, school presentations, speakers, performing arts (drama, choir, instrumental), films and AV productions, crafts classes, and Italian language classes. The museum participates in ethnic festivals.

ISTITUTO ITALIANO DI CULTURA Library
 686 Park Ave.
 New York, NY 10021 212-879-4242; Fax 212-861-4018

Contact: Furio Colombo, Dir.
Founded: 1950; Scope: National
Availability: Open by appt.; Admission: Free
Visitors: General public, Ethnic community
Staff: 18
Publications: Books and catalogs.

Collection: 32,600 books, 100 periodicals; the collection is cataloged.

Comments: Provides information on Italy and Italian American culture and attempts to foster Italian and American relations.

ITALIAN AMERICAN CULTURAL SOCIETY LIBRARY/ARCHIVES Library
 28111 Imperial Drive Archives
 Warren, MI 48093 313-751-2855

Contact: Phillip Adamo, 27721 Ursuline , St. Clair Shores, MI 48080
Founded: 1975; Scope: Local, State, Regional
Availability: Open, restricted access; Admission: Donation
Visitors: General public, School groups, Ethnic community
Staff: 6 volunteers
Publications: Membership newsletters and flyers

Collection: 2,000 books, 2,500 periodicals, audiovisual materials, artifacts, works of arts, and a 10' x 10' room of archives (pictorial materials, manuscripts, and oral histories). Newspapers and other items are in microform. The collection is partially cataloged; an unpublished guide, reading room, and copying facilities are available.

Comments: The purpose is to preserve the Italian cultural heritage through the collections and photographic exhibits. Special services include Italian classes for high school and college credit and speakers. The society participates in ethnic festivals.

ITALIAN-AMERICAN MUSEUM (MUSEO ITALO AMERICANO) Museum
 Bldg. C Fort Mason Center Library
 San Francisco, CA 94123 415-673-2200

Personnel: Robert A. Whyte, Curator
Contact: Calandra Bush, Administrator
Founded: 1978; Scope: International

Availability: Open W-Sun. 12-5; Admission: Fee (Free to school groups)
Visitors: General public, School groups
Staff: 2 ft, 6 pt, salaried; Operating budget: $240,000

Collection: Books, periodicals, audiovisual materials, 200 paintings by Italian
American artists. Collection is cataloged; reading and copying facilities are available.

Comments: Promotes the Italian American heritage by displaying works of Italian-
American artists and fostering educational programs about Italian art and culture.

ITALIAN AMERICAN RESEARCH CENTER Library
 400 St. Bernardine St.
 Reading, PA 19607 610-777-3303 or 796-8223; Fax 610-796-8347

Sponsoring organization: Alvernia College
Personnel: Carmela Capellupo-Beaver, Pres.; Pietro DiStravalo, V. Pres.
Contact: Michael Weber
Founded: 1992; Scope: Local, State, Regional, National, International
Availability: Open M-Th 8 a.m.-10 p.m., F 8-4:30, Sat 1-5, Sun. 6-10; Admission:
Free
Visitors: General public
Publications: *The Italian American Perspective*, 1994- , quarterly

Collection: Ca. 750 books, 50 periodicals, 50 audiovisual materials, and archives
(personal papers and correspondence, manuscripts). The collection is cataloged; a
reading room and copying facilities are available.

Comments: The center provides information and research assistance related to Italian
American culture. Services include guided tours, lectures, and TV programs.

ITALIAN HISTORICAL SOCIETY OF AMERICA Library
(Formerly American Italian Historical Society)
 111 Columbia Heights
 Brooklyn Heights
 Brooklyn, NY 11201 718-852-2929; Fax 718-855-3925

Contact: Dr. John J. LaCorte, Dir.
Founded: 1949; Scope: National
Availability: Open by appt.; Admission: Free
Visitors: General public, Ethnic community
Publications: *Italian-American Newsletter*, irreg.; *Italian-American Review*, quarterly;
also publishes the *Italian American Almanac*.

Comments: Preserves and promote Italian American culture and heritage, provides a
music scholarship, and maintains an Italian Hall of Fame. An annual conference is held
each June; the society participates in ethnic festivals.

ITALIAN STUDY GROUP OF TROY Archives
 4821 Forsyth
 Troy, MI 48098 313-689-7129

Personnel: Rose Vettraino, Historian; Luciana Pietrantoni, Pres.; Gloria Tonelli, V. Pres.
Contact: Luella Baron, Exec. Dir.
Founded: 1972; Scope: Local
Availability: Open, restricted access; Admission: Free
Visitors: General public, Ethnic community
Operating budget: $15,000
Publications: *Curiosita*, 1976- , 3/yr

Collection: Books, periodicals, and archival materials (personal papers and correspondence, pictorial materials, and oral histories). The collection is not cataloged.

Comments: The purpose is to promote Italian culture throughout the Detroit Metropolitan community by offering Italian language classes, folk dance, and chorus. The organization sponsors lectures, exhibits, various fund-raising activities, and assists other organizations financially in furthering mutual goals. Additional services include school presentations, speakers, consultant services, group travel, an oral history program, and in ethnic festivals with displays of Italian arts and arts.

POINT/POINTERS (PURSUING OUR ITALIAN Archives
NAMES TOGETHER)
 P. O. Box 2977
 Palos Verdes Peninsula, CA 90274

Personnel: Thomas Edward Militello, Founder and Editor
Founded: 1987; Scope: International
Availability: Not open to the public
Staff: 1 ft
Publications: *POINTers*, 1987- , quarterly; annual directory

Collection: A database of over 12,000 Italian surnames submitted from over 1,200 individuals from the U.S., Italy, and many other countries.

Comments: POINT is a network composed of the surname database and an annual directory of names and addresses contained in the database. A quarterly magazine for Italian family historians gives tips on how to conduct genealogical research.

J

JAPANESE AMERICAN RESOURCES
(*See also* Asian American Resources)

EASTERN CALIFORNIA MUSEUM Museum
 155 Grant St., Box 206
 Independence, CA 93526 619-878-0364; Fax 619-872-2712

Contact: Bill Michael, Museum Dir.
Founded: 1928; Scope: Regional
Availability: M, W-Sun. 10-4; Admission: Free
Visitors: General public
Staff: 2 ft, 4 pt, salaried; 10 pt volunteers
Publications: Newsletter (quarterly); published *Mountains to Desert*.

Collection: Artifacts, realia

Comments: Although this local and natural history museum collects cultural artifacts
related to pioneers in the area in general, it houses a unique exhibit related to the
Japanese Americans who were relocated to Manzanar during the time of World War II.
Activities include lectures.

JAPAN SOCIETY, INC. Museum
 333 East 47th St. Library
 New York, NY 10017 212-832-1155; 212-755-6752 Art Gallery

Personnel: Dr. Gunhild Avitabile, Gallery Dir.; William Gleysteen, Jr., Pres.
Contact: Linda Riddle, Dir. of Public Relations
Founded: 1907; Scope: International
Availability: Restricted access; Admission: Free (library); $2.50 donation (art
gallery)
Visitors: General public, School groups
Staff: 78 ft, 5 pt, salaried; 20 volunteers; Operating budget: $24,773,600
Publications: Exhibition catalogs; memberships newsletters; and flyers.

Collection: 10,000 books, periodicals, paintings, and other works of art.

Comments: The purpose is to collect and exhibit Japanese art (painting, sculpture,
architecture and design, ceramics, woodblock printing, lacquer ware, esoteric and folk
arts) in order to promote understanding and appreciation of Japanese culture.

JAPANESE AMERICAN CULTURAL AND COMMUNITY CENTER Library
 244 South San Pedro St., Rm. 505 Art Gallery
 Los Angeles, CA 90012-3832 213-628-2715; Fax 213-617-8576

Contact: Gerald D. Yoshitomi, Exec. Dir.
Incorporated: 1971; Scope: International
Availability: Open 9-6 (library), T-F 12-5, Sat.-Sun. 11-4 (gallery)
Visitors: General public, School groups, Ethnic community
Staff: 25 (13 ft, 11 pt, salaried; 1 volunteer); Operating budget: $2,500,000

Collection: Over 5,000 books on Japanese American history, literature, and the
performing arts, 50 audiovisual materials on the performing arts. The books in English
are cataloged; an unpublished guide, reading room, and copying facilities are available.

Comments: The purpose is to encourage understanding of Japanese culture by
presenting performing and visual arts from Japan, and by showcasing Japanese
American and Asian American artists in the local community. Services include
educational lectures, performing arts (dance, drama, instrumental), films and other AV
presentations, crafts classes, and a souvenir shop. The center sponsors Nisei Week
Japanese festival held annually in Little Tokyo.

THE JAPANESE AMERICAN NATIONAL LIBRARY Library
(Formerly The Japanese American Library) Archives
 1619 Sutter St.
 San Francisco, CA 94109 415-567-5006

Contact: Karl K. Matsushita, Dir., P. O. Box 590598, San Francisco, CA 94159
Founded: 1969; Scope: National
Availability: Open to the public; Admission: Free
Visitors: General public, Ethnic community
Staff: 11 (1 ft, 3 pt, 7 volunteers); Operating budget: $50,000
Publications: *Bulletin*, 1986- , quarterly; also publishes membership newsletters and
flyers.

Collection: 15,000 books, 1,750 periodicals, 64 boxes of archives (personal papers and
correspondence, unpublished records, theses and dissertations, manuscripts). The
collection is partially cataloged; a reading room and copying facilities are available for
researchers.

Comments: The library was organized to establish a resource center to serve and
promote interest in the Japanese American heritage by collecting and organizing news
accounts, research articles and manuscripts, as well as to meet the informational needs
of the Japanese community and the general public. Services include educational
lectures and work experience opportunities for college credit.

JAPANESE AMERICAN NATIONAL MUSEUM Museum
 369 East First St. Library
 Los Angeles, CA 90012 213-625-0414; Fax 213-625-1770 Archives

Personnel: Irene Hirano, Dir.; Dr. James Hirabayashi, Chief Curator; Dr. Akemi

Kikumura, Exhibit Curator; Karen Ishizuka, Photo and Moving Image Curator
Contact: Chris Komai
Founded: 1985; Scope: National
Availability: Open T-Th, Sat.-Sun. 10-5, F 11-8 and by appt.; Admission: Fee
Visitors: General public, School groups, Ethnic community
Staff: 24 ft, 12 pt, 150 volunteers
Publications: *Bulletin*, 1985- , quarterly; *Museum Events*, quarterly calendar; also
publishes collection and exhibition catalogs.

Collection: Books, 10,000 photos and moving images, 15,000 artifacts, ca. 200 works
of art, and archival records (personal papers and correspondence, pictorial materials,
and oral histories). The collection is partially cataloged.

Comments: The mission is to document the Japanese American experience as an
integral part of U.S. history through educational programs, workshops, exhibitions, and
documentary films. The museum provides guided tours, educational lectures, loans and
presentations to schools, crafts classes, and an arts and crafts souvenir shop; it also
participates in ethnic festivals.

JAPANESE CULTURAL CENTER OF HAWAII Museum
 2454 S. Beretania St. Library
 Honolulu, HI 96826 808-945-7633; Fax 808-944-1123

Personnel: Walter M. Saito, Pres.
Contact: Ruth Y. Tamura, Gallery Dir.
Founded: 1987; Scope: National
Availability: Open, W-Sun. 9-5; Admission: Fee
Visitors: General public, Ethnic community
Staff: 9 ft; Operating budget: $60,000
Publications: *Legacy,* 1989- , 3/yr.; *Heirloom Patterns*, 1989- , 3/yr; also published
souvenir booklet, *Japanese Cultural Center of Hawaii* (1994).

Collection: Ca. 750 books, periodicals, audiovisual materials, over 1,500 artifacts, and
archives (personal papers and correspondence, unpublished records, pictorial materials,
theses and dissertations, manuscripts, and oral histories).

Comments: The center's purpose is to preserve and promote knowledge of Japanese
American culture and history. Services include guided tours, educational lectures,
loans to schools, school presentations, radio and TV programs, speakers, performing
arts (dance, choir, instrumental), crafts classes, and an arts and crafts souvenir shop.

THE MORIKAMI MUSEUM AND JAPANESE GARDENS Museum
 4000 Morikami Park Rd.
 Delray Beach, FL 33446 407-495-0233; Fax 407-499-2557

Sponsoring organization: Palm Beach Co., Morikami, Inc.
Personnel: Larry Rosensweig, Dir.
Contact: Tom Gregersen, Sr. Curator
Founded: 1976; Scope: Local, State, Regional, National, International
Availability: Open T-Sun. 10-5; Admission: $4.25 adults

Visitors: General public, School groups, Ethnic community
Staff: 12 ft, 3 pt, salaried; volunteers; Operating Budget: $1,100,000
Publications: *Calendar*, quarterly

Collection: Ca. 2,500 books, over 100 periodicals, 100 audiovisual materials, ca. 3,000 artifacts, 120 works of art, and 50 boxes of archival materials (personal papers and correspondence and pictorial materials). The collection includes the Edward N. Potter Memorial Bonsai collection and Japanese folk art. The collection is partially cataloged, but is non-circulating; a reading room and copying facilities are available.

Comments: Presents Japanese and Japanese American history and culture in a museum located on 160 acres bequeathed by a Japanese American pioneer of Yamato Colony, a Japanese-American agricultural community. Japanese festivals are celebrated; exhibits cover Japanese folk textiles, Japanese baseball memorabilia, quilts, paper, art, garden photography, tobacco, etc. Services include guided tours, lectures, loans to schools, speakers, dance, instrumental presentations, films. crafts classes, and a souvenir shop.

U.S.-JAPAN CULTURE CENTER Library
 2600 Virginia Ave. NW, Suite 711
 Washington, DC 20037 202-342-5800; Fax 202-342-5803

Contact: Mikio Kanda, Exec. Dir.
Founded: 1978; Scope: National
Availability: Open to the public; Admission: Free
Visitors: General public, Ethnic community
Staff: 5
Publications: *News*, bimonthly

Collection: 10,000 books, ca. 120 Japanese and Japanese-American periodical titles.

Comments: The purpose is to promote the Japanese heritage and traditions and to foster positive Japanese-U.S. relations. Provides language classes in English and Japanese, educational programs, and supporting materials for researchers.

JEWISH AMERICAN RESOURCES

AMERICAN JEWISH ARCHIVES Archives
 3101 Clifton Avenue
 Cincinnati, OH 45220 513-221-1875; Fax 513-221-7812

Sponsoring organization: Hebrew Union College, Jewish Institute of Religion
Personnel: Dr. Jacob Marcus, Dir.; Dr. Abraham J. Peck, Admin. Dir.
Contact: Kevin Proffitt, Archivist
Founded: 1947; Scope: National, International
Availability: Open to the public; Admission: Free
Visitors: General public, School groups, Ethnic community
Staff: 9 (7 ft, 2 pt)
Publications: *American Jewish Archives Journal*, 1948- , semiannual.

Collection: 8,000,000 pages of archival documentation (personal papers and correspondence, unpublished records, pictorial materials, theses and dissertations, manuscripts, and oral histories). Some records are in microform. The collection is cataloged; a descriptive guide, reading room, and copying facilities are available.

Comments: The purpose is to preserve American Jewish history; understand how Jews lived, worked, and established a cultural religious community in America; interacted with the new homeland; and contributed to their new world.

AMERICAN JEWISH COMMITTEE Library
BLAUSTEIN LIBRARY AND ARCHIVES Archives
 165 East 56th St.
 New York, NY 10022 212-751-4000; Fax 212-751-4017

Personnel: Michele J. Anish, Asst. Libn.
Contact: Cyma M. Horowitz, Library Dir. and Archivist;
Founded: 1939; Scope: National
Availability: Open to the public; Admission: Donation
Visitors: General public
Staff: 2 ft, 1 pt
Publications: *News and Views,* 1978- ; organizational brochures; the library has two periodicals: *Articles of Interest in Current Periodicals,* 8/yr and *Recent Additions to the Library,* quarterly.

Collection: 40,000 books, 600 periodical titles, 70 boxes of archives (unpublished records, pictorial materials). The collection is cataloged; a published guide, reading room, and copying facilities are available. Also housed at New York Public Library is the American Jewish Committee Oral History Library (formerly William E. Wiener Oral History Library) of 2,500 oral history interviews that document the American Jewish experience (contact Dr. Leonard Gold, Chief, Jewish Div., NYPL).

Comments: The organization emphasizes contemporary American Jewish concerns, intergroup relations, civil rights and liberties, and interreligious relations. The archival collection is a record of the history and activities of the American Jewish Committee from 1906-1933. The library's primary purpose is to support the research needs of the AJC as well as its major publications, *American Jewish Year Book,* and *Commentary,* and *Present Tense* magazines.

AMERICAN JEWISH HISTORICAL SOCIETY Museum
 2 Thornton Road Library
 Waltham, MA 02154 617-891-8110; Fax 617-899-9208 Archives

Personnel: Stanley Remsberg, Asst. Dir.; Ellen Smith, Curator; Holly Snyder, Archivist; Chin-Luen, Reference Libn.
Contact: Michael J. Feldberg, Exec. Dir.
Founded: 1892; Scope: Local, State, Regional, International
Availability: Open M-F 9-5; Admission: Free
Visitors: General public, School groups
Staff: 6 ft, 3 pt; Operating budget: $500,000
Publications: *American Jewish History,* 1893- , quarterly; *Heritage,* 1970- , irreg.;

Jewish Historical Societies' Network, 1989- , quarterly

Collection: 90,000 books, 1,000 periodical titles, 500 audiovisual materials, 300 artifacts, 250 works of art, and archival materials (personal papers and correspondence, unpublished records, printed materials, pictorial materials, theses and dissertations, 12,000,000 manuscripts, oral histories, newspapers on microform). The collection is cataloged; an unpublished guide, reading room, and copying facilities are available for researchers.

Comments: The purpose of the society is to collect, preserve, and publish historical materials on the Jewish experience in the Western Hemisphere. It claims to be the oldest national ethnic historical society in the United States. Services include guided tours, educational lectures, loans to educational institutions, school presentations, speakers, and films. The society supports research and provides internships and fellowship opportunities.

ARCHIVES MUSEUM, TEMPLE MICKVE ISRAEL	Museum
20 E. Gordon St.	Library
Savannah, GA 31401 912-233-1547; Fax 912-233-3086	Archives

Contact: Rabbi Arnold Belzer
Founded: 1974; Scope: Local, State
Availability: M-F 10-12, 2-4; Admission: Free, donations accepted
Visitors: General public, Ethnic community
Staff: 16 (2 ft, 4 pt, paid; 10 volunteers)
Publications: *Third to None: The Saga of Savannah Jewry 1773-1983*

Collection: 20,000 books related to Jewish studies, artifacts (ceremonial items, church furnishings), and archival materials.

Comments: The goal is to preserve the local Jewish religious and cultural heritage. Activities include guided tours, exhibits, and a souvenir/gift shop.

BEIT HASHOAH MUSEUM OF TOLERANCE	Museum
9786 W. Pico Blvd.	Library
Los Angeles, CA 90035 310-553-9036; Fax 310-553-8007	Archives

Sponsoring organization: Simon Wiesenthal Center, Inc.
Personnel: Rabbi Marvin Hier, Dean; Dr. Gerald Margolis, Dir.; Adaire Klein, Coordinator Library and Archive Services; Cheryl Miller, Archivist
Founded: 1977; Scope: National
Availability: M-W 10-5, Th 10-8, F, 10-3, Sun. 11-6:30
Admission: $7.50 adults, $5.50 seniors, $4.50 students, $2.50 children 3-12
Visitors: General public, School groups, Ethnic community
Publications: *Response*, quarterly; also publishes books.

Collection: 23,000 books (including 300 rare books) on the Holocaust, anti-Semitism, and other topics related to Jewish studies; audiovisual materials (11,000 photographs), 4,000 artifacts, works of art, and archival materials (unpublished papers, personal papers, 26,000 documents, photographs). The collection is cataloged.

Comments: The goal is to preserve Jewish culture and to promote awareness of racism and the Holocaust. Activities include guided tours, an oral history program, lectures, films, videos, radio, traveling exhibits loaned to schools and other institutions, research in anti-Semitism and human rights, and an annual Yom Hashoah Commemoration.

BENJAMIN & DR. EDGAR R. COFELD JUDAIC MUSEUM Museum
OF TEMPLE BETH ZION Library
 805 Delaware Ave.
 Buffalo, NY 14209 716-886-7150; Fax 716-886-7150

Personnel: Harriet Spiller, Deputy Dir.
Contact: Mortimer Spiller, Dir. and Curator
Founded: 1981; Scope: Local, Regional
Availability: Open M-F 9-5, Sat. 11-12; closed Jewish holidays; Admission: Free
Visitors: General public, Ethnic community
Staff: 12 pt volunteers, 6 interns
Publications: Brochures; pamphlets; exhibit catalogs (*The Cofeld Judaic Museum of Temple Beth Zion: An Illustrated Catalogue of the Collection*).

Collection: 12,000 books related to the Jewish faith and artifacts from the tenth century to the present (including coins, medallions, books, Holocaust remembrances, historical memorabilia, folk art, and textiles).

Comments: The goal is to preserve Jewish history and culture including religious traditions and the contributions of Jewish Americans. Activities include guided tours, AV presentations, educational programs, exhibits for loan to schools, and research.

B'NAI B'RITH KLUTZNICK NATIONAL JEWISH MUSEUM Museum
 1640 Rhode Island Ave., NW Archives
 Washington, DC 20036 202-857-6583; Fax 202-857-1099

Sponsoring organization: B'nai B'rith
Personnel: Ori Z. Soltecs, Dir. and Curator
Contact: Lisa Rosenblatt, Asst. Dir.
Founded: 1957; Scope: International
Availability: Open Sun.-F 10-5; Admission: Donation suggested
Visitors: General public, School groups, Ethnic community
Staff: 37 (4 ft, 3 pt, salaried; 30 volunteers) Operating budget: $250,000
Publications: *Museum Newsletter*, 1983- , bi-annual; also publishes exhibit catalogs and brochures.

Collection: 500 books, 4,000 artifacts, 1,000 works of art, and 140 linear ft. of archival records (personal papers and correspondence, unpublished records, pictorial materials, manuscripts, and oral histories). The collection is cataloged; a published guide, reading room, and copying facilities are available.

Comments: The purpose is to present Jewish history from antiquity to the present including the Jewish experience in America. Services include guided tours, educational lectures, school presentations, drama and instrumental performances, films and AV productions, poetry readings, and an arts and crafts souvenir shop.

CENTRAL SYNAGOGUE ARCHIVES Archives
(Formerly Ahawath Chesed Shaar Hashomayim)
123 E. 55 St.
New York, NY 10022 212-838-5122; Fax 212-644-2168

Sponsoring organization: Central Synagogue
Personnel: Livia D. Thompson, Exec. Dir.
Contact: Anne Mininberg, Chairman Archives Comm.
Founded: 1839; Scope: Local
Availability: Open by special appt.; Admission: Fee
Visitors: General public, School groups, Ethnic community
Staff: volunteers; Operating budget: Ca. $7,500
Publications: *The Bulletin of Central Synagogue*, 1928- , 10/yr

Collection: Books, periodicals, AV materials, and ca. 60 cubic ft. of archival materials
(personal papers and correspondence, unpublished records, pictorial materials, and oral
histories). Financial records from the 1970s and 1980s, scrapbooks from the 1940s,
and 19th century burial permits are in microform. The collection is cataloged; a
published guide and reading room are available.

Comments: The archives is a research and preservation facility for in-house and
outside researchers. The archives cover synagogue activities, the clergy, and activities
relating to congregants. Materials are devoted entirely to the landmark sanctuary
building.

CONGREGATION BETH AHABAH MUSEUM Museum
AND ARCHIVES TRUST Archives
1109 W. Franklin St.
Richmond, VA 23220 804-353-2668; Fax 804-358-3451

Sponsoring organization: Congregation Beth Ahabah
Contact: Cynthia N. Krumbein, Dir./Archivist
Incorporated: 1977
Availability: Open Sun & M 10-3, T-W, 10-4, Th 10-2; Admission: Donation
Visitors: General public, School groups, Ethnic community
Staff: 4 pt; Operating budget: $45,000
Publications: *Generations: the Journal of Beth Ahabah Museum & Archives Trust*,
1988- , 3/yr.

Collection: 300 books, 100 audio and video tapes, 500 artifacts, 100 works of art, and
about 1,200-1,400 linear ft. of archival records (personal papers and correspondence,
unpublished records, printed materials, pictorial materials, manuscripts, and oral
histories). The collection is cataloged; a reading room and copying facilities are
available.

Comments: The goal is to gather and preserve all existing records and items
concerning KK Beth Shalome and Cong. Beth Ahabah and to promote an understanding
of the history of the Jews. Services include guided tours, educational lectures, loans to
educational institutions, school presentations, and speakers.

CONGREGATION KAHAL KADOSH MIKVEH ISRAEL <u>Archives</u>
 44 N 4th St.
 Philadelphia, PA 19106 215-922-5446

Personnel: Leon L. Levy, Pres.; Martin Yoelson, Archivist
Contact: Florence S. Finkel, Chairman Archival Trust Committee
Founded: 1981; Scope: Local, Regional
Availability: Open by special appt.; Admission: Free
Visitors: General public, Ethnic community
Staff: 2 pt (1 salaried, 1 volunteer); Operating budget: $8,500
Publications: Annual report

Collection: Over 500 books, periodicals, audiovisual materials, works of art, and
archival materials. Copying facilities are available.

Comments: An entire room is devoted to the archives which date back to the founding
of the congregation in 1740 and are maintained as a permanent record of the American
Jewish community. Claimed to be America's second oldest Jewish congregation, it
boasts famous Jewish statesmen and other outstanding contributors to American society
as members. Materials may be loaned to schools and other institutions.

CONGRESS FOR JEWISH CULTURE <u>Archives</u>
 25 E. 21st St.
 New York, NY 10010 212-505-8040

Contact: Michael Skakun, Exec. Dir.
Founded: 1948; Scope: National
Availability: Open by appt. only; Admission: Free
Visitors: General public, Ethnic community
Staff: 12
Publications: *The World of Yiddish Bulletin*, 2-3/yr.; *ZUKUNFT*, bimonthly; also
publishes books on Jewish history (including the Holocaust), literature (including
criticism), and reference tools, e.g., *Biographical Dictionary of Yiddish Literature* (8v.)

Collection: Archives (biographical materials)

Comments: This is a congress of cultural organizations pertaining to writers,
educators, publishers, and others interested in promoting Jewish cultural events.
Programs include educational lectures, performing arts presentations, and research.

DALLAS MEMORIAL CENTER FOR HOLOCAUST STUDIES <u>Museum</u>
 7900 Northaven <u>Library</u>
 Dallas, TX 75230 214-750-4654; Fax 214-750-4672 <u>Archives</u>

Personnel: Frieda Soble, Exec. Dir.
Founded: 1984; Scope: Local, State
Availability: Sun. 12-4, M-F 10-4, Th 10-9 during school year;
Admission: Free/donations
Visitors: General public, School groups, Ethnic community
Publications: *Dallas Memorial Center for Holocaust Studies Newsletter*, 1984- ,

quarterly; also publishes catalogs, bibliographies, and pamphlets.

Collection: 2,500 books on the Holocaust and anti-Semitism, 200 audiovisual materials (photographs, films), 1,000 artifacts, 50 works of art, and archives (personal papers and correspondence, unpublished records, pictorial materials, theses and dissertations, manuscripts, and oral histories). The collection is cataloged.

Comments: The goal of the center is to preserve materials that document the Holocaust and to make materials available for educational and research purposes. The center is dedicated to reducing prejudice by teaching about the Holocaust, preserving the experiences of those who survived, and honoring the memory of those who perished. Activities of the center include guided tours, lectures, loans to schools, and audiovisual presentations.

FENSTER MUSEUM OF JEWISH ART Museum
 1223 E. 17th Place Library
 Tulsa, OK 74120 918-582-3732 Archives

Contact: Diana Aaronson, Dir.
Founded: 1966; Scope: National
Availability: Open T-F 10-4, Sun. 1-4; Admission: Free, donations
Visitors: General public, Ethnic community
Publications: Newsletters; brochures; catalogs of exhibitions.

Collection: 1,000 books (art reference books), audiovisual materials (photographs, prints) works of art, artifacts (costumes, ethnographic materials), and archival materials (unpublished papers).

Comments: The goal is to recognize the important contributions of Jewish artists and craftsmen to Jewish American culture and history. Activities include educational lectures and programs, guided tours, and loans to schools and other educational institutions.

HEBREW COLLEGE Museum
(Formerly Hebrew Teachers College) Library
 43 Hawes St. Archives
 Brookline, MA 02146 617-232-8710; Fax 617-734-9769

Contact: Maurice S. Tuchman, Dir. of Library Services
Founded: 1921; Scope: International
Availability: Open Sun. 9-3, M-Th, 9-9, F 9-12; Admission: Free
Visitors: General public, School groups, Ethnic community
Staff: 3 ft, 3 pt; Operating budget: $180,000
Publications: Guides and bibliographies

Collection: 80,000 books, 20,000 periodicals; 2,000 audiovisual materials; artifacts; works of art; and 4 drawers, 25 cartons, and 9 linear ft. of archival materials (personal papers and correspondence, unpublished records, printed materials, pictorial materials, theses and dissertations, and microfilmed manuscripts). The collection is cataloged; a reading room and copying facilities are available for researchers.

Comments: The purpose is to support the curriculum of the college and to advance Hebrew scholarship in the areas of language, history, and culture. The collections support research at the graduate and undergraduate levels. The college provides in-service experiences for teachers, and courses for credit; the college also participates in ethnic festivals.

HEBREW THEOLOGICAL COLLEGE Library
 7135 North Carpenter Rd. Archives
 Skokie, IL 60077 312-267-9800 or 708-674-7750

Sponsoring organization: Beneficiary of the Jewish Fed. of Metropolitan Chicago
Contact: Nira G. Wolfe, Head Libn.
Founded: 1922; Scope: Local, State, Regional, National, International
Availability: Open to the public; Admission: Free
Visitors: General public
Staff: 2 (1 ft, 1 pt, salaried)
Publications: *Turrets of Silver*, 1989- , weekly, cumulated annually; *Or Shemuel*, 1987- , annual.

Collection: Over 1,500 books, ca. 200 periodicals, audiovisual materials, artifacts, and archives (personal papers and correspondence, unpublished records, theses and dissertations, and manuscripts). The collection is cataloged; a reading room and copying facilities are available.

Comments: The collection supports the mission and curriculum of the college, preserves Jewish history and culture, and supports graduate and undergraduate research. Services include lectures, speakers, school presentations, and participation in ethnic festivals.

HEBREW UNION COLLEGE-JEWISH INSTITUTE OF RELIGION Library
 3101 Clifton Ave.
 Cincinnati, OH 45220 513-221-1875; Fax 513-2210-0321

Sponsoring organization: Union of American Hebrew Congregations
Personnel: Herbert C. Zafren, Dir. of Libraries; Dr. David J. Gilner, Libn.
Contact: Arnona Rudavsky, Loan Services Libn.
Founded: 1875; Scope: International
Availability: Open to the public; Admission: Free
Visitors: General public
Staff: 21 ft, 2 pt, salaried; Operating budget: $1,100,000
Publications: *Studies in Bibliography and Booklore*, 1953- , irreg.

Collection: 385,000 books, 2,000 periodical titles, 38,000 audiovisual materials. The collection is cataloged; a published guide, reading room, and copying facilities are available.

Comments: The library supports the curriculum and research at the graduate level. It is noted for its outstanding collection of rare books, manuscripts, and special collections on every aspect of Judaica and Hebraica. Services offered include guided tours, loans to educational institutions, and speakers.

HEBREW UNION COLLEGE SKIRBALL MUSEUM Museum
 3077 University Ave.
 Los Angeles, CA 90007-3796 213-749-3424

Sponsoring organization: Hebrew Union College-Jewish Institute of Religion
Personnel: Nancy Berman, Dir.; Grace Cohen Grossman, Curator
Contact: Peggy Kayser, Admin.
Founded: 1972; Scope: Local, National, International
Availability: Open T-F, 11-4; Admission: Free, Donation
Visitors: General public, School groups
Staff: 17 (11 ft, 1 pt, salaried; 5 volunteers); Operating budget: $800,000
Publications: *Calendar*, 1976- , 3/yr; also publishes books and exhibition catalogs.

Collection: Books, periodicals, over 1,500 artifacts, over 1,500 works of art, and
archives (personal papers and correspondence, unpublished records, pictorial materials,
oral histories). The collection is cataloged; a reading room and copying facilities are
available.

Comments: The purpose is to support the curriculum and promote multicultural
education. Programs include interactive classroom kits on the subjects of archaeology,
multicultural celebrations, immigration and family history, Jewish ceremonial objects,
and the Torah. The museum participates in ethnic festivals and provides work
experience for college credit.

THE HINENI HERITAGE CENTER Museum
 232 West End Ave. Library
 New York, NY 10023 212-496-1660; Fax 212-496-1908

Personnel: Rebbetzin Esther Jongreis, Founder and Pres.
Contact: Barbara Janov, Exec. Dir.
Founded: 1972; Scope: International
Availability: Open, restricted access; Admission: Donation
Visitors: General public, School groups, Ethnic community
Staff: 17 (5 ft, 6 pt, salaried; 6 volunteers)
Publications: Promotional brochure, *The Hineni Heritage Center*

Collection: Ca. 1,000 books, audio and video tapes, and artifacts. The collection is
partially cataloged; a reading room and copying facilities are available.

Comments: The center preserves Jewish history, culture, heritage and identity.
Different rooms include: "The Jewish Way of Life"; "Israel, the Land and the People";
"The Holocaust Room." Programs include guided tours, educational lectures, loans to
educational institutions, TV programs, speakers, and film productions.

HISTADRUTH IVRITH OF AMERICA Library
 47 W. 34th St.
 New York, NY 10001 212-629-9443

Contact: Dr. Aviva S. Barzel, Exec. Vice Pres.
Founded: 1916; Scope: National

Availability: Open by appt.; Admission: Free
Visitors: General public, Ethnic community
Staff: 9
Publications: *Hadobar*, weekly; *Lamishpaha*, monthly.

Collection: 5,000 books on Hebrew literature

Comments: The purpose is to preserve Jewish culture and the Hebrew language by
providing language classes and sponsoring Hebrew Month and Hebrew Week.
Programs include educational lectures, dramas, concerts, and awards for contributions
to Jewish-American culture. The organization also establishes Hebrew clubs on college
and university campuses.

INDIANA JEWISH HISTORICAL SOCIETY Archives
 203 W. Wayne St.
 Fort Wayne, IN 46800 219-422-3862

Contact: Eileen Baitcher, Exec. Dir.
Founded: 1972; Scope: State
Availability: Open by special appt.; Admission: Free
Visitors: General public
Staff: 2 pt, salaried
Publications: *Indiana Jewish History*, 1972- , annual; also publishes membership
newsletters and flyers.

Collection: Over 5,000 items (personal papers and correspondence, unpublished
records, theses and dissertations, manuscripts, and oral histories). A reading room and
copying facilities are available.

Comments: The purpose is to collect, preserve, and publish Indiana Jewish history.
Programs include speakers and participation in ethnic festivals.

IRA M. BECK ARCHIVES OF ROCKY MOUNTAIN Archives
JEWISH HISTORY
 University of Denver
 2199 S. University
 Denver, CO 80204 303-871-3020; Fax 303-871-3037

Sponsoring organization: Center for Judaic Studies, University of Denver
Contact: Dr. Jeanne Abrams, Dir./Archivist
Founded: 1976; Scope: Regional
Availability: Open by special appt.; Admission: Free
Visitors: General public, Research scholars
Staff: 2 (1 ft, 1 pt); Operating budget: $55,000
Publications: *Rocky Mountain Jewish Historical Notes*, 1977- , quarterly; also
publishes monographs, collection guides, brochures.

Collection: Periodicals, audiovisual materials, ca. 1,500 artifacts, works of art, and ca.
800 linear ft. of archives (personal papers and correspondence, unpublished records,
pictorial materials, theses and dissertations, manuscripts, and oral histories). Some

records are in microform. The collection is partially cataloged; an unpublished guide, reading room, and copying facilities are available.

Comments: The purpose is to promote and preserve Jewish history and culture of the Rocky Mountain region. Services include guided tours, educational lectures, loans to other educational institutions, school presentations, radio programs, speakers, and films and AV productions. The organization participates in ethnic festivals.

JANE L. & ROBERT H. WEINER JUDAIC MUSEUM/ Museum
GOLDMAN ART GALLERY Library
(Formerly Judaic Museum)
 6125 Montrose Road
 Rockville, MD 20852

Sponsoring organization: Jewish Community Center of Greater Washington
Personnel: Sheila Bellack, Dir. of Cultural Arts
Contact: Karen Falk, Museum and Gallery Dir.
Founded: 1960; Scope: Local, National, International
Availability: Open M-Th 12-4, 7:30-9:30, Sun. 2-5; Admission: Free
Visitors: General public, School groups, Ethnic community
Staff: 1 ft; Operating budget: $120,000
Publications: *Center Scene,* monthly; books and membership newspapers.

Collection: Books, artifacts, works of art. A reading room and copying facilities are available.

Comments: The purpose is to present the art, culture, and heritage of the Jewish community, past and present, through an exhibit of Judaica and changing exhibits of local and national artists. Services include lectures, school presentations, dance, drama, and instrumental performances. The center participates in ethnic festivals.

JEWISH COMMUNITY LIBRARY-PETER M. KAHN MEMORIAL Library
 6505 Wilshire Blvd. Archives
 Los Angeles, CA 90048 213-852-1234, Ext. 3202; Fax 213-653-2151

Sponsoring organization: Bureau of Jewish Education and Jewish Federation
Council of Greater Los Angeles
Contact: Hava Ben-Zvi, Head Libn.
Founded: 1947; Scope: Local
Availability: Open M-Th, 9-5, F, 9-3:30, Sun. 1-5; Admission: Free
Visitors: General public, School groups, Ethnic community
Staff: 13 (2 ft, 1 pt, salaried; 10 volunteers)
Publications: Books; acquisition lists; bibliographies to aid teachers; formal annual reports; and flyers.

Collection: 30,000 books, 100 periodical titles, 740 audiovisual productions, 72 archival boxes, 143 reels of microfilm, 28 four-drawer steel files of archival materials (pictorial materials, theses and dissertations, manuscripts, oral histories). Official records of organizations and local Jewish newspapers are microfilmed. The collection is cataloged; an unpublished guide, reading room, and copying facilities are available.

Comments: The objectives are to provide resources for the study of Jewish history, religion, sociology, education, Zionism, Israel, and Jewish life. Services include guided tours, loans to schools, and speakers. In addition the library provides reference assistance, workshops on the use of library resources, bibliographies, displays, publications aids, in-service programs for teachers, and research support.

JEWISH HISTORICAL SOCIETY OF GREATER HARTFORD Archives
 335 Bloomfield Ave.
 West Hartford, CT 06117 203-236-4571; Fax 203-233-0802

Personnel: Dr. Leon Chameides, Pres.
Contact: Marsha Lotstein, Dir.
Founded: 1971; Scope: Local
Availability: Open M-Th, 10-4; open for research by appt.; Admission: Free
Visitors: General public
Staff: 1 pt, salaried; Operating budget: $37,000
Publications: *Connecticut Jewish History*, Vols. 1 and 2 (1990, 1992)

Collection: Ca. 5,000 books, periodicals, artifacts and realia, audiovisual materials, religious objects, and archives (personal papers and correspondence, unpublished records, pictures, theses and dissertations, manuscripts, and oral histories in over 800 linear ft. of shelving, over 125 boxes, and 18 3-ft. horizontal file drawers). The collection is partially cataloged; a reading room and copying facilities are available.

Comments: The goal is to collect and preserve historical, political, economic, social, and religious materials in order to promote historical research and to create a community awareness of Jewish contributions to the Greater Hartford area. Services include guided tours, educational lectures, speakers or resource people, participation in ethnic festivals, and support of undergraduate and graduate level research.

JEWISH HISTORICAL SOCIETY OF MARYLAND Museum
 15 Lloyd St. Library
 Baltimore, MD 21202 410-732-6400 Archives

Personnel: Barry Kessler, Asst. Dir., Curator; Virginia North, Archivist
Contact: Bernard P. Fishman, Dir.
Founded: 1960; Scope: Local, State, Regional
Availability: Open, restricted access, T-Th, Sun. 12-4; Admission: Fee
Visitors: General public, School groups, Ethnic community
Staff: 9 (5 ft, 4 pt, salaried); Operating budget: $400,000
Publications: *Generations*, 1978- , annual; catalog; membership newsletters; monographs and histories.

Collection: Ca. 1,500 books, periodicals, audiovisual materials, 4,000 artifacts, ca. 1,000 works of art, and archival materials (approximately 100,000 documents: personal papers and correspondence, printed materials, unpublished records, theses and dissertations, manuscripts, oral histories, genealogical records, and 30,000 photographs). Census records, directories, and journals are in microform. The collection is cataloged; finding aids, a reading room, and copying facilities are available for researchers.

Comments: The organization claims to possibly be the nation's largest museum and archive concerned with regional American Jewish history and the national leader in matters concerning historic synagogue research and restoration. It provides guided tours, educational lectures, loans to educational institutions, school presentations, speakers, dramas, choir and instrumental performances, films and AV productions, and a souvenir shop. It participates in ethnic festivals, and supports research.

THE JEWISH MUSEUM Museum
 1109 Fifth Ave. Library
 New York, NY 10128 212-423-3200; Fax 212-423-3232

Sponsoring organization: Jewish Theological Seminary of America
Personnel: Joan Rosenbaum, Dir.; Norman Kleeblatt, Curator, Coll.; Vivian Mann, Curator Judaica
Founded: 1904; Scope: National
Available: Open T-F, Sun. (Museum); restricted access (library); Admission: Fee
Visitors: General public, School groups, Ethnic community
Staff: 175 (62 ft, 13 pt, paid; 100 volunteers)
Publications: Annual reports; newsletters; brochures; posters; catalogs of exhibits

Collection: Books, periodicals, photographs, works of art, artifacts (ceremonial objects, textiles, coins, medals, decorative objects), and archives (unpublished papers, manuscripts, pictorial materials), exhibits related to the holocaust and Jewish artists.

Comments: The museum covers forty centuries of Jewish history, religious ceremonies, and art. Services include gallery tours, exhibit programs, craft gift shop, programs and workshops for children, and loans to schools.

THE JEWISH MUSEUM SAN FRANCISCO Museum
 121 Stueart St.
 San Francisco, CA 94105 415-543-8880; Fax 415-543-4180

Contact: Linda Steinberg, Dir.
Founded: 1984; Scope: Local, State
Availability: Open Sun.-W 11-5, Th 11-7; Admission: $3 adults, $1.50 seniors/students
Visitors: General public, School groups, Ethnic community
Staff: 9 ft, 12 volunteers, 1 intern
Publications: Catalogs of exhibits; promotional flyers

Collection: 6,670 sq. ft. of artifacts and works of art

Comments: Jewish art, culture, and tradition are preserved and displayed through permanent and travelling exhibitions. Services include guided tours, educational lectures, educational programs for both children and adults, and family holiday celebrations.

JEWISH WOMEN'S RESOURCE CENTER Library
 9 E. 69th St.
 New York, 10021 212-535-5900

Sponsoring organization: National Council of Jewish Women
Contact: Emily Milner, Coordinator
Founded: 1978; Scope: State
Availability: Open to the public; Admission: Free
Visitors: General public, Ethnic community
Staff: 1; Operating budget: Less than $25,000
Publications: *JWRC Newsletter*, 3/yr; also publishes books, reference works, and study guides.

Collection: 5,000 books and archival records (birth ceremonies, marriage contracts, directories of Jewish women).

Comments: The center supports Jewish women in the arts (literature, poetry, film, etc.). Services include reference assistance and educational programs.

JUDAH L. MAGNES MUSEUM Museum
 2911 Russell St. Library
 Berkeley, CA 94705 510-549-6950; Fax 510-849-3650 Archives

Personnel: Seymour Fromer, Dir.; Dr. Moses Rischin, Dir., Western
Jewish History Center; Ruth K. Rafael, Head Archivist/Libn.
Contact: Paula Friedman, Public Relations Dir.
Founded: 1962; Scope: International
Availability: Open Sun.-Th 10-4; some materials by appt. only;
Admission: Donation
Visitors: General public, School groups, Ethnic community
Staff: 5 ft, 15 pt, salaried; 25 volunteers; Operating budget: $500,000-$1,000,000
Publications: *Magnes News*, 1967- 3/yr.; also publishes books and exhibit catalogs.

Collection: 20,000 books, 150 years of newspaper periodicals, 100 oral history tapes, 10,000 Jewish ceremonial and folk art artifacts, 2,000 prints and drawings, hundreds of paintings and sculpture on Jewish themes, and 325 archival collections in the Western Jewish History Center (including 1,500 books, periodicals, 5,000 photographs, personal papers and correspondence, unpublished records, pictorial materials, manuscripts, and oral histories). Some records are in microform. The collection is cataloged; an unpublished guide and reading room are available.

Comments: The purpose is to preserve, collect, and make available objects of Jewish history and culture. Services include guided tours, educational lectures, loans and presentations to schools, speakers, instrumental presentations, films and AV productions, a numismatic series, and an arts and crafts souvenir shop.

THE JUDAICA MUSEUM Museum
 5961 Palisade Ave.
 Riverdale, NY 10971 718-549-8700 x294

Sponsoring organization: The Hebrew Home for the Aged at Riverdale
Personnel: Dr. Deborah Karp, Curator
Contact: Karen Spiegel Franklin, Dir.
Founded: 1982; Scope: Local, Regional

Availability: Open to the public; Admission: Free to individuals, Fees for groups
Visitors: General public, School groups, Ethnic community
Staff: 10 (6 pt, salaried; 4 volunteers); Operating budget: $100,000
Publications: *The Judaica Museum Newsletter*, 1988- , annual; catalog of collections.

Collection: Books, artifacts, paintings and works of art, over 800 Jewish ceremonial
objects from the Ralph and Leuba Baum Collection.

Comments: The collection reflects the customs and ceremonies of Jewry over the last
three centuries. The museum has a library of books related to Judaica, some dating
back to the 16th century. It sponsors guided tours, lectures, and school presentations.

JUDAICA MUSEUM OF CENTRAL SYNAGOGUE Museum
 123 E. 55th Library
 New York, NY 10022 212-838-5122 x222; Fax 212-644-2168

Personal: Liva Thompson, Synagogue Exec. Dir.; Cissy Grossman, Curator
Founded: 1962; Scope: Local, State
Availability: Open M-F 9-4:30; Admission: Free, donations
Visitors: General public, Ethnic community
Staff: pt, salaried
Publications: *A Jewish Family's Book of Days*

Collection: 100 books and catalogs, 75 artifacts, realia, 500 works of art, and
memorabilia that represent the life of the local Jewish community. The collection is
cataloged; a published guide and reading room are available.

Comments: Jewish religious life and culture is preserved through exhibits and art
objects. Services include guided tours.

LEO BAECK INSTITUTE, INC. Museums
 129 East 73rd St. Library
 New York, NY 10021 Archives

Personnel: Frank Mecklenburg, Archivist; Yitzak Kertesz, Libn; Dr. Diane
Spielmann, Reference Specialist
Contact: Robert A. Jacobs, Exec. Dir.
Founded: 1955; Scope: International
Availability: Open to the public; Admission: Free
Visitors: General public, School groups
Staff: 24 (6 ft, 8 pt, salaried; 10 volunteers); Operating budget: $600,000
Publications: *LBI News*, semiannual; *Library and Archive News*, semiannual; *Leo
Baeck Institute Yearbook*, 1956- , annual.

Collection: 60,000 books, 10,000 periodicals, 3,000 artifacts, works of art, and ca.
2,200 shelf ft. of archives (personal papers and correspondence, unpublished records,
pictures, theses and dissertations, manuscripts, Jewish communal records). The library
has extensive belles lettres written by Jews; the archives has family papers, community
histories, and business and public records dating back several centuries. The collection

is cataloged; a published guide, reading room, and copying facilities are available.

Comments: The Institute is devoted to the history of German-speaking Jewry. Each year it presents two or three exhibits of material from its collections. The collections support research on an international basis; the institute sponsors fellowships to assist doctoral and other scholars.

LILLIAN AND ALBERT SMALL JEWISH MUSEUM Museum
 701 Third St. NW Archives
 Washington, DC 20001-2624 202-789-0900

Personnel: Michael Goldstein, Pres. of the Bd.; Jessica Kaz, Curator/Archivist
Contact: Julian Feldman, Exec. Dir.
Scope: Local
Availability: Open Sun.-Th 11-3; by appt. for research; Admission: Donation
Visitors: General public, School groups
Staff: 28 (1 ft, 5 pt, salaried; 22 volunteers); Operating budget: $132,000
Publications: *The Record*, 1966- , annual; *Third Street Echoes*, quarterly newsletter

Collection: Books, periodicals, photographs of ritual art, artifacts, and 40 linear ft. of archives (personal papers and correspondence, unpublished records, pictorial materials, oral histories). The collection is cataloged.

Comments: The mission is to preserve the area's historic Jewish presence. The museum provides guided tours, educational lectures, loans and presentations to schools, speakers, and programs such as tours to "Jewish" Philadelphia, New York, etc. It sponsors work experience and internships for college credit.

A LIVING MEMORIAL TO THE HOLOCAUST Museum
MUSEUM OF JEWISH HERITAGE Library
 342 Madison Ave., Suite 717
 New York, NY 10173 212-687-9141; Fax 212-573-9847

Sponsoring organization: New York Holocaust Memorial Commission
Personnel: David Altshuler, Dir.; Esther Brumberg, Research Coordinator
Incorporated: 1984; Scope: State
Availability: Open to the public
Publications: Publishes books, including a bibliography.

Collection: 6,000 books, 14,000 artifacts, and archival materials (personal papers and correspondence, pictorial materials, theses and dissertations, and oral histories). The collection is cataloged; copying facilities are available.

Comments: The museum is New York's principal public memorial to the 6 million Jews murdered during the Holocaust and a center for the study of Jewish history and culture. Services include educational lectures, speakers, films, and AV productions.

MARTYRS MEMORIAL AND MUSEUM OF THE HOLOCAUST Museum
 6505 Wilshire Blvd. Library
 Los Angeles, CA 90048 213-852-1234 Archives

Sponsoring organization: Jewish Federation Council of Greater Los Angeles
Personnel: Michael Nutkiewicz, Dir.
Contact: Marcia Reines Josephy, Curator
Founded: 1978; Scope: Regional
Availability: Open to the public; Admission: Free
Visitors: General public, School groups
Staff: 2 ft, 1 pt; Operating budget: $185,000
Publication: *Pages*, 3/yr.; promotional brochures.

Collection: Ca. 1,500 books, periodicals, audiovisual materials, 500 artifacts, works of art, and archives (personal papers and correspondence, pictures, oral histories). The collection is accessioned; a reading room and copying facilities are available.

Comments: The museum commemorates the martyrs of the Nazi holocaust and educates about the experience of Jews in pre-war Europe. It provides work experience for college credit and in-service programs, courses, or workshops for teachers.

MIZEL MUSEUM OF JUDAICA Museum
 560 S. Monaco Pkwy. Library
 Denver, CO 80224 303-333-4156; Fax 303-336-3129

Personnel: Rabbi Stanley M. Wagner, Dir.; Joanne Marks Kauvar, Admin.
Founded: 1982; Scope: Local, State, Regional
Availability: Open M-Th 10-4, Sun. 10-12; Admission: Free
Visitors: General public, Ethnic community
Staff: 54 (2 ft, 2 pt, paid; 50 volunteers)
Publications: Newsletters

Collection: Ca. 200 books on Jewish art and religious ceremony, works of art, artifacts, audiovisual materials (films).

Comments: The purpose is to preserve local Jewish religious and cultural life. Activities include guided tours, lectures, audiovisual presentations, workshops, children's programs, and permanent and temporary exhibits.

MORTON B. WEISS MUSEUM OF JUDAICA Museum
 1100 Hyde Park Blvd.
 Chicago, IL 60615 312-924-1234; Fax 312-924-1238

Contact: Vicki Goldwyn, Admin.
Founded: 1967; Scope: Local, State
Availability: Open M-Th 9-4:30, F 9-3; Admission: Free
Visitors: General public, School groups, Ethnic community

Collection: 4,000 books related to Jewish history and life or children's literature; artifacts related to Jews in America and Europe including religious and ceremonial objects; and archival materials (wedding certificates and marriage contracts).

Comments: The purpose is to preserve local Jewish religious history and to maintain vital statistics related to parishioners and other Jews. Activities include guided tours.

MUSEUM OF THE SOUTHERN JEWISH EXPERIENCE
 4915 I-55 N, Suite 104B, P.O. Box 16528
 Jackson, MS 39236 601-362-6357; Fax 601-366-6293

<div align="right">Museum
Library</div>

Contact: Judy Grundfest, Curator
Founded: 1989; Scope: Regional
Availability: Open by appt. only; Admission: Fee
Visitors: General public, Ethnic community
Staff: 3 (1 ft, 2 pt, paid; 1 intern)
Publications: *Circu*, biennial newsletter

Collection: 500 books on Judaica and the Jewish experience, photographs of Jewish life in the South, artifacts (furnishings, ceremonial objects from synagogues in the South), archival materials (unpublished papers, personal papers and correspondence, photos and pictorial materials).

Comments: The purpose is to preserve the Jewish experience in the South, particularly religious and synagogue life. Activities include guided tours, lectures, exhibits, loans to schools, programs for both children and adults, and a souvenir/gift shop.

NATIONAL MUSEUM OF AMERICAN JEWISH HISTORY
 55 N. 5th St., Independence Mall East
 Philadelphia, PA 19106-2197 215-923-3812; Fax 215-923-0763

<div align="right">Museum
Library
Archives</div>

Personnel: Margo Bloom, Exec. Dir.
Contact: Stephen Frank, Curator
Founded: 1976; Scope: National
Availability: M-Th 10-5, F 10-3, Sun. 12-5; Admission: Fee
Visitors: General public, School groups, Ethnic community
Staff: 15 ft, 1 pt, paid; 86 volunteers

Collection: 1,000 books (monographs and reference works on Jewish American history), art slides, 225 films, art objects, artifacts, and archival materials (unpublished synagogue records and other primary sources from colonial days to the present) documenting 300 years of Jewish political, social, domestic, and business life in America. Copying facilities are available.

Comments: The museum is dedicated to the preservation of materials about the history of the Jewish people in the United States. Services include guided tours, educational lectures, loans to schools and other institutions, school presentations, and speakers.

NATIONAL MUSEUM OF AMERICAN JEWISH
MILITARY HISTORY
(Formerly Jewish War Veterans National Memorial, Inc.)
 1811 R St. NW
 Washington, DC 20009 202-265-6280; Fax 202-462-3192

<div align="right">Museum
Library
Archives</div>

Sponsoring organization: Jewish War Veterans of the USA
Personnel: Leslie M. Freudenheim, Museum Dir./Curator
Contact: Sandor B. Cohen, Asst. Museum Dir./Archivist

Founded: 1958; Scope: National
Availability: Open to the public M-F, 9-4:30; Admission: Free
Visitors: General public, School groups
Staff: 4 ft, 1 pt, salaried; 8 volunteers; Operating budget: $250,000
Publications: *Roots to Roots*, quarterly; exhibition catalogs; various books

Collection: Ca. 1,500 books and periodicals, 2,000 archival collections in 5,000 boxes
and folders (personal papers and correspondence, unpublished records, pictorial
materials, theses and dissertations, manuscripts, and oral histories). The collection is
partially collected; a reading room and copying facilities are available.

Comments: To document, preserve, and educate the public regarding the contributions
of Jewish Americans related to the peace and freedom of the United States.

NATIONAL YIDDISH BOOK CENTER Library
 48 Woodbridge St.
 South Hadley, MA 01075 413-535-1303; Fax 413-535-1007

Personnel: Aaron Lansky, Pres.; Neil Zagorin, Bibliographer
Contact: Lori McGlinchey, Program Dir.
Founded: 1980; Scope: National
Availability: Open 9-4; Admission: Free
Visitors: General public, Ethnic community
Staff: 14 ft, 20 pt, 5 volunteers; Operating budget: $1,200,000
Publications: *Der Pakn-treger* (The Book Peddler) *Newsletter*, semi-annual; *Yiddish
Book News*, 1983- , semi-annual.

Collection: 1,000,000 books, 200,000 Yiddish periodicals, 150,000 pieces of Yiddish
sheet music with cover art, artifacts (Yiddish printing equipment, antique typewriters),
works of art; a database of Yiddish titles. The collection is partially cataloged; a
published guide, reading room, and copying facilities are available.

Comments: The purpose is to preserve Jewish life and culture through collecting and
preserving Yiddish books and maintaining a deposit library available to teachers and
researchers. Programs offered include educational lectures, radio and TV programs,
speakers, films, and a souvenir shop.

NEBRASKA JEWISH HISTORICAL SOCIETY Museum
 333 S. 132nd St. Archives
 Omaha, NE 68154 402-334-8200 x277

Sponsoring organization: Jewish Federation of Omaha
Personnel: Louise Abrahamson, Pres.; Mary Fellman, Exec. Dir.
Contact: Susan Silver, Archivist
Founded: 1982; Scope: Local, State, Regional
Availability: Open to the public; Admission: Free
Visitors: General public, School groups, Ethnic community
Staff: 1 ft, 1 pt, salaried; Operating budget: $2,800

Collection: Over 250 boxes of artifacts and archival records (personal papers and

correspondence, unpublished records, pictorial materials, theses and dissertations, manuscript, oral histories). The collection is cataloged; a reading room and copying facilities are available.

PHILADELPHIA JEWISH ARCHIVES CENTER Archives
AT THE BALCH INSTITUTE
 18 S. 7th St.
 Philadelphia, PA 19106-2314 215-925-8090; Fax 215-922-3201

Sponsoring organization: Jewish Federation of Greater Philadelphia
Personnel: Franklin C. Muse, Asst. Archivist;
Contact: Lily G. Schwartz, Archivist
Founded: 1972; Scope: Regional
Availability: Open to the public; Admission: Free
Visitors: General public
Staff: 2 ft, salaried; Operating budget: $72,000
Publications: *PJACBI*, 1975- semi-annual; biannual newsletter

Collection: Audiovisual materials, works of art, 3,500 cubic ft. of archives (personal papers and correspondence, unpublished records, pictorial materials, theses and dissertations, manuscripts, and oral histories). Records of the Hebrew Sunday School Society, newspaper collections, and genealogical family records are in microform. The collection is cataloged; a reading room and copying facilities are available.

Comments: The center is the repository for the greater Philadelphia Jewish community with emphasis on Philadelphia social history. Includes records of the first Jewish orphanage and Sunday School and the first Alliance Israelite Universelle in the U.S.

PLOTKIN JUDAICA MUSEUM Museum
 3310 N. 10th Ave.
 Phoenix, AZ 85013 602-864-4428; Fax 602-864-4428

Sponsoring organization: Temple Beth Israel
Personnel: Sylvia Plotkin, Dir.; Pamela Levin, Assoc. Dir.
Founded: 1967
Availability: Open T-Th, 10:00-3:00, Sunday, 12:00-3:00; Admission: Donation
Visitors: General public, School groups, Ethnic community
Staff: Pt and Volunteer; Operating budget: $25,000

Collection: 35 audiovisual productions and 1,000 artifacts. The collection is cataloged; a reading room and copying facilities are available.

Comments: The purpose is to serve as a teaching museum to preserve the intellectual, cultural, social, and spiritual legacy of the Jewish past, present, and future. Services include guided tours, educational lectures, loans and presentations to schools and other institutions, speakers, dance, drama, choir and instrumental presentations, and films.

RESEARCH FOUNDATION FOR JEWISH IMMIGRATION Archives
 570 7th Ave., Rm. 1106
 New York, NY 10018 212-921-3871; Fax 212-575-1918

Personnel: Herbert A. Strauss, Secy. and Coord. of Research
Contact: Dennis E. Rohrbaugh, Archivist
Founded: 1971; Scope: National
Availability: Open by special appt.; Admission: Free
Visitors: General public, Ethnic community
Staff: 1 ft, salaried
Publications: *Jewish Immigrants of the Nazi Period in the U.S.A.* (series);
International Biographical Dictionary of Central European Emigres, 1933-1945.

Collection: Ca. 200 books, oral history collection on German-Jewish immigration to America since 1933; and 25,000 biographical archival records. Biographical and organizational records are in microform and include information on more than 25,000 individuals of various professional, religious, and cultural backgrounds.

Comments: Preserves the history of German-speaking victims of Nazi persecution who fled Central Europe between 1933 and 1945. Activities include lectures and speakers.

RHODE ISLAND JEWISH HISTORICAL ASSOCIATION Library
 130 Sessions St. Archives
 Providence, RI 02906 401-331-1360

Personnel: Stanley Abrams, Pres.; Bernard Kusinitz, 1st V. Pres.; Ruth C. Fixler, Secy.; Dr. Alfred Jaffe, Treas.
Contact: Eleanor F. Jorvitz, Libn./Archivist
Founded: 1951; Scope: Local, State, Regional, National, International
Staff: 11 (2 pt, 3 salaried, 6 volunteers); Operating budget: $17,000
Publications: *Rhode Island Jewish Historical Notes*, 1954- , annual; membership newsletters; *The Jews in Rhode Island* by G. S. Foster.

Collection: 114 sq. ft. of books, periodicals, audiovisual materials, artifacts, 112 sq. ft. of newspapers, 112 sq. ft. of archives (personal papers and correspondence, unpublished records, manuscripts, oral histories, and photographs). Copying facilities are available.

Comments: Promotes study of the history and experience of the Jews of Rhode Island and collects and preserves materials on the topic. The Association provides guided tours, educational lectures, loans to schools, and speakers.

RODEF SHALOM JEWISH MUSEUM Museum
 4905 5th Ave. Archives
 Pittsburgh, PA 15213 412-621-6566

Sponsoring organization: Rodef Shalom Congregation
Contact: Walter Jacob, Dir.
Availability: Open to the public; Admission: Free
Visitors: General public
Staff: 2 pt (1 salaried, 1 volunteer); Operating budget: $4,000
Publications: *Pittsburgh Platform in Retrospect* (1985)

Collection: Periodicals, artifacts, works of art, and 60 file drawers of archival

materials (personal papers and correspondence, unpublished records, oral histories). A reading room and copying facilities are available.

Comments: The purpose is to preserve materials that document Jewish history and religion, with particular emphasis on records of the congregation.

SPERTUS MUSEUM Museum
(Formerly Spertus Museum of Judaica) Archives
 618 S. Michigan Ave. Art Gallery
 Chicago, IL 60605 312-922-9012; Fax 312-922-6406

Sponsoring organization: Spertus Institute
Personnel: Olga Weiss, Curator of Perm. Coll.; Kathi Lieb, Curator of Education
Contact: Dr. Morris A. Fred, Dir.
Founded: 1968; Scope: Local
Availability: Open to the public M-Th, Sun. 10-5, F 10-3; Admission: Fee
Visitors: General public, School groups, Ethnic community
Staff: 30 (8 ft, 8 pt, 14 volunteers)
Publications: Exhibit catalogs

Collection: 4,000 artifacts and archival materials (general documents and 800 photographs). The collection is cataloged; an unpublished guide is available.

Comments: Exhibits and studies Jewish religious and cultural traditions. Services include guided tours, educational lectures, loans and presentations to schools, speakers, films, and a souvenir shop. The museum supports research, provides work experience for college credit, and in-service training and workshops for teachers.

TEMPLE BRITH KODESH MUSEUM Museum
 2131 Elmwood Ave.
 Rochester, NY 14618 716-244-7060

Personnel: Arline M. Wiseman, Co-chairman
Contact: Susanne J. Klein, Chairman, 60 Shire Oaks Dr., Pittsford, NY 14534
Founded: 1954; Scope: Local
Availability: Open by special appt. and during Temple services and events;
Admission: Free
Visitors: General public, School groups
Staff: 12 volunteers; Operating budget: $900

Collection: Ca. 250 books, periodicals, ca. 400 artifacts, works of art, and 2 file drawers of archival records (personal papers and correspondence, unpublished records, pictorial materials). The collection is cataloged.

Comments: The purpose is to preserve objects and other records of Jewish and temple history. The museum provides guided tours and displays exhibits.

THE TEMPLE MUSEUM OF RELIGIOUS ART Museum
 1855 Ansel Road, University Circle at Silver Park Library
 Cleveland, OH 44106 216-791-7755/831-3233; Fax 216-791-7043 Archives

Sponsoring organization: Temple Tifreth Israel
Personnel: Frances Tramer, Registrar; Nancy Whitman/Susan Koletsky, Museum
Educators
Contact: Claudia Z. Fechter, Dir., Curator and Archivist
Founded: 1850; Scope: Local, State, Regional, National, International
Availability: Open, restricted access; Admission: Free
Visitors: General public, School groups, Ethnic community
Staff: 34 (1 ft, 6 pt, ca. 30 volunteers)
Publications: *The Loom and the Cloth: An Exhibition of the Fabrics of Jewish Life*
(1988); other temple publications; museum/library news.

Collection: 40,000 books, periodicals, audiovisual materials, over 1,000 artifacts,
works of art, and archives (personal papers and correspondence, unpublished records,
pictorial materials, theses and dissertations, manuscripts, all papers of Rabbi Abba
Hillel Silver, and congregational records and Sermons in microform). The collection is
cataloged; a reading room and copying facilities are available.

Comments: The purpose is to teach the heritage of Judaism by preserving all formats
of materials, including rare books and manuscripts. Provides guided tours, educational
lectures, loans to museums, speakers, films and AV productions, crafts classes, and an
arts and crafts/souvenir shop. The organization participates in ethnic festivals.

TOURO SYNAGOGUE Library
 85 Touro St. Archives
 Newport, RI 02840 401-847-4794; Fax 401-847-8121

Personnel: Bernard Kusinitz, Historian; David Bazarsky, Pres.
Contact: B. Schlessinger Ross, Exec. Dir.
Founded: 1763; Scope: Local, State, Regional, National, International
Availability: Open by appt.; Admission: Free/Donation
Visitors: General public, Ethnic community
Staff: 3 ft, 2 pt, volunteers
Publications: *Society Update,* quarterly (Society of Friends of Touro Synagogue);
Touro Monthly, 10/yr (congregational bulletin)

Collection: Books, periodicals, audiovisual materials, artifacts.

Comments: The synagogue's Society of Friends promotes Jewish religion and culture
by preserving the history of one of the earliest synagogues in America. It sponsors
educational programs, guided tours, and speakers; it also operates a gift shop.

UNITED STATES HOLOCAUST MEMORIAL MUSEUM Museum
 Raoul Wallenberg Place, SW Library
 Washington, DC 20024-2150 202-488-0400; Fax 202-488-2690

Sponsoring organization: U.S. government
Personnel: Sara Bloomfield, Exec. Dir.; Shaike Weinberg, Museum Dir.; Jacek
Nowakowski, Coll. & Acquisitions; Dr. Brewster Chamberlin, Archivist
Founded: 1980 Scope: National
Availability: Open daily 10-5:30; Admission: Free

Visitors: General public, School groups, Ethnic community
Publications: *The United States Holocaust Memorial Museum Newsletter*, monthly

Collection: 18,000 books related to the Holocaust, photographs, films, videos, artifacts, realia, and archival materials (personal papers, oral histories, etc.).

Comments: The purpose of this history museum is to preserve the events of the Holocaust of 1933-1945 through various exhibits (e.g., Auschwitz: A Crime Against Humanity), film and video presentations, and other resources.

YESHIVA UNIVERSITY MUSEUM Museum
 2520 Amsterdam Ave. Library
 New York, NY 10033 212-960-5390; Fax 212-960-5406 Archives

Sponsoring organization: Yeshiva University
Personnel: Sylvia A. Herskowitz, Dir.; Gabriel Goldstein, Curator; Bonni-Dara Michaels, Registrar
Contact: Randi Glickberg, Deputy Dir.
Founded: 1973; Scope: National
Availability: Open T-Th 10:30-5, Sun. 12-6; Admission: $3 adults, $1.50 students
Visitors: General public, Students, Ethnic community
Operating budget: $600,000
Publications: *Yeshiva University Museum Newsletter*, 1987- , semi-annual; *Yeshiva University Museum Calendar of Events*, 1985- , semi-annual. Also publishes books on Jewish religious life, history, contributions and culture; exhibition catalogs and brochures.

Collections: 1,500 books, periodicals, 950 artifacts and realia, 930 works of art, and archival materials (personal papers and correspondence, pictorial materials, manuscripts, and oral histories). The collection is cataloged.

Comments: This teaching museum interprets Jewish life as it is reflected in the arts, history, and sciences. Students provide programs for children and adults. Programs include guided tours, educational lectures, exhibits, loans, school presentations, speakers, performing arts presentations, films, crafts classes, and a souvenir shop.

YIVO INSTITUTE FOR JEWISH RESEARCH Library
 1048 Fifth Ave. Archives
 New York, NY 10028 212-535-6700; Fax 212-734-1062

Contact: Allan Nadler, Interim Dir.
Founded: 1925; Scope: National
Availability: Open to the public; Admission: Free
Visitors: General public, Ethnic community
Staff: 35; Operating budget: $1,850,000
Publications: *News of the YIVO*, quarterly; *Yidishe Shprakh*, annual; also publishes books and serials.

Collection: 320,000 books, periodicals, and 22,000,000 archival records (unpublished papers, manuscripts, etc.) pertaining to Ashkenazic Jewish life in Europe and the U.S.

Comments: The purpose is to collect information and materials, conduct research related to the history of the Jews of Eastern Europe and their descendants, and preserve the Jewish cultural heritage.

YUGNTRUF-YOUTH FOR YIDDISH Library
 200 W. 72nd St., Rm. 40 Archives
 New York, NY 10023 212-989-0212; Fax 212-799-1517

Personnel: Elinor Robinson, Editor-in-Chief
Contact: Binyumenm Schaechter, Coord. of Activities
Founded: 1964; Scope: International
Availability: Open by special appt.; Admission: Free
Visitors: General public, School groups, Ethnic community
Staff: 1 pt, 1 salaried, 5 volunteers; Operating budget: $15,000
Publications: *Yugntruf Magazine*, 1964- , quarterly; also publishes books.

Collection: Over 1,000 books on Yiddish history, religion, and literature; over 1,000 periodicals, and archives (personal papers and correspondence). The collection is not cataloged.

Comments: The object is to preserve Yiddish literature, language, and cultural heritage for the young people. Programs include educational lectures, speakers, a Yiddish play group/school, an annual week-long Yiddish retreat, participation in ethnic festivals, and conversation and reading circles.

K

KOREAN AMERICAN RESOURCES

(*See also* Asian American Resources)

THE ASSOCIATION FOR KOREAN STUDIES Library
 30104 Tranquila Ave.
 Rancho Palos Verdes, CA 90274 310-544-1267

Contact: John Song, Pres.
Founded: 1975; Scope: National
Staff: 3
Publications: *Korean Communities in the U.S.*; also publishes books (*Korean Community in America: Today and Tomorrow*) and research reports.

Collection: Monographs and periodicals

Comments: Researches Korean life and culture; provides lectures and seminars.

KOREAN AMERICAN COALITION Library
 610 S. Harvard, Suite 111
 Los Angeles, CA 90005 213-380-6175; Fax 213-380-7990

Contact: Jerry Yu, Pres.
Founded: 1983; Scope: National
Availability: Open by appt.; Admission: Free
Visitors: General public, Ethnic community
Staff: 1; Operating budget: $50,000
Publications: *KAC Newsletter*, monthly

Collection: Books on issues related to Korea and the Korean-American community.

Comments: Disseminates information on the Korean American community and Korean history and culture. It conducts educational lectures and seminars.

KURDISH AMERICAN RESOURCES

KURDISH HERITAGE FOUNDATION OF AMERICA Museum
(Formerly Kurdish Program) Library
 345 Park Place Archives
 Brooklyn, NY 11238 718-783-7930; Fax 718-398-4365

Contact: Dr. Vera Beaudin Saeedpour, Dir.
Founded: Library (1986) Museum (1988)
Availability: Open 10-3 M-Th; Admission: Free/Donation
Visitors: General public, Ethnic community
Staff: 3 volunteers; Operating budget: $25,000
Publications: *The International Journal of Kurdish Studies* (formerly *Kurdish Times*),
1986- , semi-annual; *Kurdish Life*, 1991- , quarterly; also publishes monographs
(*Kurdish Proverbs*).

Collection: Ca. 2,000 books, 200 videos, 400 audiocassettes, photographs, ca. 600
artifacts (costumes, jewelry, carpets), and archival materials (personal papers and
correspondence, pictorial materials, theses and dissertations, and oral histories). The
collection is cataloged; a reading room and copying facilities are available.

Comments: The purpose is to collect, preserve, and study Kurdish history, culture, and
contemporary affairs. Programs and services include educational lectures, school
presentations, speakers, dance performances, and films.

L

LAOTIAN AMERICAN RESOURCES
(*See also* Asian American Resources)

LAOTIAN CULTURAL AND RESEARCH CENTER Library
 1413 Meriday Lane
 Santa Ana, CA 92706 714-541-4533

Contact: Seng Chidhalay, Pres.
Founded: 1983; Scope: National
Availability: Open to the public; Admission: Free
Visitors: General public, Ethnic community
Publications: *Lao Samphanh News*, bimonthly

Collection: Over 500 books and documents that illustrate Laotian history and culture.

Comments: The purpose of the center is to collect documents which preserve the history and culture of Laos. It sponsors an annual conference.

LATIN AMERICAN RESOURCES
(*See also* Cuban American, Hispanic American, Mexican American, Portuguese American, Puerto Rican American, and Spanish American Resources)

ARIZONA STATE UNIVERSITY Library
CENTER FOR LATIN AMERICAN STUDIES Archives
 Tempe, AZ 85287-2401 602-965-5127; Fax 602-965-6679

Personnel: Dr. L. Teresa Valdivieso, Interim Dir.
Contact: Santa Ann Young
Founded: 1965; Scope: Local, State, Regional, National, International
Availability: Open to the public; Admission: Free
Visitors: General public, School groups, Ethnic community
Staff: 5 (2 ft, 3 pt, salaried)
Publications: Books; monographs; newsletters; *Cosas de Aqui y de Alla*, 1989- , semiannual; *Noticias*, 1989- , annual; *Anuncios Estudiantiles*, 1989- , semiannual.

Collection: Ca. 200 periodicals, ca. 200 artifacts, works of art, 53 magazine files of archival materials. The collection is not cataloged; a reading room and copying facilities are available.

CENTER FOR LATINO STUDIES
(Formerly Instituto de Estudios Puertoriquenos)
 Brooklyn College
 2900 Bedford Ave.
 Brooklyn, NY 11210 718-951-5661/4196

Sponsoring organization: Brooklyn College
Personnel: Dr. Virginia Sanchez
Contact: Dr. Hector Carrasquillo
Founded: 1969; Scope: State
Availability: Restricted access; Admission: Free
Visitors: General public
Staff: 1 ft, 1 pt

Collection: Books and archival records; the collection is cataloged.

Comments: Promotes knowledge of Latino culture and experience through facilitating research on the socio-cultural, political, economic, and historical developments of Latin America and the Caribbean cultures and their emigrant groups in the United States. The center also functions as a resource center for the Brooklyn College community. Special services and programs include symposia, seminars, lectures, media presentations, and special speakers.

CENTRO CULTURAL DE LA MISION
 2868 Mission St.
 San Francisco, CA 78211 415-821-1155; Fax 415-821-7268

Sponsoring organization: San Francisco Arts Commission
Personnel: Mr. Juan Pablo Gutierrez, Gallery Dir.
Contact: Mr. Rene Castro, Artistic Dir./Archivist
Founded: 1977; Scope: Local, State, Regional, National, International
Availability: Open to the public (archives open by special appt. only)
Admission: Donation/Free
Visitors: General public, School groups, Ethnic community
Staff: Ft; Operating budget: $680,000
Publications: *La Voz*, 1992- , quarterly (published in English and Spanish); also numerous designs of limited edition books, serigraphs, album covers, exhibition catalogs, etc.

Collection: Works of art and archives (printed and pictorial materials). The collection is cataloged; copying facilities are available.

Comments: The goal is to promote, preserve, and develop Latino cultural values through art. The center presents the living traditions and experiences of Chicano, Mexican, Central American, South American, and Caribbean peoples. Services include guided tours, educational lectures, loans and presentations to schools, TV programs, speakers or resource people, performing arts presentations (dance, drama, instrumental), crafts classes, and an arts and crafts souvenir shop. The center participates in local ethnic festivals, and provides work experience for college credit and in-service programs for teachers.

DOCUMENTATION EXCHANGE
(Formerly Central America Resource Center)
 2520 Longview #408
 Austin, TX 78705 512-476-9841

Personnel: Jill McRae, Exec. Dir.
Contact: Charlotte McCann, Libn., P. O. Box 2327, Austin, TX 78768
Founded: 1983; Scope: National
Availability: Open by special appt.; Admission: Free
Visitors: General public
Staff: 11 (5 ft, 3 pt, 3 volunteers); Operating budget: $250,000
Publications: *Central America NewsPak*, 1986- , biweekly; *Mexico NewsPak*, 1993- ,
biweekly.

Collection: Ca. 1,000 books, over 200 periodical titles, and a clipping service from
U.S. and Latin American newspapers and magazines from 1979 to the present. The
collection is partially cataloged; a reading room and copying facilities are available for
researchers.

Comments: The Documentation Exchange is a national, nonprofit clearinghouse of
information on refugees emphasizing Central America and Central Americans in the
U.S. It distributes materials and provides services related to human rights and
refugees, and collects information related to political asylum seekers worldwide.

MISSION CULTURAL CENTER Museum
 2868 Mission
 San Francisco, CA 94110 415-821-1155

Personnel: R. Gilberto Osorio, Pres. Bd. of Dirs.
Contact: Barbara Bustillos-Armijo, Exec. Dir.
Founded: 1978 Scope: Local, State
Availability: T-F 1-8:30, Sat. 10-4; Admission: Free
Visitors: General public, Ethnic community
Publications: Calendar, quarterly

Collection: Modern Latino art exhibits

Comments: The purpose is to promote Latin American culture and the work of Latino
artists. Activities include guided tours, lectures, audiovisual presentations (films),
music and dance performances, exhibits, and programs for children and college
students.

LATVIAN AMERICAN RESOURCES

AMERICAN LATVIAN ASSOCIATION IN THE UNITED STATES Museum
(Formerly Latvian Studies Center) Library
 P. O. Box 4578
 Rockville, MD 20849 301-340-1914; Fax 301-762-5438

Contact: Anita Terauds, Secy.-Genl.
Founded: 1951; Scope: National
Availability: Open by appt.; Admission: Free
Visitors: General public, Ethnic community
Staff: 4; Operating budget: $450,000
Publications: *Ala Zinas*, quarterly; *Latvian Dimensions*, quarterly.

Collection: 10,000 books, audio, recordings, films, and artifacts.

Comments: The purpose of the organization is to unite Latvian Americans and to provide information about Latvian history and culture. It also sponsors research through the Latvian Studies Center. Services include continuing education programs.

LATVIAN CENTER GAREZERS INC. Museum
 57732 Lone Tree Rd. Library
 Three Rivers, MI 49093 616-244-5441; Fax 616-244-5449 Art Gallery

Sponsoring organization: Latvian churches, welfare organizations, etc.
Personnel: Arvids Strals
Contact: G. Strautnieks
Founded: 1965; Scope: Regional, National
Availability: Open, with restricted access; Admission: Donation
Visitors: Ethnic community
Staff: Volunteers

Collection: Books, artifacts, works of art. The collection is cataloged; a reading room is available.

Comments: The purpose is to preserve Latvian history and culture and to provide educational opportunities to Latvian Americans. Programs include school presentations, performing arts presentations, and support of research at the graduate and undergraduate levels.

LATVIAN CHOIR ASSOCIATION OF THE U.S. Archives
 7886 Anita Dr.
 Philadelphia, PA 19111 215-725-6953

Contact: Arija Sulcs, Vice Pres.
Founded: 1958; Scope: National
Availability: Not open to the public
Publications: *Latvju Muzika*, annual

Collection: Archival records (biographical materials on members)

Comments: The Latvian cultural heritage is preserved through festivals of Latvian music.

THE LATVIAN MUSEUM Museum
 400 Hurley Ave., P.O. Box 432
 Rockville, MD 20854 301-340-1914

Sponsoring organization: American Latvian Association in the United States, Inc.
(ALA)
Personnel: Mrs. Anna Zadins, Dir.
Contact: Lilita Bergs, 164 Pine St., Corning, NY 14830 (607) 936-1044
Founded: 1978; Scope: National, International
Availability: Open by special appt. only; Admission: Free
Visitors: General public, School groups, Ethnic community
Operating budget: $7,000
Publications: Brochures and promotional materials

Collection: Over 700 artifacts, textiles, numismatics, philately, decorative arts, tools,
photographs, and 2 boxes of archives (personal papers and correspondence, theses and
dissertations, manuscripts). The collection is accessioned; an unpublished guide and
copying facilities are available.

Comments: There are permanent chronologically arranged exhibitions of Latvian
prehistory, history, material and folk culture, immigration to the U.S., and life in
America. There are also temporary exhibits on current events and specific aspects of
Latvian culture. Services include guided tours, school presentations, and speakers.

LIBRARY OF THE AMERICAN NATIONAL Library
LATVIAN LEAGUE IN BOSTON Archives
 58 Irving St.
 Brookline, MA 02146 617-522-4426

Contact: Arturs Norietis, Libn. and Archivist
Founded: 1927; Scope: Local
Availability: Open to the public; Admission: Free
Visitors: Ethnic community
Staff: 14 volunteers; Operating budget: $1,000
Publications: Annual reports

Collection: 3,900 books, 900 periodical titles, 4 boxes of archival materials
(unpublished records, pictorial materials, minutes of meetings of organizational and
board meetings). A reading room is available.

Comments: Latvian language materials are available to the Latvian-speaking
community. Literary evenings and exhibits are devoted to particular authors. The
library participates in ethnic festivals and Latvian exhibits at the Boston Public Library.

WESTERN MICHIGAN UNIVERSITY Library
LATVIAN STUDIES CENTER LIBRARY Archives
 1702 Fraternity Village Dr.
 Kalamazoo, MI 49006 616-343-1922 or 616-343-0254

Personnel: Valdis Huizners, Pres.; Arnold Sildegs, Art Curator
Contact: Maira Bundza, Libn.
Founded: 1983; Scope: International
Availability: Open to the public; Admissio. Free
Visitors: General public, Ethnic community

Staff: 3 (1 ft, 2 volunteers); Operating budget: $35,000
Publications: *LSC News*, 1990- , annual; annual report; subject holdings lists.

Collection: 30,900 books, 949 periodical titles, 1,000 audiovisual titles, 665 works of art, and 250 boxes of archives (personal papers and correspondence, pictorial materials, theses and dissertations, manuscripts). Newspapers are included on 268 microfilms. An unpublished guide, reading room, and copying facilities are available.

Comments: The goals are: to support the Latvian Studies Program at Western Michigan University, to support research for scholars, to provide reference service to the Latvian community, and to preserve materials relating to Latvia and Latvians.

LITHUANIAN AMERICAN RESOURCES

ALKA-AMERICAN LITHUANIAN CULTURAL ARCHIVES <u>Museum</u>
 37 Marycrest, P.O. Box 608 <u>Library</u>
 Putnam, CT 06260 203-928-5197 <u>Archives</u>

Sponsoring organization: Lithuanian Catholic Academy of Sciences
Personnel: Rev. Rapolas Krasauskas, Curator, Libn.
Contact: Juozas S. Kriauciunas, Pres./Curator, 31 Sayles Ave.,
Putnam, CT 06260
Founded: 1922 Incorporated: 1972; Scope: National
Availability: Open by special appt. only; Admission: Free, Donation
Visitors: Ethnic community
Staff: 1 salaried; 3 volunteers; Operating budget: $18,000
Publications: *ALKA* (brochure in Lithuanian describing the collections)

Collection: Ca. 50,000 books, 500 periodicals, audiovisual materials, 1,000 artifacts, 300 works of art, 250 shelves plus 100 boxes and 500 files of archives (personal papers and correspondence, unpublished records, pictorial materials, theses and dissertations, manuscripts, oral histories, and runs of two leading newspapers on microfilm). A reading room and copying facilities are available.

Comments: Preserves materials for scholars on Lithuanian history, culture, and experience. Guided tours are provided; the organization participates in ethnic festivals.

AMERICAN LITHUANIAN MUSICIANS ALLIANCE <u>Library</u>
(Formerly American Lithuanian Organist Musicians Alliance) <u>Archives</u>
 7310 S. California Ave.
 Chicago, IL 60629 312-737-2421

Personnel: Faustas Strolis, Pres.
Contact: Anthony P. Giedraitis, Admin.
Founded: 1911; Scope: National, International
Availability: Open by appt.; Admission: Free
Visitors: General public, Ethnic community
Staff: 13 volunteers

Publications: *Muzikos Zinios* (Music News), 1913- , semiannual; annual report.

Collection: 30,000 books, periodicals, musical compositions, and items related to Lithuanian musicology and archives (biographical records of Lithuanian American musicians). The collection is cataloged; a published guide and reading room are available.

Comments: The organization preserves the Lithuanian heritage through Lithuanian church and other music, music literature, and folklore. It encourages writing of new Lithuanian music, and sponsors seminars, concerts, and conferences related to music.

BALZEKAS MUSEUM OF LITHUANIAN CULTURE Museum
 6500 S. Pulaski Road Library
 Chicago, IL 60629 312-583-6500; Fax 312-582-5133 Archives
 Art Gallery

Contact: Stanley Balzekas, Pres.
Founded: 1965; Scope: Local, State, Regional, National, International
Availability: Open M-Th, Sat.-Sun. 10-4, F 10-8; Admission: Fee
Visitors: General public
Staff: 30 (6 ft, 8 pt, 6 salaried; 16 volunteers); Operating budget: $300,000
Publications: *Lithuanian Museum Review*, 1967- , bimonthly; *Genealogy*, 1990- , quarterly.

Collection: 30,000 books, periodicals, audiovisual materials, artifacts, works of art, and 50,000 archival materials (personal papers and correspondence, unpublished records, pictorial materials, manuscripts). Some records are in microform. The collection is cataloged; a published guide, reading room, and copying facilities are available.

Comments: The museum gives public lectures about Lithuania and Lithuanian immigration to and experience in the United States. It gives guided tours, educational lectures, loans and presentations to schools, speakers, dance performances, films and AV productions, crafts classes, and maintains a souvenir shop. It also participates in ethnic festivals, supports research, and provides in-service workshops and programs for teachers.

BUDRYS LITHUANIAN PHOTO LIBRARY, INC. Archives
(Formerly Lithuanian Photo Library, Inc.)
 2345 W. 56th St.
 Chicago, IL 60636 708-749-2843

Personnel: Archivist; Milda Budrys, Chairman of the Bd.; Anuydas Reneckis, Filmmaker
Contact: Algimantas Kezys, Pres., Archivist, 4317 S. Wisconsin Ave., Stickney, IL 60402
Founded: 1966 Incorporated: 1976; Scope: National
Availability: Open by special appt. only; Admission: Donation
Visitors: General public
Staff: 3 volunteers; Operating budget: $6,000
Publications: 25th anniversary brochure; catalogs of various shows.

Collection: Ca. 1,500 audiovisual materials, 20 file drawers and 30 boxes of archival materials (pictorial materials). The collection is partially cataloged; a published guide and copying facilities are available.

Comments: The purpose is to collect, classify, publish and disseminate photographs that document Lithuanian history and culture in the United States.

LITHUANIAN-AMERICAN MUSEUM CHARITABLE TRUST Museum
MUSEUM OF THE CITY OF LAKE WORTH
 414 Lake Ave., City Hall Annex
 Lake Worth, FL 33460 407-586-1700; Fax 407-586-1750

Contact: Helen Vogt Greene, Curator-Historian
Founded: 1980; Scope: Local
Availability: Open to the public; Admission: Free
Visitors: General public, School groups, Ethnic community
Staff: 12 (1 ft, salaried; 11 volunteers); Operating budget: $20,000 plus donations
Publications: Annual report; formal budgets; articles contributed to local newspapers.

Collection: Artifacts (including amber, eggs, dolls, etc.), works of art, and 450 square ft. of archival materials (printed and pictorial materials). The collection is cataloged; a reading room and copying facilities are available.

Comments: The museum houses a permanent exhibit of Lithuanian history and culture as part of the history and cultural heritage of the City of Lake Worth.

LITHUANIAN-AMERICAN R.C. WOMEN'S ALLIANCE Archives
(Formerly American-Lithuanian R.C. Women's Alliance)
 45 Windsor Dr.
 Oak Brook, IL 60521 708-573-0066

Contact: Mrs. Dale Murray, National Pres., 3005 N. 124th St., Brookfield, WI 53005
Founded: 1914; Scope: National
Availability: Open by special appt. only; Admission: Donation
Visitors: General public
Publications: _Women's Field_ (Moteru Dirva), 1916- , annual)

Collection: Materials are housed at the American Lithuanian Catholic Archives, Putnam, CT and the Balzekas Museum, Chicago.

Comments: The purpose is to preserve the Lithuanian heritage and culture; the organization participates in ethnic festivals.

LITHUANIAN CATHOLIC PRESS SOCIETY, INC. Archives
 4545 W. 63rd St.
 Chicago, IL 60629 312-585-9500; Fax 312-585-8284

Contact: Pijus V. Stoncius, General Mgr.
Founded: 1909; Scope: International

Availability: Open, with restricted access; Admission: Donation
Visitors: Ethnic community
Publications: *Lithuanian Daily Friend*, 1909- , 5/wk; also publishes books.

Collection: 3,000 books, 15 periodicals, archival records (printed materials). Some periodicals are in microform. The collection is not cataloged; a reading room and copying facilities are available for researchers.

Comments: The society maintains archival copies of its daily newspaper and other items (including the more than 1,000 books it has published).

LITHUANIAN CATHOLIC RELIGIOUS AID, INC. Archives
 351 Highland Blvd.
 Brooklyn, NY 11207 718-647-2434; Fax 718-827-6646

Contact: Ruta Virkutis, Exec. Dir.
Founded: 1954; Scope: International
Availability: Open by special appt.; Admission: Free
Publications: *Catholic Lithuania Update* (Zinios), quarterly

Collection: Books, periodicals, and archival materials (personal papers and correspondence, unpublished records, pictorial materials, and manuscripts). The *Chronicle of the Catholic Church in Lithuania* is in microform. The collection is not cataloged; a reading room and copying facilities are available.

Comments: The organization's primary purpose is to provide aid to the Catholic Church in Lithuania. Archival material pertains mainly to human rights and religious freedom in Lithuania and the former Soviet Union. Services include speakers.

LITHUANIAN CULTURAL CENTER, INC.-MACEIKA LIBRARY Library
 355 Highland Blvd.
 Brooklyn, NY 11207-19110 718-235-8386

Contact: Walter Sidas, Dir., 28 Dorado Court, Wilton, CT 06897
Founded: 1975; Scope: Local, State, Regional
Availability: 1st Sun. of month (12-2) and by appt.; Admission: Free
Visitors: Ethnic community
Staff: 2 volunteers

Collection: Ca. 6,500 books and periodicals. The collection is cataloged; a reading room is available for researchers.

Comments: The objective is to maintain a lending library of Lithuanian books and periodicals for the Lithuanian community in the New York area. Offers guided tours.

LITHUANIAN CULTURAL MUSEUM Museum
 37 N. Broad Mountain Ave. Library
 Frackville, PA 17931

Sponsoring organization: Knights of Lithuania

Personnel: Anna K. Wargo, Treas.
Contact: Eleanor Vaicaitas, Pres., 206 S. Line St., Fracksville, PA 17931
Founded: 1982; Scope: Local, Regional
Availability: Open by special appt. only; Admission: Free
Visitors: General public, School groups, Ethnic community
Staff: Volunteers; Operating budget: $2,000

Collection: Books, periodicals, artifacts, works of art. The collection is cataloged; a reading room is available.

Comments: The objective is to preserve artifacts and books of early Lithuanian immigrants who settled in the anthracite coal region. Services offered by the museum include guided tours, school presentations, crafts classes, and a crafts/souvenir shop.

LITHUANIAN MUSEUM <u>Museum</u>
 5620 S. Claremont Ave.
 Chicago, IL 60636 312-434-4545; Fax 312-434-9363

Sponsoring organization: Lithuanian Research and Studies Center, Inc.
Personnel: Dr. John A. Rackauskas, Pres.; Nijole Mackevicius, Dir. of Museums;
Contact: Arunas Zailskas, Dir. of Research Services
Founded: 1989; Scope: National, International
Availability: Open to the public; Admission: Free
Visitors: General public
Staff: 3 volunteers
Publications: Guide to showcase displays

Collection: Books, periodicals, audiovisual materials, 1,500 artifacts, works of art, and archives (unpublished records, pictorial materials, and manuscripts). A published guide and reading room are available.

Comments: The objective is to collect and preserve works of art and artifacts pertaining to all aspects of Lithuania and Lithuanians in the United States. Materials cover Lithuanian history and culture, agriculture, weaving, music, numismatics, philately, fine and folk art, the Lithuanian armed forces, as well as the lives of selected individuals. Services include guided tours and educational lectures.

LITHUANIAN MUSEUM OF ART, INC. <u>Museum</u>
 14911 127th St. <u>Art Gallery</u>
 Lemont, IL 60439 708-257-8787; Fax 708-257-5852

Sponsoring organization: Lithuanian Foundation, Inc.
Contact: Daria E. Slenys, Dir.
Founded: 1987; Scope: National
Availability: Open to the public; Admission: Free/Donation
Visitors: General public, School groups, Ethnic community
Staff: 5 volunteers; Operating budget: $24,000

Collection: 500 works of art, 15 sq. ft. of archives (printed and pictorial materials). The collection is not cataloged; an unpublished guide and reading room are available.

Comments: The purpose is to exhibit works of art (paintings and sculpture) by Lithuanian artists. Services include guided tours, educational lectures, school presentations, in-service programs for teachers, and an art gift shop.

LITHUANIAN NATIONAL LIBRARY Library
 851-853 Hollins St.
 Baltimore, MD 21201

Personnel: Genovaite Aastra, Pres.; Juze Janciene, V. Pres.; Juozas Bradunas, Secy.; Vale Patlaba, Libn.
Contact: Marija Patlaba, Treas., 3350 Benzinger Rd., Baltimore, MD 21229
Founded: 1891; Incorporated: 1908; Scope: Local, State, Regional, National, International
Availability: Open, restricted access; Admission: Free
Visitors: General public, Ethnic community
Staff: 5 volunteers

Collection: 2,500 books, periodicals, audiovisual materials, artifacts, works of art, 20 boxes of archives (personal papers and correspondence, pictorial materials, theses and dissertations, manuscripts). The collection is cataloged; copying facilities are available.

Comments: The purpose is to preserve and provide information about Lithuanian and Lithuanian Americans, including genealogical information. The library provides school presentations and participates in ethnic festivals.

LITHUANIAN RESEARCH AND STUDIES CENTER, INC. Museum
 5620 South Claremont Ave. Library
 Chicago, IL 60636 312-434-4545; Fax 312-434-9363 Archives

Personnel: Dr. John A. Rackauskas, Pres.; Dr. Adolfas Damusis, Chairman of the Bd.;
Dr. Robert A. Vitas, Exec. V. Pres. and Treas.
Contact: Arunas Zailskas, Dir. of Research Services
Founded: 1981; Scope: National, International
Availability: Open to the public, restricted access; Admission: Free
Visitors: General public, School groups, Ethnic community
Staff: 28 (3 ft, 5 pt, 8 salaried; 20 volunteers)
Operating budget: $175,000
Publications: Monographs and periodical reprints

Collection: 100,000 books, 1,600 periodical titles, maps and posters, ca. 1,500 artifacts, ca. 750 works of art, several rooms of archives (personal papers and correspondence, unpublished records, pictorial materials, theses and dissertations, manuscripts, oral histories). The books are cataloged; a published museum guide, reading room, and copying facilities are available.

Comments: The center created the first "free Lithuanian" historical exhibit shown at the Museum of Lithuanian History and Ethnography in the Lithuanian capital. In exchange, the center hosted a special ethnographic exhibit from Vilnius in various cities in the U.S. and Canada. The center supports the research of scholars and

bibliographers. It provides guided tours, educational lectures, speakers, and participates in ethnic festivals.

LITHUANIAN SCOUTS ASSOCIATION, INC. Museum
 233 Coe Road Archives
 Clarendon Hills, IL 60514 708-325-3575

Personnel: John Paronis; A. Milasius
Contact: S. Miknaitis
Founded: 1918; Scope: National
Availability: Open by special appt. only
Visitors: Troop leaders
Staff: 20 (10 pt, 10 volunteers); Operating budget: $2,000
Publications: *Echoes of Scouts*, 1992- , 10/yr; *Scouting*, 1992- , quarterly; other periodical titles.

Collection: Books, periodicals, audiovisual materials, artifacts, and 150 boxes of archival materials (personal papers and correspondence, unpublished records, pictorial materials, manuscripts, oral histories). The collection is cataloged; an unpublished guide is available.

Comments: The purpose is to educate youth of Lithuanian descent and to teach them scouting principles. Services include educational lectures, and speakers; the association participates in ethnic festivals.

LITHUANIAN WORLD ARCHIVES Library
 5620 S. Claremont Ave. Archives
 Chicago, IL 60636 312-434-4545; Fax 312-434-9363

Sponsoring organization: Lithuanian Research and Studies Center, Inc.
Personnel: Dr. John A. Rackauskas, Pres.; Ceslovas Grincevicius, Dir. of Archives;
Magdalena Stankunas, Dir. of Art Archives
Contact: Arunas Zailskas, Dir. of Res. Services
Founded: 1950; Scope: National, International
Availability: Open to the public; Admission: Free
Visitors: General public
Staff: 5 volunteers

Collection: 100,000 books, 1,600 periodical titles, over 600 maps and posters, over 300 audiovisual materials, and 1,620 linear ft. of archival materials (unpublished records, printed and pictorial materials, theses and dissertations, manuscripts). The collection is cataloged; a reading room and copying facilities are available for researchers.

Comments: The archives was established in order to collect, preserve, and make accessible documentation of Lithuanian cultural, civic, and other activities.

SISTERS OF ST. CASIMIR LITHUANIAN CULTURE MUSEUM Library
 2601 W. Marquette Road Archives
 Chicago, IL 60629 312-776-1324

Sponsoring organization: Sisters of St. Casimir of Chicago
Personnel: Sister Christella Danish, Archivist
Contact: Sister M. Perpetua Gudas, Museum Curator and Libn.
Founded: 1935; Scope: National
Availability: Open by special appt. only; Admission: Free
Visitors: General public
Staff: 1 ft, 3 pt

Collection: 5,000 books, 150 periodicals, 80 audiovisual materials, 250 artifacts, 30 works of art, and archives (personal papers and correspondence, community records). The collection is cataloged; a reading room and copying facilities are available.

Comments: The collection preserves the Lithuanian heritage of members of the community and diocese.

SISTERS OF ST. FRANCIS OF THE PROVIDENCE OF GOD Archives
(Formerly Lithuanian Sisters of the Third Order of St. Francis)
 Grove & McRoberts Rds.
 Pittsburgh, PA 15234 412-882-9911; Fax 412-882-3231

Sponsoring organization: Roman Catholic Church, Diocese of Pittsburgh
Personnel: Sister Mary Jaskel, Archivist; Sister M. Gregoria Bernott, Asst. Archivist
Founded: 1922; Scope: Regional
Scope: Local, State, Regional, National, International
Availability: Open by special appt. only; Admission: Free
Visitors: Ethnic community
Staff: 4 (2 ft, 2 pt)
Publications: Annual report

Collection: Books, periodicals, 1,000 audiovisual materials, artifacts, works of art, and 130 bankers boxes, 45 documents boxes, and 3 file drawers of archives (personal papers and correspondence, theses and dissertations, pictorial materials, manuscripts, oral histories). The collection is partially cataloged; copying facilities are available.

Comments: Some materials were used by sisters who taught Lithuanian to adults who wanted to preserve their ethnic language and heritage. Services included are guided tours, educational lectures, loans to educational institutions, speakers or resource people, and an arts and crafts/souvenir shop. The organization participates in ethnic festivals.

ZILEVICIUS-KREIVENAS LITHUANIAN MUSICOLOGY ARCHIVE Library
 5620 S. Claremont Ave. Archives
 Chicago, IL 60636 312-434-4545; Fax 312-434-9363

Sponsoring organization: Lithuanian Research and Studies Center, Inc.
Personnel: Dr. John A. Rackauskas, Pres. (LRSC); Kazys Skaisgirys, Dir.; Juozas Sodaitis, Archivist; Charles Sable, Curator of Recordings
Contact: Arunas Zailskas, Dir. of Research Services
Founded: 1984; Scope: National, International
Availability: Open by special appt. only; Admission: Free

Visitors: General public
Staff: 4 volunteers

Collection: Books, periodicals, audiovisual materials, artifacts, and over 1,600 linear ft. of archives (unpublished records, pictorial materials, manuscripts, scores, sheet music, bound music, recordings). The collection is cataloged; an unpublished guide, reading room, and copying facilities are available.

Comments: The collection is the largest Lithuanian musicological resource outside of Lithuania. It serves researchers and musicologists, as well as individual performers, groups, and orchestras needing Lithuanian music or information on composers.

M

MACEDONIAN AMERICAN RESOURCES

MACEDONIAN PATRIOTIC ORGANIZATION (MPO)/ Museum
MACEDONIAN TRIBUNE
 124 West Wayne St.
 Fort Wayne, IN 46802 219-422-5900; Fax 219-422-4379

Personnel: Maria Ivanova Tsakova, Archivist
Contact: Virginia Nizamoff Surso, Admin. Asst.
Founded: 1922; Scope: International
Availability: Open by special appt. only; Admission: Free
Visitors: General public, Ethnic community
Staff: 5 (2 ft, 3 pt)
Publications: *Macedonian Tribune*, 1927- , biweekly

Collection: Ca. 1,500 books, periodicals, posters, audiovisual materials, artifacts,
works of art, 430 boxes of archives (personal papers and correspondence, unpublished
records, pictorial materials, manuscripts, oral histories and microform copies of the
Macedonian Tribune). The collection is partially cataloged; a reading room and
copying facilities are available.

Comments: The newspaper archives provide information about the activities of
Macedonian Americans and Macedonia. Services include guided tours, educational
lectures, school presentations, speakers, and an annual educational seminar
(Macedonian Day of Learning).

MALTESE AMERICAN RESOURCES

MALTESE AMERICAN BENEVOLENT SOCIETY Library
 1832 Michigan Ave.
 Detroit, MI 48216 313-961-8393

Contact: Joseph Micallef, Exec. Dir.
Founded: 1929; Scope: National
Availability: Open by appt.; Admission: Free
Visitors: General public, Ethnic Community
Collection: Materials on Maltese history and folklore.
Publications: *Times of Malta*, daily

Comments: The purpose is to provide scholarships for Maltese students, as well as social activities and other services to Maltese children and their families.

MEXICAN AMERICAN RESOURCES
(*See also* Hispanic American and Latin American Resources)

ARIZONA STATE UNIVERSITY Library
CHICANO RESEARCH COLLECTION Archives
(Formerly Arizona State University Chicano Studies Collection)
 Dept. of Archives & Manuscripts, University Libraries
 Arizona State University
 Tempe, AZ 85287-1006 602-965-3145; Fax 602-965-9169

Contact: Christine Marin, Archivist/Curator
Founded: 1970; Scope: International
Availability: Open to the public; Admission: Free
Visitors: General public, School groups, Ethnic community
Staff: 15 ft, 2 pt, 4 volunteers
Publications: *The Chicano Experience in Arizona* (1991); also publishes catalogs of collections.

Collection: 5,000 books, 100 periodicals, 300 audiovisual materials, archives (personal papers and correspondence, unpublished records, pictorial materials, theses and dissertations, manuscripts, and oral histories). Some records are in microform. The collection is cataloged; a reading room and copying facilities are available for researchers.

Comments: The collection was established in response to the academic needs of both Chicano students and faculty in higher education. Its purpose is to obtain works by and about Mexican Americans in the United States.

CHICANO HUMANITIES AND ARTS COUNCIL, INC. (CHAC) Archives
 4136 Tejon St. Art Gallery
 Denver, CO 80211 303-477-7733; Fax 303-433-3660

Personnel: Carmen Ramirez-Epstein, Chair/Pres.
Contact: Alberto Torres, Exec. Dir.
Founded: 1979; Scope: Local, State, Regional
Availability: Open 1-5; Admission: Free
Visitors: General public, School groups, Ethnic community
Staff: 3 volunteers; Operating budget: $100,000
Publications: *CHAC Reporter*, 1980- , monthly; annual report

Collection: Books, periodicals, audiovisual materials, paintings and other works of art, photographs, posters, and archives (personal papers and correspondence, unpublished records, pictorial materials, and manuscripts). The collection is not cataloged.

Comments: This nonprofit organization is dedicated to promotion and preservation of

Chicano/Latino art, culture, and humanities in the Colorado Rocky Mountain region.

CHICANO RESOURCE CENTER (CRC) Library
 4801 E. Third St. Archives
 Los Angeles, CA 90022 213-263-5087

Sponsoring organization: Los Angeles County Library
Contact: Luis Pedroza, Dir./Libn.
Founded: 1976; Scope: Local
Availability: Open to the public; Admission: Free
Visitors: General public
Staff: 3 (2 ft, 1 pt)
Publications: Catalog of collections

Collection: 70,000 books, 20,000 periodicals, 3,000 audiovisual materials, artifacts and realia, works of art, and archives (unpublished records, theses, pictorial materials, manuscripts). Regional newspapers and periodicals are in microform. The collection is cataloged; a reading room and copying facilities are available.

Comments: Serves the information needs of the Chicano community and makes information about its history and culture available. Emphasis is on immigration, the Chicano Movement, mural art, biographies, folklore, and health. Services include educational lectures, school presentations, speakers or resource people, and films.

CHICANO STUDIES RESEARCH LIBRARY Library
 405 Hilgard Ave.
 Los Angeles, CA 90024-1380 310-206-6052; Fax 310-206-1784

Sponsoring organization: Chicano Studies Research Center
Personnel: Maria E. Castillo, Library Asst.
Contact: Richard Chabran, Libn.
Founded: 1969; Scope: Local, State, Regional, National, International
Availability: Open M-F 8-5, restricted access; Admission: Free
Visitors: General public, Ethnic community
Staff: 3; Operating budget: $11,000

Collection: Ca. 1,500 books, 500 periodicals, 200 audiovisual materials, 50 works of art, and archives (personal papers and correspondence, unpublished records, pictorial materials, theses, manuscripts, and oral histories). Some records are in microform. The collection is partially cataloged; copying facilities are available.

Comments: The library attempts to preserve Chicano history and culture and supports research at the graduate and undergraduate levels.

MEXICAN FINE ARTS CENTER MUSEUM Museum
 1852 W. 19th St.
 Chicago, IL 60608 312-738-1503; Fax 312-738-9740

Contact: Carlos Tortolero, Exec. Dir.
Founded: 1982; Scope: International

Availability: Open T-Sun. 10-5 and by special appt.; Admission: Free
Visitors: General public, School groups, Ethnic community
Staff: 37 (21 ft, 12 pt, 4 volunteers); Operating budget: $2,000,000
Publications: Exhibition catalogs

Collection: Over 500 books, over 200 periodical titles, 100 videos, slides, 100 educational artifacts, 1,000 works of art, and over 50 boxes plus 2 file drawers of archival records (personal papers and correspondence, pictorial materials). A computerized record of original works of art and some slides are in microform. The collection is partially cataloged; a reading room and copying facilities are available.

Comments: The objectives of the museum are: to stimulate and preserve knowledge and appreciation of the Mexican culture, to sponsor special events and exhibits that exemplify the visual and performing arts found in the Mexican culture, to develop a permanent collection of Mexican art, to encourage the professional development of Mexican artists, and to offer arts education programs. Services include guided tours, educational lectures, loans and presentations to schools, speakers, performing arts (dance, drama, choir, instrumental), films and AV productions, crafts classes, and a souvenir shop. The museum participates in ethnic festivals.

THE MEXICAN MUSEUM Museum
 Fort Mason Center, Bldg. D
 Laguna & Marina Blvd.
 San Francisco, CA 94123 415-441-0445; Fax 415-441-7683

Personnel: Marie Acosta-Colon, Exec. Dir.; Tere Romo, Curator, Lilia Villanueva, Deputy Dir.
Contact: Denise Morilla-Lyons
Founded: 1974; Scope: International
Availability: Open W-Sun. 12-5; Admission: $3 adults, $2 seniors, students
Visitors: General public
Staff: 9 ft, 4 pt, salaried; 20 volunteers, 4 interns; Operating budget: $1,200,000
Publications: *The Mexican Museum Newsletter*, quarterly; also publishes catalogs.

Collection: 2,250 audiovisual materials, 6,750 artifacts. The collection is not cataloged; a reading room is available.

Comments: The purpose is to preserve and exhibit Mexican and Mexican American fine arts and to continue the artistic traditions of Mexico in the United States. Activities include guided tours, lectures, school presentations, choir and instrumental presentations, films, crafts classes, and a souvenir gift shop.

PLAZA DE LA RAZA, INC. Museum
 3540 N. Mission Rd.
 Los Angeles, CA 90031 213-223-2475

Personnel: Gema Sandoval, Exec. Dir.; Rachel Pulido Oakley, Asst. Exec. Dir.; Rosemarie Cano, Dir. Programs
Founded: 1969; Scope: State, Regional, National
Availability: Open W-Sun., 12-5; Admission: Free

Visitors: General public, Ethnic community
Publications: *Celebration*, annual catalog; also publishes newsletters for members and flyers.

Collection: Folk art of Mexican American artists of Southern California

Comments: This art museum preserves Mexican American art and culture and supports the contributions of Mexican American artists. Programs and services include dance performances, films, traveling exhibitions, and arts festivals.

SAN DIEGO STATE UNIVERSITY Library
CHICANO COLLECTION, MALCOLM A. LOVE LIBRARY
 5500 Campanile Dr.
 San Diego, CA 92182-8050 619-594-4629; Fax 619-594-2700

Contact: Cecilia Puerto, Mexican-American/Latin American Studies Libn.
Founded: 1979; Scope: Local, State, Regional, National, International
Availability: Open to the public; Admission: Free
Visitors: General public, Ethnic community
Operating budget: $2,000 (for materials)

Collection: Ca. 1,250 books, 50 periodicals, and pamphlets dealing with all aspects of Chicano life and culture with particular emphasis on San Diego and Imperial County area. It includes materials on Mexico and Mexican culture of interest to Chicanos, bilingualism, race relations, other Latinos, and the third world. The collection is cataloged; an unpublished guide, reading room, and copying facilities are available for researchers.

Comments: The purpose is to support undergraduate teaching and research programs in Mexican American Studies and to serve as a multi-disciplinary source of Chicano materials for general use. Courses for college credit are available.

UNIVERSITY OF CALIFORNIA CHICANO STUDIES LIBRARY Library
 Santa Barbara, CA 93106 805-893-2756; Fax 805-961-4676

Personnel: Raquel Quiroz Gonzalez, Library Asst.
Contact: Patrick Jose Dawson, Chicano Studies Ref. Libn.
Founded: 1969; Scope: Local, State, Regional, National, International
Availability: Open to the public; Admission: Free
Visitors: General public
Staff: 7 (2 ft, 5 pt, salaried)
Publications: *Chicanos: A Checklist of Current Materials*, 1969- , biannual

Collection: 13,500 books, 250 periodicals, 830 audiovisual materials, theses and dissertations, and 8,600 archival records (pamphlets, articles, news clippings). The collection is cataloged; a reading room and copying facilities are available for researchers. Some publications are available through ERIC (Educational Resources Information Center).

Comments: Supports research and curriculum related to Mexican Americans.

MULTI-ETHNIC RESOURCES

ADOBE HOUSE MUSEUM Museum
 501 South Ash St.
 Hillsboro, KS 67063

Sponsoring organization: Hillsboro Historical Society
Contact: David F. Wiebe, Dir.; Peggy Goertzen, Chairperson
Founded: 1958; Scope: Local
Availability: Open to the public; Admission: Fee
Visitors: General public, School groups, Ethnic community
Staff: 1 ft, 4 pt, salaried; 12 volunteers; Operating budget: $30,000
Publications: Publishes books, e.g. *Hillsboro: The City on the Prairie* (1985)

Collection: 100 books, 100 periodical titles, 2,000 artifacts, archival records (printed and pictorial materials). The collection is cataloged; a reading room is available for researchers.

Comments: The Hillsboro Historical Society sponsors the Adobe House Museum, the Frisian Dutch Mill relics, the Kreutziger Country School House, and the Schaeffler House Museum in an attempt to interpret the rich Dutch/German/Russian ethnic heritage of the community. It is also involved in documenting construction of earth homes in Holland, Prussia, and Ukraine. Services include guided tours, educational lectures, loans to schools, drama and choir presentations, films and AV productions, and an arts and crafts souvenir shop. The society participates in ethnic festivals.

ALLEN COUNTY PUBLIC LIBRARY Library
 Historical Genealogy Dept. Archives
 900 Webster St., P.O. Box 2270
 Fort Wayne, IN 46802 219-424-7241 x3305; Fax 219-422-9688

Personnel: Jeff R. Krull, Lib. Dir.
Contact: Curt B. Witcher, Mgr.
Founded: 1961; Scope: Local, State, Regional, National, International
Availability: Open M-Th 9-9, F-S, 9-6, Sun. 1-6; Admission: Free
Visitors: General public, School groups, Ethnic community
Staff: 12 ft, 9 pt, salaried; 23 volunteers; Operating budget: $580,950
Publications: *Periodical Source Index* (subject guide to genealogy and local history periodicals), 1986- , annual; *French-Canadian & Acadian Genealogy: Pathfinder 1*, *English & Welsh Genealogy: Pathfinder 2, Irish Genealogy: Pathfinder 4*; *German Genealogy: Pathfinder 6*.

Collection: Over 5,000 book titles, 5,003 periodical titles, 1,280 audio cassettes, 18 video tapes, and 210 linear ft. of local archival records (personal papers and correspondence, and 251,000 items in microform related to census, military, and county records, as well as passenger lists). The genealogy collection is particularly strong in Midwestern local history, but features holdings for the entire United States and other countries, especially England, Ireland, Scotland, and Canada. The collection is cataloged; a reading room and copying facilities are available.

Comments: The Historical Genealogy Dept. will search through indexed materials for a specific person(s) for a fee ($.20/page of information). It supports undergraduate level research, provides work experience opportunities for college credit, and in-service programs for teachers. Other services include guided tours, educational lectures, school presentations, and speakers.

AMERICAN FOLKLIFE CENTER, ARCHIVE OF FOLK CULTURE Library
 Library of Congress Archives
 Washington, DC 20540-8100 202-707-5510; Fax 202-707-2076

Contact: Alan Jabbour, Dir.
Founded: 1928 Scope: National
Availability: Open M-F, 8:30-5; Admission: Free
Visitors: General public, School groups, Ethnic community, Researchers
Staff: 11 ft, 4 pt, plus interns; Operating budget: $1,120,000
Publications: *Folklife Center News*, 1978- , quarterly; also publishes catalogs of collections, promotional brochures, reference books and monographs (e.g., *Documenting Maritime Folklore: An Introductory Guide*, 1992); *Folklife Annual* 90, 1991.

Collection: Contains over 1,000,000 items in 2,000 ethnographic collections of 4,000 reference books, ca. 1,000 periodical titles, 45,000 hours of recordings, over 200,000 photos, 300 moving image titles, 200 broadsides, 200,000 pieces of ephemera, 200 maps, and over 1,000,000 archival items (personal papers and correspondence, unpublished records, pictorial materials, theses and dissertations, ca. 700,000 manuscript sheets, and oral histories). Some records are in microform. The collection is cataloged; a reading room and copying facilities are available.

Comments: This national repository of folk culture preserves the traditional knowledge, customs, music, dance, and arts and crafts passed on by each of the world's religious and cultural ethnic groups in living records.

AMERICAN PHILOSOPHICAL SOCIETY LIBRARY Library
 105 South Fifth St. Archives
 Philadelphia, PA 19106-3386 215-440-3400; Fax 215-440-3423

Personnel: Edward C. Carter, II, Libn.; Roy E. Goodman, Curator of Printed Materials
Contact: Beth Carroll-Horrocks, Manuscripts Libn.
Founded: 1743; Scope: International
Availability: Open to the public (Appt. preferred); Admission: Free
Visitors: General public
Staff: 15 ft, 5 pt, 4 volunteers
Publications: Scholarly books, monographs, and articles; also publishes promotional brochures.

Collection: Over 159,000 books, periodicals, 7,000 microfilms, 5,125,000 manuscripts, audiovisual materials, artifacts, works of art, and archival materials (personal papers and correspondence, unpublished records, printed materials, pictorial materials, theses and dissertations, manuscripts, and oral histories).

Comments: The library contains the Philadelphia Folklife Resources collection on Native American folklore, mythology, and general ethnology. It includes the personal and professional papers of Frank Boas; Irving Hallowell's papers on Algonkian myth, tales, and crafts; Paul Radin's papers on the Winnebago; as well as those of other ethnologists, Native American peoples, and other groups (e.g., Irish, German, etc.).

AMERICAN SOCIETY FOR ETHNOHISTORY Library
(Formerly American Indian Ethnohistoric Conference) Archives
 The Newberry Library
 60 West Walton St.
 Chicago, IL 60610-3305

Personnel: Ross Hassig, Editor
Contact: William O. Autry, Secy./Treas., P. O. Box 917, Goshen, IN 46526-0917
Founded: 1953
Availability: Open to the public; Admission: Free
Visitors: General public, School groups, Ethnic community
Staff: 20 volunteers; Operating budget: $62,000
Publications: *Ethnohistory*, 1953- , quarterly

Collection: Periodicals and archival materials (personal papers and correspondence, unpublished records, manuscripts). Some materials are in microform. A reading room and copying facilities are available in the Newberry Library.

Comments: The purpose is to encourage research using ethnohistoric methods and to publish the results of such studies. The society provides educational lectures, school presentations, speakers, and supports student and faculty research.

AMISTAD RESEARCH CENTER Museum
 Tilton Hall Library
 Tulane University Archives
 New Orleans, LA 70118 Art Gallery

Sponsoring organization: American Missionary Association
Personnel: Dr. Frederick Stielow, Exec. Dir.
Contact: Brenda Squarl
Founded: 1966; Scope: International
Availability: Open to the public (also has traveling exhibits); Admission: Fee
Visitors: General public, School groups, Ethnic community
Staff: 8 ft, 3 pt, 5 student aides; Operating budget: $500,000
Publications: *Amistad Chronicles*, 1993- , annual; *Amistad Reports*, 1969- , quarterly; also publishes books, catalog of collections, and a formal annual report.

Collection: 25,000 books, 330 current periodical titles, 1,000 partial runs, over 1,000 audiovisual materials, 500 works of art, and 12,000 linear ft. of archival materials (unpublished records, pictorial materials, theses and dissertations, manuscripts, and oral histories). Some records are in microform. The collection is cataloged; a published guide, reading room, and copying facilities are available.

Comments: Amistad is the nation's largest independent minority archives and the first

repository created to document the civil rights movement. Although 90% of the materials are related to African Americans, they also provide information on many other groups. The center also houses a fine Deep South African American art collection. Services include guided tours, educational lectures, loans and presentations to schools, TV programs, speakers, films and AV productions, and a souvenir shop. The center participates in ethnic festivals.

ARCHIVES OF THE ARCHDIOCESE OF BOSTON Archives
 2121 Commonwealth Ave.
 Brighton, MA 02135 617-254-0100 x108; Fax 617-783-5642

Contact: Robert Johnson-Lally, Archivist; Sandra Sudak, Asst. Archivist
Founded: 1808; Scope: Local, State
Availability: M-F, 10-4:30; appts. requested; Admission: Free
Visitors: General public
Staff: 4 (2 ft, 2 pt, salaried); Operating budget: $130,000

Collection: Ca. 5,000 cu. ft. of archives (personal papers and correspondence, unpublished records, theses and dissertations, pictures, and manuscripts). Some sacramental records and copies of *Pilot*, the diocesan newspaper, are in microform. The collection is cataloged; a guide, reading room, and copying facilities are available for researchers.

Comments: The purpose of the institutional archives of the Archdiocese of Boston is to preserve the records of the diocese and the ethnic and immigrant groups that are a part of its history (German, Irish, Italian, Polish, French-Canadian, and Korean).

ARISE! RESOURCE CENTER Library
 2117 Lyndale Ave.
 Minneapolis, MN 55104 612-871-7110

Contact: Sara Olson
Founded: 1993; Scope: Local, State, Regional, National, International Availability: Open to the public; Admission: Free
Visitors: General public, Ethnic community
Staff: Volunteers
Publications: *Arise!*, quarterly

Collection: Books, periodicals, and archival records (printed materials, oral histories). The collection is partially cataloged; a reading room is available.

Comments: The purpose is to bring international affairs related to South Africans, and Native American, Irish, and Irish Americans to the public. Services include educational lectures, school presentations, speakers, and films and AV productions. The organization participates in ethnic festivals.

ARIZONA HISTORICAL SOCIETY Museum
 Southern Arizona Division Library
 949 East 2nd St. Archives
 Tucson, AZ 85719 602-628-5774

Personnel: Dr. Stephen Harvath, Dir.; Margaret B. Harte, Head Libn.; Rose Byrne, Archivist
Contact: Susan Peters
Founded: 1884; Scope: Local, State, Regional
Availability: Open to the public; Admission: Free
Visitors: General public, School groups, Ethnic community
Staff: 22 ft, 100 volunteers
Publications: *Journal of Arizona History*, 1960- , quarterly

Collection: 50,000 books, 500 periodicals, and 3,000 cubic ft. of archives (personal papers and correspondence, unpublished records, pictures, theses and dissertations, manuscripts, and oral histories). Newspapers and Sonora Archives are on microfilm. The collection is cataloged; a reading room and copying facilities are available.

Comments: The museum, library, and education and publications departments disseminate information about a Mexican heritage project and an African American history project. Services include guided tours, educational lectures, loans and presentations to schools, speakers, performing arts presentations (dance, drama, instrumental), crafts classes, and a souvenir shop. The organization participates in ethnic festivals, supports research, provides work experience for college credit, and in-service programs for teachers.

BAKHMETEFF ARCHIVE OF RUSSIAN AND
EAST EUROPEAN HISTORY AND CULTURE Archives
 6th Flr, East, Butler Library
 Columbia University
 New York, NY 10027 212-854-3986

Sponsoring organization: Columbia University
Personnel: Michael Stanislawski, Chair, Bakhmeteff Archive Admin. Comm.
Contact: Ellen Scaruffi, Curator
Founded: 1951; Scope: International
Availability: Open to the public; Admission: Free
Visitors: General public, School groups
Staff: 1 ft, various pt; Operating budget: $40,000
Publications: *Russia in the Twentieth Century: The Catalog of the Bakhmeteff Archive of Russian and East European History and Culture* (G. K. Hall, 1987).

Collection: Ca. 2,000 linear ft. of books, periodicals, artifacts and realia, and archives (personal papers and correspondence, unpublished records, pictorial materials, manuscripts). Some collections are in microform. The collection is cataloged; a published guide, reading room, and copying facilities are available.

Comments: The purpose is to collect and make available archival records related to Russia and the Soviet Union in the 20th century and the Russia emigre communities in Europe and the United States after 1917.

THE BALCH INSTITUTE FOR ETHNIC STUDIES Museum
 18 S. Seventh St. Library
 Philadelphia, PA 19106 215-925-8090; Fax 215-922-3201 Archives

Personnel: John Tenhula, CEO, Pres.; Pamela Nelson, Acting Museum Dir.; Joseph Anderson, Lib. Dir.
Founded: 1971; Scope: National, International
Availability: Open to the public; Admission: Free/Donation
Visitors: General public, Researchers on ethnicity, race, and immigration
Staff: 22 ft, 6 pt, salaried; volunteers, interns
Publications: *New Dimensions*, semiannual newsletter

Collection: 50,000 books, periodicals, audiovisual materials, artifacts (clothing and household goods of immigrants), 6,000 reels of microfilm, 5,000 ft. of manuscripts, 35,000,000 ship manifests of 19th century immigrants, and a database of names of 1,000,000 19th century immigrants. The collection is cataloged; a guide, reading room, and copying facilities are available.

Comments: The Balch Institute is a major research institution related to ethnicity, race, and immigration. Services include guided tours, educational lectures, performing arts presentations, ethnic festivals, educational programs for children and adults, and exhibits (temporary, permanent, and traveling).

CALIFORNIA STATE UNIVERSITY FULLERTON Archives
ORAL HISTORY PROGRAM
 P.O. Box 34080
 Fullerton, CA 92634-9480 714-773-3580

Personnel: Gail Gutierrez, Archivist
Contact: Kathy Frazee, Office Mgr.
Founded: 1967; Scope: Regional
Availability: Open M-Th 10-4; Admission: Free
Visitors: General public
Staff: pt
Publications: Brochures; catalog of collections; also publishes bound interviews and books.

Collection: 800 books, 25 audiovisual materials, and archives (personal papers and correspondence, pictorial materials, newspaper clippings, diaries, photographs, theses and dissertations, manuscripts, and oral histories). Oral histories consist of 3,500 hours of tape-recorded interviews. The collection is cataloged; a guide is available.

Comments: Organized by the History Dept., the University Library, and the Patrons of the Library, the aim is to record and preserve the experiences of participants in, or eyewitnesses to, significant historical events. Ethnic groups covered include those of Japanese, Chinese, Native American, African, Swedish, and Mexican descent. Some major ethnic collections include "Camp and Community: Manzanar and the Owens Valley, 1977"; "Voices Long Silent: An Oral Inquiry into the Japanese American Evacuation"; "Manzanar Martyr: An Interview with Harry Y. Ueno"; and "Harvest of Hate," all related to Japanese Americans in World War II.

CARVER COUNTY HISTORICAL SOCIETY Museum
 119 Cherry St.
 Waconia, MN 55387 612-442-4234

Contact: Paul Scheftel Maravelas, Dir.
Founded: 1940; Scope: Local
Availability: Open to the public; Admission: Free
Visitors: General public, School groups
Staff: 14 (1 ft, 3 pt, 10 volunteers)
Operating budget: $45,000
Publications: *Annals of the Carver Co. Historical Society*, 1975- , quarterly

Collection: 700 books, 3 periodical titles, 10,000 audiovisual materials, 10,000
artifacts, and 30 boxes of archives (manuscripts). Some records are in microform. The
collection is partially cataloged; a reading room and copying facilities are available.

Comments: The society promotes and preserves the history of Carver County through
Swedish and German lending library collections (c. 1860-1900). Services include
guided tours, educational lectures, loans, and presentations to schools.

CATHOLIC ARCHIVES OF TEXAS Archives
 1600 N. Congress Ave., P.O. Box 13327, Capitol Station
 Austin, TX 78711 512-476-3715; Fax 512-476-4888

Sponsoring organization: Texas Catholic Conference
Contact: Kinga Perzynska, Archivist
Founded: 1923; Scope: State
Availability: Open to the public; Admission: Free
Visitors: General public, School groups, Ethnic community
Staff: 11 (1 ft, 2 pt, 3 salaried, 5 volunteers)
Publications: *The Journal of Texas Catholic History and Culture*, 1990- , annual;
Texas Catholic Historical Society Newsletter, 1976- , quarterly.

Collection: Books, periodicals, audiovisual materials, artifacts, and ca. 1,250 linear ft.
of archival materials (personal papers and correspondence, unpublished records,
pictorial materials, theses and dissertations, manuscripts, oral histories). Sacramental
records and Catholic and ethnic newspapers in Texas are in microform. The collection
is cataloged; an unpublished guide, reading room, and copying facilities are available.
Records and collections include sacramental records from Our Lady of Guadalupe of
the Pass of the North in Ciudad Juarez, Mexico (1734); many Mexican and Spanish
manuscripts (1519-1881), *Manuscritos de los Conventos* concerning the history of the
religious orders in Mexico, *Archivo de la Catedral de San Fernando*, *Archivo de la
Iglesia de N.S. Guadalupe de Paso del Rio del Norte*, *Archivo de la Catedral de Ciudad
Juarez*, and *Archivo de la Iglesia de San Augustin de Laredo* (1767-1989).

Comments: The archives collects and preserves for research the records pertaining to
the activities of the Catholic Church in the state of Texas including its Hispanic, Native
American, French, German, Polish, Czech, Irish, Italian, Asian, Syrian, and Lebanese
members. Church records are particularly for genealogical and ethnic studies.

CENTER FOR MIGRATION STUDIES OF NEW YORK, INC. Library
 209 Flagg Place Archives
 Staten Island, NY 10304 718-351-8800; Fax 718-667-4598

Personnel: Dr. Lydio F. Tomasi, Exec. Dir.
Contact: Diana J. Zimmerman, Head, CMS Library/Archives
Founded: 1964 Incorporated: 1969; Scope: International
Availability: Open to the public; Admission: Free
Visitors: General public, Researchers
Staff: 17 (10 ft, 4 pt, 3 volunteers); Operating budget: $500,000
Publications: *International Migration Review*, 1966- , quarterly; *Migration World*
(formerly *Migration Today*), 1973- , bimonthly; books and monographs; catalog of
collections; newsletters.

Collections: Ca. 21,000 books, 250 periodical titles, 180 newsletters, 50 audiovisual
items, 500 microfilms, 500 dissertations, 1,000 linear ft. of archives in 87 collections
(personal papers and correspondence, unpublished records, pictorial materials, theses
and dissertations, manuscripts). The collection is cataloged; a published guide, reading
room, and copying facilities are available.

Comments: The center is an educational, nonprofit institute committed to encouraging
and facilitating the study of sociodemographic, economic, political, historical,
legislative, and pastoral aspects of human migration and refugee movements. It
provides speakers, sponsors national and international conferences on immigration and
ethnic groups, and conducts research programs.

CENTER FOR THE STUDY OF ETHNIC PUBLICATIONS Library
AND CULTURAL INSTITUTIONS Archives
 Kent State University
 P.O. Box 5190
 Kent, OH 44242 216-672-2782; Fax: 216-672-7965

Sponsoring organization: Kent State University
Personnel: Dr. Lubomyr R. Wynar, Dir.
Founded: 1971; Scope: National, International
Availability: Open to the public; Admission: Free
Visitors: General public, Ethnic community, Students, Faculty, and Researchers
Staff: 1 ft, 2 pt
Publications: *Ethnic Forum: Journal of Ethnic Studies and Ethnic Bibliography*,
1980- , semiannual; also publishes books.

Collection: Ca. 4,000 books, ethnic periodicals, and archives (personal papers and
correspondence, unpublished records, pictures, theses, manuscripts, oral histories).
The collection is cataloged; a guide, reading room, and copying facilities are available.

Comments: Conducts research and bibliographic studies related to over 70 ethnic
groups in the U.S. Major objectives are to study ethnic museums, libraries, and
archives and the ethnic press. The center supports curriculum in the School of Library
and Information Science and offers work experience for college credit.

THE CENTER FOR WESTERN STUDIES Museum
 29th & Summit Library
 Box 727 Augustana College Archives
 Sioux Falls, SD 57197 605-336-4007 Art Gallery

Sponsoring organization: Augustana College
Personnel: Dr. Arthur R. Husebor, Exec. Dir.; Dean A. Schueler, Dev. Dir.
Contact: Harry F. Thompson, Curator/Managing Editor
Founded: 1970; Scope: Regional
Availability: Open to the public; Admission: Free
Visitors: General public, School groups, Ethnic community
Staff: 7 (4 ft, 1 pt, 2 volunteers)
Operating budget: $206,000
Publications: *Center for Western Studies Newsletter*, 1975- , 3/yr.; publishes books.

Collection: 30,000 books, 50 periodicals, 100 audiovisual productions, 350 artifacts, 400 works of art, and 3,000 linear ft. of archives (personal papers and correspondence, unpublished records, pictorial materials, theses and dissertations, manuscripts, oral histories), including 25 reels of microfilm. The collection is cataloged; published and unpublished guides, a reading room, and copying facilities are available.

Comments: Major ethnic groups covered are Norwegians, Germans from Russia, and Sioux Indians. The purpose is to preserve and interpret the history and cultures of the northern prairie plains. Services include guided tours, lectures, loans and presentations to schools, and speakers. The center supports research, provides in-service programs for teachers, and offers work experience for college credit. It also participates in ethnic festivals and sponsors an annual Artists of the Plains art show and sale.

CLEVELAND PUBLIC LIBRARY Library
FOREIGN LITERATURE DEPARTMENT
 325 Superior Ave.
 Cleveland, OH 44114-1271 216-623-2895; Fax 216-623-7015

Contact: Natalia Bezugloff, Head, Foreign Literature Dept.
Founded: 1869
Availability: Open to the public; Admission: Free
Visitors: General public
Staff: 6 ft, salaried
Publications: Acquisitions lists

Collection: 200,000 books, periodicals in microform. The collection is cataloged; a published guide, reading room, and copying facilities are available.

Comments: The library serves the culturally diverse communities of Cleveland with its collections of materials for and about various ethnic groups in 45 different languages.

COMPTON PUBLIC LIBRARY Library
 240 W. Compton Blvd.
 Compton, CA 90220 310-637-0202; Fax 310-537-1141

Sponsoring organization: County of Los Angeles Public Library
Contact: Joanne N. Eldridge, Community Library Manager
Founded: 1912; Scope: Local
Availability: Open to the public; Admission: Free
Visitors: General public

Staff: 37 (6 ft, 16 pt, 15 volunteers)
Operating budget: $1,000,000

Collection: Over 90,000 books, 500 periodicals, 5,000 audiovisual materials, and 100 works of art. Some newspapers and government documents are in microform. The collection is cataloged; a reading room and copying facilities are available.

Comments: The purpose of the library is to serve the predominantly African American and Mexican American public with materials purchased especially for African and Mexican Americans in a variety of formats. Services include tours, loans, and presentations to schools, radio and TV programs, speakers, films and AV productions, and crafts classes. The library participates in ethnic festivals.

CRAFT AND FOLK ART MUSEUM Museum
 6067 Wilshire Blvd. Library
 Los Angeles, CA 90036 213-937-5544; Fax 213-937-5576 Archives

Personnel: Patrick H. Ela, Exec. Dir.
Contact: Joan Benedetti, Museum Libn.
Founded: 1975; Scope: International
Availability: Open to the public; Admission: Donation
Visitors: General public, Researchers
Staff: 20 (13 ft, 6 pt, 19 salaried; 1 volunteer); Operating budget: $750,000
Publications: *CAFAM Calendar*, 1981- , quarterly; *Notes from the Edge of the Mainstream*, 1990- , irreg.; exhibition catalogs.

Collection: 6,000 books, 140 periodical titles, 2,000 craft/folk art objects, archives (unpublished records, pictorial materials, theses and dissertations, oral histories, museum histories, slides, audiotapes). The permanent collection is not on permanent display. A reading room and copying facilities are available.

Comments: The museum maintains a separate research library at 5800 Wilshire Blvd (213-934-7289); Fax 213-937-5576. Multicultural and multidisciplinary research is conducted to present exhibits that reflect the heritage and collage of groups represented in the Los Angeles community. An international Festival of Masks is held annually. Services included guided tours, educational lectures, loans and presentations to schools, speakers or resource people, crafts classes, and a souvenir shop. Work experience for college credit is available; in-service programs are offered for educators.

ETHNIC HERITAGE MUSEUM Museum
 1129 S. Main St.
 Rockford, IL 61101 815-962-7402

Personnel: Vermont Zackery, Chairman of the Bd.; Jennie Michelon, Treas.; Vances Drago, V. Pres. of the Board; Katherine Robinson, Secy.
Contact: Menroy Mills, Curator
Founded: 1986; Scope: Local
Availability: Open to the public and also by appt.; Admission: $2.00
Visitors: General public, School groups, Ethnic community
Staff: Volunteers; Operating budget: $6,500.00

Publications: Formal annual report; quarterly newsletter, 1986- .

Collection: Artifacts, works of art, and archival records (printed and pictorial materials and oral histories). The collection is cataloged; an unpublished guide and copying facilities are available.

Comments: The purpose is to maintain the culture and history of the six major nationality groups that settled in the southwest section of Rockford. Services include school presentations, radio programs, dance productions, and crafts classes. The institution participates in ethnic festivals.

THE ETHNIC MATERIALS INFORMATION EXCHANGE (EMIE) Library
 Queens College Rosenthal Library
 Ethnic Collection, Room 339
 65-30 Kissena Blvd.
 Flushing, NY 11367 718-997-3626; Fax 718-997-3753

Personnel: Sharon Bonk, Chief Libn.; Suzanne Li, Education Libn.
Contact: David Cohen
Founded: 1991; Scope: Regional
Availability: Open to the public; Available online via CUNY-Plus and OCLC
Admission: Free (Donations accepted)
Visitors: General public, School groups, Ethnic community
Staff: 3 pt; Operating budget: $5,000
Publications: *EMIE Bulletin*, 1972- , quarterly (edited by David Cohen and published by the Ethnic Materials and Information Exchange Round Table of the American Library Association in cooperation with Queens College Graduate School of Library and Information Studies).

Collection: 1,200 books (ethnic materials for the college and the community). The collection is cataloged and available online with CUNY-PLUS and OCLC; a guide, reading room, and copying facilities are available.

Comments: EMIE has connections with ALA EMIE Round Table and New York Ethnic Services Round Table. The library school and the School of Education give courses on multicultural librarianship.

EVANGELICAL LUTHERAN CHURCH IN AMERICA ARCHIVES Archives
 8765 W. Higgins Rd.
 Chicago, IL 60631 312-380-2818; Fax 312-380-2799

Contact: Elisabeth Wittman, Dir. for Archives and Chief Archivist
Founded: 1987; Scope: National
Availability: Open M-F 8:30-5:00; Admission: Free/Donations; $20 for genealogy research
Visitors: General public
Staff: 9 (3 ft, 2 pt, salaried; 4 volunteers); Operating budget: $247,219
Publications: *ELCA Archives Network News*, 1992- , 2-3/yr

Collection: 1,814 books, periodicals, 3,900 microfilm reels, 49,690 microfiche pieces,

audiovisual materials (191 linear ft. of photos, 30,610 negatives, 2,163 films, 870 filmstrips, 51 linear ft. of slides, and over 100 linear ft. of other film materials, 1,690 video recordings, 11,942 audio recordings; 126 works of art (posters, drawings, prints); 5,427.7 cubic ft. of archival records (635.4 cubic ft. of personal papers, unpublished records, pictorial materials, manuscripts, oral histories, sound and video recordings, and microfilms of official church records, congregational records, periodicals, and papers). The collection is cataloged, some in OCLC database. In-house finding aids, a published guide to predecessor archives now at the ELCA, a reading room, and copying facilities are available.

Comments: The purpose is to promote the history and heritage of the ELCA. Groups covered include German, Swedish, Finnish, Norwegian, Danish, Slovak, Icelandic, Puerto Rican, Mexican, African American, and Hungarian American. Services include guided tours, speakers or resource people, and provision of historical materials for research. Programs in conjunction with colleges and universities support research at the undergraduate and graduate levels; they also provide work experience for college credit.

THE FILSON CLUB HISTORICAL SOCIETY, INC. Museum
 1310 S. 3rd St. Library
 Louisville, KY 40208 502-635-5083; Fax 502-635-5086 Archives

Personnel: James J. Holmberg, Curator of Manuscripts; Dorothy Rush, Libn.; Mary Jean Kinsman, Curator of Photographs/Prints; Nelson Dawson, Editor of Publications
Contact: Candace Perry, Museum Mgr.
Founded: 1884; Scope: State
Availability: Open to the public; Admission: Fee
Visitors: General public, School groups, Ethnic community
Staff: 31 (16 ft, salaried; 3 pt; 12 volunteers); Operating budget: $750,000
Publications: *The Filson Club Quarterly*, 1927- , quarterly; *Connections*, 1991- , monthly; also publishes books and scholarly and genealogical materials.

Collection: Over 50,000 books and periodicals, 55,000 artifacts, 500 works of art, and 1,550 linear ft. of archival materials (personal papers and correspondence, unpublished records, pictorial materials, theses and dissertations, manuscripts, oral histories). Newspapers (including the German Louisville *Anzeiger*); census, tax, and marriage records are in microform. The collection is partially cataloged; a card catalog, reading room, and copying facilities are available.

Comments: The purpose is to preserve historical information related to the cultural diversity of the community. Black History Month, for example, has become an annual emphasis with exhibits and special programs. Additional groups covered include German, Irish, Anglo-American, French, Scotch and Native American. Services include guided tours, educational lectures, loans and presentations to schools, radio and TV programs, speakers, films and AV productions, a souvenir shop, and permanent and temporary exhibition programs.

FONDO DEL SOL VISUAL ARTS CENTER Museum
 2112 R St., NW Art Gallery
 Washington, DC 20008 202-483-2777

Personnel: Irma Talabi Francis, Deputy Dir.; Michael Auld, Chair of Bd.
Contact: Marc Zuver, Exec. Dir. and Chief Curator
Founded: 1973; Scope: Local, Regional, National, International
Availability: Open to the public
Visitors: General public, School groups, Ethnic community
Staff: 17 (1 ft, 12 pt, 4 volunteers); Operating budget: $120,000
Publications: *Cuba-USA: The First Generation* (1991); also publishes catalogs.

Collection: Books, videos, artifacts, over 500 works of art.

Comments: Fondo Del Sol was founded by a group of artists and writers from Central, South, and North America to promote recognition of their artistic heritage. It has produced four major international touring exhibitions. And includes works of African American, Caribbean, Native American, Russian, German, Latino, and other artists.

FORT HAYS STATE UNIVERSITY Library
FORSYTH LIBRARY CENTER FOR ETHNIC STUDIES
 600 Park St.
 Hays, KS 67601-4099 913-628-4431; Fax 913-628-4096

Personnel: Francis Schippers, Bd. Chairman; Jerry Braun, Secy.
Contact: Phyllis Schmidt, Collection Supervisor
Availability: Open, with restricted access; Admission: Free
Visitors: General public, School groups, Ethnic community
Staff: 3 (2 pt, 1 volunteer); Operating budget: $700
Publications: Pamphlets; bibliographies; and books.

Collection: Ca. 750 books, periodicals, audiovisual materials, artifacts, works of art, and archives (personal papers and correspondence, unpublished records, pictorial materials, theses and dissertations, manuscripts, and oral histories). The collection is cataloged; an unpublished guide, reading room, and copying facilities are available.

Comments: The purpose of the center is to preserve and promote ethnic history in Western Kansas. It is also supported by the Volga German Society of Rush and Ellis counties and the Bukovina Society of the Americas. It provides work experience in conjunction with receipt of scholarships from the Volga German Society. Groups prominent in the area include Germans (Volga, Bukovina), Czechs, Scandinavians, English, African Americans, and Hispanics. Activities include guided tours, loans to educational institutions, and film presentations.

FORT MYERS HISTORICAL MUSEUM Museum
 2300 Peck St. Archives
 Fort Myers, FL 33901 813-332-5955

Personnel: Patricia Bartlett, Dir.; Mark Appleby, Exhibits; Mildred Santiago, Admin. Asst.
Contact: Richard Beattie, Educator
Founded: 1982; Scope: Regional
Availability: Open to the public; Admission: Fee
Visitors: General public, School groups, Ethnic community

Staff: 4 ft; Operating budget: $210,000
Publications: *Museum Association Notes*, 1985- , monthly; promotional brochures.

Collection: Ca. 1,250 books, ca. 750 periodicals, videos and films, 5,000 photographs, 7,000 artifacts, works of art, and 50 boxes and cartons of archival materials (personal papers and correspondence, unpublished records, pictorial materials, and oral histories). The collection is cataloged; copying facilities are available.

Comments: The museum is dedicated to the collection, preservation, and interpretation of the history and tradition of Fort Myers. It includes artifacts left by the native Calusa and Seminole Indians; it also features special Black History Month presentations and has a collection of African masks and other items of relevance to African Americans. Services include guided tours, educational lectures, loans and presentations to schools, speakers, and an arts and crafts souvenir shop.

GYPSY LORE SOCIETY Archives
 5607 Greenleaf Rd.
 Cheverly, MD 20785 301-341-1261

Contact: Sheila Salo, Treas.
Founded: 1977; Scope: National, International
Availability: Not open to the public
Collection: The Victor Weybright Archives of Gypsy Studies specializes in recent scholarly work in Gypsy Studies.

Publications: *Journal of the Gypsy Lore Society*, 1991- , semi-annual *Newsletter of the Gypsy Lore Society*, 1977- , quarterly; also publishes various bibliographies, conference papers, and a membership directory.

Comments: Goals of the society include promotion of the study of the Gypsy peoples and analogous itinerant or nomadic groups, dissemination of information, increased understanding of Gypsy culture in its diverse forms, and establishment of closer contacts among Gypsy scholars. It sponsors programs and conferences.

HISTORICAL SOCIETY OF PENNSYLVANIA Museum
 1300 Locust St. Library
 Philadelphia, PA 19107 215-732-6201; Fax 215-732-2680 Archives
 Art Gallery
Personnel: Susan Stitt, Pres.; Linda Stanley, V. Pres. for Coll.; Cynthia Little, V. Pres. for Interpretation
Contact: Dick Rominiecki, Public Relations Officer
Founded: 1824; Scope: Local, State, Regional, National
Availability: Open to the public; Admission: Fee
Visitors: General public, School groups
Staff: 28 ft, 12 pt; Operating budget: $1,400,000
Publications: *Guide to the Manuscript Collections of the Historical Society of Pennsylvania* (3d ed., 1991); *The Pennsylvania Magazine of History and Biography*, 1877- , 3/yr.; *Pennsylvania Correspondent Newsletter*, 1993- , 3/yr.

Collection: 563,200 books, 2,000 periodicals, 250,000 audiovisual materials, 5,000

artifacts, 1,000 works of art, and 14 million archival items (personal papers and correspondence, unpublished records, pictorial materials, theses and dissertations, manuscripts, and oral histories). Some items (newspapers; genealogies; census, tax, and church records; wills) are in microform. The collection is cataloged; a published guide, reading room, and copying facilities are available.

Comments: The mission is to collect and preserve the best available historical materials. The collections emphasize the Delaware Valley region of Pennsylvania and the original 13 colonies, the states of migration east of the Mississippi, Europe, African American history; and genealogy related to ethnic Americans from England, Scotland, Ireland, and Germany. Services include guided tours, educational lectures, loans to schools, radio and TV programs, speakers, and performing arts presentations.

HOOVER INSTITUTION ON WAR, REVOLUTION & PEACE Library
 Stanford University Archives
 Stanford, CA 94305-6010 415-723-0603

Sponsoring organization: Stanford University
Personnel: Dr. John Raisian, Dir.
Contact: Charles G. Palm, Dep. Dir.
Founded: 1919; Scope: International
Availability: Open to the public; Admission: Free
Staff: Ca. 200; Operating budget: $18,500,000
Publications: Annual report; quarterly newsletter.

Collection: 1,600,000 books, 4,000 archival collections, 44 ms. boxes, 3 albums of archival records on Chinese refugees in the United States including the Records of Aid Refugee Chinese Intellectuals, minutes, reports, photographs; 53 ms. boxes, 8 scrapbooks on Jewish civil liberties in the U.S. and Germany (personal papers, correspondence, clippings, etc.); 17 ms. boxes containing the Records of the American Emergency Committee for Tibetan Refugees (correspondence, annual reports, minutes, photographs, 1959-1970).

Comments: Although this nonprofit major research organization does not focus on ethnic studies, it does contain extensive collections of materials of relevance to ethnicity, racial relations, immigration, etc. Activities include educational lectures, speakers, and research projects.

HUMAN RELATIONS AREA FILES, INC. Library
 755 Prospect St.
 New Haven, CT 203-777-2334; Fax 203-777-2337

Personnel: Melvin Ember, Pres.; David Levinson, V. Pres.
Contact: Marlene Martin, Bibliographer and Libn.
Founded: 1949; Scope: International
Availability: Open, restricted access; Admission: Free
Visitors: General public
Staff: 8 ft

Collection: 1,000 books, periodicals, and archives (over 800,000 text pages). The

collection is cataloged; a published guide, reading room, and copying facilities are available.

Comments: HRAF facilitates cross-cultural study of ethnic groups, society, and behavior through continuous expansion of the HRAF Cultural Information Archives. CD-ROM full-text databases covering books and articles on anthropological, sociological, and psychological aspects of life during the 19th and 20th centuries on over 60 cultures are available.

IMMIGRANT CITY ARCHIVES, HISTORICAL SOCIETY OF Museum
LAWRENCE AND ITS PEOPLES Archives
 6 Essex St., P.O. Box 1638
 Lawrence, MA 01840 508-686-9230

Personnel: Eartha Dengler, Executive Dir.; Ken Skulski, Archivist
Founded: 1978; Scope: Local
Availability: Open to the public M-Th 9-4:30; Admission: $5 adults
Visitors: General public
Staff: 1 ft, 3 pt, paid
Publications: *Immigrant City Archives Cookbook*; publishes tour guides and booklets.

Collection: 4 historic buildings, ethnic art, archives (personal papers and correspondence, photographs, prints, documents related to the city and immigrant labor force, genealogical records, and oral histories).

Comments: This historical society museum attempts to preserve the immigrant heritage of the city of Lawrence. Major recent exhibits include one on the German heritage. Activities include exhibitions related to ethnic labor and art, walking tours, and performing arts presentations.

IMMIGRATION HISTORY RESEARCH CENTER Library
 826 Berry St. Archives
 St. Paul, MN 55114 612-627-4208; Fax 612-627-4190

Sponsoring organization: University of Minnesota, College of Liberal Arts
Personnel: Rudolph J. Vecoli, Dir.; Joel Wurl, Curator and Asst. Dir.
Founded: 1965; Scope: International
Availability: Open to the public; Admission: Free
Visitors: Ethnic community, Scholars, Journalists, Students, Family historians
Staff: 13 (8 ft, 5 pt; 11 salaried, 2 volunteers); Operating budget: $352,000
Publications: *IHRC News*, 1980- , 3/yr.; *Spectrum*, 1975- , irreg. (annual as of 1994); also publishes books.

Collection: 25,000 books, 3,900 periodicals, ca. 500 audiovisual materials (oral histories and video tapes), and ca. 5,000 linear ft. of archival collections (personal papers and correspondence, unpublished records, printed materials, pictorial materials, theses and dissertations, manuscripts, and oral histories). Numerous newspaper and serial titles, among other materials, have been microfilmed,. The collection is cataloged; a published guide, reading room, and copying facilities are available for researchers.

Comments: The center promotes research on the history of American immigration and is a major American repository of source materials on ethnicity. It maintains the records of 24 ethnic groups that originated in Eastern, Central, and Southern Europe and the Near East. Focus is on the immigrant groups that came during the Great Migration in the 1880s and first decades of the 20th century (Albanians, Armenians, Bulgarians, Byelorussians, Carpatho-Rusyns, Croats, Czechs, Estonians, Finns, Greeks, Hungarians, Italians, Jews of Eastern Europe, Latvians, Lithuanians, Macedonians, Near Eastern Peoples, Poles, Romanians, Russians, Serbs, Slovaks, Slovenes, and Ukrainians). Services include guided tours, educational lectures, loans to schools, and speakers. The center also sponsors conferences and exhibits, participates in ethnic festivals, supports research at the graduate and undergraduate levels, and provides work experience for college credit.

INSTITUTE OF TEXAN CULTURES Museum
 801 S. Bowie St. Library
 San Antonio, TX 78205-3296 210-558-2300; Fax 210-558-2205 Archives

Sponsoring organization: University of Texas at San Antonio
Personnel: Dr. Rex Ball, Exec. Dir.; Laurie Gudzikowski, Interim Dir., Research; Nancy McNaul, Dir., Educational Programs; Leah Lewis, Curator of Collections; Tom Shelton, Photo archivist.
Contact: Lynn Catalina, Dir., Communications & Marketing
Founded: 1968; Scope: State
Availability: Open to the public; Admission: Donation
Visitors: General public, School groups, Ethnic community
Staff: 114 ft, 13 pt, salaried; 454 volunteer docents; Operating budget: $4,483,399
Publications: *Texican*, 1990- , 3-4/yr; also publishes brochures related to traveling exhibits; catalog of collections; annual report; membership newsletters and flyers; books; and audiovisual productions (Contemporary Indians of Texas series).

Collection: 6,000 books, 5,000 artifacts, 2,000,000 historic and contemporary still photographs, 5 file drawers of oral histories, 135 file drawers of ethnic/cultural information. The collection is cataloged; a reading room and copying facilities are available.

Comments: The institute is an educational center dedicated to enhancing historical and multicultural understanding. It maintains more than 50,000 sq. ft. of exhibits highlighting 27 of the ethnic groups that helped build Texas. The 15-acre grounds house buildings and other artifacts including an "immigrant wagon," and an adobe dwelling. Services include guided tours, educational lectures, loans and presentations to schools, radio programs, speakers, films and AV productions, and an arts and crafts souvenir shop. The institute participates in and sponsors ethnic and folk festivals, provides work experience for college credit, and in-service programs for teachers.

IRON COUNTY MUSEUM Museum
 Box 272, 101-2 Museum Rd. Archives
 Caspian, MI 49915 906-265-2617

Sponsoring organization: Iron County Historical & Museum Society
Personnel: Harold Bernhardt, Pres.

Contact: Marcia Bernhardt, Dir., 233 Bernhardt Rd., Iron River, MI 49935
Founded: 1962; Scope: Local
Availability: Open to the public; Admission: $2.50 Fee
Visitors: General public, School groups
Staff: Volunteers; Operating budget: $40,000
Publications: *Past-Present Prints*, 1968- , annual; also publishes books on local
history, folklore, cookbooks, etc.

Collection: 20,000 artifacts, 200 works of art, 5,000 photos, 8,000 maps, 90 boxes
and 16 drawers of archives (personal papers and correspondence). The collection is
partially cataloged; a published guide, reading room, and copying facilities are
available.

Comments: The museum preserves the ethnic heritage of miners, lumberers, and
farmers who immigrated to the area. Major groups include Scandinavians, Polish,
Italians, and English. The museum and park is composed of 19 buildings, a cultural
center, and art gallery. The Heritage Hall boasts ethnic art on the beams. Offers
guided tours, educational lectures, school presentations, speakers, dance, drama, choir,
and instrumental performances, films, crafts classes, and a souvenir shop.

LUTHER SEMINARY ARCHIVES AND MUSEUM Museum
 2481 Como Ave. Archives
 St. Paul, MN 55108 612-641-3205

Sponsoring organization: Luther Seminary and Evangelical Lutheran Church in
America, Region 3
Contact: Paul A. Daniels, Archivist and Curator
Founded: 1960; Scope: Regional
Availability: Open 9-4:30; Admission: Free
Visitors: General public, School groups, Ethnic community
Staff: 10 (1 ft, 3 pt, 6 volunteers)
Publications: Annual report

Collection: Ca. 750 books, 50 periodicals, 200 audiovisual materials, 3,500 artifacts,
50 works of art, and archival materials (personal papers and correspondence,
unpublished records, pictorial materials, theses and dissertations, manuscripts, and oral
histories). The collection is partially cataloged; an unpublished guide, reading room,
and copying facilities are available.

Comments: Serves as the organizational archive for the Scandinavian (Norwegian,
Danish, Swedish), and German antecedents of the Evangelical Lutheran Church in
America. The museum documents global mission work of ethnic Lutherans. Archival
collection spans 1840-1988, much in native languages. Provides guided tours, films,
lectures, loans to schools, speakers, and participation in ethnic festivals.

LUTHERAN ARCHIVES CENTER AT PHILADELPHIA Archives
 Krauth Memorial Library
 Lutheran Theological Seminary at Philadelphia
 7301 Germantown Ave.
 Philadelphia, PA 19119-1794 215-248-4616; Fax 215-248-4577

Sponsoring organization: Lutheran Theological Seminary at Philadelphia
Contact: John E. Peterson, Curator of the Archives, David J. Wartluft, Lib. Dir.
Founded: 1864; Scope: Regional, National
Availability: Restricted access/hours (archives); Admission: Free (library); fee
(archives)
Visitors: General public, School groups, Ethnic community
Staff: 6 ft, 2 pt, salaried; Operating budget: $280,000 (library), $20,000 (archives)
Publications: *The Reporter*, 1981-

Collection: Ca. 170,000 titles including books, periodicals, artifacts, and 2,500 linear
ft. of archives (personal papers and correspondence, unpublished records, pictorial
materials, manuscripts, oral histories). Journals of Henry Melchior Muhlenberg and
some periodical titles are in microform. The collection is cataloged, but the archives
are only partially cataloged. Most of the collection is available on OCLC.

Comments: Documents and preserves for research the legacy of German and Slovak
Lutheranism, particularly the Halle tradition in America. The society provides speakers
and workshops on archives and congregational history writing.

LYMAN HOUSE MEMORIAL MUSEUM Museum
 276 Haili St. Library
 Hilo, HI 96720 Archives

Personnel: Dr. Leon Bruno, Dir.
Contact: Charlene Dahlquist
Founded: 1932; Scope: Local, State, Regional, National, International
Availability: Open to the public; Admission: Fee
Visitors: General public, School groups
Staff: 70 (14 ft, 6 pt, salaried 20; 50 volunteers)
Publications: Exhibition catalogs

Collection: 3,300 books, 500 periodical titles, over 1,500 audiovisual materials, works
of art, archival materials (unpublished records, printed materials and pictorial
materials). The collection is cataloged; a reading room and copying facilities are
available.

Comments: The purpose is to preserve and present the history of Hawaii and the
cultures of its various ethnic and cultural groups (Chinese, Japanese, Portugese,
Filipino, Korean). Services include guided tours, educational lectures, loans and
presentations to schools and other educational institutions, and films and AV
productions.

MAHONING VALLEY HISTORICAL SOCIETY Museum
 648 Wilk Ave. Archives
 Youngstown, OH 44502-1289 216-743-2589

Personnel: Susan Baxter, Curator; Joan Reedy, Asst. Dir.; Elisabeth Spiro, Archivist
Contact: H. William Lawson, Dir.
Founded: 1875; Incorporated: 1909; Scope: Regional
Availability: Restricted access; Admission: Fee

Visitors: General public
Staff: 4 ft, 2 pt, 10 volunteers; Operating budget: $259,595
Publications: *Historical Happenings*, quarterly

Collection: Archives (personal papers and correspondence, unpublished records,
pictorial materials, theses and dissertations, manuscripts, oral histories). The collection
is cataloged; a reading room and copying facilities are available.

Comments: The purpose is to preserve and present the historical and cultural diversity
of the community through guided tours, educational lectures, school presentations, and
speakers. Exhibits reflect the culture of the Native Americans followed by other
pioneer ethnic groups (e.g, German, Italian, Ukrainian, Polish, Slovak, Czech, Greek).

MERCER COUNTY HISTORICAL MUSEUM Museum
 130 East Market, P.O. Box 512 Archives
 Celina, OH 45822 419-586-6065 or 419-678-2614

Sponsoring organization: Mercer County Historical Society, Inc.
Contact: Joyce Alig, Dir. and Archivist
Founded: 1959; Scope: Local
Availability: Open W-F, Sun.; Admission: Free
Visitors: General public, School groups, Ethnic community
Staff: 1 ft, 2 pt, 250 volunteers; Operating budget: $50,000-$80,000.
Publications: Annual report; Catalog of collections; membership newsletters; flyers;
publications about Native Americans and early ethnic settlers, 1780s to 1980s.

Collection: Books, periodicals, audiovisual materials, artifacts, works of art and 150
cubic ft. of archives (personal papers and correspondence, unpublished records,
pictorial materials, theses and dissertations, manuscripts, and oral histories). Included
are the Captain James Riley Collection, James Zura Riley Klonkyke Expedition
Collection, and the German and Alsatian Barn Photograph Collection. On microfilm
are the Riley collection as well as city records and newspaper and cemetery records for
Mercer County, Ohio. The collection is cataloged; an unpublished guide, reading
room, and copying facilities are available.

Comments: The purpose is to preserve the heritage of Mercer County and to assist
those in quest of German and/or French research materials. Guided tours, educational
lectures, loans to schools, school presentations, radio programs, films and AV
productions, work experience for college credit, in-service programs, and workshops
for teachers are available. Research at graduate and undergraduate levels is supported.

MILLICENT ROGERS MUSEUM Museum
 Museum Road, P.O. Box A
 Taos, NM 87571 505-758-2462

Personnel: Patrick Houlihan, Dir.; Guadalupe Tafoya, Vincente Martinez, Soge Track,
Curators
Contact: Ann L. McVicar, Libn.
Founded: 1953; Scope: International
Availability: Open to the public (museum); by appt. only (library) Admission: Fee

Visitors: General public
Staff: 23 (5 ft, 18 pt); Operating budget: $500,000
Publications: *Las Palabras*, 1970- , 3/yr.; *Padre Martinez*; also publishes a catalog of collections.

Collection: Ca. 1,500 books, periodicals, audiovisual materials, ca. 1,500 artifacts, ca. 1,500 works of art, and 15 linear ft. of archives (personal papers and correspondence). The collection is cataloged; a reading room and copying facilities are available for researchers.

Comments: The collections preserve both Native American and Hispanic history, art, and culture. The former features Navajo and Pueblo jewelry, Navajo textiles, Pueblo pottery, kachina dolls from Hopi and Zuni, and basketry from diverse Southwestern tribes. The Hispanic collections feature religious and decorative arts, furniture, weavings, colcha embroideries, tin work, agricultural implements, domestic utensils, and tools. Services include guided tours, loans to schools, speakers, crafts classes, and an arts and crafts souvenir shop. The museum participates in ethnic festivals.

MUSEUM OF AMERICAN FOLK ART Museum
 Two Lincoln Square
 New York, NY 10023-6214 212-977-7170; Fax 212-977-8134
 Mailing address: 61 W. 62nd St., New York, NY 10023-7015

Personnel: Ralph Esmerian, Pres.; Gerard Wertkin, Dir.; Stacy Hollander, Curator of Coll.
Founded: 1961; Scope: Local, State, Regional, National
Availability: T-Sun. 11:30-7:30; Admission: Free
Visitors: General public
Staff: 26 ft, 9 pt, paid; 2 ft volunteers; 55 pt volunteers, 2 interns
Publications: *Folk Art*; also publishes catalogs of exhibitions.

Collection: Folk arts, decorative arts, textiles, quilts

Comments: The purpose is to preserve and display the wide variety of folk arts in the United States. Programs include guided tours, exhibits, crafts and folk art classes, an internship program in conjunction with New York University, loans to schools, slide presentations, and workshops.

MUSEUM OF NEW MEXICO Museum
 110 Washington Ave. Library
 Santa Fe, NM 87501 505-827-6472

Personnel: Richard Rudisill, Curator of Photographic History
Contact: Arthur L. Olivas, Photographic Archivist
Founded: 1909; Scope: Local, State, Regional, National, International
Availability: Open daily, 10-5: Admission: Free
Visitors: General public, Ethnic community
Staff: 3 ft; Operating budget: $35,000
Publications: Picture and exhibit catalogs; collection guides; and the Frederick Monsen at Hopi (1907) reprint series of photo archives.

Collection: 2,500 books, 500 periodicals, 400,000 photos, and archival manuscript materials. The collection is cataloged; an unpublished guide, reading room, and copying facilities are available. The museum, Palace of the Governors, is an ancient adobe which has housed the headquarters of the Spanish crown, Spanish and Mexican governors, a Pueblo Indian community, and a museum. The artifact collection includes armor, porcelain, religious items, garments and costumes, agricultural tools, a portrait gallery, a reconstructed Spanish colonial chapel, print shop, and bindery.

Comments: The purpose is to preserve the primarily Spanish and Mexican art and culture of the area as well as the Native American experience. Walk-in guided tours are conducted daily.

MUSEUM OF THE CITY OF LAKE WORTH Museum
 414 Lake Ave., City Hall Annex
 Lake Worth, FL 33460 407-586-1700; Fax 407-586-1750

Contact: Helen Vogt Greene, Curator-Historian
Founded: 1980; Scope: Local
Availability: Open to the public; Admission: Free
Visitors: General public, School groups, Ethnic community
Staff: 12 (1 ft, salaried; 11 volunteers)
Operating budget: $20,000 plus donations
Publications: Annual report; budgets approved by the city manager and commission; articles contributed to local newspapers by the museum.

Collection: Artifacts, works of art, and 50 sq. ft. of archival and pictorial materials, and exhibits on the history of Poland and the contributions of Polish Americans. The collection is cataloged; a reading room and copying facilities are available.

Comments: The museum has exhibits related to Finnish, Lithuanian, and Polish history and culture. The purpose is to preserve and protect the cultural heritage of Lake Worth, which has one of the largest Finnish populations in the United States.

NATIONAL ARCHIVES-PACIFIC SIERRA REGION Archives
 1000 Commodore Dr.
 San Bruno, CA 94066 415-876-9009; Fax 415-876-9233

Sponsoring organization: National Archives & Records Administration
Contact: Waverly B. Lowell, Dir.
Founded: 1970; Scope: Regional
Availability: Open to the public; Admission: Free
Visitors: General public
Staff: 8 ft

Collection: 40,000 cubic ft. of archival materials (unpublished records). Ca. 50,000 rolls of microfilm which are mostly U.S. census records from 1790-1920 used for genealogical purposes and for ethnic studies research. The collection is cataloged; a published guide, reading room, and copying facilities are available.

Comments: The purpose is to preserve and make available federal records of enduring

value, particularly those related to Native Americans, Hispanic, and Asian Americans. Programs in conjunction with colleges and universities include graduate level research, sponsorship of work experience for college credit, and in-service courses, or workshops for teachers. The archives participates in ethnic festivals.

NATIONAL ARCHIVES-SOUTHEAST REGION Archives
(Formerly National Archives-Atlanta Branch)
 1557 St. Joseph Ave.
 East Point, GA 30344 404-763-7477; Fax 404-763-7033

Sponsoring organization: National Archives and Records Administration
Personnel: Gayle Peters, Dir.; Dr. Charles Reeves, Asst. Dir.; Mary Ann Hawkins, Archivist; Lonnie McIntosh, Archives Technician
Contact: David Hilkert, Archivist
Founded: 1969; Scope: Regional, National
Availability: Open to the public; Admission: Free
Visitors: General public
Staff: 45 (6 ft, 9 pt, 30 volunteers); Operating budget: $350,000
Publications: Guides; indexes to archival records; microfilm catalogs; reference information papers; inventories; special checklists (e.g,. *Checklist of Records Available for Research on American Indians, Checklist of Records Available for Research on Black History*).

Collection: 58,760 cubic feet of archival materials (unpublished records, pictorial materials, manuscripts, oral histories and 60,000 rolls of microfilm). The collection is cataloged; an unpublished guide, reading room, and copying facilities are available.

Comments: The National Archives documents American history from the time of the First Continental Congress and includes records related to immigration, desegregation, and various ethnic and multiethnic groups. Services include guided tours, educational lectures, loans and presentations to schools, speakers, drama, and exhibits. The archives participates in ethnic festivals, supports research, and provides in-service programs for educators.

NATIONAL CENTER FOR URBAN ETHNIC AFFAIRS Library
 Box 20, Cardinal Station
 Washington, DC 20064 202-232-3600/319-5128

Personnel: Msgr. Salvatore Pulizzi, Chairman of the Bd.
Contact: John Kromkowski, Pres.
Scope: International
Availability: Open to the public
Visitors: General public
Staff: 7 ft, 35 pt
Publications: Books (e.g., *Geno: The Life and Mission of Geno Baroni, Content of the 1990 Census Questionnaires: Race, Ethnicity, and Ancestry*).

Collection: Ca. 1,500 books, ca. 1,500 periodicals, and audiovisual materials.

Comments: Publishes research and other information on urban affairs, ethnic

neighborhoods (e.g., Cabrini-Green in Chicago), and other titles related to ethnicity, minorities, and cultural diversity. Services include educational lectures, loans to educational institutions, radio and TV programs, speakers, performing arts presentations, and films and AV productions. The center participates in ethnic festivals; it supports research at the graduate and undergraduate levels and provides in-service programs for teachers.

NATIONALITY ROOMS AT THE UNIVERSITY OF PITTSBURGH Museum
 157 Cathedral of Learning Archives
 4200 Fifth Ave.
 Pittsburgh, PA 15260 412-624-6000; Fax 412-624-4214

Sponsoring organization: University of Pittsburgh
Contact: Maxine Bruhns, Dir.
Founded: 1926; Scope: International
Availability: Open to the public; Admission: Fee
Visitors: General public, School groups, Ethnic community
Staff: 28 (6 ft, 2 pt, 20 volunteers); Operating budget: $200,000
Publications: *Nationality Rooms Newsletter*, 1965- , biannual; *The Nationality Rooms*, 1990, c1975; Nationality Rooms book and brochure, Nationality Rooms recipe book.

Collection: Permanent classrooms constructed and decorated to reflect cultural heritages. Included are books, audiovisual materials, artifacts and realia, paintings and other works of art, and 150 linear ft. of archives (personal papers and correspondence, unpublished records, pictorial materials, oral histories). The collection is cataloged; an unpublished guide, reading room, and copying facilities are available.

Comments: The purpose is to preserve the ethnic heritages of Pittsburgh through 23 nationality classrooms which serve as resources for study and research. Services include guided tours, educational lectures, loans and presentations to schools, speakers, dance performances, films and AV productions, and an arts and crafts/souvenir shop. Also sponsored are workshops in handmade Christmas ornaments and international Christmas carols with the rooms decorated in traditional ethnic holiday styles during December. Graduate and undergraduate research, as well as student scholarships and faculty grants for study and research abroad, are options.

NEBRASKA STATE HISTORICAL SOCIETY Museum
 1500 R St., P.O. Box 82554 Library
 Lincoln, NE 68501-2554 402-471-4771; Fax 402-471-3200 Archives

Personnel: Lawrence Sommer, Dir.; Lynne Ireland, Assoc. Dir. Museum; Cindy Drake, Technical Services Libn.; Paul Eisloeffel, Curator of Manuscripts and AV Coll.; John Carter, Curator of Photographs; Steve Wolz, Public Records Archivist
Contact: Andrea Paul, Assoc. Dir. Library/Archives
Founded: 1878; Scope: Local, State, Regional
Availability: Open to the public; Admission: Free (Donation)
Visitors: General public, School groups, Ethnic community
Staff: 19 ft, salaried; volunteers; Operating budget: $673,700
Publications: *Nebraska History*, 1918- , quarterly; *Historical Newsletter*, 1948- , monthly; also publishes a formal annual report.

Collection: Ca. 80,000 books, 100 periodical titles, 500 audio collections, 1,700 photo collections, 200 motion picture collections, and 37,000 cu. ft. of archives (personal papers and correspondence, unpublished records, pictorial materials, theses and dissertations, manuscripts, maps and other audiovisual materials, and oral histories). Newspapers are on microfilm. The collection is cataloged; an unpublished guide is available (published guides for many collections).

Comments: Preserves and interprets documentary materials and exhibits relating to Nebraska's heritage and the Native American, African American, German, Czech, and Scandinavian groups who settled the area. Approximately 12,000 researchers use these facilities annually. Services include guided tours, educational lectures, speakers, reference service by mail, and a film series. Research at graduate and undergraduate levels, internships, and courses for college credit are available.

NEW KUBAN EDUCATION AND WELFARE ASSOCIATION Museum
Don Road Library
Buena, NJ 08310 609-697-2255 Archives
 Art Gallery

Personnel: Ebbeny Davidov, V. Pres.; Nina Sienczenko, Secy.-Treas.
Contact: Anthony M. Sienczenko, Pres., R. D. 2, Box 369, Buena, NJ 08310
Founded: 1952; Scope: Local, State, International
Availability: Open by special appt. only; Admission: Free
Visitors: General public, School groups, Ethnic community
Staff: 2 part-time volunteers; Operating budget: $5,000

Collection: Archival materials contain personal papers and correspondence, unpublished records, pictorial materials, and manuscripts. The collection is not cataloged; a reading room is available.

Comments: The purpose is to preserve the history and culture of the Cossack people. Services include guided tours, dance and choir performances. The organization participates in ethnic festivals.

NORTHWEST MINNESOTA HISTORICAL CENTER Archives
Moorhead State University
Moorhead, MN 56563 218-236-2343; Fax 218-299-5924

Sponsoring organization: Moorhead State University
Contact: Terry L. Shoptaugh, Archivist
Founded: 1973; Scope: Local, State, Regional
Availability: Open to the public; Admission: Free
Visitors: General public
Staff: 1 ft, 1 pt; salaried; Operating budget: $35,000
Publications: Catalog of collections

Collection: Books, periodicals, ca. 2,500 photographs, artifacts, works of art, 900 linear ft. of archives (personal papers and correspondence, unpublished records, theses and dissertations, pictorial materials, manuscripts, oral histories, and business records). Some church records, maps, Minnesota prisoner of war reports/documents, naturalization records, and newspapers are microfilmed. The collection is cataloged; a

published guide, reading room, and copying facilities are available.

Comments: The center was established for the purpose of collecting, preserving, and making available historical and cultural sources of northwest Minnesota and the Red River Valley and the Germans, Hispanics, and Scandinavians who settled there. Services include educational lectures, loans to schools, TV programs, speakers, traveling exhibits, and seminars for teachers. The center collected oral interviews with local sugarbeet growers and supports research at the graduate and undergraduate levels. It provides work experience for college credit, in-service programs, courses or workshops for teachers, and courses for college credit.

OLD MISSION MUSEUM Museum
 782 Monterey St.
 San Luis Obispo, CA 93401 915-546-9273

Sponsoring organization: Monterey Diocese, Roman Catholic Church
Contact: Elizabeth R. Zevely, Mgr.
Founded: 1950
Availability: Open to the public; Admission: Donation
Visitors: General public, School groups
Staff: 4 (2 ft, 2 pt)
Publications: Catalog of collections

Collection: Books, periodicals, 1,500 artifacts, works of art and seven rooms of archives (personal papers and correspondence, unpublished printed and pictorial materials, oral histories). The collection is cataloged; a reading room is available.

Comments: The mission is a state historical site and includes displays of American Indian groups of the area (Chumash and Navajo), as well as those related to Hispanic settlers (Spanish and Mexican), and other ethnic groups, such as Portuguese, German, who settled in the diocese area. Services include guided tours, educational lectures, and school presentations.

OLD MISSION SANTA INES Museum
 1760 Mission Dr. Archives
 Solvang, CA 93463 805-688-6017

Sponsoring organization: Archdiocese of Los Angeles
Contact: Wm. S. Warwick, Curator, Box 408, Solvang, CA 93463
Founded: 1804; Scope: State
Availability: Open to the public; Admission: Fee (donation)
Visitors: General public, School groups
Staff: 10 ft

Collection: Books, artifacts, works of art, and 500 cubic ft. of archival materials (unpublished records, pictorial materials, manuscripts). The collection is partially cataloged; copying facilities are available.

Comments: The purpose is to promote an awareness of California history and its Indian and Hispanic cultures. Services and programs include guided tours, speakers,

and an annual visitation program for elementary schools as a required part of the California history curriculum. The museum participates in ethnic festivals.

PAGE LIBRARY'S ETHNIC STUDIES CENTER OF LINCOLN UNIVERSITY

Library

820 Chestnut St.
Jefferson City, MO 65102-0029 314-681-5514; Fax 314-681-5511

Sponsoring organization: Advanced Institutions Development Program (AIDP), Lincoln University
Personnel: Elizabeth A. Wilson (University Libn.), Dir.
Contact: Carla Williams-Turner or Yvette Ford
Founded: 1978; Scope: State
Availability: Open to the public; Admission: Free
Visitors: General public, School groups, Ethnic community
Staff: 8 pt, (salaried; volunteers)
Publications: Annual university catalogs; formal annual reports; membership newsletters and flyers.

Collection: 9,000 books, periodicals, audiovisual materials, 200 artifacts, 18 works of art, and ca. 45 archival records (pictorial materials, theses and dissertations, manuscripts, oral histories). The collection is partially cataloged; historical Black newspapers, dissertations by or about African Americans, 144 reels from the Schomburg Collection of Negro Literature and History, the FBI files of Malcolm X, Martin Luther King, and Marcus Garvey are on microfilm. A reading room and copying facilities are available.

Comments: The center was established to provide opportunities for multicultural and multiracial experiences for faculty, students, and the surrounding community. It promotes ethnicity through ethnic-related workshops; displaying archival artifacts, arts, and other exhibits; obtaining collections and gathering bibliographies of ethnic-related newspapers, journals, books, films, and filmstrips. Services include guided tours, educational lectures, loans and presentations to schools, performing arts (dance, drama, instrumental), films and AV productions, an arts and crafts souvenir shop, support of research at the graduate and undergraduate levels, and opportunities for students to attend and/or participate in activities in the center for extra credit.

PHILADELPHIA FOLKLORE PROJECT

Library
Archives

719 Catharine St.
Philadelphia, PA 19147 215-238-0096; Fax 215-922-5327

Contact: Debora Kodish, Dir.
Founded: 1987; Scope: Regional
Availability: Open to the public; Admission: Free
Visitors: General public, School groups, Ethnic community
Staff: 1 ft, 7 pt; Operating budget: $180,000
Publications: *Works-in-Progress* (PFP newsletter), 1987- , 3/yr.; also publishes books and a series of working papers.

Collection: Books, periodicals, audiovisual materials, works of art, and archives (150

audiotapes of field research interviews, 15,000 slides, 30 videotapes, notes for PFP directory of folklife resources, pictorial materials, and oral histories). The collection is cataloged; copying facilities are available.

Comments: The PFP documents and supports the folk arts in Philadelphia. It offers folklife exhibitions, workshops, community concerts, publications, and outreach and technical assistance programs. It provides loans or gifts to schools, performing arts presentations (dance, drama, instrumental), films and AV productions, crafts classes, and grants workshops.

PIMERIA ALTA HISTORICAL SOCIETY Museum
 136 N. Grand Ave., P.O. Box 2281 Library
 Nogales, AZ 85621 602-287-4621 Archives

Personnel: Susan Clarke Spater, Dir.; Oscar Lizardi, Pres.; Anne B. Wheeler, Registrar
Contact: Patricia Berrnes, Bilingual Exec. Secy.
Founded: 1948; Scope: Local, Regional, International
Availability: Open, restricted access; Admission: Free/Donation
Visitors: General public, School groups, Ethnic community
Staff: 10 (2 ft, 6 pt, 8 salaried); 2 volunteers
Operating budget: $130,000
Publications: Annual trilingual (English, Spanish, Tohono O'odham) calendar; monthly newsletter; monographs and other books.

Collection: 1,500 books, periodicals, 10,000 photographs, audiovisual materials, 5,000 artifacts, works of art, and 150 linear ft. of archives (personal papers and correspondence, unpublished records, pictures, manuscripts, oral histories). The collection is partially cataloged; a reading room and copying facilities are available.

Comments: Preserves the unique cultural heritages of inhabitants of the Pimeria Alta area on the border of northern Arizona and Mexico: Native Americans, Mexican Americans and Mexican nationals. Services include guided tours, educational lectures, loans and presentations to schools, radio and TV programs, speakers, arts and crafts classes, souvenir shop, trips into Mexico, and exhibits. It also supports research at the graduate and undergraduate levels, provides work experience for college credit, and in-service programs for educators.

POPULATION RESEARCH CENTER LIBRARY Library
 University of Texas
 1800 Main Building
 Austin, TX 78712 512-471-8335; Fax 512-471-4886

Sponsoring organization: University of Texas
Contact: Gera Draaijer, Head Libn.
Founded: 1963; Scope: International
Availability: Available, restricted access; Admission: Free
Visitors: General public
Staff: 2 pt; Operating budget: $10,000
Publications: Monthly acquisition list; also publishes the APLIC census network list.

Collection: 30,000 census volumes (international collection); older materials are in microform. The collection is cataloged; a reading room and copying facilities are available.

Comments: Provides access to researchers to demographic census data for all ethnic groups. Research is conducted in conjunction with college and university programs.

ST. STEPHEN'S PARISH LIBRARY Library
 3705 Woodlawn Ave.
 Los Angeles, CA 90011 213-234-9246; Fax 213-234-2455

Sponsoring organization: St. Stephen's Church
Contact: Rev. Hermann Joseph Rettig, Pastor
Availability: Open by appt. only; Admission: Free
Visitors: General public

Collection: Church records; the collection is not cataloged.

Comments: The library maintains family records and other materials which document the history of the German and Hungarian-speaking communities.

SANGAMON STATE UNIVERSITY ARCHIVES Archives
 Brookens Library, Rm. 144,
 Shepherd Road
 Springfield, IL 62794-9243

Contact: Thomas J. Wood, Archivist
Founded: 1970; Scope: Regional
Availability: Open M-F, 9-5; Admission: Free
Visitors: General public
Staff: 1 ft, 5 pt; Operating budget: $40,000
Publications: *Guide to Manuscript Collections in the Sangamon State University Archives*

Collection: Archival materials (personal papers and correspondence, unpublished records, theses and dissertations, pictures, manuscripts, and oral histories). The collection is cataloged; a published guide, reading room, and copying facilities are available.

Comments: Some major ethnic archival files include the Records of the Asian American Study of the Center for the Study of Middle Size Cities; those related to the civil rights movement and Martin Luther King; the G. Cullom Davis papers related to school desegregation, race riots, abolition, and other racial and ethnic topics related to Springfield, Illinois, including ethnic newspapers of the area; Black newspaper *Voice of the Black Community*; etc. It also has oral history project materials related to African, German, Irish, and Italian Americans. Activities include speakers/resource people.

SLAVIC AND EAST EUROPEAN LIBRARY Library
 225 Library, 1408 W. Gregory Dr. Archives
 Urbana, IL 61801 217-244-0398; Fax 217-333-1349

Sponsoring organization: University of Illinois Library
Contact: Robert H. Burger, Head
Founded: 1970; Scope: International
Availability: Available, but with restricted access; Admission: Free
Visitors: General public
Staff: 16 ft; Operating budget: $450,000

Collection: 620,000 books, periodicals, and archives (personal papers and
correspondence, unpublished records); 90,000 volumes (serials and monographs) are in
microform. The collection is cataloged; a reading room and copying facilities are
available.

Comments: As part of the university library system, this special collection contains
materials on Slavics and East Europeans in the United States and abroad. Activities
include tours, educational lectures, and speakers or resource people.

STATUE OF LIBERTY NATIONAL MONUMENT/ Museum
ELLIS ISLAND IMMIGRATION MUSEUM Library
 Liberty Island Archives
 New York, NY 11238 212-363-5803; Fax 212-363-8347

Sponsoring organization: U.S. Dept. of the Interior, National Park Service
Personnel: M. Ann Belkov, CEO; Larry Steeler, Chief of Operations; Felice Ciccione,
Curator of Coll.; Marcy Davidson, Curator of Exhibits; Geraldine Santoro, Registrar;
Paul Sigrist, Oral Historian; Barry Moreneo, Library Tech.; Jeffrey Dosik, Library
Tech. and Volunteer Coordinator
Contact: Diana Pardue, Chief of Museums
Founded: 1924; Scope: International
Availability: Open 9:15-5 (Labor Day-Memorial Day); 9:15-6 (Memorial Day-Labor
Day); Admission: Free
Visitors: General public
Staff: 185 (160 ft, 15 volunteers); Operating budget: $7 million
Publications: Souvenir guide

Collection: 2,000 books, periodicals, audiovisual materials (Augustus F. Sherman
photographs), 23,672 artifacts, works of art, and 500 boxes (500,000 documents) of
archival materials (personal papers and correspondence, unpublished records, pictorial
materials, manuscripts, oral histories of immigrants). The collection is cataloged; an
unpublished guide, reading room, and copying facilities are available for researchers.

Comments: The collections focus on the immigration experience of all ethnic groups
arriving through Ellis Island. The staff have compiled bibliographies on Ellis Island,
immigration, and related topics. This national monument provides guided tours,
participation in radio and TV programs, and performing arts presentations. The
museum sponsors research at the graduate and undergraduate level and provides work
experience for college credit.

SWEETWATER COUNTY HISTORICAL MUSEUM Museum
 80 West Flaming Gorge Way Archives
 Green River, WY 82935 307-872-6435; Fax 307-872-6337

Personnel: Ruth Lauritzen, Dir.
Contact: Mark Nelson, Curator
Founded: 1967; Scope: Local, State
Availability: M-F, 9-5; Admission: Free
Visitors: General public, School groups
Staff: 4 ft; Operating budget: $233,000

Collection: Books, periodicals, audiovisual materials, artifacts and realia, and ca. 95 boxes of archival records. The newspaper collection is in microform. The collection is partially cataloged; a reading room and copying facilities are available.

Comments: Preserves items of historical importance to Sweetwater County in order to educate about the county's history and that of Native Americans, Asians (Chinese and Japanese), and the Eastern European ethnic groups that settled there.

TAMBURITZA ASSOCIATION OF AMERICA Library
 2 Gandy Dr. Archives
 St. Louis, MO 63146

Contact: Alex Marchaskee, Pres.
Founded: 1967; Scope: National
Publications: *Tamburitza Extravaganza Bulletin*, semiannual; *Tamburitza Times*, quarterly; promotional brochures, programs, and a membership directory.

Collection: Audio tapes of annual concerts, musical instruments, music, and related artifacts. The collection also contains materials for maintaining hall of fame exhibits of tamburitza players and archival materials (photographs).

Comments: The objective is to preserve Yugoslavian culture in general and to perform tamburitza music in particular. Services include performing arts presentations.

TUMACACORI NATIONAL HISTORICAL PARK Museum
(Formerly Tumacacori National Monument)
 P.O. Box 67
 Tumacacori, AZ 85640 602-398-2341; Fax 602-398-9271

Sponsoring organization: National Park Service
Contact: Don Garate
Founded: 1908; Scope: Local, State, Regional, National, International
Availability: Open 8-5 (Library by special appt.); Admission: Fee
Visitors: General public, School groups, Ethnic community
Staff: 29 (9 ft, salaried, 20 volunteers); Operating budget: $330,000
Publications: *Tumacacori*; *Juan Bautista de Anza* (1994); promotional brochures and flyers.

Collection: Ca. 350 books, periodicals, artifacts and realia, and archival materials (pictorial materials, theses and dissertations, manuscripts, and oral histories). Old Spanish records are in microform. The collection is cataloged; no guide is available.

Comments: The purpose is to preserve and protect the Spanish culture, particularly the

San Jose de Tumacacori Spanish Mission Church dating from 1691. La Fiesta de Tumacacori is sponsored yearly in December with Native American, Mexican, Spanish, and Anglo music, dance, food and crafts; also sponsors Anza Days with performing arts presentations and reenactments of the 1776 Expedition from Culiacan Mexico to San Francisco, and a luminarias program every Christmas. Services include guided tours, educational lectures, presentations to schools, films and AV productions, performances (drama, choir), and an arts and crafts souvenir shop.

UNIVERSITY OF CALIFORNIA, BERKELEY Library
REGIONAL ORAL HISTORY OFFICE OF THE BANCROFT LIBRARY
 Rm. 486 Library
 University of California
 Berkeley, CA 94707 510-642-7395

Personnel: Willa Klug Baum, Div. Head, Regional Oral History Office
Contact: Suzanne Riess, Sr. Editor
Founded: 1955; Scope: Local, State, Regional
Availability: Open (materials available in Bancroft Library); Admission: Free
Visitors: Researchers
Staff: 30 pt

Collection: Over 500 books and archival records (oral histories). Some materials are in microform. The collection is cataloged; a published guide and copying facilities are available.

Comments: The purpose is to conduct oral history research related to major trends or events in the history of the United States, particularly Northern California. Emphasis is on the following ethnic groups: African Americans, Italians, Russians, Jews, Chicano-Latino, and Chinese.

UNIVERSITY OF ST. THOMAS O'SHAUGHNESSY-FEY LIBRARY Library
SPECIAL COLLECTIONS DEPT. Archives
 2115 Summit Ave.
 St. Paul, MN 55105-1096 612-647-4446; Fax 612-962-5406

Personnel: John B. Davenport; James D. Kellen, Spec. Coll. Libn.
Founded: 1948 (archives); Incorporated: 1885
Scope: Local, State, Regional, National
Availability: Open, restricted access; Admission: Free
Visitors: General public
Staff: 1 ft, 1 pt; Operating budget: $10,000

Collection: 9,890 books, periodicals, works of art, and 1,078 linear ft. of archives (personal papers and correspondence, unpublished records, pictorial materials, theses and dissertations, manuscripts, and oral histories). Some records are in microform. The collection is cataloged; a reading room and copying facilities are available.

Comments: The collection preserves the historical and cultural records of various Celtic groups (Irish, Scottish, Welsh, Manx, Cornish, Breton).

UNIVERSITY OF SOUTHWESTERN LOUISIANA
DUPRE LIBRARY, SPECIAL COLLECTIONS DEPT.
 302 E. St. Mary Blvd.
 Lafayette, LA 70503 318-482-6031; Fax 318-482-5841

Personnel: Jean Kiesel, Louisiana Room Libn.
Contact: Bruce Turner, Head of Archives and Spec. Coll.
Founded: 1962 (Louisiana Room), 1965 (Southwestern Archives and Manuscripts Coll.)
Scope: Local, State, Regional
Availability: Open M-F, 8-4; Admission: Free
Visitors: General public, School groups, Ethnic community
Staff: 14 (4 ft, 10 pt)
Publications: *La Chene*, 1984- , quarterly

Collection: Over 5,000 books, periodicals, ca. 1,250 oral history and folklore audio and video tapes, over 5,000 photographs, and 75 linear ft. of archives (personal papers and correspondence, unpublished records, theses and dissertations, pictorial materials, manuscripts). Census and parish records, passenger lists, and monographs are in microform. The collection is cataloged; a guide, reading room, and copying facilities are available.

Comments: The Louisiana Room collects materials in various formats on the state; Southwestern Archives and Manuscripts Collection focuses on Acadiana region (22 parish areas) of Louisiana. Both departments collect ethnic materials as they are a portion of the overall mission. Major collections are related to Cajuns; other collections cover Creoles, African Americans, Lebanese, French, Native Americans, Germans, and Ukrainians. Services include speakers or resource people. USL personnel are heavily involved in Festival Acadiens and Festivale Internationale.

UNIVERSITY OF THE PACIFIC
HOLT-ATHERTON DEPT. OF SPECIAL COLLECTIONS
 3601 Pacific Ave.
 Stockton, CA 95211 209-946-2404; Fax 209-946-2810

Contact: Ms. Daryl Morrison, Head of Spec. Coll.
Founded: 1974; Scope: State, Regional
Availability: Open M-F 10-F; Admission: Free
Visitors: General public
Staff: 3 ft, 1.5 FTE student employees
Publications: Library Associates Newsletter

Collection: Over 5,000 books, ca. 200 periodicals, over 5,000 audiovisual materials, archives (pictorial materials, manuscripts, and oral histories). Includes records of the U.S. Bureau of Indian Affairs (5 linear ft., 12 document boxes of field reports, photographs of reservation life also known as the Evander M. Sweet Collection); materials related to Japanese Americans and the papers of Roy Y. Nakatani and James Tanji, who were relocated to Amache, Colorado during World War II, and other relocation materials; Chinese American materials in the San Francisco Chinatown Residential Inspection Records and 3 linear ft. of the Vacabille, California oral history

tapes, among other Asian collections. An unpublished guide, reading room, and copying facilities are available.

Comments: The emphasis of this research library is on Western American history and San Joaquin County California and the ethnic groups (primarily Native Americans and Asians) that settled there. Services include guided tours and talks about the collections by appointment. Programs support research and courses are offered for college credit.

N

NATIVE AMERICAN RESOURCES

AKWESASNE MUSEUM
 R. R. 1, Box 14C
 Hogansburg, NY 13655-9705 518-358-2240/2461

Museum
Library

Sponsoring organization: Akwesasne Cultural Center, Inc.
Contact: Carol White, Library Dir.; Roberta Lazore, Museum Dir.
Founded: 1971; Scope: Regional
Availability: Open to the public; Admission: Fee
Visitors: General public, School groups
Staff: 5 (4 ft, 1 pt); Operating budget: $118,000
Publications: *Kari wenhawi*, 1972- , monthly; catalog of collections; flyers.

Collection: Books, periodicals, paintings and other works of art. The collection is cataloged; a reading room and copying facilities are available.

Comments: Services include guided tours, educational lectures, loans and presentations to schools, speakers, crafts classes, and an arts and crafts souvenir shop. The center participates in ethnic festivals.

THE AMERIND FOUNDATION, INC.
 P.O. Box 400
 Dragoon, AZ 85609 602-586-3666

Museum
Library
Archives
Art Gallery

Personnel: Allan J. McIntyre, Coll. Mgr
Contact: Dr. Anne I. Woosley, Dir.
Founded: 1937; Scope: International
Availability: Open to the public; Admission: Fee (Free to school groups)
Visitors: General public, School groups, Ethnic community
Staff: 7 ft, 1 pt, 20 volunteers; Operating budget: $300,000
Publications: *Amerind Foundation Publications Series*, 1940- , irreg.; *Amerind New World Studies Series*, 1991- , irreg.

Collection: 20,000 books, 75 periodical titles, hundreds of thousands of artifacts, 500 works of art, and 30 linear ft. of archival materials (unpublished records, pictorial materials, theses and dissertations, manuscripts). Some items are in microform. The collection is cataloged; a reading room and copying facilities are available for researchers.

Comments: Amerind is a private, nonprofit archaeological research facility and museum focusing on Native Americans. It conducts field research in the greater Southwest, organizes advanced seminar programs, and offers an internship program. Programs include guided tours, educational lectures, school presentations, and speakers.

ANGEL MOUNDS STATE HISTORIC SITE Museum
 8215 Pollack Ave.
 Evansville, IN 47715 812-853-3956

Personnel: Rebecca Harris, Curator
Contact: Kate Jones, Asst. Curator
Availability: Open to the public; Admission: Free/Donation
Staff: 5 ft, 2 pt
Publications: *Smoke Signals*, quarterly

Collection: Artifacts, realia, and archives (personal papers and correspondence, and pictorial materials).

Comments: This prehistoric Native American village consists of reconstructed houses, a temple, stockade, and one of the largest Indian mounds in the U.S. Services include loans and presentations to schools, speakers, films and AV productions, crafts seminars, an arts and crafts souvenir shop and participation in ethnic festivals.

ANTELOPE VALLEY INDIAN MUSEUM Museum
 1052 W. Ave. M., Suite 201
 Lancaster, CA 93534 805-946-6900; Fax 805-940-3727

Sponsoring organization: State Parks & Cooperative Assn: Friends of the Antelope Valley Museum
Contact: Edra Moore, Curator/Dir.
Founded: 1940 Scope: Local, State, Regional
Availability: Open Sat. and Sun; T and Th, scheduled tours only; Admission: $2 adults, $1 children
Visitors: General public, School groups, Ethnic community
Staff: 1 ft, 1 pt, salaried, 100 volunteers
Publications: *Docent Chants*, 1985- , quarterly; *FAVIM Bulletin,* quarterly.

Collection: Ca. 1,000 books and periodicals, 20 videos, 8,000-10,000 artifacts, 100 works of art, and ca. 150 cubic ft. of archival materials (personal papers and correspondence, unpublished records, printed materials, pictorial materials, theses and dissertations, manuscripts, oral histories, histories, and memorabilia). The collection is partially cataloged; an unpublished guide and reading room are available for researchers.

Comments: Houses major Native American collections from California, the Great Basin Region, and the southwestern United States donated from private collectors in the 1920s and 1930s. The focus is on folk art, archaeology, and ethnographic materials. Services include guided tours, educational lectures, loans and presentations to schools, speakers, films and AV productions, and a souvenir shop. The museum collections support research at the undergraduate and graduate levels.

BIG HOLE NATIONAL BATTLEFIELD Museum
 Highway 43 Library
 Wisdom, MT 59761 406-689-3155 Archives

Sponsoring organization: Natl. Park Service, U.S. Dept. of the Interior
Contact: Jock Whitworth, Supt.
Founded: 1883; Scope: Local, State, Regional, National
Availability: Open, restricted access; Admission: Fee (except senior citizens)
Visitors: General public, School groups, Ethnic community
Staff: 3 ft, 5 pt (seasonal), volunteers; Operating budget: $198,000
Publications: Trail guides

Collection: Books, periodicals, audiovisual materials, over 1,500 artifacts, works of
art, and 18 cubic ft. of archival materials (personal papers and correspondence,
unpublished records, pictorial materials, and manuscripts). The collection is cataloged.

Comments: Big Hole National Battlefield consists of 655 acres where the Battle of the
Big Hole was fought, August 9-10, 1877 as a turning point in the Nez Pierce War.
Collections are specialized to this era as the prime purpose of the site is to portray the
contrasting values and cultures related to this war.

BUECHEL MEMORIAL LAKOTA MUSEUM Museum
 350 South Oak St., P.O. Box 149 Archives
 St. Francis, SD 57572 605-747-2361

Sponsoring organization: Rosebud Education Society
Contact: Donna DuBray-Cordier, Acting Dir.
Founded: 1947; Scope: Local, State, National, International
Availability: Open to the public; Admission: Free
Visitors: General public, School groups, Ethnic community
Staff: 3 (1 ft, 2 pt, 1 salaried); Operating budget: $58,000

Collection: Books, audiovisual materials, ca. 750 artifacts, works of art, and 196 sq.
ft. of archives (personal papers and correspondence, unpublished records).

Comments: The objectives are to preserve the history, language, costumes, and written
record of Native Americans. Services include guided tours, loans to schools, and an
arts and crafts souvenir shop.

CALIFORNIA STATE INDIAN MUSEUM Museum
 2618 K St. Library
 Sacramento, CA 95816 916-324-0971

Sponsoring organization: California State Parks, Dept. of Parks and Recreation
Personnel: Michael Tucker, Curator
Contact: Tom Tanner, State Parks Ranger
Founded: 1960; Scope: Regional
Availability: Open to the public (museum); library for staff only; Admission: Fee
Visitors: General public, School groups, Ethnic community
Staff: 2 ft, 2 pt, salaried; volunteers

Publications: Annual report; membership newsletters; and flyers.

Collection: Ca. 100 books, ca. 600-700 artifacts, 10 works of art, an orientation film, and archival (pictorial) materials. The collection is cataloged.

Comments: The mission is to preserve and interpret the Native American culture of California. Services include guided tours, school presentations, speakers, films and AV productions, and a souvenir shop.

CHEROKEE NATIONAL HISTORICAL SOCIETY, INC. Museum
 P.O. Box 515 Library
 Tahlequah, OK 74465 918-456-6007 Archives
 Art Gallery

Personnel: Myrna Moss, Exec. Dir.; Lisa Finley, Dev. Dir.
Contact: Tom Mooney, Curator
Founded: 1963; Scope: National
Availability: Open, with restricted access
Visitors: General public, School groups
Staff: 6 ft, 175 pt; Operating budget: $900,000
Publications: *The Columns*, 1980- , quarterly

Collection: Ca. 750 books, periodicals, audiovisual materials, ca. 1,250 artifacts, ca. 750 works of art, and archival materials (personal papers and correspondence, unpublished records, pictorial materials, manuscripts, oral histories). Some records are in microform (Dawes Commission rolls). The collection is cataloged; a reading room and copying facilities are available for researchers.

Comments: The society operates the Cherokee National Museum, the Ancient Village at Tsa-La-Gi, Adams Corner Rural Village, and the Trail of Tears. The mission is to preserve and perpetuate the history and culture of the Cherokee Nation of Oklahoma. Services include guided tours, educational lectures, loans and presentations to schools, drama, films and AV productions, and an arts and crafts souvenir shop.

CHIEF PLENTY COUPS MUSEUM Museum
 Chief Plenty Coups State Park Library
 P.O. Box 100
 Pryor, MT 59066 406-752-1289

Sponsoring organization: Chief Plenty Coups State Park
Personnel: Lawrence Flat Lip, Interpreter
Contact: Rich Pittsley, Dir.
Founded: 1973; Scope: Local, State, Regional, National, International
Availability: Open, with restricted access; Admission: Fee
Visitors: General public, School groups, Ethnic community
Staff: 1 ft; Operating budget: $20,000
Publications: Promotional brochures

Collection: Books, periodicals, audiovisual materials, artifacts, works of art, and archives (personal papers and correspondence, unpublished records, pictorial materials, oral histories, and sacred items). The collection is cataloged.

Comments: The objective is to share the heritage and culture of Chief Plenty Coups and the Crow Indians. Services include guided tours, educational lectures, school presentations, speakers, dance performances, films and AV productions, and an arts and crafts souvenir shop. The museum participates in Native American Awareness Week the fourth week of September.

CHOCTAW NATION MUSEUM Museum
 Rt. 1, Box 105 AAA
 Tuskahoma, OK 74574 918-569-4465

Contact: Donna Jo Heflin, Curator, P.O. Box 133, Clayton, OK 74536
Incorporated: 1975; Scope: State
Availability: Open to the public; Admission: Donation
Visitors: General public
Staff: 1 ft
Publications: Promotional brochures

Collection: Books, artifacts and realia, paintings and other works of art, and archives (personal papers and correspondence).

Comments: The purpose is to preserve Choctaw Indian history and culture. Exhibits include a courtroom which seats three tribal judges, a display of items moved over the Trail of Tears, Choctaw pottery, and garments, etc. Programs include guided tours of the museum, and sale of items through the gift shop.

COLORADO RIVER INDIAN TRIBES MUSEUM/LIBRARY Museum
 Rt. 1, Box 23-B Library
 Parker, AZ 85344 602-669-9211 Archives

Personnel: Harold Claw, Registrar/Curator; Amelia Flores, Libn.; Anna Scott, Asst. Libn.
Contact: Betty L. Cornelius, Museum Dir.
Founded: 1966; Scope: Local, Regional
Availability: Open, with restricted access; Admission: Donation
Visitors: General public, School groups, Ethnic community
Staff: 10 (6 ft, 4 pt); Operating budget: $106,000

Collection: 22,000 books, periodicals, audiovisual materials, 2,000 artifacts, works of art, and archives (personal papers and correspondence, pictorial materials, theses and dissertations, oral histories). Some records are in microform. The collection is cataloged; an unpublished guide, reading room, and copying facilities are available.

Comments: The museum preserves the history and culture of American Indian cultures along the lower Colorado River, mainly Mohave and Chemehuivi Tribes. Services include guided tours, educational lectures, school presentations, films, arts and crafts demonstrations, and a souvenir shop. The museum and library support research.

CRAZY HORSE MEMORIAL Museum
 Avenue of the Chiefs Library
 Crazy Horse, SD 57730 605-673-4681 Archives

Sponsoring organization: Crazy Horse Memorial Foundation
Personnel: Anne Ziolkowski, Museum Dir.
Contact: Ruth Ziolkowski, Chief Exec. Officer
Founded: 1947; Scope: Local, State, Regional, National
Availability: Open to the public; Admission: Fee (except for Native Americans)
Visitors: General public, School groups, Ethnic community
Staff: ca. 25 (ft, pt, and volunteers)
Publications: *Progress*, 1979- , 3/year; also publishes books.

Collection: 14,000 books, periodicals, audiovisual materials, 3,000 artifacts, 200 works of art, and 200 cubic ft. or archives (personal papers and correspondence, unpublished records, pictorial materials, manuscripts and in-house records). The collection is cataloged; a reading room and copying facilities are available.

Comments: The foundation is committed to the carving of the Crazy Horse Memorial at the request of Sioux Indians. The objectives are to enhance Native Americans' pride in their unique cultural heritage, and to promote education and economic opportunity. Services include guided tours, educational lectures, loans and presentations to schools, TV programs, performing arts (dance, drama, instrumental), films and AV productions, crafts classes, and a souvenir shop. The foundation participates in ethnic festivals.

DACOTAH PRAIRIE MUSEUM Museum
 21 S. Main Archives
 Aberdeen, SD 57401 605-622-7117 Art Gallery

Personnel: Merry Coleman, Dir.
Contact: Sue Batteen, Coll. Curator
Founded: 1964; Scope: Local
Availability: Open, with restricted access; Admission: Free
Visitors: General public, School groups, Ethnic community
Staff: 3 ft, 3 pt, 75 volunteers; Operating budget: $85,000
Publications: *Dacotah Prairie Times*, quarterly

Collection: Books, periodicals, artifacts, works of art, and 15 boxes of archives (personal papers and correspondence, unpublished records, theses and dissertations, manuscripts, and oral histories). A reading room and copying facilities are available.

Comments: The objective is to relate the history of Brown County, South Dakota and its native inhabitants (Arikara, Sioux). Programs include guided tours, educational lectures, loans and presentations to schools, speakers, and an arts and crafts shop.

DULL KNIFE MEMORIAL COLLEGE, Library
JOHN WOODENLEGS MEMORIAL Archives
 P. O. Box 98
 Lame Deer, MT 59043 406-477-8293; Fax 406-477-6575

Personnel: Bill Tall Bull, Cultural Historian; Judi Davis, Archivist
Contact: Michal Arpan, Acting Dir., Assoc. Libn.
Founded: 1982; Scope: Local, State, Regional, National
Availability: Open to the public; Admission: Free

Visitors: General public
Staff: 4 (3 ft, 1 pt; salaried); Operating budget: $41,190

Collection: Books, periodicals, audiovisual materials, artifacts and realia, paintings and other works of art, and 200 cubic ft. of archives (personal papers and correspondence, unpublished records, pictorial materials, theses and dissertations, and oral histories). The collection is cataloged; an unpublished guide, reading room, and copying facilities are available.

Comments: This tribal library serves the Northern Cheyenne people both as an academic library that supports the curriculum and as a public library. The archives preserve Cheyenne cultural materials and provide information for researchers.

ETOWAH INDIAN MOUNDS STATE HISTORIC SITE Museum
 813 Indian Mounds Rd. SW
 Cartersville, GA 30120 706-387-3747

Personnel: Lonice Barrett, Dir., Parks, Recreation & Historic Sites
Contact: Libby Forehand Bell, Manager Etowah Mounds
Founded: 1953; Scope: Local
Availability: Open to the public; Admission: Fee
Visitors: General public, School groups
Staff: 9 (3 ft, 3 pt, 3 volunteers); Operating budget: $100,000

Collection: Artifacts and realia; copies of *State Archaeologist* are in microform. The collection is cataloged; an unpublished guide is available.

Comments: The purpose is to help explain the lives and culture of the Etowah Indians through their costumes, decorative arts, ceremonial objects, domestic tools, arts and crafts, weapons, etc. Etowah was the center of political and religious life in the Etowah Valley and was home to the chiefs between 700 and 1650. Services and programs include guided tours, educational lectures, school presentations, and participation in ethnic festivals.

FAVELL MUSEUM OF WESTERN ART AND INDIAN ARTIFACTS Museum
 125 West Main St. Art Gallery
 Klamath Falls, OR 97601

Personnel: Gene Favell, Dir./Curator, Owner
Contact: Bev Jackson, Admin./Mgr.
Availability: Open to the public; Admission: Fee
Visitors: General public, School groups, Ethnic community
Staff: 2 ft, 1 pt; Operating budget: Gift shop and gallery sales
Publications: *A Treasury of our Western Heritage* (1985); also publishes catalog of collections.

Collection: Over 1,500 artifacts and realia, almost 1,000 works of art. A published guide to the collection is available.

Comments: The museum is dedicated to the Indians who lived in this area and their art

is preserved as an important part of their heritage. Services include speakers, school presentations, arts and crafts shop, art gallery, and bookstore.

THE FIVE CIVILIZED TRIBES MUSEUM Museum
 Agency Hill Library
 Muskogee, OK 74401 918-683-1701 Archives
 Art Gallery

Contact: Dianne S. Haralson, Museum Mgr.
Founded: 1966; Scope: Local, State, Regional, National, International
Availability: Open to the public; Admission: Fee
Visitors: General public, School groups
Staff: 31 (3 ft, 3 pt, salaried; 25 volunteers); Operating budget: $400,000
Publications: Annual report; membership newsletters; and flyers.

Collection: Ca. 1,500 books, ca. 1,500 periodicals, audiovisual materials, artifacts, works of art, and 6,000 sq. ft. of archives (personal papers and correspondence, unpublished records, pictorial materials, manuscripts, and oral histories).

Comments: The museum showcases the history, arts, and crafts of the Cherokees, Choctaws, Chickasaws, Creeks, and Seminoles of the Southeastern United States. Services include guided tours, educational lectures, loans to schools, speakers, crafts classes, and a souvenir shop.

FLATHEAD INDIAN MUSEUM Museum
 Hwy. 93, Box 460
 St. Ignatius, MT 59865 406-745-2951

Personnel: L. Doug Allard, Owner/Curator
Contact: Jeanine Allard, Dir.
Founded: 1974; Scope: Local, State, Regional, National
Availability: Open to the public; Admission: Free
Visitors: General public
Staff: 7 (4 ft, 3 pt; salaried)
Publications: *Allard Auction Catalog*, 1978- , semi-annual

Collection: Artifacts, works of art, archival records (pictorial materials)

Comments: This privately owned collection is open to the public; the collection catalog serves as a reference guide for identification and pricing of Native American Indian artifacts. Services include guided tours, educational lectures, school presentations, and an arts and crafts souvenir shop. The museum participates in ethnic festivals.

FORT BELKNAP COLLEGE LIBRARY AND TRIBAL ARCHIVES Library
 P.O. Box 159 Archives
 Harlem, MT 59526 406-353-4977

Contact: Eva English, Library and Tribal Archives Dir.
Founded: 1989; Scope: Local, State
Availability: Open to the public; Admission: Free
Visitors: Ethnic community

Staff: 1 ft; Operating budget: $40,000
Publications: Tribal archives directory

Collection: Ca. 1,500 books, periodicals, photographs, 8 file drawers and 12 ft. of archival materials (community records, unpublished records, pictures, and oral histories). Census records and treaty copies are in microform. The collection is partially cataloged; an unpublished guide, reading room, and copying facilities are available.

Comments: The purpose is to serve students and faculty of the college as well as the community and general public in providing information about the cultural heritage of the Gros Ventre and Assiniboine Indians. Programs include guided tours and participation in ethnic festivals.

FORT LEWIS COLLEGE CENTER OF SOUTHWEST STUDIES Museum
 1000 Rim Drive Library
 Durango, CO 81301-3999 303-247-7456; Fax 303-247-7457 Archives

Personnel: Todd Ellison, Archivist
Contact: Dr. Richard N. Ellis
Founded: 1964; Scope: Local, State, Regional
Availability: Open Sun. 2-7 (Sept.-April); M-Th 9:30-8, F 9:30-4:30; Admission: Free
Visitors: General public
Staff: ca. 20

Collection: Over 5,000 books, ca. 200 periodicals, ca. 750 audiovisual materials, over 5,000 artifacts, ca. 350 works of art, and 1,000 linear ft. of archives (personal papers and correspondence, unpublished records, pictorial materials, theses and dissertations, manuscripts, and oral histories). Historic Southwest newspapers and National Archives records on federal Indian affairs are in microform. The collection is partially cataloged; an unpublished guide, reading room, and copying facilities are available.

Comments: The center presents the unique historical identity of this college (where qualified Native Americans attend tuition free) and provides materials pertaining to the southwestern United States and Native Americans. Programs include guided tours, educational lectures, and speakers. The center supports research, offers work experience for college credit, provides in-service programs, workshops for teachers, and courses for college credit.

GARDNER MANSION AND MUSEUM Museum
 Route 1, Box 576
 Broken Bow, OK 74728 405-584-6588

Personnel: Lewis R. Stiles, Pres., Curator; Frances Stiles, Operator, Curator
Founded: 1940; Scope: State
Availability: Open to the public; Admission: Fee
Visitors: General public, School groups, Ethnic community
Staff: 2 (1 ft, 1 pt)

Collection: Ca. 1,500 artifacts and realia

Comments: The purpose is to provide public education on prehistoric and historic Indian cultures with emphasis on Choctaw and Creek Tribes. Services include guided tours and school presentations; tours in conjunction with Native American courses of study are also provided.

H. EARL CLACK MEMORIAL MUSEUM Museum
 c/o Hill County Courthouse
 Havre, MT 59501 406-265-9913

Contact: Vyonne Sheppard, Mgr.
Founded: 1964; Scope: Local
Availability: Open to the public; Admission: Free
Visitors: General public, School groups
Staff: 6 pt; Operating budget: $40,000

Collection: Artifacts and realia, paintings and other works of art, including dioramas. The collection is cataloged.

Comments: The purpose is to illustrate and interpret local Native American history. Services include guided tours of the Wahpka Chug'n archaeological site and Fort Assiniboine site, educational lectures, presentations to schools, and speakers.

HAMPSON MUSEUM STATE PARK Museum
 U.S. Hwy. 61 at Lake Drive, P.O. Box 156
 Wilson, AR 72395 501-655-8622

Sponsoring organization: Arkansas Dept. of Parks & Tourism
Contact: Corinne Fletcher, Superintendent
Availability: Open to the public; Admission: Fee
Visitors: General public, School groups
Staff: 4 (2 ft, 2 pt volunteers); Operating budget: $50,000
Publications: *Hampson Museum Guide*, 1980- , irreg.; promotional brochures.

Collection: 40,000 artifacts and realia and archival materials (personal papers and correspondence, printed materials). The collection is not cataloged; a published guide to the exhibit area is available.

Comments: The purpose is to educate the public about the prehistoric Mississippian mound builders. Services include guided tours, educational lectures, loans and presentations to schools, speakers, crafts classes, pottery demonstrations, and an arts and crafts souvenir shop. The museum supports research.

THE HEARD MUSEUM Museum
 22 East Monte Vista Rd. Library
 Phoenix, AZ 85004 602-252-8840 Archives

Personnel: Mario Klimiades, Libn./Archivist
Contact: Martin Sullivan, Dir.

Founded: 1929; Scope: Regional, National, International
Availability: Open to the public; Admission: Fee
Visitors: General public, School groups
Staff: 66 (60 ft, 6 pt); Operating budget: $2,600,000
Publications: Annual reports; membership newsletters; and flyers.

Collection: 24,000 books, 1,916 bound periodicals, 100 current periodicals, 500 audiovisual materials, 26,000 artifacts, 4,000 works of art, 15,000 photographs, ca. 200 linear ft. of archival materials (personal papers and correspondence, unpublished records, pictorial materials, manuscripts, oral histories). HRAF files are in microform. The museum catalog is automated; a reading room and copying facilities are available.

Comments: The mission is to promote appreciation for native people and their cultural heritage, with an emphasis on the traditional cultures of the greater southwest and on the evolving Native American fine arts movement. Services include guided tours, educational lectures, loans and presentations to schools, speakers, dance and instrumental performances, films and AV productions, crafts classes, and a souvenir shop. The museum cooperates closely with Arizona State University and offers work experience for college credit.

THE HERITAGE CENTER Museum
 Red Cloud Indian School Archives
 Highway 18 W.
 Pine Ridge, SD 57770 605-867-5491; Fax 605-867-1291

Contact: Brother Simon, S.J., Dir.
Founded: 1982; Scope: National
Availability: Open to the public; Admission: Donation
Visitors: General public, School groups, Ethnic community
Staff: 2 (1 ft, 1 pt); Operating budget: $50,000
Publications: Promotional brochures

Collection: Books, periodicals, audiovisual materials, ca. 1,500 artifacts, ca. 1,500 works of art, and 75 cartons of archives (personal papers and correspondence, unpublished records, pictorial materials). The collection is partially cataloged.

Comments: The museum sponsors a yearly show of prize-winning and other paintings by Native American artists. It includes graphics and sculptures from the annual Red Cloud Indian Art Show, one of the most important national competitions for Native American artists in North America. It also cooperates with colleges and universities through touring shows, provides guided tours, loans to schools, and a souvenir shop.

HISTORICAL SOCIETY MUSEUM Museum
 115 Westview Ave. Library
 Valparaiso, FL 32580 904-678-2615

Sponsoring organization: Historical Society of Okaloosa and Walton Counties, Inc.
Personnel: Mrs. Christian S. LaRoche, Museum Dir.
Contact: Christian S. LaRoche, P.O. Box 488, Valparaiso, FL 32580
Founded: 1969; Scope: Local

Availability: Open to the public; Admission: Free
Visitors: General public, School groups, Ethnic community
Staff: 26 (1 ft, salaried; 25 volunteers); Operating budget: $23,000
Publications: *New Growth*, quarterly

Collection: Ca. 1,500 books, periodicals, audiovisual materials, artifacts, works of art, and archives (personal papers and correspondence, theses and dissertations, manuscripts, oral histories). The collection is partially cataloged.

Comments: The mission is to preserve documentary and photographic data and artifacts that illustrate the Native American history and cultural composition of the area.

HOPEWELL CULTURE NATIONAL HISTORICAL PARK Museum
(Formerly Mound City Group National Monument) Library
 16062 State Route 104
 Chillicothe, OH 45601 614-774-1125

Personnel: William Gibson, Supt.; Robert Petersen, Park Rgr., Curator
Founded: 1923; Scope: National
Availability: Open to the public (museum); restricted access (library); Admission:
Fee
Visitors: General public
Staff: 8 ft
Publications: Promotional brochures

Collection: Ca. 1,500 books, periodicals, audiovisual materials, over 2,500 artifacts.
The collection is cataloged.

Comments: The purpose is to preserve and interpret the Hopewell culture; emphasis is on the period between 200 BC and 500 AD.

INDIAN CITY USA, INC. Museum
 Hwy. 8
 Anadarko, OK 73005 405-257-5661

Personal: Kathleen Winsted, Pres.
Contact: George F. Moran, Genl. Mgr.
Founded: 1955 Scope: Local, State, Regional, National, International
Availability: Open to the public; Admission: Fee
Visitors: General public
Staff: 10 ft, 20 pt (2 salaried)
Publications: Promotional brochures and guide books

Collection: Books, artifacts and realia, works of art, and archival records (oral histories). The collection is cataloged; an unpublished guide is available.

Comments: Authentic Indian villages, planned and implemented under the supervision of the Department of Anthropology, University of Oklahoma, preserve the history and culture of the American Indian. Services and programs include guided tours, educational lectures, school presentations, Indian dancing, arts and crafts.

INDIAN MUSEUM OF LAKE COUNTY, OHIO Museum
 391 West Washington
 Painesville, OH 44060 216-352-1911

Sponsoring organization: Lake County Chapter of the Archaeological Society of Ohio
Personnel: Christine Walich, Ann Dewalt, Asst. Dirs.; Wm M. King, Pres. Bd. of
Trustees; Deborah Muzik, Secy.
Contact: Gwen G. King, Dir.
Founded: 1979; Scope: Local, State, National
Availability: Open to the public; Admission: Donation
Visitors: General public, School groups, Ethnic community
Staff: 26 pt volunteers; Operating budget: $17,000
Publications: Membership newsletters and flyers; educational pamphlets; and books,
e.g., *Prehistoric Pipes: A Study of the Reeve Village Site* (1979); *What Indians Lived in
Ohio?* (1991); *Early Indians of Ohio* (1988).

Collection: Books, periodicals, audiovisual materials, 20,000 artifacts and realia, and
archival records (printed and pictorial materials). The collection is partially cataloged.

Comments: The objectives are to discover and preserve archaeological sites and
materials related to the history and antiquities of Native Americans of Lake County,
Ohio. One culture is featured in a major exhibit each year. Services include guided
tours, educational lectures, radio and TV programs, speakers, an arts and crafts
souvenir shop, and summer workshops for teachers and students. Students at Lake
Erie College work at the museum on a work-study scholarship.

IROQUOIS INDIAN MUSEUM Museum
(Formerly Schoharie Museum of the Iroquois Indian)
 P.O. Box 7, Caverns Rd.
 Howes Cave, NY 12092 518-296-8949; Fax 518-296-8955

Contact: Stephanie Shultes, Curator
Founded: 1980; Scope: State, Regional, National, International
Availability: Open to the public; Admission: Fee $5 adults, Seniors $4, Ages 7-12
$2.50, Under 7 Free
Visitors: General public
Staff: 8 ft, 8 pt (seasonal), 45 volunteers; Operating budget: $435,000
Publications: *Museum Notes*, 1981- , quarterly; catalogs of the collection.

Collection: 1,500 books, 500 periodicals, audiovisual materials, 10,000 artifacts,
1,700 works of art, and 14 drawers of archival materials (personal papers and
correspondence, unpublished records, pictorial materials, and oral histories). The
collection is cataloged; a reading room and copying facilities are available.

Comments: Hands-on exhibits, craft demonstrations, lectures, festivals, and story
hours trace the lives of the Iroquois from 10,000 years ago to the present. The museum
offers guided tours, educational lectures, loans and presentations to schools, speakers,
dance, films, crafts classes, and a souvenir shop. It has sponsored archeological
research on the Mohawk Village site and on Iroquois performing artists. It supports
graduate level research and offers work experience and courses for college credit.

KODIAK HISTORICAL SOCIETY Museum
 101 Marine Way Archives
 Kodiak, AK 99615 907-486-5920

Personnel: Marian Johnson, Dir.; Alice Ryser, Archivist; Beverly Horn, Curator of
Collections
Founded: 1954; Scope: Local
Availability: Open to the public; Admission: Fee
Visitors: General public, School groups
Staff: 18 (1 ft, 3 pt, salaried; 14 volunteers); Operating budget: $130,000
Publications: Promotional materials; catalogs

Collection: Books, periodicals, 5,000 photographs, ca. 1,500 artifacts, works of art,
and 7 cabinets of archives (personal papers and correspondence, unpublished records,
pictures, theses, manuscripts, and oral histories). Some records are in microform. The
collection is cataloged; a reading room and copying facilities are available.

Comments: The purpose is to encourage and assist in the restoration, preservation,
recovery, and exploration of the historical data and materials related to the Aleut and
Koniag (Pacific Eskimo) cultures in the Kodiak and Aleutian Island area. The museum
provides guided tours, loans to schools and other educational institutions, school
presentations, and an arts and crafts souvenir shop.

KOSHARE INDIAN MUSEUM, INC. Museum
 115 W. 18th St., P.O. Box 580 Library
 La Junta, CO 81050 719-384-4412 Art Gallery

Personnel: M. Jon Kolomitz, Pres., Bd. of Dirs.
Contact: Michael J. Menard, Museum Dir.
Founded: 1949; Scope: Local, State, Regional, National
Availability: Open to the public; Admission: Fee
Visitors: General public
Staff: 3 ft, 4 pt, salaried; 50 volunteers; Operating budget: $210,000
Publications: *Koshare News*, semiannual

Collection: Ca. 750 books, over 1,000 periodicals, over 250 audiovisual materials,
6,000 artifacts, over 500 works of art, and 150 cubic ft. of archival records (personal
papers and correspondence, unpublished records, pictorial materials, manuscripts). The
collection is cataloged; copying facilities are available for researchers.

Comments: The purpose is to preserve art, where the American Indian is either artist
or subject of the art, as well as Native American culture. Services include guided
tours, lectures, loans and presentations to schools, speakers, dance, and crafts classes.

MEMPHIS STATE UNIVERSITY Museum
CHUCALISSA ARCHAEOLOGICAL MUSEUM Library
(C. H. NASH MUSEUM) Archives
 Department of Anthropology
 1987 Indian Village Dr.
 Memphis, TN 38109 901-785-3160

Personnel: Dr. Daniel Beaslye, Interim Dir.; John Hesse, Asst. Dir.; Camille Wharey, Coll. Mgr.
Contact: Mary L. Kwas, Curator of Education
Founded: 1955; Scope: Local, State, Regional
Availability: Open to the public, restricted access; Admission: Fee
Visitors: General public, School groups
Staff: 11 (10 ft, 1 pt, salaried); Operating budget: $280,000
Publications: *Chucalissa Revisited*

Collection: Ca. 2,000 books, 15 periodicals, 20 audiovisual productions, thousands of artifacts, and 12 file drawers of archival materials (personal papers and correspondence, unpublished records, pictorial materials, theses and dissertations, manuscripts, and archaeological records). The collection is partially cataloged; a reading room and copying facilities are available.

Comments: Chucalissa is the name of the 15th century restored Indian village of which the C. H. Nash Museum is a part. The purpose is to protect, research, and interpret the prehistoric Native American site for the education and enjoyment of the public, and to preserve and share the past and present cultural heritage of the American Indian.

MUSEUM OF INDIAN ARTS AND CULTURE Museum
 710 Camino Lejo Library
 P. O. Box 2087 Archives
 Santa Fe, NM 87501 505-827-6344; Fax 505-827-6497

Sponsoring organization: Museum of New Mexico
Personnel: Stephen Becker, Dir.; Bruce Bernstein, Asst. Dir. & Chief Curator;
Willow Powers, Archivist; Laura Holt, Libn.
Contact: Pam Farnham, P. O. Box 2087, Santa Fe, NM 87504-2087
Founded: 1929; Scope: Regional
Availability: Open to the public (Exhibits); By appt. only (collections); Admission: Fee
Visitors: General public, School groups
Publications: *El Palacio*, 1913- , tri-annual

Collection: 4,000 books, 1,000 periodical titles (20,000 vols.), 63,000 artifacts, 2,000 works of art, archives (personal papers and correspondence, unpublished records, pictorial materials, manuscripts, institutional archives, systematic archaeological and ethnographic paper collections). The collection is cataloged; an unpublished guide, reading room, and copying facilities are available.

Comments: The collections highlight American Indian art and culture. Guided tours, educational lectures, loans and presentations to schools, speakers, performing arts (dance and instrumental), literary arts, artist demonstrations, and gallery talks are provided. The museum participates in ethnic festivals.

MUSEUM OF NORTHERN ARIZONA Museum
 Rt. 4, Box 720 (Fort Valley Rd.) Library
 Flagstaff, AZ 86001 602-774-5211 Archives
 Art Gallery

Contact: Philip M. Thompson, Dir.
Founded: 1928; Scope: Regional
Availability: Open to the public (collections on exhibit); Admission: Fee
Visitors: General public
Staff: 111 (62 ft, 24 pt, 25 volunteers); Operating budget: $4,200,000
Publications: *Plateau*, 1928- , quarterly; *Museum Notes*, 1974- , bimonthly; also
publishes a scholarly bulletin on an irregular basis and occasional monographs.

Collection: 100,000 library items, 200,000 artifacts, 2,200 works of art, miscellaneous
audiovisual materials, and 300 archival collections (personal papers and
correspondence, unpublished records, pictorial materials, theses and dissertations,
manuscripts, and oral histories). Catalogs and site films are on microfilm. Most of the
collections are cataloged; many archaeological collections and archives are not. A
reading room and copying facilities are available.

Comments: The purpose is to disseminate knowledge about the Colorado Plateau.
Exhibits focus on the Hopi, Navajo, and prehistoric cultures of northern Arizona.
Programs include children's classes and workshops, adult outdoor interpreted hikes,
river trips, bus excursions, children's outdoor experiential education programs, gallery
lectures, and a traveling kit program to nearby reservation schools. Docents are also
speakers and resource people. Dance and instrumental performances are given as are
films and AV productions. Craft classes and a souvenir shop are available; the museum
participates in ethnic festivals. The organization supports research and provides work
experience for college credit.

MUSEUM OF THE GREAT PLAINS Museum
 601 Ferris Ave., P.O. Box 68 Library
 Lawton, OK 73502 405-581-3460 Archives

Personnel: Steve Wilson, Dir.
Founded: 1960; Scope: Regional
Availability: Open by special appt.; Admission: Fee
Visitors: General public, School groups
Staff: 10 ft, 3 pt, salaried; 8 volunteers
Publications: *Great Plains Journal*, 1961- , annual; *Museum of the Great Plains
Newsletter*, 1976- , irreg.; also publishes flyers, advertisements, and monographs.

Collection: 23,000 books, periodicals, 251,000 artifacts, and 1,800 sq. ft. of archives
(personal papers and correspondence, unpublished records, pictorial materials), 30,000
photographs, and 20,000 maps. A reading room and copying facilities are available for
researchers.

Comments: Exhibits items about the cultural history of the Great Plains and Native
Americans. Services include lectures, loans and presentations to schools, speakers,
films, living history reenactments, a souvenir shop, research, work experience for
college credit, and graduate internships in Public History with local universities.

MUSEUM OF THE PLAINS INDIAN Museum
 P. O. Box 400
 Browning, MT 59417 406-338-2230

Sponsoring organization: Indian Arts and Crafts Board, U.S. Dept. of the Interior
Founded: 1941; Scope: National
Availability: Open to the public; Admission: Free
Visitors: General public
Publications: Exhibition catalogs and brochures.

Collection: Artifacts, realia, and works of art created by the tribal peoples of the
Northern Plains, including the Blackfeet, Crow, Northern Cheyenne, Sioux,
Assiniboine, Arapaho, Shoshone, Nez Pierce, Flathead, Chippewa, and Cree.

Comments: Historic displays are devoted to art forms related to the social and
ceremonial aspects of the tribal cultures of the region. A five-screen multimedia
presentation, *Winds of Change*, is also on view. Services include guided tours, gallery
discussions, presentations to school groups, performing arts presentations, AV
productions, and an arts and crafts gift/souvenir shop.

NATIONAL HALL OF FAME FOR FAMOUS AMERICAN INDIANS Museum
 Hwy 62 E., P.O. Box 548
 Anadarko, OK 73005-0548; Fax 405-247-5571

Personnel: Allie Reynolds, Pres.; Joe McBride, Jr., V. Pres.; George Moran, Treas.
Contact: Carolyn McBride, Secy.
Founded: 1982; Scope: National
Availability: Open to the public; Admission: Free
Visitors: General public, School groups, Ethnic community
Staff: 4 (ft and volunteers); Operating budget: $20,000

Collection: Videos of induction ceremonies of bronze busts of famous Native
Americans; a published guide to the collection is available.

Comments: The organization promotes contributions of Native American through 37
portraits of famous American Indians presented in a garden setting. A walking tour and
lecture are available.

NATIONAL MUSEUM OF THE AMERICAN INDIAN Museum
(Formerly Museum of the American Indian-Heye Foundation) Library
 Smithsonian Institution Archives
 3753 Broadway at 155th St. Art Gallery
 New York, NY 10032 212-283-2420

Sponsoring organization: Smithsonian Institution
Personnel: W. Richard West, Jr., Dir. (Washington, DC); Archivist; Mary Jame
Lenz, Assoc. Curator
Contact: Dr. Duane H. King, Asst. Dir. (New York)
Founded: 1916; Scope: National, International
Availability: Open to the public; Admission: Fee
Visitors: General public
Staff: 98 (90 ft, 8 pt, salaried); Operating budget: $10 million
Publications: *Smithsonian Runner*, bimonthly; also publishes catalogs of the collection
(National Museum of the American Indian) and promotional brochures.

Collection: Over 1,500 books, periodicals, ca. 750 audiovisual materials, over 1,500 artifacts, over 1,500 works of art, and 600 boxes of archival materials (personal papers and correspondence, pictorial materials). Some records are in microform (Huntington Library collection of 40,000 titles). The collection is cataloged; a reading room and copying facilities are available.

Comments: The museum studies and exhibits the life, languages, literature, history, and arts of Native Americans. Programs include guided tours, educational lectures, speakers, drama and instrumental performances, films and AV productions, arts and crafts demonstrations, demonstrations of musical instruments, and a souvenir shop. The museum supports and conducts research at the undergraduate and graduate levels, and offers in-service programs for teachers.

NORTH AMERICAN INDIAN INFORMATION Museum
AND TRADE CENTER Library
 P.O. Box 27626 Art Gallery
 Tucson, AZ 85726 602-622-4900

Contact: Fred Synder, Dir.
Founded: 1969; Scope: National, International
Availability: Open by special appt.; Admission: Donation
Visitors: General public, Ethnic community
Staff: 2 ft
Publications: Books; a directory of Native Americans; *Pow-Wow on the Red Road* (calendar of American Indian events); promotional brochures and flyers.

Collection: Books, periodicals, audiovisual materials, artifacts, and realia. The collection is not cataloged; an unpublished guide and reading room are available.

Comments: Sponsors Indian pow-wows, rodeos, and other events that preserve Native American history and culture. Services include guided tours, lectures, school presentations, dance and instrumental performances, crafts classes, and a souvenir shop.

OCMULGEE NATIONAL MONUMENT Museum
 1207 Emery Hwy.
 Macon, GA 31201 912-752-8259

Sponsoring organization: National Park Service, Dept. of the Interior
Personnel: Guy LaChine, Acting Supt.
Contact: Sylvia Flowers, Cultural Resources Specialist
Founded: 1936; Scope: National
Availability: Open with restricted access; Admission: Fee
Visitors: General public, School groups
Staff: 10 (6 ft, 4 pt)
Publications: Membership newsletters and flyers

Collection: Ca. 1,500 books, audiovisual materials, ca. 1,500 artifacts, works of art, and archival records (unpublished records, printed materials, pictorial materials, manuscripts, oral histories). A reading room and copying facilities are available for researchers.

Comments: Emphasis is on the Mississippians at Ocmulgee, a skillful farming people who lived on this site between AD 900 and 1100 and whose culture spread throughout much of the central and eastern United States. Services include guided tours, educational lectures, loans and presentations to schools, speakers, films, and an arts and crafts souvenir shop. The museum participates in ethnic festivals.

OREGON PROVINCE ARCHIVES OF THE SOCIETY OF JESUS Archives
 Gonzaga University
 Spokane, WA 99258 509-328-4220

Sponsoring organization: Gonzaga University
Contact: Bro. Edward S. Jennings, S.J., Asst. Special Collections Libn.
Founded: 1934; Scope: Regional, National
Availability: Open regular hours, restricted access; Admission: Free
Visitors: General public, Ethnic community

Collection: 5,000 books, periodicals, and 3,220 linear ft. of archives (personal papers and correspondence, unpublished records, pictures, theses, manuscripts, and oral histories). Records of Indian wars, languages, missions are in microform. Tribes include Crow, Blackfoot, Coeur d'Alene, Flathead, Assiniboine, Alhabasean, Yup'ak, and Innupiak. The collection is partially cataloged; an unpublished guide, reading room, and copying facilities are available.

Comments: Serves authors, researchers, and Native Americans seeking ancestral genealogical records. Jesuit history, from 1841 when Fr. Peter DeSmet, S.J. arrived in the Northwest, is also preserved. Provides guided tours, research, and ethnic festivals.

OSCAR HOWE ART CENTER Museum
 119 W. Third
 Mitchell, SD 57301 605-996-4111

Sponsoring organization: Mitchell Area Arts Council
Personnel: Jeffrey F. Morrison, Curator
Contact: Patricia Amert, Exec. Dir.
Founded: 1971; Scope: Regional, National, International
Availability: Open to the public; Admission: Free
Visitors: Open to the public
Staff: 8 (4 ft, 1 pt, 3 volunteers); Operating budget: $150,000
Publications: *Art News*, 1971- , quarterly

Collection: 200 works of art; an unpublished guide and copying facilities are available.

Comments: Promotes the artistic heritage of Native Americans and opportunities in the arts. Provides guided tours, lectures, loans and presentations to schools, radio programs, speakers, performing arts, films, crafts classes, and souvenir shop.

OWASCO TEYETASTA/CAYUGA MUSEUM Museum
(Formerly Owasco Indian Village) Archives
 203 Genessee St.
 Auburn, NY 13021 315-253-8051

Sponsoring organization: Cayuga Museum
Personnel: Peter L. Gabak, Curator
Contact: Peter L. Jones, Exec. Dir.
Founded: 1936; Scope: Regional
Availability: Open; restricted access; Admission: Donation
Visitors: General public
Staff: 18 (2 ft, 1 pt salaried; 15 volunteers); Operating budget: $6,000
Publications: *Cayuga Chief*, bimonthly; promotional brochures

Collection: Books, ca. 3,000 artifacts and archives; a reading room and copying
facilities are available.

Comments: Owasco Teyetasta is a meeting place for sharing knowledge of the cultures
of Upstate New York Native Americans from prehistoric times to the present. The
Cayuga Museum houses the collections and sponsors festivals. Services include
educational lectures, school presentations, and dance performances.

PACIFIC UNIVERSITY ARCHIVES Archives
 2043 College Way
 Forest Grove, OR 97116 503-357-6151 ext. 2617

Contact: Richard T. Read, Archivist
Founded: 1989; Scope: Regional, International
Availability: Open by special appt.; Admission: Free
Visitors: General public
Staff: 1 salaried

Collection: Books and archival records (personal papers and correspondence,
unpublished records, theses and dissertations, and manuscripts). Materials related to
Native Americans, including Mission Press missionary period imprints, are included.
The collection is cataloged; a reading room and copying facilities are available.

Comments: A major purpose is to preserve Native American history and culture.
Programs include educational lectures, loans to schools, and speakers. The archives
support undergraduate level research and offer work experience for college credit.

PEMBROKE STATE UNIVERSITY Museum
NATIVE AMERICAN RESOURCE CENTER
 Pembroke, NC 28372 919-521-6282

Contact: Dr. Stanley Knick, Dir./Curator
Founded: 1979; Scope: International
Availability: Open to the public; Admission: Free
Visitors: General public, School groups
Staff: 2 ft
Publications: *Robeson Trail Archaeological Survey* (1988); *Along the Trail: A Reader
about Native Americans; SPIRIT!*, 1988- , quarterly; also publishes promotional
brochures.

Collection: Ca. 250 books, audiovisual materials, over 1,500 artifacts, ca. 500 works

of art, 40 cubic ft. of archives (personal papers and correspondence, unpublished records, pictorial materials, manuscripts, oral histories). The collection is cataloged; a reading room and copying facilities are available.

Comments: The purpose is to collect and preserve art, artifacts, and other documents to educate the public about Native American prehistory, history, art, culture, and contemporary issues. Services include guided tours, educational lectures, loans and presentations to schools, speakers, performing arts, films and AV productions, and Indian storytelling sessions. The museum supports research at the undergraduate level and provides courses for college credit as well as in-service programs for teachers.

PONCA CITY CULTURAL CENTER AND MUSEUM Museum
 1000 E. Grand
 Ponca City, OK 74604 405-767-0427

Contact: La Wanda French, Dir.
Founded: 1939; Scope: National
Availability: Open to the public; Admission: Fee
Visitors: General public
Staff: 2 ft, 1 pt

Collection: Books, over 1,500 artifacts, works of art; the collection is cataloged.

Comments: The museum preserves the history and culture of local Native American.

PUEBLO GRANDE MUSEUM AND CULTURAL PARK Museum
 4619 E. Washington St.
 Phoenix, AZ 85034-1909 602-495-0901; Fax 602-495-5645

Personnel: Todd Bostwick, Archaeologist; Barbara Moulard, Curator
Contact: Roger Lidman, Dir.
Founded: 1929; Scope: Local
Availability: Open to the public; Admission: $.50 (donation)
Visitors: General public
Staff: 7 ft, 6 pt, 30 volunteers; Operating budget: $450,000
Publications: *The Hohokam*, 1983- , bimonthly; also publishes membership newsletters and flyers and an anthropological series.

Collection: 1,900 books, 200 audiovisual materials, 100,300 artifacts, 14,491 works of art, 560 cubic ft. of archives (personal papers and correspondence, unpublished records, manuscripts, archaeological records). Of the archives, 80% is in microfilm; the collection is cataloged, and a reading room and copying facilities are available for researchers.

Comments: The museum preserves the Hohokam Indian culture through exhibits of artifacts. A video describes their lifestyle and accomplishments. The permanent exhibit room displays and interprets pottery, tools, and other artifacts. Services include guided tours, educational lectures, school presentations, workshops for adults and children on Native American studies, speakers, crafts classes, and an arts and crafts souvenir shop. The museum participates in the annual Indian Market each December.

THE ROCKWELL MUSEUM Museum
 111 Cedar St.
 Corning, NY 14830 607-937-5386; Fax 607-974-4536

Personnel: Dr. Kent Ahrens, Dir.
Contact: Dr. Robyn G. Peterson, Curator of Collections
Founded: 1976; Scope: Regional
Availability: Open to the public; Admission: Fee
Visitors: General public, School groups, Ethnic community
Staff: 15 ft, 2 pt (salaried); Operating budget: $1,500,000
Publications: Annual reports; newsletters; a catalog to part of the collection; and
temporary exhibition catalogs.

Collection: Artifacts and realia (particularly those located in the Eastern U.S.),
paintings and other works of art. The collection is cataloged; a reading room and
copying facilities are available.

Comments: The goal is to collect, preserve, and interpret the art and artifacts of the
North American frontier. Services include guided tours, educational lectures, loans and
presentations to schools, speakers, dance and instrumental performances, films and AV
productions, crafts classes, arts and crafts souvenir shop, symposia, and travel
programs. The museum supports research at the graduate and undergraduate levels,
and provides in-service programs for teachers and volunteer internships.

SAN ILDEFONSO PUEBLO GOVERNOR'S OFFICE Museum
 Rt. 5, Box 315-A Library
 Santa Fe, NM 87501 505-455-2273

Sponsoring organization: Bureau of Indian Affairs
Personnel: Pete Martinez, Governor of San Ildefonso
Contact: Irene Tse-Pe Folwell, Special Projects Admin.
Scope: Local, Regional
Availability: Open to the public; Admission: Fee
Visitors: General public
Staff: 1 ft; Operating budget: $10,000

Collection: Books, periodicals, works of art, and archives (pictorial materials). The
collection is cataloged.

Comments: The collection preserves the history, art, and culture of Native American
peoples. The organization participates in ethnic festivals.

SEMINOLE NATION MUSEUM Museum
 524 S. Wewoka, P.O. Box 1532
 Wewoka, OK 74884 405-257-5580

Sponsoring organization: Seminole Nation Historical Society
Personnel: Margaret Jane Norman, Curator; Alan Emarthle, Co-Dir.
Contact: Jan Wyrick, Co-Dir.
Founded: 1974; Scope: Local, Regional

Availability: Open to the public; Admission: Donation
Visitors: General public
Staff: 41 (2 pt, salaried; 39 volunteers)

Collection: Ca. 1,500 books, periodicals, 200,000 artifacts, works of art, and archives (personal papers and correspondence, printed materials). The collection is cataloged; a reading room and copying facilities are available.

Comments: This cultural center for the Seminole Nation provides guided tours, educational lectures, and presentations to schools. It also sponsors and participates in ethnic festivals.

SENECA-IROQUOIS NATIONAL MUSEUM Museum
 Broad St. Extension, P. O. Box 442
 Salamanca, NY 14779 716-945-1738

Sponsoring organization: Seneca Nation of Indians
Personnel: Calvin E. Lay, Chair, Bd. of Trustees; Jeanne Jemison, Co-chair, Bd. of Trustees
Contact: Judith Greene, Dir.
Founded: 1977; Scope: Local, State, Regional, National, International
Availability: Open to the public, restricted access; Admission: Donation
Visitors: General public
Staff: 8 ft.; Operating budget: $168,000

Collection: Books, periodicals, audiovisual materials, ca. 1,500 artifacts, works of art, and ca. 1,500 archival records (personal papers and correspondence, unpublished records, theses and dissertations, oral histories). The collection is cataloged.

Comments: The purpose is to provide information about the history, culture, and current experience of the Seneca Indians. Services include guided tours, educational lectures, loans and presentations to schools, speakers, and an arts and crafts souvenir shop; the museum participates in ethnic festivals.

SHELDON MUSEUM AND CULTURAL CENTER Museum
 Main Street, P. O. Box 269 Library
 Haines, AK 99827 907-766-2366 Archives

Sponsoring organization: Chilkat Valley Historical Society
Personnel: Rebecca Nelson, Director, Archivist
Contact: Cynthia Jones, Curator
Founded: 1980; Scope: Local
Availability: Open to the public; Admission: Fee
Visitors: General public, School groups
Staff: 2 ft, 2 pt (salaried); 30 volunteers
Publications: Membership newsletters and flyers

Collections: Over 500 books, audiovisual materials, ca. 1,500 artifacts, 30 linear ft. of archives (personal papers and correspondence, pictorial materials, and oral histories). The collection is cataloged.

Comments: Preserves and interprets the culture of the Chilkat Valley and Tlingit Indians.

SIOUX INDIAN MUSEUM Museum
 P.O. Box 1504
 Rapid City, SD 57709

Sponsoring organization: Indian Arts and Crafts Board, U.S. Dept. of Interior
Founded: 1939; Scope: Local, State, Regional, National
Availability: Open to the public; Admission: Free
Visitors: General public
Publications: Catalogs of the collections; promotional brochures.

Collection: Artifacts, realia (horse gear, weapons, household utensils, tipi decorations, containers, baby carriers, children's games and musical instruments), and works of art created by Native Americans of the Sioux and other tribes. The museum features permanent and special exhibits.

Comments: Services include guided tours, educational lectures, audiovisual presentations, participation in ethnic festivals, and a souvenir shop which sells Native American crafts and works of art.

SITKA HISTORICAL SOCIETY Museum
 330 Harbor Dr.
 Sitka, AK 99835 907-747-6455

Personnel: Barbara Dadd Shaffer, Admin.
Contact: John Hallum, Coll. Mgr.
Founded: 1955; Scope: Local
Availability: Open daily 8-5 (summer), T-F 10-4 (winter); Admission: Free
Visitors: General public, School groups
Staff: 6 pt, salaried, 50 volunteers; Operating budget: $100,000

Collection: Books, periodicals, audiovisual materials, artifacts, over 5,000 photographs, and archival materials (personal papers and correspondence, unpublished records, numerous manuscripts and oral histories). The collection is cataloged; copying facilities are available.

Comments: The museum preserves the cultural history of the Tlingit native Alaskans from prehistory to the present. Activities include guided tours, school presentations, speakers, and exhibits.

SIX NATIONS INDIAN MUSEUM Museum
 HCR1, Box 10, Roakdale Road
 Onchiota, NY 12968 518-891-2299

Contact: John Kahionhes Fadden
Founded: 1954; Scope: Local
Availability: Open to the public; Admission: Fee (except to Native Americans)
Visitors: General public, School groups, Ethnic community

Staff: 6 (2 ft, 4 pt)
Publications: Pamphlets; posters; charts.

Collection: Books, artifacts and realia, paintings and other works of art, and archives (personal papers and correspondence, pictorial materials, and oral histories). Copying facilities are available.

Comments: The goals are to preserve Native American culture and to educate the general public about it. Services include educational lectures, an arts and crafts souvenir shop, and storytelling sessions. The collection supports research at the undergraduate level for area university students.

SOUTHERN PLAINS INDIAN MUSEUM Museum
 P.O. Box 749
 Anadarko, OK 73005 405-247-6221

Sponsoring organization: Indian Arts and Crafts Bd., U.S. Dept. of Interior
Founded: 1947; Scope: Regional, State, National
Availability: Open to the public; Admission: Free
Visitors: General public, School groups
Publications: Illustrated catalogs; promotional brochures.

Collection: A permanent exhibition gallery features the historic arts created by the Kiowa, Comanche, Kiowa-Apache, Southern Cheyenne, Southern Arapaho, Wichita, Caddo, Delaware, and Ft. Sill Apache Indian tribes people. Collections include artifacts and realia, works of art, costumes, dioramas, murals, and painted tipis.

Comments: The museum exhibits the creative artistry of Native Americans and demonstrates their arts and crafts techniques in a variety of media. Services include tours, educational lectures, audiovisual presentations, presentations to schools, and participation in ethnic festivals.

SOUTHERN UTE CULTURAL CENTER/MUSEUM Museum
 P.O. Box 737, Hwy 172 North
 Ignacio, CO 81137-0737 303-563-9466; Fax 303-563-0396

Personnel: Gary Grey, Curator of Collections
Contact: Helen Hoskins, Museum Dir.
Founded: 1972; Scope: Local, State, Regional
Availability: Open to the public; Admission: $1.00
Visitors: General public, School groups, Ethnic community
Staff: 7 (4 ft, 3 pt, salaried); Operating budget: $131,000
Publications: Booklets; study guides; and promotional brochures.

Collection: 300 books, 412 artifacts, 10 works of art, and archives (personal papers and correspondence, unpublished records, theses and dissertations). Southern Ute tribal correspondence is in microform. The collection is cataloged; an unpublished guide, reading room, and copying facilities are available.

Comments: The purpose is to collect and preserve Ute history and to educate Utes and

others about Southern Ute tribal culture and heritage. Services include guided tours, loans and presentations to schools, TV programs, speakers, dance performances, films and AV productions, and an arts and crafts souvenir shop. The center participates in ethnic festivals, supports research, and provides in-service programs for teachers.

TANTAQUIDGEON INDIAN MUSEUM Museum
 1819 Norwich-New London Rd.
 Uncasville, CT 06382 203-848-9145

Contact: Gladys Tantaquidgeon
Founded: 1931; Scope: Local, Regional
Availability: Open to the public; Admission: Donation
Visitors: General public
Staff: 1 ft
Publications: Promotional brochures and flyers

Collection: Artifacts and works of art include objects of stone, bone, and wood made by Mohegan and other New England Indian artists and craftsmen, past and present.

Comments: The purpose of the museum is to preserve and perpetuate the history and traditions of the Mohegan and other Indian tribes. Also on display are examples of the expert craftsmanship of the tribes of the Southeast, Southwest, and Northern Plains.

TEYSEN'S WOODLAND INDIAN MUSEUM Museum
 416 S. Huron Ave.
 Mackinaw City, MI 49701 616-436-7011; Fax 616-436-5932

Personnel: Kenneth C. Teysen, Owner and Dir.
Contact: Greg Teysen
Founded: 1950; Scope: Regional
Availability: Open to the public; Admission: $2 adults; $1 children 11-16
Visitors: School groups, Ethnic community
Staff: 2 pt

Collection: 1,200 artifacts; the collection is cataloged and an unpublished guide is available.

Comments: The museum contains Indian relics and artifacts, northern Michigan lumbering memorabilia, and Great Lakes shipwreck artifacts; 80% of the displays are related to Native American culture with special emphasis on the Woodland Indians. The goal is to dispel the stereotype of Indians as "poor, ignorant savages."

THOMAS GILCREASE INSTITUTE Museum
OF AMERICAN HISTORY AND ART Library
 1499 Gilcrease Museum Rd.
 Tulsa, OK 74127 918-582-3122; Fax 918-592-2248

Sponsoring organization: City of Tulsa
Personnel: Dr. Joan Troccoli, Dir.; Gary Moore, Asst. Dir.; Dan McPike, Curator of Anthropology; Anne Morand, Curator of Art; Sarah Erwin, Curator of Archival Colls.

Founded: 1943; Scope: Regional, National
Availability: Open to the public; Admission: Donation
Visitors: General public
Staff: 375 (25 ft, 350 volunteers)
Publications: *The Gilcrease Magazine of History and Art*, 1958- , semiannual
(published as *The American Scene Magazine* until 1979); also publishes promotional
brochures.

Collection: 40,000 books, over 1,000 periodical titles, 100,000 artifacts, 10,000 works
of art, and archival records (personal papers and correspondence, pictorial materials,
40,000 manuscripts). The majority of the manuscripts are on microfilm. An
unpublished guide to the art collection is provided; a reading room and copying
facilities are available.

Comments: Native American materials represent a major aspect of this American
history collection. Numerous programs are designed for regional school groups. Other
services include guided tours, educational lectures, and speakers or resource people.
Work experience for college credit is also possible.

UNIVERSITY OF CALIFORNIA AT LOS ANGELES Library
AMERICAN INDIAN STUDIES CENTER
 3220 Campbell Ave.
 Los Angeles, CA 90024-1548 310-206-7510

Personnel: Duane Champagne, Dir.
Contact: Velma Salabiye, Libn.
Founded: 1970; Scope: Local, State, Regional, National
Availability: Open to the public; Admission: Free
Visitors: General public
Staff: 2 (1 ft, 1 pt); Operating budget: $5,300
Publications: Quarterly academic journal; books; bibliographies; and monographs.

Collection: Ca. 1,250 books, periodicals. The collection is cataloged; a reading room
and copying facilities are available.

Comments: The center serves the educational and cultural needs of the university's
American Indian community, including faculty, staff, resident scholars, researchers,
and students and is active in developing the American Indian curriculum. It sponsors
lectures, symposia, national conferences, workshops, and research. It also administers
competitive grants.

UNIVERSITY OF OKLAHOMA, Library
WESTERN HISTORY COLLECTIONS Archives
 630 Parrington Oval, Rm. 452
 Norman, OK 73019

Personnel: Brad Koplowitz, Asst. Curator; John Lovett, Libn.; Shirley Clark, Admin.
Asst.
Contact: Donald L. DeWitt, Curator
Founded: 1927; Scope: Regional

Availability: Open to the public; Admission: Free
Visitors: General public
Staff: 7 (5 ft, 2 pt, salaried)
Publications: *American Indian Resource Materials in the Western History Collections*

Collection: 60,000 books, 250 periodicals, 2,000 audiovisual materials, archives
(personal papers and correspondence, unpublished records, pictorial materials, 1,500
manuscript collections, oral histories). Some records are in microform. The collection
is cataloged; an unpublished guide, reading room, and copying facilities are available.

Comments: The purpose is to acquire, preserve, and offer researchers materials
relating to the Trans-Mississippi west and the Indians of North America.

UTE INDIAN MUSEUM Museum
 17253 Chipeta Dr.
 Montrose, CO 81407 303-249-3098

Sponsoring organization: Colorado Historical Society
Contact: Glen Cross, Admin.
Founded: 1956; Scope: State
Availability: Open to the public (May-September); Admission: Fee
Visitors: General public, School groups
Staff: 1 ft, 2 pt; Operating budget: $10,000
Publications: Promotional brochures

Collection: Artifacts, realia; some records in microform. The collection is cataloged.

Comments: The purpose of the museum is to display materials that preserve the history
and culture of the Ute Indians of Colorado. The museum also provides educational
programs, loans and presentations to schools, radio programs, speakers, performing arts
presentations, and an arts and crafts souvenir shop; it participates in annual ethnic
festivals.

UTE MOUNTAIN UTE TRIBAL PARK Museum
CULTURAL RESEARCH AND EDUCATION CENTER Library
 General Delivery
 Towaoc, CO 81334 303-565-3751, x282

Contact: Sharon Russom, Dir.
Founded: 1980; Scope: Local, State, Regional, National, International
Availability: Open by special appt. only; Admission: Fee
Visitors: General public
Staff: 9 (3 ft, 6 pt); Operating budget: $120,000
Publications: Annual newsletter

Collection: Books, audiovisual materials, ca. 1,500 artifacts and realia, archaeological
reports, and archival materials (unpublished records, printed materials).

Comments: The center promotes research, preservation, education, and various
scientific studies and publications of the historic and prehistoric cultures and natural

resources of the Ute Mountain Tribal Park (Ute Indian Reservation). It also participates in ethnic festivals. Services include guided tours, loans and presentations to schools, speakers, dance performances, and a crafts souvenir shop.

WHEELWRIGHT MUSEUM OF THE AMERICAN INDIAN Museum
(Formerly Museum of Navajo Ceremonial Art) Library
 704 Camino Lejo, P.O. Box 5153 Archives
 Santa Fe, NM 87501 505-982-4636 Art Gallery

Personnel: Jonathan Batkin, Dir.; Lunette Miller, Curator; Eunice Kahn, Asst.
Contact: Yvonne Bond, Public Relations Dir./Exec. Secy.
Founded: 1937; Scope: Local, State, Regional
Availability: Open by special appt.; Admission: Donation
Visitors: General public
Staff: 15 ft, 2 pt, 150 volunteers
Publications: *The Messenger*; promotional brochures.

Collection: 3,000 books, filmstrips and recordings, numerous artifacts, and archival records (unpublished records, pictorial materials, manuscripts). The collection is cataloged; an unpublished guide is available.

Comments: Records the traditions and creative expressions of Native Americans via guided tours, lectures, loans and presentations to schools, speakers, films, crafts classes, a souvenir shop, children's workshops, and participation in ethnic festivals.

NORWEGIAN AMERICAN RESOURCES
(*See also* Scandinavian American Resources)

LITTLE NORWAY Museum
 3576 Highway JG
 Blue Mounds, WI 53517 608-437-8211

Personnel: Brian Bigler, Curator; Greta Cunningham, Curator
Contact: Scott P. Winne, Mgr.
Founded: 1937; Scope: Regional
Availability: Open daily 9-5 (May-June, Sept.-Oct.); 9-7 (July-Aug.), restricted access; Admission: $5 adults, $4.50 seniors and group rate, $2 children 6-12
Visitors: General public
Staff: 20 (9 ft, 11 pt)
Publications: Promotional brochures

Collection: 5,000 books, artifacts and realia, paintings and other works of art, archival records (printed materials), and original historic buildings. The collection is cataloged; a published guide is available.

Comments: Little Norway is a pioneer homestead with buildings of authentic Norse architecture and furnishings. These include a church, cabins, farm buildings, and the Norwegian Pavilion from the 1893 World's Columbian Exposition. The objective is to

preserve Norwegian and Norwegian American life and culture. The museum features guided tours and an arts and crafts souvenir shop.

LUTHER COLLEGE ARCHIVES Library
 Preus Library Archives
 700 College Dr.
 Decorah, IA 52101 319-387-1805; Fax 319-387-1657

Contact: Norma Hervey, Head Libn.
Founded: 1867; Scope: Regional
Availability: Open M-F 8-12, 1-5; Admission: Free
Visitors: General public; Faculty and students
Staff: 4 (1 ft, 3 pt)

Collection: 5,000 books, periodicals, audiovisual materials, artifacts, and 1,600 linear ft. of archival materials (personal papers and correspondence, unpublished records, theses and dissertations, pictorial materials, manuscripts, and oral histories). Norwegian newspapers and census records are in microform. The collection is partially cataloged; a reading room and copying facilities are available.

Comments: The archives document the history of Luther College and founding congregations of the Norwegian Synod. Graduate research programs are supported.

NORTH NORWEGIAN ASSOCIATION Archives
OF THE UNITED STATES AND CANADA
 7389 Memory Lane, NE
 Fridley, MN 55432 612-786-2427

Contact: Christian K. Skjervold
Founded: 1909; Scope: National
Admission: Fee
Staff: 2 volunteers

Collection: Archives (see Norwegian American Historical Association).

Comments: The purpose is to provide fraternal benefits to Norwegian Americans and to promote interest in Norwegian history and culture.

NORWEGIAN-AMERICAN HISTORICAL ASSOCIATION Archives
 St. Olaf College
 1510 St. Olaf Ave.
 Northfield, MN 55057-1097 507-646-3221

Personnel: Lloyd Hustvedt, Exec. Secy.; Odd S. Lovoll, Editor; Forrest Brown, Archivist; Lawrence O. Hauge, Pres.
Contact: Ruth Hanold Crane, Asst. Secy.
Founded: 1925; Scope: National
Availability: Open M-F 8-12; other times by appt.; Admission: Free
Visitors: Ethnic community, Researchers, Family historians
Staff: 4 pt (2 salaried, 2 volunteers)

Publications: *Norwegian-American Studies*, Vols. 1-33; various books; travel and description series; authors series; biographical series; and topical series.
Comments: The association's goal is to locate, collect, preserve, and interpret Norwegian-American history, experience, and culture.

Collection: Over 1,400 separate archival collections (personal papers and correspondence, unpublished records, pictorial materials, theses and dissertations, manuscripts, oral histories). The Rowberg clipping file is on microfiche; emigration registration records are on microfilm (registration out of Norway at the police station of the port of debarkation). The collection is cataloged; a guide (1979) is available.

NORWEGIAN SINGERS ASSOCIATION OF AMERICA Archives
 Rt. 2, Box 137
 Kenyon, MN 55946-9340 507-789-6666

Founded: 1892; Scope: Regional
Availability: Open to the public; Admission: Free
Visitors: Ethnic community
Publications: *Sanger-Hilsen* ("Singers' Greeting"), 1910- , bimonthly; Sangerfest booklets published by host chorus.

Collection: Music scores and other materials; the collection is cataloged.

Comments: The purpose is to preserve Norwegian culture through Norwegian American male choral singing; the association participates in ethnic festivals.

SONS OF NORWAY INTERNATIONAL HEADQUARTERS Library
 1455 W. Lake St.
 Minneapolis, MN 55408 612-827-3611

Personnel: Liv Dahl, Admin. Dir., Heritage Programs
Founded: 1905; Scope: Local, State, Regional, National, International
Availability: Open to the public; Admission: Free
Visitors: General public
Staff: 60 ft
Publications: *Heritage Books* (annual book and gift catalog); brochures describing the Heritage Program collections (music, radio manuscripts, etc.).

Collection: Ca. 1,500 books, periodicals, and audiovisual materials in a non-lending library. A reading room and copying facilities are available.

Comments: This fraternal benefit society offers financial security to members and also promotes preservation of the Norwegian cultural heritage. Programs include loans and presentations to schools, radio programs, speakers, performing arts presentations, films and AV productions, crafts classes, souvenir shop, an ethnic book service, language and culture classes, and a complete reference service.

VESTERHEIM NORWEGIAN AMERICAN MUSEUM Museum
 502 West Water St. Library
 Decorah, IA 52101 319-382-9681 Archives

Personnel: Carol Hasvold, Registrar; Charles Langton, Archivist; Laurann Figg,
Textile Curator; Steven Johnson, Jacobson Farm Curator
Contact: Darrell Henning, Dir.
Founded: 1877; Incorporated: 1967; Scope: National, International
Availability: Open to the public; special collections by appt.
Visitors: General public
Staff: 21 salaried (12 ft, 9 pt); 450 volunteers; Operating budget: $480,000
Publications: *Vesterheim Newsletter*, 1965- , quarterly; *Vesterheim Rosemaling
Newsletter*, 1967; *Vesterheim Woodworking Newsletter*, quarterly; *Norwegian Tracks*
(genealogy), quarterly; also publishes books; exhibition catalogs; and special
publications in Norwegian American history and folk arts.

Collection: 10,000 books, 200 periodicals, 17,500 artifacts, 2,500 works of art, and
archives (personal papers and correspondence, unpublished records, pictorial materials,
theses and dissertations, manuscripts, oral histories). The collection is cataloged; a
published guide, reading room, and copying facilities are available.

Comments: The purpose is to exhibit artifacts that describe the life of people of
Norwegian birth and descent, both in their home environment in Norway and in their
American settlements. Services include guided tours, educational lectures, loans and
presentations to schools, speakers or resource people, performing arts (dance, choir,
instrumental), films and AV productions, crafts classes, and a souvenir shop. The
organization supports research at the graduate and undergraduate levels, and provides
work experience for college credit, as well as work study jobs for college students.

P

POLISH AMERICAN RESOURCES

ALLIANCE OF POLES LIBRARY <u>Library</u>
 6966 Broadway Ave.
 Cleveland, OH 44105 216-883-3131

Sponsoring organization: Alliance of Poles of America
Personnel: Ewa Trzeciak, Libn.
Contact: Alina Szczesniak, Chair, 5875 Mural Dr., Seven Hills, OH 44131
Founded: 1928; Scope: National
Availability: Open to the public (twice/week); Admission: Free
Visitors: General public
Staff: 2 (1 pt, salaried; 1 volunteer); Operating budget: $1,000
Publications: *The Alliancer*, semi-monthly

Collection: 5,000 books, periodicals, artifacts, works of art. The collection is
cataloged; a reading room is available.

Comments: The objectives are to keep Polish traditions alive through information
about them, books in English and Polish, performing arts presentations, and exhibits.

ALVERNIA COLLEGE <u>Library</u>
DR. FRANK A. FRANCO LIBRARY LEARNING CENTER
 Alvernia College
 400 St. Bernardine St.
 Reading, PA 19607 610-796-8223; Fax 610-796-8347

Sponsoring organization: Alvernia College
Contact: Eugene S. Mitchell, Dir. of Library Services
Founded: 1958; Scope: Regional, National
Availability: M-Th, 8am-10 pm; F 8-4:30; Sat. 1-5, Sun. 6-10; Admission: Free
Visitors: General public
Staff: 4 ft, 5 pt

Collection: Ca. 3,500 books and postcards. The collection is cataloged; a reading room
and copying facilities are available.

Comments: The Polish collection consists of Polish-language works primarily in the
areas of literature, history, and theology.

AMERICAN ASSOCIATION FOR THE ADVANCEMENT <u>Archives</u>
OF POLISH CULTURE
 3436 N. Dousman St.
 Milwaukee, WI 53212 414-962-0687

Sponsoring organization: American Council for Polish Culture
Personnel: Mr. George R. Janicki
Contact: Dr. Michael P. Wnuk
 Founded: 1983; Scope: National
Availability: Open to the public; Admission: Free
Visitors: General public
Staff: 27 volunteers; Operating budget: $3,000
Publications: *AAAPC Newsletter*, 1983- , quarterly; also publishes books (e.g., *Dawn
of a New Russia*).

Collection: Books, periodicals, and archives (pictorial materials and manuscripts). The
collection is not cataloged.

Comments: The objective is to promote all forms of Polish culture including the fine
arts, cinema, music, theater, etc. Services include educational lectures, school
presentations, radio programs, speakers or resource people, and films and AV
productions. The organization supports research at the undergraduate level.

AMERICAN CENTER OF POLISH CULTURE, INC. <u>Museum</u>
 2025 O St. NW <u>Library</u>
 Washington, DC 20036 202-785-2320; Fax 202-785-2159

Personnel: Albin Obal, Chairman of the Bd.
Contact: Dr. Kaya Mirecka Ploss, Exec. Dir.
Founded: 1991; Scope: National
Availability: Open M-F, 10-4; weekends by appt.; Admission: Free
Visitors: General public
Staff: 13 (1 ft, 2 pt, 10 volunteers); Operating budget: $120,000
Publications: *Center Line*, 1991- , quarterly

Collection: Over 500 books, periodicals, archives, artifacts, works of art. The
collection is cataloged; a published guide is available.

Comments: The purpose is to preserve and depict Polish American history, art,
culture, and traditions through guided tours of the center and its furnishings,
educational lectures, school presentations, speakers, instrumental performances, crafts
classes, art gallery, exhibitions of Polish and Polish American artists, and a gift shop.

AMERICAN COMMITTEE FOR AID TO POLAND (ACAP) <u>Archives</u>
(Formerly Emergency Committee for Aid to Poland, ECAP)
 1364 Beverly Rd., Suite 304, P.O. Box 6275
 McLean, VA 22106

Personnel: Gifford D. Malone, Pres.
Contact: Caryle Cammisa, Sr. Program Officer

Founded: 1990; Scope: International
Availability: Information databases are accessible upon request.
Staff: 4 (3 ft, 1 pt)
Publications: Reports of meetings, *ACAP PVO Consortium Report*, 1990- , bimonthly.

Collection: Reports, directories, newsletters, and journals, plus several boxes and file
drawers of archival materials (personal papers and correspondence, unpublished
records, manuscripts, and oral histories). The collection is not cataloged; copying
facilities can be arranged.

Comments: The purpose of ACAP is to assist the Polish people in establishing a
democratic society by developing human service organizations and through training in
leadership, management, and fundraising. Services include educational lectures,
speakers, and workshops.

AMERICAN COUNCIL FOR POLISH CULTURE Museum
(Formerly American Council of Polish Cultural Clubs) Library
 5205 Sangamore Rd. Archives
 Bethesda, MD 20816 301-320-5688; Fax 202-785-2159

Contact: Dr. Kaya Mirecka-Ploss, Exec. Dir.
Founded: 1948; Scope: National
Availability: Open by appt.; Admission: Free
Visitors: General public, Ethnic community
Publications: *Polish Heritage*, quarterly; also publishes a membership directory.

Collection: Books, periodicals, audiovisual materials, artifacts, and archival materials
related to Polish and Polish American history and culture.

Comments: The organization is a national umbrella organization for affiliated groups
devoted to preserving, promoting, educating, and disseminating information about
Polish culture and contributions in the creative arts by Polish Americans. The museum
conducts research; services include a speakers' bureau and educational seminars.

AMERICAN INSTITUTE OF POLISH CULTURE Library
(Formerly Polish-American Cultural Institute of Miami)
 1440 79th St. Causeway, Suite 117
 Miami, FL 33141 305-864-2349; Fax 305-865-5150

Contact: Blanka A. Rosenstiel, Founder and Pres.
Founded: 1972; Scope: National
Availability: Open by appt.; Admission: Free
Visitors: General public, Ethnic community
Staff: 3
Publications: *Good News*, annual; also publishes books.

Collection: 2,000 books (history, biography, literature, science)

Comments: The goal is to increase knowledge about Polish history, culture, and
contributions in science and the arts. Programs include seminars, exhibits, musical

performances, awarding of scholarships, book clubs, and traveling exhibits.

BIBLIOTEKA POLSKA Library
 1081 Broadway Archives
 Buffalo, NY 14212

Contact: Mrs. Janina Lewandowski, Pres., Piotr Stadnitski Gardent Apart., 100 Beck
St., Buffalo, NY 14212
Founded: 1889; Scope: International
Availability: Open W, Th 1-3 by special appt.; Admission: Donation
Visitors: General public, School groups, Ethnic community
Staff: 8 volunteers
Publications: Anniversary programs

Collection: 8,000 books, periodicals, photographs, works of art, and archives
(personal papers and correspondence, unpublished records, pictures, manuscripts).

Comments: Promotes and educates about the culture of the Polish and Polish American
people through literature, costumes, music, art, religion, and language.

FRANCISCANS OF THE ASSUMPTION B.V.M. PROVINCE Archives
 143 E. Pulaski St.
 Pulaski, WI 54162 414-822-5423; Fax 414-822-5423

Founded: 1887; Scope: Regional
Availability: Open by appt. only; Admission: Free; also inquiries by letter
Staff: 1
Publications: *Franciscan Monthly*, 1907- , monthly; *Franciscan Message*, 1947-1972;
Franciscan Calendar, 1912-1981

Collection: Books, periodicals, audiovisual materials, and 1,000 boxes and 30 file
drawers of archives (personal papers and correspondence, pictorial materials, theses and
dissertations). Some records are in microform.

Comments: The purpose is to document Polish history, immigration to the U.S., and
life and culture, particularly in Wisconsin, Ohio, Pennsylvania, and Illinois from the
1880s to World War II.

THE FRONCZAK ROOM, E. H. BUTLER LIBRARY Library
 Buffalo State College
 1300 Elmwood Ave.
 Buffalo, NY 14222-1095 716-878-3134

Sponsoring organization: Buffalo State College
Personnel: Sister Martin Joseph Jones, Archivist/Special Coll. Libn.
Contact: Wanda M. Slawinska, Curator, Fronczak Room, 716-878-6317
Founded: 1970; Scope: Local, Regional, National, International
Availability: Available, with restricted access; Admission: Free
Visitors: General public, Ethnic community
Staff: 2 (1 ft, 1 pt, salaried)

Publications: _Catalog of collections_

Collection: Books, periodicals, audiovisual materials, artifacts, works of art, and archives (personal papers and correspondence, unpublished records, pictorial materials, and manuscripts). The collection is cataloged; a published guide, reading room, and copying facilities are available.

Comments: The purpose is to preserve the papers and artifacts of Dr. Francis E. Fronczak, a prominent Polish American doctor (1900-1955), and to collect materials relating to the Polonia of Buffalo. Emphasis is placed on manuscript materials rather than books, the latter being a specialty of the Polish Room of the State University of New York at Buffalo. Programs include guided tours and educational lectures.

GALERIA Art Gallery
 3535 Indian Trail
 Orchard Lake, MI 48324 810-683-0345

Contact: Marian Owczarski, Director
Founded: 1963; Scope: Regional
Availability: Open daily 1-5; Admission: Free
Visitors: General public

Collection: Works of art

Comments: The purpose is to preserve Polish American culture and to recognize the contributions of Polish and Polish American artists. Activities include guided tours, lectures, performing arts presentations, and exhibits.

JOSEF PILSUDSKI INSTITUTE OF AMERICA Library
 381 Park Avenue South
 New York, NY 10016 212-683-4342

Personnel: Stanislaw Jordanowski, Pres.; Janusz Cisek, Exec. Dir.
Contact: Halina Janiszewski, Secy. of the Bd.
Founded: 1943; Scope: International
Availability: Open to the public; Admission: Free
Visitors: Researchers, Visiting scholars
Staff: 6 ft, 1 salaried; 5 volunteers
Publications: _Independence_ (Niepodleglosc), 1948- , yearly; _Bulletin_ (Biuletyn), 1943- , yearly; _The Collections of the Political, Social and Cultural History of the Polish-American Ethnic Community 1890-1980 at the Pilsudski Institute_ (1981); also publishes historical books.

Collection: 16,000 books, periodicals, works of art, and archives (unpublished records, theses and dissertations, manuscripts). Some records are in microform. The collection is cataloged; a reading room is available.

Comments: The Institute supports international research in the modern history of Poland and maintains collections related to the political, social, and cultural history of the Polish American community.

KOSCIUSZKO FOUNDATION Art Gallery
 15 E. 65th St.
 New York, NY 10021 212-734-2130; Fax 212-628-4552

Contact: Joseph E. Gore, Pres. and Exec. Dir.
Founded: 1925; Scope: International
Availability: Open by appt.; Admission: Free
Visitors: General public, Ethnic community
Staff: 16; Operating budget: $1,200,000
Publications: *Kosciuszko Foundation Newsletter*, 1945- , quarterly; catalogs of
collection.

Collection: 2,500 books, 300 periodicals, 100 artifacts, 250 works of art.

Comments: The foundation promotes Polish and Polish American culture by
supporting cultural and scholarly exchange programs between Poland and the U.S. It
also assists Polish American students financially in Polish studies and medical
programs. It has on permanent display a Polish art collection; it also sponsors exhibits
of Polish artists' works.

MUTUAL AID ASSOCIATION OF THE Library
NEW POLISH IMMIGRATION
 4841 Rutherford St.
 Chicago, IL 60656 312-774-9367

Contact: Tadeusz Szebert, Pres.
Founded: 1949; Scope: National
Availability: Open by appt.; Admission: Free
Visitors: General public, Ethnic community

Collection: 7,000 books related to Polish literature

Comments: Provides welfare assistance to post-WW II Polish immigrants who have
settled in the Chicago area, and provides English language classes and placement
services.

POLISH AMERICAN CULTURAL INSTITUTE OF MINNESOTA Library
(Formerly Polish Cultural Education Association, Inc.)
 6220 Baker Ave.
 Fridley, MN 55432 612-571-9602; 612-337-9779

Personnel: Edzio Rajtar, Pres.; Bruce Rubin, V. Pres.; Stanley Wiatros, Treas.; Ella
Brodziak, Libn.
Contact: Judith Blanchard, Secy.
Founded: 1980; Scope: State
Availability: Restricted access; Admission: Free
Visitors: General public
Staff: 7 (pt and volunteers); Operating budget: $500
Publications: Publishes a regular column, "Culture," in *Kultura*, a Polish American
newspaper; also publishes membership newsletters and flyers.

Collection: 1,000 books, periodicals; the collection is cataloged. An unpublished guide and reading room are available.

Comments: The institute coordinates efforts of Polish organizations in their artistic, scholastic, and cultural endeavors, promotes the cultural accomplishments of Polish Americans, sponsors educational lectures, art classes, school presentations, speakers, Polish dance performances, films, and crafts classes, and participates in ethnic festivals.

POLISH AMERICAN HISTORICAL ASSOCIATION Archives
(Formerly Polish American Historical Commission of the Polish
 Institute of Arts and Sciences in America)
 984 N. Milwaukee Ave.
 Chicago, IL 60622 312-384-3352

Founded: 1941; Scope: National
Availability: Open by appt.; Admission: Free
Visitors: General public, Ethnic community
Operating budget: Less than $25,000
Publications: *Polish American Studies*, semiannual; *Index to Polish American Studies*; also publishes quarterly newsletter.

Collection: Books, periodicals, and archives are maintained in cooperation with the Polish Museum Archives in Chicago.

Comments: The association sponsors research related to Polish American studies.

POLISH AMERICAN MUSEUM Museum
 16 Belleview Ave. Library
 Port Washington, NY 11050 516-883-6542 or 516-767-1936 Archives
 Art Gallery

Personnel: Walter Mick, Libn.: Raymond Adamczak, Curator; Henry Archacki, Archivist; Helen Scuderi, Art Gallery
Contact: Julian S. Jurus, Pres.
Founded: 1977; Scope: Regional, National, International
Availability: Open M-F 10-4, Sat.-Sun. 1-4
Admission: Free/Donation
Visitors: General public, School groups, Ethnic community
Staff: 1 ft, salaried; 8 pt, 25 volunteers; Operating budget: $55,000
Publications: *Annual Journal*, 1981- , annual.; also publishes brochures.

Collection: 10,000 books, ca. 350 periodicals, ca. 50 audiovisual productions, ca. 1,500 artifacts, ca. 200 works of art, and 25 boxes and 55 file drawers of archival materials (personal papers and correspondence, pictorial materials). The collection is cataloged; an unpublished guide, reading room, and copying facilities are available.

Comments: The objective of the museum is to preserve Polish American history and culture through guided tours, educational lectures, school presentations, speakers or resource people, and choir and instrumental performances, and an arts and crafts souvenir shop.

POLISH AMERICAN WORLD
 3100 Grand Blvd.
 Baldwin, NY 11510 516-223-6514; Fax 516-223-6514

Contact: Tom Poskroyski
Founded: 1959; Scope: National
Availability: Open by appt.; Admission: Free
Visitors: General public
Staff: 4 ft
Publications: *Polish American World*, 1959-

Collection: Newspaper library (*Polish American World*)

THE POLISH ARTS AND CULTURE FOUNDATION
 1290 Sutter St.
 San Francisco, CA 94109 415-474-7070

Collection: 1,000 books and archival materials (manuscripts, unpublished papers and
correspondence, and other documents related to Polish American organizations and the
Polish American community in northern California. Materials are in Polish and
English; some books cover Polish history from the 16th century.

Comments: The purpose is to preserve the Polish cultural heritage and to provide
information for historians and scholars interested in the Polish American community.

POLISH FALCONS OF AMERICA
 615 Iron City Dr.
 Pittsburgh, PA 15205 412-922-2244; Fax 412-922-5029

Personnel: Lawrence R. Wujcikowski, Pres.
Contact: Timothy Kuzma, Heritage Comm. Ch., Editor
Founded: 1887; Scope: National
Availability: Open to the public; Admission: Free
Visitors: General public
Staff: 14 ft
Publications: *Polish Falcon* (*Sokol Polski*), 1896- , semi-monthly.

Collection: Archival records documenting the center's activities, flags, photos,
memorabilia, and records of officers and members.

Comments: This fraternal organization provides assistance to members of Polish
background and heritage. The center participates in ethnic festivals.

POLISH FOLK DANCE ASSOCIATION OF THE AMERICAS
 1001-Lorimer St.
 Brooklyn, NY 11222 718-389-1141

Personnel: Stanley Pelc, Pres.
Contact: Christine Biestek, 817 Berkshire, Grosse Pointe Pk., MI 48230 313-822-
3379

Founded: 1983; Scope: National
Availability: Open by special appt. only
Staff: Volunteers

Collection: Books, periodicals, audiovisual materials, artifacts, and archives (personal papers and correspondence, printed and pictorial materials).

Comments: The purpose is to preserve Polish art and culture and to promote its preservation in the United States. The association participates in ethnic festivals.

POLISH GENEALOGICAL SOCIETY OF CONNECTICUT, INC. Library
 8 Lyle Rd. Archives
 New Britain, CT 06053 203-229-8873 and 223-5596

Contact: Jonathan D. Shea, Archivist; Constance M. Ochnio, Archival Asst.
Founded: 1984; Scope: Regional
Availability: Open to the public (with advance appt.); Admission: Free
Visitors: General public
Staff: 2 pt, 6 volunteers
Publications: *Pathways and Passages*, 1984- , semiannual; also publishes reference works on Polish family history and archival sources.

Collection: 500 books and 150 linear ft. of archival records (personal papers and correspondence, unpublished records, pictorial materials, theses and dissertations, manuscripts, and oral histories). The collection is partially cataloged; a reading room and copying facilities are available.

Comments: The purpose is to help Polish Americans trace Polish family members and heritage. Services include database searches for researchers of cemetery inscriptions, access to directories of Polish Roman Catholic parishes in Europe, educational lectures, and speakers or resource people. The organization participates in ethnic festivals.

POLISH HERITAGE ASSOCIATION Museum
OF THE SOUTHEAST-AIKEN (PHASE A) Library
 1018 Hayne Ave. SW
 Aiken, SC 29801 803-648-9172; Fax 803-648-4049

Contact: Dr. L. V. Kosinski, Pres./Founder, 516 Platt Terrace, Aiken, SC 29801
Founded: 1985; Scope: Local, Regional, National, International
Availability: Open to the public, restricted access; Admission: Free
Visitors: General public, School groups, Ethnic community
Staff: Pt, volunteers; Operating budget: $2,000
Publications: Quarterly report of activities in the *Polish Heritage*

Collection: Over 1,000 books, 200 periodicals, 100 artifacts, 40 works of art, and archival materials (personal papers and correspondence, unpublished records, pictorial materials, theses and dissertations, manuscripts, and oral histories). The collection is not cataloged; copying facilities are available.

Comments: The organization was formed to act as an open platform to inform citizens

about the contributions made by Poles and Polish Americans. Services include guided tours, educational lectures, loans and presentations to schools, radio programs, speakers, films and AV productions, and participation in ethnic festivals.

POLISH HISTORICAL COMMISSION OF CENTRAL COUNCIL Archives
OF POLISH ORGANIZATIONS
 4291 Stanton Ave.
 Pittsburgh, PA 15201 412-782-2166

Sponsoring organization: Central Council of Polish Organizations of
Pittsburgh, PA
Personnel: Edward J. Pampuch V
Contact: Joseph A. Borkowski, Chairman
Founded: 1965; Scope: Local
Availability: Open by special appt.; Admission: Free
Staff: 2 volunteers

Collection: Audiovisual materials and archives pertaining to Polish ethnicity, local history, and Polish Day programs and anniversary celebrations of Polish churches and social organizations (printed materials and manuscripts). Records are in microform at the Hillman Library, Special Collections Department, University of Pittsburgh. Information can be obtained from A. Zabrosky, Curator and Archivist. The collection is cataloged; a reading room and copying facilities are available.

Comments: The purpose of this Polish umbrella organization is to preserve Polish history and culture by coordinating activities of Polish organizations. It sponsors an annual Polish Day at Kennywood Park, usually the first Tuesday of August. Activities include tours, radio and TV programs, and speakers.

POLISH IMMIGRANT MUSEUM Museum
 Lincoln St. & Hallett St.
 Riverhead, NY 11901 516-369-1616

Sponsoring organization: Polish Town Civic Association
Contact: Irene J. Pendzick, Dir.
Founded: 1990; Scope: Regional
Availability: Open to the public; Admission: Free
Visitors: General public, School groups, Ethnic community
Staff: Volunteers; Operating budget: $1,000
Publications: Formal annual report

Collection: Artifacts and 12 cu. ft. of archival records (personal papers and correspondence, printed materials and pictorial materials). The collection is not cataloged.

Comments: The museum provides information on the history of the immigration and assimilation of Poles on Long Island from 1880 on. Emphasis is also on the contributions of Polish Americans. Services include guided tours, school presentations, arts and crafts souvenir shop, and work experience for college credit. The museum participates in ethnic festivals.

POLISH INSTITUTE OF ARTS AND SCIENCES OF AMERICA, INC. Library
 208 E. 30th St. Archives
 New York, NY 10016 212-686-4164 Art Gallery

Contact: Dr. Thaddeus V. Gromada, 22 Purple Martin Dr., Hackettstown, NJ 07840
Founded: 1942; Scope: National, International
Availability: Open to the public; Admission: Free
Visitors: General public
Staff: 11 (9 pt, salaried; 2 volunteers)
Operating budget: ca. $200,000

Collection: 30,000 books, 400 periodical titles, 8,000 brochures, audiovisual
materials, works of art, and 300 linear ft. of archives (personal papers and
correspondence, unpublished records, manuscripts, and oral histories). The collection
is cataloged; a published guide to the archives, a reading room, and copying facilities
are available.

Comments: The organization is dedicated to advancing knowledge about the Polish
heritage and Polish American contributions to the United States. It operates the Alfred
Jurzkowski Memorial Library on Polish studies, and collects and processes materials
for a center of research, documentation, and information. Services include lectures,
symposia, seminars, authors' evenings, exhibits, artists, scholarly conferences,
counseling, English-language tutoring and referral services to refugees who are scholars
from Poland, an annual Book Fair, and an Arts and Crafts Bazaar. The institute offers
language courses and serves as a resource on Polish topics for film, TV, and radio
producers. It provides speakers and resource people and cooperates with colleges,
universities, and professional organizations in sponsoring conferences.

POLISH MUSEUM OF AMERICA Museum
 984 N. Milwaukee Ave. Library
 Chicago, IL 60622 312-384-3799 Archives

Sponsoring organization: Polish Roman Catholic Union of America
Personnel: Violetta Woznicka, Archivist; Joanna Janowska, Acting Curator and Dir.
Contact: Anna Gliszczynska, Libn.
Founded: 1935; Scope: National
Availability: Open daily 12-5; library M-Sat. 10-4; Admission: Donation/Free
Visitors: General public, School groups, Ethnic community
Staff: 11 (6 ft, 5 volunteers); Operating budget: $200,000
Publications: *Narod Polski*, 1897- , biweekly; also publishes a formal annual report.

Collection: 62,000 books, periodicals, AV materials, artifacts (military memorabilia,
costumes, religious items), 1,400 original works of art by Polish and Polish American
artists, and archival records (personal papers and correspondence, unpublished records,
pictures, theses and dissertations, manuscripts). Polish newspapers are on microfilm.
The collection is not cataloged; a reading room and copying facilities are available.

Comments: The museum collects and preserves materials related to Polish culture and
Polish contributions to America. Emphasis is on religious artifacts, work by Polish
artists, publications by Polish American authors and/or Polish American publishers,

costumes, and memorabilia of outstanding Polish Americans. The museum sponsors guided tours, educational lectures, school presentations, and radio and TV programs. It also features special art exhibits and concerts of Polish music several times a year.

POLISH NATIONAL CATHOLIC CHURCH IN AMERICA Library
1002 Pittston Ave. Archives
Scranton, PA 18505 717-343-0100

Sponsoring organization: Central Diocese Polish National Catholic Church
Contact: Dr. Joseph W. Wieczerzak, Chairman, Commission on History and Archives
Founded: 1897; Scope: National, International
Availability: Open by special appt.; Admission: Free
Visitors: General public
Staff: 5 volunteers; Operating budget: $10,000+

Collection: Ca. 1,500 books and periodicals, artifacts, and archival materials (personal papers and correspondence, unpublished records, oral histories). The collection is partially cataloged; a reading room and copying facilities are available.

POLISH NATIONAL CATHOLIC CHURCH IN AMERICA Library
CENTRAL DIOCESE ARCHIVES AND LIBRARY Archives
515 East Locust St.
Scranton, PA 18505 717-341-5150 or 363-6017

Sponsoring organization: Central Diocese, Polish National Catholic Church
Contact: Very Rev. Casimir J. Grotnik, Archivist
Founded: 1990; Scope: International
Availability: Open by special appt. only; Admission: Free
Visitors: Scholars
Staff: 2 volunteers

Collection: 10,000 books, 5,000 periodicals, audiovisual materials, artifacts, works of art, 250 boxes of archives (personal papers and correspondence, unpublished records, pictorial materials, manuscripts, vital statistics and newspapers in microform). The collection is partially cataloged; a reading room and copying facilities are available.

Comments: The purpose is to collect materials pertaining to the Diocese, the Church, and Polonia in the United States.

POLISH SINGERS ALLIANCE OF AMERICA (PSAA) Library
180 2nd Ave. Archives
New York, NY 10003 718-720-6089

Personnel: Bernice D. Gruszka, Pres.; Waclaw Grygorcewicz, 1st V. Pres.; Frances X. Gates, 2d V. Pres.; Walter Budweil, General Choral Dir.
Contact: Barbara R. Blyskal, Genl. Secy., 7 Norwood Ct., Staten Island, NY 10304-2121
Founded: 1949; Scope: International
Availability: Not open to the public
Staff: 2 volunteers

Publications: *Singers Bulletin*, 1891- , quarterly; formal annual report; membership newsletters and flyers.

Collection: Music, periodicals, artifacts, and archives (personal papers and correspondence, unpublished records, pictures). The collection is not cataloged.

Comments: This music library supports mixed male and female choruses that provide choral concerts of Polish and other music.

POLISH SLAVIC INFORMATION CENTER <u>Archives</u>
 36 Pulaski St., P.O. Box 631 <u>Art Gallery</u>
 Stamford, CT 06904 203-356-9888

Contact: Alexander R. Koproski, Dir., 222 Ocean Dr. East, Stamford, CT 06902
Founded: 1976; Scope: Local
Availability: Open to the public; Admission: Free
Visitors: Ethnic community
Staff: 2 volunteers
Publications: *Polish Slavic Newsletter of Fairfield County*, 1976- , quarterly

Collection: Books, periodicals, artifacts, works of art, and archival records (personal papers and correspondence, printed materials). The collection is not cataloged; a reading room and copying facilities are available.

Comments: The purpose is to promote an understanding of Polish culture via loans to schools, speakers or resource people, crafts classes, and participates in ethnic festivals.

POLISH UNION OF AMERICA <u>Museum</u>
(Formerly Polska Unia W Ameryce) <u>Library</u>
 Box 97, 761 Fillmore Ave. <u>Archives</u>
 Buffalo, NY 14212 716-893-1365; Fax 716-893-9782

Contact: Wallace Kiotorwoski, Pres.
Availability: Open by special appt.; Admission: Free
Visitors: General public, Ethnic community
Publications: *PUA Parade*, irreg.

Collection: 2,000 books on Polish American history, statistical sources, audiovisual materials, artifacts, and archival materials (biographies, unpublished materials).

Comments: This fraternal life insurance organization provides activities that assist Polish Americans and preserve Polish history and culture. It sponsors a placement service, a speakers' bureau, a museum, and college scholarships for members' families.

POLISH WOMEN'S ALLIANCE OF AMERICA <u>Library</u>
 205 S. Northwest Hwy
 Park Ridge, IL 60068 708-692-2247

Contact: Helen Wojcik, Pres.
Founded: 1898; Scope: National

Availability: Open by appt.; Admission: Free
Visitors: General public, Ethnic community
Staff: 36
Publications: *Glos Polek* (in English and Polish), bimonthly

Collection: 7,500 books in Polish and English on Polish and Polish American history
and culture.

Comments: The purpose of the organization is to provide fraternal life insurance
benefits to members. It also sponsors cultural and recreational activities for young
people.

STATE UNIVERSITY OF NEW YORK AT BUFFALO Library
LOCKWOOD MEMORIAL LIBRARY POLISH COLLECTION
 Buffalo, NY 14260

Contact: Jean Dickson, Curator
Founded: 1955; Scope: Local, Regional
Availability: Open to the public; Admission: Free
Visitors: General public
Staff: 1 pt, salaried
Publications: Monthly acquisitions list

Collection: Over 6,000 books, periodicals, audiovisual materials, and archival
materials (unpublished records, printed materials, etc.). Books and periodicals are
cataloged; an unpublished guide, reading room and copying facilities are available for
researchers.

Comments: The library serves the local and regional community as a source of both
popular and scholarly information on Poland and Polish Americans. The primary
language of the materials is Polish. Services include guided tours and educational
lectures; the library collections support research at the graduate and undergraduate
levels.

THE UNION OF POLES IN AMERICA Archives
(Formerly Polish Roman Catholic Union)
 6501 Lansing Ave.
 Cleveland, OH 44105 216-341-2103

Personnel: Richard E. Jablonski, Pres.
Contact: Robert F. Jess, Genl. Secy.
Founded: 1894; Scope: National
Availability: Not open to the public

Collection: Archival materials (unpublished records and printed materials); a reading
room and copying facilities are available.

Comments: Objective of the organization is to provide fraternal life insurance benefits
to members. It also promotes the cultural heritage of Polish American immigrants and
their descendants.

PORTUGUESE AMERICAN RESOURCES
(See also Latin American Resources)

LUSO-AMERICAN EDUCATION FOUNDATION Library
(Formerly Luso-American Fraternal Federation Scholarship Committee)
 P. O. Box 1768
 Oakland, CA 94604 510-452-4465

Contact: Eduardo Eusebio, Pres.
Scope: National
Availability: Open by appt.; Admission: Free
Visitors: General public, Ethnic community
Operating budget: $50,600

Collection: Books and instructional materials

Comments: The objective is to preserve Portuguese ethnic culture by offering courses for high school and college students in Portuguese history and language. Programs include grants and scholarships and celebration of an annual Portuguese Day in June.

PORTUGUESE AMERICAN PROGRESSIVE CLUB Archives
 46 Grand St.
 New York, NY 10013 212-219-0894

Sponsoring organization: Portuguese Consulate
Personnel: Joaquim Ascenso, Pres.
Founded: 1933; Scope: Local
Availability: For members only

Collection: Records are obtained that document the activities of and for the membership of the club.

Comments: The purpose is to provide a social club for Americans of Portuguese descent and to sponsor Portuguese elementary schools. The organization participates in ethnic festivals.

PORTUGUESE CONTINENTAL UNION OF U.S.A. Library
(Uniad Portuguesa Continental Dos E.U.A.)
 899 Boylston St.
 Boston, MA 02115 617-536-2916; Fax 617-536-8301

Founded: 1926; Scope: Regional
Availability: Open, restricted access; Admission: Free
Visitors: General public
Staff: Salaried
Publications: *The Bulletin*; also publishes books and an annual report.

Collection: Books, periodicals, and printed archival records. The collection is cataloged; a reading room is available for researchers.

Comments: The purpose is to serve as a fraternal benefit society for Portuguese Americans. Other services include educational lectures and loans to schools.

UNIAO PORTUGUESA DO ESTADO DA CALIFORNIA Museum
PORTUGUESE UNION OF THE STATE OF CALIFORNIA (UPEC) Library
 1120 E. 14th St. Archives
 San Leandro, CA 94577 510-483-7676

Contact: Carlos Almeida, Dir.
Founded: 1880
Availability: Open to the public; Admission: Free
Visitors: General public, School groups, Ethnic community
Staff 192 (9 ft, 1 pt, salaried; 182 volunteers)
Operating budget: $10,000
Publications: *U.P.E.C. Life*, 1895- , quarterly; *Portuguese Immigrants* (2d ed., 1992)

Collection: 8,000 books, periodicals, audiovisual materials, artifacts, and archives (personal papers and correspondence, unpublished records, printed materials, pictorial materials, theses and dissertations, manuscripts, and newspapers in microform). The collection is cataloged; a reading room and copying facilities are available.

Comments: This fraternal benefit society attempts to preserve Portuguese family values and culture. It provides educational lectures, school presentations, speakers or resource people, films and AV productions; sponsors a Portuguese folklore dance group, and participates in ethnic festivals, including Portuguese Day.

PUERTO RICAN AMERICAN RESOURCES
(*See also* Hispanic American and Latin American Resources)

ASSOCIATION FOR PUERTO RICAN-HISPANIC CULTURE INC. Museum
(Asociacion pro cultura Hispanica Puertorriquena)
 83 Park Terrace West
 New York, NY 10034

Contact: Peter Bloch
Founded: 1965; Scope: National
Availability: Restricted access
Visitors: General public

Collection: Over 50 works of art (the Alfred Fahndrich Collection of Puerto Rican "Santos" wood carvings).

Comments: Preserves Puerto Rican religious folk art and culture.

PUERTO RICAN CULTURAL CENTER Museum
 1671 N. Claremont Ave. Library
 Chicago, IL 60647 312-342-8023; Fax 312-342-6609 Archives
 Art Gallery

Personnel: Jose Lopez, Exec. Dir.
Contact: Alejendro Molina, Assoc. Dir.
Founded: 1972; Scope: National
Availability: Open to the public on weekends; Admission: Donation
Visitors: General public, School groups, Ethnic community
Staff: 3 (1 pt, 2 volunteers); Operating budget: $10,000
Publications: *El Boletin*, 1982- , quarterly

Collection: 3,500 books, 1,000 periodicals, audiovisual materials, artifacts, works of art, and archives (personal papers and correspondence, pictorial materials, theses and dissertations). The collection is not cataloged; a reading room is available.

Comments: The center's goals are to preserve Puerto Rican history and culture and to educate visitors via guided tours, lectures, school presentations, speakers, films, and crafts classes. A souvenir shop is maintained; the center participates in ethnic festivals.

TALLER PUERTORRIQUENO, INC. Archives
 2721 N. 5th St.
 Philadelphia, PA 19133 215-426-3311; Fax 215-426-5682

Personnel: Carmen Febo San Miguel, M.D., Pres.
Contact: Johnny Irizarry, Exec. Dir.
Founded: 1974; Scope: Local
Availability: Open by special appt.; Admission: Free
Visitors: General public, School groups, Ethnic community
Staff: 8 ft, 6 pt, salaried, 20+ volunteers; Operating budget: $450,000
Publications: Membership newsletters and flyers

Collection: Ca. 200 books, ca. 350 periodicals, audiovisual materials, artifacts, works of art, and archives (personal papers and correspondence, unpublished records, pictorial materials, theses and dissertations, oral histories). The collection is partially cataloged; a reading room and copying facilities are available.

Comments: The purpose of this educational organization is to preserve, develop, and promote Puerto Rican artistic and cultural traditions. Activities include guided tours, educational lectures, school presentations, speakers, films, crafts classes, and a souvenir shop.

R

ROMANIAN AMERICAN RESOURCES

AMERICAN ROMANIAN ACADEMY OF ARTS AND SCIENCES Library
University of California-Davis
Dept. of French and Italian
Davis, CA 95616 916-752-6442

Contact: Prof. Maria Manea Manoliu
Founded: 1975; Scope: National
Availability: Open by appt.; Admission: Free
Visitors: General public, Ethnic community
Publications: *ARA Journal*, annual; also publishes books on Romanian history and culture.

Collection: 5,000 books, periodicals, and archival materials (biographical and genealogical records).

Comments: This organization of Romanian American artists and scholars participates in the promotion and preservation of Romanian traditions and cultural heritage. It sponsors and provides materials for graduate and undergraduate level research in the arts and sciences through the American Romian Academy of Arts and Science Research Institute.

ASSOCIATION OF ROMANIAN CATHOLICS OF AMERICA Museum
1240 E. 700 South Library
Wolcottville, IN 46795

Personnel: John Cernica, Pres.; Daniel Ardelean, V. Pres.; David Hopman, Treas.; Maria Popa, Secy.
Contact: Dr. George T. Stroia, Dir., 1700 Dale Dr., Merrillville, IN 46420
Founded: 1946; Scope: National
Availability: Open to the public; Admission: Donation, Free
Visitors: General public
Staff: 15 volunteers; Operating budget: $12,000
Publications: Membership newsletters and flyers

Collection: Periodicals, works of art, and archival materials (printed materials, oral histories). The collection is not cataloged; an unpublished guide and a reading room are available.

Comments: The objective is to serve the Romanian Catholic Church through annual ARCA meetings, youth groups, and the ARCA Fellowship. Services include educational lectures, loans and presentations to schools, and dance and instrumental performances. The association provides courses and work experience for college credit, in-service programs for teachers, and allows local colleges and universities to use the facilities for classes, conferences, and workshops.

IULIU MANIU AMERICAN ROMANIAN RELIEF FOUNDATION Library
 P. O. Box 1151, Gracie Square Station
 New York, NY 10128 212-734-3714

Contact: Ariane A. Popa, Pres.
Founded: 1952; Scope: National
Availability: Open by appt.; Admission: Free
Visitors: General public, Ethnic community
Operating budget: Less than $25,000

Collection: Maintains books and archival materials (personal papers and other biographical information) about Romanians and Romanian Americans.

Comments: The foundation provides monetary assistance to Romanian immigrants and educational grants to young Romanian refugees. It conducts research and collects data and information for dissemination to American libraries and other libraries about Romania and Romanian Americans. Services include a speakers' bureau.

ROMANIAN CULTURAL CENTER Library
(Formerly Romanian Library) Art Gallery
 200 East 38th St.
 New York, NY 10016 212-687-0181; Fax 212-678-0181

Sponsoring organization: Romanian Foreign Ministry, Romanian Cultural Ministry, Romanian Academy, Romanian Cultural Foundation
Personnel: Liviu Petrescu, Dir.; Alexander Grigorescu, Libn.
Founded: 1971; Scope: National
Availability: Open to the public; Admission: Free
Visitors: General public, School groups
Staff: 5 ft, salaried

Collection: Ca. 16,000 books, periodicals, audiovisual materials, works of art; a reading room is available.

Comments: The center's major objective is to help the American public get acquainted with Romanian culture (literature, history, language, , music, art, architecture, etc.). Programs include educational lectures, drama and instrumental performances, films and AV productions, and a temporary exhibit of Romanian contemporary arts.

ROMANIAN ETHNIC ART MUSEUM Museum
(Formerly St. Mary's Romanian Museum)
 3256 Warren Rd.
 Cleveland, OH 44111 216-941-5550

Sponsoring organization: St. Mary's Parishioners and Geruys
Personnel: Virginia Martin, Dir. and Chair; George Dobrea, V. Chair
Founded: 1963; Scope: Local, State
Availability: Open by appt. M-F 8:30-4:00
Admission: Free, donations accepted
Visitors: General public, Ethnic community
Staff: 6 (1 ft, 5 pt volunteers)

Collection: Ca. 500 books, ca. 450 artifacts, 128 paintings, 17 old icons, 9 sculptures. A reading room and copying facilities are available.

Comments: This folk art museum aims to preserve Romanian art and culture through guided tours, lectures, films, and exhibits.

ROMANIAN ORTHODOX EPISCOPATE OF AMERICA Archives
(Episcopia Ortodoxa Romana Din America)
 2522 Grey Tower Rd
 Jackson, MI 49201 517-522-4800; Fax 517-522-5907

Contact: Nathaniel Popp, Bishop Pres. of the Episcopate Congress and Council
Founded: 1929; Scope: International
Availability: Open by special appt. only; Admission: Free
Visitors: General public, Ethnic community
Staff: ft
Publications: *The Herald* (Solia), 1935- , monthly; also publishes an annual almanac *(Calendarul Solia)*.

Collection: Books, periodicals, audiovisual materials, artifacts, works of art, and archival materials (personal papers and correspondence, unpublished records, pictorial materials, manuscripts, and videocassettes). Some records are in microform. The collection is cataloged; a reading room and copying facilities are available for researchers.

Comments: The purpose is to preserve documents which provide statistical and other information used to educate the public about Romania and Romanian Americans in the Romanian Orthodox Diocese.

UNION & LEAGUE OF ROMANIAN SOCIETIES OF AMERICA, INC. Archives
 23203 Lorain Rd.
 North Olmsted, OH 44070-1624 216-779-9913; Fax 216-779-9151

Personnel: Peter Lucaci, Pres.
Contact: Virginia Tekushan
Founded: 1906; Scope: National
Availability: Open by special appt.; Admission: Free
Staff: 3 salaried
Publications: *"America" Romanian News (Ziarul America)*, 1906- , monthly; *America Almanac (Calendarul Ziarului America)*, 1912- , annual; also publishes books (e.g., *Romania is a Song* by Eli Popa; *Romanian Culture in America* by V. Rev. Fr. Vaile Hategan; *Transylvania* by Theodore Andrica, etc.).

Collection: Books, periodicals, and archives (personal papers and correspondence, unpublished records, manuscripts). Some records are in microform at the University of Minnesota. The collection is cataloged; copying facilities are available.

Comments: Provides fraternal benefits and supports Romanian culture and history.

VALERIAN D. TRIFA ROMANIAN AMERICAN HERITAGE CENTER Library
(Formerly Romanian-American Heritage Center)
 2540 Grey Tower Rd.
 Jackson, MI 49201 517-522-8260

Personnel: Traian Lascu, Chairman
Contact: Alexandru Nemoianu, Secy./Resident Historian
Founded: 1975; Scope: National
Availability: Open to the public; Admission: Free
Visitors: General public, School groups
Staff: 1 ft; Operating budget: $45,000.
Publications: *Information Bulletin*, 1983- , bi-monthly

Collection: 3,000 books, periodicals, archival records (personal papers and correspondence, printed materials, theses and dissertations). The collection is cataloged; a reading room and copying facilities are available.

Comments: The purpose is to promote a better understanding of Romanian Americans and to preserve Romanian history and cultural heritage.

RUSSIAN AMERICAN RESOURCES

CONGRESS OF RUSSIAN AMERICANS, INC. Archives
 P.O. Box 818
 Nyack, NY 10960 914-358-2723; Fax 914-353-5453

Personnel: George B. Avisov, Pres.; Peter N. Budzilovich, 1st Vice Pres.
Contact: Dr. Serge P. Keysytski, Secy.
Founded: 1972; Scope: National
Publications: *CRA News* (bilingual), quarterly; *The Russian American* (annual survey); also publishes books and periodicals.

Collection: Archives (correspondence, pictorial materials, and miscellaneous records); the collection is not cataloged; a reading room and copying facilities are available.

Comments: The organization promotes the interests and civil rights of the Russian ethnic minority. Activities include radio and TV programs, speakers, and a study of the Russian ethnic heritage in America, and participation in ethnic festivals.

HILLWOOD MUSEUM Museum
 4155 Linnean Ave. NW Library
 Washington, DC 20008 202-686-8500; Fax 202-966-7846 Archives

Sponsoring organization: Marjorie Merriweather Post Foundation
Personnel: Frederick Fisher, Dir.
Contact: Mary Alexander, Asst. Dir.
Founded: 1977; Scope: International
Availability: Available, restricted access; Admission: Donation
Visitors: General public
Staff: 135 (47 ft, 78 pt, 10 volunteers); Operating budget: $4.3 million
Publications: Membership newsletters and flyers; also publishes books.

Collection: 6,000 books, 35 periodical titles and 20,000 works of art. The collection
is cataloged; a reading room and copying facilities are available.

Comments: The collection describes Russian history and culture. Programs include
guided tours, educational lectures, speakers, choir and instrumental performances, films
and AV productions, crafts classes, and an arts and crafts souvenir shop. The museum
supports research at the college level and provides in-service programs for teachers and
work experience for college credit.

MUSEUM OF RUSSIAN CULTURE Museum
 2450 Sutter St. Library
 San Francisco, CA 94115 415-921-4082

Personnel: Dmitri G. Brauns, Dir.; Alex Karamzin, Curator
Founded: 1984; Scope: Local, State, Regional, National
Availability: Open W, Sat. 11-3; Admission: Free
Visitors: General public
Publications: *Sbornik Museia Russkoy Kultury*, biennial

Collection: 10,000 books on Russian history and immigration, artifacts, and archives
(personal papers and correspondence, unpublished records, manuscripts).

Comments: This ethnic history museum preserves Russian heritage and culture in the
U. S. Services include educational lectures, exhibits, loans, and interlibrary loan.

RUSSIAN NOBILITY ASSOCIATION IN AMERICA Library
(Formerly Russian Historical & Genealogical Society in America) Archives
 971 1st Ave.
 New York, NY 10022 212-755-7528

Contact: Alexis Scherbatow, Pres.
Founded: 1938; Scope: National
Availability: Open by special appt.; Admission: Free
Visitors: General public, Ethnic community
Operating budget: $30,000

Collection: 2,000 books and archival materials (unpublished papers, biographical, and
genealogical materials).

Comments: The purpose is to compile biographical and immigration records of
Russians listed in the nobility archives of the former Russian Imperial Senate who are

now residing in America. The organization also has charitable objectives.

SITKA NATIONAL HISTORICAL PARK Museum
 106 Metlakatla St., P.O. Box 738 Library
 Sitka, AK 99835 907-747-6281; Fax 907-747-5938

Contact: Sue Thorsen, Curator
Founded: 1910; Scope: National
Availability: Open daily 8-5; Admission: Free
Visitors: General public, School groups, Ethnic community
Publications: Promotional brochures

Collection: 1,000 books, audiovisual materials, artifacts, furnishings (restored 1842 Russian Bishop's House)

Comments: The purpose is to preserve Russian American history and culture and to commemorate the Battle of Sitka which took place between the Tlingit Indians and the Russian Americans in 1804.

S

SCANDINAVIAN AMERICAN RESOURCES

(*See also* Danish American, Finnish American, Icelandic American, Norwegian
American, and Swedish American Resources)

THE AMERICAN SCANDINAVIAN FOUNDATION Archives
 725 Park Ave.
 New York, NY 10021 212-879-9779; Fax 212-249-3444

Personnel: Lynn Carter, Dir.; Lena Biorck Kaplan, Pres.
Contact: Adrienne Gyongy, Editor
Founded: 1910; Scope: International
Availability: Open by special appt. only
Staff: 12 ft
Publications: *Scandinavian Review*, 1913- , 3/yr.; *SCAN*, 1954- , quarterly; also
publishes annual reports and calendars of events.

Collection: Books, periodicals. Archival records are on microfilm at University
Microfilms, Ann Arbor, MI. The collection is partially cataloged. A published guide,
Index Nordicus, is available.

Comments: The foundation offers programs of educational and cultural exchange and
awards university level scholarships. It also sponsors educational lectures, speakers,
resource people, performing arts presentations, films and audiovisual productions, and
study abroad programs through international exchange. The foundation regularly
participates in local ethnic festivals and sponsers an annual Christmas party and gift
shop.

NORDIC HERITAGE MUSEUM Museum
 3014 N. W. 67th St. Library
 Seattle, WA 98117 206-789-5708; Fax 206-789-3271 Archives
 Art Gallery
Sponsoring organization: Nordic Heritage Museum Foundation
Personnel: Marianne Forssblad, Dir.; Lisa Hill-Testa, Curator of Collections
Founded: 1979; Scope: Regional
Availability: Open T-Sat. 10-4, Sun. 12-4; Admission: Fee
Visitors: General public, School groups, Ethnic community
Staff: 4 ft, 3 pt, salaried, 200 volunteers; Operating budget: $400,000
Publications: *Nordic News*, 1980- , bimonthly; published *The Dream of America*
(1986).

Collection: 10,000 books, 50 periodicals, audiovisual materials, 15,000 artifacts, 500 works of art, archival materials (pictorial materials and oral histories).

Comments: This historic museum preserves Scandinavian traditions and heritage with rotating Nordic exhibits and works of art. It provides guided tours, educational lectures, loans to schools, speakers, crafts classes, traveling exhibits, and an arts and crafts souvenir shop. Two Nordic festivals a year are sponsored in July and November.

ST. ANSGAR'S SCANDINAVIAN CATHOLIC LEAGUE Library
 40 West 13th St.
 New York, NY 10011

Contact: Viggo F. E. Rambusch
Founded: 1910; Scope: Local, State, National, International
Availability: Not open to the public
Staff: 10 pt; 10 volunteers
Publications: *St. Ansgar's Bulletin*, 1910- , annual

Collection: Periodicals

Comments: Provides news concerning activities of the Catholic Church in Scandinavian countries, holds yearly commemorations of the Feast of St. Lucy (December 13), Patroness of Sweden, and sponsors an annual picnic for fellowship among Scandinavian Americans.

SCANDINAVIAN AMERICAN GENEALOGICAL SOCIETY Archives
 P. O. Box 16069
 St. Paul, MN 55116-0069 612-645-3671

Sponsoring organization: Minnesota Genealogical Society
Contact: Mrs. Frances Hillier, Secy.
Availability: Open to the public; Admission: Free
Visitors: General public, Ethnic community
Staff: pt volunteers
Publications: *The Saga*, biannual; brochures.

Collection: Books, periodicals, audiovisual materials; some records are on microfiche (copies of the I.G.I. of the Mormon Church records). The collection is cataloged; a reading room and copying facilities are available.

Comments: The purpose is to promote genealogy of Scandinavian families (Danish, Finnish, Icelandic, Norwegian, and Swedish). Services include lectures and speakers.

SCANDINAVIAN COLLECTORS CLUB LIBRARY Library
 6229 Wildlife Dr.
 Allenton, WI 53002 414-629-5251

Personnel: Dr. Roger Schnell, Pres.; Robert Lang, Exec. Secy. and Bd. of Directors
Contact: Dr. W. E. Melberg, Libn., P. O. Box 135, Allenton, WI 53002
Founded: 1935 (Club) Scope: Local, State, Regional, National, International

Availability: Open by special appt. only; Admission: Free
Visitors: SCC Membership
Staff: 1 volunteer; Operating budget: $200
Publications: *Posthorn*, quarterly; *Scandinavian Collectors Club*; also publishes library indexes and various handbooks.

Collection: Books, periodicals, audiovisual materials, exhibit and auction catalogs, and archives (unpublished records). The collection is cataloged; a published guide and reading room are available.

Comments: The library supports the research of members of the organization with respect to their Scandinavian history and heritage and Scandinavian philately. Services include films and AV productions; the organization participates in ethnic festivals.

SCOTCH-IRISH AMERICAN RESOURCES
(*See also* Irish American and Scottish American Resources)

THE SCOTCH-IRISH FOUNDATION Library
 P. O. Box 181 Archives
 Bryn Mawr, PA 19010 215-527-1818

Sponsoring organization: The Scotch-Irish Society of the U.S.A.
Personnel: John C. Tuten, Jr., Secy.
Contact: John W. McPherson, Pres. & Treas., P.O. Box 1180, Bryn Mawr, PA 19010
Founded: 1949; Scope: National
Availability: Open to the public (Library at the Balch Institute for Ethnic Studies, Philadelphia); Admission: Fee
Visitors: General public
Operating budget: $2,500
Publications: Catalog of collections

Collection: 600 books, 50 periodical titles, 15 cubic ft. of archival materials (personal papers and correspondence, printed materials related to the origin and history of the Scotch-Irish in Scotland, Ireland, and the United States). The library contains genealogical information and is cataloged in the OCLC database; a published guide is available (1991).

Comments: The principal objective is to preserve the history of the Scotch-Irish people in Scotland, Ireland, and the United States.

SCOTTISH AMERICAN RESOURCES
(*See also* Scotch-Irish American Resources)

CLAN CUNNING ASSOCIATION Archives
 3824 Lanewood Dr.
 Des Moines, IA 50311 515-255-4594

Personnel: Willis L. Cunning, Pres.
Contact: Robert A. Cunning, 993 W. Cook Rd., Mansfield, OH 44906
Founded: 1977; Scope: International
Publications: *The Crofter*, ceased in 1985.

Collection: Archival materials (personal papers and correspondence, unpublished records, pictorial materials, manuscripts). The collection is not cataloged and is in the hands of Robert A. Cunning, genealogist, 993 W. Cook Rd., Mansfield, OH 44906 and at the Scottish Clan's Archives Center in Moultrie, Georgia.

Comments: The association provides information on Clan Cunning, provides performing arts presentations (piping, dancing), and participates in ethnic festivals.

THE JACOB MORE SOCIETY Archives
 235 Via Bonita
 Alamo, CA 94507 510-837-8199

Personnel: Michael Moore, Pres.; Allen Moore, V. Pres.
Founded: 1976; Scope: Local
Availability: Not open to the public
Staff: 1 volunteer; Operating budget: $30,000

Collection: Books, artifacts, works of art, and archival records (printed materials and manuscripts).

Comments: The purpose is to promote research and the publication of works related to Scottish history and the contributions of Scottish-Americans, with particular emphasis on Clan Campbell. The society sponsors research at Inverary Castle in Scotland.

SCOTTISH HISTORIC AND RESEARCH SOCIETY OF THE Library
DELAWARE VALLEY, INC. Archives
 102 St. Pauls Rd.
 Ardmore, PA 19003-2811 215-649-4144

Contact: Blair C. Stonier, Editor, Past Pres.
Founded: 1964; Scope: Local, State, Regional, National, International
Availability: Open by special appt. only; Admission: Free
Visitors: General public, Ethnic community
Staff: 2 volunteers; Operating budget: $25,000
Publications: *The Rampant Lion*, 1964- , 11/year; membership newsletters and books (e.g., *How to Search for Your Scottish Ancestors*, 1976).

Collection: Ca. 2,000 books, 50 periodicals, audiovisual materials, artifacts, works of art, and archival records (personal papers and correspondence, pictorial materials, theses and dissertations). A reading room and copying facilities are available.

Comments: The purpose is to preserve and present the culture and history of Scotland and related areas. Activities include educational lectures, school presentations, radio and TV programs, speakers, dance and instrumental performances, films and AV productions, arts and crafts souvenir shop. The Society participates in ethnic festivals.

TARTAN EDUCATIONAL AND CULTURAL ASSOCIATION <u>Library</u>
(Formerly Scottish Tartans Society Members Association in U.S.) <u>Archives</u>
 Box 138
 Skippack, PA 19474 215-584-4220

Personnel: William Steed, V. Pres.; Philip D. Smith, Secy.; Otis C. Johnston, Treas.
Contact: William H. Johnston, Pres.
Founded: 1984; Scope: International
Availability: Restricted access; Admission: Free
Staff: 4 (1 pt, 3 volunteers)
Publications: *The Tartan Banner*, 1984- , semi-annual; promotional brochures.

Collection: Books, audiovisual materials, artifacts, archives (personal papers and
correspondence, unpublished records, pictorial materials, and computerized records.
The collection is cataloged.

Comments: The association consists of both scholars and supporters who are dedicated
to research and education, providing information about Scottish culture and the Tartan,
Scotland's unique art form. Other services include lectures, speakers, and seminars.

SERBIAN AMERICAN RESOURCES

ST. SAVA SERBIAN ORTHODOX CATHEDRAL <u>Library</u>
 3201 S. 51st St.
 Milwaukee, WI 53219 414-545-4080; Fax 414-545-4087

Personnel: V. Rev. Fr. Milan Markovina, Dean; V. Rev. Fr. Dragan Veleusic, Pastor
Contact: Vlasta Vranjes, Secy.
Scope: National, International
Availability: Open regular hours and by special appt.; Admission: Free
Visitors: General public
Staff: Volunteers; Operating budget: Donations

Collection: Books and periodicals in English and Serbian. The collection is not
cataloged; copying facilities are available.

Comments: The library includes works by American, British, Serbian, Russian, and
other foreign authors, both in English and Serbian and in translations. The church also
participates in ethnic festivals.

SERBIAN NATIONAL DEFENSE COUNCIL OF AMERICA <u>Library</u>
 5782 N. Elston Ave. <u>Archives</u>
 Chicago, IL 60646-5546 312-775-7772; Fax 312-775-7779

Personnel: Louis Milicich, National V. Pres.
Contact: Slavko Panovich
Founded: 1914; Scope: National
Availability: Open by special appt.; Admission: Free

Visitors: Ethnic community
Staff: pt
Publications: *Liberty* (*Sloboda*), 1950- , bimonthly; also publishes miscellaneous
books and almanacs.

Collection: Books, periodicals, and archival materials (personal papers and correspon-
dence, unpublished records, pictorial materials, theses and dissertations, manuscripts,
and oral histories). The collection is not cataloged; copying facilities are available.

Comments: The purpose is to act as the voice of the Serbian American community and
to educate and inform the public about Serbians and their status in the ancestral
homeland. Activities include educational lectures, school presentations, radio
programs, and speakers. The organization participates in ethnic festivals.

SLOVAK AMERICAN RESOURCES
(*See also* Czechoslovak American Resources)

BAINE/CINCEBEAUX COLLECTION Museum
OF SLOVAK FOLK DRESS & FOLK ART Library
　151 Colebrook Dr.
　Rochester, NY 14617-2215 716-342-9383

Personnel: Helen Zemeh Baine
Contact: Helene Cincebeaux, Dir.
Founded: 1986; Scope: International
Availability: Open by special appt. only; Admission: Free, Donation
Visitors: General public, Ethnic community
Publications: *Treasures of Slovakia* (100 color photos of Slovak people, places,
customs) by Helene Baine Cincebeaux, 1993).

Collection: 200 books, 200 periodicals, 2,500 artifacts, over 2,000 folk dress items,
over 500 works of folk art, and archives (2,000 slides and 400 photographs, personal
papers and correspondence, unpublished records, pictorial materials), and a traveling
photo exhibit, "Treasures of Slovakia," consisting of 190 color photos exhibited in the
U.S., Slovak and Czech Republics, and Hungary. The collection is partially cataloged;
an unpublished guide, reading room, and copying facilities are available.

Comments: The purpose is to preserve folk culture, particularly folk dress and art
(embroidery, weaving, beading, lace, Batik, leather work, wood, ceramics, etc.).
Services include guided tours, educational lectures, school presentations, speakers, and
major exhibits with museums and libraries.

JANKOLA LIBRARY AND SLOVAK ARCHIVES Library
　Villa Sacred Heart Archives
　Danville, PA 17821-1698 717-275-5606

Sponsoring organization: Sisters of SS. Cyril and Methodius
Contact: Sister Mercedes Voytko, Dir. or Sister Martina Tybor, Dir. and Archivist

Founded: 1968; Scope: National, International
Availability: Open to the public; Admission: Free
Visitors: General public, School groups
Staff: 1 ft, salaried; volunteers

Collection: Ca. 1,500 books, 50 periodicals, 50 bound newspapers, 250 audiovisual materials, artifacts, works of art, and 8 file drawers of archives (personal papers and correspondence, pictorial materials, theses and dissertations, manuscripts, and oral histories). Some materials are in microform. The collection is cataloged; a reading room is available.

Comments: The objectives are to identify and preserve scholarly resources on Slovak studies and Slovak American history and culture. Activities include educational lectures, loans to schools, speakers, interlibrary loan, and sale of reference and general works on Slovak history and culture.

NATIONAL SLOVAK SOCIETY OF THE USA Museum
2325 East Carson St. Library
Pittsburgh, PA 15203 412-488-0327; 412-488-1890 Art Gallery

Contact: Dave Blazek, Pres.
Personnel: Paul Payerchin, Secy./Treas.; Dean Burns, V. Pres.
Founded: 1890; Scope: National
Availability: Open to the public; Admission: Free
Visitors: General public, Ethnic community
Staff: 10 ft, 1 pt
Publications: *Narodne Noviny*, monthly; *Narodny Kalendar*, annual

Collection: Books, periodicals, artifacts and realia, and works of art. Some office records are in microform; the collection is not cataloged.

Comments: The society is a fraternal life insurance agency that provides service to Slovak Americans. It is also interested in preserving Slovak American history and culture.

SLOVAK EASTERN CATHOLIC SYNOD OF AMERICA Library
515 West Main
Monongahela, PA 15063 412-258-6415

Founded: 1967; Scope: Regional, National

Collection: 1,210 books

Comments: The Synod preserves the religious and cultural heritage of Slovak Americans who practice the Byzantine rite. The library supports courses in the history of St. Cyril and St. Methodius.

SLOVAK HERITAGE AND FOLKLORE SOCIETY INTERNATIONAL Library
151 Colebrook Dr.
Rochester, NY 14617-2215 716-342-9383

Personnel: Helen Z. Baine, Treas.
Contact: Helene Cincebeaux, Dir.
Founded: 1986; Scope: International
Availability: Open by special appt.; Admission: Free, Donation
Visitors: Ethnic community
Publications: *Slovakia: A Slovak Heritage Newsletter*, 1987- , quarterly; *Slovak Pride*, 1991- , triennual; also publishes books.

Collection: 150 books, 200 periodicals, archival records (personal papers, unpublished records, pictorial materials). The collection is not cataloged; a reading room and copying facilities are available.

Comments: The society provides information on Slovak heritage and culture (music, art, folk dress, customs, crafts, and genealogy). The newsletter publicizes people, events of interest, services, sources, tips on travel in Slovakia, and how to find long lost relatives. Services include educational lectures, school presentations, and participation in ethnic festivals.

SLOVAK INSTITUTE Library
St. Andrew's Abbey Archives
10510 Buckeye Rd.
Cleveland, OH 44104-3728 216-721-5300

Personnel: Rt. Rev. Roger Gries, Pres., O.S.B.
Contact: Rev. Andrew Pier, O.S.B., Dir.
Founded: 1952: Scope: International
Publications: *Slovak Studies*, annual; *Ave Marie*, monthly; also publishes the periodical *Most*.

Collection: 10,000 books and archival records

Comments: The purpose is to promote, preserve, and study Slovak culture.

SLOVAK LEAGUE OF AMERICA Archives
313 Ridge Ave.
Middletown, PA 17057 717-944-9933

Founded: 1967; Scope: National
Staff: 1
Publications: *Slovakia*, 1951- , annual; also publishes books.

Collection: Archives (personal papers and correspondence, unpublished materials).

Comments: The purpose is to document the history and activities of the organization and to preserve the Slovak American culture and experience.

SLOVAK MUSEUM AND ARCHIVES Museum
(Formerly Jednota Museum) Library
Rosedale Ave. and Jednota Ln., P.O. Box 750 Archives
Middletown, PA 17057 717-944-2403; Fax 717-944-3107

Sponsoring organization: First Catholic Slovak Union
Contact: Dr. Edward A. Tuleya, Curator and Archivist
Founded: 1883; Scope: National
Availability: Open M-F, restricted access; Admission: Free
Visitors: General public, School groups, Ethnic community
Staff: 2 (1 ft, 1 pt, salaried); Operating budget: $20,000
Publications: Promotional brochures and newspaper articles in *Jednota*.

Collection: 3,000 books, periodicals, audiovisual materials, artifacts, 8 file cabinets of archival records (personal papers and correspondence, unpublished records, theses and dissertations, pictorial materials, manuscripts). The newspaper *Jednota* (1903-1940) is on microfilm. The collection is cataloged; copying facilities are available.

Comments: The Slovak Museum and Archives were established to promote the history and culture of the Slovak people. The museum displays Slovak folk costumes, lace, porcelain, and memorabilia of Slovak fraternal organizations. Programs include guided tours, educational lectures, loans to schools and other educational institutions, and participation in ethnic festivals.

SLOVAK WRITERS AND ARTISTS ASSOCIATION Library
c/o Slovak Institute
10510 Buckeye Rd.
Cleveland, OH 44104 216-721-5300

Founded: 1954; Scope: National
Availability: Open by appt. only; Admission: Free
Visitors: General public, Ethnic community
Publications: *Most*, quarterly

Collection: Books on Slovak history, literature, the arts, and the contributions of Slovak Americans.

Comments: This organization aims to preserve Slovak culture through the arts. It also conducts activities that recognize Slovak writers and artists for their contributions to American life.

UNITED LUTHERAN SOCIETY Archives
(Formerly Slovak Evangelical Union and Evangelical Slovak
Women's Union)
Ross Mt. Park Rd., P.O. Box 947
Ligonier, PA 15658-0947 412-238-9505

Contact: Paul M. Payerchin, Jr., Pres.
Founded: 1893; Scope: National
Availability: Open to the public; Admission: Free
Visitors: General public
Staff: 6 ft, salaried
Publications: *United Lutheran*, 1962- . bi-monthly; *A Slovak Christmas Eve.*

Collection: Books, periodicals, audiovisual materials, artifacts, works of art, and

archives (personal papers and correspondence, pictorial materials). Newspapers and organizational minutes are in microform. A reading room and copying facilities are available.

Comments: This fraternal insurance society provides benefits for members and preserves Slovak and Slovak Lutheran culture, traditions, and values.

SLOVENIAN AMERICAN RESOURCES

SLOVENE HERITAGE CENTER Museum
 SNPJ Recreation Center Library
 R.D. 1 Martin Rd., Box 87
 Enon Valley, PA 16120 412-336-5180

Sponsoring organization: Slovene National Benefit Society
Personnel: Agnes Elish
Contact: Louis Serjak, Chair, 674 N. Market St., East Palestine, OH 44413
Founded: 1976; Scope: Regional, National
Availability: Open Sun. 1-5 (April 1-Oct. 1); also by special appt.; Admission: Free/donations
Visitors: General public, School groups, Ethnic community
Staff: 11 volunteers; Operating budget: $2,500

Collection: Ca. 1,500 books, periodicals, artifacts, works of art, and archival records (printed materials, newspaper clippings, pictures). A reading room and copying facilities are available for researchers.

Comments: The center is dedicated to preserving the customs and traditions that the Slovene immigrants brought with them to America. The museum displays Slovene embroidery, cipka lace, splatter cloths, decorated wooden plates, ethnic costumes, works of art by artists of Slovenian heritage, etc. It also conducts a summer camp for young people, provides guided tours, educational lectures, and speakers.

SLOVENE NATIONAL BENEFIT SOCIETY Archives
(Formerly Ethnic Heritage Center)
 166 Shore Dr.
 Burr Ridge, IL 60521 708-887-7660; Fax 708-887-7668

Contact: Grace Doerk, Secy.
Founded: 1904; Scope: National
Availability: Open by special appt.; Admission: Free
Visitors: General public, Ethnic community
Staff: 30
Publications: *Prosveta*, weekly; *Voice of Youth*, monthly; also publishes an annual roster of member lodges.

Collection: Archives (personal papers and correspondence, unpublished and biographical materials).

Comments: This is a major fraternal benefit life insurance society which sponsors sports and other activities for Slovenian Americans, particularly for children and young adults. It sponsors a recreation center, an ethnic heritage center, and educational scholarships.

SLOVENIAN HERITAGE MUSEUM Museum
 431 N. Chicago Library
 Joliet, IL 60435 815-727-1926 Archives
 Art Gallery

Sponsoring organization: Slovenian Women's Union of America
Personnel: Victoria Bobence, Natl. Pres.; Irene Oderizzi, Museum Dir.
Contact: Jonita Ruth, 417 N. Chicago St., Joliet, IL 60432
Founded: 1981; Scope: Local, State, Regional, National
Availability: Open by special appt.; Admission: Free
Visitors: General public, School groups
Staff: 9 (1 part-time, 8 volunteers); Operating budget: $3,300
Publications: *The Dawn*, 1926- , monthly; *In Their Footsteps* (Slovenian Women's Union of America); *Slovenia to America*; *Footsteps through Time*; *Slovenian Song Book*; also publishes promotional and other brochures.

Collection: 1,000 books, periodicals, audiovisual materials, 500 artifacts, 50 works of art, and archival records (unpublished records, printed materials). The collection is cataloged; a reading room is available.

Comments: The objective is to promote the Slovenian cultural heritage. Collections and programs provide information about the history of Slovenian settlement in the United States.

SPANISH AMERICAN RESOURCES
(*See also* Hispanic American and Latin American Resources)

ANCIENT SPANISH MONASTERY OF ST. BERNARD Museum
DE CLAIRVAUX CLOISTERS Library
 16711 W. Dixie Hwy.
 North Miami Beach, FL 33160 305-945-1462

Sponsoring organization: Episcopal Church of St. Bernard de Clairvaux
Contact: Father Bruce E. Bailey, Exec. Dir.
Founded: 1952; Scope: Local, state, regional
Availability: M-Sat. 10-4, Sun. 12-4; Admission: $4 adults, $2.50 seniors, students 12 and under $1
Visitors: General public

Collection: Works of art, artifacts, religious items.

Comments: This museum, a reconstructed 12th century monastery built in Segovia, Spain, preserves Spanish art and culture. Services include guided tours, performing arts presentations, permanent and traveling exhibits, art festivals, and a souvenir gift shop.

EL RANCHO DE LAS GOLONDRINAS MUSEUM Museum
(Formerly Old Cienega Village Museum)
 334 Los Pinos Rd.
 Santa Fe, NM 87505 505-471-2261; Fax 505-986-0608

Sponsoring organization: The Rancho de las Golondrinas Charitable Trust
Personnel: Felipe R. Mirabal, Curator of Collections
Contact: George B. Paloheimo, Dir.
Founded: 1971; Scope: Local, State, Regional
Availability: Open W-Sun. 10-4 (June-Sept.), other times by appt.
Admission: $3.50 adults, $2 seniors and students, $1 children 5-12
Visitors: General public, School groups
Staff: 12 ft, 3 pt, salaried, volunteers; Operating budget: $600,000
Publications: *Newsletter of El Rancho de las Golondrinas*, 1983- , quarterly; *El Rancho De Las Golondrinas: Spanish Colonial Life in New Mexico* (1993); official guidebook.

Collection: Books, periodicals, audiovisual materials, 1,500 artifacts, works of art, archives (personal papers and correspondence, unpublished records, pictorial materials, theses and dissertations, manuscripts, and oral histories), and historic buildings of the Spanish colonial period. The collection is cataloged; copying facilities are available.

Comments: This is a living historical farm set in a Spanish style village. Its purpose is to preserve Spanish colonial traditions by guided tours, educational lectures, school presentations, speakers, performing arts (dance, choir, instrumental), crafts classes, and a souvenir shop. The museum participates in ethnic festivals, supports research programs, and offers work experience for college credit in conjunction with colleges and universities.

INSTITUTO CERVANTES Library
(Formerly Casa de Espana)
 122 E. 42nd St., Suite 807
 New York, NY 10168 212-689-4232; Fax 212-545-8837

Contact: Ramon Abad, Head Libn.
Founded: 1993; Scope: International
Availability: Open to the public; Admission: Free
Staff: 5 (3 ft, 2 pt)
Publications: Membership newsletters and flyers

Collection: 35,000 books, 107 periodicals, 2,000 audiovisual materials. The collection is cataloged; a reading room and copying facilities are available.

Comments: The objectives are to promote Spanish language and culture. The institute collaborates with other groups to organize film series, concerts, and lectures about Spanish American life and culture.

JUNIPERO SERRA MUSEUM Museum
 2727 Presidio Dr.
 San Diego, CA 92110 619-297-3258; Fax 619-232-6297

Sponsoring organization: San Diego Historical Society
Personnel: James Vaughan, CEO,
Contact: Mark Allen, Asst. Curator
Founded: 1928; Scope: Regional
Availability: Open T-Sat. 10-4:30, Sun. 12-4:30; Admission: Fee
Visitors: General public
Publications: *Journal of San Diego History*, quarterly; also publishes books and
monthly newspaper.

Collection: Books, religious and other Spanish artifacts and furnishings from the 16th,
17th, and 18th centuries.

Comments: The museum preserves materials from the first Spanish mission and from
the Presidio excavation. Activities include guided tours, lectures, audiovisual
presentations, exhibits, and loans to other institutions.

LOS CALIFORNIANOS Library
 P. O. Box 1693 Archives
 San Leandro, CA 94577-0169 510-276-5429

Contact: Beatrice C. Turner, Treas.
Founded: 1969; Scope: National
Availability: Open by appt; Admission: Free
Visitors: General public, Ethnic community
Publications: *Antepasados*, biennial

Collection: Books and archival materials (personal papers and correspondence,
California mission records, Spanish American family genealogies).

Comments: Members are descendants of Spaniards who settled in northern California
prior to 1848. The goal of the organization is to preserve the ethnic and cultural
heritage of the early Spanish settlers of the Alta California area and to conduct research
on the group's history and religious, military, and cultural activities. Services include
speakers and educational lectures.

MISSION BASILICA DE ALCALA Museum
 10818 San Diego Mission Rd.
 San Diego, CA 92108 619-283-7319; Fax 619-283-7762

Personnel: Rev. Msgr. Thomas Prendergast, Pastor; Mary C. Whelan, Curator, Sister
Catherine Louise LaCoste, Archivist
Founded: 1769; Scope: Local, State, Regional
Availability: Open daily 9-5; Admission: $1 adults, Free for children under 12
Visitors: General public
Publications: *Mission San Diego de Alcala*, annual

Collection: Artifacts from the Spanish colonial period (including religious and church
ceremonial objects) and archival materials (church records).

Comments: This historic site preserves Spanish religious life and culture, features

mediated walking tours and exhibits, and offers educational programs in conjunction with colleges and universities.

MISSION SAN CARLOS BORROMEO DEL RIO CARMELO Museum
 3080 Rio Rd.
 Carmel, CA 93923 408-624-3600; Fax 408-624-0658

Contact: Richard J. Menn, Curator
Founded: 1770; Scope: Regional
Availability: Open M-Sat. 9:30-4:30, Sun. 10:30-4:30; Admission: Free
Visitors: General public

Collection: Books published between 1615 and 1833, Spanish colonial religious artifacts, and works of art.

Comments: The purpose of this history museum is to preserve the religious and ethnic culture of the early Spanish American founders of the mission through Spanish literature, art, and historical documents.

MISSION SAN LUIS REY MUSEUM Museum
 4050 Mission Ave.
 San Luis Rey, CA 92068 619-757-4613

Sponsoring organization: Roman Catholic Church
Contact: Mary C. Whelan, Dir. and Curator
Founded: 1798; Scope: Local, State, Regional
Availability: M-Sat. 10-4, Sun. 12-4; Admission: Free, donations accepted
Visitors: General public

Collection: Books, works of art, church vestments, furnishings, religious articles.

Comments: Spanish traditions and religious culture are preserved at this historic mission building and site. Services include guided tours; a souvenir gift shop is maintained.

OLD SPANISH FORT AND MUSEUM Museum
 4602 Fort St. Archives
 Pasagoula, MS 39567 601-769-1505

Contact: Mrs. Anais F. Penola, Dir.
Founded: 1949; Scope: Local, state
Availability: Open M-Sat. 10-5, Sun. 12:30-5; Admission: $2 adults, $1 children
Visitors: General public, Ethnic community

Collection: Artifacts, furnishings, and a historic building.

Comments: This historical museum is in an early 18th century outpost building that preserves the military and cultural history of the early Spanish American settlers in the area. Activities include guided tours, permanent and temporary exhibits, and a souvenir gift shop.

PALACE OF THE GOVERNORS Museum
 On the Plaza Library
 Santa Fe, NM 87501 505-827-6474
 Mailing address: P.O. Box 2088, Santa Fe, NM 87504

Sponsoring organization: Museum of New Mexico
Personnel: Dr. Thomas Chavez, Dir.; Dr. Donna Pierce, Charles Bennett, Richard
Rudisill, Arthur Olivas, Pamela Smith, Diana Ortega DeSantis, Cordelia Snow, and
William Sneeberger, Curators; Hazel Romero, Libn.
Founded: 1909; Scope: Local, State, Regional
Availability: Open daily 10-5 (Mar.-Dec.); T-Sun. 10-5 (Jan.-Feb.); Admission: Fee
Visitors: General public, School groups
Publications: Historical novels (reissues)

Collection: 12,000 books, 380,000 photographs, 15,000 artifacts (furnishings,
decorative arts, religious relics), and archival materials.

Comments: This history museum is housed in a Spanish-style government building (ca.
1610), and it attempts to preserve the southwestern Spanish heritage through exhibits of
cultural artifacts.

RANCHO LOS CERRITOS Museum
 4600 Virginia Rd. Library
 Long Beach, CA 90807 310-424-9423 Archives

Contact: Stephen C. Iverson, Curator
Founded: 1955; Scope: Local, state, regional
Availability: Open W-Sun. 1-5; Admission: Free
Visitors: General public
Staff: 3 ft, 3 pt, paid; 80 volunteers, 2 interns
Publications: *Friends Footnotes* (newsletter)

Collection: 5,500 books, audiovisual materials, artifacts (costumes, furnishings,
photos, tools), and archival materials (manuscripts, maps, unpublished materials and
personal papers).

Comments: This colonial Spanish mission style building, furnishings, and primary
sources document Spanish traditions and heritage. Services include guided tours,
audiovisual programs, programs for children, exhibits (permanent and rotating), and a
souvenir/gift shop.

ST. AUGUSTINE HISTORICAL SOCIETY Museum
 271 Charlotte St. Library
 St. Augustine, FL 32084 904-824-2872

Personnel: Page Edwards Jr., Exec. Dir.; Eddie Joyce Geyer, Asst. Dir.
Contact: Taryn Rodriguez-Boette, Library Dir.
Founded: 1883; Scope: Regional
Availability: Open M-F 9-12, 1-5; Admission: Fee (Museum); Free (Library)
Visitors: General public, School groups

Staff: 25 (6 ft, 11 pt, 8 volunteers)
Publications: *El Escribano*, 1955- , annual; *East Florida Gazette*, 1979- , 3/yr.; also publishes books and promotional materials.

Collection: Ca. 1,500 books, ca. 50 periodicals, ca. 400 artifacts and realia, 200 works of art. Additional records are maintained in microform. The collection is cataloged; an unpublished guide, reading room, and copying facilities are available for researchers.

Comments: The society is dedicated to preserving the history of the city founded by Spaniard Pedro Memendez de Aviles including the "Oldest House," the Gonzalez-Alvarez House. Activities include guided tours, educational lectures, school presentations, speakers, and a souvenir shop.

SAN BUENAVENTURA MISSION MUSEUM Museum
 225 E. Main St.
 Ventura, CA 93001 805-643-4318
 Mailing address: 211 E. Main St., Ventura, CA 93001

Sponsoring organization: Roman Catholic Archbishop of Los Angeles
Contact: Msgr. Patrick J. O'Brien, Dir.
Founded: 1782; Scope: Regional
Availability: Open M-Sat. 10-5, Sun. 10-4; Admission: Free
Visitors: General public
Publications: Histories of the mission

Collection: Books (the *Bibliotheca Sancti Bonaventurae*), artifacts related to Juan Camarillo II, works of art, and archival materials.

Comments: This historical museum is housed in the San Buenaventura Spanish Mission and preserves Spanish religious history and culture. Activities include guided tours, educational programs for children, and a souvenir gift shop.

SPANISH COLONIAL ARTS SOCIETY Library
 P. O. Box 1611
 Santa Fe, NM 87504 505-983-4038; Fax 983-982-4585

Contact: Bud Redding, Exec. Dir. or Dr. Donna Pierce, Curator
Founded: 1925; Scope: National
Availability: Open by appt.; Admission: Free
Visitors: General public, Ethnic community
Staff: 2 ft, 1 pt, 173 volunteers; Operating budget: $200,000
Publications: *Spanish Market Magazine*, 1989- irreg.; *Noticias*, annual; also publishes books.

Collection: Lending library of 200,000 books and periodicals, 2,500 works of art, and archives (personal papers and correspondence, unpublished records, theses and dissertations, pictorial materials, and manuscripts).

Comments: The Spanish cultural heritage is promoted and preserved through the

production, display, and sale of Spanish colonial arts and crafts, and loan of library materials. The society sponsors the annual Spanish Market and Winter Market, the first weekend in December. The major part of the collection is housed at the Museum of International Folk Art in Sante Fe. Programs include educational lectures, loans to schools, and an arts and crafts market.

SPANISH GOVERNOR'S PALACE Museum
 105 Plasa de Armas
 San Antonio, TX 78205 512-224-0601

Contact: Nora F. Ward, Curator
Founded: 1749; Scope: Local, State, Regional, National, International
Availability: Open to the public M-Sat. 9-5, Sun. 10-5; Admission: Fee
Visitors: General public, School groups, Ethnic community
Staff: 3 (2 ft, 1 pt, salaried); Operating budget: $64,000
Publications: Promotional brochures

Collection: Books, ca. 750 artifacts, works of art, and 10 boxes of archival materials (personal papers and correspondence, pictorial materials, oral histories). The collection is cataloged; an unpublished guide is available.

Comments: In 1970 the Governor's Palace was named a national historic landmark. It highlights religious and festive ceremonies commemorating the founding of Villa San Fernando (San Antonio) in March, 1731. It provides educational lectures, speakers or resource people, and an arts and crafts souvenir shop.

THE SPANISH INSTITUTE Library
 684 Park Ave. Art Gallery
 New York, NY 10021 212-628-0420

Personnel: Suzanne Stratton, Dir. of Fine Arts & Cultural Programs
Contact: Edward Schumacher, Dir.
Founded: 1954; Scope: International
Availability: Open M-Sat. 11-6 (Sept.-July); Admission: Free
Visitors: General public, School groups
Staff: 41 (14 ft, 17 pt, salaried; 10 volunteers)
Operating budget: $1,000,000
Publications: Publishes a catalog of collections and membership newsletters.

Collection: Books and periodicals; the collection is cataloged. A reading room and copying facilities are available.

Comments: The mission is to support the study and teaching of Spanish arts, letters, and public affairs in the United States. An integral component of the mission is the dissemination of Spanish cultural wealth to Hispanic communities.

THE SPANISH QUARTER Museum
 Government House Library
 48 King St., P.O. Box 1987 Archives
 St. Augustine, FL 32084 904-825-5033; Fax 904-825-5096

Personnel: Ross Fullam, Dir.; William N. Rose, Chairman, Tracy Spikes, Curator,
Rita O'Brien, Information Officer
Founded: 1959; Scope: Local, State, Regional
Availability: Open daily 9-5; Admission: Free
Visitors: General public, School groups
Publications: Brochures; tour guides.

Collection: 3,000 books, works of art, artifacts (restored and reconstructed 18th and
19th century Spanish colonial buildings, and furnishings), archives (Spanish documents
on microfilm).

Comments: The museum preserves the early Spanish tradition and heritage in Florida.
Services include guided tours, arts and crafts demonstrations, permanent and rotating
exhibits, and a souvenir/gift shop.

SRI LANKAN AMERICAN RESOURCES
(*See also* Asian American Resources)

ASSOCIATION OF SRI-LANKANS IN AMERICA Archives
 2 E. Glen Rd.
 Denville, NJ 07834 201-627-7855; Fax 201-586-3411

Founded: 1978; Scope: National
Availability: Open by special appt.; Admission: Free
Visitors: General public, Ethnic community
Operating budget: Less than $25,000
Publications: Brochures; tour guides.

Collection: Archival records (unpublished papers, correspondence, and biographical
materials).

Comments: The association was founded to assist Sri Lankans in the U.S., particularly
in dealing with governmental matters. It promotes Sri Lankan culture and heritage,
conducts research, and maintains a speakers' bureau.

EELAM TAMILS ASSOCIATION OF AMERICA Library
 21 Lebanon St.
 Winchester, MA 01890 617-721-2791

Contact: T. Sri Tharan, Secy.-Genl.
Founded: 1979; Scope: National
Publications: Quarterly reports

Collection: Documents and statistical sources related to Tamil.

Comments: This fraternal association sponsors activities that raise monies for projects
concerned with human rights of Sri Lankans in the homeland; it also promotes the
Tamil language in America.

SWEDISH AMERICAN RESOURCES
(*See also* Scandinavian American Resources)

AMERICAN SWEDISH HISTORICAL MUSEUM <u>Museum</u>
 1900 Pattison Ave.
 Philadelphia, PA 19145-5901 215-389-1776; Fax 215-389-7701

Sponsoring organization: American Swedish Historical Foundation
Personnel: Cindy Palmer, Curator
Contact: Ann Bartin Brown, Exec. Dir.
Founded: 1926; Scope: International
Availability: T-F 10-4, Sat. 12-4, Sun. 12-4
Admission: $2 adults, $1 seniors and students, Free for children under 12
Visitors: General public
Staff: 6 ft, 4 pt; volunteers; Operating budget: $350,950
Publications: *American Swedish Historical Museum Newsletter*, 1980- , quarterly; also
publishes promotional brochures and reports.

Collection: 10,000 books, 80 periodical titles, 50 audiovisual titles, 4,000 artifacts,
1,000 works of art, and 25 boxes and 50 file drawers of archival records (personal
papers and correspondence, unpublished records, pictorial materials, manuscripts, and
oral histories). The collections include archaeological artifacts from settlement prior to
William Penn, the "Golden Map" room highlighting Sweden's history and culture, and
a recreation of a room from a 19th century farm cottage. A reading room and copying
facilities are available.

Comments: The museum is committed to preserving and teaching the history of people
of Swedish heritage and their contribution to America since the 17th century. Programs
cover Swedish Immigration and Life on the Prairie, The Sankta Lucia Festival of Light
and Swedish Christmas Traditions, New Sweden Colony, Vikings!, Life of Early
Swedish Settlers, among others. Activities include guided tours, educational lectures,
crafts classes, and a souvenir shop; the museum participates in ethnic festivals.

THE AMERICAN SWEDISH INSTITUTE <u>Museum</u>
 2600 Park Ave. <u>Library</u>
 Minneapolis, MN 55407 612-871-4907; Fax 612-871-8682 <u>Archives</u>
 <u>Art Gallery</u>
Personnel: Wendy Egan, Assoc. Dir.; Linda Fransen, Curator;
Marita Karlisch, Archivist
Contact: Bruce N. Karstadt, Exec. Dir.
Founded: 1929; Scope: Local, State, Regional, National, International
Availability: Open to the public; Admission: Fee
Visitors: General public
Staff: 19 (11 ft, 8 pt, salaried); Operating budget: $500,000
Publications: *ASI Posten*, 1982- , monthly; *The American Swedish Institute: A Living
Heritage* (1988); also publishes promotional brochures.

Collection: 20,000 books and periodicals, 150 audiovisual materials, 4,000 artifacts,
3,500 works of art, and archival records (personal papers and correspondence,

unpublished records, pictorial materials, manuscripts, oral histories). Genealogy records from Swedish parishes and embarkation records are in microform. An unpublished guide, reading room, and copying facilities are available.

Comments: The mission is to celebrate and educate others, about the Swedish-American heritage, culture, and traditions, as well as about contemporary Sweden. The institute headquarters are in a 33-room mansion constructed around 1900 by a wealthy Swedish-American newspaper publisher. Programs include guided tours, educational lectures, loans and presentations to schools, speakers, performing arts presentations (dance, choir, instrumental), films and AV productions, crafts classes, souvenir shop, bookstore, language classes, festivals, ethnic celebrations, and internships for college students from both Swedish and American universities.

ARCHIVAL CENTER OF THE (SWEDISH) BAPTIST CONFERENCE Archives
 3949 Bethel Dr.
 New Brighton, MN 55112 612-638-6282

Sponsoring organization: Baptist General Conference and Bethel Theological Seminary
Contact: Norris Magnuson, Archivist
Founded: 1890; Scope: National, International
Availability: Available, with restricted access; Admission: Free
Visitors: General public, Ethnic community
Staff: 3 part-time, 2 volunteers; Operating budget: $7,200
Publications: "Decade histories" of the Baptist General Conference and Bethel College and Seminaries, 1960-

Collection: Ca. 3,000 books, 1,500 periodicals, 1,500 audiovisual materials, artifacts, works of art, and archives (personal papers and correspondence, unpublished records, pictorial materials, theses and dissertations, manuscripts, and oral histories). The collection is partially cataloged; an unpublished guide, reading room, and copying facilities are available.

Comments: The purpose is to preserve the records of the Baptist General Conference and Bethel Theological Seminary.

AUGUSTANA COLLEGE ART GALLERY Museum
(Formerly Augustana College Gallery of Art) Art Gallery
 Art & Art History Dept.
 7th Ave. & 38th St.
 Rock Island, IL 61201-2296 309-794-7469; Fax 309-794-7431

Contact: Sherry C. Maurer, Dir.
Founded: 1983; Scope: Regional
Availability: Open to the public; Admission: Free
Visitors: General public

Collection: Works of art (19th and 20th century Swedish-American art).

Comments: The purpose is to recognize the contributions of Swedish-American artists. Activities include tours, lectures, and exhibits.

BISHOP HILL HERITAGE ASSOCIATION Museum
 P. O. Box 1853, 103 Bishop Hill St. Library
 Bishop Hill, IL 61419 309-927-3899 Archives

Personnel: Carrie L. Floto, Admin. Asst.
Contact: Steven J. Carleson, Dir.
Founded: 1961; Scope: Local
Availability: Open by special appt.; Admission: Fee
Visitors: General public, School groups, Ethnic community
Staff: 2 ft, 2 pt, salaried; volunteers
Publications: Bishop Hill Heritage Association Newsletter, 1962- , quarterly; *Bishop Hill Swedish American Showcase*; *Faces of Utopia--A Bishop Hill Photo Album*; also publishes a guide book to buildings.

Collection: 450 books, 1000 periodicals, 3,000 artifacts, works of art, audiovisual materials, and archives (personal papers and correspondence, unpublished records, 3,000 photos, theses and dissertations, oral histories). Some documents are in microform. The collection is partially cataloged; a reading room and copying facilities are available.

Comments: The association owns eight historic buildings that preserve Swedish American history and culture, including a museum containing a gift shop. The objective is to preserve the history of the Swedish immigrants who settled the community of Bishop Hill. The information center provides an orientation film; other services provided include guided tours, educational lectures, school presentations, speakers, performing arts presentations (dance, drama, choir, instrumental), films and AV productions, and crafts classes.

COVENANT ARCHIVES AND HISTORICAL LIBRARY Library
 5125 N. Spaulding Ave. Archives
 Chicago, IL 60625-4987

Sponsoring organization: Evangelical Covenant Church of America
Contact: Timothy J. Johnson, Curator of Archives
Founded: 1935; Scope: National
Availability: Open M-F 8-Noon, or by appt.; Admission: Free
Visitors: General public, Ethnic community
Staff: 1 ft
Operating budget: $55,000 (combined with Swedish American Archives of Greater Chicago)
Publications: *Covenant Heritage Society Newsletter*, semi-annual

Collection: Ca. 3,500 books, ca. 200 periodical titles, audiovisual materials (including 11,000 photographs), artifacts, works of art, and 2,500 linear ft. of archives (personal papers and correspondence, unpublished records, theses and dissertations, pictorial materials, manuscripts, and oral histories). Local church records and newspapers are in microform. The collection is cataloged; an unpublished guide, reading room, and copying facilities are available.

Comments: The purpose is to document the Swedish immigrant experience in Chicago

and the Evangelical Covenant Church. Special services include speakers and research programs in conjunction with graduate level research with colleges and universities. Automated indexing provides access to various collections (photograph collection, biographical archives, etc.).

FOLKLIFE INSTITUTE OF CENTRAL KANSAS Archives
118 South Main St.
Lindsborg, KS 67456 913-227-2007

Personnel: Dr. Grota Swanson, Dir.
Contact: Mark Esping, Asst. Dir.
Founded: 1989; Scope: Regional
Availability: Restricted access; Admission: Free
Visitors: General public
Staff: 8 volunteers; Operating budget: $3,000

Collection: Books, slides on Ljuskrona (Swedish candelabra), archival records (printed and pictorial materials, oral histories).

Comments: The purpose of this research organization is to document Swedish-American folklife on the Midwestern Plains. The Institute provides speakers or resource people and participates in ethnic festivals.

GUSTAVUS ADOLPHUS COLLEGE Library
FOLKE BERNADOTTE MEMORIAL LIBRARY
St. Peter, MN 56082 507-931-755

Scope: International
Availability: Open to the public; Admission: Free
Visitors: General public

Collection: Biographical card file of over 16,000 names, microfilms of Lutheran Church in America records, microfilms and originals of some Swedish language newspapers, many books (including congregational histories).

HENDRICKSON HOUSE MUSEUM AND OLD SWEDES CHURCH Museum
606 Church St.
Wilmington, DE 19801 302-652-5629

Contact: Ashlin S. Bray, Pres.
Founded: 1947; Scope: Regional
Availability: Open M, W, F, Sat. 1-4; Admission: Free
Visitors: General public
Publications: Newsletter

Collection: 150 books, artifacts, furnishings, historic Andrew Hendrickson House (1690), and Holy Trinity (Old Swedes) Church (1698).

Comments: The purpose is to preserve early colonial life, particularly that of the Swedish settlers of the area. Activities include guided tours and exhibits.

MCPHERSON COUNTY OLD MILL MUSEUM AND PARK Museum
120 Mill St., P.O. Box 94
Lindsborg, KS 67456 913-227-3595

Contact: Dorman Lehman, Dir.; Lenora Lynam, Admin. Asst.
Founded: 1962; Scope: Local
Availability: Open to the public; Admission: Fee
Visitors: General public, School groups
Staff: 10 (2 ft, 7 pt, salaried; 1 volunteer); Operating budget: $100,000
Publications: Books, promotional brochures and pamphlets.

Collection: Ca. 3,000 books, periodicals, audiovisual materials, ca. 14,000 artifacts,
works of art, and archival materials (160 linear ft. of tax books, 75 cubic ft. of
newspapers, 11 cubic ft. of photos, 12 file drawers of manuscripts). Materials include
unpublished records, pictorial materials, and oral histories. The collection is cataloged;
a reading room and copying facilities are available.

Comments: The purpose is to collect, preserve, and display materials and buildings
that illustrate the natural and social history of the area and its Swedish heritage.
Services include guided tours, loans to schools, arts and crafts souvenir shop, and
camping and picnic facilities.

NEW SWEDEN HISTORICAL SOCIETY Museum
Capitol Hill Rd.
New Sweden, ME 04762 207-896-3018

Contact: David G. Anderson, CEO
Founded: 1925; Scope: Local, State, Regional
Availability: T-Sat. 9:30-4:30 (June-Aug.), other times by appt.; Admission: Free
Visitors: General public
Publications: Newsletter

Collection: Artifacts (household furnishings, farm tools, and equipment), and archival
materials (photographs and portraits of immigrants) housed in replica of historical
building (original museum) destroyed by fire in 1971.

Comments: Preserves Swedish culture and traditions in America by documenting the
lives of the early Swedish settlers of New Sweden in Maine. Activities include guided
tours, audiovisual presentations, Swedish language lessons, and participation in ethnic
festivals (Midsummer Celebration, Founder's Day Celebration).

PHELPS COUNTY HISTORICAL SOCIETY Museum
N. Burlington St., P.O. Box 164 Library
Holdrege, NE 68949 308-995-5015 Archives

Personnel: Eileen Schrock, V. Pres.; Faye Stevens, Secy.; Bernice Lindgren, Treas.
Contact: Don Lindgren, Pres., 1020 Sherman St., Holdrege, NE 68949-0164
Founded: 1966; Scope: Local, State
Availability: Open to the public; Admission: Donation
Visitors: General public, School groups, Ethnic community

Staff: 31 (1 pt, salaried; 30 volunteers); Operating budget: $34,000
Publications: *Stereoscope*, 1986- , quarterly

Collection: 50 books, 500 artifacts, and 4 file drawers of archival records (personal papers and correspondence, unpublished records, pictorial materials, manuscripts, oral histories). The collection is cataloged; a reading room and copying facilities are available.

Comments: The collection is related to Swedish heritage and history. Services include guided tours, school presentations, radio and TV programs, and speakers. The organization participates in ethnic festivals.

SWEDISH AMERICAN HISTORICAL SOCIETY Library
(Formerly Swedish Pioneer Historical Society) Archives
 5125 N. Spaulding Ave.
 Chicago, IL 60625

Personnel: Philip J. Anderson, Pres.; Byron J. Nordstrom, Chairman of the Bd.;
Timothy J. Johnson, Archivist
Contact: Beth E. Johnson, Admin. Asst.
Founded: 1948; Scope: International
Availability: Open by special appt; Admission: Fee
Visitors: General public
Staff: 1 ft, 1 pt; Operating budget: $40,000
Publications: *Swedish American Historical Quarterly*, 1950- , quarterly; books.

Collection: 3,000 books, 550 periodical titles, audio tapes and records, and 300 linear ft. of archives (personal papers and correspondence, unpublished records, pictorial materials, theses, manuscripts, diaries, family histories, organization records, newspapers, pamphlets, music, and oral histories). Newspapers are preserved in microform. The collection is cataloged; an unpublished guide, reading room, and copying facilities are available.

Comments: The archives document the Swedish-American experience, especially that of Swedes in Chicago--at one time the second largest Swedish city in the world. Activities include educational lectures, speakers, conferences, travel programs, research grants, volunteer and intern programs, and participation in ethnic festivals.

SWEDISH-AMERICAN MUSEUM CENTER OF CHICAGO Museum
 5211 N. Clark Library
 Chicago, IL 60640 (312) 728-8111 Fax 312-728-8870 Archives
 Art Gallery
Personnel: Kerstin Lane, Exec. Dir.; Jennifer Mathison, Curator
Founded: 1976; Scope: International
Availability: Open to the public; Admission: Donation
Visitors: General public
Publications: *SAMAC News*, 1987- , quarterly; also publishes books, memberships newsletters and flyers.

Staff: 49 (2 ft, 2 pt, salaried; 45 volunteers); Operating budget: $160,000

Collection: Over 1,500 books, periodicals, audiovisual materials, over 1,500 artifacts, works of art, and ca. 1,500 archival records (personal papers and correspondence, unpublished records, pictorial materials). The collection is cataloged.

Comments: The center provides educational and cultural activities for the public; it houses a permanent exhibit that tells the story of the Swedes who immigrated to Chicago. Contemporary Swedish culture is also presented through art exhibits, classes in Swedish, crafts, and folk dancing. It provides guided tours, educational lectures, loans and presentations to schools, speakers, performing arts presentations (dance, choir, instrumental), films and AV productions, and a souvenir shop. The center participates in ethnic festivals and celebrations of Swedish holidays.

SWEDISH COLONIAL SOCIETY Archives
 336 S. Devon Ave.
 Philadelphia, PA 19087 215-688-1766

Contact: Wallace F. Richter
Founded: 1908; Scope: State
Availability: Open by appt.; Admission: Free
Visitors: General public, Ethnic community
Publications: *Directory*, irreg.; newsletter; also publishes organizational charters and by-laws.

Collection: Archival materials (biographical records)

Comments: Preserves Swedish American history and culture through maintenance of historical landmarks and erection of monuments to honor Swedish immigrant pioneers.

SWEDISH COUNCIL OF AMERICA Archives
 2600 Park Ave.
 Minneapolis, MN 55407 612-871-0593; Fax 612-871-8682

Contact: Christopher Olsson, Exec. Dir.
Founded: 1972; Scope: National
Availability: Open by special appt.; Admission: Free
Visitors: General public, Ethnic community
Staff: 2; Operating budget: $175,000
Publications: *Sweden & America*, quarterly; also published an *American-Swedish handbook*.

Collection: Archival materials (unpublished papers and correspondence, oral histories)

Comments: This union of Swedish organizations provides information about the Swedish cultural heritage. It conducts research on Swedish history, including immigration to and life in America, and it is involved in preservation of Swedish historical sites. Services include speakers and scholarships for college students.

SWEDISH HISTORICAL SOCIETY OF ROCKFORD Museum
 404 S. 3rd St.
 Rockford, IL 61104 815-963-5559

Personnel: Armer Severin, V. Pres.
Contact: Sheldon A. Parker, Pres.
Founded: 1939; Scope: Local, State, Regional, National, International
Availability: Open weekdays plus 2-4 p.m. on Sundays; Admission: Fee
Visitors: General public, School groups, Ethnic community
Staff: 45 volunteers
Publications: *Swedish Heritage*, 1986- , annual; also publishes flyers and monographs.

Collection: 2,000 books, periodical titles, audiovisual materials, works of art, 400 artifacts, and archives (personal papers and correspondence, unpublished records, pictorial materials). The collection is cataloged.

Comments: The purpose is to preserve and promote Swedish culture and heritage and to operate and manage the Erlander Home/Museum. Services include guided tours, educational lectures, school presentations, speakers, and a genealogy study class.

SWENSON SWEDISH IMMIGRATION RESEARCH CENTER Library
 Augustana College, Denkmann Memorial Hall Archives
 639 38th St.
 Rock Island, IL 61201-2296 309-794-7204; Fax 309-794-7443

Sponsoring organization: Augustana College
Personnel: Dag Blanck, Dir.; Kermit Westerberg, Archivist
Contact: Vicky Oliver, Admin. Asst.
Founded: 1981; Scope: Local, State, Regional, National, International
Availability: Open to the public; Admission: Free
Visitors: General public, School groups, Ethnic community
Staff: 4 (3 ft, 1 pt); Operating budget: $90,000-95,000
Publications: *Swenson Center News*, 1986- , annual; *Swedish-American Newspapers* (1981); *The Problem of the Third Generation Immigrant* (1987); *Guide to Resources and Holdings*; also publishes books, *Occasional Papers Series*, 1991- , irreg.; promotional brochures; and newspaper indexes.

Collection: 10,000 books, 5,000 periodicals, 100 audiovisual materials, ca. 400 linear ft. of archival records (unpublished records, pictorial materials, theses and dissertations, manuscripts, oral histories); 2,000 reels of Swedish American church records; over 400 reels of records and papers for Swedish American benevolent, fraternal, social and cultural organizations; over 60 reels of personal and professional papers from Swedish immigrants and/or families; 1,560 reels of Swedish American newspapers and periodicals; 59 reels and 6 loose-leaf volumes of name indexes to embarkation records from Swedish ports of Gothenburg (1869-1930) and Malmo (1874-1895); over 70 reels of Chicago city directories (1839-1929) with gaps); 14 reels and 14 microfiche of name indexes to Norwegian ports of embarkation (Bergen, 1874-1924); Kristiania/Oslo (1871-1902); Trondheim (1867-1890); other indexes to Swedish emigrants (on fiche and paper) from specific areas of Sweden (ports, towns, and parishes) and from the nation at large; 14,000 fiche of parish records (Church of Sweden/Lutheran). The collection is cataloged; a published guide is available.

Comments: This major national archives and research center collects, preserves and interprets the records of Swedish immigration to North America and provides materials

for historians, social scientists, journalists, genealogists, and others studying the impact and contributions of Swedish immigrants and their descendants to American life and society.

VASA MUSEUM Museum
 County Road 7 Library
 Vasa, MN 55089 612-258-4327

Sponsoring organization: Vasa Lutheran Church
Contact: Everett Lindquist, Bd. Chair
Founded: 1929; Scope: Local, international
Availability: Sun. 1-5 May through Sept.; other times by appt.
Admission: Free, donations
Visitors: General public
Staff: 12 pt volunteers; Operating budget: $2,000

Collection: Over 1,500 items (books in Swedish and English, Bibles, song books (including the Augustana Synod hymnals), periodicals, artifacts, and other items related to the history and other activities of the Vasa Lutheran Church. Some records are preserved in microform. The collection is cataloged; copying facilities are available for researchers.

Comments: The museum collects, preserves, interprets, and displays items related to Swedish history, life, cultural heritage, and various religious traditions over the past 150 years. Programs include guided tours and loans to schools and other educational institutions.

THE VASA ORDER OF AMERICA NATIONAL ARCHIVES, INC. Archives
 Box 101, 109 S. Main St.
 Bishop Hill, IL 61419 309-927-3898

Personnel: Bertil G. Winstrom, Pres.
Contact: Richard W. Horngren, Archivist
Scope: International
Availability: Open to the public; Admission: Free
Visitors: General public, School groups, Ethnic community
Staff: Pt and various volunteers
Publications: *The Vasa Star*, 1910- , monthly

Collection: 2,000 books, 500 periodicals, 10 audiovisual materials, 100 artifacts, 50 works of art, and archival materials (personal papers and correspondence, unpublished records, printed materials, pictorial materials, theses and dissertations). The collection is partially cataloged; membership records and minutes of local lodge meetings are preserved on microfilm. A reading room and copying facilities are available for researchers.

Comments: The purpose is to preserve Swedish culture and heritage through guided tours, educational lectures, presentations to schools, radio and TV programs, speakers or resource people, performing arts presentations (dance, choir, instrumental), and crafts classes.

SWISS AMERICAN RESOURCES
(*See also* German American Resources)

CHALET OF THE GOLDEN FLEECE <u>Museum</u>
618 2nd St.
New Glarus, WI 53574 608-527-2614; Fax 608-527-2062

Personnel: Hubert Elmer, CEO; Phyllis Richert, Curator
Founded: 1955; Scope: Local, State, Regional
Availability: Open daily 9-4:30 (May-Oct.)
Admission: $3; $1 children 6-17, Free for children under 6
Visitors: General public
Publications: Promotional brochures

Collection: Swiss chalet and the artifacts, furnishings and art work contained in it (Swiss carvings, Swiss furniture, Swiss doll collection).

Comments: Swiss history, culture, art, and lifestyle are preserved in this historic museum. Guided tours are available.

HELVETIA MUSEUM <u>Museum</u>
Historical Square
Helvetia, WV 26224 304-924-7435

Sponsoring organization: Helvetia Restoration and Development Organization, Inc.
Personnel: Heidi Arnett, Pres.; Margaret Isch, Curator
Contact: Bruce Betler, HC 76, Box 209, Helvetia, WV 26224
Founded: 1968; Scope: Local, International
Availability: Open Sat.-Sun. 12-4 (May-Sept.); other times by appt.; Admission: Donation
Visitors: General public, School groups, Ethnic community
Staff: 2 volunteers; Operating budget: $500
Publications: *One's Own Hearth is Like Gold* by David Sutton

Collection: Audiovisual materials (photos), artifacts, and archives (personal papers and correspondence, unpublished records, pictorial materials, and oral histories). The collection is not cataloged; a reading room and copying facilities are available.

Comments: This historical preservation society is interested in preservation of Swiss history and culture in Helvetia. Services include guided tours, educational lectures, speakers, dance performances, films, and exhibits.

KIDRON-SONNENBERG HERITAGE CENTER <u>Museum</u>
Kidron, OH 44618 216-857-7302 <u>Library</u>
<u>Archives</u>
Personnel: Wayne Liechty, Pres., Kidron Community Hist. Soc. <u>Art Gallery</u>
Contact: Celia Lehman, 13170 Arnold Rd., Dalton, OH 44618
Founded: 1993; Scope: Local
Availability: Open to the public; Admission: Fee

Visitors: General public
Staff: Volunteers
Publications: Promotional brochures

Collection: Books, periodicals, artifacts, works of art, and archives (genealogical records, pictorial materials, unpublished records).

Comments: The center was built to commemorate the 175th anniversary of the city of Kidron which was settled by Swiss immigrants. The museum displays house artifacts crafted by early settlers; decorated records of births, baptisms, marriages and deaths, etc.; songbooks, and woven baskets. It includes permanent and rotating exhibits, audiovisual materials, demonstrations, presentations for local school children, tours, and an arts and crafts souvenir shop.

NEW GLARUS HISTORICAL SOCIETY Museum
 612 7th Ave., P.O. Box 745 Archives
 New Glarus, WI 53574-0745 608-527-2317

Personnel: Margaret Duerst, Pres.
Contact: Jim Haldiman, Secy.
Founded: 1938; Scope: Local
Availability: Open to the public; Admission: Fee
Visitors: General public
Staff: 15 pt; Operating budget: $60,000

Collections: Books, periodicals, artifacts, and archival records (personal papers and correspondence, unpublished records, theses and dissertations, pictorial materials). The collection is cataloged; a reading room is available.

Comments: The society sponsors the Swiss Historical Village, a museum (see Swiss Historical Village) devoted to preserving Swiss history and culture. It offers tours and school presentations, and participates in ethnic festivals.

SWISS AMERICAN HISTORICAL SOCIETY Archives
 6440 N. Bosworth Ave.
 Chicago, IL 60626 312-262-8336

Contact: Prof. Erdmann Schmocker, Pres.
Founded: 1927; Scope: International
Availability: Not open to the public
Staff: 3 volunteers; Operating budget: $7,000
Publications: *Swiss-American Historical Society Review*, 1965- , 3/yr.; promotional materials

Collection: Archives

Comments: The society unites people interested in the involvement of the Swiss and their descendants in American life and in all aspects of Swiss American relations. Emphasis is on historical and genealogical research relating to Swiss immigrants. The society provides seed money for dissertations related to Swiss American history.

SWISS HISTORICAL VILLAGE
 6th Ave. & 7th St., P.O. Box 745
 New Glarus, WI 53574 608-527-2317

Sponsoring organization: New Glarus Historical Society
Contact: Mr. William S. Hoesly, Pres.
Founded: 1938; Scope: Local, State, Regional
Availability: Open daily 9-5 (May-Oct.); Admission: $4 adults, $1 children 6-13
Visitors: General public

Collection: Replicas of historic buildings built by early Swiss settlers and the artifacts
contained in them (tools, furnishings, etc.). The village includes a reconstructed log
church, log cabin, print shop, blacksmith shop, store, school house, cheese factory, etc.

Comments: The purpose is to preserve early Swiss American life and culture.
Activities include guided tours and exhibits.

SWISS INSTITUTE NEW YORK Art Gallery
 35 West 67th St.
 New York, NY 10023 212-496-1874; Fax 212-496-1874

Sponsoring organization: Swiss Federation, Swiss Council on Arts (Pro Helvetia)
Personnel: Gisele Samuel, Office Mgr.; Christine Crowther, Admin. Asst.
Contact: Carin Kuoni, Dir.
Founded: 1986; Scope: Local, State, Regional, National, International
Availability: Open to the public; Admission: Free
Visitors: General public
Staff: 3 ft, salaried; Operating budget: $250,000
Publications: Annual reports; exhibit catalogs (6/yr.)

Collection: Books and periodicals

Comments: This nonprofit cultural organization provides exhibition opportunities to
Swiss artists and a forum for Swiss culture, visual arts, literature, music, and dance.
Services include educational lectures, dance and instrumental performances, and films
and AV productions.

TINKER SWISS COTTAGE MUSEUM Museum
 411 Kent St. Library
 Rockford, IL 61102 Archives

Personnel: George Harnish, Pres.; Kris Anderson, Curator
Contact: Deborah L. Ellerman, Museum Dir.
Founded: 1943; Scope: Local, State, Regional
Availability: Open W-Sun.; group tours by appt.; Admission: Fee
Visitors: General public, School groups
Staff: 2 ft, 1 pt, paid
Publications: Quarterly newsletter

Collection: Books and papers from the personal library and archives (personal papers

and correspondence) of Robert Tinker and the artifacts contained in a Swiss Chalet built in 1865.

Comments: Preserves Swiss culture through Swiss architecture and art work. Activities include guided tours.

T

THAI AMERICAN RESOURCES
(*See also* Asian American Resources)

AMERICAN SIAM SOCIETY Library
 633 24th St.
 Santa Monica, CA 90402-3135

Contact: Dr. H. Carroll Parish, Pres.
Founded: 1956; Scope: National
Availability: Open by appt.; Admission: Free
Visitors: General public, Ethnic community

Collection: 200 books and periodicals

Comments: This organization promotes the study of Thailand and provides cultural and social support to Thai scholars and visitors who are living in the U.S.

TIBETAN AMERICAN RESOURCES
(*See also* Asian American Resources)

FRIENDS OF THE TIBETAN LIBRARY Library
 P.O. Box 279
 Junction City, CA 96048 916-623-2714

Sponsoring organization: Chagdud Gonpa Foundation
Personnel: Chagdud Tulku Rinpoche, Pres.; Marilyn Montgomery
Founded: 1990; Scope: International
Availability: Restricted access

Collection: Books and archives (printed materials, manuscripts, and oral histories). The collection is not cataloged.

Comments: The objective is to preserve Tibetan Buddhist texts.

JACQUES MARCHAIS MUSEUM OF TIBETAN ART Museum
 338 Lighthouse Ave.
 Staten Island, NY 10306-0002 718-987-3500; Fax 718-351-0402

Personnel: Barbara Lipton, Dir.
Contact: Dorothy Reilly, Asst. Dir.
Founded: 1945; Scope: International
Availability: Open W-Sun. 1-5 (Apr.-Nov.); Admission: $3 adults, $2.50 seniors, $1 children under 12
Visitors: General public, School groups
Staff: 31 (3 ft, 8 pt, salaried; 20 volunteers)
Publications: *Calendar of Events*, bi-annual; museum papers and commemorative books.

Collection: Artifacts and realia, over 1,000 works of art and archival records (personal papers and correspondence, unpublished records, pictorial materials). The collection is cataloged; a published guide is in progress.

Comments: The museum was founded to foster interest in and study the art and culture of peoples of Tibetan heritage. Services include guided tours, educational lectures, school presentations, radio and TV programs, speakers, performing arts (dance, drama, instrumental), films, crafts classes, programs for the visually-impaired, and an arts and crafts souvenir shop. It also provides a teacher training program for education students interested in utilizing the museum and its resources in their classrooms.

NYINGMA INSTITUTE: TIBETAN AID PROJECT Archives
 2425 Hillside Ave.
 Berkeley, CA 94704 1-800-33TIBET; Fax 510-845-7540

Sponsoring organization: Tibetan Nyingma Meditation Center
Contact: Judy Rasmussen
Founded: 1969 Incorporated: 1974; Scope: International
Availability: Open to the public; Admission: Free
Visitors: General public, School groups, Ethnic community
Staff: Pt volunteers; Operating budget: $200,000
Publications: *TAP Newsletter*, 1992- , quarterly; also publishes books.

Collection: 50,000 books, artifacts, works of art, and archival materials (personal papers and correspondence, unpublished records, printed materials, pictorial materials, manuscripts, and oral histories). Some materials have been microfilmed. The collection is not cataloged; a reading room and copying facilities are available.

Comments: The purpose is to promote the preservation of Tibetan culture and to assist Tibetans both inside and outside of Tibet. Services include educational lectures, loans to schools and other educational institutions, radio and TV programs, speakers, films and audiovisual productions. The organization participates in ethnic festivals.

TURKISH AMERICAN RESOURCES

THE AMERICAN TURKISH SOCIETY, INC. Library
 850 Third Ave., 18th Flr.
 New York, NY 10022 212-319-2452; Fax 212-752-6971

Personnel: Huseyin Unver, Pres.; Ahmet Birsel, Exec. Dir.
Founded: 1949; Scope: Regional, International
Availability: Open by special appt. only; Admission: Fee (Donation)
Visitors: General public
Staff: 1 ft
Publications: *ATS Turkey Bulletin*, 1991- , quarterly; also publishes promotional
brochures, membership newsletters and flyers.

Collection: Books and periodicals; a reading room is available.

Comments: This volunteer association fosters commercial and cultural relations
between Turkey and the United States. It sponsors cultural programs, symposia, and
participates in ethnic festivals. It supports research at the graduate level.

ASSEMBLY OF TURKISH AMERICAN ASSOCIATIONS Library
 1522 Connecticut Ave. NW Archives
 Washington, DC 20036 202-483-9090; Fax 202-483-9092

Contact: Harun Kazaz, Exec. Dir.
Founded: 1979; Scope: National
Availability: Open by appt.; Admission: Free
Visitors: General public, Ethnic community
Staff: 4; Operating budget: $400,000
Publications: *The Turkish Times* (English and Turkish), weekly; *ATAA Clip Board*,
bimonthly; *ATAA Newsline*, irreg.; occasional papers series.

Collection: 1,500 books, periodicals and archives (personal papers and
correspondence, unpublished materials and biographical records).

Comments: This umbrella organization promotes education in the Turkish American
community by providing instructional materials, lectures, speakers, workshops,
conferences, and training sessions. It sponsors an annual Turkish American Heritage
Week.

FEDERATION OF TURKISH-AMERICAN ASSOCIATIONS Library
(Formerly Federation of Turkish-American Societies)
 821 United Nations Plaza, 2nd Flr.
 New York, NY 10017 212-682-7688; Fax 212-687-3026

Contact: Egemen Bagis, Exec. Dir.
Founded: 1956; Scope: National
Availability: Not open to the public
Visitors: Ethnic community
Staff: 2 ft, 2 pt; Operating budget: $200,000
Publications: *Gorus*, 1985- , quarterly; *Vision* 1986- , annual; also publishes formal
annual report.

Collection: 500 books on Turkish history and culture, periodicals, audiovisual
materials, artifacts, works of art, and archival materials (oral histories). The collection
is not cataloged.

Comments: This umbrella organization unites Turkish American organizations interested in promoting and preserving Turkish culture and heritage. Members of these organizations consist of different ethnic, technical, and social backgrounds (e.g., Azeris, Uzbek, Karacays, doctors, engineers, etc.). It provides educational lectures, promotes business relations between Turkish and non-Turkish companies, and sponsors Turkish cultural events.

TURKISH AMERICAN ASSOCIATIONS Library
 1600 Broadway, 48th St., Suite 318
 New York, NY 10019-7413 212-956-1560; Fax 212-956-1562

Contact: Inci Fenik, Secy.
Founded: 1965; Scope: National
Availability: Open by appt.; Admission: Free
Visitors: General public, Ethnic community

Collection: 1,500 books and periodicals

Comments: The association promotes Turkish culture and Turkish-U.S. relations. Services provided include educational lectures, audiovisual productions, films, and musical concerts. An annual conference is held in New York each year in June.

U

UKRAINIAN AMERICAN RESOURCES

(*See also* Carpatho-Ruthenian American Resources)

CENTER FOR UKRAINIAN AND RELIGIOUS STUDIES

2247 West Chicago Ave.
Chicago, IL 60622 312-489-1339

Library
Archives

Sponsoring organization: Holy Wisdom Society
Personnel: Dr. Vasyl Markus, Exec. Officer
Contact: Emilian Basiuk, Archivist
Founded: 1973; Scope: Local
Availability: Open by special appt. only; Admission: Free
Visitors: General public
Staff: 3 (1 ft, 2 pt, volunteers); Operating budget: $5,000
Publications: Alphabetical list of files

Collection: 3,500 books, periodicals, audiovisual materials, 150 artifacts, and archives (personal papers and correspondence, unpublished records, pictorial materials). An unpublished guide to the collection and copying facilities are available.

Comments: The purpose of the center is to collect and preserve materials about the history and religious and other activities of the members of St. Volodymyr and Olha Ukrainian Catholic Churches in Chicago from 1968 to the present. The organizations provides speakers and resource people.

EKO GALLERY

26795 Ryan Rd.
Warren, MI 48091 313-755-3535; Fax 313-755-3706

Art Gallery

Contact: Lida Kolodchin, Curator
Founded: 1972; Scope: Local
Availability: Open to the public; Admission: Free
Visitors: General public, Ethnic community
Staff: 1 ft, 2 pt

Collection: Books, periodicals, works of art, and archival materials.

Comments: Preserves Ukrainian culture through permanent and changing exhibits of cultural artifacts.

HARVARD UKRAINIAN RESEARCH INSTITUTE REFERENCE LIBRARY
1583 Massachusetts Ave.
Cambridge, MA 02138 617-496-5891; Fax 617-495-8097

Library
Archives

Sponsoring organization: Harvard University
Personnel: George G. Grabowicz, Dir. of the Ukrainian Research Institute
Contact: Ksenya Kiebuzinski, Archivist, Bibliographer
Founded: 1973; Scope: National, International
Availability: Open to the public; Admission: Free
Visitors: General public
Staff: 1 ft, salaried

Collection: Over 2,500 books, 160 periodical titles, over 1,500 audiovisual materials, and 200 linear ft. of archives (personal papers and correspondence, unpublished records, pictorial materials, manuscripts). Some serial titles are in microform; a reading room and copying facilities are available.

Comments: The institute has hosted over 100 research associates, fellows, and graduate students from universities worldwide. It sponsors conferences on Ukrainian studies devoted to Ukrainian economic thought, history, literature, bibliography, demography, immigration, and the Ukrainian religious experience. The reserve collection supports courses, seminars, and tutorials offered by the Ukrainian studies program.

LIBRARY-UKRAINIAN ORTHODOX CHURCH OF THE U.S.A.
(Formerly Library-St. Sophia Ukrainian Orthodox Theological Seminary)
135 Davidson Ave.
Somerset, NJ 08873 908-356-3017; Fax 908-356-5556

Library
Archives

Sponsoring organization: Ukrainian Orthodox Church of the U.S.A.
Contact: Dr. Vera Ortynsky, Dir., Libn.
Founded: 1952; Scope: Local, State, Regional, National, International
Availability: Open, restricted access; Admission: Free
Visitors: General public, School groups
Staff: 1 pt, salaried; Operating budget: $20,000
Publications: Annual report

Collection: 35,000 books, 550 periodicals, audiovisual materials, works of art, and 85 boxes of archives (personal papers and correspondence, unpublished records, pictorial materials, theses and dissertations, manuscripts, and oral histories). The collection is partially cataloged; a reading room and copying facilities are available.

Comments: The purpose is to collect and preserve material pertaining to the Ukrainian Orthodox Church in America and to support education and research related to it. Services include guided tours and loans to schools and other educational institutions.

PROVIDENCE ASSOCIATION OF UKRAINIAN CATHOLICS IN AMERICA
817 North Franklin St.
Philadelphia, PA 19123 215-627-4993

Archives

Personnel: Rev. Ihor Kushnir, Acting Pres.; Ihor Smolij, Secy. Genl.
Founded: 1912; Scope: National
Publications: *America*, weekly

Collection: Archival materials pertaining to the activities of the association.

Comments: This fraternal organization sponsors various cultural activities and programs to preserve Ukrainian traditions in the United States.

ST. NICHOLAS UKRAINIAN ORTHODOX CHURCH Museum
 376 Third St.
 Troy, NY 12180 518-273-6386

Contact: Michael Korhun, Curator
Founded: 1990; Scope: Local
Availability: Open Sun. mornings; Admission: Free
Visitors: General public
Staff: 2 volunteers; Operating budget: $100

Collection: Books, 112 audiovisual titles, and 20 cubic ft. of display cases and exhibition area. Archival materials include pictorial materials, oral histories, and church records. The collection is cataloged; a reading room is available.

Comments: The purpose is to preserve the history of the local Ukrainian community in the church. Services include guided tours and an arts and crafts souvenir shop.

SELF RELIANCE ASSOCIATION OF AMERICAN UKRAINIANS Library
 98 2nd Ave.
 New York, NY 10003

Contact: Mychajlo Juzeniw, General Mgr.
Founded: 1947; Scope: National
Availability: Open by special appt.; Admission: Free
Visitors: General public, Ethnic community
Staff: 2; Operating budget: $34,000

Collection: 2,291 books, audiovisual materials, and 20 cubic ft. of display cases and exhibition areas. Archival materials include pictorial materials, oral histories, and church records. The collection is cataloged; a reading room is available.

Comments: The association was founded to provide economic aid to Ukrainian immigrants to the United States. It offers courses in Ukrainian literature and history.

SHEVCHENKO SCIENTIFIC SOCIETY LIBRARY AND ARCHIVES Library
 63 Fourth Ave. Archives
 New York, NY 10003 212-254-5130; Fax 212-254-5239

Sponsoring organization: Shevchenko Scientific Society
Personnel: Mykola Haliw, Mgr.; Yurii Nawrotskyi, Archivist
Contact: Svitlana Andruskiw, Dir.

Founded: 1948; Scope: National, International
Availability: Open, restricted access; Admission: Free
Staff: 3 (1 ft, 1 pt, salaried; 1 volunteer)
Publications: *Zapysky NTSh* (Papers of the NTSh), 1898- , irreg.; also publishes
monographs and membership newsletters.

Collection: Books, periodicals, audiovisual materials, and over 80 cataloged archives
(personal papers and correspondence, unpublished records, theses and dissertations, and
manuscripts). Some records are in microform. The collection is cataloged; a reading
room and copying facilities are available.

Comments: The purpose is to acquire and preserve materials dealing with Ukrainian
studies and the life of Ukrainians in the diaspora. The emphasis is on records and
publications of Ukrainian immigrant organizations. The library supports the society's
research and scholarly endeavors.

SMOLOSKYP, INC. Library
 3045 St. Johns Lane
 Ellicott City, MD 21043 410-461-1764

Contact: Osyp Zinkewych, Exec. Dir.
Founded: 1968; Scope: International
Availability: Not open to the public; Admission: Donations accepted
Staff: 2 pt, 3 volunteers; Operating budget: $100,000
Publications: *Smoloskyp Magazine*, 1977-1989, monthly; also publishes books (e.g., *A
Thousand Years of Christianity in Ukraine: An Encyclopedic Chronology*, 1988).

Collection: 5,000 books, 240 periodical titles, and archival materials (unpublished
records and manuscripts) consisting primarily of Ukrainian samizdat, or dissident
literature. *Smoloskyp Magazine* is in microform. The collection is partially cataloged;
a reading room and copying facilities are available.

Comments: During the Soviet era, the primary goal was to publish and disseminate
Ukrainian dissident literature. The organization supports research and publishes works
about Ukraine and Ukrainians in English and Ukrainian.

UKRAINIAN ACADEMY OF ARTS AND SCIENCES IN THE U.S. Library
 206 West 100th St. Archives
 New York, NY 10025 212-222-1866

Personnel: Dr. Marko Antonovych, Pres.; Halyna Efremov, Libn.
Contact: Dr. W. Omelchenko, Dir. and V. Pres.
Founded: 1945; Scope: National, International
Availability: Open by special appt.; Admission: Free
Visitors: General public
Staff: Pt and volunteers; Operating budget: $50,000
Publications: *Annals of the Ukrainian Academy of Arts & Sciences in the U.S.*, 1951- ,
irreg.; also publishes books, journals, monographs and guides to the collection (e.g.,
*Guide to the Archival and Manuscript Collection of the Ukrainian Academy of Arts and
Sciences in the USA* (Yury Boshyk. Edmonton: University of Alberta, 1988).

Collection: Books, periodicals, over 55,000 artifacts, works of art, and over 300 archives (personal papers and correspondence, unpublished records, theses and dissertations, pictorial materials, manuscripts). The Vynnychenko section of the archive is physically located at Columbia University Library's Bakhmeteff Archive. The collection is cataloged; a reading room is available.

Comments: The primary purpose is to advance the availability of books, artifacts, and other research materials about Ukrainian and Eastern Europeans, their culture, and economic development. Services include educational lectures and exhibitions; the institution participates in ethnic festivals and cooperates with colleges and universities in courses for credit. The academy's resources constitute one of the major collections on Ukraine and Ukrainians in the western world.

UKRAINIAN AMERICAN ARCHIVES, Museum
MUSEUM AND LIBRARY, INC. Library
(Formerly Ukrajinstyj Narodnyj Archiw) Archives
 11756 Charest St.
 Detroit, MI 48212 313-366-9756
 26601 Ryan Rd.
 Warren, MI 48091 313-268-6265 (Warren Branch)

Contact: Roman Dacko, Curator; Irene Zacharkiw (Warren Branch)
Founded: 1958; Scope: Local, State, Regional, National, International
Availability: Open to the public; Admission: Free
Visitors: General public, School groups
Staff: 3 ft, 4 pt, 10 volunteers; Operating budget: $18,000
Publications: Annual reports; 25th anniversary publication; and promotional brochures.

Collection: 72,000 books, periodicals, audiovisual materials, thousands of artifacts, 160 works of art, and archives (personal papers and correspondence, unpublished records, pictorial materials, manuscripts). The collection is partially cataloged.

Comments: Collects and preserves Ukrainian historical documents, art, and literature. The purpose is to procure and preserve data related to the early history of Ukraine and the U.S.

UKRAINIAN AMERICAN COORDINATING COUNCIL Archives
 140 Second Ave.
 New York, NY 10003 212-505-1765; Fax: 212-475-6181

Personnel: Ivan Oleksyn, Volodymyr Procyk, Jurij Ichtiarow, Eugene Stachiw, Michael Nytsch, V. Pres.
Contact: Ulana M. Diachuk, Pres., 30 Montgomery St., Jersey City, NJ 07302
Founded: 1983 Scope: National
Admission: Free
Visitors: General public
Staff: Pt and volunteers; Operating budget: $40,000

Collection: 20 boxes of unpublished archival records. The collection is cataloged.

Comments: UACC is an umbrella organization consisting of 76 member organizations and 23 branches. Through the Fund for Rebirth of Ukraine, UACC is helping to establish a democratic society in Ukraine.

UKRAINIAN ARTISTS ASSOCIATION IN U.S.A. Library
 1022 N. Lawrence St. Archives
 Philadelphia, PA 19123 215-922-2647

Contact: Petro Mehyk, Chair
Founded: 1952; Scope: National
Availability: Open by appt,; Admission: Free
Visitors: Ethnic community
Publications: *Ukrainian Art in Diaspora*; also publishes exhibition catalogs.

Collection: 400 books on the history of Ukrainian art; archival materials (biographical records).

Comments: All sculptors, painters, graphic artists, art historians, and other professional artists of Ukrainian descent are united to preserve Ukrainian art and to present it in exhibits and shows for the public. Programs include educational lectures and discussions, financial assistance to Ukrainian American artists, and research to discover additional Ukrainian American works of art.

UKRAINIAN BIBLIOGRAPHICAL REFERENCE CENTER Library
 2453 W. Chicago Ave.
 Chicago, IL 60622 312-276-6565

Sponsoring organization: Ukrainian Library Association; Association for the Advancement of Ukrainian Studies
Personnel: Dr. Dmytro Shtohryn, Dir.
Contact: Emilian Basiuk, Secy.
Founded: 1970; Scope: National
Availability: Restricted access; Admission: Free
Visitors: School groups, Ethnic community
Staff: 2 volunteers; Operating budget: $5,000

Collection: Books, periodicals, audiovisual materials. The collection is cataloged; an unpublished guide, reading room, and copying facilities are available.

Comments: The purpose is to collect and preserve Ukrainian bibliographies, indexes, directories, catalogs, etc. Programs include loans to schools and other educational institutions and radio programs. The library supports undergraduate level research.

UKRAINIAN CATHOLIC SOYUZ OF Archives
BROTHERHOODS AND SISTERHOODS IN THE USA
 2247 W. Chicago Ave.
 Chicago, IL 60622 312-489-1339

Sponsoring organization: St. Volodymyr and Olha Church
Personnel: Emilian Basiuk, Pres.

Contact: Halyna Zayats, Secy.
Founded: 1976; Scope: National
Admission: Donation
Staff: 5 (1 ft volunteer, 4 pt volunteers); Operating budget: $5,000
Publications: *Brotherhood Newsletter*, 1976- , semiannual

Collection: Periodicals, audiovisual materials, artifacts, and 12 file drawers of archival materials (personal papers and correspondence, unpublished records, pictorial materials). Some records are in microform. The collection is cataloged; an unpublished guide and reading room are available.

Comments: The objective is to coordinate Christian education efforts in the Ukrainian church and to preserve its traditional religious values, patriarchal structure, and the purity of the Easter rite. It supports research on the history of brotherhoods, conducts seminars, and provides a speakers' bureau, educational lectures, dance and choir presentations, and a gift shop.

UKRAINIAN DIOCESAN MUSEUM AND LIBRARY Museum
 161 Glenbrook Rd. Library
 Stamford, CT 06902 203-324-0488/4578; Fax 203-967-9948 Archives

Sponsoring organization: Ukrainian Catholic Diocese of Stamford
Personnel: Bishop Basil H. Losten; Dr. Wasyl Lencyk, Dir.; Rev. John Terlecky
Contact: Lubow K. Wolynetz, Curator
Founded: 1933; Scope: International
Availability: Open by special appt.; Admission: Donation
Visitors: General public, School groups

Staff: 6 (3 ft, 2 pt, salaried; 1 volunteer); Operating budget: $80,000
Collection: 49,000 books, 2,000 periodicals, 3,500 photographs, 300 audiovisual materials, 7,000 artifacts, 3,000 works of art, and 40 boxes and 4 file cabinets of archival materials (unpublished records, pictorial materials, manuscripts). The collection is cataloged; a reading room and copying facilities are available.

Comments: The library attracts researchers from many universities; it specializes in Ukrainian history and literature and is reported to house the finest collections of the complete works of Taras Shevchenko, Ivan Franko, and other classical Ukrainian authors. It is also a repository for rare Ukrainian books. The museum preserves Ukrainian art, costumes, sculpture, and other cultural treasures. Bishop Losten has dedicated the entire space in the Bishop's palace for exclusive use of the museum and its artifacts.

UKRAINIAN FRATERNAL ASSOCIATION Library
(Formerly Ukrainian Workingmen's Association) Archives
 440 Wyoming Ave.
 Scranton, PA 18503 717-341-0937

Personnel: Ivan Oleksyn, Pres.
Founded: 1910; Scope: National
Staff: 2 volunteers

Publications: *Forum: A Ukrainian Review*, 1967- , quarterly; *Narodna Volya*, 1910- , weekly newspaper; also publishes books.

Collection: Reference and other books, archival materials (personal papers and correspondence, unpublished records).

Comments: The goal is to publish and promote educational material on Ukraine and Ukrainians, to operate the cultural center Verkhovyna, and to publish the weekly Ukrainian and English-language newspaper *Narodna Volya* and the journal *Forum*. The association also publishes books pertaining to Ukrainians. This fraternal association supports social and cultural activities of various Ukrainian organizations in the United States; it is also currently engaged in organizing aid to Ukraine.

UKRAINIAN HERITAGE STUDIES CENTER Museum
MANOR JUNIOR COLLEGE Library
 700 Fox Chase Rd.
 Jenkintown, PA 19046-3399 215-885-2360; Fax 215-576-6564

Personnel: Sister Marie Francis Walchonsky, OSBM, Dir.; Anna Maksymowych, Libn. (Ukrainian section)
Contact: Chrystyna Prokopovych, Curator
Founded: 1976; Scope: Local
Availability: Open to the public; Admission: Free
Visitors: General public, School groups, Ethnic community
Staff: 2 pt; Operating budget: $21,500
Publications: Catalog of collections; promotional brochures of exhibits.

Collection: Ca. 4,000 books, periodicals, 400 artifacts, and works of art. The Ukrainian books are cataloged; a reading room and copying facilities are available.

Comments: The center preserves and promotes Ukrainian culture, heritage, and traditional arts. It houses a museum collection of art, musical recordings, and films. The center sponsors exhibits, conferences, workshops on Pysanky making, embroidery, and a Ukrainian festival each fall which includes a concert of Ukrainian dance and music, art displays, master craftsmen demonstrations, a "yarmarok," or folk market, and ethnic foods. A Pysanky Expo is held annually to showcase Ukrainian Easter eggs. Also includes guided tours, lectures, loans and presentations to schools, speakers or resource people, and crafts classes. The library is located in the Basileiad Building.

UKRAINIAN HISTORICAL ASSOCIATION, INC. Archives
 16 Clinton Terrace
 Jamaica, NY 11432

Sponsoring organization: Ukrainian Historical Association, Affiliate of American Historical Association
Personnel: Dr. Lubomyr R. Wynar, Pres.;
Contact: Dr. Oleksander Dombrowsky, Exec. Secy.
Founded: 1965; Scope: International
Publications: *Ukrainian Historian*, 1963- , quarterly; *Hrushevsky Studies*, 1970- , irreg.

Collection: Publications and records of members, especially Hrushevskiana collection.

Comments: Objectives are to promote studies and collect materials on Ukrainian history, and to bring together people interested in Ukrainian and East European history.

UKRAINIAN INSTITUTE OF AMERICA <u>Library</u>
 2 E. 79th St. <u>Archives</u>
 New York, NY 10021 212-288-8660

Contact: Walter Baranetsky, Pres.
Founded: 1948; Scope: National
Availability: Open by appt.; Admission: Free
Visitors: General public, Ethnic community
Staff: 3; Operating budget: $150,000

Collection: 22,000 books, periodicals, audiovisual materials, artifacts, realia, and archival materials (biographical records). Includes the collection of the Gritchenko Foundation, objects of art, religious and church relics, and paintings from the Ukrainian Historical Gallery. Programs and services include educational lectures, English language courses, conferences, concerts, exhibits, and assistance to Ukrainian immigrants, particularly those in the fine arts.

UKRAINIAN LEMKO MUSEUM <u>Museum</u>
(Formerly Museum of the World Lemkos' Federation) <u>Library</u>
 161 Glenbrook Rd. <u>Archives</u>
 Stamford, CT 06902 203-762-5912

Sponsoring organization: Organization for Defense of Lemko Western Ukraine
Contact: Steven Howansky, Curator; Marie Duplak, Pres. of ODLWU, Inc.
Founded: 1969; Scope: International
Availability: Open by special appt. only; Admission: Free/Donations
Visitors: School groups, Ethnic community
Staff: pt, volunteers
Publications: *Lemkivshchyna*, 1979- , (in Ukrainian and English)

Collection: 300 books, 60 periodicals, 500 audiovisual materials, 50 artifacts, 60 works of art, and archives (personal papers and correspondence, unpublished records, pictorial materials, manuscripts, and oral histories). An unpublished guide is available.

Comments: The museum preserves for future generations all possible cultural artifacts from the Ukrainian ethnic land of Lemkivshchyna destroyed by Poland. The library also collects all literature about the Lemkos and Lemkivshchyna, including literature about the Ukrainian insurgent army. Services include guided tours and speakers; the museum participates in ethnic festivals.

THE UKRAINIAN MUSEUM <u>Museum</u>
 203 Second Ave.
 New York, NY 10003 212-228-0110; Fax 212-228-1947

Sponsoring organization: Ukrainian National Womens League of America, Inc.

Personnel: Maria Shust, Dir.; Daria Bajko, Admin. Dir.
Founded: 1976; Scope: International
Availability: Open to the public; Admission: Fee
Visitors: General public
Staff: 12 (4 ft, 8 pt; salaried); Operating budget: $317,359
Publications: *Annual Report*, 1979- ; catalog of collections; brochures; membership
newsletters; monographs on various aspects of the fine arts.

Collection: 2,249 books, audiovisual materials, 7,500 artifacts, 1,692 works of art,
and 18,926 archival records (personal papers and correspondence, pictorial materials
and photos). Also includes numismatic and genealogical collections. The major folk
art collection covers all crafts (embroidered and woven textiles, ceramics, woodwork,
etc.) and reveals the regional diversity in Ukrainian folk culture. The collection is
cataloged; copying facilities are available.

Comments: The purpose is to preserve objects of artistic or historic merit related to
Ukrainian life and culture. Services include guided tours, lectures, and programs,
scholarly research and publications, souvenir shop, and arts and crafts workshops. The
museum sponsors local and travelling exhibits and serves as host for specialized
workshops organized by the Metropolitan Museum of Art. The museum is a member
of the American Association of Museums and the International Council of Museums.

UKRAINIAN MUSUEM-ARCHIVES, INC. Museum
 1202 Kenilworth Ave. Library
 Cleveland, OH 44113 216-781-4329

Personnel: Andrew Fedynsky, Dir.; Ihor Kowalysko, Cataloger and Research Dir.;
Volodymyr Storoahynsky, Current Periodicals Libn.
Founded: 1952; Scope: Local, State
Availability: Open by appt. only; Admission: Free
Visitors: General public, Ethnic community
Staff: 3 pt, paid; 15-20 volunteers; live-in caretaker
Publications: Quarterly newsletter to members; pamphlets; bibliographical indexes;
books.

Collection: Over 20,000 books in Ukrainian or about Ukrainians, 2,400 periodical
titles in Ukrainian or about Ukrainians, audiovisual materials, artifacts, works of art,
and 5 bookcases of archival materials (personal papers and correspondence, unpublished
records, documents, newspapers, pictures, manuscripts, and ephemera) related to
Ukrainians in the United States. Some Ukrainian periodicals are in microform. The
collection is partially cataloged; all DP camp publications are in an electronic database,
for which a guide is available.

Comments: The objectives are to preserve Ukrainian culture and heritage including the
history and immigration experience in the United States, particularly in Ohio. Services
include a reading room for researchers, community discussion groups, etc.

UKRAINIAN NATIONAL AID ASSOCIATION OF AMERICA (UNAAA) Archives
 925 N. Western Ave.
 Chicago, IL 60622 312-342-5102

Personnel: Wolodymyr Mazur, Pres.; Iwan Telwak, Secy.
Founded: 1914; Scope: National
Publications: *Ukrains'ke Narodne Slovo* (Ukrainian National Word), quarterly

Collection: Archival materials pertaining to the UNAAA's history, its publication *Ukrains'ke Narodne Slovo*, and legal documents.

UKRAINIAN NATIONAL ASSOCIATION, INC. Archives
 30 Montgomery St.
 Jersey City, NJ 07303 201-451-2200; Fax 201-451-2093

Personnel: Nestor L. Olesnycky, Pres.; Peter Savaryn, V. Pres.; Alexander Blahitka, Treas.; Anya Dydyk-Petrenko, Dir (Canada); Martha Lysko, V. Pres.
Contact: Ulana M. Diachuk, Pres.
Founded: 1894; Scope: National
Availability: Open by special appt.; Admission: Free
Visitors: General public, Ethnic community
Publications: *Svoboda*, 1893- , daily except Sat. and Sun. (in Ukrainian); *The Ukrainian Weekly*, 1933- , weekly (in English); *Veselka*, monthly children's magazine; also publishes books and yearly almanacs.

Collection: 9,000 books, periodicals, archives of Svoboda Publishing House (personal papers and correspondence, unpublished records, pictorial materials). *Svoboda* and *The Ukrainian Weekly* are on microfilm. The collection is not cataloged; a reading room and copying facilities are available.

Comments: The association is the oldest Ukrainian fraternal life insurance association in the U.S. It fosters the Ukrainian heritage, language, and culture throughout 350 branches in the United States and Canada. It awards scholarships to needy students, provides educational lectures, speakers, performing arts presentations (dance, drama, choir, instrumental), films and AV productions, crafts classes, and a souvenir shop.

UKRAINIAN NATIONAL INFORMATION SERVICE (UNIS) Library
 214 Massachusetts Ave. NE, Suite 225 Archives
 Washington, DC 20002

Sponsoring organization: Ukrainian Congress Committee of America (UCCA)
Contact: Tamara Gallo, Dir.
Founded: 1977; Scope: Local, National
Availability: Open, restricted access; Admission: Donation
Visitors: General public
Staff: 5 (2 ft, 3 volunteers); Admission: Donation

Publications: *Ukrainian Quarterly*, quarterly; *UNN Monthly Newsletter*, 1992- , monthly; also publishes books.

Collection: Books, periodicals, audiovisual materials, artifacts, works of art, and archives (personal papers and correspondence, printed materials, pictorial materials, oral histories). An unpublished guide, reading room and copying facilities are available for researchers.

Comments: UNIS apprises members of the Congress and Senate of issues concerning the Ukrainian American community; it provides translation services and educates the academic community and the general public about Ukraine and the Ukrainian American experience. It sponsors educational lectures, forums, and seminars; provides speakers; gives school presentations; and sponsors films and audiovisual productions, video screenings, and press conferences.

UKRAINIAN NATIONAL MUSEUM OF CHICAGO Museum
 2453 W. Chicago Ave. Library
 Chicago, IL 60622 Archives

Personnel: Orest Horodysky, Dir.
Contact: George Hrycelak, Pres.
Founded: 1952; Scope: National
Availability: Open to the public; Admission: Donation
Visitors: General public, School groups, Ethnic community
Staff: 2 pt, salaried, 5 volunteers; Operating budget: $25,000
Publications: *On The Traces*, 1955-1956, bimonthly; *Museum News*, 1956-1958, bimonthly; *Museum Chronicle*, 1985-1988, semiannual; also publishes catalog of collections.

Collection: 23,000 books, 1,250 periodicals, audiovisual materials, ca. 400 artifacts, works of art, and 320 3-ft. shelves of archives (personal papers and correspondence, manuscripts, and periodicals that ceased publication either before Soviet occupation or in the Free World). Some records are in microform. The collection is cataloged; an unpublished guide, reading room, and copying facilities are available.

Comments: The museum displays samples of arts and crafts related to the Ukrainian cultural heritage in order to educate the public about Ukrainian culture. Programs include guided tours, educational lectures, loans to schools, speakers, crafts classes, and an arts and crafts souvenir shop. It also supports research at the undergraduate and graduate levels and provides work experience for college credit. The museum also participates in annual Illinois state fairs and Chicago ethnic exhibits.

UKRAINIAN ORTHODOX CHURCH OF THE U.S.A. Archives
 244 Main St.
 South Bound Brook, NJ 08880 908-356-4956; Fax 908-271-8908

Contact: Helen Pavlovsky, Chancery Secy., 283 Main St., South Bound Brook, NJ 08880 908-356-6239
Founded: 1973; Scope: National, International
Availability: Open by appt. only; Admission: Free (Donation)
Visitors: Researchers and scholars

Collection: 844 books, 601 periodicals, 47 calendars/almanacs, audiovisual materials, works of art, and 12 cabinets and 8 bookcases (ca. 500 linear ft.) of archival materials (personal papers and correspondence, manuscripts). The collection is cataloged; an unpublished guide, reading room, and copying facilities are available.

Comments: The main objectives are to preserve the records of prominent Ukrainian

church and civic dignitaries for studying the life of Ukrainians in exile by present and future historians.

UKRAINIAN PHILATELIC AND NUMISMATIC SOCIETY Library
 P.O. Box 11184 Archives
 Chicago, IL 60611-0184 312-276-0355

Personnel: Dr. Bohdan J. Bodnaruk, Exec. V. Pres.
Contact: Bohdan Pauk, Pres.
Founded: 1952; Scope: International
Availability: Not open to the public
Staff: 325 ft; Operating budget: $10,000
Publications: *Ukrainian Philatelist*, 1954- , semi-annual; *Ukrainian Philatelist: Supplement* (1992); *Trident-Visnyk*, 1954- , monthly; newsletters and flyers.

Collection: Books, over 1,000 periodical titles, audiovisual materials, and archival records (personal papers and correspondence, unpublished records, pictorial materials, manuscripts, newspaper clippings since 1947). The collection is partially cataloged; a published guide is available.

Comments: The general goal is to unite all collectors of Ukrainian philately and numismatics to stimulate research in this area. Services include educational lectures, loans to schools, radio and TV programs, speakers, and an annual convention and exhibition, "Ukrainpex."

UKRAINIAN POLITICAL SCIENCE ASSOCIATION IN THE U.S. Library
 P. O. Box 12963, Commerce Station Archives
 Philadelphia, PA 19108

Personnel: Adrij Szul, Jr.; Ivan Zytyniuk
Contact: Petro Diachenko, Pres.
Availability: Open by special appt. only; Admission: Donation
Visitors: General public, School groups, Ethnic community
Staff: 5 (2 pt, 3 volunteers)
Publications: Books and monographs

Collection: 4,000 books, periodicals, and archives (personal papers and correspondence, unpublished records, theses and dissertations, and manuscripts). An unpublished guide and reading room are available for researchers.

Comments: The purpose is to facilitate research on Ukrainian history, politics, and interpretational observations in relationship to Russia and other ethnic groups. The association supports research, provides work experience for college credit, in-service programs for educators, and travel to the University of Kiev for students and other scholars. Services include guided tours, educational lectures, speakers, and radio and TV programs. The association also participates in ethnic festivals.

UNITED UKRAINIAN WAR VETERANS IN AMERICA Archives
 962 Lehigh Ave.
 Union, NJ 07083 909-688-6133

Personnel: Kost Hrechak, Curator and Archivist
Contact: Joseph Trush, Pres.
Founded: 1949; Scope: National
Availability: Open by special appt.; Admission free
Visitors: General public, School groups, Ethnic community
Staff: 3 volunteers; Operating budget: $22,000

Collection: Books and archival records (personal papers and correspondence, over 2,500 pictorial materials, newspaper reports of Legion of Ukrainian Sitch Riflemen, military records related to the 1917-1920 period of the liberation of Ukraine, as well as documents related to the Ukrainian Veterans Organization after WWI and WWII); the collection is partially cataloged and an unpublished guide is available.

Comments: The organization presents the collection for public viewing at the Ukrainian Commemoration of Historical Events in Ukrainian History.

VOLHYNIAN BIBLIOGRAPHIC CENTER Library
(Oseredokk Bibliohrafii Volvni) Archives
 307 N. Overhill Dr.
 Bloomington, IN 47408 812-339-5475

Personnel: Dr. Maksym Boyko
Founded: 1967; Scope: Regional, National
Staff: 2 ft; Operating budget: $500-$1,000
Publications: Catalog of collections; 31 bibliographic publications are in Ukrainian, 2 in English.

Collection: Books, periodicals, bibliographies, 145 pounds of archives preserved in the National Archives of Ottawa, Ontario, Canada (printed materials, manuscripts). The collection is cataloged; a published guide is available.

Comments: The Center is involved in publication of regional and national titles of Ukrainian bibliography in the U.S. and abroad.

V

VIETNAMESE AMERICAN RESOURCES
(See also Asian American Resources)

VIETNAM REFUGEE FUND Library
 6433 Nothana Dr.
 Springfield, VA 22150 703-971-9178

Contact: Dao Thi Hoi
Founded: 1971; Scope: National
Publications: Promotional brochures; pamphlets

Collection: 3,000 books and periodicals

Comments: The purpose is to assist Vietnamese refugees and Vietnamese Americans in
citizenship and language classes and other matters related to their settlement into
American life and society. Services also include seminars related to Vietnamese culture
and performing arts presentations.

INTERNATIONAL ASSOCIATION FOR RESEARCH Library
IN VIETNAMESE MUSIC
 P.O. Box 16
 Kent, OH 44240 216-677-9703 Archives

Contact: Tuyen Tonnu, General Officer
Founded: 1989
Availability: Not open to the public
Staff: 6; Operating budget: $1,500
Publications: *Journal of Vietnamese Music*, semiannual

Collection: Reference books, periodicals, and archives (personal papers and
correspondence, unpublished materials, business records).

Comments: The association studies Vietnamese music and promotes the appreciation of
Vietnamese music in the United States and other countries. Services include reference
assistance.

W

WELSH AMERICAN RESOURCES

GREEN MOUNTAIN COLLEGE GRISWALD LIBRARY Library
 Poultney, VT 05764 802-287-93131

Contact: Katharine Reickert, Librarian
Founded: 1977; Scope: Local
Availability: Restricted access; Admission: Donation
Visitors: General public

Collection: Books, periodicals, audiovisual materials, artifacts and archival materials
(personal papers and correspondence and oral histories). The collection is partially
cataloged; a reading room and copying facilities are available.

Comments: The purpose of the library collection is to preserve the Welsh culture and
heritage.

ST. DAVID'S SOCIETY OF THE STATE OF NEW YORK Library
 71 West 23rd St.
 New York, NY 10010 212-924-8415

Personnel: John Tudor Roberts, Pres.
Contact: James Thomas
Founded: 1835; Scope: State, International
Availability: Open by special appt.; Admission: Free
Visitors: Ethnic community
Staff: Volunteers

Collection: Books and archival records (personal papers and correspondence, pictorial
materials). Copying facilities are available.

Comments: The society preserves the Welsh heritage and encourages study of it via
scholarships to college students in the arts and humanities. It sponsors speakers on
Wales and contributions to American society by Welsh and Welsh Americans.

WELSH-AMERICAN HERITAGE MUSEUM SOCIETY Museum
 412 East Main St.
 Oak Hill, OH 45656 614-682-7172

Contact: Mildred Bangert, Curator, 415 East Main St.. Oak Hill, OH 45656

Founded: 1971; Scope: Local, State, Regional, National, International
Availability: Open to the public; Admission: Donation
Visitors: General public, School groups
Staff: 1 volunteer
Publications: Membership newsletters and flyers

Collection: Ca. 750 books, periodicals, artifacts and realia, and archival records (personal papers and correspondence, pictorial materials, theses and dissertations). Some materials are in microform.

Comments: To preserve, in the old Welsh Church, Welsh heritage and culture and to educate the public about them. Services include guided tours, talks on early Welsh history, school presentations, radio programs, speakers, drama performances, films and AV productions, and an arts and crafts souvenir shop.

THE WELSH GUILD OF ARCH ST. PRESBYTERIAN CHURCH Library
(Formerly Girard Ave. Welsh Presbyterian, First Welsh Presbyterian)
 1724 Arch St.
 Philadelphia, PA 19103 215-563-3763

Sponsoring organization: Arch St. Presbyterian Church
Personnel: Robert O. Jones, V. Pres.; Phyllis J. Jones, Treas.; Morfydd H. Livezey, Rec. Secy.; Lawrence R. Souder, Corr. Secy.; Irene O. Pritchard, Libn.
Contact: Daniel E. Williams, Pres., 450 E. Broadway, Camden, NJ
Founded: 1971; Scope: Regional
Availability: Open by special appt. only; Admission: Free
Visitors: General public, Ethnic community
Staff: 3 volunteers; Operating budget: $1000
Publications: Publishes special sermons and other brochures, e.g., *The Welsh Heritage in Christian and American History*, and *A Collection of Welsh Thoughts*.

Collection: Books, periodicals, audiovisual materials, 3 file drawers of archival records (personal papers and correspondence, unpublished records, theses and dissertations, manuscripts, plaques, awards, church bulletins and programs). A reading room is available.

Comments: The guild's purpose is to support the church by acquainting others with the values inherent in the Welsh heritage through Christian fellowship, Welsh music, Christian cultural and ethnic programs, and missionary activity and support.

Institution Index

A

Adams County Historical Society, 99
Adobe House Museum, 203
Afghanistan Studies Association, 1
African American Collection, 1
African American Museum (Cleveland), 2
African American Museum (Texas), 2
African American Resource Center, Howard
 University, 2
African Cultural Center, 3
Afro-American Cultural Foundation, 3
Afro-American Historical and Cultural
 Museum, 4
Afro-American Historical and Genealogical
 Society, 4
Afro-American Historical Society Museum, 5
Akwesasne Museum, 237
Alexandria Library, Lloyd House, Archives, 5
ALKA, (American Lithuanian Cultural
 Archives), 189
Allen County Public Library, 203
Alliance of Poles Library, 269
Alpine Hills Historical Museum, 99
Alvernia College, Dr. Frank A. Franco Learning
 Center, 269
Amana Heritage Society, 100
American Aid to Ulster, 144
American Association for the Advancement of
 Polish Culture, 270
American-Canadian Genealogical Society, 91
American Center of Polish Culture, Inc., 270
American Committee for Aid to Poland
 (ACAP), 270
American Committee on Italian Migration, 149
American Conference for Irish Studies
 (ACIS), 144
American Coptic Association, 87
American Council for Polish Culture, 271
American Folklife Center, Archive of Folk
 Culture, 204

American-French Genealogical Society, 91
American Hellenic Educational Progressive
 Association (AHEPA), 127
American Historical Society of Germans from
 Russia, (Nebraska), 100
American Historical Society of Germans from
 Russia, Central California Chapter, 101
American Hungarian Educators' Association, 136
American Hungarian Foundation, 136
American Hungarian Library and Historical
 Society, 136
American Hungarian Museum, Passaic, 137
American Hungarian Review, 137
American Institute for Contemporary German
 Studies-AICGS, 101
American Institute of Polish Culture, 271
American Ireland Education Foundation,
 Inc., 145
American Irish Bicentennial Committee, 145
American Irish Historical Society, 145
American Italian Congress, 150
American Italian Historical Association, 150
American Jewish Archives, 157
American Jewish Committee Blaustein Library
 and Archives, 158
American Jewish Historical Society, 158
American Latvian Association in the United
 States, 186
American Lithuanian Musicians Alliance, 189
American Philosophical Society Library, 204
American Romanian Academy of Arts and
 Sciences, 286
American Scandinavian Foundation, 292
American Siam Society, 323
American Society for Ethnohistory, 205
American Sokol Educational and Physical Culture
 Organization, 71
American Swedish Historical Museum, 310
American Swedish Institute, 310
American Turkish Society, Inc., 324
Amerind Foundation, Inc., 237

Amistad Research Center, 205
An Claidheamh Soluis - The Irish Arts
 Center, 146
Anacostia Museum, 6
Ancient Spanish Monastery of St. Bernard de
 Clairvaux Cloisters, 302
Angel Mounds State Historic Site, 238
Antelope Valley Indian Museum, 238
Antiochian Village Heritage and Learning
 Center, 34
Arab American Institute, 35
Ararat Foundation, 36
Archbishop Fan Noli Library, 33
Archival Center of the (Swedish) Baptist
 Conference, 311
Archives Museum, Temple Mickve Israel, 159
Archives of the Archdiocese of Boston, 206
Archives of the Mennonite Church, 102
Arise! Resource Center, 206
Arizona Historical Society, 206
Arizona State University, Center for Latin
 American Studies, 184
Arizona State University, Chicano Research
 Collection, 199
Armenian Artists Association of America, 37
Armenian Assembly Resource Library, 37
Armenian Behavioral Science Association, 37
Armenian Cultural Foundation, 38
Armenian Film Foundation, 38
Armenian General Benevolent Union, 38
Armenian Library & Museum of America, 39
Armenian Literary Society-New York, 39
Armenian Missionary Association of America,
 A.A. Bedikian Library, 39
Armenian Numismatic Society, 40
Armenian Reference and Research Library, 40
Armenian Society of Los Angeles, Armenak and
 Nunia Haroutunian Library, 41
Asia Resource Center, 45
Asia Society, 46
Asian American Arts Alliance, 46
Asian American Arts Centre, 47
Asian Art Museum of San Francisco, 47
Asian Cinevision, 47
Asian Studies Newsletter Archives, 48
Assembly of Turkish American Associations, 325
Association Canado American, 92
Association for Korean Studies, 182
Association for Puerto Rican-Hispanic Culture,
 Inc., 284
Association for the Study of Afro-American Life
 and History, 6
Association of Indian Muslims of America, 142
Association of Romanian Catholics of
 America, 286
Association of Sri-Lankans in America, 309
Astoria Public Library, 89
Augustana College Art Gallery, 311
Austrian Cultural Institute, 53
Avery Research Center for African American
 History and Culture, 7

AWAIR: Arab World and Islamic Resources and
 School Services, 35

B

Baca House and Pioneer Museum in Trinidad,
 CO., 130
Baine/Cincebeaux Collection of Slovak Folk
 Dress and Folk Art, 297
Bakhmeteff Archive of Russian and East
 European History and Culture, 207
Balch Institute for Ethnic Studies, 207
Balzekas Museum of Lithuanian Culture, 190
Basque Educational Organization, 54
Bayou Folk Museum, 92
Beck Cultural Exchange Center, 7
Beit Hashoah Museum of Tolerance, 159
Belarusan-American Community Center
 Polacak, 55
Benjamin & Dr. Edgar R. Cofeld Judaic Museum
 of Temple Beth Zion, 160
Bethel College Mennonite Library and
 Archives, 102
Biblioteka Polska, 272
Big Hole National Battlefield, 239
Bily Clock Exhibit, 71
Bishop Hill Heritage Association, 312
Black American Cinema Society, 8
Black Archives, History and Research Foundation
 of South Florida, Inc., 8
Black Archives of Mid-America, Inc., 9
Black Filmmakers Hall of Fame, Inc., 9
Black Heritage Museum, 9
Black Resources Information Coordinating
 Services, 10
B'nai B'rith Klutznick National Jewish
 Museum, 160
Booker T. Washington National Monument, 10
Budrys Lithuanian Photo Library, Inc., 190
Buechel Memorial Lakota Museum, 239
Buffalo and Erie County Public Library North
 Jefferson Branch, 11
Bukovina Society of the Americas, 102
Burlington County Historical Society, 11
Byelorussian Institute of Arts and Sciences,
 Inc., 55
Byzantine Catholic Seminary Library, 60

C

California Afro-American Museum, 11
California State Indian Museum, 239
California State University, Fullerton, Oral
 History Program, 208
California State University, Fresno, Kalfayan
 Center for Armenian Studies Program, 41
Calvin College and Calvin Theological Seminary
 Archives, 80
Cambodian Buddhist Society, 60
Cappon House Museum, 81
Carver County Historical Society, 208

Casa de Unidad Cultural Arts and Media
Center, 130
Catholic Archives of Texas, 209
Center for Afro-American Studies Library, 12
Center for Arab-Islamic Studies, 35
Center for Belgian Culture of Western Illinois,
Inc., 56
Center for Cuban Studies/Cuban Art Project, 70
Center for Latino Studies, 185
Center for Migration Studies of New York,
Inc., 209
Center for Neo-Hellenic Studies, 128
Center for the Study of Ethnic Publications and
Cultural Institutions, 210
Center for Ukrainian and Religious Studies, 327
Center for Western Studies, 210
Central Synagogue Archives, 161
Centro Cultural de la Mision, 185
Chalet of the Golden Fleece, 319
Charles L. Blockson Afro-American
Collection, 12
Chattanooga African-American Museum, 13
Cherokee National Historical Society, Inc., 240
Chew Kee, 62
Chicano Humanities and Arts Council, Inc., 199
Chicano Resource Center (CRC), 200
Chicano Studies Research Library, 200
Chief Plenty Coups Museum, 240
China Institute in America, 63
Chinatown Branch Library, Los Angeles Public
Library, 63
Chinatown History Museum, 64
Chinese Consolidated Benevolent Association, 64
Chinese Culture Center of San Francisco, 64
Chinese Culture Institute, 65
Chinese Historical Society of America, 65
Chinese Information and Culture Center, 66
Chinese Music Society of North America, 66
Choctaw Nation Museum, 241
Christ the Redeemer Parish Library, 56
Clan Cunning Association, 294
Clarkson Historical Society, 72
Cleveland Hungarian Heritage Society
Museum, 137
Cleveland Public Library Foreign Literature
Department, 211
Colorado River Indian Tribes Museum/
Library, 241
Compton Public Library, 211
Congregation Beth Ahabah Museum and Archives
Trust, 161
Congregation Kahal Kadosh Mikveh Israel, 162
Congress for Jewish Culture, 162
Congress of Russian Americans, Inc., 289
Connecticut Afro-American Historical Society, 13
Connolly Books, 146
County of Los Angeles Public Library Black
Resource Center, 14
Covenant Archives and Historical Library, 312
Craft and Folk Art Museum, 212
Crazy Horse Memorial, 241

Croatian Ethnic Institute, 68
Cuban Museum of Arts and Culture, 70
Cultural Association of Bengal, 143
Czech and Slovak Museum and
Library, 76
Czech Catholic Union, 72
Czechoslovak Daily Herald, 72
Czechoslovak Genealogical Society
International, 76
Czechoslovak Heritage Museum, Library, and
Archive, 77

D

Dacotah Prairie Museum, 242
Dallas Memorial Center for Holocaust
Studies, 162
Dana College, C. A. Dana-Life Library, 79
Danish Brotherhood in America, 79
Danish Immigrant Archives, 79
Danish Immigrant Museum and Bedstemor's
(Grandmother's) House, 80
Delta Blue Museum, A Division of the Carnegie
Public Library of Clarksdale, MS, 14
Detroit Public Library, E. Azalia Hackley
Memorial Collection, 15
Deutschheim State Historic Site, 103
Diocesan Cultural Museum, 61
Documentation Exchange, 186
Donn V. Hart Southeast Asia Collection, NIU
Libraries, 48
Dordt College Library/Dutch Memorial
Collection, 81
Dull Knife Memorial College, John Woodenlegs
Memorial, 242
DuSable Museum of African American History,
Inc., 15
Dutch Family Heritage Society, 82

E

East-West Cultural Center, 49
Eastern California Museum, 154
Eden Theological Seminary, Eden Archives, 103
Eelam Tamils Association of America, 309
EKO Gallery, 327
El Pueblo Museum, 131
El Rancho de Las Golondrinas Museum, 303
Estonian Archives in the U.S., Inc., 88
Estonian House, 88
Ethnic Heritage Museum, 212
Ethnic Materials Information Exchange
(EMIE), 213
Etowah Indian Mounds State Historic Site, 243
Evangelical Lutheran Church in America
Archives, 213

F

Favell Museum of Western Art and Indian
Artifacts, 243

Federation of Alpine and Schuhplattler Clubs in
North America, 53
Federation of Turkish-American
Associations, 325
Fenster Museum of Jewish Art, 163
Filipinas Americas Science and Art
Foundation, 89
Filipino American Women's Network, 89
Filson Club Historical Society, Inc., 214
Finnish-American Historical Society of the
West, 90
Five Civilized Tribes Museum, 244
Flathead Indian Museum, 244
Folklife Institute of Central Kansas, 313
Fondo Del Sol Visual Arts Center, 214
Fort Belknap College Library and Tribal
Archives, 244
Fort Hays State University, Forsyth
Library Center for Ethnic Studies, 215
Fort Lewis College Center of Southwest
Studies, 245
Fort Myers Historical Museum, 215
Foundation for Research in the Afro-American
Creative Arts, 16
Franciscans of the Assumption B.V.M.
Province, 272
Frankenmuth Historical Association, 104
Franklin and Marshall College, Shadek-
Fockenthal Library, 104
Frederick Douglass National Historic Site, 16
Free Library of Philadelphia Rare Book
Department, 105
Freeman Academy Heritage Archives and
Museum, 105
Freistadt Historical Society, 106
French Art Colony, 92
French Azilum, Inc., 93
French Institute/Alliance Francais, 93
French Legation, 94
French Library in Boston, 94
Friends of the Tibetan Library, 323
Fronczak Room, E.H. Butler Library, 272

G

Galeria, 273
Gardner Mansion and Museum, 245
Garibaldi-Meucci Museum of the Order of the
Sons of Italy in America, 150
Genealogical Society of Flemish Americans, 57
George Washington Carver National
Monument, 16
Georgia Salzburger Society Museum, 106
German-American Information and Education
Association, 106
German American World Society, 107
German Historical Institute, 107
German Society of Pennsylvania, Joseph Horner
Memorial Library, 108
Germans from Russia Heritage Society, 108
Germantown Historical Society, 108

Gluckstal Colonies Research Association, 109
Goethe House New York German Cultural
Center, 109
Goschenhoppen Historians, Inc., 110
Goshen College Mennonite Historical
Library, 110
Great Blacks in Wax Museum, Inc., 17
Great Plains Black Museum, 17
Green Mountain College, Griswald Library, 342
Gustavus Adolphus College Folke Bernadotte
Memorial Library, 313
Gypsy Lore Society, 216

H

H. Earl Clack Memorial Museum, 246
Hampson Museum State Park, 246
Hans Herr House, 111
Harriet Beecher Stowe Center, 18
Harvard Ukrainian Research Institute Reference
Library, 328
Hatch-Billops Collection, Inc., 18
Heard Museum, 246
Heartman Collection, 19
Hebrew College, 163
Hebrew Theological College, 164
Hebrew Union College-Jewish Institute of
Religion, 164
Hebrew Union College Skirball Museum, 165
Helvetia Museum, 319
Hendrickson House Museum and Old Swedes
Church, 313
Heritage Center, 247
Heritage Institute of the Byzantine Catholic
Diocese of Passaic, 61
Herrick Public Library, 82
Hillwood Museum, 289
Hineni Heritage Center, 165
Hispanic Society of America, 131
Histadruth Ivrith of America, 165
Historic Hermann Museum, 111
Historical Society Museum, 247
Historical Society of Pennsylvania, 216
Holland Museum, 82
Holland Society of New York, 83
Holmes County Public Library, 112
Honolulu Academy of Arts, 49
Hoover Institution on War, Revolution &
Peace, 217
Hopewell Culture National Historical
Park, 248
Hugenot Historical Society, 95
Huguenot Society of South Carolina, 95
Human Relations Area Files, Inc., 217
Hungarian/American Friendship Society, 138
Hungarian Communion of Friends, 138
Hungarian Cultural and Educational House,
Inc., 139
Hungarian Cultural Foundation, 139
Hungarian Folk-Art Museum, 139
Hungarian Scout Association Abroad, 140

I

Immigrant City Archives, Historical Society of
Lawrence and Its Peoples, 218
Immigration History Research Center, 218
India Study Circle for Philately, 143
Indian City USA, Inc., 248
Indian Museum of Lake County, Ohio, 249
Indiana Jewish Historical Society, 166
Indiana University-Purdue University at
Indianapolis Special Collections and
Archives, 112
Institute of Texan Cultures, 219
Instituto Cervantes, 303
International Association for Research in
Vietnamese Music, 341
International Black Writers, 19
Iowa Wesleyan College Chadwick Library, 112
Ira M. Beck Archives of Rocky Mountain Jewish
History, 166
Irish American Cultural Association (IACA), 146
Irish American Cultural Institute, 147
Irish American Heritage Museum, 147
Irish Family Names Society, 147
Irish Genealogical Foundation, 148
Irish Genealogical Society, 148
Irish Heritage Foundation, 148
Iron County Museum, 219
Iroquois Indian Museum, 249
Istituto Italiano Di Cultura, 151
Italian American Cultural Society
Library/Archives, 151
Italian-American Museum, 151
Italian American Research Center, 152
Italian Historical Society of America, 152
Italian Study Group of Troy, 152
Iuliu Maniu American Romanian Relief
Foundation, 287

J

Jacob More Society, 295
Jacques Marchais Museum of Tibetan Art, 323
Jane L. & Robert H. Weiner Judaic
Museum/Goldman Art Gallery, 167
Jankola Library and Slovak Archives, 297
Japan Society, Inc., 154
Japanese American Cultural and Community
Center, 155
Japanese American National Library, 155
Japanese American National Museum, 155
Japanese Cultural Center of Hawaii, 156
Jewish Community Library-Peter M. Kahn
Memorial, 167
Jewish Historical Society of Greater
Hartford, 168
Jewish Historical Society of Maryland, 168
Jewish Museum, 169
Jewish Museum San Francisco, 169
Jewish Women's Resource Center, 169
Joint Archives of Holland, 83

Josef Pilsudski Institute of America, 273
Judah L. Magnes Museum, 170
Judaica Museum, 170
Judaica Museum of Central Synagogue, 171
Jugoslavia Study Group, 69
Juniata College Beeghly Library, 113
Juniata District Mennonite Historical Society, 113
Junipero Serra Museum, 303

K

Kam Wah Chung & Co. Museum, 67
Kidron-Sonnenberg Heritage Center, 319
Kodiak Historical Society, 250
Korean American Coalition, 182
Kosciuszko Foundation, 274
Koshare Indian Museum, Inc., 250
Kossuth Foundation, 140
Krikor and Clara Zohrab Information Center of
the Armenian Diocese, 42
Kurdish Heritage Foundation of America, 182

L

La Casa de la Raza/Galleria Posada, 132
Lancaster Mennonite Historical Society, 114
Langston Hughes Community Library & Cultural
Center, 20
Langston Hughes Memorial Library Special
Collections and Archives, 20
Laotian Cultural and Research Center, 184
La Raza/Galleria Posada, 132
Latvian Center for Garezers, Inc., 187
Latvian Choir Association of the U.S., 187
Latvian Museum, 187
Lemko Association, 62
Leo Baeck Institute, Inc., 171
Library of the American National Latvian League
in Boston, 188
Library-Ukrainian Orthodox Church of the
U.S.A., 328
Lillian and Albert Small Jewish Museum, 172
Lithuanian-American Museum Charitable Trust,
Museum of the City of Lake Worth, 191
Lithuanian-American R.C. Women's
Alliance, 191
Lithuanian Catholic Press Society, Inc., 191
Lithuanian Catholic Religious Aid, Inc., 192
Lithuanian Cultural Center, Inc.,-Maceika
Library, 192
Lithuanian Cultural Museum, 192
Lithuanian Museum, 193
Lithuanian Museum of Art, Inc., 193
Lithuanian National Library, 194
Lithuanian Research and Studies Center,
Inc., 194
Lithuanian Scouts Association, Inc., 195
Lithuanian World Archives, 195
Living Memorial to the Holocaust-Museum of
Jewish Heritage, 172
Little Norway, 265

Los Californianos, 304
Los Colores, 132
Luso-American Education Foundation, 283
Luther College Archives, 266
Luther Seminary Archives and Museum, 220
Lutheran Archives Center at Philadelphia, 220
Lutheran Theological Seminary at Philadelphia,
 Krauth Memorial Library, 114
Lyman House Memorial Museum, 221

M

Macedonian Patriotic Organization (MPO)
 Macedonian Tribune, 198
Madawaska Historical Society, 95
Mahoning Valley Historical Society, 221
Maltese American Benevolent Society, 198
Mamigonian Foundation, 42
Martin Luther King, Jr. Center for Nonviolent
 Social Change, Inc., 21
Martin Luther King, Jr. National Historic Site
 and Preservation District, 21
Martyrs Memorial and Museum of the
 Holocaust, 172
Mattye Reed African Heritage Center, 22
McPherson County Old Mill Museum and
 Park, 314
Melvin B. Tolson Black Heritage Center, 22
Memphis State University Chucalissa
 Archaeological Museum (C.H. Nash
 Museum), 250
Menno-Hof Mennonite Amish Visitors
 Center, 115
Mennonite Heritage Museum, 115
Mennonite Historians of Eastern
 Pennsylvania, 115
Mennonite Historical Society of Iowa, 116
Mennonite Information Center, 116
Mercer County Historical Museum, 222
Mexican Fine Arts Center Museum, 200
Mexican Museum, 201
Michel Brouillet House & Museum, 96
Millicent Rogers Museum, 222
Minnesota Hungarians, 140
Mission Basilica de Alcala, 304
Mission Cultural Center, 186
Mission San Carlos Borromeo del Rio
 Carmelo, 305
Mission San Juan Bautista Museum, 133
Mission San Juan Capistrano Museum, 133
Mission San Luis Rey Museum, 305
Mizel Museum of Judaica, 173
Moorland-Spingarn Research Center, 22
Moravian Historical Society, 117
Moravian Museums of Bethlehem, Inc., 117
Moravian Music Foundation, 118
Morikami Museum and Japanese Gardens, 156
Morton B. Weiss Museum of Judaica, 173
Museum for African Art, 23
Museum of African American Art, 23
Museum of African-American Culture, 24

Museum of African American History, 24
Museum of African American Life and
 Culture, 25
Museum of Afro-American History, 25
Museum of Amana History, 118
Museum of American Folk Art, 223
Museum of Indian Arts and Culture, 251
Museum of New Mexico, 223
Museum of Northern Arizona, 251
Museum of Russian Culture, 290
Museum of the City of Lake Worth, 224
Museum of the Great Plains, 252
Museum of the National Center of Afro-American
 Artists, 26
Museum of the Plains Indian, 252
Museum of the Southern Jewish Experience, 174
Mutual Aid Association of the New Polish
 Immigration, 274

N

National Afro American Museum and Cultural
 Center, 26
National Archives-Pacific Sierra Region, 224
National Archives-Southeast Region, 225
National Association for Armenian Studies and
 Research, 42
National Black Programming Consortium, 26
National Center for Urban Ethnic Affairs, 225
National Czech and Slovak Museum and
 Library, 77
National Hall of Fame for Famous American
 Indians, 253
National Huguenot Society, 96
National Museum of American History,
 Smithsonian Institution Arab American
 Collection, 36
National Museum of American Jewish
 History, 174
National Museum of American Jewish Military
 History, 174
National Museum of the American Indian, 253
National Slovak Society of the USA, 298
National Yiddish Book Center, 175
Nationality Rooms at the University of
 Pittsburgh, 226
Native Hawaiian Culture and Arts
 Program, 49
Nebraska Jewish Historical Society, 175
Nebraska State Historical Society, 226
New Castle Historical Society, 84
New Glarus Historical Society, 320
New Kuban Education and Welfare
 Association, 227
New Sweden Historical Society, 314
Nordic Heritage Museum, 292
North American Indian Information and Trade
 Center, 254
North Dakota State University Libraries,
 Germans from Russia Heritage
 Collection, 118

North Norwegian Association of the United States and Canada, 266
Northern California Center for Afro-American History and Life, 27
Northwest Minnesota Historical Center, 227
Norwegian-American Historical Association, 266
Norwegian Singers Association of America, 267
Nyingma Institute: Tibetan Aid Project, 324

O

Oakland Public Library-Asian Branch, 50
Oberlin College Archives, 27
Ocmulgee National Monument, 254
Ohio Amish Library, Inc., 119
Ohio State University Black Studies Library, 28
Old Dutch Parsonage, 84
Old Mission Museum, 228
Old Mission Santa Ines, 228
Old Spanish Fort and Museum, 305
Orangeburgh German-Swiss Genealogical Society, 119
Oregon Mennonite Archives and Library (OMAL), 120
Oregon Province Archives of the Society of Jesus, 255
Organization of Chinese Americans, 67
Oroville Chinese Temple, 68
Oscar Howe Art Center, 255
Owasco Teyetasta/Cayuga Museum, 255
Our Croatia Inc./Croatian Heritage Museum and Library, 69

P

Pa. Dutch Folk Culture Society, Inc., 120
Pacific Asian Museum, 50
Pacific University Archives, 256
Page Library's Ethnic Studies Center of Lincoln University, 229
Palace of the Governors, 306
Palatines to America, 121
Paul Robeson Library, 28
Pembroke State University Native American Resource Center, 256
Pennsylvania German Society, 121
Pequa Bruderschaft (Brotherhood) Library, 121
Peter Alriche Foundation, 84
Phelps County Historical Society, 314
Philadelphia Folklore Project, 229
Philadelphia Jewish Archives Center at the Balch Institute, 176
Pimeria Alta Historical Society, 230
Pinal County Historical Society and Museum, 133
Pioneer Heritage Center at Icelandic State Park, 142
Pioneer Museum Complex and Verein Kirche Archives, 122
Plaza de La Raza, Inc., 201
Plotkin Judaica Museum, 176

Point/Pointers (Pursuing our Italian Names Together), 153
Polish American Cultural Institute of Minnesota, 274
Polish American Historical Association, 275
Polish American Museum, 275
Polish American World, 276
Polish Arts and Culture Foundation, 276
Polish Falcons of America, 276
Polish Folk Dance Association of the Americas, 276
Polish Genealogical Society of Connecticut, Inc., 277
Polish Heritage Association of the Southeast-Aiken (Phase-A), 277
Polish Historical Commission of Central Council of Polish Organizations, 278
Polish Immigrant Museum, 278
Polish Institute of Arts and Sciences of America, Inc., 279
Polish Museum of America, 279
Polish National Catholic Church in America, 280
Polish National Catholic Church in America, Central Diocese Archives and Library, 280
Polish Singers Alliance of America, 280
Polish Slavic Information Center, 281
Polish Union of America, 281
Polish Women's Alliance of America, 281
Ponca City Cultural Center and Museums, 257
Population Research Center Library, 230
Portuguese American Progressive Club, 283
Portuguese Continental Union of U.S.A., 283
Project SAVE, Inc., 43
Providence Association of Ukrainian Catholics in America, 328
Public Libraries of Saginaw, 122
Pueblo Grande Museum and Cultural Park, 257
Puerto Rican Cultural Center, 284

R

Rancho Los Cerritos, 306
Rensselaer Polytechnic Institute, Armenian Architectural Archives Project, 43
Research Foundation for Jewish Immigration, 176
Rhode Island Black Heritage Society, 29
Rhode Island Jewish Historical Association, 177
Rockwell Museum, 258
Rodef Shalom Jewish Museum, 177
Romanian Cultural Center, 287
Romanian Ethnic Art Museum, 287
Romanian Orthodox Episcopate of America, 288
Roque House, 97
Rosicrucian Egyptian Museum and Art Gallery, 87
Russian Nobility Association in America, 290

S

St. Ansgar's Scandinavian Catholic League, 293
St. Augustine Historical Society, 306

St. David's Society of the State of New York, 342
St. John's Church and Parish Museum, 58
St. Mary's Armenian Apostolic Church, Balian Library, 44
St. Nerses Shnorhali Library, 44
St. Nicholas Ukrainian Orthodox Church, 329
St. Photios National Greek Orthodox Shrine, 128
St. Sava Serbian Orthodox Cathedral, 296
St. Stephen's Parish Library, 231
St. Vladimir's Orthodox Theological Seminary Library, 62
Sainte Marie Among the Iroquois, 97
San Buenaventura Mission Museum, 307
San Diego State University, Chicano Collection, Malcolm A. Love Library, 202
San Francisco African American Historical and Cultural Society, Inc., 29
San Francisco Public Library-Chinatown Branch, 51
San Ildefonso Pueblo Governor's Office, 258
Sangamon State University Archives, 231
Santa Barbara Historical Society, 134
Santa Barbara Mission Archive-Library, 134
Santuario de Nuestra Senora de Guadalupe, 135
Scandinavian American Genealogical Society, 293
Scandinavian Collectors Club Library, 293
Schoenbrunn Village State Memorial, 123
Schomburg Center for Research in Black Culture, 29
Schwenkfelder Library, 123
Scotch-Irish Foundation, 294
Scottish Historic and Research Society of the Delaware Valley, Inc., 295
Self Reliance Association of American Ukrainians, 329
Seminole Nation Museum, 258
Seneca-Iroquois National Museum, 259
Serbian National Defense Council of America, 296
Sheldon Museum and Cultural Center, 259
Shevchenko Scientific Society Library and Archives, 329
Sioux Indian Museum, 260
Sisters of St. Casimir Lithuanian Culture Museum, 195
Sisters of St. Francis of the Providence of God, 196
Sitka Historical Society, 260
Sitka National Historical Park, 291
Six Nations Indian Museum, 260
Slavic and East European Library, 231
Slavonic Benevolent Order of the State of Texas (SPJST) Museum, 73
Slovak Eastern Catholic Synod of America, 298
Slovak Heritage and Folklore Society International, 298
Slovak Institute, 299
Slovak League of America, 299
Slovak Museum and Archives, 299

Slovak Writers and Artists Association, 300
Slovene Heritage Center, 301
Slovene National Benefit Society, 301
Slovenian Heritage Museum, 302
Smoloskyp, Inc., 330
Society for the History of the Germans in Maryland, 124
Society of Basque Studies in America, 54
Sokol Detroit, 73
Sokol Greater Cleveland, 74
Sokol Gymnastic Association St. Louis, 74
Sokol Minnesota, 78
Sokol South Omaha, 74
Sons of Norway International Headquarters, 267
Sophienburg Museum and Archives, 124
Southeast Asia Resource Action Center, 51
Southern Plains Indian Museum, 261
Southern Ute Cultural Center/Museum, 261
Spanish Colonial Arts Society, 307
Spanish Governor's Palace, 308
Spanish Institute, 308
Spanish Quarter, 308
Spertus Museum, 178
State University of New York at Buffalo, Lockwood Memorial Library Polish Collection, 282
Statue of Liberty National Monument/Ellis Island Immigration Museum, 232
Suffolk University Collection of Afro-American Literature, 30
Suomi College Finnish-American Heritage Center, 90
Swedish American Historical Society, 315
Swedish-American Museum Center of Chicago, 315
Swedish Colonial Society, 316
Swedish Council of America, 316
Swedish Historical Society of Rockford, 316
Sweetwater County Historical Museum, 232
Swenson Swedish Immigration Research Center, 317
Swiss American Historical Society, 320
Swiss Historical Village, 321
Swiss Institute New York, 321

T

Tabor College Center for Mennonite Brethren Studies, 125
Taller Puertorriqueno, Inc., 285
Tamburitza Association of America, 233
Tantaquidgeon Indian Museum, 262
Tante Blanche Museum, 97
Tarpon Springs Cultural Center, 129
Tartan Educational and Cultural Association, 296
Temple Brith Kodesh Museum, 178
Temple Museum of Religious Art, 178
Teysen's Woodland Indian Museum, 262
Theodore J. George Library (and Bookstore), 129

Thomas Gilcrease Institute of American History and Art, 262
Tinker Swiss Cottage Museum, 321
Touro Synagogue, 179
Trinity Christian College Dutch Heritage Center, 85
Tubac Presidio State Historic Park, 135
Tumacacori National Historical Park, 233
Turkish-American Associations, 326
Tuskegee Institute National Historic Site, 30

U

U.S.-Japan Culture Center, 157
Ukrainian Academy of Arts and Sciences in the U.S., 330
Ukrainian American Archives, Museum and Library, Inc., 331
Ukrainian American Coordinating Council, 331
Ukrainian Artists Association in U.S.A., 332
Ukrainian Bibliographical Reference Center, 332
Ukrainian Catholic Soyuz of Brotherhoods and Sisterhoods in the USA, 332
Ukrainian Diocesan Museum and Library, 333
Ukrainian Fraternal Association, 333
Ukrainian Heritage Studies Center, Manor Junior College, 334
Ukrainian Historical Association, Inc., 334
Ukrainian Institute of America, 335
Ukrainian Lemko Museum, 335
Ukrainian Museum, 335
Ukrainian Museum-Archives, Inc., 336
Ukrainian National Aid Association of America (UNAAA), 336
Ukrainian National Association, Inc., 337
Ukrainian National Information Service, 337
Ukrainian National Museum of Chicago, 338
Ukrainian Orthodox Church of the USA (New Jersey), 338
Ukrainian Philatelic and Numismatic Society, 339
Ukrainian Political Science Association in the U.S., 339
Uniao Portuguesa do Estado da California, Portuguese Union of the State of California (UPEC), 284
Union and League of Romanian Societies of America, Inc., 288
Union of Poles in America, 282
Union Saint Jean Baptiste Mallet Library, 98
United Irish Cultural Center, 149
United Lutheran Society, 300
United States Holocaust Memorial Museum, 179
United Ukrainian War Veterans in America, 339
University of California at Los Angeles American Indian Studies Center, 263
University of California, Berkeley, Regional Oral History Office of the Bancroft Library, 234
University of California Center for Chinese Studies Library, 68

University of California Chicano Studies Library, 202
University of Chicago Library Archives of Czechs and Slovaks Abroad, 78
University of Cincinnati German-Americana Collection, 125
University or Idaho Asian American Comparative Collection, 51
University of Miami, Otto G. Richter Library Archives and Special Collections, 71
University of Michigan American Oriental Society, 52
University of Michigan, Dearborn, Center for Armenian Research, Publication and Economic Development, 44
University of Nebraska, Lincoln, Czech Heritage Collection, 75
University of Nevada, Reno, Basque Studies Program, 54
University of Oklahoma, Western History Collections, 263
University of St. Thomas O'Shaughnessy-Fey Library Special Collections Department, 234
University of Southwestern Louisiana, Dupre Library Special Collections Dept., 235
University of Texas at Austin Winedale Historical Center, 126
University of the Pacific, Holt-Atherton Department of Special Collections, 235
University of Wisconsin, Green Bay, Cofrin Library Special Collections Dept., 57
Ute Indian Museum, 264
Ute Mountain Ute Tribal Park Cultural Research and Education Center, 264

V

Valerian D. Trifa Romanian American Heritage Center, 289
Van Wyck Homestead Museum, 85
Vardy Collection, Hungarian Cultural Society of Western Pennsylvania, 141
VASA Museum, 318
VASA Order of America National Archives, Inc., 318
Vesterheim Norwegian American Museum, 267
Vietnam Refugee Fund, 341
Virginia Union University, 31
Vivekananda Vedanta Society, 143
Vivian G. Harsh Research Collection of Afro-American History and Literature, 31
Volhynian Bibliographic Center, 340

W

Weld Library District, Lincoln Park Branch, 126
Wellesley College, Clapp Library, Special Collections, 32
Welsh-American Heritage Museum Society, 342

Welsh Guild of Arch St. Presbyterian
 Church, 343
Western States Black Research Educational
 Ctr., 32
Western Fraternal Life Association, 75
Western Michigan University Latvian Studies
 Center Library, 188
Wheelwright Museum of the American
 Indian, 265
Wilber Czech Museum, 75
Wilberforce University Rembert E. Stokes LRC
 Library, 33
Willard Library of Evansville Regional and
 Family History Center, 126
William Hunter Society, 58
Wing Luke Asian Museum, 52

Y

Yale Center for British Art, 58
Yeshiva University Museum, 180
YIVO Institute for Jewish
 Research, 180
Yolo County Historical Museum, 135
YUGNTRUF-Youth for Yiddish, 181

Z

Zeeland Historical Society, 86
Zilevicius-Kreivenas Lithuanian Musicology
 Archive, 196
Zoar Village State Memorial, 127
Zoryan Institute Library, 45

Geographic Index

A

ALABAMA
Tuskegee Institute
Tuskegee Institute National Historic Site
(African American), 30
ALASKA
Haines
Sheldon Museum and Cultural Center
(Native American), 259
Kodiak
Kodiak Historical Society (Native
American), 250
Sitka
Sitka Historical Society (Native
American), 260
Sitka National Historical Park (Russian), 291
ARIZONA
Dragoon
Amerind Foundation (Native
American), 237
Flagstaff
Museum of Northern Arizona (Native
American), 251
Florence
Pinal County Historical Society and Museum
(Hispanic), 133
Nogales
Pimeria Alta Historical Society (Multi-
ethnic), 230
Parker
Colorado River Indian Tribes
Museum/Library (Native American), 241
Phoenix
Heard Museum (Native American), 246
Plotkin Judaica Museum (Jewish), 176
Pueblo Grande Museum and Cultural Park
(Native American), 257
Tempe
Arizona State University Chicano Research
Collection (Mexican), 199

Arizona State University Center for Latin
American Studies, 184
Tubac
Tubac Presidio State Historical Park
(Hispanic), 135
Tucson
Arizona Historical Society (Multi-
ethnic), 206
North American Indian Information and
Trade Center, 254
Tumacacori
Tumacacori National Historical Park (Multi-
ethnic), 233
ARKANSAS
Wilson
Hampson Museum State Park (Native
American), 246

C

CALIFORNIA
Alamo
Jacob More Society, 295
Berkeley
AWAIR: Arab World and Islamic Resources
and School Services, 35
Judah L. Magnes Museum (Jewish), 170
Nyingma Institute: Tibetan Aid
Project, 324
University of California, Berkeley Regional
Oral History Office of the Bancroft Library
(Multi-ethnic), 234
University of California Center for Chinese
Studies Library, 68
Carmel
Mission San Carlos Borromeo Del Rio
Carmelo (Spanish), 305
Compton
Compton Public Library (Multi-ethnic), 211
Culver City
East-West Cultural Center (Asian), 49

Davis
American Romanian Academy of Arts and
Sciences, 286
Fiddletown
Chew Kee (Chinese American), 62
Fresno
American Historical Society of Germans
from Russia Central California
Chapter, 101
California State University, Fresno Kalfayan
Center for Armenian Studies Program, 41
Fullerton
California State University Fullerton Oral
History Program (Multi-ethnic), 208
Glendale
Armenian Society of Los Angeles, Armenak
and Nunia Haroutunian Library, 40
Independence
Eastern California Museum
(Japanese), 154
Junction City
Friends of the Tibetan Library, 323
La Mesa
Irish Family Names Society, 147
Lancaster
Antelope Valley Indian Museum (Native
American), 238
Long Beach
Rancho Los Cerritos (Spanish), 306
Los Angeles
Beit Hashoah Museum of Tolerance
(Jewish), 159
Black American Cinema Society, 8
California Afro-American Museum, 11
Center for Afro-American Studies
Library, 12
Chicano Resource Center (Mexican), 200
Chicano Studies Research Library
(Mexican), 200
Chinatown Branch Library Los Angeles
Public Library, 63
County of Los Angeles Public Library Black
Resource Center, 14
Craft and Folk Art Museum (Multi-
ethnic), 212
Hebrew Union College Skirball Museum
(Jewish), 165
Japanese American Cultural and Community
Center, 155
Japanese American National Museum, 155
Jewish Community Library-Peter M. Kahn
Memorial, 167
Korean American Coalition, 182
Martyrs Memorial and Museum of the
Holocaust (Jewish), 172
Museum of African American Art, 23
Plaza de la Raza, Inc. (Mexican), 201
St. Stephen's Parish Library
(Multi-ethnic), 231
University of California at Los Angeles
American Indian Studies Center, 263

Western States Black Research
Educational Center, 32
Oakland
Black Filmmakers Hall of Fame,
Inc., 9
Luso-American Education Foundation
(Portuguese), 283
Oakland Public Library-Asian Branch
(Asian), 50
Northern California Center for Afro-
American History and Life, 27
Oroville
Oroville Chinese Temple, 68
Palos Verdes Peninsula
POINT/POINTERS (Pursuing our Italian
Names Together), 153
Pasadena
Pacific Asian Museum (Asian), 50
Pico Rivera
Armenian Numismatic Society, 40
Rancho Palos Verdes
Association for Korean Studies, 182
Redondo Beach
Glückstal Colonies Research Association
(German), 109
Sacramento
California State Indian Museum (Native
American), 239
Hungarian/American Friendship Society, 138
La Raza/Galleria Posada (Hispanic), 132
San Bruno
National Archives-Pacific Sierra Region
(Multi-ethnic), 224
San Diego
Junipero Serra Museum (Spanish), 303
Mission Basilica de Alcala (Spanish), 304
San Diego State University Chicano
Collection, Malcolm A. Love Library
(Mexican), 202
San Francisco
Asian Art Museum of San Francisco, 47
Basque Educational Organization, 54
Centro Cultural de la Mision (Latin
American), 185
Chinese Culture Center of San Francisco, 64
Chinese Historical Society of America, 65
Italian-American Museum (Museo Italo
Americano), 151
Irish Heritage Foundation (IHF), 148
Japanese American National
Library, 155
Jewish Museum San Francisco, 169
Mexican Museum, 201
Mission Cultural Center
(Latin American), 186
Museum of Russian Culture, 290
Polish Arts and Culture Foundation, 276
Russian Nobility Association in
America, 290
San Francisco African American Historical
and Cultural Society, Inc., 29

San Francisco Public Library-Chinatown
Branch (Asian), 51
United Irish Cultural Center, 149
San Jose
Rosicrucian Egyptian Museum and Art
Gallery, 87
San Juan Bautista
Mission San Juan Bautista (Hispanic), 133
San Juan Capistrano
Mission San Juan Capistrano Museum
(Hispanic), 133
San Leandro
Los Californianos (Spanish), 304
Uniao Portuguesa do Estado da California
(Portuguese Union of the State of
California), 284
San Luis Obispo
Old Mission Museum (Multi-ethnic), 228
San Luis Rey
Mission San Luis Rey Museum
(Spanish), 305
Santa Ana
Laotian Cultural and Research
Center, 184
Santa Barbara
La Casa de la Raza, Inc. (Hispanic), 132
Santa Barbara Historical Society
(Hispanic), 134
Santa Barbara Mission Archive-Library
(Hispanic), 134
University of California Chicano Studies
Library (Mexican), 202
Santa Monica
American Siam Society (Thai), 323
Solvang
Old Mission Santa Ines (Multi-ethnic), 228
Stanford
Hoover Institution on War, Revolution &
Peace (Multi-ethnic), 217
Stockton
University of the Pacific Holt-
Atherton Dept. of Special Collections
(Multi-ethnic), 235
Thousand Oaks
Armenian Film Foundation, 38
Ventura
San Buenaventura Mission Museum
(Spanish), 307
Woodland
Yolo County Historical Museum
(Hispanic), 135
COLORADO
Denver
Chicano Humanities and Arts Council, Inc.
(Mexican), 199
Ira M. Beck Archives of Rocky Mountain
Jewish History, 166
Mizel Museum of Judaica, 173
Durango
Fort Lewis College Center of Southwest
Studies (Native American), 245

Greeley
Weld Library District, (German), 126
Ignacio
Southern Ute Cultural Center/Museum
(Native American), 261
La Junta
Koshare Indian Museum, Inc. (Native
American), 250
Montrose
Ute Indian Museum (Native American), 264
Pueblo
El Pueblo Museum (Hispanic), 131
Towaoc
Ute Mountain Ute Tribal Park Cultural
Research and Education Center (Native
American), 264
Trinidad
Baca House and Pioneer Museum in
Trinidad, CO (Hispanic), 130
CONNECTICUT
Hartford
Harriet Beecher Stowe Center (African
American), 18
New Britain
Polish Genealogical Society of Connecticut,
Inc., 277
New Haven
Connecticut Afro-American Historical
Society, 13
Human Relations area Files, Inc. (Multi-
ethnic), 217
Yale Center for British Art, 58
Putnam
ALKA-American Lithuanian Cultural
Archives, 189
Stamford
Polish Slavic Information Center, 281
Ukrainian Diocesan Museum and
Library, 333
Ukrainian Lemko Museum, 335
Uncasville
Tantaquidgeon Indian Museum (Native
American), 262
West Hartford
Jewish Historical Society of Greater
Hartford, 168

D

DELAWARE
New Castle
New Castle Historical Society (Dutch), 84
Wilmington
Hendrickson House Museum and Old Swedes
Church, 313

F

FLORIDA
Coral Gables
Black Heritage Museum, 9

University of Miami Otto G. Richter
 Library, (Cuban), 71
Delray Beach
 The Morikami Museum and Japanese
 Gardens, 156
Fort Myers
 Fort Myers Historical Museum, 215
Lake Worth
 Lithuanian-American Museum Charitable
 Trust, 191
 Museum of the City of Lake Worth (Multi-
 ethnic), 224
Miami
 American Institute of Polish Culture, 271
 Black Archives, History and Research
 Foundation of South Florida, Inc., 8
 Cuban Museum of Arts and Culture, 70
North Miami Beach
 Ancient Spanish Monastery of St. Bernard
 De Clairvaux Cloisters, 302
Port Orange
 Hungarian Folk-Art Museum, 139
St. Augustine
 St. Augustine Historical Society
 (Spanish), 306
 St. Photios National Greek Orthodox Shrine
 (Greek), 128
 Spanish Quarter, 308
Tallahassee
 Black Resources Information Coordinating
 Services, 10
Tarpon Springs
 Tarpon Springs Cultural Center (Greek), 129
Valparaiso
 Historical Society Museum (Native
 American), 247

G

GEORGIA
Atlanta
 Martin Luther King, Jr., Center for
 Nonviolent Social Change, Inc., 21
 Martin Luther King, Jr. National Historic
 Site and Preservation District, 21
Cartersville
 Etowah Indian Mounds State Historic Site
 (Native American), 243
Decatur
 Hungarian Cultural Foundation , 139
East Point
 National Archives-Southeast Region, 225
Macon
 Ocmulgee National Monument (Native
 American), 254
Rincon
 Georgia Salzburger Society Museum
 (German), 106
Savannah
 Archives Museum, Temple Mickve Israel
 (Jewish), 159

H

HAWAII
Hilo
 Lyman House Memorial Museum (Multi-
 ethnic), 221
Honolulu
 Honolulu Academy of Arts (Asian), 49
 Japanese Cultural Center of Hawaii, 156
 Native Hawaiian Culture and Arts Program
 (Asian), 49

I

IDAHO
Moscow
 University of Idaho Asian American
 Comparative Collection, 51
ILLINOIS
Berwyn
 American Sokol Educational & Physical
 Culture Organization (Czech), 71
 Czechoslovak Daily Herald (Czech), 72
 Czechoslovak Heritage Museum, Library,
 and Archive, 77
Bishop Hill
 Bishop Hill Heritage Association
 (Swedish), 312
 Vasa Order of America National Archives,
 Inc. (Swedish), 318
Burr Ridge
 Slovene National Benefit Society, 301
Chicago
 American Lithuanian Musicians
 Alliance, 189
 American Society for Ethnohistory
 (Multi-ethnic), 205
 Balzekas Museum of Lithuanian Culture, 190
 Budrys Lithuanian Photo Library, Inc., 190
 Center for Ukrainian and Religious
 Studies, 327
 Christ the Redeemer Parish Library, 56
 Covenant Archives and Historical Library
 (Swedish), 312
 Croatian Ethnic Institute, 68
 DuSable Museum of African American
 History, Inc., 15
 Evangelical Lutheran Church in America
 Archives (Multi-ethnic), 213
 Hungarian Cultural and Educational House,
 Inc., 139
 International Black Writers, 19
 Irish American Cultural Association
 (IACA), 146
 Lithuanian Catholic Press Society, Inc., 191
 Lithuanian Museum, 193
 Lithuanian Research and Studies Center,
 Inc., 194
 Lithuanian World Archives, 195
 Mexican Fine Arts Center Museum, 200
 Morton B. Weiss Museum of Judaica, 173

Mutual Aid Association of the New Polish
Immigration, 274
Polish American Historical Association, 275
Polish Museum of America, 279
Puerto Rican Cultural Center, 284
Serbian National Defense Council of
America, 296
Sisters of St. Casimir Lithuanian Culture
Museum, 195
Spertus Museum (Jewish), 178
Swedish American Historical Society, 315
Swedish-American Museum Center of
Chicago, 315
Swiss American Historical Society
(Swiss), 320
Ukrainian Bibliographical Reference
Center, 332
Ukrainian Catholic Soyuz of Brotherhoods
and Sisterhoods in the USA, 332
Ukrainian National Aid Association of
America, 336
Ukrainian National Museum of Chicago, 338
Ukrainian Philatelic and Numismatic
Society, 339
University of Chicago Library Archives of
Czechs and Slovaks Abroad, 78
Vivekananda Vedanta Society (Indian), 143
Vivian G. Harsh Research Collection of
Afro-American History and Literature, 31
Zilevicius-Kreivenas Lithuanian Musicology
Archive, 196
Clarendon Hills
Lithuanian Scouts Association, Inc., 195
DeKalb
Donn V. Hart Southeast Asia Collection,
NIU Libraries, 48
Joliet
Slovenian Heritage Museum, 302
Lemont
Lithuanian Museum of Art, Inc., 193
Moline
Center for Belgian Culture of Western
Illinois, Inc., 56
Oak Brook
Lithuanian-American R.C. Women's
Alliance, 191
Palos Heights
Trinity Christian College Dutch Heritage
Center, 85
Park Ridge
Polish Women's Alliance of America, 281
Rock Island
Augustana College Art Gallery
(Swedish), 311
Swenson Swedish Immigration Research
Center, 317
Rockford
Ethnic Heritage Museum (Multi), 212
Swedish Historical Society of
Rockford, 316
Tinker Swiss Cottage Museum, 321

Skokie
Hebrew Theological College (Jewish), 164
Springfield
Sangamon State University Archives (Multi-
ethnic), 231
Urbana
Slavic and East European Library (Multi-
ethnic), 231
Woodridge
Chinese Music Society of North
America, 66
Zoar
Zoar Village State Memorial (German), 127
INDIANA
Bloomington
Volhynian Bibliographic Center, 340
Evansville
Angel Mounds State Historic Site (Native
American), 238
Willard Library of Evansville Regional and
Family History Center (German), 126
Fort Wayne
Allen County Public Library (Multi-
ethnic), 203
American Conference for Irish Studies
(ACIS), 144
Indiana Jewish Historical Society, 166
Macedonian Patriotic Organization, 198
Goshen
Archives of the Mennonite Church
(German), 102
Goshen College Mennonite Historical Library
(German), 110
Indianapolis
Indiana University-Purdue University at
Indianapolis Special Collections and
Archives (German), 112
Kossuth Foundation (Hungarian), 140
Shipshewanna
Menno-Hof Mennonite Amish Visitors
Center (German), 115
Vincennes
Michel Brouillet House & Museum
(French), 96
Wolcottville
Association of Romanian Catholics of
America, 286
IOWA
Amana
Amana Heritage Society (German), 100
Museum of Amana History (German), 118
Cedar Rapids
Czech and Slovak Museum and Library, 76
National Czech and Slovak Museum and
Library, 77
Western Fraternal Life Association
(Czech), 75
Decorah
Luther College Archives (Norwegian), 266
Vesterheim Norwegian American
Museum, 267

Des Moines
Clan Cunning Association, 294
Danish Immigrant Archives, 79
Elk Horn
Danish Immigrant Museum and
Bedstemor's (Grandmother's)
House, 80
Kalona
Mennonite Historical Society of Iowa
(German), 116
Mt. Pleasant
Iowa Wesleyan College Chadwick Library
(German), 112
Sioux Center
Dordt College Library/Dutch Memorial
Collection, 81
Spillville
Bily Clock Exhibit (Czech), 71

K

KANSAS
Ellis
Bukovina Society of the Americas, 102
Goessel
Mennonite Heritage Museum (German), 115
Hays
Fort Hays State University Center for Ethnic
Studies at Forsyth Library (Multi-
ethnic), 215
Hillsboro
Adobe House Museum (Multi-
ethnic), 203
Tabor College Center for Mennonite
Brethren Studies (German), 125
Lindsborg
Folklife Institute of Central Kansas
(Swedish), 313
McPherson County Old Mill Museum and
Park (Swedish), 314
North Newton
Bethel College Mennonite Library and
Archives, 102
KENTUCKY
Louisville
Filson Club Historical Society, Inc.
(Multi-ethnic), 214

L

LOUISIANA
Cloutierville
Bayou Folk Museum (French), 92
Lafayette
University of Southwestern Louisiana Dupre
Library (Multi-ethnic), 235
Natchitoches
Roque House (French), 97
New Orleans
Amistad Research Center (Multi-
ethnic), 205

M

MAINE
Madawska
Madawaska Historical Society (French), 95
Tante Blanche Museum (French), 97
New Sweden
New Sweden Historical Society, 314
MARYLAND
Baltimore
Great Blacks in Wax Museum, Inc., 17
Jewish Historical Society of Maryland, 168
Lithuanian National Library, 194
Society for the History of the Germans in
Maryland, 124
Theodore J. George Library (Greek), 129
Bethesda
American Council for Polish
Culture, 271
Cheverly
Gypsy Lore Society, (Multi-ethnic), 216
College Park
Asian Studies Newsletter Archives, 48
Ellicott City
Smoloskyp, Inc. (Ukrainian), 330
Rockville
American Latvian Association in the United
States, 186
Jane L. & Robert H. Weiner Judaic Museum/
Goldman Art Gallery, 167
Latvian Museum, 187
Mamigonian Foundation (Armenian), 42
Silver Spring
American Hungarian Educators'
Association, 136
Association of Indian Muslims of
America, 142
Cambodian Buddhist Society, Inc., 60
MASSACHUSETTS
Arlington
Armenian Cultural Foundation, 38
Belmont
Armenian Reference and Research
Library, 40
National Association for Armenian Studies
and Research, 42
Boston
Chinese Culture Institute, 65
French Library in Boston, 94
Museum of Afro-American History, 25
Museum of the National Center of Afro-
American Artists, 26
Portuguese Continental Union of
U.S.A., 283
Suffolk University Collection of Afro-
American Literature, 30
Brighton
Archives of the Archdiocese of Boston
(Multi-ethnic), 206
Brookline
Hebrew College, 163

Library of the American National
Latvian League in Boston, 188
Cambridge
Harvard Ukrainian Research Institute
Reference Library, 328
Zoryan Institute Library (Armenian), 45
Lawrence
Immigrant City Archives (Multi-
ethnic), 218
Somerville
Irish Genealogical Society, 148
South Boston
Archbishop Fan Noli Library
(Albanian), 33
South Hadley
National Yiddish Book Center (Jewish), 175
Waltham
American Jewish Historical Society, 158
Watertown
Armenian Artists Association of
America, 37
Armenian Library & Museum of
America, 39
Project Save, Inc. (Armenian), 43
Wellesley
Wellesley College, Clapp Library, Special
Collections, 32
Winchester
Eelam Tamils Association of America (Sri
Lankan), 309
MICHIGAN
Ann Arbor
University of Michigan American Oriental
Society (Asian), 52
Caspian
Iron County Museum (Multi-ethnic), 219
Dearborn
University of Michigan, Dearborn Center
for Armenian Research, Publication &
Economic Development, 44
Dearborn Heights
Sokol Detroit, 73
Detroit
Casa De Unidad Cultural Arts and Media
Center (Hispanic), 130
Connolly Books (Irish), 146
Detroit Public Library E. Azalia Hackley
Memorial Collection (African
American), 15
Maltese American Benevolent Society, 198
Museum of African American History, 24
Ukrainian American Archives, Museum and
Library, Inc., 331
Frankenmuth
Frankenmuth Historical Association
(German), 104
Grand Rapids
Calvin College/Calvin Theological Seminary
Archives (Dutch), 80
Hancock
Suomi College Finnish-American Heritage

Center, 90
Holland
Cappon House Museum (Dutch), 81
Herrick Public Library (Dutch), 82
Holland Museum (Dutch), 82
Joint Archives of Holland (Dutch), 83
Jackson
Romanian Orthodox Episcopate of
America, 288
Valerian D. Trifa Romanian American
Heritage Center, 289
Kalamazoo
Western Michigan University Latvian
Studies Center Library, 188
Mackinaw City
Teysen's Woodland Indian Museum (Native
American), 262
Orchard Lake
Galeria (Polish), 273
Roseville
Genealogical Society of Flemish
Americans, 57
Saginaw
Public Libraries of Saginaw, 122
Three Rivers
Latvian Center Garezers Inc., 187
Troy
Italian Study Group of Troy, 152
Warren
EKO Gallery (Ukrainian), 327
Italian American Cultural Society Library/
Archives, 151
Ukrainian American Archives Museum and
Library, Inc., 331
Zeeland
Zeeland Historical Society (Dutch), 86
MINNESOTA
Bloomington
National Huguenot Society (French), 96
Fridley
North Norwegian Association of the United
States and Canada, 266
Polish American Cultural Institute of
Minnesota, 274
Kenyon
Norwegian Singers Association of America
(Norwegian), 267
Minneapolis
American Swedish Institute, 310
Arise! Resource Center (Multi-
ethnic), 206
Filipino American Women's Network, 89
Sons of Norway International
Headquarters, 267
Swedish Council of America, 316
Moorhead
Northwest Minnesota Historical Center
(Multi-ethnic), 227
New Brighton
Archival Center of the (Swedish) Baptist
Conference, 311

Northfield
Norwegian-American Historical
Association, 266
St. Paul
Czechoslovak Genealogical Society
International, 76
Immigration History Research Center
(Multi-ethnic), 218
Luther Seminary Archives and Museum
(Multi-ethnic), 220
Minnesota Hungarians, 140
Scandinavian American Genealogical
Society, 293
Sokol Minnesota (Czechoslovak), 78
University of St. Thomas O'Shaughnessy-
Fey Library (Multi-ethnic), 234
St. Peter
Gustavus Adolphus College Folke
Bernadotte Memorial Library
(Swedish), 313
Vasa
Vasa Museum (Swedish), 318
Waconia
Carver County Historical Society
(Multi-ethnic), 208
MISSISSIPPI
Clarksdale
Delta Blues Museum, Division of the
Carnegie Public Library of Clarksdale MS
(African American), 14
Jackson
Museum of the Southern Jewish
Experience, 174
Pasagoula
Old Spanish Fort and Museum, 305
MISSOURI
Diamond
George Washington Carver National
Monument (African American), 16
Hermann
Deutschheim State Historic Site
(German), 103
Historic Hermann Museum (German), 111
Jefferson City
Page Library's Ethnic Studies Center of
Lincoln University (Multi-ethnic), 229
Kansas City
Black Archives of Mid-America, Inc., 9
Irish Genealogical Foundation, 148
St. Louis
American Hungarian Review, 137
Eden Theological Seminary, Eden Archives
(German), 103
Sokol Gymnastic Association St. Louis
(Czech), 74
Tamburitza Association of America (Multi-
ethnic), 233
MONTANA
Browning
Museum of the Plains Indian (Native
American), 252

Harlem
Fort Belknap College Library and Tribal
Archives (Native American), 244
Havre
H. Earl Clack Memorial Museum
(Native American), 246
Lame Deer
Dull Knife Memorial College, John
Woodenlegs Memorial (Native
American), 242
Pryor
Chief Plenty Coups Museum (Native
American), 240
St. Ignatius
Flathead Indian Museum (Native
American), 244
Wisdom
Big Hole National Battlefield (Native
American), 239

N

NEBRASKA
Blair
Dana College, C.A. Dana-Life Library
(Danish), 79
Clarkson
Clarkson Historical Society (Czech), 72
Hastings
Adams County Historical Society
(German), 99
Holdrege
Phelps County Historical Society,
(Swedish), 314
Lincoln
American Historical Society of Germans
from Russia (German), 100
Nebraska State Historical Society (Multi-
ethnic), 226
University of Nebraska, Lincoln Czech
Heritage Collection, 75
Omaha
Afghanistan Studies Association, 1
Danish Brotherhood in America, 79
Great Plains Black Museum, 17
Nebraska Jewish Historical Society, 175
Sokol South Omaha (Czech), 74
Wilber
Wilber Czech Museum, 75
NEVADA
Reno
University of Nevada, Reno Basque Studies
Program, 54
NEW HAMPSHIRE
Manchester
American-Canadian Genealogical Society
(French), 91
Association Canado American (French), 92
NEW JERSEY
Bogota
American Hungarian Museum, Passaic, 137

Buena
New Kuban Education and Welfare
Association (Multi-ethnic), 227
Burlington
Burlington County Historical Society
(African American), 11
Demarest
Armenian Literary Society-New York, 39
Denville
Association of Sri-Lankans in America, 309
Garfield
Hungarian Scout Association Abroad, 140
Jersey City
Afro-American Historical Society
Museum, 5
American Coptic Association (Egyptian), 87
German American World Society, 107
Ukrainian National Association, Inc., 337
Lakewood
Estonian Archives in the U.S., Inc., 88
Morristown
Irish American Cultural Institute, 147
New Brunswick
American Hungarian Foundation, 136
Paramus
Armenian Behavioral Science Assn., 37
Armenian Missionary Association of
America A. A. Bedikian Library, 39
Rutherford
Byelorussian Institute of Arts and Sciences,
Inc., 55
Saddle Brook
Armenian General Benevolent Union, 38
Somerset
Library-Ukrainian Orthodox Church of the
U.S.A., 328
Somerville
Old Dutch Parsonage, 84
South Bound Brook
Ukrainian Orthodox Church of the
U.S.A., 338
Union
United Ukrainian War Veterans in
America, 339
West Paterson
Heritage Institute of the Byzantine Catholic
Diocese of Passaic (Carpatho-
Ruthenian), 61
NEW MEXICO
Corrales
Los Colores (Hispanic), 132
Santa Fe
El Rancho de las Golondrinas Museum, 303
Museum of Indian Arts and Culture (Native
American), 251
Museum of New Mexico, 223
Palace of the Governors (Spanish), 306
San Ildefonso Pueblo Governor's Office
(Native American), 258
Santuario de Nuestra Senora de Guadalupe
(Hispanic), 135

Spanish Colonial Arts Society, Inc., 307
Wheelwright Museum of the American
Indian, 265
Taos
Millicent Rogers Museum (Multi-
ethnic), 222
NEW YORK
Albany
Irish American Heritage Museum, 147
Auburn
Owasco Teyetasta/Cayuga Museum (Native
American), 255
Baldwin
Polish American World, 276
Brooklyn
American Italian Congress, 150
Center for Latino Studies (Latin
American), 185
Italian Historical Society of America, 152
Kurdish Heritage Foundation of
America, 182
Lithuanian Catholic Religious Aid, Inc., 192
Lithuanian Cultural Center, Inc.-Maceika
Library, 192
Polish Folk Dance Association of the
Americas, 276
Society of Basque Studies in America, 54
Buffalo
Benjamin & Dr. Edgar R. Cofeld Judaic
Museum of Temple Beth Zion, 160
Biblioteka Polska (Polish), 272
Buffalo and Erie County Public Library,
North Jefferson Branch (African
American), 11
Fronczak Room, E. H. Butler Library
(Polish), 272
Polish Union of America, 281
State University of New York at Buffalo
Lockwood Memorial Library Polish
Collection, 282
Cambria Heights
Foundation for Research in the Afro-
American Creative Arts, 16
Cheektowaga
Federation of Alpine and Schuhplattler Clubs
in North America (Austrian), 53
Corning
Rockwell Museum (Native
American), 258
Corona
Langston Hughes Community Library &
Cultural Center (African American), 20
Crestwood
St. Vladimir's Orthodox Theological
Seminary Library (Carpatho-
Ruthenian), 62
Fishkill
Van Wyck Homestead Museum (Dutch), 85
Flushing
Ethnic Materials Information Exchange
(EMIE) (Multi), 213

Hogansburg
Akwesasne Museum (Native American), 237
Howes Cave
Iroquois Indian Museum (Native American), 249
Jamaica
Ukrainian Historical Association, Inc., 334
Liverpool
Sainte Marie Among the Iroquois (French), 97
Mt. Vernon
Afro-American Cultural Foundation, 3
New Paltz
Huguenot Historical Society (French), 95
New York
American Committee on Italian Migration, 149
American Hungarian Library and Historical Society, 136
American Irish Historical Society, 145
American Jewish Committee Blaustein Library and Archives, 158
American Scandinavian Foundation, 292
American Turkish Society, Inc., 324
An Claidheamh Soluis-The Irish Arts Center, 146
Asia Society , 46
Asian American Arts Alliance, 46
Asian American Arts Centre, 47
Asian Cinevision, 47
Association for Puerto Rican-Hispanic Culture, Inc., 284
Austrian Cultural Institute, 53
Bakhmeteff Archive of Russian and East European History and Culture (Multi-ethnic), 207
Center for Cuban Studies/Cuban Art Project, 70
Central Synagogue Archives (Jewish), 161
China Institute in America, 63
Chinatown History Museum, 64
Chinese Consolidated Benevolent Association, 64
Chinese Information and Culture Center, 66
Congress for Jewish Culture, 162
Estonian House, 88
Federation of Turkish-American Associations, 325
Filipinas Americas Science and Art Foundation, 89
French Institute/Alliance Francais, 93
Goethe House New York German Cultural Center, 109
Hatch-Billops Collection, Inc., 18
Hineni Heritage Center (Jewish), 165
Hispanic Society of America, 131
Histadruth Ivrith of America (Jewish), 165
Holland Society of New York (Dutch), 83
Instituto Cervantes, 303
Istituto Italiano di Cultura, 151
Iuliu Maniu American Romanian Relief

Foundation, 287
Japan Society, Inc., 154
Jewish Museum, 169
Jewish Women's Resource Center, 169
Josef Pilsudski Institute of America (Polish), 273
Judaica Museum of Central Synagogue, 171
Kosciuszko Foundation (Polish), 274
Krikor and Clara Zohrab Information Center of the Armenian Diocese, 42
Leo Baeck Institute, Inc. (Jewish), 171
Living Memorial to the Holocaust Museum of Jewish Heritage, 172
Museum of American Folk Art (Multi-ethnic), 223
Museum for African Art, 23
National Museum of the American Indian, 253
Polish Institute of Arts and Sciences of America, Inc., 279
Polish Singers Alliance of America, 280
Portuguese American Progressive Club, 283
Research Foundation for Jewish Immigration, 176
Romanian Cultural Center, 287
Russian Nobility Association in America, 290
St. Ansgar's Scandinavian Catholic League, 293
St. David's Society of the State of New York (Welsh), 342
St. Nerses Shnorhali Library (Armenian), 44
Schomburg Center for Research in Black Culture, 29
Self Reliance Association of American Ukrainians, 329
Shevchenko Scientific Society Library and Archives (Ukrainian), 329
Spanish Institute, 308
Statue of Liberty National Monument/Ellis Island Immigration Museum (Multi-ethnic), 232
Swiss Institute New York, 321
Turkish American Associations, 326
Ukrainian Academy of Arts and Sciences in the U.S., 330
Ukrainian American Coordinating Council, 331
Ukrainian Institute of America, 335
Ukrainian Museum, 335
Yeshiva University Museum (Jewish), 180
Yivo Institute for Jewish Research, 180
YUGNTRUF-Youth for Yiddish (Jewish), 181
Nyack
Congress of Russian Americans, Inc., 289
Onchiota
Six Nations Indian Museum (Native American), 260
Pelham Manor
Cultural Association of Bengal, 143

Port Washington
Polish American Museum, 275
Riverdale
Judaica Museum, 170
Riverhead
Polish Immigrant Museum, 278
Rochester
Baine/Cincebeaux Collection of Slovak Folk
Dress & Folk Art, 297
Slovak Heritage and Folklore Society
International, 298
Temple Brith Kodesh Museum (Jewish), 178
Salamanca
Seneca-Iroquois National Museum (Native
American), 259
Staten Island
American Italian Historical Association, 150
Center for Migration Studies of New York,
Inc. (Multi-ethnic), 209
Garibaldi-Meucci Museum of the Order of
the Sons of Italy in America, 150
Jacques Marchais Museum of Tibetan
Art, 323
Stony Point
American Ireland Education Foundation,
Inc., 145
Syracuse
Paul Robeson Library (African
American), 28
Troy
Rensselaer Polytechnic Institute Armenian
Architectural Archives Project, 43
St. Nicholas Ukrainian Orthodox
Church, 329
Yonkers
Lemko Association (Carpatho-
Ruthenian), 62
NORTH CAROLINA
Greensboro
Mattye Reed African Heritage Center, 22
Pembroke
Pembroke State University Native American
Resource Center, 256
Winston-Salem
Moravian Music Foundation (German), 118
NORTH DAKOTA
Bismarck
Germans from Russia Heritage Society, 108
Cavalier
Pioneer Heritage Center at Icelandic State
Park (Icelandic), 142
Fargo
North Dakota State University Libraries
Germans from Russia Heritage
Collection, 118

O

OHIO
Ada
Hungarian Communion of Friends, 138

Berlin
Mennonite Information Center
(German), 116
Celina
Mercer County Historical Museum (Multi-
ethnic), 222
Chillicothe
Hopewell Culture National Historical Park
(Native American), 248
Cincinnati
American Jewish Archives, 157
Hebrew Union College-Jewish Institute of
Religion (Jewish), 164
University of Cincinnati German-Americana
Collection, 125
Cleveland
African American Museum, 2
Alliance of Poles Library, 269
Cleveland Hungarian Heritage Society
Museum, 137
Cleveland Public Library Foreign Literature
Department (Multi-ethnic), 211
Czech Catholic Union, 72
Romanian Ethnic Art Museum, 287
Slovak Institute, 299
Slovak Writers and Artists Association, 300
Sokol Greater Cleveland (Czech), 74
Temple Museum of Religious Art
(Jewish), 178
Ukrainian Museum-Archives, Inc., 336
Union of Poles in America, 282
Columbus
National Black Programming
Consortium, 26
Ohio State University Black Studies
Library, 28
Palatines to America (German), 121
Eastlake
Our Croatia Inc./Croatian Heritage
Museum and Library, 69
Gallipolis
French Art Colony, 92
Kent
Center for the Study of Ethnic Publications
and Cultural Institutions (Multi-
ethnic), 210
International Association for Research in
Vietnamese Music, 341
Kidron
Kidron-Sonnenberg Heritage Center
(Swiss), 319
Millersburg
Holmes County Public Library
(German), 112
Ohio Amish Library, Inc., (German), 119
New Philadelphia
Schoenbrunn Village State Memorial
(German), 123
North Olmsted
Union & League of Romanian Societies of
America, Inc., 288

Oak Hill
Welsh-American Heritage Museum
Society, 342
Oberlin
Oberlin College Archives (African
American), 27
Painesville
Indian Museum of Lake County, Ohio
(Native American), 249
Parma
Diocesan Cultural Museum (Carpatho-
Ruthenian), 61
Strongsville
Belarusan-American Community Center
Polacak, 55
Sugarcreek
Alpine Hills Historical Museum
(German), 99
Wilberforce
Wilberforce University Rembert E. Stokes
LRC Library (African American), 33
National Afro American Museum and
Cultural Center, 26
Youngstown
Mahoning Valley Historical Society (Multi-
ethnic), 221
Zoar
Zoar Village State Memorial, 127
OKLAHOMA
Anadarko
Indian City USA, Inc. (Native
American), 248
National Hall of Fame for Famous American
Indians, 253
Southern Plains Indian Museum (Native
American), 261
Broken Bow
Gardner Mansion and Museum (Native
American), 245
Langston
Melvin B. Tolson Black Heritage
Center, 22
Lawton
Museum of the Great Plains (Native
American), 252
Muskogee
Five Civilized Tribes Museum (Native
American), 244
Norman
University of Oklahoma, Western History
Collections (Native American), 263
Ponca City
Ponca City Cultural Center and Museum
(Native American), 257
Tahlequah
Cherokee National Historical Society, Inc.
(Native American), 240
Tulsa
Fenster Museum of Jewish Art, 163
Thomas Gilcrease Institute of American
History and Art (Native American), 262

Tuskahoma
Choctaw Nation Museum (Native
American), 241
Wewoka
Seminole Nation Museum (Native
American), 258
OREGON
Astoria
Astoria Public Library (Finnish), 89
Forest Grove
Pacific University Archives (Native
American), 256
John Day
Kam Wah Chung & Co. Museum
(Chinese), 67
Klamath Falls
Favell Museum of Western Art and Indian
Artifacts (Native American), 243
Portland
Finnish-American Historical Society of the
West, 90
Salem
Oregon Mennonite Archives and Library
(OMAL) (German), 120

P

PENNSYLVANIA
Ardmore
Scottish Historic and Research Society of the
Delaware Valley, Inc., 295
Bethlehem
Moravian Museums of Bethlehem, Inc.
(German), 117
Birdsboro
Pennsylvania German Society, 121
Bryn Mawr
Scotch-Irish Foundation, 294
Danville
Jankola Library and Slovak Archives, 297
Enon Valley
Slovene Heritage Center, 301
Frackville
Lithuanian Cultural Museum, 192
Gordonville
Pequa Bruderschaft (Brotherhood)
Library, (German), 121
Green Lane
Goschenhoppen Historians, Inc.
(German), 110
Harleysville
Mennonite Historians of Eastern
Pennsylvania (German), 115
Huntington
Juniata College Beeghly Library
(German), 113
Jenkintown
Ukrainian Heritage Studies Center, 334
Lancaster
Franklin and Marshall College Shadek-
Fockenthal Library, 104

Lancaster Mennonite Historical Society
(German), 114
Lenhartsville
PA Dutch Folk Culture Society, Inc.
(German), 120
Ligonier
Antiochian Village Heritage and Learning
Center (Arab), 34
United Lutheran Society, 300
Lincoln University
Langston Hughes Memorial Library Special
Collections and Archives, 20
Middletown
Slovak League of America, 299
Slovak Museum and Archives, 299
Monongahela
Slovak Eastern Catholic Synod of
America, 298
Nazareth
Moravian Historical Society (German), 117
Pennsburg
Schwenkfelder Library (German), 123
Philadelphia
Afro-American Historical and Cultural
Museum, 4
American Aid to Ulster (Irish), 144
American Philosophical Society Library
(Multi-ethnic), 204
American Swedish Historical Museum, 310
Balch Institute for Ethnic Studies
(Multi-ethnic), 207
Charles L. Blockson Afro-American
Collection, 12
Congregation Kahal Kadosh Mikveh Israel
(Jewish), 162
Free Library of Philadelphia Rare Book
Department (German), 105
German Society of Pennsylvania Joseph
Horner Memorial Library, 108
Germantown Historical Society
(German), 108
Historical Society of Pennsylvania, 216
Latvian Choir Association of the U.S., 187
Lutheran Archives Center at
Philadelphia, 220
Lutheran Theological Seminary at
Philadelphia Krauth Memorial Library
(German), 114
National Museum of American Jewish
History, 174
Philadelphia Folklore Project (Multi-
ethnic), 229
Philadelphia Jewish Archives Center, 176
Providence Association of Ukrainian
Catholics in America, 328
Swedish Colonial Society, 316
Taller Puertorriqueno, Inc., 285
Ukrainian Artists Association in
U.S.A., 332
Ukrainian Political Science Association in
the U.S., 339

Welsh Guild of Arch St. Pres. Church, 343
Pittsburgh
African American Collection, 1
Byzantine Catholic Seminary Library
(Carpatho-Ruthenian), 60
Nationality Rooms at the University of
Pittsburgh (Multi-ethnic), 226
National Slovak Society of the USA, 298
Polish Falcons of America, 276
Polish Historical Commission of Central
Council of Polish Organizations, 278
Rodef Shalom Jewish Museum, 177
Sisters of St. Francis of the Providence of
God (Lithuanian), 196
Vardy Collection Hungarian Cultural
Society of Western Pennsylvania, 141
Radnor
Peter Alriche Foundation (Dutch), 84
Reading
Alvernia College Dr. Frank A. Franco
Library Learning Center (Polish), 269
Italian American Research Center, 152
Richfield
Juniata District Mennonite Historical Society
(German), 113
Scranton
Polish National Catholic Church in
America, 280
Polish National Catholic Church in America
Central Diocese Archives and
Library, 280
Ukrainian Fraternal Association, 333
Skippack
Tartan Educational and Cultural
Association, 296
Towanda
French Azilum, Inc., 93
Willow Street
Hans Herr House (German), 111

R

RHODE ISLAND
Newport
Touro Synagogue (Jewish), 179
William Hunter Society, 58
Pawtucket
American-French Genealogical Society, 91
Providence
Rhode Island Black Heritage Society, 29
Rhode Island Jewish Historical Assn., 177
Woonsocket
Union Saint Jean Baptiste Mallet Library
(French), 98

S

SOUTH CAROLINA
Aiken
Polish Heritage Association of the Southeast-
Aiken (Phase A), 277

Charleston
Avery Research Center for African
 American History and Culture, 7
Huguenot Society of South Carolina
 (French), 95
Columbia
Museum of African-American
 Culture, 24
Orangeburgh
Orangeburgh German-Swiss Genealogical
 Society, 119
SOUTH DAKOTA
Aberdeen
Dacotah Prairie Museum (Native
 American), 242
Crazy Horse
Crazy Horse Memorial (Native
 American), 241
Freeman
Freeman Academy Heritage Archives and
 Museum (German), 105
Mitchell
Oscar Howe Art Center (Native
 American), 255
Pine Ridge
Heritage Center (Native American), 247
Rapid City
Sioux Indian Museum (Native
 American), 260
St. Francis
Buechel Memorial Lakota Museum (Native
 American), 239
Sioux Falls
Center for Western Studies (Multi-
 ethnic), 210

T

TENNESSEE
Chattanooga
Chattanooga African-American Museum, 13
Knoxville
Beck Cultural Exchange Center (African
 American), 7
Memphis State University Chucalissa
 Archaeological Museum (Native
 American), 250
TEXAS
Austin
Catholic Archives of Texas (Multi-
 ethnic), 209
Center for Neo-Hellenic Studies
 (Greek), 128
Documentation Exchange (Latin
 American), 186
French Legation, 94
Population Research Center Library (Multi-
 ethnic), 230
Dallas
African American Museum, 2
Dallas Memorial Center for Holocaust

Studies (Jewish), 162
Museum of African American Life &
 Culture, 25
Fredericksburg
Pioneer Museum Complex and Verein
 Kirche Archives (German), 122
Houston
Heartman Collection (African American), 19
New Braunfels
Sophienburg Museum and Archives
 (German), 124
Round Top
University of Texas at Austin Winedale
 Historical Center (German), 126
San Antonio
Institute of Texan Cultures (Multi-
 ethnic), 219
Spanish Governor's Palace, 308
Temple
Slavonic Benevolent Order of the State of
 Texas (SPJST) Museum (Czech), 73

U

UTAH
West Jordan
Dutch Family Heritage Society, 82

V

VERMONT
Brattleboro
Center for Arab-Islamic Studies, 35
Poultney
Green Mountain College Griswold Library
 (Welsh), 342
VIRGINIA
Alexandria
Alexandria Library, Lloyd House Archives
 (African American), 5
Ararat Foundation (Armenian), 36
Annandale
American Irish Bicentennial Committee, 145
Burke
German-American Information and
 Education Association, 106
Hampton
St. John's Church and Parish Museum, 58
Hardy
Booker T. Washington National Monument
 (African American), 10
McLean
American Committee for Aid to
 Poland, 270
Richmond
Congregation Beth Ahabah Museum and
 Archives Trust (Jewish), 161
Virginia Union University (African
 American), 31
Springfield
Vietnam Refugee Fund, 341

W

WASHINGTON
 Seattle
 Nordic Heritage Museum, 292
 Wing Luke Asian Museum, 52
 Spokane
 Oregon Province Archives of the Society of
 Jesus (Native American), 255
WASHINGTON, DC
 African American Resource Center, Howard
 University, 2
 African Cultural Center, 3
 Afro-American Historical and Genealogical
 Society, 4
 American Center of Polish Culture, Inc., 270
 American Folklife Center, Archive of Folk
 Culture (Multi), 204
 American Institute for Contemporary German
 Studies-AICGS, 101
 American Hellenic Educational Progressive
 Association (AHEPA), 127
 Anacostia Museum (African American), 6
 Arab American Institute, 35
 Armenian Assembly Resource Library, 37
 Asia Resource Center, 45
 Assembly of Turkish American
 Associations, 325
 Association for the Study of Afro-American
 Life and History, 6
 B'nai B'rith Klutznick National Jewish
 Museum, 160
 Fondo del Sol Visual Arts Center (Multi-
 ethnic), 214
 Frederick Douglass National Historic Site
 (African American), 16
 German Historical Institute, 107
 Hillwood Museum (Russian), 289
 India Study Circle for Philately (Indian), 143
 Lillian and Albert Small Jewish Museum, 172
 Moorland-Spingarn Research Center (African
 American), 22
 National Center for Urban Ethnic Affairs
 (Multi-ethnic), 225

 National Museum of American History
 Smithsonian Institution Arab American
 Collection, 36
 National Museum of American Jewish Military
 History, 174
 Organization of Chinese Americans, 67
 Southeast Asia Resource Action Center-
 SEARAC, 51
 St. Mary's Armenian Apostolic Church, Balian
 Library, 44
 Ukrainian National Information Service, 337
 United States Holocaust Memorial Museum
 (Jewish), 179
 U.S.-Japan Culture Center, 157
WEST VIRGINIA
 Helvetia
 Helvetia Museum (Swiss), 319
WISCONSIN
 Allenton
 Scandinavian Collectors Club Library, 293
 Blue Mounds
 Little Norway, 265
 Green Bay
 University of Wisconsin-Green Bay Cofrin
 Library Special Collections Dept., 57
 McQuon
 Freistadt Historical Society (German), 106
 Milwaukee
 American Association for the Advancement
 of Polish Culture, 270
 St. Sava Serbian Orthodox Cathedral, 296
 New Glarus
 Chalet of the Golden Fleece (Swiss), 319
 New Glarus Historical Society (Swiss), 320
 Swiss Historical Village, 321
 Pulaski
 Franciscans of the Assumption B.V.M.
 Province (Polish), 272
 Wausau
 Jugoslavia Study Group (Croatian), 69
WYOMING
 Green River
 Sweetwater County Historical Museum
 (Multi-ethnic), 232

About the Compilers

LOIS J. BUTTLAR is Associate Professor, School of Library and Information Science, Kent State University. She has published books and articles related to education, ethnic collections, and multicultural librarianship. She co-authored (with Rosemary Du Mont and William Caynon) *Multiculturalism in Libraries* (Greenwood, 1994) and was Associate Editor of *Ethnic Forum: Journal of Ethnic Studies and Ethnic Bibliography* from 1980 to 1995.

LUBOMYR R. WYNAR is Editor of *Ethnic Forum: Journal of Ethnic Studies and Ethnic Bibliography* and is Director of the Center for the Study of Ethnic Publications and Cultural Institutions at Kent State University. He has authored over 1,300 books, reference guides, articles, and reviews in the areas of history, ethnic studies, bibliography, library science, and other subjects. He is presently Professor Emeritus at Kent State University and Professor of History at the Ukrainische Freie Universitaet in Munich.

ISBN 0-313-29846-7

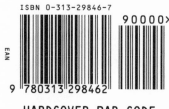

90000>

EAN

9 780313 298462

HARDCOVER BAR CODE